McBroom's
CAMERA
BLUEBOOK

A complete, up-to-date
price and buyer's guide
for
NEW and USED
CAMERAS, LENSES & ACCESSORIES

6th Edition

MICHAEL MCBROOM

AMHERST MEDIA, INC. ■ BUFFALO, NY

Published by:
Amherst Media, Inc.
P.O. Box 586
Buffalo, N.Y. 14226
Fax: 716-874-4508
www.AmherstMediaInc.com

Publisher: Craig Alesse
Senior Editor/Project Manager: Michelle Perkins
Assistant Editor: Matthew A. Kreib

ISBN: 1-58428-013-1
Library of Congress Card Catalog Number: 95-79174

Printed in the United States of America.
10 9 8 7 6 5 4 3 2 1

Acknowledgements

Anyone who takes on the task of writing a comprehensive book soon realizes that it cannot be created in a vacuum. Such is especially the case here. I have many people to thank for their unflagging support, encouragement and advice. I would like to thank them all personally, although I know I will leave someone out, so I apologize in advance for any omissions.

Special thanks go out to Silvio Bello of Silvio's Photo-works in Torrance, California, for providing many of the cameras used for illustrations, and for his help with tracking down answers to a host of questions; to Tod Maltby of Alpha Photo-Technical in Salt Lake City, Utah, for providing me with hundreds of listings, especially those in the large format section; to Charles Duckworth of Sierra Camera in Reno, Nevada, for his help with the Leica, Zeiss and large format sections; to Roger Adams, for his tutelage on the Graflex system; to Bob and Laura Greenberg and the courteous crew at Alhambra Camera in Alhambra, California, for providing information on many recent camera models; to the helpful folks at Samy's and B&H; to James Spencer of James Spencer Photography in Phoenix, Arizona for his coaching and insight with the large format arcana; and especially to Craig Alesse at Amherst Media, whose unsinkable optimism, cajoling and support kept me going, even when I was convinced I couldn't possibly write another word.

Others who have passed on valuable advice, or provided cameras for illustrations, must be mentioned also, although I know I'll be leaving many out. Thanks to Peter Ashworth, Mark Baehr, Bill Bagnall, Tom Bates, Don E. Brown, Jack Chalais, Bill Carrol, Bill and Cecilia Cox, Imre de Pozgay, Keith Fornof, Jim and Mike Frizle, Bill Gabb, Eric Gilbert, Richard Griffin, Murray Gutman, Les Hobbs, Manfred Kallweit, Reza Kami, Gigi Lash, Filippo Laveneziana, Gene Lester, Phil Lohman, Greg Locke, Chuck Mahan, Rob McBerge, Joe McGerald, Steve Molitor at Long Beach Camera, Roger Newsham, Grant Perkins, Bill Rogers, Gene Taylor, Raja Vejendla, Ricky Yen, and the rest. Simply put, this book would not have been possible without you.

Table of Contents

Advanced Photo System

Panoramic Cameras

Medium Format Cameras

Introduction

JUST IN CASE YOU WERE WONDERING

I don't know about you, but from where I sit, a tremendous number of things have changed since the last edition of this book:

- The explosion of the Internet and the resultant echoic explosion of digital imaging technologies.
- The emergence of the first new film format in decades – APS.
- The maturation of autofocus technology to the point that current state-of-the-art 35mm AF cameras are capable of recording crisp images of most any event the average human is likely to come across.
- The long-awaited first steps at introducing autofocus to medium format.
- The relentless and almost geometric progression of computer processing speed and drive storage capacities, rendering commonplace many of the digital imaging tasks that only a few short years ago were simply beyond the means of most people.

Sadly, though, these same hotrods on the desktop are just barely able to keep ahead of the demands placed on them by the ever-more-bloated and bug-ridden code that a certain Washington-based software behemoth continues to burden the computer using public with. I know, buy a Mac, right? Sorry, I already had a couple for lunch. I'll have a Linux partition to go, please.

So, just in case you have been wondering why it has taken so long to get this latest edition of my book out, it is at least partially because so much more has had to go into it as the result of all the new stuff around now. And it is because, besides Amherst Media's fine editorial staff who have done a magnificent job of assembling my manuscript into the easy-to-use format you have before you, there is still only a single person responsible for researching, collating, and then writing down all the data that appears between the covers of this latest edition: Me.

SO, WHAT'S THIS BOOK ABOUT?

This book is about cameras and other pieces of photo gear that people buy to use. This is not a collector's price guide, although there is some inevitable overlap with a few makes, such as Leica and Rollei. In such cases, only models still bought and sold as user cameras, or those that are available in "user", i.e., not collectible condition, are included. I have intentionally omitted special and limited edition models, since these were intended as collectibles from their inception. Also omitted are certain rare makes and models that, while not originally intended as collectibles, have become such. Why have I done this? It isn't some sort of perverse feeling of pleasure I derive from denying you easy access to this knowledge. It's three things, actually. For one, it would be adding an extreme burden to the already daunting task of researching prices if I were to add in the highly collectible stuff, and two, prices for the very collectible items can be subject to all sorts of moves and corrections, which means whatever price I might quote will be inaccurate to some degree by the time the book leaves the printer. Lastly, in many cases the differences between an unusually valuable piece and a run-of-the-mill one can be very minute. Thus, quite often a special and expert knowledge is required to impart this information to the reader. I simply don't have the time or the resources to do this. This lack of necessary attention to detail would ultimately end up diminishing the value of the collectible references in my book. And none of us need that.

Instead, the intent of this book is to provide the reader with a comprehensive listing of prices and descriptions for popular photo equipment. All the popular camera brands are listed, while a number of borderline and lesser-known makes haven't been included. From a purely logistical standpoint, the line had to be drawn somewhere. It's called the Law of Diminishing Returns. It takes much more time to compile information and prices on Konica, for example, than it does for Nikon. Yet, in terms of sales, especially with used

equipment, there may be a hundred Nikons sold for every Konica.

☐ THE MCBROOM'S CAMERA BLUEBOOK CONDITION RATING SYSTEM

I've adopted a simplified version of the system popularized by *Shutterbug* magazine for describing equipment condition. Price ranges are broken down into four categories: New, Mint, Excellent and User. Using the Excellent range as an example, a price on the high end of the range usually represents an item whose condition is known in Shutterbug parlance as "Excellent Plus" (often abbreviated as Exc+), while the low price represents "Excellent Minus" (Exc-).

Yes, but what does this mean, you ask? Well, since you asked, here it is in a nutshell: New is self-explanatory. Mint = new condition, but previously sold. Mint minus (the lower end of the Mint range) = a minor mark or two. Excellent = light signs of use, minor brassing or bright marks on corners (less wear for the high end of the range, more for the lower end). User = noticeable signs of use, pronounced brassing or bright marks on corners, expect to find a ding here and there. An item whose price is listed in the lower end of the User range won't be pretty.

These ratings reflect an item's cosmetic condition only. An item's mechanical, electrical or optical condition is always assumed to be in good working order unless specifically stated otherwise.

☐ PRICES

Although a few price-guide pretenders would have you believe otherwise, *McBroom's Camera Bluebook* is still the only book available that provides the reader with a comprehensive listing of current, real-world prices for popular photo equipment. You'll find no photocopies of manufacturers' price lists here. Nor will you find sliding-scale pricing strategies based on list prices. The prices for new and used equipment shown in the following pages were obtained from a variety of sources, ranging from businesses who advertise in national photo-oriented publications, such as *Shutterbug, Popular Photography,* and *Petersen's Photographic,* to camera swap meets and shows. Be aware that the prices shown are asking prices and much of the time an item can be obtained for less if you're willing to haggle. Also, if you attend camera shows, you will generally see lower prices than those shown here. The reasons are simple: dealers at camera shows often have less overhead than advertisers in national magazines and pass their savings to their customers, plus the competition at these shows drives prices down.

All prices are grouped within ranges and rounded off to the nearest five dollars. The range of new prices usually reflects the differences found between the large East Coast mail order retailers (lower), and most other discount retailers (higher). List prices are given only when the items are sold at list, even by discount retailers.

New prices were included for a few reasons:

1. This book can serve as a quick reference when shopping for new camera equipment.
2. For many items, especially newer ones, used prices were unavailable. Having a price range for an item in new condition allows the buyer to make an informed judgement when buying that item in used ondition. It is not unlike the transitive property in algebra: If a=b and b=c, then a=c. If Knowledge = Power and Power = Money, then

Knowledge = Money. In this case it means money saved, which is money in your pocket that may not have been there otherwise.

3. To put used prices in perspective. In some instances prices for used equipment are higher than new. Some mail order retailers have been known to advertise new equipment for cheap prices when it's not readily available or not even in stock. However, another factor is more often the case: If a dealer's price for a new item falls around the high end of the "New" range, he or she may price a used item based on a discount of his or her own new price. This is usually why you will see occasional overlaps in prices between the New and the Mint ranges.

One should keep in mind this fact when I price lenses: I will adjust the used prices shown in the book only if the most recent prices I have obtained fall outside the existing ranges. If the current prices I find fall comfortably within the ranges, and are not excessively bunched up toward the high or low end, I will just leave the prices alone. So don't think that, just because you may see several price ranges that are the same as in a previous edition that I have somehow overlooked something. I assure you, literally months of time has been spent accumulating the pricing data you see in this book, and if a price range is the same in the current edition as it is in an earlier edition, it is entirely due to the fact that the prices have not moved appreciably enough for me to adjust the ranges.

☐ PHOTO EQUIPMENT AND THE INTERNATIONAL EXCHANGE RATE

As I write this, the U.S. dollar just hit a 7-year high against the Japanese yen (135 yen to the dollar), plus it remains very strong against the

benchmark European currencies. Those of you who have copies of the previous edition of this book may remember my discussing the slide of the dollar on foreign markets and the skyrocketing prices of cameras and photo equipment.

Well, things seem to have come full circle. . . again. Now the Asian markets are the ones that are suffering, and prices for photo gear are, for the most part, very close to where they were when the last edition of the book was completed. In some cases, the prices are a bit higher, in some cases, lower, and in a few cases they simply stretch the bounds of credibility because of the amount by which they have risen. Certainly inflation or exchange rates aren't the cause. Typically, when you see enormous price hikes confined to a single manufacturer, this denotes an attempt to preserve profits in the face of shrinking market share. A sure ticket to disaster for most companies, but certain well-known ones in the photo industry seem to get away with these sorts of practices. Snob appeal is what I figure.

Setting such exceptions aside for the sake of this discussion, we in the United States (and other countries where the local currency remains strong) should expect to see a continued downward trend in new camera prices as long as the dollar remains strong. Obviously, however, exchange rates fluctuate continually abd are subject to factors beyond our control. Y2K is an annoying concern as I write this (it hasn't happened yet), and is an example of one of these events.

Buying Pointers

☐ NEW PHOTO EQUIPMENT

There are essentially three ways to buy a new item:

1. Your local camera shop. If you value service both before and after the sale, there is no better way to go. Your local camera shop will take the time to point out an item's features, demonstrate it, and compare it with similar items. Their prices are usually higher than those of the other alternatives, but you're getting personalized service. Plus, you've established a rapport that may well prove invaluable as years go by, especially if you're a pro or a serious amateur. In this day and age, the local camera shop has become an endangered species. If you can afford it, support your local camera shop. You'll be glad you did.

2. Your local discount retailer. Usually a discount department store that carries photo equipment in addition to clothing, major and minor appliances, recliners, sporting goods, hardware and tires, has better prices than your local camera shop, since they buy in large quantities. But there are trade-offs. You'll more often than not be discussing an item's features with someone who knows next to nothing about it and the selection may be limited. In other words, if you want cheap prices, you take what they give you and don't count on service after the sale.

3. A mail-order photo equipment house. Buying from a mail-order photo retailer, whether by phone, through the mail or over the internet, is usually the best way to save money, but it has risks. Mail-order houses buy in tremendous quantities compared to your local camera shop. When a mail-order house sells tens of thousands of dollars of a single manufacturer's merchandise each week, as opposed to that much per year from a small retailer, it only stands to reason that these large retailers will receive more favorable price breaks from a manufacturer than small retailers will. However, there are trade-offs to buying by mail and they are several: No personalized service; you can't see the item before you buy it; it may not have a U.S. warranty; it may not be complete as supplied by the manufacturer; it may have been sold before. You should consider buying an item via mail order only if you are already familiar with its features and capabilities.

Horror stories abound about buying photo equipment through the mail. Some mail-order dealers are more reputable than others. If you're unsure, ask around. Your local camera club might be a good place to start.

In all fairness, I must tell you that my good experiences outweigh the bad. In large part my good fortune is due to being selective. My success has also been due to the way I have ordered. What follows is a list of some practices I've employed to help me decide when to purchase by mail, and how to minimize problems:

1. *Read the ad thoroughly before calling, especially the fine print.* Is there a disclaimer stating that "some" merchandise may be "parallel imports" (aka gray market)? Be aware that gray market merchandise will not have a U.S. warrantee. In the aftermarket lens listings, are all lens mounts offered at the same price? If words such as "other mounts may vary [in price]" are used, you can count on the fact that any mount other than the one for which their prices apply will be higher.

If no price is listed for an item and the advertizement says "Call" instead, call their toll-free number. This number is usually reserved for credit card orders only, but if they won't (or can't) print an item's price, why should you have to pay for the call? With very new items, a store's ad for an item may list "Call" instead of a price, because they may only know that it will be available soon, but do not know what its selling price will be. This is usually due to publication deadlines. A lead time of up to three months may be required to place an ad. Obviously, a store doesn't want to

miss out on any sales, even though it may not yet know what it will sell for, so its ad will say "Call." In other cases, stores may choose to print "Call" if an item is new, but is also in very short supply. Stores will then charge whatever price they feel the market will bear. Beware. Sometimes you're paying for availability.

But in other instances, a store can't print the price without being subjected to a significant penalty. Why can't a store print a price? It has to do with something called shared-cost advertising. Manufacturers frequently help stores defray the cost of advertising by sharing in the cost of these ads. In their efforts to protect smaller dealers, however, some manufacturers set prices below which their products cannot be advertised. If a store advertises an item below these set prices, it runs the risk of losing a manufacturer's ad contributions. In a national publication, the cost of one, full-page ad can run into thousands of dollars, so it behooves the store to do what it can to lower this cost.

2. *Does the store offer a 30-day money-back guarantee? Is there a restocking fee?* If the answers are No and Yes (in that order), take your business somewhere else.

3. *When you call, ask if the advertised price includes a U.S. warranty.* If the item comes with an "international warranty," be aware that an international warranty is valid only if the item is purchased outside the U.S. Some mail-order houses offer warranties on their gray market merchandise, but they may not be as comprehensive as those offered by the manufacturers. Be advised that with many of the latest computerized cameras, only the manufacturer's factory-trained service personnel know how to repair them.

Ask what the item's price will be with a U.S. warranty. You can bet it will be higher. Armed with this knowledge, you can make an informed decision as to which way you want to go.

4. *Ask what the shipping and handling charge will be.* This single item on the invoice often contains most of the store's profit from a sale. Don't be surprised if the shipping and handling charge for even a small, inexpensive accessory is in the neighborhood of $10.

5. *Make sure the item comes complete with all accessories as supplied by the manufacturer.* Some unscrupulous dealers remove accessories from camera boxes, such as straps, eyecups, batteries, or separate lenses from factory-supplied lens cases, then sell them back to the customers at inflated prices. This practice, called stripping, isn't nearly as big a problem as it used to be, but it still happens occasionally.

6. *To minimize the possibility that the seller will back-order your merchandise, use a credit card or have the seller send the item COD, shipped UPS second-day air and ask them to check stock.* You'll have to pay a few extra dollars for second-day service, but it may remove the temptation for them to tell you they have it in stock when they really don't. If they don't have an item in stock, by law they have up to 30 days before they must notify you that the item has been back ordered. Meanwhile, they have the use of your money and you don't.

If you order by anything other than a credit card, send a money order, or have it shipped COD. If you send a personal check, the order may be held until the check clears. If you plan to send a money order, you should still ask them to check stock. The chances that the item won't be

back-ordered are at least reduced. Another downside to ordering by mail is that you can't use these stores' toll-free numbers. They're for credit card orders only.

7. *Be patient.* If you plan to order several items, start by ordering one item from one store. See what sort of service you get. If it's not to your liking, take your business elsewhere.

If all this seems to be too much trouble, remember why you were ordering the item through the mail in the first place – to save money. If it still seems like too much trouble, do what most professionals do and patronize your local camera shop.

☐ USED PHOTO EQUIPMENT

Before buying any piece of used equipment, check it thoroughly. It's always a good idea to get some sort of assurance from the seller that a piece of photo equipment is working properly. Many camera dealers will supply their used equipment with warranties, typically from 30 to 60 days. Others offer a 10 to 15 day return privilege, which gives the buyer ample time to try it out. If the dealer is unwilling to offer a warranty or return privilege, take your business somewhere else.

Camera Buying Pointers

1. *If the camera has a meter, does it work?* Is it accurate? Compare its readings with another camera or hand-held meter of known accuracy. To avoid metering errors due to different metering patterns, these tests should be conducted by using lenses of the same focal length, both set at infinity (if you're comparing two cameras' meters), and by metering a blank, evenly lit surface. A 50mm lens is best for this, especially if you're comparing the camera with a hand-held light meter. If the readings are within

$^1/_2$ stop of each other, chances are it's close to factory specifications. Different camera manufacturers have different philosophies about what correct exposure is. A manufacturer may incorporate an exposure factor into a camera's meter. This is why you should allow up to $^1/_2$ stop latitude between readings from two different cameras.

2. *Do the other features of the camera work properly?* Check them all. If you don't know how, have the seller demonstrate them.

3. *Set the camera on its slowest shutter speed (other than B or T) and trip the shutter.* The slowest speeds are seldom used and sometimes become sluggish because the lubricant in the timing mechanism may have become gummy. If the slowest speed times out reasonably well, then all the other slow speeds should be close. If the camera has an electronically-controlled shutter, still check the one or two second setting. I rarely check shutter speeds that extend to 30 seconds or more. With an electronic shutter, if one second works, chances are the slowest speed will work as well.

4. *Check the inside of the camera, especially the film transport areas.* Look for abrasions, corrosion, excessive amounts of dust, and make sure that somebody hasn't tried to put a finger through the shutter. Examine the film pressure plate for wear or scratches. It should be smooth. Cameras that have seen lots of use will often show some wear on the pressure plate, but it should still be smooth. To look for pinholes in a focal plane shutter, gently raise the mirror (if possible), and, with the shutter closed and the back open, point the camera toward a light source. Examine the shutter. There should be absolutely no light leaks.

Because focal plane shutters have two shutter curtains, this procedure should be performed twice: with the shutter cocked and uncocked.

5. *Look into the viewfinder. Is it dirty?* One or two specks is nothing to worry about; dirt in the viewfinder can in no way affect the quality of your photos. But if the finder is really dirty, chances are pretty good that the rest of the camera's interior is, too, and that it wasn't well cared for by its previous owner. At the very least, it will need a cleaning.

6. *Check around the metal joints and screws for any evidence of corrosion.* Most cameras will tolerate a little moisture without showing any effects. However, lots of people take their cameras to the beach and then forget to clean them off afterward. Salt air may be invigorating to humans, but it is death to metal. If a camera has been in contact with salt water, forget it. It's junk.

Lens Buying Pointers

1. *Check that the aperture iris blades move freely.* If the lens has been stored on its side for a long time, or if it has seen the inside of a hot car once too often, the lubricant for the focusing helical may have oozed out and coated the aperture blades. If this happened, the lens must be dismantled and cleaned.

2. *Check the focusing ring. Does it move freely?* If it's stiff, the lubricant has begun to coagulate. To remedy this, the lens must be dismantled, the old lubricant removed and replaced with fresh lubricant. Does the focusing ring move freely, but bind noticeably in one spot? If it's a very slight sluggishness, this could be caused by a patch of the lubricant that's begun to coagulate, which can often be worked out by turning the ring back and forth. But if there is a

noticeable drag in one spot, chances are the lens has been dropped and the focusing ring was bent, in which case the ring must be replaced. If the focusing ring moves with almost no resistance, the lens has probably been used a lot. This does not necessarily indicate a problem; in fact lots of folks prefer their lenses this way.

3. *If the lens is a one-touch zoom lens, check for wobble.* Zoom the lens out to its maximum extension and, holding an end in each hand, gently flex the lens. Cheap zooms, even when new, often show significant amounts of wobble. Good quality zooms should not.

Does the zoom collar slip? Some folks mind this, others don't. Nikon makes some of the finest zoom lenses money can buy, but many Nikkor zooms are particularly prone to this problem. In fact, of all the zoom lenses that usually exhibit collar-slippage, the worst is the Nikkor 80-200 f/4.5, but optically it's one of the best 80-200's that has ever been made. Nevertheless, this can be annoying, especially when the camera is mounted on a tripod and inclined away from horizontal. Short of having the lens dismantled and re-lubricated, there are a couple of other solutions. The first is to place a wide rubber band on the barrel behind the collar. This will prevent the collar from slipping toward the camera. To prevent it from slipping forward, the rubber band can be positioned so its width overlaps the rear edge of the collar. The other solution is simpler: use a piece of tape.

4. *Make sure the lens focuses at infinity.* Try to focus on something as far away as possible. Distant mountains or the moon are best, if available. Many telephotos with focal lengths of 300 millimeters or longer

will actually focus past infinity. They are designed in this way to counter the expansion experienced in hot weather, which can affect infinity focus.

5. *With the lens off the camera, look through it at a strong light source (not the sun!).* A mini penlight works great for this. Is there dust inside? If there is, don't worry. Even a moderate amount of dust inside a lens will not affect your photographs, but it can be used as a negotiating point.

Check for element separation and for imperfections or scratches in the coating or surface of both front and rear lens elements. Much misconception exists about the effect scratches have on photographs. Generally, a scratch on the rear element of a lens – especially a wide-angle lens – will have a greater effect on photographs than a scratch on the front element. But, in all except the most severe instances, the only effect a scratch will have is on a lens' resale value.

Try this: take a piece of string and hold it to the front of your mounted camera lens. Look through the viewfinder and focus on whatever you want. Can't see the string, can you? Neither will the photograph. Now, imagine how ugly the front element of that lens would look if it had a scratch the same size as that piece of string.

In the worst of instances, a scratch may cause a loss of contrast because extraneous light rays are being refracted from the scratch and are bouncing around inside the lens. But even this isn't incurable. An old optician's trick is to fill scratches with india ink. Astronomers and telescope makers have known about this for years and it works beautifully.

Although lenses with scratches are often priced far cheaper than those in equivalent condition without scratches, many uninformed buyers will reject them out-of-hand. But for you, the knowledgeable lens buyer, those scratches have become transformed from a detriment into a negotiating tool.

Far worse than a scratch is fungus. In severe cases, fungus will cause noticeable degradation in contrast and will kill the resale value of a lens. Fungus results when equipment has been stored for years in a dark place with a sufficient amount of moisture for it to propagate, or when stored for shorter periods in a hot and humid environment. Fungus attacks the coating and sometimes even the cement that may hold elements together. If caught early, the fungus can be removed without having caused any noticeable damage. If it has been eating away at the coating for some time, however, it's very likely that it will have actually etched the glass. In any case, the lens must be entirely dismantled, cleaned, then recollimated and reassembled.

Remember, when shopping for used equipment, if it's priced too low, there's usually a reason. As always, caveat emptor – and happy hunting!

Canon

Canon manual-focus systems are listed first, followed by EOS SLRs and lenses. Camera descriptions appear in the approximate order of their introduction. Canon rangefinder cameras, which use the Leica thread lens mount, are listed in the Screw-Mount Leica section.

Following is a brief overview of Canon FL and FD SLRs. Excluded are the R-series Canons, such as the Canonflex and Canon R2000, which were the predecessors to the FL-series, and a few other Canon SLRs contemporary to FL cameras that, while having generally rendered photos of excellent quality, have become somewhat obscure. One other Canon SLR that is not listed is the Canon Pellix. Its popularity has always been due to its novelty instead of its picture-taking ability. Pellixes in very clean condition are still popular on the used market, but only for their collectible value.

☐ CANON FL-MOUNT CAMERAS

The following cameras were designed to accept Canon's FL-style breech lock lenses. The most significant difference between these cameras and later models designed to accept FD-style lenses is that the subject must be metered at taking apertures. But, so as not to render FL-mount cameras obsolete, Canon designed the FD lens line to be backward-compatible, hence FD lenses work well with these older cameras.

Canon FT-QL

This was Canon's first model with through the lens (TTL) metering and, perhaps more importantly, was the first Canon that let the photo world know Canon was serious about building quality 35mm SLR cameras.

The FT-QL's meter is activated by pushing the large, contoured lever (which doubles as a self-timer) toward the lens mount. This same motion stops the lens down and provides a depth-of-field check. Moving the lever in the opposite direction charges the self timer. Metering occurs only within a central rectangle, which encompasses about 12% of the image area. This metering rectangle is easily noticeable, being slightly darker than the surrounding viewing area.

Shutter speeds range from 1 second to 1/1000, plus B. X-sync occurs at 1/60. The camera has a "cold shoe," that is, an accessory shoe without a flash contact, and a PC socket. Other handy features are mirror lock-up, a

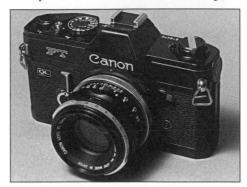

Canon FT-QL

self-timer, and Canon's unique-at-the-time QL (Quick Load) feature.

Canon FX & FP

The FX is a well-made, solid picture taker, even if it appears to be rather antiquated by today's standards. An external CdS exposure meter is located on the front of the camera, just below the film rewind crank. The meter readout scale is on the top left of the camera body. There is no meter information inside the viewfinder.

Shutter speeds cover the standard range, from 1 second to 1/1000, plus B. X sync is at 1/60. Other features are a self timer, mirror lock-up, an accessory shoe and a PC socket.

The FP is identical to the FX, except it lacks a meter.

Canon TL-QL

The TL-QL is a simplified FT-QL with a top shutter speed of 1/500 second, no mirror lock-up, no battery check and no shutter-release lock.

☐ CANON FD-MOUNT CAMERAS

Canon's design work for FD-mount cameras and lenses began in the mid-1960s, although the first examples weren't released until 1971. FD-mount Canon cameras were an enormous success during the 1970s and 1980s. Since the advent of the EOS line, however, Canon's interest in FD-mount cameras has plummeted despite the fact that there are millions of dedicated users of

the older, manual-focus system. Canon pledged in 1990 that it would continue to support the FD line for another ten years, but this statement may be deceptive. "Support" may mean nothing more than a pledge to provide technical support, service and repairs on FD lenses and the more recent FD-mount cameras until this ten-year period ends. Currently, the only FD-mount camera still being produced by Canon is the New F-1. The T-60 is made by Cosina.

Canon FTb & FTbn

The FTb was Canon's first SLR designed specifically for use with FD lenses to reach the retail market. As one might expect by the model designation, the FTb closely resembles the FT. Most notable among the similarities to its predecessor, the FTb retains Canon's QL feature, its full range of shutter speeds, and employs the same selective-area metering design used with the FT.

The main difference is the updated lens-to-body coupling, which allows full-aperture metering. Other differences include the mirror lock-up feature that, on the FTb, was combined with the self-timer/lens stop-down lever, resulting in an assembly that performs four separate functions. (See the accompanying section. explaining this ingenious four-in-one device.) The FTb has a hot shoe. The battery-check switch coaxial with the rewind crank was changed to a three-position meter on-off/battery-check switch. The shutter speed dial was simplified. Because of its FD-mount lens design the FTb was the first Canon SLR to employ full-aperture, match-needle metering. Depth-of-field preview was retained, as was stop-down metering so FL lenses could still be used. Note: When mounting an FD lens to an FTb, the aperture ring must be moved off the "A" setting, or the lens will not mount.

In 1973, Canon introduced an updated version of the FTb. It was, and

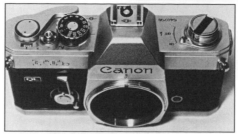
Canon FTb

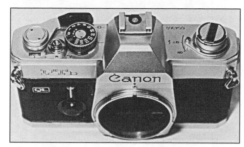
Canon FTbn with restyled film advance lever, shutter speed dial and self-timer shown

still is, referred to as the FTbn, but nowhere is this designation indicated on the camera. The differences are as follows: the all-metal film advance lever of the original model was redesigned for the FTbn and a black plastic tip was added; the shutter speed dial was changed slightly; shutter speeds are visible within the viewfinder of the FTbn. The FTb has a contoured stop-down/self-timer lever, whereas the FTbn's is a simpler-looking black affair with a white stripe in the center (identical in appearance to those on the EF and the original F-1).

Over twenty years after its introduction, the FTb still commands a large and loyal following. The FTb is an ideal, yet economical choice for photography students, Canon users with battery-dependent SLRs, or those who simply prefer to eschew automation.

□ CANON'S QL FEATURE

QL (Quick Load), an ingenious film loading system Canon introduced in the mid-sixties, was the forerunner to almost all the various recent, quick-loading designs used on today's do-everything photographic techno-wonders. All Canon cameras with this feature display

the QL symbol on the front of the camera. To use it is simplicity itself. You drop the film cassette into its well, draw the leader out to the red mark, close the camera back and advance the film to the first frame.

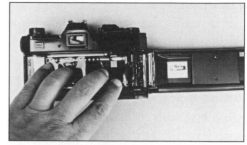
The film leader is pulled out to the red mark.

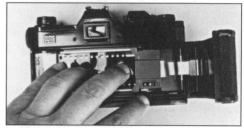
As the back is closed, a retainer plate holds the film in place.

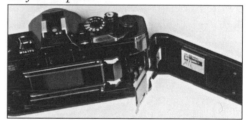
A look at the Canon QL mechanism. Note the illustration on the inside of the camera back.

□ CANON'S 4-IN-1 STOP-DOWN/SELF-TIMER MECHANISM

Unless you're mechanically inclined, it may take you a little while to puzzle out everything this arrangement can do. Let's examine the lever itself first. When facing the camera, rotating the lever fully counter-clockwise charges the self-timer. It's activated by depressing the shutter release. Pushing the lever clockwise stops the lens down momentarily for checking depth of field (this function operates only when the lens is off the "A" setting). By moving the small knob on the bottom of the assembly to the "L" posi-

tion and pushing the lever clockwise, the lens is locked in its stopped-down position. This setting is used most often when FL or other non-FD lenses are mounted. After having done this, moving the small knob to the "M" position raises the mirror. To get everything back to the way it was before, just move the small knob on the bottom of the assembly back to its original position.

Now, let's say you're out in your backyard and you want to take some-close-up shots of your prize-winning snapdragons with your trusty F-1. You have everything set up: your camera and macro lens are mounted on a sturdy tripod, you've decided on your composition and the lighting's just right. You've loaded slow slide film and metered the scene at $^1/_4$ second, so mirror lock-up will be essential — then your faithful dog Ralph eats your cable release. What to do? Use the self-timer, right? But wait! Remember how you had to push the lever clockwise to lock the aperture down, but that to use the self-timer, the lever has to be rotated counter-clockwise? What do you do now? Grab a stomach pump and chase after Ralph? Not to worry, Canon foresaw this problem when they designed this four-in-one unit. The lever itself does not lock in any position, only the mechanisms the lever actuates. It can still be rotated to charge the self timer and there is even a small white dot close to the hub to show when the self-timer has been charged.

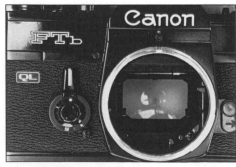

Canon's 4-in-1 self-timer/ mirror-lock/ stop-down mechanism. Shown in the normal position.

Self-timer charged with the mirror up.

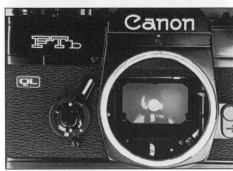

Stop-down metering position. The small knob is moved to 'L' (for Lock) and the stop-down/ self-timer lever is moved to the right until it locks in place. Note that the aperture coupling lever at the bottom of the mirror box has moved to the left, exposing a red dot. The stop-down/self-timer lever can also be pushed to the left for checking depth of field without moving the knob to 'L'.

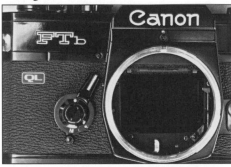

Mirror lock-up position. The small knob is moved to 'M' which raises the mirror.

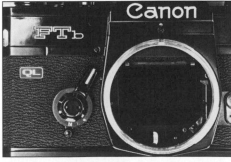

Same as before, but the lever has been moved back to its original position. Note the white dot above and to the left of the 'M'. This indicates the charged state of the self-timer.

Canon TLb & TX

The TLb, introduced a couple of years after the FTb, is a simplified, scaled down version of its big brother. It performs full-aperture, selective area metering with FD lenses, same as the FTb. The top shutter speed was trimmed to 1/500. It does not have the QL feature that the TL, its immediate predecessor, has. When introduced, it was a solid photographic workhorse and it remains so today.

The TX is a TLb with a hot shoe. Here's an aside for you: the Bell & Howell FD35 is virtually identical to the TX, the only differences being a few touches of cosmetics and the different name and logo. The FD35 was made by Canon for Bell & Howell as a result of their marketing agreement in the U.S. When pricing an FD35, use the TX listing below.

Canon EF

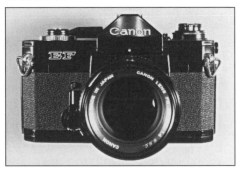

Canon EF

Fondly dubbed 'the Black Beauty,' the Canon EF was at the forefront of photo technology when it was introduced in 1973. It was expensive, selling for close to the same price as the professional model F-1. Sales of the EF were soft, and few were made. Clean examples are still highly prized and, even by today's standards, are capable, full-featured picture-takers.

The EF's exposure modes are shutter-priority AE and metered manual, using a centerweighted metering pattern. The extremely sensitive silicon photo cell meter has an ISO 100 EV

range from -2 to 18 (-2 = 8 seconds at f/1.4). Shutter speeds range from 30 seconds to 1/1000, plus B, with X sync at 1/125. Speeds from 30 seconds to 1 second are electronically-controlled; the remainder are mechanical. Other features include an AE lock, multiple exposure capability, mirror lock-up, depth-of-field preview and a self-timer. Unique to the EF is a system that allows the user to advance a freshly-loaded roll of film to the first frame without having to trip the shutter. After inserting the film leader on to the take-up spool and closing the back, crank the film advance lever until it stops. The shutter is cocked and the film is set to the first frame.

□ CANON F-1 SYSTEMS: THE ORIGINAL MECHANICAL MARVEL VS. THE MODERN HYBRID

Canon's F-1 cameras are regarded as some of the sturdiest and most accurate cameras ever built. Designed for the practicing professional, either system is fully modular, accepting interchangeable viewfinders, focusing screens, backs and both motor and winder options. Two principal versions have been produced since its introduction in 1971 and, since Canon elected to keep the same name for these two entirely different systems, keeping track of it all can be confusing.

Canon Original F-1 & F-1n

The original, mechanical F-1 was produced in two versions. The later model, introduced in 1976, was essentially an update of the earlier one. Both accept Canon's full line of original F-1 accessories.

The F-1 uses a 12% selective area metering pattern, which is seen within the viewfinder as a slightly darker central rectangle. Match-needle manual metering is handled by an extremely accurate CdS meter. Shutter speeds range from 1 second to 1/2000, plus B, with X sync at 1/60. Other features include a

self-timer, depth-of-field preview and mirror lock-up. The addition of the optional Servo-EE finder converts the F-1 into a shutter-priority AE camera. When the Booster-T finder is installed, the low-light metering sensitivity and slow shutter speeds are extended.

Now, for the obvious differences. The later model, commonly called the F-1n, differs from the original in a few noticeable areas. The most obvious are a redesigned film advance lever, now sporting a plastic tip, and the addition of a film memo holder to the back.

There are differences that aren't as apparent. The F-1n's meter switch is spring-loaded in the "C" (battery check) position, thereby preventing inadvertent drain. Multiple exposures are possible with the F-1n by depressing the film rewind button and cocking the advance lever (the film won't advance, but the counter will). The F-1n's film advance lever has a somewhat shorter stroke, and the shutter release collar was redesigned. Finally, the film ISO range was extended from 2000 to 3200.

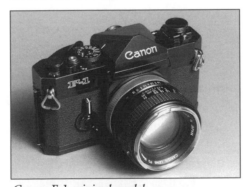
Canon F-1 original model.

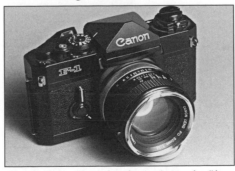
Canon F-1n. Note the plastic tip on the film advance lever.

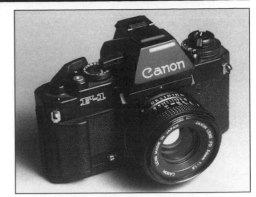
Canon New F-1 with the AE Finder FN.

Canon New F-1

The current F-1, called the New F-1 when it was introduced in 1981, is more commonly referred to in the trade as the F-1N (note the capital "N"). It's similar to the original F-1 in name only.

Exposure modes available depend on which viewfinder is attached and whether a film winding accessory is being used. With the Eye-Level Finder FN, match-needle manual is the only exposure mode. After attaching the AE Finder FN, the camera's available exposure modes expand to include both aperture-priority AE and metered manual. When either the Motor Drive FN or the Winder FN is attached, shutter-priority AE is available, independent of the finder being used.

Exposure metering is dependent upon the focusing screen installed. Three metering options are available through choice of the appropriate screens: center-weighted averaging, 12% selective area and 3% spot.

The New F-1 has a hybrid electro-mechanical shutter which provides electronically-controlled shutter speeds from 8 seconds to 1/60 and mechanical speeds from 1/90 to 1/2000, plus B. X sync occurs at 1/90. This dual-mode design provides the photographer with an adequate selection of shutter speeds in the event of battery failure.

Other features include: non-TTL flash AE, multiple-exposure capability, depth-of-field preview and a self-timer.

Canon dropped the mirror lock-up feature from the new design.

The original F-1 with a New F-1 exe-level finder attached.

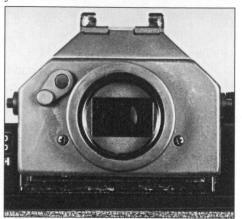

Rear view of above. Note the gap between finder and body.

Old & New F-1: Interchangeability

While Canon claims that no interchangeability exists between the two F-1 systems (except for eyepiece rings, eyecups and diopters), there is more than they would have you believe. A New F-1 viewfinder will fit onto an original F-1 body, but not vice-versa. Though the finder will slide onto the body without being forced and will click into place, it is not a precise fit. There is a slight gap between the finder and the body in the front and a larger one in the rear. The eye relief seems to be somewhat mismatched between the two finders also, making focusing more difficult. So, if you try using late-model finders on your early-model F-1, expect to have a tougher time focusing and do so only in situations where there is no chance of dust or moisture entering the camera.

☐ CANON A-SERIES CAMERAS

All A-series cameras are battery dependent and feature bottom- center-weighted metering, top shutter speeds of 1/1000 second and flash sync at 1/60. They also accept the standard A-series accessories, such as databacks and winders. The A-1 and AE-1 Program are the only two, however, which can use the Motor Drive MA. A brief explanation of each camera's features follow, listed in the order of their introduction to the market.

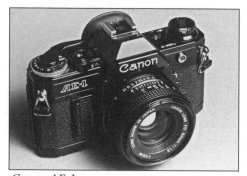

Canon AE-1

Canon AE-1

By today's standards the AE-1 is a simple, no-frills camera with limited auto options. When it was introduced in the mid-seventies, it was nothing less than revolutionary. Its lightweight design, incorporating state-of- the-art microcircuit technology, and its low price captured the interest of amateur photographers worldwide – leaving other manufacturers scrambling to catch up.

The AE-1 has two exposure modes: metered manual and shutter-priority AE. Non-TTL flash AE is also possible with dedicated flash units, as is stop-down metering for use with some of the older Canon FL and non-FD lenses. Shutter speeds range from 2 seconds to 1/1000, plus B. Other features include an AE lock, backlight control, multiple exposure capability, depth-of-field preview and a self timer.

Canon AT-1

Introduced shortly after the AE-1, the AT-1 is the only manual-exposure-

only A-series model. It features match-needle metering, reminiscent of the FTb, and shutter speeds from B to 1/1000. It is also the only A-series Canon that has an exposure needle (or indicator) coupled to the lens aperture ring – a nice feature. While the AT-1 is a manual camera, it is not a mechanical one. The electronic shutter is the same as that in the AE-1 and requires a battery to operate. Other features include stop-down metering, multiple exposure, depth-of-field preview, a hot shoe and a self-timer.

Canon A-1

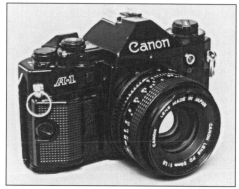

Canon A-1

Hexaphotocybernetic. Remember that mouthful? Just in case you weren't paying attention (or were a Nikon user or something), it was a word Canon's ad agency execs dreamed up to describe the feature-laden A-1 when it was introduced amidst much fanfare in 1978. Back then, its dazzling array of capabilities sent shock waves throughout the industry. A milestone in photography had been passed, portending what was to become commonplace in just a few short years. Photography would never be the same again.

Here's a little-known tidbit for you. As far back as 1976, Canon was testing working copies of the A-1, but it was called the New F-1. Apparently, Canon's management thought that professional photographers of the day would forsake their heavy, indestructible, mechanical cameras for the A-1's technical wizardry.

Knowing how conservative working pros can be, and considering the departure from the norm the A-1 represented at the time, I would bet early responses were. . . well, less than enthusiastic. But time has a way of proving worth, and such has been the case with the A-1. Ironically, many pros have come to depend on the features, lightness and reliability of the A-1.

The A-1's capabilities are so extensive that the following list of features is incomplete, but we'll take a stab at the high points. As the term Hexaphotocybernetic implies, the A-1 has six exposure modes: standard program, both shutter and aperture-priority AE, metered manual, non-TTL flash AE and stop-down AE. Shutter speeds range from 30 seconds to 1/1000, plus B. The A-1 has interchangeable focusing screens, but they must be interchanged by Canon or a qualified service center. Other features include exposure compensation, an ASA dial that ranges from 6 to 12,800, an AE lock, a back-light control, an eyepiece shutter, a multiple exposure switch, depth-of-field preview and a two-speed self timer (2 seconds and 10 seconds). The A-1 will accept all three film winding accessories Canon produced for the A-series cameras, the Winder A, the Winder A2 and the Motor Drive MA. With alkaline batteries, the Motor Drive MA will advance film at speeds up to 4.5 frames per second, slightly faster with the NiCad pack.

Canon AV-1

The AV-1, introduced in 1979, was targeted toward beginning photographers and those folks who preferred aperture-priority AE, but who didn't want to shell out the extra dollars for the host of other features one got with an A-1. The AV-1 is essentially an aperture-priority only auto exposure SLR, having just two user-selectable shutter speeds: 1/60 (flash sync) and B. The top

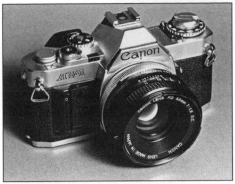
Canon AV-1

dial, which on most cameras is a shutter speed dial, has those two selections, plus the "A" setting for aperture-priority AE, and the self-timer setting. Shutter speeds from 1/1000 to two seconds are available.

Canon AE-1 Program

The AE-1 Program, introduced in 1981, is not just an AE-1 with a program mode tacked on. It was totally redesigned, more closely resembling a scaled-down version of the A-1 than an evolution of the AE-1. As the name suggests, the AE-1 Program has a program mode in addition to shutter-priority AE and metered manual. It has the same range of shutter speeds as the AE-1. The meter needle was replaced with LEDs. One feature of the AE-1 Program that represents an improvement over even the A-1 is its user-interchangeable focusing screens. When coupled to the AE-1 Program, the Motor Drive MA provides film advance speeds up to about 4 frames per second, slightly less than it does when used with the A-1.

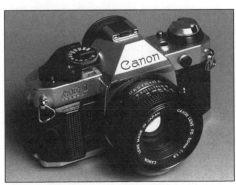
Canon AE-1 Program

Canon AL-1

The AL-1 was the last variant of Canon's A-series cameras, introduced in 1983 or so. It is the only A-series camera with a focus-assist feature, identified by the "QF" badge (for Quick Focus) on the front of the body. This system, a predecessor to auto-focus technology, works reasonably well, even in subdued light or with somewhat slow lenses.

Basic features include two exposure modes, aperture-priority AE and metered manual, and a self-timer. Shutter speeds range from 2 seconds to 1/1000 (1/15 to 1/1000 in manual mode), plus B. The AL-1 is the only A-series Canon that is powered by penlight batteries (two required).

Of all the A-series Canons, the AL-1 is probably the most often overlooked. Many folks who switch to autofocus systems do so because their eyesight 'ain't what it used to be' and often find themselves overwhelmed, bewildered, even turned off by the computerized picture takers that today's autofocus cameras have become. Also, for people who use the Canon FD system, the switch to autofocus can be an expensive one, since there is no interchangeability between FD and EOS lens mounts. The AL-1 offers a serviceable alternative.

☐ CANON T-SERIES CAMERAS

Canon's venture into the wonders of polycarbonate construction began with the introduction of the T-50 and the company hasn't looked back since. There is a lot to be said for using polycarbonate as a replacement for metal. When well-formulated and properly reinforced, it resists dings and dents because it can spring back to its original shape. Its tensile strength can even be greater than that of the metal it has replaced. But it isn't as hard as metal, so it scratches and abrades much easier.

Canon T-50

The T-50 is a simple-to-use beginner's camera, designed for the complete neophyte — or so you would think. I've known at least one professional who used a T-50 as a "grab-shot" camera. And I'll bet there are more out there who have used T-50s, but who would rather be caught without film than be seen by their peers actually (gasp!) using one.

On the T-50, there is a shutter speed dial where one would expect to find it, but it only has three settings: Program, Self timer and Lock. It has a built-in motor drive with auto film advance and rewind only. Limited flash AE is available with dedicated flash units.

Canon T-60

Introduced in 1990, the T-60 represents a return to the basics, offering features most beginning photographers want and need. Its price should appeal to the budget-conscious photographer who may have wanted to buy a new camera, but who otherwise may have had to resort to buying a used one.

The T-60 has two exposure modes: aperture-priority AE and metered manual. Shutter speeds range from 8 seconds to 1/1000 (1 second to 1/1000 in manual), plus B, with X sync at 1/60. Film is advanced and rewound manually and there are no provisions for attaching a motor or winder accessory. It has a self-timer. There are no DX film contacts; film speeds must be set manually. The T-60 has a hot shoe, but no built-in flash automation.

Canon T-70

Canon incorporated many of the best features of the A-1 into the T-70 and added a few more for good measure. Instead of having a single program mode it has three: a standard program, a telephoto program (high shutter speed bias) and a wide angle program

(increased depth-of-field bias). Its other exposure modes are shutter-priority, metered manual, stop-down AE (for use with FL-mount and other non-FD lenses) and non-TTL programmed flash AE. The T-70 also features two metering patterns, either center- weighted averaging or partial, the latter of which is very tight and almost a spot pattern. This is a very nice feature for determining correct exposure in difficult lighting situations. Shutter speeds range from 2 seconds to 1/1000, plus B. X sync is at 1/90 with

Canon T-70

dedicated flash units, 1/60 with others.

Other features include multiple exposure capability, depth- of-field preview, a self-timer and integral winder.

Canon T-80

The T-80 was Canon's first attempt at an autofocus SLR and, because of bad timing or bad luck, became an Edsel almost overnight. The T-80 was introduced by Canon nearly the same time Minolta unveiled the Maxxum 7000. It wasn't a pretty sight, folks. The T-80 was blown away by the Maxxum's vastly superior autofocus technology and performance. But then, the Maxxum 7000 blew everyone away, and had virtually no competition for two years.

One of the few good things that can be said about the T-80 is that it accepts standard FD lenses and will provide focus confirmation with them. In addition to manual-focus override, the T-80 has two autofocus modes: single-shot (focus priority) and continuous (servo). The lenses meant to be used with the

T-80 are designated "AC" for "Automatic Control." Only three focal lengths were made: the 50mm f/1.8, the 35-70 f/3.5-4.5 and the 75-200 f/4.5. AC lenses have their own drive motors, like the EF lenses, but can be easily told apart because of their humps. These lenses use the FD mounting style, so they can't be used on EOS cameras.

The T-80 has a built-in winder, which is good for 1.2 fps, and has powered film rewind. For exposure information, Canon used a pictograph system to illustrate the following exposure modes: standard program, deep focus (for maximum depth of field), stop action (high shutter speeds), shallow focus (for minimum depth of field) and "flowing" (low shutter speeds). Shutter speeds range from 2 seconds to 1/1000, plus B. X sync is at 1/90.

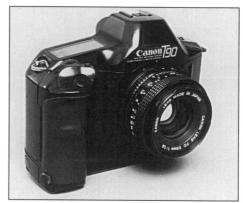

Canon T-90

Canon T-90

It took a lot of courage for Canon to buck the trend toward auto-everything cameras in the mid-1980's and bring the T-90 to market, and many Canon users, professional and amateur alike, were glad they did. Sadly, Canon elected to discontinue the T-90 in 1991. Within days of Canon's announcement, warehouse stocks were sold out.

Originally targeted for the advanced amateur, the T-90 has found a loyal following among professionals, largely because until 1990 it stood alone as the most technically advanced manual-focus 35mm camera made. Now it shares

that distinction with the Contax RTS III and a small select group, which includes the likes of the Leica R8.

The T-90's exposure modes include program with a seven-step shift adjustment and a safety shift, aperture and shutter-priority AE, and metered manual. Exposure options include TTL flash with the 300TL Speedlite or Macrolite ML 2, highlight/shadow compensation, exposure compensation and an AE lock. Available metering modes are center-weighted averaging, 13% central area, or 2.7% spot. Up to eight spot readings can be stored and averaged. The camera has DX contacts, but the DX coding can be overridden.

Shutter speeds range from 30 seconds to 1/4000, plus B. X sync occurs at 1/250. (Only two other Canons have this fast a flash sync and they're both EOS.) The built-in motor drive will advance film at speeds up to 4.5 fps. The camera features auto film load and auto rewind, as well as mid-roll rewind. Other features include interchangeable focus-ing screens, multiple exposure capability, a self timer, depth-of-field preview, stop-down metering and second-curtain flash sync with the 300TL.

Another handy feature is that everything is powered by four AA alkaline batteries. While it is true the T-90 will not function at all without batteries, AAs are so common they can be obtained virtually anywhere in the world.

☐ CANON FL LENSES

FL lenses employ Canon's older meter coupling design that does not allow for full-aperture metering. A camera originally intended for use with FL lenses, such as the FT-QL or the TL-QL, meters the scene at the lens' taking aperture. For focusing ease, an FL lens has an additional ring next to the aperture ring or a button near the mount that can be used to momentarily open or close the diaphragm. FL lenses are interchangeable with FD lenses, but when using a camera designed to accept FD lenses, metering must be done in the camera's

Rear view of a Canon FL lens. Note there is only one lens-to-body coupling lever.

stop-down mode. If your camera was designed for use with FD lenses and does not have a stop-down function, it will not expose correctly with FL lenses.

In addition, a few FL lenses will not work properly on some FD-mount cameras that do have a stop-down mode (for example, the 19mm f/3.5 FL will not work properly on the AE-1 or A-1 but works just fine on the FTb and mechanical F-1). The list of non-useable lenses varies from camera to camera. If in doubt check your owner's manual. One FL lens, though, should not be mounted

Canon FL and FD-Mount SLRs

Camera	Yrs Made	New		Mint		Excellent		User	
A-1	1978-87			350	295	300	180	190	150
AE-1 chr	1976-85			180	130	150	95	110	80
AE-1 blk	1976-85					200	150	140	120
AE-1 Program chr	1981-87			220	175	210	140	150	125
AE-1 Program blk	1981-87			280	210	240	190	210	160
AL-1	1983-85					150	125	120	90
AT-1	1977-85			200	170	180	120	125	90
AV-1	1979-85					150	105	110	80
EF	1973-78			300	230	250	195	185	150
F-1	1971-76			400	325	350	245	260	210
F-1n	1976-81			525	370	400	300	290	245
F-1N, std. finder	1981-	1695	1500	850	650	575	420	430	350
F-1N, AE finder	1981-	1795	1600	900	750	650	480	575	470
FT QL chr	1966-72					125	80	95	80
FT QL blk	1966-72			295	230				
FTb QL chr	1971-74			190	150	150	125	115	90
FTb QL blk	1971-74							180	130
FTbn QL chr	1973-78			225	185	180	125	125	100
FTbn QL blk	1973-78			315	280	250	195	180	130

Canon FL and FD-Mount SLRs (cont'd)

Camera	Yrs Made	New		Mint		Excellent		User	
FX	1964-69					120	90	90	65
TL QL	1968-72			125	100	100	85	90	75
TLb QL	1972-77					125	100	90	80
TX	1975-79			135	120	100	90	80	70
T-50	1983-89			130	115	110	90		
T-60	1990-96?					140	100		
T-70	1984-87			210	175	180	135	140	100
T-80 w/50/1.8AF	1985-86			220	190	185	150		
T-90*	1985-91	1150	1000	800	625	600	450	440	380

New T90 prices are "NOS" (New Old Stock)

on any camera except the Canon Pellix. This is the 38mm f/2.8 FLP.

FL lenses often go overlooked by users of FD cameras, mostly because they require a little more patience and thought to use. In my humble opinion, this is a big mistake. FL lenses are, with no doubt, the sturdiest of Canon's SLR lens styles. Regarding their optical quality, they still hold their own very well when compared to today's computer-designed optics, providing sharp images with great contrast and color.

☐ CANON FD LENSES

Canon FD lenses exist in two main versions. The earlier version, commonly called the "breech-lock" style (abbreviated as "bl"), has a knurled chrome mounting ring that rotates an eighth to a quarter turn to lock the lens securely in place. The later version, which Canon calls "New FD," but everyone else calls "bayonet mount," is mounted by rotating the entire lens until it clicks into place. Both styles are interchangeable.

Many Canon aficionados prefer the older breech-lock style. They claim the lens mounts more securely and that the mount itself is less apt to wear out. Most

Canon FL Lenses

Lens	Mint		Excellent		User	
19mm f/3.5	400	350	325	250	220	180
28mm f/3.5	75	50	50	35		
35mm f/2.5	75	60	70	50	60	40
35mm f/3.5	50	40	35	30		
38mm f/2.8 FLP (Pellix only)	125	100				
50mm f/1.4			60	50	50	40
50mm f/1.8	35	25	30	20		
50mm f/3.5 Macro (w/1:1)	175	150	160	125		
55mm f/1.2			150	90	90	70
58mm f/1.2			130	80	70	60
85mm f/1.8	250	200	175	150		
100mm f/3.5	150	120	140	100		
135mm f/2.5	75	60	50	40		
135mm f/3.5	50	40	40	35		
200mm f/3.5			125	90	90	60
200mm f/4.5	100	85	70	55		
300mm f/2.8 SSC Fluorite	1650	1200				
300mm f/5.6 SC Fluorite	500	400				
400mm f/5.6 (w/Focusing Unit)			1000	800		
500mm f/5.6 SSC Fluorite	1750	1500				

Canon FL Lenses (cont'd)

Lens	Mint	Excellent	User
600mm f/5.6 (w/Focusing Unit)			
800mm f/8 (w/Focusing Unit)			
1200mm f/11 SSC (w/Focusing Unit)			

The 600mm, 800mm, and 1200mm Canon lenses with the R Focusing Units have become extremely collectible in recent years. They are almost impossible to come by, and command very high prices now. I have chosen to maintain the listings for reference purposes, however, albeit sans prices.

Canon FL Zoom Lenses

Lens	Mint		Excellent		User
55-135 f/3.5			200	140	
85-300 f/5	400	350	325	250	
100-200 f/5.6	120	95	100	60	

breech-lock lenses are more massive in construction than their New FD counterparts, a feature that also fuels loyalty. But the disadvantage to the breech-lock style is that it takes practice and some dexterity to mount the lens with one

Rear view of a Canon New FD lens. The additional dot on the top is the mounting alignment mark. Note the lens release switch on the left side.

Rear view of a Canon FD breech-lock lens. Note the two coupling levers and two additional fixed posts.

hand while holding the camera with the other. Even when using both hands to mount the lens, the process is slower than when mounting a New FD lens one-handed. Nonetheless, the breech-lock lenses remain popular, so the price differential between equivalent examples of the old and new styles is small and, in some cases, somewhat more for the breech-lock style.

Lenses with an "L" suffix incorporate special low-dispersion glass elements and, in some cases, internal fluorite elements for greatly reduced color aberration and increased sharpness at maximum apertures. Canon says the "L" stands for Luxury, and with the prices these lenses sell for, it's no wonder. Precursors to the L lenses were the breech-lock FL and FD Fluorite and FD Aspherical lenses, and three of the breech-lock super-telephotos. The Fluorite lenses include one or more fluorite elements to produce the same effect as low-dispersion glass, and are not to be confused with Canon FL lenses, although only one lens carrying the Fluorite label is an FD lens; the rest are FL lenses (got that?). "Al" in the following listings stands for Aspherical, a design using an aspherical surface to

control a number of aberrations and to improve flare correction, much the same way low-dispersion elements do. The 400mm f/4.5 SSC, 600mm f/4.5 SSC and 800mm f/5.6 SSC lenses all incorporate low-dispersion glass in their design, but this is not indicated anywhere on the lenses; you just have to know it. Canon made a distinction between the low-dispersion glass used in these three lenses and the glass used in the 500mm f/4.5 L when it was first introduced (the 500mm f/4.5 L was Canon's first L-series FD lens), referring to its glass at the time as "ultra-low dispersion" (UD). Confused yet?

Most breech-lock lenses are labeled SC or SSC. SC stands for Spectra Coating and SSC stands for Super Spectra Coating. Both are single-layer coatings that rivaled the quality of the best multi-layer coatings of their day (or so Canon claimed). Canon switched to multi-layer coatings with the bayonet mount lenses, however, and dropped the SC and SSC designations. (Canon still produces one breech-lock SSC lens, the TS35 f/2.8. The TS35 is designed to control perspective much as one would with a large format camera by allowing both tilt and shift movements of the

front element.) The earliest model breech-lock FD lenses did not have either an SC or SSC designation. Price differences between early and later breech-locks are minor.

Most of Canon's later bayonet-mount long telephoto lenses include an internal focusing design, indicated by "IF" in the listings below. Focusing is achieved by moving inner elements, which keeps the overall length of the lens the same, hence no light loss when focusing from infinity to closest distance.

Canon FD Lenses

Lens	New	Mint	Excellent	User
200mm f/1.8 L IF			3500 2450	
200mm f/2.8 IF (latest)		525 470	450 350	
200mm f/2.8		400 370	375 300	
200mm f/2.8 SSC bl		400 350	370 270	
200mm f/4		200 185	190 140	
200mm f/4 SSC bl		185 170	165 110	100 85
200mm f/4 Macro		750 650	595 500	
300mm f/2.8 L IF		3100 2600	2250 1950	
300mm f/2.8 SSC Fluorite		1850 1400	1500 1250	
300mm f/4 L IF	1695 1400	1100 950	850 680	
300mm f/4 IF	650 575	490 440	450 350	
300mm f/5.6 IF		250 180	200 170	
300mm f/5.6 SSC bl		250 190	200 160	
400mm f/2.8 L IF		5500 5000	4450 3900	
400mm f/4.5 IF		1200 990	875 650	
400mm f/4.5 SSC bl			950 800	735 570
500mm f/4.5 L IF		3750 3500	3450 2900	
500mm f/8 Mirror (New FD & bl)*	420 300	450 400	390 280	
600mm f/4.5 IF		3000 2500	2295 1950	
600mm f/4.5 SSC bl		2450 1900	1950 1800	
800mm f/5.6 L IF		3895 3500	3200 2900	
800mm f/5.6 SSC bl		2750 2620	2500 2000	
Extender FD 1.4x-A	395 350	225 200	180 150	
Extender FD 2x-A	250 210	195 150	160 120	
Extender FD 2x-B		225 200	180 150	
7.5mm f/5.6	1450 1300	1250 1100	957 760	545 350
7.5mm f/5.6 bl		950 700	780 550	465 320
14mm f/2.8 L		1500 1350	1300 1000	
15mm f/2.8	1250 1100	950 860	800 650	
15mm f/2.8 SSC bl		675 595	520 465	
17mm f/4	745 600	570 475	425 380	
17mm f/4 SSC bl		520 390	395 325	
20mm f/2.8		520 460	450 400	
20mm f/2.8 SSC bl		450 395	375 330	
24mm f/1.4 L	1740 1450	1200 1000	900 700	650 600
24mm f/1.4 SSC Al bl		900 800	850 600	600 550
24mm f/2		525 470	485 350	
24mm f/2.8			295 200	
24mm f/2.8 SSC bl		230 175	190 145	150 125
28mm f/2	620 500	425 350	325 250	
28mm f/2 SSC bl			325 240	220 175
28mm f/2.8		100 90	75 55	
28mm f/2.8 SC bl		100 75	80 50	

New prices on the 500mm f/8 appear to reflect factory close-outs, causing used prices to appear incorrect.

Canon FD Lenses (cont'd)

Lens	New		Mint		Excellent		User	
28mm f/3.5 bl			90	70	80	55		
35mm f/2	560	470	400	375	350	205	180	140
35mm f/2 SSC bl			300	200	225	150	160	125
35mm f/2.8			100	70	75	65	70	60
35mm f/2.8 TS SSC bl	1520	1300	950	750	700	575		
35mm f/3.5 SC bl			85	70	75	55		
50mm f/1.2 L			700	550	485	400		
50mm f/1.2					260	150		
50mm f/1.4	160	120	90	70	80	50		
50mm f/1.4 SSC bl			100	70	65	50		
50mm f/1.8			50	40	40	25		
50mm f/1.8 SC bl			45	30	45	25	25	20
50mm f/1.8 AC (T-80)			55	45				
50mm f/3.5 Macro (w/1:1)			300	250	235	185	150	135
50mm f/3.5 Macro SSC bl (w/1:1)			230	200	200	165		
55mm f/1.2 SSC AI bl			550	450	475	400		
55mm f/1.2 SSC bl			250	230	235	170	170	150
85mm f/1.2 L			800	700	750	650		
85mm f/1.2 SSC AI bl					625	550		
85mm f/1.8					300	225		
85mm f/1.8 SSC bl					270	200		
85mm f/2.8 Soft Focus					450	380		
100mm f/2.0			375	320	290	225		
100mm f/2.8			175	150	150	125		
100mm f/2.8 SSC bl			160	140	150	110	120	100
100mm f/4 Macro (w/1:1)	835	750	595	470	480	440		
100mm f/4 Macro SC bl (w/1:1)					450	350		
135mm f/2.0			495	400	375	300	260	220
135mm f/2.5 SC bl					160	125		
135mm f/2.8	150	120			150	100	85	60
135mm f/3.5			75	50	60	45	50	40
135mm f/3.5 SC bl			80	55	65	50		

Canon FD Zoom Lenses

Lens	New		Mint		Excellent		User	
20-35 f/3.5 L	1220	1000	895	750	750	600		
24-35 f/3.5 L					575	520		
24-35 f/3.5 SSC Al bl					575	480		
28-50 f/3.5					400	300		
28-50 f/3.5 SSC bl					375	325		
28-55 f/3.5-4.5			150	145	140	115		
28-85 f/4					430	350		
35-70 f/2.8-3.5			400	325	350	280		
35-70 f/2.8-3.5 SSC bl					350	250		
35-70 f/3.5-4.5			100	80	90	75		
35-70 f/4			125	100	120	80		
35-70 f/4 AF			200	125				

The 35-70 f/4 AF will autofocus on any Canon camera that accepts FD lenses.

Lens	New		Mint		Excellent		User	
35-70 f/3.5-4.5 AC (T-80)			165	120				
35-105 f/3.5					325	260		
35-105 f/3.5-4.5			225	170	150	125		
50-135 f/3.5			220	175	180	150		
50-300 f/4.5 L			1800	1450	1395	1100		
70-150 f/4.5			120	100	90	80		
70-210 f/4			225	170	200	150	140	100
75-200 f/4.5			160	150	150	120	100	80
75-200 f/4.5 AC (T-80)			180	160				
80-200 f/4 (2 ring)			320	250	250	190	200	145
80-200 f/4 SSC bl (2 ring)					240	200	195	150
80-200 f/4 L	800	750	500	450	475	380		
85-300 f/4.5			900	750	700	575		
85-300 f/4.5 SSC bl			950	750	795	625	650	480
100-200 f/5.6			125	100	115	90		
100-200 f/5.6 SC bl			110	80	85	50		
100-300 f/5.6 L			400	355	375	325		
100-300 f/5.6 (latest)			250	230	280	195		
100-300 f/5.6 (early)			240	220	200	135		
150-600 f/5.6 L			10000+					

The 150-600 f/5.6 L is in high demand among members of the movie industry. Specialists align the zoom mechanism so the optical center does not shift during zooming and then they retrofit the lens to mount on 35mm movie cameras. They sell the conversions for $25,000 and up.

A-Series Accessories

Item	New		Mint		Excellent		User	
Data Back A					50	30		
Motor Drive MA set			350	240	270	195	200	150
Motor Drive MA (w/Nicad Pack MA & Chgr)			400	325	350	285		

The Motor Drive MA fits A-1 and AE-1 Program only

Item	New		Mint		Excellent		User	
Nicad Charger MA/FN	150	115						
External Battery Pack	110	85						
Power Winder A					100	50		
Power Winder A-2	160	135	150	120	120	95		
Generic Winder (Not Canon)	50	45	35	25	30	20		
Remote Switch 3 (MD MA, Winder A2)		15	15					
Remote Switch 60 (MD MA, Winder A2)		10	10					
Extension Cord E1000 (MD MA, Winder A2)	30	25						

Original F-1 System Accessories

Lens	New		Mint		Excellent		User	
Std. Eye Level Finder			100	75	50	40		
Speed Finder			250	200	210	180		
Waist Level Finder			100	70	60	50		
Booster T Finder			290	225	250	150		
Servo EE Finder			250	165	150	125		
w/case, EE Coupler, battery magazine and cord, or connecting cord MF								
Motor Drive Unit			300	250	280	225		
w/cord, Battery Magazine 15V or Battery Case D								
Motor Drive MF			400	375	350	280	275	220
Connecting Cord MF			40	30				
Winder F			250	200	225	180		
Data Back F			150	100	100	50		
Film Chamber 250 (w/magazines)			250	200	220	150		
Film Loader 250 or 250-II			150	125	120	100		
NPC or Forscher Polaroid Back	700	630			450	385		
Flash Coupler D			30	25				
Flash Coupler F	45	30			35	30		
Flash Coupler L	75	60			50	40	40	35
Finder Illuminator F					35	25	25	20

New F-1 System Accessories

Item	New		Mint		Excellent		User	
AE Finder FN			195	150	150	100		
Eye Level Finder FN			100	80	70	50		
Speed Finder FN	345	290	295	250	250	195		
Waist Level Finder FN	110	90	95	70				
Waist Level Finder FN-6X	340	270	170	150				
AE Motor Drive FN Set	590	500	400	325	350	275		
AE Motor Drive FN (w/Nicad Pack, chgr)	750	675			425	350		
AE Motor Drive FN (w/Hi-Pwr Nicad Pack, chgr)	840	785			550	420		
AE Battery Pack FN	195	150						
Nicad Pack FN			75	65				
Hi-Power Nicad Pack FN	260	210			150	125		
Nicad Charger MA/FN	150	115						
AE Power Winder FN					250	200		
AC/DC Converter Set AD-1	410	300						
Data Back FN			120	100	90	75		
Film Chamber FN-100 (w/magazines)		580	500		350		300	
Film Loader 250 or 250-II			175	150	140	120		
NPC or Forscher Polaroid Back	740	695			400	385		
Remote Switch 3 (MD & Winder FN)		15	15					
Remote Switch 60 (MD & Winder FN)		10	10					
Extension Cord E1000 (MD & Winder FN)	30	25						
Battery Cord C FN	90	75						

T-Series Accessories

Item	New		Mint		Excellent		User	
T-70 Command Back 70			250	220	220	190		
T-80 Command Back 80			75	65				
T-90 Command Back 90			140	100	100	80		
T-90 Data Memory Back			380	300	270	250		
Forscher Pro Back (T-90)	740	700						
NPC Pro Back II (T-90)	760	730	600	550				
Remote Switch 60 T3 (T-50/70/80/90)		45	35	25	20	20	15	
Remote Switch Adapter T3 (T-50/70/80/90)	35	25						
Cable Release Adapter T3 (T-50/70/80/90)	40	30						
Extension Cord 1000 T3 (T-50/70/80/90)		45	35					

Canon Flashes

Item	New		Mint		Excellent		User	
011A			40	30	20	15		
133A					30	20		
133D "CAT" w/ring					50	40		
155A			50	35	45	30		
166A			55	45	45	30		
177A					50	35		
188A			55	45	55	40		
199A			100	80	85	65		
244T (T-50)			50	40	40	30		
277T			60	50	45	35		
299T			120	100	110	90		
300TL (TTL flash w/T-90)			250	200	180	120	115	90
533G Set			200	175	170	140		
577G Set			290	250	265	200		
Transistor Pack G set (533G/577G)			100	75				
Transistor Pack G set (NiCads: 533G/577G)			200	150				
ML-1 Macro Light			350	275	250	180		
ML-2 Macro Light (TTL w/T-90)			210	170	175	140		
ML-3 Macro Light (TTL w/T-90)	290	210	180	150	160	125		
TTL Distributor (T-90)	60	40						
TTL Hot Shoe Adapter 2 (T-90)	60	45						
Connecting Cord 60 (T-90)	45	30	20	15				
Connecting Cord 300 (T-90)	50	35	25	20				
Off Camera Shoe Adapter (T-90)	30	25						
Off Camera Shoe Cord (T-90)	60	45						
60F (T-60)	15							

Close-up Accessories

Item	New		Mint		Excellent		User
20mm f/3.5 Macrophoto lens	225	165			125	95	
35mm f/2.8 Macrophoto lens	245	190			150	120	

The 20/3.5 Macrophoto and 35/2.8 Macrophoto are special high-magnification lenses that must be used in conjunction with bellows.

Item	New		Mint		Excellent		User
Angle Finder A-2			60	50			
Angle Finder B (w/adapter S)	120	85	75	60	65	50	
Auto Bellows (w/double cable release)		270	230	195	160	175	140
Slide Duplicator 35-52R	140	120	95	80			

w/roll film stage and adapter ring — for use with Auto Bellows only

Item	New		Mint		Excellent		User
Bellows FL			125	100	90	80	
Slide Duplicator FL (w/adapter ring)					80		50
Bellows M			60	50			
Extension Tube FD 15	95	80					
Extension Tube FD 25	85	65			35	25	
Extension Tube FD 50	95	80					
Extension Tube FL 25			25	20			
Extension Tube M set (manual diaphragm)	70	55					
FD Auto Extension Tube set (not Canon)			75	50			
Variable Extension Tube set M15-25		85	65				
Variable Extension Tube set M30-55		110	85				
Focusing Rail	130	120	75	60			
Macro Auto Ring	65	50					
Macrophoto Coupler FL (55mm or 58mm)			25	20	20	15	
Macro Stage	100	85	60	50	45	40	
Magnifier R or S	60	40	30	20			
Copy Stand 4			125	100			
Copy Stand 5			350	300			
Macrophoto Adapter	40	35					
Macrophoto Coupler	50						
Photo Micro Unit F	60	50					
G-20 Sensor	60	50					

Other Canon Accessories

Item	New		Mint		Excellent		User
Hasselblad Lens to Canon FD Body Adapter	140	120					
Nikon Lens to Canon FD Body Adapter		160	140	100	70	60	40
Pentax Lens to Canon FD Body Adapter					25	20	
Canon Booster Meter (Pellix, FT, FTb, FTbn)			45	40	40	30	
LC-1 Wireless Controller Set			135	115	95	85	
LC-2 Wireless Controller Set			80	70			
LC-3 Wireless Controller Set	360	290	150	100			
TM-1 Quartz Interval Timer	160	110					

The Wireless Controller LC-1 set is compatible with the AE Motor Drive FN, Power Winder FN, Motor Drive MA and Winder A2. When combined with the Remote Switch Adapter T3, it can also be used with T3-compatible T-series and EOS cameras. The Wireless Controller LC-2 and LC-3 are for use with T3-compatible T-series and EOS cameras only. The Quartz Interval Timer TM-1 has the same compatibility requirements as the LC-1.

Canon EOS

EOS-1n

☐ EOS

Canon's line of EOS autofocus cameras and lenses continues to grow in popularity among amateurs and professionals alike. EOS cameras have arguably the most advanced lens mount in the industry, which can be coupled with some of the best performing lenses ever made.

Currently (and presumably for the foreseeable future) competition is extremely intense between major autofocus SLR manufacturers. The result is an almost uninterrupted stream of new models being introduced, superceding older ones as technology evolves. In these days of computer-controlled manufacturing processes, look for such trends to continue.

Because there have been so many EOS models introduced since the original EOS 650, the following camera descriptions are listed alphanumerically rather than chronologically.

EOS A2 & A2E

In the ultra-competitive autofocus SLR market, either a camera maker constantly pushes the limits of the envelope, or it quickly becomes an also-ran. Canon is obviously determined not to let this happen with its EOS line, and the A2E convincingly reinforces this point.

With Canon's Eye Controlled Focus, it is possible to look at a subject within the viewfinder and havie the camera focus on it automatically. Instead of having one, two, or even three autofocus sensors, the A2E has five, any of which can be triggered just by looking at it. Canon has applied its experience in the design of optometric instruments to the world of autofocus camera technology, with its Eye Controlled Focus system being the fruits of its labors. How does it work? Putting it simply, the camera analyzes a ghost image reflected from the eye's cornea via four infrared diodes located around the viewfinder and a CCD (charge coupled device) located next to the pentaprism. This system also tracks the eyeball as it moves, which is what enables it to determine which sensor the eye is looking at. In order for the Eye Controlled Focus System to work at all, however, the camera must be calibrated to each user's eye (a total of five calibrations can be stored). Fortunately, the calibration process is easy to do and takes only seconds to complete. This can be very handy if more than one person uses the camera, or if one wears glasses and/or contacts.

Canon has attempted to market the A2E to advanced amateurs, claiming that professionals will prefer the A2 with its more straightforward approach and lack of the Eye Controlled Focus System. Based on what I've observed, though, I'd say Canon's spin hasn't worked. A professional will use every tool at his or her disposal to get that one unique, timeless shot that will separate them from the rest of the pack. In a previous edition, I predicted there would be a strong demand for the A2E among professional EOS users. With the release of the pro-level EOS 3 and its third-generation Eye Controlled Focus technology, my prediction seems to have been on track.

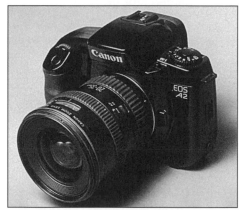

EOS-A2

Canon didn't limit this eye-point concept in the A2E just to the autofocus sensors, however. Another, smaller rectangle is visible in the top left corner of the viewfinder. By glancing there, the lens will stop down to taking aperture to allow a momentary preview of depth of

field. This is a dazzling concept, and strikes one as being not so much a depth-of-field preview only, but a preview of things to come. One can only speculate as to what sort of tantalizing offshoots will be incorporated into later cameras based on this technology – control of autoexposure modes, exposure compensation, or metering patterns, for example.

Both cameras use the aforementioned 5-segment autofocus sensor array (the A2 works like an updated 10s in this respect), but coupled with this expanded capability is a 16-segment evaluative metering pattern. Both cameras also have a high-speed integral motor drive, capable of burning through a roll of film at the rate of five frames per second. The motor drive uses a belt transport similar to the Elan's, but has a quiet rewind mode claimed by Canon to be $2^1/_2$ times quieter. It also has a higher speed rewind mode which is slightly louder, but which is twice as fast (9 seconds for a 36-exposure roll versus 18 seconds).

With the exception of the features outlined previously, the A2 and A2E's autofocus systems closely resemble those of other contemporary EOS cameras, which include autoswitching from single-shot AF to AI Servo when subject movement is detected, and predictive autofocus. The central autofocus sensor is cross-based, which will enable the camera to focus easily on both horizontal and vertical lines.

Exposure modes include what has become a standard array of selections on EOS cameras: program, full-auto, portrait, landscape, close-up, sports, aperture- and shutter-priority, depth-of-field, and metered manual. Both the A2 and A2E have the thumbwheel found on the EOS-1 and Elan, located on the camera back. The wheel can be used to alter either aperture or shutter speed selections, depending on the user's preference. Other available exposure modes

include autobracketing, ±2 EV exposure compensation, multi-exposures, TTL-flash with the built-in flash (GN 43 @ 28mm) and accessory units such as the 430 EZ, second-curtain flash sync, and red-eye reduction with the built-in flash.

Shutter speeds range from 30 seconds to 1/8000 second, plus B, with X sync occurring at 1/200. Some of the many other features include 16 user-set custom functions, a 3% spot metering pattern which can be shifted between five different areas (set by one of the user-set functions), interchangeable focusing screens, a threaded manual flash PC socket, a T3 remote switch socket, a two-position self-timer, mirror lock-up (set by one of the user-set functions), a built-in focus aid light, and with the A2, built-in eyepiece dioptric correction. Add the optional accessory grip VG10 to either camera and you have the main input dial, shutter release, manual-focusing point-selection button and AE lock button located conveniently for vertical operation – a worthwhile addition any serious photographer will consider indispensible.

EOS EF-M

If you've ever felt the need for a camera that accepts autofocus lenses, but doesn't autofocus, then the EF-M (EF lenses-Manual focus) may be the one for you. Canon designed the EF-M with the photography student in mind, since often students are not allowed to use autofocus cameras in their course work.

The EF-M's exposure modes consist of program, shutter and aperture-priority AE, and metered manual. The metering modes include 3-zone evaluative (for program), centerweighted (for shutter-priority AE, aperture-priority AE and manual), and partial metering. The latter can be selected by the user at any time. Other exposure features include exposure compensation and AE lock.

Shutter speeds range from 2 seconds to 1/1000 second, plus B, with X sync at 1/90. The hot shoe has dedicated flash contacts for the Speedlite 200M, but does not offer TTL flash metering. Other features include DX film coding with override and a self-timer.

The EF-M has a built-in single-shot winder that prewinds to the end of the roll. Auto film rewind and mid-roll rewind are available.

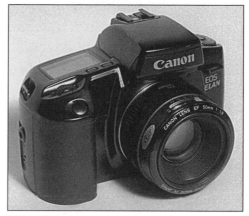

EOS Elan

EOS Elan

Intended to replace the EOS 630, the Elan has many of the features found on its higher-priced contemporaries, yet was priced to fit snugly between the 10s and the Rebel XS. It was the first EOS to feature a unique film winding system called Whisper Drive. Instead of using the traditional gear train to advance the film, the Elan uses a belt drive, which goes a long way toward reducing winder noise.

Autofocus modes are single shot (focus priority) and AI Servo (predictive continuous autofocus). Manual focus is also available.

Exposure modes include program with shift, shutter-priority and aperture-priority AE, depth-of-field AE, and metered manual. The Elan also has the same four PIC (Program Image Control) modes found on the Rebel models and has the Bar Code program similar to that found on the 10s, but

which can store up to five programs at a time (the 10s can store only one at a time). TTL flash AE is available with the built-in flash or dedicated accessory units. The built-in flash will zoom to adjust its coverage from 28mm to 80mm, and has a pre-flash red-eye-reduction system.

Metering modes include a six-zone evaluative mode, centerweighted averaging, and partial (the central 6.5% of the viewfinder). Shutter speeds range from 30 seconds to 1/4000, plus B, with flash sync at 1/125.

Other features include the Quick Control dial found on the EOS-1, seven built-in Custom Functions (including depth-of-field preview, second-curtain flash sync and mirror lock-up), a self timer, DX film coding with override, automatic film rewind and mid-roll rewind.

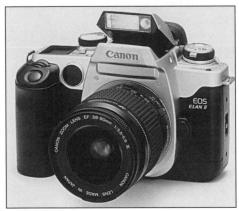

EOS Elan II

EOS Elan II and IIE

The Elan II and IIE differ in one primary area: the Elan IIE has Canon's unique Eye-Level Focus tehnology, originally introduced with the A2E, although it has been vastly improved over the first generation system found on the A2E. Because of this singular difference, the description for the II applies to the IIE as well.

While the Elan II shares the same name and many of its features with the original Elan, it doesn't share much in the way of looks. The Elan II is clad in an aluminum top cover and sports prominent top dials, the resulting combination giving it that retro look that has become so popular of late. A number of new features and improvements have been added to accompany the facelift, as well, so let's take a look.

The single item that set the original Elan apart from other cameras, regardless of make or model was its belt-driven Whisper Drive motor drive system. On the Elan II, the Whisper Drive has two available rewind modes: silent and high speed. The silent mode will rewind a 24-exposure roll in 12 seconds, whereas in high-speed mode, the same roll of film will rewind in only 6 seconds.

The Elan II's three-point autofocusing system retains the One-Shot AF and AI Servo modes found on the original, plus it has an additional mode called AI Focus that works as a combination of the two. In AI Focus mode, the camera starts out in One-Shot AF mode, but once movement is sensed, it will automatically shift to AI Servo mode. While in AI Servo mode, the Elan II can track moving subjects at the rate of 2.5 frames per second, using the built-in motor drive, as they move from one focusing point to another. All three modes are accessed via the raised dial atop the right side of the camera body. Designed into the Elan II's AF system is Canon's exclusive Advanced Integrated Multi-Point Control (AIM) system. AIM links the camera's 3-point autofocus system to its multi-zone metering system for available light and flash photography, thereby rendering sharp, correctly exposed photographs, no matter where the main subject is within the image area.

The same five exposure modes and four PIC modes found on the Elan are also available on the Elan II, and are accessed by the raised "Command Dial" on the top left of the camera body. On the Elan IIE, the Eye-Control calibra-tion mode is also located here. Shutter speeds remain unchanged, as do the three metering modes, although the partial mode is now 9.5% of the image area.

The non-zooming built-in flash (GN 43 @ ISO 100) covers focal lengths down to 28mm. When combined with the Speedlite 220EX or 380EX, Canon's Evaluative TTL (E-TTL) flash system is available. E-TTL takes advantage of the above-mentioned AIM system, whereby ambient light levels, subject position, and pre-flash data are analyzed, resulting in a natural balance between subject and background. Other flash automation features available when the II and IIE are used in conjunction with the 380EX include FE Lock (Flash Exposure Lock), which provides an AE lock fucntion for flash photography, and FP Mode (FP = Focal Plane), a setting on the flash that enables it to sync at all speeds (up to 1/4000 sec.) with the Elan II.

The number of custom functions has been expanded from seven to eleven on the Elan II, while the bar-code reader has been dropped. A built-in wireless remote control has also been added. The II will accept the accessory BP-50 battery pack, which not only replaces the lithium battery with much more common AA-size batteries, but which also has an additional ON/OFF switch and a shutter release positioned for vertical shooting. All other features of the original Elan are applicable to the II as well.

The Elan IIE is also the beneficiary of an updated Eye Controlled Focusing system, first available on the A2E. The focusing response time has been much improved, plus it operates in both the horizontal and vertical positions. Additionally, the IIE's Eye Controlled Focus system is linked directly to the camera's Servo AF mode and Depth-of-Field indicator, and operates in concert with the AIM system. Calibration of the Eye Controlled Focus system is much simpler with the Elan IIE as well. The

user sets the Command Dial (that's the one on the photographer's left) to the CAL setting, and looks at the flashing focusing point in the viewfinder while depressing the shutter release halfway. The user repeats this operation for all three focusing points. Up to three separate user settings can be stored.

EOS Rebel G

The Rebel G is the most recent version of Canon's ever-popular Rebel series. While earlier models were available both with and without a built-in flash, the Rebel G is only available with the flash. In this way, and given the fact that it looks almost identical to the Rebel XS, it appears to be more of an update to the Rebel XS, rather than a totally new design. An examination of the two cameras will bear this out, since many of the features are unchanged (Canon's PIC modes, shutter speeds, etc.).

New for the Rebel G are the following: when using the Speedlite 220EX or 380EX, the Rebel G now incorporates the same E-TTL flash automation found on the Elan II; the 3-point AF system is the same as is found in the Elan II; the user can choose which of the 3 AF points to use; auto exposure bracketing is available in fi stop increments up to ± 2 stops. A feature called "Night Scene" has also been included, which is used to bias TTL flash photos toward longer shutter speeds – useful in situations, for example, where one might wish to freeze a foreground subject against a twilight sky. Canon has also developed a new mirror-coating technology that increases the light transmission within the Rebel's roof-type prism to the point that it rivals a traditional pentaprism in brightness.

Improvements on the Rebel G include a redesigned meter display for the manual mode, a partial-metering and AE lock button that will "remember" its setting for up to four seconds, allowing sufficient time for recomposition before taking the shot (previous versions required the button to be depressed during exposure), a red-eye reduction override system, where, if the photographer suddenly needs to "capture the moment," the camera will not force the user to wait for its output to take effect, and an in-focus alarm that may be activated or deactivated in all operating modes (the alarm could be activated or deactivated only in specific modes on previous models).

EOS Rebel: S, II & S II

The original EOS Rebel was sold both as a camera body only or as part of a kit, which included the EF 35-80 f/4-5.6 lens and the 200E flash. Canon took polycarbonate construction to new heights with this puppy. Gone are the metal film guide rails and metal lens mounting flange of an older, bygone era. The result is a compact and almost unbelievably light camera that is so feature-packed and fun to use, it's almost habit-forming.

The autofocus control system used in the Rebel is the same as that in the 630, although the way it works for the user has been simplified in the Rebel. Depending upon the shooting mode the user selects, it will use either single shot, continuous (called "Predictive AI Servo"), or a combination of the two. The shutter will not fire until focus is correct. Manual focus override exists, also.

Exposure modes include a user-shift program, shutter and aperture-priority, metered manual, depth-of-field AE and the same four PIC modes used on the 10s. The metering options available (depending on the mode selected) are three-segment evaluative, centerweighted and partial (9.5%). Other exposure options include: exposure compensation, exposure preview, an exposure/focus lock, multi-exposures and TTL flash with dedicated Canon Speedlites.

Shutter speeds range from 30 seconds to 1/1000, with flash sync occurring at 1/90. Other features include: auto film prewinding as used with the 700, 750 and 850, auto rewind, mid-roll rewind, DX film coding with override and a self timer.

The Rebel S has all the above features plus a built-in flash. It was available as a camera body alone, or in two kit packages: with the 35-80 f/4-5.6 lens, or with the 35-105 f/3.5-4.5 lens.

The Rebel II and Rebel S II are minor updates of the original Rebels. The most significant differences are: a musical self-timer with four different selections: beep, Bach, Beethoven and Vivaldi (the Hip Hop models never made it); a 1/2000 second top shutter speed; a quieter film transport; and a Soft Focus mode, which takes a double exposure on a single frame, defocusing the lens slightly between exposures. The amount of soft focus can be controlled somewhat – the mode has two coffee-maker-style settings: weak and strong. Both the Rebel II and Rebel S II were available with the same kits as the original Rebel models.

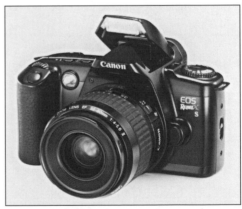

Canon EOS Rebel XS w/EF 35-80mm 1:4-5.6II (with flash up)

EOS Rebel X & XS

The Rebel XS still carries the Rebel label, but while it shares some style points with its predecessors, it nevertheless underwent a major update.

When compared to the original Rebel and Rebel II, the Rebel X is noticeably smaller and lighter. Canon accomplished the weight loss feat by – you guessed it – using even more plastic on the Rebel X than on its predecessors and by doing away with the traditional one-piece glass pentaprism and replacing it with a hollow, plastic and glass, roof-type prism. Now, it's well known among optics buffs that this arrangement is not as bright as a pentaprism, but Canon was able to make up for the light loss somewhat by reducing viewfinder magnification slightly (from 77 to 72 percent). To the user's eye, light loss is negligible.

As part of the update, the Rebel X was fitted with a three-sensor, wide-area autofocus system. The central sensor is of the cross-type BASIS variety, which is sensitive to both horizontal- and vertical-lined subjects, while the two outer sensors are vertical CCD arrays, which are sensitive to horizontal-lined subjects.

The Command Dial for controlling built-in AE settings is located in the regular place, but it was reduced in size to match the rest of the camera's pint-sized proportions. Its settings include four PIC modes (Sports, Close-up, Scenic and Portrait), plus Full Auto (displayed as a green square – this is a no-brainer snapshot mode that works surprisingly well), Intelligent Program AE, shutter- and aperture-priority AE, Manual, a simplified depth-of-field mode which requires only a single push of the shutter release, a beeper and ISO override. Gone is the soft focus feature found on the Rebel II, but added is a mid-roll rewind feature – a welcome change from the old method of dismounting the lens, setting the Command Dial to ISO and pushing both of those two small buttons on the right side of the back of the camera. Now, you just set the Command Dial to the rewind setting and push one of two buttons on the top of the camera. All

other exposure controls from previous Rebels have been retained.

The Rebel X's meter uses a six-zone evaluative system tied in directly to the AF system. This is a highly effective method of determining exposure, since the meter will bias exposure toward the AF sensor in use. The meter also will handle exposure compensation with backlit subjects automatically, but will not dial in enough compensation in very strongly backlit situations. Not to worry, the Rebel X has a ±2 stop exposure compensation capability when you need it. Another effective tool for unusually lit scenes found on the Rebel X is partial metering – first implemented by Canon on the FT and later employed with great success in the FTb and F-1 cameras. The Rebel X's partial metering pattern uses the central AF sensor, the central metering zone and AE lock to achieve critical exposure. The pattern is so tight, however, that it's really more effective to think of it as a spot meter, even though it's a bit broader than the spot metering patterns found on other EOS models.

The Rebel XS has a three-zone, four-segment TTL flashmeter, which uses the active AF sensor to determine flash exposure – a surprisingly advanced feature for a camera of this type. This camera is so advanced, in fact, that the EOS-1n uses virtually the same system. The XS's built-in pop-up flash's range (GN 39 @ ISO 100 in feet) has been expanded from 35mm to 28mm – a welcome addition for those tight group shots come holiday time. It also has a combined low-light focus assist beam and red-eye reduction light, located next to the lens, where one would normally expect to find the infrared focus-assist beam on most autofocus SLRs. By locating the red-eye reduction feature in this way, Canon was able to shrink the XS's pop-up flash. Apparently, though, this little halogen lamp throws out a good imitation of a high-beam headlight, and

can catch potential subjects off guard in low-light situations, causing them to squint from the bright light. So, if you've been trying to catch that elusive deer-in-the-headlights expression with your subjects, this bright little guy may be just what you're looking for.

Shutter speeds range from 30 seconds to 1/2000 second, plus B, with flash sync occurring at 1/90. Although all Rebels have a "B" setting, the Rebel X and XS are the first ones where it can be put to practical use. Located on the side of the camera is a jack that will accept an electronic remote release. The built-in winder has single-frame and continuous modes. Set to the latter, the camera will burn through a roll of film at the blazing speed of 1 fps. Other features include a self-timer and a camera-shake alert.

Finally, a word about an accessory available for the X and XS that most owners will want to think about purchasing: the GR-80TP accessory grip extender. If you have large hands, this accessory will make the camera easier to hold, but that's incidental. Built into the bottom of the grip is a handy little table-top tripod that's a snap to set up – perfect for those situations when you need a stable platform, but didn't want to lug around a tripod.

EOS RT

RT (Real Time) is the feature that separates the RT from all other EOS cameras (and most others, regardless of make), except the EOS-1n RS. The RT contains a fixed, pellicle mirror, the same arrangement used originally with the Canon Pellix and later with the high-speed F-1 cameras, and most recently with the EOS-1n RS, in which about 30% of the light entering the camera is reflected upward by the semi-transparent mirror and then through the viewfinder, while the remaining light travels directly to the film plane. The pri-

mary advantage to this arrangement is that the photographer can "capture the moment" much more decisively with a RT than with conventional SLRs, which, by their very nature, do not allow the photographer to see the subject at the moment of exposure. Other advantages are reductions in shooting-time lag, vibration and noise. Light fall-off due to the fixed mirror is minimal.

The EOS RT has all the features of the 630 except "Programmed Image Control". It also has Canon's "Custom Function Control" feature, which provides eight additional user-set custom functions.

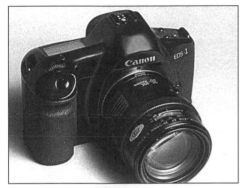

EOS-1

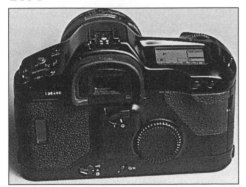

Rear view of the EOS-1 showing thumbwheel

EOS-1

Canon's first autofocus flagship, the EOS-1, was obviously designed to go toe-to-toe with the only other autofocus heavyweight on the block at the time of its introduction, Nikon's F4. Despite the F4's popularity among the professional community, many have deserted the Nikon ranks and switched to the EOS-1. Such a pivotal (and costly) move is justi-

fied by those who have made the switch for a couple of reasons. Perhaps the most significant reason is that the EOS-1 outperforms the F-4 in terms of sheer autofocusing speed. In the super-competitive world of photojournalism, even the slightest edge in performance can be the difference between an award-winning photograph and an honorable mention. Secondly, as sophisticated as the EOS-1 is, ultimately it is only as good as its lenses. Canon's high-performance, ultra-expensive L-series EF lenses have been consistently rated as top performers, and are establishing a reputation among photo professionals as some of the finest 35mm SLR lenses ever made.

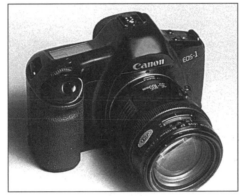

EOS-1

The EOS-1's autofocus modes include one-shot (focus priority) or continuous (servo) with "Focus Prediction" at speeds up to 4.5 fps with the optional power drive booster (up to 2.5 fps with the standard built-in drive). The EOS-1's "cross-type" AF sensors detect both horizontally-lined or (with f/2.8 and faster lenses) vertically-lined subjects.

Shutter speeds range from 30 seconds to 1/8000, plus B (which includes an elapsed time indicator). Flash sync occurs at 1/250. DX film coding is there, but so is the option to override it. Metering options include six-zone evaluative, centerweighted, partial (5.8%), or spot (2.3%). Exposure modes include program (w/shift), aperture and shutter priority, depth-of-field program and, of

course, metered manual. Other exposure features are exposure compensation, AE lock and auto-bracketing. With the Canon 420 EZ, 430 EZ, or later flash units, TTL flash, auto fill-flash, adjustable fill ratios, second-curtain sync, multi-strobe effects and variable power levels are all at your fingertips. The most innovative feature of the EOS-1 is the Quick-Control Dial (aka thumbwheel) on the back, which the user can choose to select either shutter speeds or apertures. In addition, the EOS-1 has eight user-set custom functions for AF control, AE control, meter patterns, film advance and DX coding. And a first for Canon SLRs: the EOS-1 has a viewfinder that displays 100% of the actual image, a basic requirement for critical copy work or exact framing.

Some other features are built-in diopter correction, multi-exposure, a self timer, and auto film loading and rewind with mid-roll rewind. The optional Power Drive Booster advances film at speeds up to 5.5 fps.

EOS-1n

If you feel the temptation to believe the "n" in the EOS-1n's name stands for "minor update," you'd be dead wrong. When introduced, the EOS-1n was an entirely new camera that just happened to share some of the same subcomponents as the original.

The EOS-1n's AF system was tweaked to render even faster performance, especially with moving subjects. It also benefits from the same 5-sensor AF technology that is found in the A2, although the central sensor is more similar to the original EOS-1's than the one used in the A2. The like the A2, does not have the Eye Controlled Focus System found on the A2E. Why not? The spin was that Canon was still working on an ECF system that would work reliably when the camera is held either horizon-

tally or vertically. It would appear that, as far back as the A2's introduction, Canon was already preparing a cushion for the letdown many users would feel when the EOS-1n would be released without ECF, by referring to the A2 as the camera designed with the professional in mind. (Translation: get used to the A2 and you won't be as angry at us when the EOS-1n is released with no ECF.) Despite this omission, however, this is an impressive update, and still worth a look.

The EOS-1n's metering system has five different patterns from which to choose: 16-zone evaluative (similar to that found on the A2 and A2E), a 3.5% spot pattern that is coupled to the active AF sensor, 9% spot, 2.3% spot, and centerweighted. Flash exposure is measured by employing a 3-zone selective system linked to the active AF sensor for improved flash and fill flash performance.

The EOS-1n's range of user-selectable custom functions has increased from six to fourteen. Included in the list of options are such choice selections as mirror lock-up, AF sensor selection with the quick-control dial, adjustment of shutter speed and aperture increment sizes, various auto bracketing adjustments, and more. The camera has a redesigned film rewind system that manages to be whisper quiet without forsaking the ruggedness of a gear drive. When using the updated Power Drive Booster (interchangeable with the original one), the maximum film advance speed was edged up to a full 6 fps.

Canon EOS 3

Ever since Canon released the Elan IIE, with its much improved version of Canon's Eye Controlled Focus system, first introduced on the A2E, and especially since Nikon's release of its remarkable new flagship camera, the F5, Canon watchers have been speculating over the

company's next high-end entry. Which camera will it replace, the A2E or the EOS-1n? Well, as it turns out, the answer is neither. Both the EOS-1n and the A2E remain current models, with the EOS 3 wedged securely between them. However, at this point in time, the just-announced EOS 3's street price seems to be much more closely situated to the EOS-1n's than to the A2E's. Regardless of pricing, though, the EOS 3 is definitely not some sort of downscaled EOS-1n – or upscaled A2E, for that matter. In terms of autofocusing performance, the EOS 3 is now Canon's top performer. In terms of market niche, the EOS 3 is intended and built for the demands of the professional. It is, in anyone's terms, an altogether new camera, incorporating a number of improvements not found on any other EOS. Most significant of all, though, the EOS 3 departs from all other AF cameras with an astounding array of 45 autofocus sensors, providing the user with a dazzling viewfinder presentation as the group of active AF sensors light up in response to one's eye placement, thanks to Canon's Eye Controlled Focus technology. The 45-sensor array is located within a 15mm by 8mm oval, and is linked to a 21-sensor array of exposure sensors for optimum exposure accuracy.

An obvious question is, since conventional Charge-Coupled Device (CCD) AF sensors are expensive to produce, how was Canon able to incorporate a 45–AF-sensor array, while keeping the EOS 3's price down to a "pro/am" price point? The answer, as it turns out, lies in the technology of the sensors themselves. All current autofocus SLRs, except the EOS 3, rely on (CCD) technology to accomplish their autofocusing chores. For the EOS 3, Canon opted to use CMOS sensors (Complementary Metal Oxide Semiconductors) instead. CMOS sensors have been around for quite a while and are relatively easy and

cheap to produce, thus a lot of CMOS sensors can be packed into the design for the same price as a few CCDs, resulting in an overall superior and more sensitive AF system. In fact, while most AF cameras require a maximum aperture of f/5.6 or greater, the EOS 3 is capable of focusing with an f/8 maximum aperture.

Let's take a look at the some of the other capabilities of this feature-packed camera. Despite its large AF array, the AF system is relatively straightforward, with two available autofocusing modes: One-Shot AF and Predictive AF with AI Servo AF. The former enables AF lock, in which the shutter will not fire until the subject is in focus. The latter allows the shutter to be tripped at any time and uses predictive focus technology to render in-focus images. Three methods of selecting focusing points are possible: automatic selection, manual selection, and Eye Controlled Focus selection.

The latest generation of Canon's Eye Controlled Focus technology, as found on the EOS 3, is now called High Speed Eye Controlled Focus, presumably because it must function properly in conjunction with the EOS 3's improved focusing speed. Speaking of which, with the optional Power Drive Booster PB-E2, the camera is capable of delivering up to 7 frames per second in Predictive AF mode. Without the PB-E2, the camera's maximum continuous speed is 4.3 frames per second.

The EOS 3 benefits as well from a selection of metering modes. It's likely, that the camera will be used the most in its 21-zone evaluative metering mode, where the zone or zones linked to the active AF sensors will measure exposure information. But for those of us die-hards that still prefer partial metering, it's there too (approximately the central 8.5% of the viewfinder area). Spot metering, with the sensor locked to the active focusing point (about 2.4%) is available, as is multi-spot metering, where up to 8

readings can be stored and averaged. And the camera retains that archaic standard, good old centerweighted averaging.

Exposure modes consist of Program AE with shift, shutter- and aperture-priority AE, Depth-of-field AE, E-TTL program flash AE with the 550 EX, A-TTL program flash AE, TTL program flash AE, manual, and bulb. ISO speed ranges from 6 to 6400. Exposure compensation is available using auto exposure bracketing (AEB), which is a 3-shot group consisting of standard, over, and under exposures, and which can span a range of ±3 stops in 1/3 stop increments. Manual exposure compensation is available via the Quick Control Dial, or the exposure compensation button and the main dial. Plus AEB and manual exposure compensation can be used together. AE lock and full manual exposure control are available, as is multiple exposure capability. When the 550EX Speedlite is attached, flash exposure bracketing is possible, as well.

Shutter speeds range from 30 seconds to 1/8000 second, plus B, and are adjustable in 1/3-stop increments. Flash sync occurs at 1/200 second. The EOS 3 has 18 custom functions, which include such niceties as choosing to leave the film leader in or out, AEB sequencing, mirror lock-up, first or second-curtain flash sync, and a bunch more. The self-timer has a 2-second and a 10-second setting. An optional programmable remote release is also available, as is a programmable data back DB-E2. The EOS 3 takes the same focusing screens as the EOS-1n, automatically superimposing its 45-sensor array on the new screens.

EOS 10s

Introduced with EOS 10s were several advances that have found their way into subsequent EOS SLRs. The focusing control system as found on the 10s

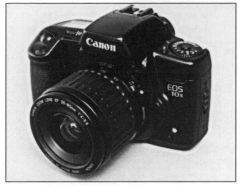

EOS 10s

was enhanced considerably with the addition of Canon's "Multi-Basis" system's three focusing sensors, which provide the user greater flexibility for subject positioning and also improve tracking of moving subjects.

The 10s autofocus modes include the "One-shot AF Mode" (focus-priority) and the "AI Focus AF Mode" (predictive, continuous autofocus). One program selection switches the AI Focus mode between one-shot and continuous, depending on whether or not the subject is moving.

Exposure is determined either by an eight-zone evaluative metering system, due to the three active AF points, or by the partial-metering method, which places heavy emphasis on the center of the viewfinder. Exposure modes include program, shutter and aperture priority AE, depth-of-field AE, metered manual, Canon's "Programmed Image Control" (PIC), which, on the 10s, includes four different preset exposure modes, and, a first for Canon back then, a bar code system. Using the optional bar code reader and bar code book, the user can program the 10s for special shooting situations.

Other exposure features include: TTL flash with the built-in flash or accessory Canon speedlites, auto exposure bracketing, exposure compensation, multi-exposures and an interval timer.

Shutter speeds range from 30 seconds to 1/4000, plus B, with flash sync occurring at 1/125. Other features include: DX film coding with override, a

self timer, film transport speeds up to 5 fps with the built-in motor drive (up to 3.3 fps in AI Servo Mode), and auto film loading and rewind. The 10s has fourteen custom function controls that let the user tailor functions such as film rewind, DX coding, shutter-speed lock, depth-of-field check and, something that was missing from Canon's lineup for way too long, a mirror lock-up feature.

EOS 620

Despite its age, the EOS 620 still remains somewhat popular on the used market because of its top flash sync speed: 1/250 second. The only other EOS cameras with this flash sync speed are the professional models.

Available autofocus modes are one-shot (focus priority) or continuous (servo). Metering patterns include a six-zone evaluative pattern or partial area (6.5%). Exposure modes include a program mode with manual shift override, aperture and shutter-priority AE and metered manual. Additional exposure controls include auto-bracketing, multi-exposure capability and a depth-of-field check button. Shutter speeds range from 30 seconds to 1/4000, plus B, with the above-mentioned X sync of 1/250 second.

Other features include interchangeable focusing screens, exposure compensation, DX coding with manual override, a self timer, TTL flash, auto fill-flash, second-curtain flash sync and multi-strobe effects. The integral motor drive advances film at speeds up to 3 fps with auto film loading and rewind, and mid-roll film rewind.

EOS 630

The EOS 630 replaced the 620, although it lacks a couple of features its predecessor has, most notably the top shutter speed and flash sync. Both speeds got bumped down a notch with the 630 to 1/2000 and 1/125, respectively.

EOS Autofocus SLRs

Camera	Yrs Made	New		Mint		Excellent		User	
EOS A2	1992-	595	495						
EOS A2E	1992-	690	590	600	520	495	425		
EOS EF-M w/50 f/1.8	1991-95			250	195				
EOS EF-M w/35-80	1991-95			325	250				
EOS Elan	1991-95					300	250		
EOS Elan kit w/28-80 USM	1991-95					450	390		
EOS Elan II	1991-	450	330						
EOS Elan II kit w/28-80 USM	1996-	650	530						
EOS Elan II E	1991-	500	370						
EOS Elan II E kit w/28-80 USM	1996-	700	570						
EOS Rebel	1990-91			150	130				
EOS Rebel kit	1990-91			275	225				
EOS Rebel II	1991-94			220	170				
EOS Rebel II kit	1991-94			310	230				
EOS Rebel G	1995-	260	230						
EOS Rebel G w/35-80	1995-	390	340						
EOS Rebel S	1990-91			200	175				
EOS Rebel S w/35-80	1990-91			325	280				
EOS Rebel S w/35-105	1990-91			360	330				
EOS Rebel S II	1991-94			200	180				
EOS Rebel S II w/35-80	1991-94			300	260				
EOS Rebel S w/35-105	1990-91			360	330				
EOS Rebel S II	1991-94			200	180				
EOS Rebel S II w/35-80	1991-94			300	260				
EOS Rebel S II w/35-105	1991-94			420	330				
EOS Rebel X	1994-95			225	180				
EOS Rebel X w/35-80 II	1994-95			320	275				
EOS Rebel XS	1994-95			270	230				
EOS Rebel XS w/35-80 II	1994-95			365	325				
EOS RT	1989-94			500	450	450	375		
EOS 1	1989-1994			850	785				
EOS 1 w/pwr drv	1989-1994			1100	950				
EOS 1n	1994-	1275	1200						
EOS 1n RS	1996-	2100	1700						
EOS 3	1994-		1300						
EOS 10s	1990-94					350	270		
EOS 620	1986-89			300	270	280	200		
EOS 630	1989-91					350	285		
EOS 650	1986-89			280	250	250	160		
EOS 700 w/35-80	1990-90			260	240				
EOS 750	1988-90			175	150				
EOS 850	1988-90			170	150	150	100		

The 630 makes up for this with a host of improvements. For starters, Canon claimed the 630 focuses twice as fast as previous models (the 620 and 650). It still has two AF modes, one-shot (focus-priority) and continuous (servo), but the latter was improved with an added "Focus Prediction" feature for sharper results when shooting high-speed action photos. To complement this faster autofocus capability, the motor drive's speed was boosted to 5 fps (slower when tracking moving subjects in the continuous AF mode).

The 630 combines the best exposure modes of the 650 and 620, plus a lot more. In addition to program with shift, aperture and shutter-priority AE, and metered manual modes, are both depth-of-field AE and auto-bracketing. It also has Canon's "Programmed Image Control" (PIC) system, a set of seven preset program modes, and "Custom Function Control," a set of seven user-

set custom functions for film advance, DX coding, AF control, AE control and metering patterns. Other features include multi-exposure capability and a depth-of-field check button. TTL Flash AE options are the same for the 630 as with the 620.

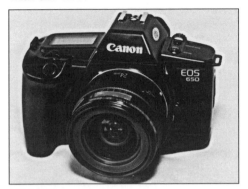

EOS 650

EOS 650

Available autofocus modes are one-shot (focus priority) or continuous (servo). Metering patterns include a six-zone evaluative pattern or partial area (6.5%). Exposure modes include a program mode that shifts automatically depending on the lens mounted, aperture and shutter-priority AE, metered manual and depth-of-field AE. Other features include interchangeable focusing screens, exposure compensation, DX coding with manual override, a self-timer, TTL flash, auto fill-flash, second-curtain flash sync and multi-strobe effects.

Shutter speeds range from 30 seconds to 1/2000, plus B, with X sync at 1/125. The integral motor drive advances film at speeds up to 3 fps with auto film loading and rewind, and mid-roll film rewind.

EOS 700

The EOS 700 was released after the EOS 750. The two cameras look similar, but shouldn't be confused. The EOS 700 is an entirely different camera with a broader array of features.

The autofocus system used in the 700 is similar to that used in the 630,

ensuring rapid autofocus. Two modes are possible: one-shot (focus-priority) or "One-Shot/AI Servo Automatic Changeover." The latter selection will switch automatically from single shot to continuous predictive autofocus based on subject movement.

Exposure options, using the six-zone evaluative metering pattern, include the same program mode as the 650's, depth-of-field AE, and Canon's "Programmed Image Control" with 8 settings, Shutter-priority and TTL programmed flash with the built-in flash or other EOS speedlites. Shutter speeds range from 2 seconds to 1/2000 ($^1/_4$ -1/2000 in shutter-priority), with flash sync at 1/125.

The 700 uses the same film prewind system as in the 750/850 and, like them, has DX film speed settings only with no manual override. The built-in motor winds the film at speeds up to 1.2 fps.

EOS 750 & 850

Both cameras have a single autofocus mode, one-shot (focus priority) operation. The 750 has a built-in flash and a hot shoe, the 850 has a hot shoe only. The E-160E flash was designed for use with the 850, but other EOS units will work as well.

Exposure modes are program and depth-of-field AE using the six-zone evaluative metering pattern, ala the 650. Shutter speeds range from 2 seconds to 1/2000. Film ISO is set automatically by DX film coding. There is no manual DX override. The built-in motor provides film wind speeds to 1.5 fps. Mid-roll rewind is not possible. When film is inserted, the film is prewound to the end of the roll, then drawn back into the film cassette with each exposure, thereby protecting exposed frames if the camera back is accidentally opened. The frame counter shows the number of frames remaining on the roll.

TTL flash and fill-flash are possible with either the built-in flash (750 only, GN of 39 at ISO 100), or add-on EZ speedlites.

▢ EOS (EF) AUTOFOCUS LENSES

EOS optics have established a reputation for optical quality, especially the ultra-expensive L-series and the various almost-silent Ultrasonic models. More and more members of the photographic press and others whose work requires the finest lenses available seem to agree that Canon's L-series EF lenses are superior to all other 35mm SLR lenses currently being produced. But that shouldn't be too surprising, considering the prices tags these optics carry.

When Canon decided to switch from the tried-and-proven, backward-compatible FD mount with its millions of users to an altogether new mount with no backward-compatibility, you can bet that the company had some pretty good reasons for doing so. For starters, Canon was getting clobbered by Minolta. Clearly, Canon engineers saw the necessity of coming up with a design which would not only meet the competition's capabilities, but which would give Canon a decided edge. So, instead of another attempt at an autofocus design based on the FD mount (they had already been burned pretty good trying that before – remember the T-80?), Canon elected to start with a clean slate. Once again, in a departure from the industry norm, Canon decided to locate autofocus motors in its lenses instead of camera bodies. Even though this idea didn't work so well with the T-80, Canon was on the right track, largely due to its own advances in motor design. By foregoing a mechanical autofocus power coupling between the camera and lens, and instead providing each lens with its own motor, the number of moving parts was reduced, which translates directly

EOS Autofocus Lenses

Lens	New		Mint		Excellent		User
14mm f/2.8 L USM	2320	2180					
15mm f/2.8	695	650					
20mm f/2.8 USM	575	470	400	320			
24mm f/1.4 L	1425	1330					
24mm f/2.8	485	360	360	290			
24mm f/3.5 L TS	1370	1310	1100	950			
28mm f/1.8	520	450					
28mm f/2.8	230	190	125	95	100	85	
35mm f/2	325	280					
45mm f/2.8 L TS	1370	1290					
50mm f/1.0 L USM	2995	2500					
50mm f/1.8	95	75	55	45	50	40	
50mm f/1.4	385	320					
50mm f/2.5 Macro	365	295	220	190	200	160	
Life Size Converter EF	250	200	150	120	120	90	
85mm f/1.2 L USM	1850	1730	1550	1495			
85mm f/1.8 USM	425	370	295	260			
90mm f/2.8 L TS	1350	1270					
100mm f/2 USM	480	395					
100mm f/2.8 Macro	650	575					
135mm f/2 L USM	1050	950					
135mm f/2.8 Soft Focus	410	340			190	170	
180mm f/3.5 Macro L USM	1630	1550					
200mm f/1.8 L USM	4695	4450					
200mm f/2.8 L USM (early)			625	550			
200mm f/2.8 L USM II	765	690					
300mm f/2.8 L USM	4950	4600					
300mm f/4 L USM	1270	1090					
300mm f/4 L IS USM	1800	1590					
400mm f/2.8 L USM (early)			6900	6200			
400mm f/2.8 L USM (late)	8200	7550					
400mm f/5.6 L USM	1770	1470					
500mm f/4.5 L USM	5750	5300					
600mm f/4 L USM	9100	8400					
1.4X APO	495	420					
2X APO	380	320					
17-35 f/2.8 L	1695	1530					
20-35 f/2.8 L	1440	1290	1060	1000			
20-35 f/3.5-4.5 USM	495	430	395	370			
24-85 f/3.5-4.5 USM	485	340					
28-70 f/3.5-4.5			225	175			
28-70 II f/3.5-4.5			170	160			
28-70 f/2.8 L USM	1550	1340					
28-80 f/2.8-4 L USM			1020	950			
28-80 f/3.5-5.6	175	140					
28-80 f/3.5-5.6 USM*	200	160					
28-105 f/3.5-4.5 USM	375	295					
28-135 f/3.5-5.6 IS USM	645	500					
35-70 f/3.5-4.5			150	125	125	100	
35-70 f/3.5-4.5 A	140	110	90	75			
35-80 f/4-5.6*	150	105	95	60			

The current model of the 28-80 f/3.5-5.6 USM lens is the fourth one, and the current model of the 35-80 f/4-5.6 is the third. In both cases, instead of attempting to track the prices of all models, I have included the earlier models in the used price ranges for each optic. Price differences between the various models are negligible.

EOS Autofocus Lenses (cont'd)

Lens	New		Mint		Excellent		User
35-80 f/4-5.6 USM	170	150					
35-105 f/3.5-4.5			175	150			
35-105 f/4.5-5.6			150	125			
35-105 f/4.5-5.6 USM			200	150			

EOS Autofocus Zoom Lenses

Lens	New		Mint		Excellent		User
35-135 f/3.5-4.5					200	150	
35-135 f/4-5.6 USM			205	190			
35-350 f/3.5-5.6 L USM	2295	2000					
50-200 f/3.5-4.5			200	175	175	150	
50-200 f/3.5-4.5 L			500	420			
70-200 f/2.8 L USM	1595	1440	1325	1270			
70-210 f/3.5-4.5 USM			225	185			
70-210 f/4			195	170	160	150	
75-300 f/4-5.6 I, II	245	180	150	140			
75-300 f/4-5.6 USM	280	210					
75-300 f/4-5.6 USM IS	595	510					
80-200 f/2.8 L			950	850	820	740	
80-200 f/4.5-5.6 I, II	145	100					
80-200 f/4.5-5.6 USM	165	120					
100-200 f/4.5 A			100	80			
100-300 f/4.5-5.6 USM	355	290					
100-300 f/5.6			250	200			
100-300 f/5.6 L	695	620	525	480			

into a focusing system that is not only inherently faster, but, with the new Ultrasonic lenses, the quietest in the industry – although your dog may not agree.

If you're an experienced photographer, but new to EOS, something else you're sure to notice right away is perhaps the second most significant aspect of an EOS lens. There is no aperture ring. Lens apertures are controlled by setting the aperture value on the camera instead of the lens. To many photographers from an earlier, bygone era, this may seem to be unnecessary gimmickry – more retraining for the end user disguised as convenience. Maybe not, though. For example, the EOS TS (Tilt-Shift) lenses have automatic diaphragms, whereas the FD-mount TS 35 does not. Because EOS lenses communicate aperture information electron-

ically, an automatic diaphragm on a TS lens is no longer the stumbling block it once used to be with the FD lens' mechanical design. Look for other new products that will take advantage of the EOS electrical-contact coupling. Like what? How about an EOS auto bellows that doesn't need a double cable release? Makes sense, doesn't it.

Another improvement over the FD mount is the larger diameter of the EOS mount. It has been reported that Canon felt the larger mount size was necessary to prevent vignetting in the viewfinder when using super telephoto lenses with focal lengths of 800 millimeters and greater. This is an interesting tidbit, since the longest focal length EOS telephoto currently available is the 600mm f/4. Can this mean that Canon has even longer focal lengths planned for the EOS system?

One other peculiarity found with many of the L-series lenses should be mentioned: the 50mm f/1.0 L, 85mm f/1.2 L, 200mm f/1.8 L, 300mm f/2.8 L, 400mm f/2.8 L and 600mm f/4 L all have power-assisted manual focus. The traditional helical or rack-and-pinion methods of mechanical focusing have been abandoned in favor of an electronic coupling between the focusing ring and the movable elements, allowing manual focus to be performed by the internal drive motor. Because of this the camera must be switched on to focus one of these lenses manually.

In the lens listings (above and previous page), the following abbreviations are used: L = Low dispersion glass (See the FD lens section for an explanation), USM = UltraSonic Motor, TS = Tilt-Shift, and A= Autofocus only.

EOS Accessories

Item	New		Mint		Excellent	User
A2E Eyepiece Extender	25	20				
Command Back E-1 (EOS-1/1n)	250	175				
Data Back DBE-2 (EOS-1/1n)	250	175				
Quartz Ddata Back E/E2	270	200				
Long Lens Adapter FD (EOS-1/1n)	125	100				
NPC Polaroid Back (EOS-1/1n)	740	670	570	500		
NPC Polaroid Back (EOS-1 w/Power Drive Booster)	785	750				
NPC Polaroid Back (620, 650, RT)	740	670	570	500		
Quartz Data Back E (620/630/650/RT)		80	65	70	50	
Technical Back E w/kbrd (620/630/650)		690	550			
Interface Unit TB*	150	120				

Connects Technical Back E to IBM PC or compatible computers

EOS Motor & Remote Accessories

Item	New		Mint		Excellent	User
Power Drive Booster (EOS-1/1n)	330	260				
Power Drive Booster-2 (EOS-3)	300	est.				
Handstrap E-1 (for Power Drive Booster)	30	25				
Nicad Pack E-1 w/charger	400	315				
BP-E1 Battery Pack (EOS-1)	145	100				
BP-5 Battery Back (A2/A2E)	80	55				
RC-1 Remote Controller (10s/Elan)	20	20				
Remote Switch 60 T3*	45	30	25	20		
Remote Switch Adapter T3	35	30				
Cable Release Adapter T3*	30	25				
Extension Cord 1000 T3*	35	30				
LC-2 Wireless Controller Set*	195	150	120	90		
LC-3 Wireless Controller Set*	345	310				
TM-1 Quartz Interval Timer*	160	110				

The Remote Switch 60 T3, Cable Release Adapter T3, Extension Cord 1000 T3, and the LC-2 and LC-3 Wireless Controller Sets are for use with T3-compatible EOS cameras. The TM-1 Quartz Interval Timer requires the Remote Switch Adapter T3 to be used with T3-compatible EOS cameras.

EOS Grips

Item	New		Mint		Excellent	User
GR-10 Grip (620/630/650/RT)	55	45	30	25		
GR-20 Grip (620/630/650/RT: w/T3 socket)	45	35	20	15		
GR-50 Grip (700/750/850)	35	25				
GR-60 Grip (10s)	45	35				
GR-70 Grip (Rebel/Rebel S)	35	25				
GR-80TP (Rebel X/XS)	45	35				
VG-10 Grip (A2/A2E)	130	90				
Handstrap for VG-10 Grip	30	25				

EOS Close-up Accessories

Item	New		Mint		Excellent		User
Angle Finder B (w/adapter S)	110	75	55	35	50	35	
Angle Finder Adapter (A2/A2E)	20	15					
Magnifier S	50	35	30	20			
EF-12 Extension Tube*	90	60					
EF-25 Extension Tube*	125	100					
Macro Lens Mount Converter FD-EOS		85		65			

The EF-12 and EF-25 Extension Tubes provide fully coupled extensions (12mm and 25mm respectively) between body and lens, and can be used with all EOS cameras. The Macro Lens Mount Converter FD-EOS is designed to couple EOS cameras to FD close-up accessories, such as the Auto Bellows, for high-magnification photography. Although an FD lens can be mounted directly to an EOS camera using this accessory, infinity focus will be lost.

Miscellaneous EOS Accessories

Item	New		Mint		Excellent		User
FD to EOS Adapter (not Canon)*	60	40					
Pentax SM to EOS Adapter (not Canon)**	35	25					
Nikon F to EOS Adapter (not Canon)**	70	45					
Bar Code Reader E (10s & Elan)	65	45					
Bar Code Book	20	15					

*• Manual diaphragm, loss of infinity focus. ** Manual diaphragm operation.*

EOS Flashes

Item	New		Mint		Excellent		User
160E (EOS 850)					35	25	
200E (EOS Rebel)	70	50			40	35	
200M (EOS EF-M)			45	35			
220EX	150	115					
300EZ			90	80	75	60	
380EX	195	160					
420EZ					175	140	
430EZ			215	190			
480EG Set	540	480					
540EZ	340	245					
550EX	350 est.						
Compact Battery Pack E	120	70					
Nicad Pack TP	135	110					
Nicad Charger TP	50	35					
Transistor Pack E set	165	120	90	75	75	60	
Trans Pack E set w/NiCads, chgr	300	240	200	150			

The Compact Battery Pack E and the Transistor Pack E set are for use with the 430EZ and 480EG only.

Item	New		Mint		Excellent		User
ML-3 Macro Light	260	200	180	150	160	125	
TTL Distributor	60	45					
TTL Hot Shoe Adapter	80	60					
Connecting Cord 60	45	30	20	15			
Connecting Cord 300	60	45	25	20			
Off Camera Shoe Adapter	30	25					
Off Camera Shoe Cord (except 630, RT)	60	45					
Slave Unit E	65	50					

Contax/Yashica

□ CONTAX CAMERAS

Modern Contax 35mm cameras (as opposed to the Contax rangefinders and SLRs of the 1930's-50's) are the result of a 1973 cooperative agreement between Carl Zeiss of Germany and Yashica of Japan.

The Contax mystique was reborn when the RTS was introduced in 1976. Sporting a sleek exterior created by Porsche's design studios, Contax cameras have always been a sensual experience to hold and, well, just to look at. The modern Contax is not just a beautifully-designed machine, it is a well-engineered and constructed photographic tool that accepts some of the finest optics ever made, the Zeiss T* lenses.

Contax G-1

The Contax G-1 is the first genuinely new design in interchangeable-lens rangefinder cameras since the introduction of the Leica CL

Right off the bat, the engineers at Contax decided to house the G-1 in titanium – a smart move. Press-corps duty can be brutal and housing a camera in titanium is the most effective means of prolonging its life. Underneath the titanium skin is an all-metal frame made from copper-silumin alloy, a material that Contax is using in all its latest SLRs now.

The G-1's most significant feature is also a big departure from the Contax philosophy of "user control": autofocus. The AF system uses an advanced passive AF design with an extended base length to enhance autofocus accuracy.

The TTL meter is of the center-weighted averaging variety. The exposure modes provided are aperture-priority AE, manual, and TTL auto flash. Shutter speeds range from 16 seconds to 1/2000 (1 second to 1/2000 in manual), plus B, with X sync occurring at 1/100 second. The G-1 has an integral motor that provides what has become the standard array of features: auto first-frame film wind and auto rewind, plus single and continuous frame advance modes at speeds up to 2 frames per second. Other features include an AE lock, eyepiece dioptric adjustment, and an adapter that will allow the user to fit Contax SLR lenses on the G-1.

Contax G2

As nice a camera as the G1 is, the G2 demonstrates resoundingly that it can be improved. On the G2, the built-in motor's continuous speed was doubled from the G1's 2 frames per second to 4 frames per second. A release-priority continuous AF mode was added, and top shutter speeds were increased to 1/6000 second. The focusing wheel was repositioned from the top to a more ergonomically suitable location on the front of the camera body. The viewfinder was enlarged and the AF system was improved, as well.

The AF system incorporates both external passive and active infrared focusing technology. Custom functions available include AE lock, autobracketing, film leader status (in or out), focus operation in manual focus mode, multiple exposure ISO setting, and more.

Contax Aria

Small, lightweight, and easy to use – those words seem to associate themselves naturally with the Contax Aria. But a closer examination will reveal a camera packed with features. It has a comprehensive array of exposure modes and options, which includes program, shutter-priority, and aperture-priority AE, manual exposure, three auto TTL flash modes, plus a manual flash mode. Exposure compensation (+/- 2 EV in 1/3-stop increments) and autobracketing are also available. Three metering patterns are available: five-segment evaluative, centerweighted averaging, and spot. Shutter speeds range from 16 seconds to 1/4000 second when in auto modes, and 4 seconds to 1/4000 in manual. Flash sync is at 1/125 second. The built-in winder advances film up to 3 frames per second and features auto film prewind and rewind. Other options include a 10-second electronic self-timer and interchangeable focusing screens. When used with a TLA flash, such as the TLA360, second-curtain flash sync is also available. A lot of camera for a reasonable sum – and one that just happens to take some of the finest lenses ever made.

Contax AX

Let's say you're the CEO of a company that you feel — no, that you know makes the best products on the market. But let's say that the market has changed fundamentally and is now heading in a direction that you feel you cannot take your company, since it would mean that you would be forced to compromise the quality of your products in the short term. But you know you have to do something because if you don't, the market will leave you and your company behind, and sooner rather than later, your company, maker of the finest products on the market, will be naught but a fading, albeit beloved, memory. The long term solution, which might be more appealing would require huge R&D investments and time you do not have so that you could maintain the high road that you had carved out for yourself. But then you ask yourself, "If it ain't broke, why fix it?"

Surely something not too dissimilar from this was going through the frustrated heads of the movers and shakers at Contax. The official spin goes that Contax realized early on it would be impossible to design AF versions of the Zeiss lenses used on its cameras, but I don't buy this story for a couple of reasons: one, nothing is impossible if you put your mind to it. Canon and Nikon have demonstrated that. Their current generation autofocus optics are superior in optical performance to their earlier manual focus ones. But look how long it took them to do it. Two, please recall that Contax is not Zeiss. Contax is licensed to produce Zeiss lenses, and is contractually obligated to abide by Zeiss's stringent design and quality control requirements. If Zeiss says, "No, it's impossible," regardless of what the reason might be – and in Zeiss' case, I believe it to be pure ego-driven recalcitrance – then Contax must say, "No, it's impossible" too.

So what's a company to do? Well, I suppose it helps to keep in mind that, as the old saw goes, there's nothing really new under the sun. Fortunately for Contax, this tired old saying had some wisdom to it.

Those of you who are at least moderately experienced camera collectors will perhaps recall the original Mamiya 6, which was produced during the late 1940s and early 1950s. The novel, but still probably not new, thing about this otherwise traditional folding-bed, bellows-type square medium format camera is that it employs a knurled ring located on the camera body to move the film plane into focus. Bingo.

Fast forward fifty years, and, lo and behold, we see history repeating itself with the Contax AX. And, not only is the AX a brilliant feat of design and engineering, but the introduction of this camera surely must have caused a huge sigh of relief to go up among Contax users everywhere. Why? Well, because Zeiss lenses aren't exactly cheap, are they? Now, for the price of one or two Zeiss lenses, the Contax user can buy a camera body that will convert his or her entire lens inventory to autofocus. In a world, brilliant.

The AX's Automatic Back Focusing System amounts to a camera body within a body. The internal body slides fore and aft on a ceramic collar and rail arrangement that holds an exceedingly tight tolerance of two microns (0.0002 mm). Such a close fit insures perfect alignment of the film plane at the point of focus. Undoubtedly, Contax was the direct beneficiary of its parent company Kyocera's experience in ceramics manufacture and design for the development of this crucial AX subcomponent. One nice side benefit to the AX's focusing method is that any lens will focus closer than normal. Because of its design, the Automatic Back Focusing System provides an additional 10mm of extension, so now every lens will, in effect, have a macro setting.

Rather than target this camera toward the advanced amateur, Contax had the professional user in mind. The AX is not small, and not particularly light. At 38.1 ounces (1,080 grams), it is only a few ounces lighter than the Nikon F5, but boasts a die cast aluminum alloy chassis and titanium top cover.

Autofocusing is done via Contax's phase difference detection system. Focusing modes include Single Autofocus (SAF), Continous Autofocus (CAF), M (manual focus), and Macro. While the AX's AF performance is not as fast as its competitors, its accuracy is second to none.

Exposure modes include program AE, shutter- and aperture-priority AE, metered manual, and TTL auto flash. Either centerweighted averaging or spot metering is available. Other exposure options include exposure compensation, autobracketing, multiple exposure capability, and an AE lock.

Shutter speeds range from 32 seconds to 1/6000 second, plus B, with flash sync occuring at 1/200 second. The integral film winder has the standard array of features and will advance film at a maximum rate of 5 frames per second. Other features include a selection of eight custom functions, interchangeable viewing screens, a PC terminal, depth-of-field preview, DX film coding with override, and built-in diopter correction. Optional is the Multifunction Data Back D-8, which will print data between frames or store it in the camera's onboard memory, then download it onto the first and second frames upon completion of the roll. The DB-8 can also be configured to operate as an intervalometer.

Contax RTS with Yashica winder

Contax RTS

The RTS' exposure features include aperture-priority AE and metered manual modes using a bottom-centerweighted metering pattern, exposure compensation and multi-exposure capability. Shutter speeds range from 4 seconds to 1/2000, plus B, with X sync at 1/60. Other features include user-interchangeable focusing screens, a self-timer and depth-of-field preview. The RTS Winder can be attached for motor-driven speeds up to 2 fps. There was also a motor drive made for the original RTS, called the Professional Motor Drive. The W-6 Professional Motor Drive (not to be confused with the aforementioned one), while designed for the RTS II, will function on the RTS, as well.

Contax RTS II

The RTS II features the same exposure options and metering pattern as the RTS. The shutter speed range was extended on the low end to 16 seconds (4 seconds in manual mode), plus B, with X sync at 1/60 (apparently, even though it's labeled as being 1/60, the actual mechanical shutter speed is 1/50 second). Only B and X sync operate without batteries. Other features include TTL flash automation with dedicated flash units, exposure compensation, an AE lock, interchangeable focusing screens, a self-timer and depth-of-field

preview. Either the accessory 3 fps W-3 Winder or the 5 fps W-6 Motor Drive can be attached.

Contax RTS III

Contax RTS III

The RTS III is the new leader in the dubious "Most Expensive Japanese 35mm SLR" category. Being that it's more expensive than the Nikon F4 and the Canon EOS-1n by several hundred dollars, you'd probably expect it to be crammed with features, offering the latest state-of-the-are technology and, of course, exhibiting the very best of craftsmanship The response to such expectations is an unqualified "Sort of." For example, your 2,000 plus semolians doesn't buy you autofocus, nor do you get even a single program mode, and you can forget about the latest smart technology in multi-segmented metering patterns. But what you do get is impressive.

The RTS III has a unique vacuum mechanism coupled with a ceramic pressure plate that sucks the film flat at the film plane, insuring maximum sharpness. Another unique feature is its TTL pre-flash spot metering system, which allows the user to check exposure with any flash, from wink lights to studio strobes, not just dedicated units. The RTS III joins the Nikon F family and the EOS-1 as one of a handful of 35mm SLRs that offer a 100% field of view through the viewfinder (most other 35mm SLRs

have a field of view ranging from 90% to 97%).

Exposure modes include shutter or aperture-priority AE and metered manual using centerweighted or spot metering. Other exposure features include TTL flash metering with dedicated flash units (second-curtain sync with the TLA280 flash), autobracketing, an AE lock and exposure compensation. Shutter speeds range from 32 seconds to 1/8000 (4 seconds to 1/8000 in manual), plus B, with X sync at 1/250.

Other features include a built-in databack that records information between the frames, mirror lock-up, interchangeable focusing screens, diopter correction, an eyepiece shutter, depth-of-field preview, multiple exposure capability, DX film coding with override, a die-cast aluminum body with a magnesium top plate and a titanium bottom plate, and an integral motor drive that provides continuous speeds up to 5 fps.

Contax RX with Planar T 50mm F1.4mm Lens*

Contax RX

One must be familiar with Contax's tenacious adherence to manual focus technology to appreciate the milestone the Contax RX represents. The engineers at Contax have finally conceded that a focus-assist feature, called the Digital Focus Indicator on the RX, could be of some value. Contax still draws the line at autofocus, though, claiming that the Zeiss T* lenses cannot be enhanced by adding autofocus capability, mostly due

to weight and focus accuracy. The RX nevertheless represents a fundamentally new direction for Contax, so let's take a look at what they've come up with.

The RX bears a strong resemblance to the ST. Its body components are made from the same materials, the same type of precision drive motor system is used; the same metering components and oversized pentaprism are found in the RX as in the ST. But the differences between the two cameras are considerable.

The RX's Digital Focus Indicator (DFI) function is a unique focus-assist system that uses the principle of the Circle of Confusion to determine best focus. Put simply, the circle of confusion is the minimum size of a light source when projected onto the film plane. Have you ever noticed how, when you defocus a lens in either direction, the image not only blurs but grows in size? That's the principle at work here. The RX is able to determine the minimum size of the subject at the point of focus, and as a result is able to indicate when critical sharpness has been reached. The RX also has two Focus Indicator Scale modes. Not only will the DFI render the subject in absolute focus, but it can also provide the user with a depth of field scale, showing an acceptable focus range and where within that range the point of focus lies. For the photographer who prefers focus accuracy over focus speed, the RX, with its DFI system, could be just the ticket.

The RX has six exposure modes: aperture preferred AE, shutter preferred AE, program AE, manual, TTL auto flash AE and manual flash. Also found on the RX is Automatic Bracketing Control, which will bracket three shots either in single or continuous frame advance in $1/2$ EV increments. AE lock, ±2 EV exposure compensation and second-curtain flash

sync with dedicated TLA flashes are also available.

The user can select between two metering systems: centerweighted averaging and spot. Shutter speeds range from 16 seconds to 1/4000 second (4 seconds to 1/4000 in manual and shutter preferred AE), with X sync occurring at 1/125, plus B. The RX can be personalized, as well, with a selection of nine user-defined Custom Functions to choose from.

Other features include a self-timer, DX-film coding with override, dioptric adjustment, interchangeable focusing screens, auto film loading and rewind with mid-roll rewind available, single or continuous frame advance (speeds up to 3 fps), a PC connector, a built-in data back that prints data between frames and a depth-of-field preview button.

Contax S2 & S2B

If you're like many photographers who cut their teeth on mechanical, manual-focus, manual-exposure SLRs, and if you find yourself longing for the good old days, then news of the release of the Contax S2 may come as sweet comfort to your soul. Imagine a rugged, titanium-housed Nikon FM2, and you'll have a pretty good picture of the Contax S2 (even the shutter speed dial is located where a non-Contax user would expect to find it). One unusual feature of the S2 is its metering pattern: indicated by the focusing screen's microprism circle, the pattern is a 5mm spot, which works out to about 2% of the image area – an unusual choice for a single metering pattern. Contax sees the prospective S2 user as a meticulous photographer, either a dedicated amateur or professional who needs the tight discrimination a spot meter provides. The S2B, however, employs the more conventional center-weighted metering pattern, which is, as far as I've been able to determine, the

only feature that distinguishes the S2B from the S2.

The S2's mechanical, vertical-travelling, metal-bladed shutter provides speeds from 1 second to 1/4000, plus B, with X sync occurring at 1/250. Other features include interchangeable focusing screens, a mechanical self-timer, depth-of-field preview, a multiple-exposure lever, a semi-dedicated hot shoe (with dedicated Contax strobes, a ready light will illuminate in the viewfinder), a PC connector, and a manual ISO film-speed setting dial (No DX coding here, folks.).

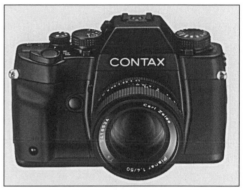

Contax ST with Planar T 50mm F1.4 lens*

Contax ST

The Contax ST represents a superb balance of form and function. Its form can only be described as elegant. Its function, however, is very traditional by today's auto everything standards. Nevertheless, the elements of the ST combine to provide the serious photographer with a perfect extension of his view. Designed to accompany the professional or ardent amateur into most any environment – be it friendly or hostile – the ST is as rugged as it is sleek. The camera is housed entirely in metal: the body is composed of copper-silumin alloy, while the top and bottom cover are brass. Contax engineers opted for brass covers over higher-tech substances because of brass's inherent shock-absorbing properties. And, given the fact that the ST is designed to accept the Carl Zeiss T* lenses, one has the capability to

produce images of unrivaled quality.

The ST is billed as having seven exposure modes. These are aperture-priority AE, shutter-priority AE, programmed auto, manual, TTL auto flash, manual TTL auto flash and manual flash. Exposure compensation is available (±2EV in third-stop increments) as is AE lock. An auto-bracketing mode can be selected as well, which will provide a 3 frame continuous exposure control by switch-over from ±0.5EV to ±1.0EV. Available metering patterns are centerweighted averaging and spot. The spot pattern is indicated by the 5mm diameter microprism ring in the viewfinder. Another nice feature that makes viewing and composition all the more easier is an oversized high-eyepoint pentaprism.

Shutter speeds range from 16 seconds to 1/6000 second (1 second to 1/4000 second in manual and shutter-priority AE), plus B with an elapsed time indicator. X sync occurs at 1/200. Second curtain flash sync is available with Contax flashes (such as the TLA 280) that support the feature.

Other features include auto film loading and rewind with the built-in winder, single or continuous film advance with speeds up to 3 fps, mid-roll film rewind, user-interchangeable focusing screens, a cable release socket and a PC connector (two features overlooked all too often by other manufacturers), a self-timer, dioptric adjustment from -3 to +1 diopters and DX film coding with override.

Contax 137 MD Quartz

The 137 Quartz, introduced in 1979, offers aperture-priority AE as its single exposure mode. Shutter speeds range from 11 seconds to 1/1000, plus B, and X sync at 1/100. Other features include TTL flash with dedicated flash units, a self-timer, and an integral winder, which provides film advance

speeds up to 2 fps. It has no manual film advance lever, but it does have a rewind crank, lacking auto-film rewind.

Contax 137 MA Quartz

The 137MA superseded the 137 MD Quartz, and came with the following improvements: A manual exposure mode was added. The shutter speeds remain the same in the aperture-priority AE mode, but are 1 second to 1/1000 in the manual mode. Frame numbers are visible inside the full-information viewfinder. Exposure compensation was added, as was an AE lock. The integral winder's speed was boosted to 3 fps.

Contax 139 Quartz

The Contax 139, released in 1979, is in some areas a scaled down version of the RTS and in other areas has a few features the RTS lacks. Like the RTS, the 139's exposure modes are aperture-priority AE and metered manual, with exposure compensation. Added to the 139 is an auto-exposure lock and TTL flash with dedicated flash units.

Shutter speeds range from 11 seconds to 1/1000 (manual mode speeds are 1 second to 1/1000), plus B, with X sync at 1/100. Other features include a self-timer and a multiple exposure lever located on top of the camera.

Contax 159MM

The Contax 159MM was the first Contax to utilize the new-style Zeiss MM lenses. To engage any of its three program modes, an MM lens must be used, although any bayonet Zeiss or Yashica lens may be used for its other exposure modes.

The 159MM's program modes are: HP, a high-speed program for shallow depth of field and/or stop-action photography; P, the standard program; and LP, a low-speed program for maximum depth of field. In addition, aperture-priority AE and metered manual are

available, as well as an AE lock and exposure compensation. Centerweighted metering is handled by silicon photo cells.

Shutter speeds range from 60 seconds to 1/4000 (1 second to 1/4000 in manual mode), plus B, with X sync occurring at 1/250 (1/100 in AE modes). TTL-OTF flash metering is available with dedicated flash units. Other exposure options include an AE lock and exposure compensation.

Other features include a self timer, depth-of-field preview, multiple exposure capability, interchangeable focusing screens (although not by the user) and power film winding with the optional W-7 Winder.

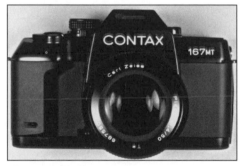

Contax 167MT

Contax 167MT

The Contax 167MT was the second Contax SLR designed to accept Contax MM lenses and was the sole remaining current production model until the introduction of the RTS III. As was mentioned with the 159MM, the Contax MM lenses must be used to engage either the 167MT's program or shutter-priority mode. Exposure modes include program with a three-stop shift feature, aperture and shutter-priority AE, and metered manual. Other exposure features include a safety shift, three-shot autobracketing, an AE lock and exposure compensation. Metering choices are centerweighted averaging and spot.

Shutter speeds range from 16 seconds to 1/4000, plus B, with X sync at 1/125. Other features include DX film

coding with override, user-interchangeable focusing screens, depth-of-field preview, a self timer, TTL flash with dedicated units and a PC socket. Film is advanced via an integral motor drive at speeds up to 3 fps. The film handling features also include auto film loading and motorized rewind.

☐ YASHICA SLRs

Ever since the reintroduction of the Contax marque, Yashica SLRs have languished in the shadows of their more upscale cousins. It isn't that they aren't good cameras. In fact, they're quite well made, as one would expect when considering that Yashica also manufactures the Contax. Nevertheless, they haven't enjoyed near the popularity or attention. All this tends to depress a Yashica's value on both the new and used market, which means that one can obtain a nice camera for a minimum investment. Yashicas are often purchased by Contax owners to be used as back-up or second cameras when they don't wish to make another heavy investment, but when they need another camera body that will accept their Zeiss lenses.

The Yashica SLRs listed below are the later generation, bayonet-mount cameras. They will accept both Zeiss T* and Yashica ML lenses. Those employing the Universal Screw lens mount are not listed. These older cameras are capable, but nowadays are even more rare than their bayonet-mount successors. Nowadays, a screw-mount Yashica in clean used condition can be picked up for as little as $50 to $75 with a normal lens.

Yashica FX-1

The Yashica FX-1 was the first SLR bearing the Yashica name to use the Contax/Yashica bayonet mount. Exposure options include metered manual and aperture-priority AE. Shutter speeds range from 2 seconds to 1/1000

(1 second to 1/1000 in manual), plus B, with X sync at 1/60. Other features include a hot shoe, a self timer and depth-of-field preview.

Yashica FX-2

Yashica FX-2

Back to the basics was the theme of the FX-2 when it was introduced. This is a manual-mode, center-the-needle SLR with the standard array of features. Shutter speeds range from 1 second to 1/1000, plus B, with X sync at 1/60. The camera has a hot shoe, a self-timer and depth-of-field preview.

Yashica FR-II

Yashica FR, FR-I & FR-II

The FR uses the same shutter and mirror assembly found in the RTS. Its features are the same as those of the FX-2. It accepts the Winder FR for film advance up to 2 fps. The FR-I has all the features of the FR, plus the addition of an aperture-priority mode and exposure compensation. The FR-II is essentially

an FR-I without a manual exposure mode. The Contax W-3 and RTS winders can be used with these three cameras.

Yashica FX-3, FX-3 Super 2000 & FX-7

The FX-3 is essentially the same as the FX-2 with a couple of improvements: The flash sync speed was increased to 1/125 and the meter needle was replaced by an LED array.

As its name implies, the FX-3 Super 2000 has a 1/2000 second top shutter speed. All other features of the FX-3 were retained. The FX-7 is identical to the FX-3, except it sports a chrome body (the FX-3 is all black).

Yashica FX-D

The FX-D offers two exposure modes: aperture-priority AE and match-diode metered manual using a centerweighted metering pattern. Shutter speeds range from 11 seconds to 1/1000 (1 second to 1/1000 in manual mode), plus B. Other features include non-TTL flash automation with dedicated units, an AE lock and exposure compensation.

Yashica FX-70

The FX-70 has a single exposure mode: aperture-priority AE using a centerweighted metering pattern. Shutter speeds range from 11 seconds to 1/1000, plus B, with X sync at 1/100. Other features are exposure compensation, an AE lock and a self-timer.

Yashica FX-103 Program

The FX-103 Program offers two program modes (normal and high speed) in addition to aperture-priority AE and metered manual. Also, TTL flash capability was added with dedicated flash units. Auto mode shutter speeds range from 16 seconds to 1/1000 (1 second to 1/1000 in manual mode), plus B, with X

sync at 1/100. Other features are exposure compensation, an AE lock and a self-timer.

Yashica 107 Multi Program & 108 Multi Program

The 107 Multi Program has three program modes, normal, high speed and low speed, plus non-metered manual. Shutter speeds range from 16 seconds to 1/2000, plus B, with X sync at 1/90. Other features include exposure compensation, DX film coding and a built-in winder with auto loading. Film must be rewound manually.

The 108 Multi Program updates the 107, with changes in exposure modes: There's no low-speed program mode, aperture-priority AE was added and the manual mode is metered.

Yashica 200 & 230-AF

Yashica autofocus SLRs accept Yashica autofocus and Contax/Yashica bayonet mount lenses. Manual focus lenses can only be used on these cameras with the AF 1.6X teleconverter. Both cameras have three standard autofocus modes: one-shot (focus-priority), continuous (servo), and trap-focus. Both have AF-lock buttons and manual focus override.

Several exposure modes include: program (with program shift on the 230-AF), aperture-priority AE, shutter-priority AE, and metered manual. In the shutter or aperture-priority modes, the system will shift to the closest appropriate setting if the user-selected value will result in incorrect exposure. Metering patterns are centerweighted averaging and, on the 230-AF, 3% spot. The 230-AF also has exposure compensation, AE lock and auto-backlight compensation, a system that switches automatically to spot metering if the frame edges are lighter than the center.

Shutter speeds differ between the two models. On the 230-AF, speeds range from 16 seconds to 1/2000. On the 200-AF, they extend from 8 seconds to 1/2000. Both cameras have a B setting with an elapsed time indicator, flash sync at 1/90 and DX film coding. Manual override of DX coding is possible on the 230-AF. Each has a self timer, built-in motor drive with speeds up to 1.8 fps, auto-film loading and mid-roll rewind, if so desired.

TTL flash is possible with the 230-AF's built-in flash (GN 19 @ ISO 100), or with a dedicated flash. The 200-AF has auto-flash capability, called "CPU-matic," but it isn't TTL.

Yashica 230-AF Super & Kyocera 270-AF

The Yashica 230-AF Super and the Kyocera 270-AF are the same camera. Kyocera, Yashica's parent company, markets Yashica cameras under the Kyocera brand name outside of the U.S. A small number of 270 AF cameras were sold in the U.S. to fulfill contractual obligations. Except for the few improvements listed below, the 230-AF Super more closely resembles the now-discontinued 200-AF in features, price and performance.

The 230-AF Super shares many features of its predecessor, the 230-AF, but is a totally new camera. Instead of listing all the similarities, let's look at the differences and improvements. The 230-AF Super has an integral, near-infrared AF light, which projects a beam onto dimly lit subjects as a low-light autofocus aid – pretty standard fare for modern autofocus cameras, but something its predecessor lacked. It has red-eye reduction preflash with the built-in flash. Yashica has included what it calls "Advanced Autofocus Function," otherwise known as predictive autofocus. Unique to the 230-AF Super is a built-in autofocus zone selector, which allows the user to choose between two focus ranges (up to three meters, and three meters to infinity). This can greatly reduce focusing time. The ergonomically redesigned body cloaks a few other differences, which include a simplified viewfinder readout, a dual-exposure program determined by lens focal length, a shutter speed range that has been trimmed to 8 seconds on the low end, no spot meter, and non-TTL flash.

Yashica 300 Auto Focus

Kyocera's latest entry into the super-competitive amateur autofocus SLR market is the Yashica 300 Auto Focus (for the balance of this description, we'll refer to it as the 300 AF). It is a sleek-looking camera, just what you might expect from the same company that produces the Contax, and it is a capable camera, with a sufficient array of features to satisfy most amateur's needs.

The 300 AF has a 3-speed power zooming feature with the new AF Power Zoom lenses. The zoom rate is controlled by how firmly one twists the zoom ring: a light pressure will cause it to zoom at the slowest rate, a moderate pressure will bump the rate up a notch, and rotating it to its stop will engage the high speed zoom mode. There is also a manual zoom override.

The autofocus system employs a single CCD sensor and provides the user with three AF modes: standard, continuous predictive autofocus and trap focus. In addition, the camera has a 3-step AF zone selector, allowing you to select a range in which the AF system will operate. Also included is a near-infrared focus assist beam for reliable autofocus in low-light.

Exposure modes include program AE with a 3-selection shift, aperture- and shutter-priority modes, a metered manual mode and automatic backlight compensation. Exposure compensation is also available: ±2 EV in half-stop increments. The metering system employs centerweighted averaging.

The 300 AF has a built-in pop-up flash (GN 39 @ ISO 100 in feet) with an angle of coverage down to 35mm, and will also accept optional dedicated TTL units, such as the CS-240 or CS-250. Flash exposure modes include auto fill-flash and slow shutter flash in addition to the standard TTL mode. A pre-flash function for red-eye reduction is also available.

Other features include AE Lock, a self-timer, a built-in winder that provides single frame and continuous advance at speeds up to 2 fps, auto film loading and rewind, mid-roll rewind, DX film coding with no override, capability to attach the optional DA-5 data back, and a panoramic adapter which stores in the camera back.

Contax G-1 and G-2 Systems

Camera	Yrs Made	New		Mint		Excellent		User	
G-1	1994-	1000	750	750	695	650	595		
G-2	1996-	1400	950						
16mm f/8 Hologon (w/meter and finder)		2200	1800						
21mm f/2.8 Biogon (w/finder)		1350	1200						
28mm f/2.8 Biogon		520	495	445	425				
35mm f/2 Planar		500	470						
45mm f/2 Planar		340	300	250	230				
90mm f/2.8 Sonnar		520	495	450	425				
TLA 140 Flash		190	140	135	100				
TLA 200 Flash		300	200						
SA-1 Flash Adapter		80	60						
GA-1Contax SLR Lens Adapter		190	160						
GD-1 Databack		170	140						
GD-2 Databack		550	500						
GP-1 Power Pack Adapter		70	50						
P-8 Power Pack		90	70						

Contax SLRs

Camera	Yrs Made	New		Mint		Excellent		User	
Aria	1998-	700	590						
AX	1996-	1900	1600						
RTS	1976-80			425	320	325	225		
RTS II Quartz	1980-88			595	560	570	450		
RTS III	1990-	2400	2250	1550	1490	1495	1350		
RX	1994-	1295	1000	995	935				
S2	1992-	1150	1050	820	750				
S2b	1993-	1225	1100						
ST	1993-	1450	1350	995	920	850	795		
137 MA Quartz	1983-87			295	225	225	200		
137 MD Quartz	1978-83			295	220	250	175	165	150
139 Quartz	1978-87			210	150	170	125		
159 MM Quartz	1985-89			300	250	260	200		
167 MT Quartz	1987-98			450	395	350	275		

Yashica SLRs

Camera	Yrs. Made	New		Mint		Excellent		User	
FR	1976-80					130	80		
FR-I	1978-81					150	100		
FR-II	1978-81					140	100		
FX-1	1975-78					95	65		
FX-2	1976-80					100	75		
FX-3, FX-7	1979-?			125	100	90	65		
FX-3 Super 2000	1987-	210	150	120	90				
FX-D Quartz	1980-?			125	100				
FX-70				120	100	110	80		
FX-103 Program				170	125				
107 Multi Program	1988-90					150	130		
108 Multi Program	1988-			150	125				
109 Multi-Program	1996-	220	180						
200AF	1987-91			190	165				
230AF	1987-91			200	175	150	125		
230AF Super	1991-93			225	190				
300 Auto Focus	1993-97			180	140				

Contax T* Lenses

Contax MM lenses are backward compatible to all bayonet-mount Contax and Yashica SLRs. They must be used with the Contax 159MM, 167MT, RX and ST to access the shutter-priority and program modes. AE lenses are the predecessors of the MM lens, but are still the current design with some focal lengths. The easiest way to differentiate between MM and AE lenses is by looking at the smallest aperture (i.e., highest aperture number). It will be green on an MM lens. Pricing information on new lenses is a bit sketchy; any question marks in the following listings reflect this. Yashica AF lenses are not compatible with Contax or Yashica manual focus SLRs.

Lens	New		Mint		Excellent		User	
15mm f/3.5 Distagon AE	4000							
16mm f/2.8 Distagon AE	2800							
18mm f/4 Distagon AE			750	600				
18mm f/4 MM Distagon	1365	980	900	800				
21mm f/2.8 MM Distagon	1735	1400	1400	1200				
25mm f/2.8 Distagon AE			650	625	600	520		
25mm f/2.8 MM Distagon	895	630	620	550				
28mm f/2 Distagon AE			690	650				
28mm f/2 MM Distagon			890	770				
28mm f/2.8 Distagon AE					250	200		
28mm f/2.8 MM Distagon	400	320	350	295				
35mm f/1.4 Distagon AE					850	675		
35mm f/1.4 MM Distagon	1265	990	1000	825				
35mm f/2.8 Distagon AE			225	180	170	145		
35mm f/2.8 MM Distagon	335	280	275	220	205	150		
35m f/2.8 PC Distagon AE	3250	2440	2470	1895	1795			
45mm f/2.8 Tessar AE					295	225		
45mm f/2.8 MM Tessar			275	240				
50mm f/1.4 Planar AE			190	135	140	100		
50mm f/1.4 MM Planar	275	220	160	150	120			
50mm f/1.7 Planar AE			100	75	80	65		
50mm f/1.7 MM Planar	205	100	135	120	125	90		

Contax T* Lenses (cont'd)

Lens	New		Mint		Excellent		User	
60mm f/2.8 S-Planar (Macro) AE			890	775	775	700	670	550
60mm f/2.8 MM Macro Planar C	1120	780						
85mm f/1.2 MM Planar			2200	1895				
85mm f/1.4 Planar AE			790	670	650	590		
85mm f/1.4 MM Planar		740	845	695	700	650		
85mm f/2.8 Sonnar AE			430	350	320	250		
85mm f/2.8 MM Sonnar			480	420	400	320		
100mm f/2 Planar AE			1200	850	825	750		
100mm f/2 MM Planar		1000	1275	1150	1095	950		
100mm f/2.8 Makro Planar AE		1500	1535	1370				
100mm f/3.5 Sonnar AE			300	250				
100mm f/3.5 MM Sonnar			450	325				
135mm f/2 Planar AE			990	775				
135mm f/2 MM Planar			1490	1270				
135mm f/2.8 Planar AE			275	225	250	190		
135mm f/2.8 MM Sonnar		390	365	250	325	200		
180mm f/2.8 Sonnar AE					950	700		
180mm f/2.8 MM Sonnar		1455	1150	950	850			
200mm f/2 APO Sonnar MM		7250						
200mm f/3.5 Tele-Tessar AE			520	420	440	385		
200mm f/4 Tele-Tessar AE			475	400	400	350		
200mm f/4 MM Tele-Tessar			550	475				
300mm f/2.8 Tele-Apotessar AE	18250	15900						
300mm f/4 Tele-Tessar AE			650	550	550	500		
300mm f/4 MM Tele-Tessar		1200	1080	950	850	760		
500mm f/4.5 Mirotar (special order only)								
500mm f/8 Mirotar		1750						
1000mm f/5.6 Mirotar (special order only)								
100 DX Medical Macro-flash			1200	900				
Mutar I		450	420	390				
Mutar II		350	320	270				

Contax T* Zoom Lenses

Lens	New		Mint		Excellent		User	
28-70 f/3.5-4.5 Vario-Sonnar MM		750	675					
28-85 f/3.3-4 Vario-Sonnar MM	1100	900						
35-70 f/3.4 Vario-Sonnar MM	1000	800	730	695	595	495		
35-105 f/3.3-4.5 Vario-Sonnar MM			300		1150			
35-135 f/3.5-4.5 Vario-Sonnar MM		2105	1600	1700	1450			
40-80 f/3.5 Vario-Sonnar AE			600	550	550	500		
70-210 f/3.5 Vario-Sonnar AE					1250	1000		
80-200 f/4 Vario-Sonnar MM	950	770	775	650				
100-300 f/4.5-5.6 Vario Sonnar MM		1895	1700	1695	1580			

Yashica ML Lenses

Lens	New		Mint		Excellent		User	
15mm f/2.8			350	250				
24mm f/2.8			175	125				
28mm f/2.8	120	100	75	60				
35mm f/2.8			80	60				
50mm f/1.4			85	65				
50mm f/1.7			50	35	40	25		
50mm f/1.9	60	40	45	40	35	20		
55mm f/2.8 Macro			150	135				
100mm f/3.5 Macro			175	150				
135mm f/2.8	100	80	75	55				
200mm f/4			120	80				
300mm f/5.6			175	150				
500mm f/8 Reflex			250	200				
1000mm f/11			700	650				

Yashica ML Zoom Lenses

Lens	New		Mint		Excellent		User	
28-50 f/3.5			100	80				
28-85 f/3.5-4.5	150	110						
35-70 f/3.5-4.5	85	55						
38-90 f/3.5			80	50				
42-75 f/3.5-4.5			60	50	40	25		
70-210 f/4.5			90	65				
70-210 f/4.5-5.6			100	80				
75-150 f/4			80	60				
75-200 f/4.5	130	95						
80-200 f/4.5			120	100				

Yashica AF Lenses

Lens	New		Mint		Excellent		User	
24mm f/2.8	180	160	150	130				
28mm f/2.8	100	80	80	70				
50mm f/1.8	75	55			50	40		
60mm f/2.8 Macro	250	200	180	150				
28-70 f/3.5-4.5	140	110						
28-70 f/3.5-4.5 PZ	150	120						
28-85 f/3.5-4.5	195	150						
35-70 f/3.3-4.5	140	125	100	80				
35-105 f/3.5-4.5	240	210						
70-210 f/4-5.6	180	140	150	125				
70-210 f/4-5.6 PZ	235	180						
75-300 f/4.5-5.6	340	295						
80-200 f/4-4.8			150	100				
1.6 AF Teleconverter	125	110						

Contax/Yashica Accessories

Item	New		Mint		Excellent		User	
RTS Winder (Contax RTS/RTS II)					110	85	70	65
139 Winder 2 (Contax 139/Yashica FX-D)			100	90	80	70	70	60
W-3 Winder (Contax RTS/RTS II)			110	85	90	75		
W-6 Motor Drive (w/PMD Pack)			400	325	300	250		
W-7 Winder (Contax 159MM)			100	80	80	65		
Winder FR (Yashica FR)	115	85	60	35				
Winder FX (Yashica FX)	85	65	50	35				
Data Back D-3 (RTS)			90	70				
Data Back D-4 (RTS II)	130	100						
Data Back D-5 (137MA/MD)	130	110	90	80				
Data Back D-6 (139/159MM)	130	80	100	75				
Data Back D-7 (167MT)	250	230						
Data Back DA-1 (Yashica 200/230 AF)		80	60					
FR Data Back (Yashica FR)			75	50				
FX Data Back (Yashica FX)			85	65				
Contax 250 Exp Back	700	650						
250 Exp Bulk Film Loader w/spool			45	40				
Medical Eye Camera 3000		1100						
Yashica Dental Eye I			600	550				
Yashica Dental Eye II	930	820						
Yashica Dental Eye III	1240	1130						
2x Lens for Dental Eye	105	85						
Mirror Set for Dental Eye	195	150						
Quartz Data Back for Dental Eye I	150	110						
AC Adapter for Dental Eye II	85	50						
Contax Auto Bellows PC			200	150				
Yashica (FX) Auto Bellows	150	130						
Auto Ext Tube Set (Y or C)	160	100						
Focusing Rail (Y or C)	80	50						
Slide Copier (Y or C)	150	80						
Macro Stand (Y or C)	90	40						
Right Angle Finder (Y or C)	110	95						
Contax/Hasselblad Adapter	185	150						

Mounts Hasselblad lenses on Contax cameras

Item	New		Mint		Excellent		User	
AC Control Box	660	550						
IR Remote Control Set F					150	100		
IR Remote Control Set S	120	100	80	70				
Interval Timer			100	70				
TLA-20 Flash	90	70	60	45	40	30		
TLA-30 Flash	160	140	120	80	75	65		
TLA-140 Flash (G-1, G-2)	185	140						
TLA-220 Flash	295	240	225	180				
TLA-280 Flash	190	160	150	100				
TLA-360 Flash	440	360						
TLA-480 Flash	695	650						
TLA-480 Battery Pack		215						
RTF 540 Flash w/bracket			200	150				
RTF 540 Power Pack			80	70				
RTF 540 510v Battery Pack			70	65				
CS-14 Flash	25	15						
CS-15 Flash	35	25						
CS-140 Flash	35	25						
CS-201 Auto Flash	50	40						
CS-220 Auto Flash	45	30						
CS-240 Auto Flash	60	40						
CS-250 AF Flash	110	90						

Hasselblad XPAN

Developed in cooperation with Fuji Photo Film Ltd., the Hasselblad XPAN is an impressive achievement. The XPAN is an interchangeable-lens, multiple exposure mode, motor-driven, dual-format rangefinder that, complete with 45mm f/4 lens, can be obtained for less than the cost of a Leica M6 body alone. Got your attention? Let's take a look at this camera in some detail.

The XPAN employs a centerweighted averaging TTL meter that reads exposure at the film plane. Available exposure modes include aperture-priority AE and manual, plus ± 2 EV exposure compensation. The XPAN also has an auto bracketing mode that will fire off three consecutive exposures in ± 1/2 or 1 stop increments. Of course, the brightline viewfinder features parallax correction and the rangefinder is coupled to the lenses.

The two formats available on the XPAN are the standard 24mm x 36mm one, plus a true panoramic format of 24mm x 65mm. When set to continuous mode, the integral winder will advance film at the rate of 3 frames per second when the camera is set to standard format, and 2 frames per second when the camera is set to panoramic format. 36, 24, and 12 exposure rolls will render 21, 13, and 6 frames respectively on the panoramic setting. The winder also has a single-frame setting and auto film prewind and rewind.

Currently, Hasselblad is producing two lenses for the XPAN, a 45mm f/4 and a 90mm f/4. At first glance, the maximum apertures may strike one as being remarkably slow, especially for a focal plane-shutter camera. When one reminds oneself, however, that the lenses must cover 65mm at the panoramic setting, then one may begin to realize why Hasselblad stayed conservative regarding maximum apertures. It is much easier (and cheaper) to produce a lens with a large circle of coverage that has a small maximum aperture than it is to produce one of the same focal length and circle of coverage that has a large maximum aperture. It is also much easier to keep the lens well corrected in terms of flare, chromatic, and sperical aberrations.

Thus, regarding future lens offerings, one must keep in mind the amount of film area that these lenses must cover. The 45mm lens covering 65mm is the equivalent of a 25mm lens covering 36mm. So, don't expect Hasselblad to offer anything much wider than the 45mm f/4 for a while, and if they do, don't expect it to be inexpensive.

Taking a page out of the EOS Rebel's playbook, the XPAN prewinds the film to the last frame after it is first loaded, then draws the exposed frames into the cassette after exposure. Canon chose this method for the Rebel because it was reasoned that, if the back were accidentally opened, the exposed frames would be preserved, and only the unexposed film would be lost. Hasselblad went with this method for another reason, however, one that makes simple sense in its own respect. When you have a dual-format camera, it is simpler — and much less confusing – to count remaining exposures than total ones. For example, instead of having to remember that a 36-exposure roll produces only 21 exposures on the panoramic setting, one just watches them count down as one works.

The focal plane shutter has a speed range from 8 seconds to 1/1000 second, plus B, with flash sync at 1/125 second. Other features include an aluminum and titanium construction with a partially rubberized exterior, a hot shoe, a PC connector, a cable release socket, auto film DX coding with manual override, and a self-timer.

Hasselblad XPAN

Camera	Yrs. Made	New	Mint	Excellent	User
XPAN	1998-	1700	1620		

Leica & Canon Screw-Mount Rangefinder Cameras

In spite of the age of many models, screw-mount Leicas and Canons still see regular use by an active, hard-core group of anachronists. Certainly one endearing feature of these cameras is their small size. With a collapsible lens, a screw-mount Leica or Canon is the same size as a point-and-shoot camera and fits easily into a jacket pocket – a true, take-any-where camera. It may not have autofocus, a built-in flash or a meter, or any of the other bells and whistles of modern P&S cameras, but the features these cameras lack are more than made up for by their craftsmanship, durability and the optical quality of most lenses available in Leica thread.

☐ LEICA SCREW-MOUNT CAMERAS

This section is not intended to replace, or compete with, Leica collector's guides or collector's guides that have comprehensive Leica listings. Because this is a book intended for the practicing photographer, only the most common Leica screw-mount cameras are listed. Still, any screw-mount Leica is collectible – even models from huge production runs, like the IIIa and IIIc (in mint condition).

If you're buying a Leica with collecting in mind, or if you would just like to know more about the various models, I strongly recommend that you pick up one or more of the several publications currently available that cover the subject of Leica from a collectible standpoint.

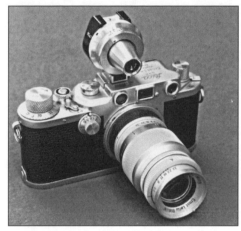

Leica IIIC with 90mm f/4 Elmar and Imarect finder

Why? Because minor differences in these cameras and lenses can translate into major differences in price. Probably the handiest publication is a three-volume, pocket-size set from Hove Photo Books: *Leica Pocket Book, Leica Accessory Guide,* and *Leica International Price Guide*.

You should keep in mind a couple of other caveats. *Any* alterations made to a camera affect its collectible value. Many early Leica models were converted by Leitz to later models. Many have been refinished (especially black ones), some by Leitz, some by others. Such modifications, even when done by Leitz, have a negative impact on a camera's collectible value. Also, because some models command exceedingly high prices due to their rarity, counterfeits exist. As always, it pays to be informed.

The cameras below are listed in chronological order. The following listings are for German-made (Wetzlar) Leicas. Canadian-made screw-mount

Leicas are rarer and are not listed. Those listings followed by a letter in parentheses are known by that designation also. For example, a Leica III is also known as a Leica model F, not a IIIf; a Leica IIIa is also known as a Leica model G, not a IIIg.

While the following prices are for cameras bodies only, frequently they're offered for sale only with normal lenses. Depending on the lens, the difference in price can be from minimal to substantial.

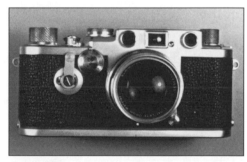

Leica IIIf

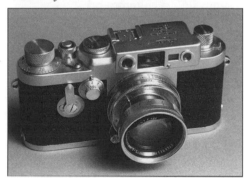

Leica IIIg

☐ CANON SCREW-MOUNT CAMERAS

During the heyday of screw-mount Leicas, a host of copycat manufacturers sprang up in Japan and elsewhere. Most

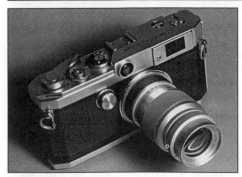

Leitz 90mm Elmar lens on a Canon L-1

of the cameras produced were direct copies of the most popular Leica models. Of all the copies, however, the Canon screw-mount cameras are the most common. In fact, Canon produced more screw-mount cameras than all the other Leica copy-cats put together. Canon rangefinders are also not direct Leica copies, either, which lends them their own personality.

Canon screw-mount cameras as a class are slowly increasing in collectible value. A few of the earliest Canon rangefinders, such as the legendary Hansa and the S, are extremely rare and highly sought after.

Canon VT Deluxe

Some late model Canon rangefinders were produced in both chrome and

Leica Screw-Mount Cameras

Camera	Yrs. Made	Mint		Excellent		User	
II (D) chr	1933-48			550	325	280	190
II (D) blk	1932-39			875	550	350	250
III (F) chr	1933-39			395	320	290	240
III (F) blk	1933-39			500	370	300	250
IIIa (G) chr	1935-48			350	280	250	160
IIIb chr	1938-46			375	275	250	200
IIIc (SN<400,000)	1940-45			550	475	370	250
IIIc (SN>400,000)	1946-51			450	300	250	160
IIc	1948-51			320	200		
Ic	1949-52			450	350		
IIIf black dial	1950-52			450	390	250	175
IIIf red dial	1952-53			600	550	320	250
IIIf red dial/ST	1954-57			895	660	350	280
IIf black dial	1951-52			550	450	250	200
IIf red dial	1952-56			650	450		
If red dial	1952-58			700	425		
IIIg	1957-60	1990	1795	1700	1250	550	390

Leitz Screw-Mount Lenses

With many of the lenses listed, variations exist that often greatly affect price. Only the most common Leitz screw-mount lenses are listed.

Lens	Mint		Excellent		User	
28mm f/5.6 Summaron			900	750		
28mm f/6.3 Hektor	975	750	695	550		
35mm f/2 Summicron			2490	2200		
35mm f/2.8 Summaron			650	500		
35mm f/3.5 Elmar			290	235		
35mm f/3.5 Summaron	425	380	350	300		
50mm f/1.5 Summarit			495	425		
50mm f/2 Summar collapsible			200	140		
50mm f/2 Summicron collapsible			395	300		
50mm f/2 Summitar			250	200		
50mm f/2.5 Hektor			495	375		
50mm f/2.8 Elmar collapsible			495	270		
50mm f/3.5 Elmar chr collapsible			295	180		
65mm f/3.5 Elmar chr			450	350		
90mm f/4 Elmar blk or chr (A36 filter)			280	200		
90mm f/4 Elmar chr (E39 filter)			325	250		
135mm f/4.5 Elmar			295	180		
135mm f/4.5 Hektor	300	250	235	150	90	70

Canon VT Deluxe

black enamel finishes. The black ones were made in small numbers and are rare. Black examples of the VT-Deluxe (all versions), VI-L, VI-T, 7, L1 and P exist, but are not included in the listings.

They are highly collectable and are often five to ten times the price of chrome models in the same condition. If you're buying a camera to use, get a chrome one. You'll save a lot of money and the chrome is more durable. As with the Leicas, only Canons you are most likely to find are listed.

For more detailed information about Canon screw-mount cameras, several good source books are available. The most notable is Peter Dechert's *Canon Rangefinder Cameras – 1933-1968*, which is the most exhaustive study of Canon rangefinders undertaken to date.

It does not list prices, however.

While the following prices are for cameras bodies only, frequently they're offered for sale only with normal lenses. Usually, price differences are minimal.

Aftermarket Screw-Mount Lenses

Until 1948, the lenses Canon offered with their rangefinder cameras were mostly Nikkors. Back then, Canon was a camera maker, and Nippon Kogaku Tokyo (later known as Nikon) was primarily a lens maker. Some of the more pedestrian varieties of

Canon Screw-Mount Cameras

Camera	Yrs. Made	Mint	Excellent		User	
IIB	1949-52		500	275		
IID	1952-55		425	295		
IID1	1952-54		550	325		
IID2	1955-56		425	300		
IIF	1953-55		400	290		
IIF2	1955-56		665	490		
IIS	1954-55		550	420		
IIS2	1955-56		420	250		
III	1951-52		400	300		
IIIA	1951-53		400	280		
IV	1951-52		580	385		
IVF	1951-52		420	290		
IVS	1952-53		335	250		
IVSB (IVS2)	1952-55		420	300		
IVSB2	1954-56		335	250		
VT	1956-57		395	325		
VT-Deluxe	1957-57		550	460		
VT-Deluxe-M	1958-58		585	375		
VT-Deluxe-Z	1957-58		550	375		
VL	1957-58		550	375		
VL2	1958-58		550	375		
VI-T	1958-60		500	340		
VI-L	1958-61		460	335		
7	1961-64		580	375		
7S	1965-67		595	425		
7Sz	1967-68		650	440		
L1	1957-57		420	290		
L2	1956-57		460	325		
L3	1957-58		420	290		
P	1958-61		540	340	200	150

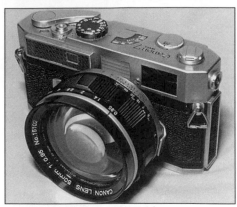

Canon 7 with 50mm f/0.95 lens

screw-mount Nikkors are listed below. Others, deemed rare or desirable by collectors, are not listed because of their scarcity and extremely high prices. Still others, which are quite collectible but which remain popular as user lenses because of their focal lengths, are listed.

Unless indicated otherwise, the prices are for lenses without accessory viewfinders. Expect to pay slightly more for lenses with viewfinders in the more common focal lengths, and substantially more for lenses in less common ones – especially the wide angles.

Canon Screw-Mount Lenses

Canon lens prices do not include accessory viewfinders. For the more common lenses, prices with finders are only moderately higher. For others, especially a few of the wide angles, expect to pay significantly more.

Lens	Mint		Excellent		User	
25mm f/3.5			800	480		
28mm f/2.8	685	625	640	440		
28mm f/3.5 Serenar		500	395	270		
35mm f/1.5	640	560	545	450		
35mm f/1.8			560	400	160	90
35mm f/2			320	205		
35mm f/2.8 Serenar			360	240		
35mm f/3.2 Serenar			240	160		
35mm f/3.5 Serenar			195	130		
50mm f/0.95 (7/7S/7Sz only)	1200	1120	960	800		
50mm f/1.2	475	430	400	320		
50mm f/1.4			480	320		
50mm f/1.5	255	225	210	6150		
50mm f/1.8 Serenar	160	115	125	80		
50mm f/1.8 chr	160	120	130	95	50	40
50mm f/1.8 blk	200	160	145	105		
50mm f/1.9 Serenar			150	90		
50mm f/2.8	360	250	280	200		
85mm f/1.8	480	400				
85mm f/1.9 Serenar	320	290	280	160		
85mm f/2 Serenar	240	210	160	105		
100mm f/2 blk	920	800	780	560		
100mm f/3.5 Serenar			240	195		
100mm f/4 Serenar			200	145		
135mm f/3.5 chr or blk	240	160	210	120	80	50
135mm f/3.5 Serenar			180	130		
135mm f/4 Serenar			130	80		

Aftermarket Screw-Mount Lenses

Lens	Mint		Excellent		User	
20mm f/5.6 Russian (Jupiter?) (w/finder)				425	350	
25mm f/4 Nikkor (w/finder)			1495	1250		
28mm f/3.3 SOM Berthiot			250	175		
28mm f/2.8 Soligor			120	75		
28mm f/3.5 Nikkor		800	675	550		
35mm f/1.8 Nikkor			450	350		
35mm f/2.5 Nikkor			225	175		
35mm f/2.8 Jupiter			180	145		
35mm f/2.8 Schneider Xenogon			150	95		
35mm f/2.8 Tanar			100	80		
35mm f/2.8 Tanaka (w/finder)		250				
35mm f/2.8 Topcor			125	80		
35mm f/3.5 Alcall			90	75		
35mm f/3.5 Komura			100	75		
35mm f/3.5 Nikkor		395	350	250		
35mm f/3.5 Soligor			100	75		
35mm f/3.5 Staebel Linogon			100	75		
35mm f/3.5 Travegon			95	75		
35mm f/4.5 Steinheil Orthostigmat				140	80	
45mm f/2.8 Steinheil			80	60		
47mm f/2 Kodak Ektar			100	90		
50mm f/1.4 Nikkor			200	100		
50mm f/1.5 Zeiss Sonnar			150	100		
50mm f/1.8 Yashinon			100	70		
50mm f/2 Chiyoko Rokkor			150	120		
50mm f/2 Cooke Amatal			125	100		
50mm f/2 Nikkor			175	125		
50mm f/2 Tanar			100	75		
50mm f/2.8 Steinheil Collapsible			100	70		
80mm f/1.8 Komura			100	70		
85mm f/2 Nikkor			250	170		
85mm f/2 Zeiss Sonnar			175	125		
90mm f/4.5 Wollensak			100	80		
105mm f/2.5 Nikkor	350	350	300	200	175	140
105mm f/3.5 Komura			100	75		
105mm f/3.5 Schneider Xenar			150	100		
105mm f/3.5 Super Acall			75	50		
127mm f/4.5 Wollensak			125	95		
135mm f/2.8 Komura			90	75		
135mm f/3.5 Arco Tokyo		200				
135mm f/3.5 Komura			75	50		
135mm f/3.5 Nikkor			150	110	90	70
135mm f/3.5 Steinheil			80	50		
135mm f/3.5 Super Acall			75	50		
135mm f/3.5 Topcor			150	100		
135mm f/4 Jupiter			40	25		
135mm f/4 Tele Rokkor			150	100		
135mm f/4.5 Steinheil			100	80		
200mm f/4.5 Komura (w/finder)			150	120		

Leica M-Series Rangefinders

The Leica M-series rangefinder camera is an enduring classic, much sought after by professionals and collectors alike. Because anything with the name Leica on it is collectible to some degree, minor differences among cameras of the same model can translate into major differences in price. The fine points of Leica collecting are beyond the scope of this book, so only a few differences that affect price will be addressed below. If you're buying or selling Leica with collecting in mind, several fine publications are available. Probably the handiest is a three volume pocket-size set from Hove Photo Books: *Leica Pocket Book*, *Leica Accessory Guide*, and *Leica International Price Guide*. Since this book is intended primarily for the practicing photographer and not the collector, I have omitted the special edition Leicas (such as the Everest, Jubilee and Safari editions), those cameras that were made in very small quantities (such as the MP and M4 MOT) and the cameras intended primarily for scientific use (such as the MD, MDa and MD2). These Leicas are prized by collectors and are bought and sold almost exclusively with collecting in mind, hence it serves no purpose to include them in a price guide for the practicing photographer.

Leica M3, M2 & M1

For the Leica M3, the following abbreviations are used: DS = Double Stroke advance lever, SS = Single Stroke advance lever. Some other abbreviations

you may run across (not shown here) are: ST (Self Timer) and PV (Preview lever, which shows frames in the viewfinder for different focal lengths). Some M2s and DS M3s have no self timer and no preview lever. Some have a self timer, but no preview lever. I haven't listed the variants because the price differences are small. Many double-stroke M3s were converted by Leica to single stroke. These cameras, while not listed, sell for about the same as single-stroke M3s with serial numbers below 1 million. Because many sellers price their single-stroke M3s according to the serial number, I've listed separate prices for single-stroke M3s with serial numbers above and below 1 million.

The M3 was Leica's first bayonet-mount rangefinder camera and, while the design dates back to 1954, it is still considered one of the finest cameras ever made. The M3 has a bright viewfinder, incorporating a parallax- corrected rangefinder and brightline frames for 50mm, 90mm and 135mm lenses. Shutter speeds range from 1 second to 1/1000, plus B, with M and X sync. M3s with serial numbers greater than 915,000 have single-stroke film advance levers.

The M2 was originally intended as a less-costly alternative to the M3 and is very similar to its immediate predecessor. The main differences include an external film-counter that must be manually reset and viewfinder frames for 35mm, 50mm and 90mm lenses. Early models have a

button release for rewinding the film, later ones have a lever, like the M3. Some collectors make a distinction in price between these two models, but I haven't here since the price variance is small.

Less than 10,000 M1s were made, although they are not particularly hard to find on the used market at this time. I suspect this is because they are not very practical for photographic use. Essentially a simplified M2, the M1 lacks a coupled rangefinder and has brightline frames for the 35mm and 50mm lenses only.

Leica M4, M4-2 & M4-P

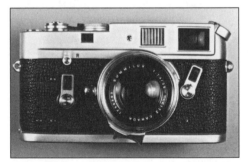

Leica M4

The Leica M4 was made in chrome and black. About 2,500 of them were made in Canada in both chrome and black. Altogether, less than 9,000 black M4s were made. Black M4s, whether Canadian, black enamel or black anodized, fetch quite a premium because of their relative scarcity and popularity among collectors, and aren't listed. Neither are chrome Canadian M4s (for the same reason). None of the above

cameras should be confused with the M4-2 and M4-P.

The M4's physical appearance is similar to that of the M3, the most notable differences being the slanted film rewind knob with a built-in crank and a plastic-tipped film advance lever. Other differences are brightline frames for 35mm, 50mm, 90mm and 135mm lenses and a three-pronged drop-in film loading system that speeds film loading considerably.

Leica M4-2

The M4-2 is an M4 with the following differences: it has a hot shoe, it does not have a self-timer and, most significantly, it was the first regular production M-series Leica to which a separate electric winder could be attached.

The M4-P is similar to the M4-2, with one notable difference: 28mm and 75mm viewfinder frames were added, necessitating that all frames be shown in pairs. They are paired as follows: 28mm and 90mm, 50mm and 75mm, 35mm and 135mm. Like the M4-2, a separate winder can be attached.

Leica M5

The Leica M5 represented a departure from Leitz's traditional rangefinder design in a couple of ways. It was the first Leica rangefinder with a meter and it also was much larger than its predecessors. Its popularity never really caught on, although it is a fine picture taker. The semaphore-style behind-the-lens metering system hasn't been without its problems over the years and, because of this arrangement, a few lenses cannot be used on this camera; namely the 21mm Super Angulons and 28mm lenses with serial numbers below 2,315,000.

Leica M6

The Leica M6 is similar to the M4-P and differs primarily from its predecessor in that it has an integral TTL light meter. Unlike the M5, the M6's meter employs a backward-facing silicon diode that reads a white spot on the shutter curtain to determine exposure. This provides the

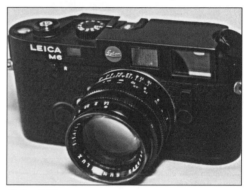

Leica M6

Leica M-Series Rangefinder Cameras

Camera	Yrs. Made	New	Mint		Excellent		User	
Leica CL	1972-81		850	700	695	450	350	300
Leica CL w/40 Summicron	1972-81		1200	995	950	720		
Leitz-Minolta CL	1972-81			700	600	425	350	300
Leitz-Minolta CL w/40 Rokkor	1972-81		995	850	875	600		
Minolta CLE	1981-84		1000	850	900	725		
Minolta CLE w/40 Rokkor	1981-84				1100	900		
M1	1959-64			1195	950	700		
M2 chr	1957-67				995	700		
M3 DS	1954-58				1050	725		
M3 SS (SN<1,000,000)	1958-60		1695	1495	1095	785		
M3 SS (SN>1,000,000)	1960-66				1530	995		
M4 chr (Wetzlar)	1967-70		1900	1795	1795	1400		
M4-2	1978-80		1195	1050	995	880	850	750
M4-P	1981-87		1395	1095	1050	900	875	750
M5 chr (2 lug)	1971-?				1500	1300		
M5 blk (2 lug)	1971-?				1650	1420		
M5 chr (3 lug)	?-75		1800	1400	1350	995		
M5 blk (3 lug)	?-75		2095	1600	1595	1350		
M6 chr	1984-	1995	1795	1650	1700	1400		
M6 blk	1984-	1995	1895	1740	1750	1425		
M6 Hi-Mag VF chr	1997-	1995						
M6 Hi-Mag VF blk	1997-	1995						
M6 Titanium	1993-	2495	2250	1995				

user with match-diode metering of the central 13% of the framed viewfinder area. The electronics for the meter are located where the self-timer is on the M4. As with the M4-2 and M4-P, a winder can be attached.

Leica CL, Leitz-Minolta CL & Minolta CLE

The Leica CL was designed by Leitz, but manufactured by Minolta under license from Leitz. It has a built-in semaphore-style TTL light meter (similar to the M5's) and is considerably more compact and lighter than M-series Leicas. Leitz built a 40mm Summicron and a 90mm Elmar C especially for the CL. At almost the same time as the advent of the CL, Minolta began producing the

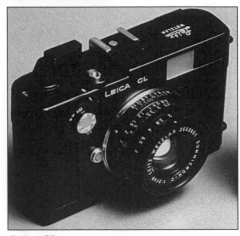

Leica CL

Leitz-Minolta CL. It was the same camera, available with a 40mm M-Rokkor and a Leitz made 90mm M-Rokkor. Later, Leitz marketed the Leitz-Minolta in the US after supplies of the original

Leitz CL ran out. As with the M5, most all M-style bayonet mount lenses will work on these cameras, but there are a couple that won't. These are the 21mm Super Angulon and 28mm lenses with serial numbers below 2,315,000. It is my understanding that these lenses will bayonet onto the camera, but should not be used because of the risk of damaging the semaphore mechanism.

Minolta CLE

After the CL was discontinued around 1981, Minolta introduced the CLE. It resembles the CL in outward appearances only. Just a few of its features include off-the-film-plane metering (instead of the troublesome semaphore in the CL), TTL flash

Leitz M-Series Lenses

Lens	New		Mint		Excellent		User	
16mm f/8 Zeiss Hologon w/finder	3295	3195						

The Carl Zeiss 16mm f/8 Hologon is a new lens originally intended for the Contax G-series, but converted to fit Leica M cameras.

Lens	New		Mint		Excellent		User	
21mm f/2.8 Elmarit	1495		1400	1200	1300	1000		
21mm f/2.8 Elmarit Aspherical	2195							
21mm f/3.4 Super Angulon					1495	1250		
21mm f/4 Super Angulon					995	680		
24mm f/2.8 Aspherical	1995							
28mm f/2.8 Elmarit			750	700	600	500		
28mm f/2.8 Elmarit (late)	1895		1650	1250	1170	800		
28mm f/2.8 M Rokkor (CLE)					795	600		
28mm-35mm-50mm f/4 Aspherical			2295					
35mm f/1.4 Summilux (chr or blk)			1395	1000	1095	850		
35mm f/1.4 Summilux (M3 Windows)				1150	950			
35mm f/1.4 Summilux Aspherical blk	2595							
35mm f/1.4 Summilux Aspherical chr	2695							
35mm f/1.4 Summilux Aspherical Titanium	2795							
35mm f/1.4 Summilux Titanium	1300							
35mm f/2 Summicron Aspherical blk			1495					
35mm f/2 Summicron Aspherical chr			1595					
35mm f/2 Summicron blk			995	780	750	600	550	450
35mm f/2 Summicron blk (late)			1100	950	900	750		
35mm f/2 Summicron chr			1050	795				
35mm f/2 Summicron chr (late)			1150	895	950	700		
35mm f/2 Summicron (M3 Windows)				800	750	760	500	
35mm f/2.8 Summaron				620	400			
35mm f/2.8 Summaron (M3 Windows)				600	495	500	350	
35mm f/3.5 Summaron				550	425	450	395	

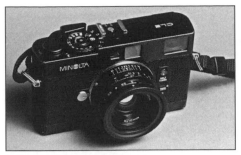

Minolta CLE

metering, exposure compensation, and aperture-priority AE. Minolta also introduced a 28mm M-Rokkor, made especially for this camera. Until the release of the Contax G-1 in 1994, the CLE had been the most advanced mass produced interchangeable-lens 35mm rangefinder ever. Largely because of this, the CLE is highly sought after. It is also quite collectible. As a result, prices for clean examples remain high.

Leitz M-Series Lenses

The many permutations that exist among Leitz lenses can make decisions about which one should buy difficult at the very least. One focal length may have more than a half-dozen varieties, each difference having a substantial affect on the value of the lens. Some were made in very small quantities and are quite rare. Lenses with low production numbers are not listed below. For the more pedestrian varieties, there are separate listings when significant price differences warrant it, but I would caution the buyer or seller to be well-informed before the sale is made.

Leitz M-Series Lenses (cont'd)

Lens	New	Mint		Excellent		User	
35mm f/3.5 Summaron (M3 Windows)			400	325	335	280	
40mm f/2 M Rokkor (CL,CLE)		250	220	225	185		
40mm f/2 Summicron (CL,CLE)		425	350	350	250		
50mm f/1.0 Noctilux	2895	2150	1995	1950	1725		
50mm f/1.4 Summilux blk		1000	900	875	725		
50mm f/1.4 Summilux blk (late)	1895	1495	1200	1295	950		
50mm f/1.4 Summilux chr		990	910	895	700		
50mm f/1.4 Summilux chr (late)	1995						
50mm f/1.4 Summilux Titanium	2195						
50mm f/1.5 Summarit Wetzlar				595	400	295	180
50mm f/2 Summicron blk		595	500	450	365	335	295
50mm f/2 Summicron blk (late)	945	795	595	600	475		
50mm f/2 Summicron chr				625	495		
50mm f/2 Summicron chr (late)	1095	850	795				
50mm f/2 Summicron Collapsible chr			600	500	450	300	
50mm f/2 Summicron Rigid chr		695	650	650	450		
50mm f/2 Summicron DR (w/finder)			750	595	550	475	
50mm f/2.8 Elmar		700	650	690	550		
50mm f/2.8 blk (late)	895						
50mm f/2.8 chr (late)	995						
50mm f/3.5 Elmar				395	325		
75mm f/1.4 Summilux	2495	2275	1795	1795	1500		
90mm f/2 Summicron chr	1895	1450	1195	950	800		
90mm f/2 Summicron blk (late, E49 filter)	1695	1595	1200	1000	900		
90mm f/2 Summicron (early, E48 filter)			980	895	990	750	
90mm f/2.8 Elmarit blk or chr (late)	1345	1245	995	750	895	690	
90mm f/2.8 Elmarit chr		795	600	550	420		
90mm f/2.8 Tele-Elmarit		895	700	650	525		
90mm f/4 Elmar		350	300	275	200		
90mm f/4 Elmar C (CL, CLE)		495	450	390	325		
90mm f/4 Elmar Collapsible		800	600	600	495		
90mm f/4 Leitz-Rokkor (CL, CLE)		400	350	275	250		

Leitz M-Series Lenses (cont'd)

Lens	New	Mint		Excellent		User	
90mm f/4 M Rokkor (CL, CLE)		525	400	380	295		
135mm f/2.8 Elmarit (S7 filter)		600	550	495	395		
135mm f/2.8 Elmarit (E55 filter)	2095	1400	1200	1000	750		
135mm f/4 Elmar		600	460	500	300		
135mm f/4 Tele-Elmar	1695	1100	900	800	550	450	375
135mm f/4.5 Hektor				350	165	120	90

Leitz Viso Lenses

Lens	New	Mint		Excellent		User	
65mm f/3.5 Elmar				450	350		
125mm f/2.5 Hektor				1000	800		
200mm f/4 Telyt				400	300		
200mm f/4.5 Telyt				350	250		
280mm f/4.8 Telyt				600	450		
400mm f/5 Telyt (late: built-in hood)				1000	750		
400mm f/5.6 Telyt				700	600		
400mm f/6.8 Telyt		500	390	450	350		
560mm f/6.8 Telyt		1000	850				

Leica M-Series Accessories

Item	New	Mint		Excellent		User	
M Rapid Winder (not Leica)	550 425						
Motor Drive M	895 795						
M Winder (#14214: M4-2 only)		200	140	155	120		
M Winder (#14400: M4-2/M4-P/M6)*			250	225	230	175	
M Winder (#14401: M4-P, M6)*		250	200				
M Winder (#14402)*		450	300				
M Winder (#14403: M6)*	680	550	460				
MC Meter chr				50	30		
MC Meter blk				45	40		
MR Meter chr/blk				180	125	110	90

* *These winders will work with the M6.*

Leica M-Series Accessories

Item	New		Mint		Excellent		User	
MR-4 Meter chr			230	170	170	140		
MR-4 Meter blk chr			255	240	230	150		
Dual Range Finder (50mm f/2 Dual Range Summicron)·					100	60		
Imarect Finder·					90	50		
21mm BL Finder·	400	350	295	270	265	200	175	150
24mm BL Finder·		300						
28mm BL Finder·	375	335	270	250	250	200	175	150
35mm BL Finder·			250	200	225	150		
90mm BL Finder·					250	175		
135mm BL Finder·					200	160		
R to M adapter (#22228)			200	150				
Screw-mount to M adapter			95	60				
M Grip (fits most M cameras)	100	80						
Bellows I			220	190	175	90		
Bellows II			200	180	200	140		
Visoflex I					100	85		
Visoflex II					140	90		
Visoflex III			350	300	295	200		

A variety of accessory universal viewfinders, commonly called "Imarect" finders (for Erect Image), were produced by Leitz for use with screw-mount Leicas. The most common ones offer parallax correction and viewfinder frames for 35mm, 50mm, 73mm, 90mm and 135mm lenses. For the single-focal-length finders above, "BL" stands for the Bright Line frame visible when looking through the viewfinder. Those made in Canada are more rare, hence more $. Finders originally designed for screw-mount cameras will work with the M-series as well.

Leica SLRs

Included below are price listings for the original Leicaflex, SL and R-series Leicas with explanatory notes. Since this book is intended primarily for the practicing photographer and not the collector, I have omitted from the following list such commemorative models as the R3 Gold, R3 Safari, the Anniversary models, and models with low production runs such as the SL MOT and SL2 MOT. These Leicas are highly prized by collectors and are bought and sold almost exclusively with collecting in mind, hence it serves no purpose to include them in a price guide designed for the user.

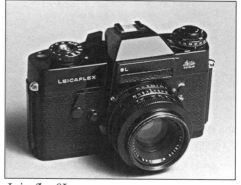

Leicaflex SL

Leicaflex, Leicaflex SL & SL2

Introduced in 1964, the Leicaflex is the original Leica SLR. It incorporates a non-TTL, match-needle meter, visible as a small window on the face of the pentaprism housing. Shutter speeds range from 1 second to 1/2000, plus B, with flash sync at 1/100. Other features include mirror-lock-up, a self-timer and PC sockets for x and m sync. The origi-

nal Leicaflex takes the 1-cam R-mount lenses.

The SL is similar in appearance to the Leicaflex, the most notable exterior difference being the lack of a meter window. A TTL light meter was incorporated into the SL design, providing the user with a selective area metering pattern (confined to the microprism area of the focusing screen). A depth-of-field preview button was also added, but the mirror-lock-up feature was dropped. Shutter speeds and flash options remained the same as with the previous model. A new series of 2-cam lenses was designed to be used with the SL because of its TTL meter. 1-cam lenses can be used, but the meter will not operate.

The SL2 incorporated several improvements over its predecessor, the SL. The SL2's light meter sensitivity was increased by a factor of four, full exposure information is visible in the viewfinder, the mirror was redesigned to allow the use of the new-at-the-time 16mm and 19mm wide angle lenses, and a hot shoe was added. Shutter speeds remain the same as on the two previous models.

Leica R3

Introduced in 1974, the R3 was the first Leica SLR to emerge from the cooperative agreement between Leitz and Minolta and was a radical departure from its manual, mechanical predecessors. A new series of 3-cam lenses was also introduced with this camera, which remains

the current lens-to-body coupling style. The R3's two exposure modes are aperture-priority AE and metered manual. The electronic shutter provides speeds from 4 seconds to 1/1000, plus B, with X sync at 1/90. In the event of battery failure, only B and 1/90 will operate. Metering patterns are centerweighted and spot. Other features include a memory lock, self-timer, depth-of-field preview and a hot shoe. The R3 MOT was designed to accept a compact motor winder, which would provide continuous speeds up to 2 fps.

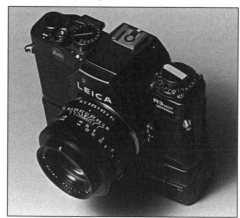

Leica R3 MOT with motor drive attached

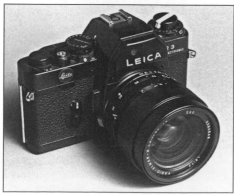

Leicaflex R3

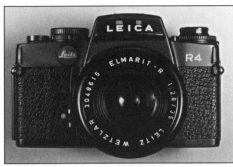

Leica R4

Leica R4, R4-S & R4S-P

The R4 was updated three times following its debut. Apparently it took Leica four tries to get it right, because the first three were plagued with electronics problems. So, if you're considering the purchase of an R4 (or R4-S), avoid those with serial numbers below 1,600,000 unless the seller provides you with some sort of warrantee. As always, caveat emptor, forewarned is forearmed and all that.

The R4 comes with five exposure modes: program, aperture priority, shutter priority, metered manual and limited flash AE. Two metering patterns are

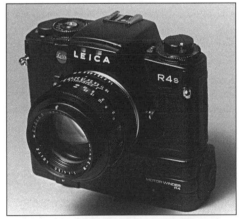

Leica R4-S MOD P with winder attached

Leica R4-S MOD P — the easiest way to tell the R4-S and the R4-S MOD P apart.

available: centerweighted and spot. Shutter speeds range from 1 second to 1/1000, plus B, with X sync at 1/100. Other features include a motor drive option, interchangeable focusing screens, depth-of-field preview, exposure compensation, AE lock, a hot shoe and a self-timer. Earlier models of the R4 were labeled R4 MOT ELECTRONIC. Prices for these cameras have been included in the R4 listings.

The R4-S is a simplified R4, having aperture-priority and metered manual exposure modes only. All other R4 features were retained.

The R4-S MOD P (or MOD 2) is an update of the R4-S. The Model P designation was used for those cameras imported to the United States. In Europe, it's known as the Model 2. The most significant differences are: the Model P displays shutter speeds in the viewfinder and switching from spot to centerweighted metering is accomplished by pushing the program selector. A few other minor improvements were made, such as an enlarged film rewind crank, a sliding switch instead of a button for the exposure compensation feature, and a redesigned eyepiece that will accept eyecups, etc.

Leica R5 & RE

The Leica R5 is best looked at as an improved and updated R4. It has the same exposure modes, except the program mode has an 11-step shift capabili-

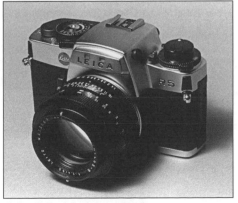

Leica R5 with chrome finish

ty. TTL flash exposure with SCA-series flash units was added as was an eyepiece with built-in diopter adjustments. The viewfinder was also redesigned for greater eye-relief. The shutter speed range was increased: 15 seconds to 1/2000. All other features of the R4 were retained on the R5. The RE is basically an R5 without a program mode.

Leica R6 & R6.2

The R6 was the first mechanical, manual-exposure-only SLR produced by Leica since the SL2 was discontinued. Metering modes are center-weighted averaging or a central 7mm spot. Metering is done via a match-diode display in the viewfinder. Shutter speeds range from 1 second to 1/1000, plus B, with X sync occurring at 1/100. Other features include a motor drive option, mirror-lock-up (the first Leica since the original Leicaflex to have one), interchangeable focusing screens, TTL flash metering with SCA-compatible flash units, depth-of-field preview, a self-timer and viewfinder diopter adjustments.

The R6.2 is an update of the R6. The two most significant changes are a higher top shutter speed (1/2000 second) and an improved TTL flash mode that will meter flash exposure at any shutter speed from 1/100 to B.

Leica R7

If you're a long-time Leica purist, you probably know already that Leica prefers the steady, evolutionary approach to product development over the totally new and sensational gee-whiz kind of gimcrackery. The R7 once again reinforces the Wetzlar philosophy. It's best, perhaps, to think of the R7 as being an R5 to which several features found on the more up-to-date R6 (now R6.2) have been added.

The R7 has a more full-featured TTL flash mode. Using SCA-compatible flash units, fill flash is now available

with shutter-priority AE, and the system will switch automatically between fill flash and full flash in Program mode. Exposure compensation has been increased from ±2 EV (in ⅓ stop increments) to ±3 EV (in ½ stop increments). The R7 also takes four 1.5 volt batteries instead of the R5's two, extending service life between battery changes. Finally, the frame counter was repositioned for easier viewing. All other features of the R5 were retained.

Leica R8

In typical teutonic fashion Leica has bowed to the vagaries of global SLR fashion, but it has done so on its own terms. There's no denying that, in terms of appearance, the R8 is a radical departure from previous Leica SLR designs, but yet, where other makers incorporate swoopy contours into their cameras' exteriors, slaves to fashion that they are, Leica instead chose a comfortable, functional shape which suggests modernity, while maintained the austere, yet classic lines

that seem to be hallmarks of German design.

The R8 is still a manual focus camera, but its new lensmount, with nine gold-plated contacts, certainly seems to indicate possible future directions. The R8 uses the contacts in conjunction with the new ROM lenses to improve exposure accuracy during both ambient and flash photography.

The R8's metering system provides for centerweighted averaging, selective (7mm central area), six-zone evaluative, and TTL centerweighted flash metering. Exposure modes include program AE with shift, aperture- and shutter-priority AE, and metered manual. An AE lock stores the selective metering values for all exposure modes. Exposure compensation is also available with a total of ± 3 stops, adjustable in 1//2-EV steps.

Shutter speeds range from 32 seconds to 1/8000 second, plus B, with flash sync at 1/250 second. Other features include interchangeable focusing screens, mirror lockup, built-in dioptric correction, a self-timer selectable for 2 or 12 seconds, a multiple exposure lever,

and a four-contact hot shoe dedicated for TTL autoexposure with Metz flash units using the SCA 3501 module.

Leica SLRs

Camera	Yrs. Made	New		Mint		Excellent		User	
Leicaflex chr	1964-68					350	250		
Leicaflex blk	1964-68					800	650		
Leicaflex SL chr	1968-74	795	620			650	450		
Leicaflex SL blk	1968-74	995	695			850	500		
Leicaflex SL2 chr	1974-76	1495	1250			1200	900		
Leicaflex SL2 blk	1974-76					1250	1150		
R3 blk	1976-79	495	450			395	300	300	210
R3 chr	1976-79			650	595				
R3 MOT w/winder	1978-79			550	450	450	380		
R4	1980-86			500	380	450	300		
R4-S	1983-85			550	400	420	350		
R4-S MOD P (MOD 2)	1985-88			800	700	700	550		
R5	1987-92			950	850	900	650		
R6	1988-92			1395	1195	1050	950		
R6.2	1992-	2195							
R7	1992-			1595	1295				
R8	1997-	2395							
RE	1990-95			795	695	595	480		

Leica SLR Lenses

All lenses are 3-cam unless noted. 2-cam lenses that have been converted to 3-cam are not listed. Such converted lenses sell for more than 2-cam lenses, but less than factory original 3-cam. The latest R lenses have the "ROM" designation following them. ROM lenses have the electrical contacts to comminicate aperture and focusing information to the Leica R8.

Lens	New		Mint		Excellent		User
15mm f/3.5 Super Elmar	5995		4400	2950			
16mm f/2.8 Elmarit			1500	1370	1220	950	
16mm f/2.8 Elmarit ROM	2495						
19mm f/2.8 Elmarit ROM	3095	2995					
19mm f/2.8 Elmarit (late)			2195	1895			
19mm f/2.8 Elmarit			1500	1200	1150	1000	
21mm f/3.4 Super Angulon					800	650	
The 3.4 Super Angulon is for Leica SLRs with Mirror Lock Up.							
21mm f/4 Super Angulon			1395	1000	995	830	
21mm f/4 Super Angulon (2-cam)			800	750	700	620	
24mm f/2.8 Elmarit ROM	2395	2195					
24mm f/2.8 Elmarit			1350	1095	1000	775	
28mm f/2.8 Elmarit ROM	1995	1795					
28mm f/2.8 Elmarit			995	700	600	500	
28mm f/2.8 Elmarit (2-cam)					500	350	
28mm f/2.8 PC Super Angulon	2395		2095	1895			
35mm f/1.4 Summilux ROM	2795						
35mm f/1.4 Summilux			1995	1750	1695	1300	
35mm f/2 Summicron	1795		1200	950	995	750	
35mm f/2 Summicron (2-cam)			650	500	450	300	
35mm f/2.8 Elmarit			770	695	600	450	
35mm f/2.8 Elmarit (2-cam)					325	250	
35mm f/2.8 Elmarit (1-cam)			250	200	195	170	
35mm f/4 PA Curtagon			795	750	740	600	
50mm f/1.4 Summilux ROM	1995						
50mm f/1.4 Summilux			1495	1250	1195	950	
50mm f/1.4 Summilux (2-cam)			600	550	580	500	
50mm f/2 Summicron ROM	895						
50mm f/2 Summicron			495	395	350	300	
50mm f/2 Summicron (2-cam)			350	250	250	195	
50mm f/2 Summicron (1-cam)			150	100	90	80	
60mm f/2.8 Macro Elmarit ROM	1795						
60mm f/2.8 Macro Elmarit			1495	1295	1100	695	
1:1 Tube (14256) for above	300	275	150	100	90	75	
60mm f/2.8 Macro Elmarit (2-cam)					600	500	
1:1 Tube (14198) for above					100	75	
80mm f/1.4 Summilux ROM	2795						
80mm f/1.4 Summilux			1895	1750	1695	1300	
90mm f/2 Summicron ROM	2050						
90mm f/2 Summicron			1295	1050	950	800	
90mm f/2 Summicron (2-cam)			600	450	500	350	
90mm f/2.8 Elmarit			695	600	640	375	
90mm f/2.8 Elmarit (2-cam)			495	350	400	300	
90mm f/2.8 Elmarit (1-cam)					350	225	
100mm f/2.8 APO Macro ROM	2695						
100mm f/2.8 APO Macro			1895	1495			

Leica SLR Lenses (cont'd)

Lens	New	Mint		Excellent		User
1:1 Elpro (16545) for above	595					
100mm f/4 Macro Elmar (Bellows)	1295	425	300	280	200	
100mm f/4 Macro Elmar ROM	1695					
100mm f/4 Macro Elmar		995	700	760	550	
1:1 Tube (14262) for above	300	275	150	100	95	70
135mm f/2.8 Elmarit ROM	1695					
135mm f/2.8 Elmarit		950	750	690	400	
135mm f/2.8 Elmarit (2-cam)		375	270	290	200	
135mm f/2.8 Elmarit (1-cam)				250	150	
180mm f/2 APO ROM	5995					
180mm f/2 APO		5495	4995			
180mm f/2.8 APO ROM	2995					
180mm f/2.8 APO		2200	1895			
180mm f/2.8 Elmarit (E67 filter)	1995	1795	1550	1495	895	
180mm f/2.8 Elmarit (S8 filter)		800	695	650	450	
180mm f/2.8 Elmarit (2-cam)		595	500	475	400	
180mm f/3.4 APO-Telyt ROM	2895					
180mm f/3.4 APO-Telyt		1895	1395	1400	995	
180mm f/3.4 APO-Telyt (2-cam)				950	600	
180mm f/4 Elmar		1095	800	750	600	
250mm f/4 Telyt (latest)		2000	1400	1300	1100	
250mm f/4 Telyt (S8 filter)		750	595	570	480	
250mm f/4 Telyt (2-cam)		600	550	580	400	
280mm f/2.8 APO-Telyt ROM	7595					
280mm f/2.8 APO-Telyt		5500	4000	4400	3495	
280mm f/4 APO-Telyt ROM	4795					
280mm f/4 APO-Telyt		3850	3500			
280/400/560mm APO Head* (requires R-focus Module)		3595				
350mm f/4.8 Telyt		2400	1920	1300	995	
400mm f/2.8 APO-Telyt ROM	12950					
400mm f/2.8 APO-Telyt		8500	7995			
400mm f/5.6 (w/stock)				1400	1100	
400mm f/6.8 (w/stock)		1300	1100	900	725	
400mm f/6.8 (lens only)	2395	795	695	700	500	
400mm f/6.8 (w/stock, 2-cam)		995	895	640	530	
400/560/800mm APO Head* (requires R-focus Module)		8795				

*The above two APO heads' focal lengths are determined by which R-focus Module is selected. Six different mix-and-match configurations are possible, but four unique focal lengths are possible. All possible focal lengths can be accessed through the use of both heads and the 1x and 2x R-focus Modules.

All lenses are 3-cam unless noted. 2-cam lenses that have been converted to 3-cam are not listed. Such converted lenses sell for more than 2-cam lenses, but less than factory original 3-cam.

Leica SLR Lenses

Lens	New	Mint		Excellent		User
500mm f/8 MR-Telyt Mirror		1750	1495			
560mm f/5.6 (w/stock)		1600	1450			
560mm f/6.8 (w/stock)		1550	1240	1200	1095	
560mm f/6.8 (lens only)	3295	1400	1300	1250	1095	
800mm f/6.3 R Telyt		20500	17500			
800mm f/8 Minolta Reflex				1000	800	

The 800mm f/8 Minolta was produced in both Minolta and Leica R lens mounts.

Lens	New	Mint		Excellent		User
1.4X APO Extender R ROM	1245					
1.4X APO Extender R		985	775			
2X (for SL, SL2)		650	500			
2X Tele-Extender R		595	495	550	360	
2X APO Extender R ROM	1495					
2X APO Extender R		1000	800			
R-focus Module 1x*	3645					
R-focus Module 1.4*x	4795					
R-focus Module 2x*	6195					

All lenses are 3-cam unless noted. 2-cam lenses that have been converted to 3-cam are not listed. Such converted lenses sell for more than 2-cam lenses, but less than factory original 3-cam.

Leica SLR Zoom Lenses

Lens	New	Mint		Excellent		User
28-70 f/3.5-4.5 Vario Elmar ROM	1095					
28-70 f/3.5-4.5 Vario Elmar		995	850			
28-70 f/3.5 Vario Elmar		795	695			
35-70 f/2.5-3.3 Angenieux		800	695	750	500	
35-70 f/3.5 Vario-Elmar (Germany) ROM	2250	1895				
35-70 f/3.5 Vario-Elmar (Germany)		1500	1300	1100		850
35-70 f/3.5 Vario-Elmar (Japan)		950	750	795	695	
35-70 f/4 Vario-Elmar ROM	1195					
35-70 f/4 Vario-Elmar		945	800			
45-90 f/2.8 Angenieux		900	800	795	600	
70-180 f/2.8 Vario-APO ROM	5395					
70-180 f/2.8 Vario-APO		4795	4500			
70-210 f/3.5 Angenieux		850	740	700	600	
70-210 f/4 Vario-Elmar		1400	1200	1200	900	
75-200 f/4.5 Vario-Elmar		1000	850	900	600	
80-200 f/4 Vario-Elmar ROM	1895					
80-200 f/4 Vario-Elmar		1650	1495			
80-200 f/4.5 Vario-Elmar		750	675	595	475	
105-200 f/4.2 Vario-Elmar ROM	5295					

Leica SLR Accessories

Item	New	Mint	Excellent	User
Motor Winder R3 (14270: R3 MOT)		100 75	80 60	
Motor Winder R4 (14282)		170 140	125 100	
Motor Winder R (14208: R4/5/6/E)	400	330 280	200 200	150
Motor Winder R8	450			
Motor Drive R4 (14292)		260 200	240 160	150 120
Motor Drive R (14309: R4/5/6/E)		300 225	250 200	
Motor Drive R (14310: R4/5/6/E)	700 580	450 350	375 275	
Motor Drive R8				
Handgrip R3 (14271)		30 20		
Handgrip R4 (14283)		40 30		
Handgrip R (14308)	125	90 75	65 50	
Handgrip R7 (14317)	125			
Universal Handgrip (14188)			150 100	
Universal Handgrip R (14239)	380 335		220 175	
Remote Control R (14277)	150 130	95 80		
Remote Control R8	420			
Electric Release MD-R/MW-R (14237)	90	80		
Electric Release R (14238)	65 55			
Tripod Holder R3 (14276)		30 25		
Tripod Holder R (14284: R4/5/6/E)		150		
APO Macro Tripod Holder (14636)	85			
Data Back DB (14297: R4)			150 100	
Data Back DB2 (14230: R4)	590 495	350 290	250 140	
Data Back DB2 (14216: R5/R6/RE)	590 495	400 320	295 200	
Data Back R	760			
Minolta Data Back D (fits R4/5/6)		100 90		
Right Angle Fndr (14186/286: SL/SL2)		125	100	
Right Angle Fndr (14287/288: R3)		125 100		
Right Angle Fndr (14326: R4)		125 100		
Right Angle Fndr 1X/2X (14329: R3)		150	130	
Right Angle Fndr 1X/2X (14328: R4)		140	120	
Right Angle Fndr 1X/2X (14300: R5/6/7/E)	470			
Bellows R (3-cam: 16860)		650 500	400 300	
Bellows R (2-cam)			275 200	
Bellows R (1-cam)		200 180		
Macro Adapter R (14256)	640	400 350		
Elpro 1 or 2	230			
Elpro 3 or 4	230			
Leitz-Braun 340M SCA Flash		110 95	90 80	
Leitz-Braun 340 SCA Flash		100 90		
Leitz-Braun 400M Logic Flash	140	120 100		
Leitz-Braun 400M Flash Cord	30			
Leitz-Braun SCA 351 Module	80 60		35 30	
Braun Macro Flash		70 65		

Numbers shown in parentheses are Leica catalog numbers.

Minolta

Minolta's history as a camera manufacturer dates from 1928. Early on, the company established a reputation for innovation, a Minolta tradition that has continued for over six decades. To name just a few firsts for which Minolta was responsible, it was the first Japanese camera company to manufacture every component of its cameras, it marketed the first 35mm SLR with a coupled meter (SR-7), as well as the first 35mm SLR with an integral motor drive (SR-M). Minolta was the first to introduce a multi-exposure mode 35mm camera (XD-11) and, of course, it marketed the first successful autofocus interchangeable-lens 35mm SLR (Maxxum 7000).

☐ Minolta SR

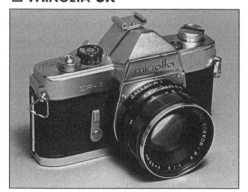

Minolta SR-1 with accessory 'cold' shoe

Minolta's first series of SLRs consists of the various SR models. With the possible exception of the SR-M, all bear close resemblance to each other with only minor differences in features. Following is a brief overview.

The SR-1 has shutter speeds which range from 1 second to 1/500, plus B,

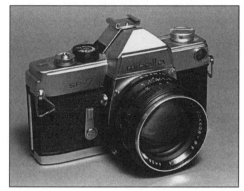

Minolta SR-7 with accessory 'cold' shoe. Note the meter window just below the film rewind crank.

with X sync at 1/60. Early SR-1's have no depth-of-field preview button. Late SR-1's have mirror lock-up and an attachment point for a non-TTL CdS exposure meter. The SR-1s appears to be identical to the late SR-1 (also known as the SR-1 Model V), and was produced concurrently with the SR-T 101. The SR-2 (Minolta's first SLR) has a full range of shutter speeds, from 1 second to 1/1000, plus B, with X sync at 1/60. It was replaced by the SR-3, which featured a detachable selenium non-TTL exposure meter.

The SR-3 was superseded by the SR-7, which has a built-in non-TTL exposure meter coupled to the camera's shutter speeds, and was the first Minolta SLR (as far as I've been able to tell) with mirror lock-up. The SR-M was Minolta's first motorized camera and was introduced four years after the SR-T 101. It has a built-in motor drive with a large, detachable hand grip and features both motorized film advance and rewind. It

also has mirror lock-up. The SR-M has no meter, nor does it have a provision for attaching one of the above accessory meters. All the above SR-series cameras have self-timers except the SR-M.

☐ Minolta SR-T

The success of the workhorse SR-T-series was largely responsible for positioning Minolta as a major player in the 35mm camera market. There are six basic models, most which underwent slight modifications during their production lives. Just to make matters confusing, though, the model numbers varied according to the countries in which they were sold. Following is a more-or-less chronological listing of SR-T cameras, with brief descriptions of features.

Minolta SR-T 101

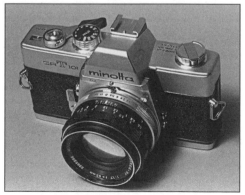

Minolta SR-T 101

The SR-T 101 debuted in 1966. It is a full-size, full-featured, manual, mechanical SLR. The TTL CdS meter provides centerweighted average metering. Exposure is determined by the

match-needle method. Shutter speeds range from 1 second to 1/1000, plus B, with X sync at 1/60. The camera has a "cold shoe" (an accessory shoe without flash contacts) and PC sockets for X sync and FP bulbs. Other niceties include a depth-of-field preview lever and a self-timer. Most SRT-101s have mirror lock up, although those made at the very end of the production run do not.

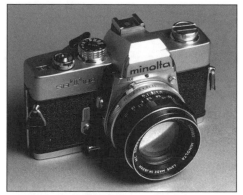

SR-T 100

Minolta SR-T 100

Introduced in 1971, the SR-T 100 is a scaled-down version of the 101. The top shutter speed is 1/500. It doesn't have a self-timer, depth-of-field preview, or mirror lock-up.

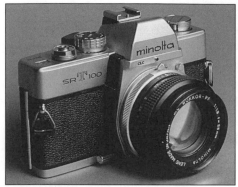

Minolta SR-T 102

Minolta SR-T 102, SR-T 303 & SR-T Super

The SR-T 102, introduced in 1973, is basically a 101 with improvements. It has a hot shoe, multiple exposure capability and lens apertures are visible in the viewfinder. Examples can be found with or without mirror lock-up. The SR-T 303 and SR-T Super are identical to the

102, marketed in Europe and Japan, respectively.

Minolta SR-T 201, SR-101 & SR-T 101B

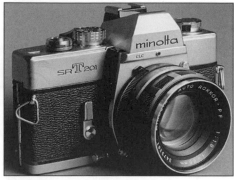

SR-T 201

Things get a little confusing at this point. Introduced in 1975, the SR-T 201 is a 101 with a hot shoe. Most examples do not have mirror lock up. It almost seems as if Minolta still had a few 101s lying around that got new top covers. The SR-101 and SRT-101B are identical to the SR-T 201, marketed in Japan and Europe, respectively.

Minolta SR-T 202, SR-T 303B & SR-505

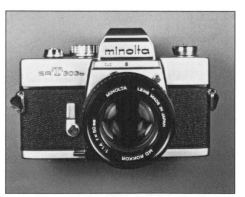

Minolta SR-T 303b. Identical to the SR-T 202.

The SR-T 202 was introduced in 1975 and is almost identical to a late SR-T 102. Most 202s do not have mirror lock-up. Two features added to this camera are a window under the film advance lever that has an indicator for correct film transport and a memo holder. The SR-T 303B and SR-505 are identical and

were marketed in Europe and Japan, respectively.

Minolta SR-T 200

Also introduced in 1975, the SR-T 200 replaced the 100. It has a full range of shutter speeds, however.

Minolta SR-T MC, SR-T MCII, SR-T SC & SR-T SCII

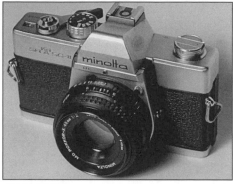

SR-T SCII

These cameras were marketed through major national department stores, such as K-Mart and others. As far as I could determine, the SR-T MC is the same as the SR-T 101, the SR-T MCII is an SR-T 202, the SR-T SC is an SR-T 100 and the SR-T SCII is an SR-T 200. Don't hold me to this, though. If you have specific details on these models, I'd be interested in finding out how close I am.

Minolta XD-11, XD-7, XD-5 & XD

The XD-11, when introduced back in 1977, was billed as the first SLR with more than one auto-exposure mode and caused the photo industry to take notice. It's an elegantly-designed camera; controls are uncluttered and easily understood. If you happen to run across an XD or an XD-7, these are XD-11's originally marketed in Japan and Europe, respectively.

The XD-11's exposure modes include both aperture and shutter-priority AE, and metered manual. Minolta MD lenses must be used to engage the

XD-11's shutter priority mode (see illustration in lens section). In shutter-priority AE, if the user has selected a setting that will result in improper exposure, the camera will automatically adjust things so that a well-exposed photo will result. Though it was never billed as such by Minolta, what this override function amounts to is a program mode, because the camera is selecting both shutter speeds and apertures. Thus, it could be argued that the XD-11 was the first SLR featuring multi-exposure modes that included program. Non-TTL flash AE is also available (auto-setting of flash sync) with dedicated flash units. Silicon photo diodes provide centerweighted metering. Shutter speeds range from 1 second to 1/1000, plus B, with X sync at 1/100. Should the battery fail, two mechanical speeds are available: B and "O". The latter will sync with a flash at about 1/100 second.

Other features include multiple-exposure capability, a viewfinder window for direct aperture readout, a viewfinder shutter, depth-of-field preview, a variable self-timer and a 2 fps winder option with the Minolta Auto Winder D.

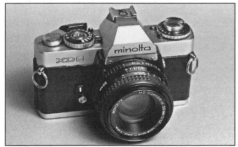
Minolta XD-5

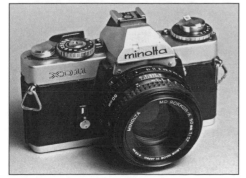
Minolta XD-11

The XD-5, as far as I have been able to ascertain, is identical to the XD-11, except it lacks the direct aperture readout window.

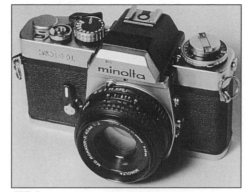
XE-1

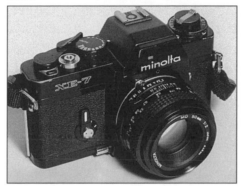
XE-7

XE-7, XE-5, XE-1 & XE

The XE-7 was available in black finish only and bears more than a passing resemblance to the Leica R3 for a very good reason. This camera was Minolta's first payoff from the shared technology agreement between the two companies. The XE-1 and XE are identical to the XE-7, marketed in Japan and Europe, respectively.

Exposure modes include aperture-priority AE, metered manual and stop-down metering for non-MC or preset lenses. Shutter speeds range from 4 seconds to 1/1000, plus B, with X sync at 1/90. Without batteries, only B and 1/90 are available. Other features include exposure compensation, an eyepiece shutter, a direct aperture readout window in the viewfinder, a film transport indicator, a hot shoe and a PC socket, multi-exposure capability, depth-of-field preview and a variable self-timer.

The XE-5 is much the same camera, except for the following differences: It was available only in chrome finish with a black finder. It lacks depth-of-field preview, the direct aperture readout window, the eyepiece shutter and multiple exposure capability.

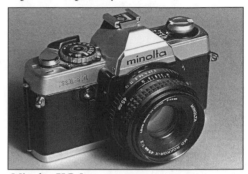
Minolta XG-1

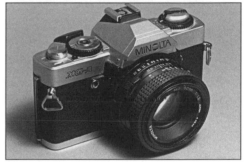
Minolta XG-A

XG-1, XG-7, XG-9, XG-A, XG-M & XG-SE

These five cameras are almost identical in features and most are almost identical in appearance. Exposure modes are aperture-priority AE, employing a centerweighted averaging meter, non-metered manual (except the XG-A) and limited flash AE (shutter speed is set automatically with dedicated flash units). Shutter speeds range from 1 second to 1/1000, plus B, with X sync occurring at 1/60. Other features include exposure compensation and a self-timer. All models accept the Winder G for film advance speeds up to 2 fps.

Now, for the differences:

The XG-1 was made in two models, known within the trade as the XG-1 and XG-1n. At least these two are easy to tell apart. The XG-1 has the older-style body, while the XG-1n has an updated

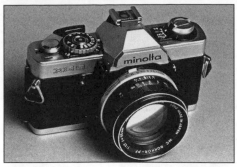

Minolta XG-9

body, similar to that of the X-370 and X-570. It also has the current Minolta logo on its nameplate. The XG-1 will not take the Databack G, whereas the XG-1n will. The XG-7 is an XG-1 with a film memo holder and the capability to accept the Data Back G. The XG-9 is an XG-7 with a window in the viewfinder for direct aperture readout and a depth-of-field preview lever. The XG-A is an XG-7 without a manual exposure mode. The XG-M is an XG-9 with AE lock and a body similar to the XG-1n's. The XG-SE is a black XG-7 with an Acute Matte focusing screen (much brighter). There was also an XG-7A, which is apparently a black XG-M.

There. I hope that's been settled.

Minolta XK & XK Motor, XM, & X-1

The XK was the first Minolta that used the X prefix in its model designation. Introduced in 1973, it was an attempt by Minolta to go up against the Nikon F and F2, and the Canon F-1. Built in that tradition, it is a solid, heavy camera, obviously designed to withstand

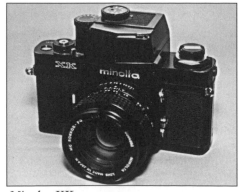

Minolta XK

years of hard use. Minolta may have been more successful with the original XK if it had had motor drive capability when introduced. Instead, the company waited until 1976 before finally introducing the XK Motor. Another difference that may have contributed to its lack of acceptance is the fact that it is an electronic, battery-dependent camera. If one looks at the XK's features, though, it was years ahead of its time.

The XK has two basic exposure modes: aperture-priority AE and metered manual. Shutter speeds range from 16 seconds to 1/2000 (1 second to 1/2000 in manual), plus B, with X sync at 1/100. B and X sync are the only mechanical speeds. A variety of interchangeable viewfinders were offered, although the camera is usually found with the AE finder. Other features include interchangeable focusing screens, depth-of-field preview, mirror lock up and a self-timer.

The XK Motor is an XK adapted for the XK motor drive, and came with the improved AE-S finder when new. An interesting addition to the XK Motor is a microswitch that allows the motor drive to operate only when film is in the camera. The motor drive is built every bit as ruggedly as is the camera, yet its grip is sculpted to fit one's hand comfortably. When new, the XK Motor was usually sold with the motor drive. The set was expensive, as well. Discount new prices for the outfit in the mid-to-late 1970's were over $1,000. The XK Motor is a beautiful combination for the diehard Minoltaphile, but clean examples still fetch a high premium on the used market.

The XM and X-1 cameras are identical to the XK and were marketed in Europe and Japan, respectively.

Minolta X-700

This lightweight camera just feels good resting in the palm of your hand.

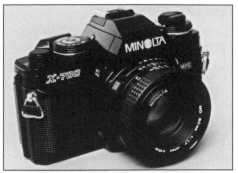

Minolta X-700

Years before radical streamlining became chic, Minolta came up with the subtle ergonomics responsible for the way it feels. In addition to looking good, it functions well and remains a very popular camera on both new and used markets.

The X-700 has four exposure modes: program, aperture-priority, metered manual, and TTL flash with dedicated flash units. Other exposure features include AE lock and exposure compensation. The metering pattern employed is the tried-and-true center-weighted method. Shutter speeds range from 4 seconds to 1/1000 (1 second to 1/1000 in manual mode), plus B, with X sync at 1/60. Other features include interchangeable Acute Matte focusing screens, a direct aperture readout window, a PC socket, depth-of-field preview and a self-timer. The X-700 will accept either the winder G for film advance speeds up to 2 fps, or the Motor Drive 1, for continuous speeds up to 3.5 fps. MD lenses must be employed to engage the X-700's program mode (see illustrations in lens section).

Minolta X-570

At first glance, this camera appears to be a scaled-down version of the X-700 and it is – sort of. It lacks the X-700's program mode, as well as the X-700's exposure compensation, depth-of-field preview and PC socket. Like the X-700, the X-570 accepts both the Winder G and the Motor Drive 1.

The big difference between the two cameras, and one reason why many people prefer the X-570 to the X-700 has to do with the LED readout. In manual mode, the LED readout in the X-570 viewfinder is coupled to both the lens aperture ring and the shutter speed dial, allowing one to do match-diode metering without having to remove one's eye from

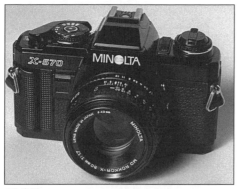

X-570

the viewfinder. With the X-700, the selected apertures are shown in the viewfinder, but the shutter speed shown is that which the camera recommends for correct exposure. It does not change as the shutter speed dial is adjusted. This forces the user to look away from the viewfinder, glance at the shutter speed dial to see what's been set, then recompose and shoot. As a result, the X-570 is a much more convenient camera to use for manual work.

Minolta X-370 & X-7A

The only differences between the X-370 and the X-570 is that the X-370 does not have TTL flash automation and it will not accept the X-series data backs. beside this, they're the same camera. The X-7A is a domestic Japanese X-370,

available in black only. Although never officially imported into the U.S., it is common on the used market.

Minolta X-370n & X-9

The X-370n is a redesigned X-370, styled to be more ergonomic. It probably has the same amount of plastic as the original, but looks as if it has more. As

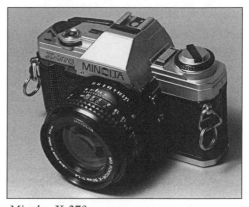

Minolta X-370

Minolta Manual Focus SLRs

Camera	Yrs. Made	New		Mint		Excellent		User	
SR-M w/grip	1970-75					550	400		
SR-1 or SR-1s	1959-70					100	60		
SR-2	1958-61					95	50		
SR-3 w/meter	1961-62					100	80		
SR-7	1962-66					110	90		
SR-T 100	1971-75					100	80	75	50
SR-T 101	1966-75			150	120	130	100	90	55
SR-T 102	1973-75			175	150	150	110		
SR-T 200	1975-81					120	75		
SR-T 201	1975-81			180	160	150	95		
SR-T 202	1975-78			190	175	160	125		
XD-5	1979-83			170	140	150	120		
XD-11 chr	1977-82			225	185	180	150	140	120
XD-11 blk	1977-82			300	265	250	175		
XE-5	1975-78			170	150	160	115		
XE-7	1975-78			225	180	170	150		
XG-A	c1981-85			100	90	80	70		
XG-M	1981-84			125	100	100	90		
XG-1	1979-84			125	110	115	80		
XG-7, XG-SE	1978-81			140	110	125	90		
XG-9	1979-84			150	125	130	100		
XK w/AE finder	1973-77			450	400	370	300	275	195
XK Motor W/AES fndr & mtr drv	1976-87			1500	1200	1150.	950	850	780
X-9	1990-96					120	110		
X-370, X7A	1984-89			140	110	125	100		
X-370n	1990-96			150	140				
X-370s	1990-	180	150						
X-570	1984-87					150	125		
X-700	1983-	280	240	195	160	160	125		

far as I can tell, the only improvement over the original X-370 is that the X-370n has a window for direct aperture readout. The X-9 is identical to the X-370n, except it has a depth-of-field preview lever.

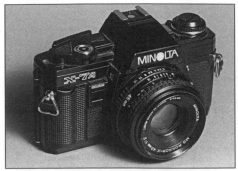

Minolta X-7A

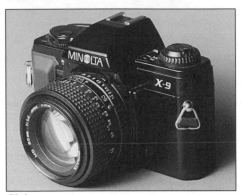

X-9

□ **MINOLTA LENSES**

Minolta Auto, MC and MD lenses will fit all manual focus Minolta cameras, allowing varying degrees of automation depending on the camera.

The first generation of lenses produced for Minolta SLRs were the Auto Rokkor-PF lenses. Most of these lenses have auto diaphragms, but none have meter couplings. Many of these early lenses can be used on later cameras that support stop-down metering. Chances are pretty good, though, that if your Minolta has a meter, you'll probably want to use lenses that will couple to it.

MC or MD – what's the difference, and which style do you need for your camera? MC lenses have a tab on the aperture ring of the lens that engages the meter coupling pin on the camera. MD lenses have an additional tab, which, when the lens is set to its smallest aperture (highest number), engages another pin on the camera (see illustration). Only three Minolta cameras support the MD feature: the XD-11, the XD-5 and the X-700. With the X-700, for example, the engagement of this pin lets the camera

know everything is ready to go when the shutter speed dial is set to program. Thus, if your camera has shutter-priority exposure automation (XD-11 or XD-5) or a program feature (X-700), and if you wish to use these functions, you will need MD lenses. If your camera does not have a program mode or shutter-priority AE, or if you don't use these features, then you can get by just fine with MC lenses and your camera will never know the difference.

MC lenses were made in three styles: the early Rokkors, most of which have metal focusing rings; the Rokkor-X lenses, which have rubberized inserts on the focusing rings; and the MC Celtic lenses. The Celtics were priced and marketed as economy models and are fine lenses optically, although not as sturdy as their Rokkor and Rokkor-X counterparts.

MD lenses exist in two basic styles. The earlier style, labeled MD Rokkor-X (sometimes MD Rokkor), resemble late MC lenses in appearance and are generally larger than the later MD style (labeled Minolta MD).

Minolta Auto Rokkor-PF Lenses

Lens	Mint	Excellent		Use
18mm f/9.5 Fish-eye		250	100	
21mm f/4 w/finder		150	125	
The 21mm f/4 is for Minolta SLRs with mirror lock-up				
35mm f/2.8		50	35	
55mm f/1.8		30	20	
55mm f/2		25	15	
58mm f/1.4		50	30	

Minolta MC Lenses

Lens	New	Mint	Excellent		User	
7.5mm f/4 Fish-eye			350	300		
16mm f/2.8 Fish-eye		375 350	300	275	250	180
17mm f/4			350	250		
21mm f/2.8		260 200	225	180		
24mm f/2.8			125	100		
24mm f/2.8 VFC		350 300	325	250		
28mm f/2			200	150		
28mm f/2.5		100 80	70	60		

Price differences between MD Rokkor-X and Minolta MD lenses are usually negligible, although it is not unusual to see Rokkor-X lenses commanding higher prices than their latest-generation plastic counterparts. Another difference is that Minolta MD lenses have a sliding switch that locks the lens aperture ring in the AE setting (see illustration). The earlier style does not have this switch, so it is easier for the aperture ring to be moved inadvertently from the AE position. Minolta also produced MD Celtic lenses.

There are also a variety of Minolta lenses concurrent with the MC and MD lenses, which lack meter-coupling tabs. Those listed here are the mirror and bellows lenses. Both groups are listed separately following the MD lens listings.

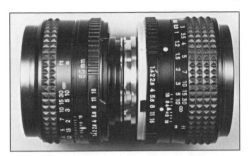

Flange to flange comparison of Minolta MD and MC lenses. Note the additional tab on the aperture ring of the MD lens (left).

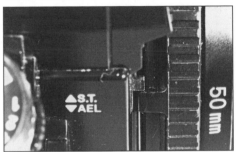

Close-up of the MD len's program coupling tab and the body switch it engages. Minolta X-700 shown.

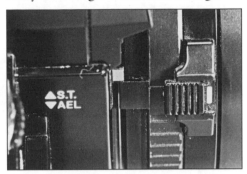

Same as before, but new style MD lens with lens AE lock engaged. A green mark is uncovered when the lens is unlocked.

Minolta MC Lenses (cont'd)

Lens	New		Mint		Excellent		User	
28mm f/2.8			95	75	60	50		
28mm f/2.8 Celtic					50	30		
28mm f/3.5					50	40		
35mm f/1.8					175	125		
35mm f/2.5					75	60		
35mm f/2.8			80	65	60	40		
35mm f/2.8 Celtic					60	45		
50mm f/1.4			65	50	55	50		
50mm f/1.7					50	25		
50mm f/2			30	25	25	20		
50mm f/3.5 Macro (w/1:1)			165	145	160	120		
50mm f/3.5 Celtic Macro					100	85		
55mm f/1.7					40	25		
55mm f/1.9					35	25		
58mm f/1.2					150	125		
58mm f/1.4			75	50	60	40		
85mm f/1.7					175	125		
85mm f/2.8 Varisoft	700	400	500	425	400	345		
100mm f/2.5					125	80	100	75
100mm f/3.5 Macro (w/1:1)					250	200		
135mm f/2.8					70	45		
135mm f/2.8 Celtic					55	40		
135mm f/3.5					60	30		
135mm f/3.5 Celtic					40	30		
200mm f/3.5					100	75		
200mm f/4.5 Celtic					60	50		
200mm f/4.5					75	60		
300mm f/4.5			300	280	290	225		
400mm f/5.6 APO					850	600		
600mm f/5.6			1000	800				
MC 2X APO Teleconverter					240	200		
MC 2X 200L Teleconverter			125	100				
SR 2X M/A Teleconverter			120	100	90	70		

Minolta MC Zoom Lenses

Lens	New	Mint	Excellent	User
40-80 f/2.8			160 125	
80-160 f/3.5			125 100	
80-200 f/4.5		200 190		
100-200 f/5.6 Celtic			60 40	
100-500 f/8			500 400	

Minolta MD Lenses

Some of the following MD lenses for which new prices are listed may be limited to existing stock. Minolta has been trimming down its manual focus lens line and, as stocks of some of these lenses become depleted, they may not be replenished.

Lens	New	Mint	Excellent	User
7.5mm f/4			400 300	
16mm f/2.8		375 300	275 225	
17mm f/4		425 350		
20mm f/2.8		375 300	290 225	
24mm f/2.8		300 250	225 195	
24mm f/2.8 VFC	395 350		290 225	
28mm f/2	590	250 175	200 150	
28mm f/2.8	150	100 80	90 65	
28mm f/2.8 Celtic			65 50	
28mm f/3.5			60 40	
35mm f/1.8			280 195	
35mm f/2.8		100 80	70 40	
35mm f/2.8 Shift			600 400	
45mm f/2		40 30	30 20	
50mm f/1.2		240 190		
50mm f/1.4		130 115	95 70	
50mm f/1.7	70	50 40	40 20	
50mm f/2		35 30	30 25	
50mm f/2.8		40 25		
50mm f/3.5 Macro (w/1:1)	300		250 170	
85mm f/1.7		220 180	175 150	
85mm f/2		250 190		
100mm f/2.5		185 150	150 125	
100mm f/3.5 Macro (w/1:1)			385 270	
100mm f/4 Macro (w/1:1)	600	395 350	340 260	
135mm f/2		350 300	285 250	
135mm f/2.8	150		80 65	
135mm f/3.5 (MD or Celtic)		50 35	35 30	
200mm f/2.8		300 250	275 220	
200mm f/4			95 60	
300mm f/4.5		360 330	325 250	
300mm f/5.6			180 90	
400mm f/5.6 APO		800 730		
600mm f/6.3 APO		2195 1850		
MD-2X 300S	320		160 120	
MD-2X 300L	290		100 80	

Minolta MD Zoom Lenses

Lens	New		Mint		Excellent		User	
24-35 f/3.5			250	200				
24-50 f/4	445		270	240	250	170		
28-70 f/3.5-4.5	125		70	60				
28-85 f/3.5-4.5			225	170	175	140		
35-70 f/3.5					150	100		
35-105 f/3.5-4.5			190	150				
35-135 f/3.5-4.5			290	250	225	150		
50-135 f/3.5			200	180	170	140		
70-210 f/4			175	150	160	120		
70-210 f/4.5-?	195	175						
70-300 f/4.5-?			225	190				
75-150 f/4			140	115	110	85		
75-200 f/4.5					150	120		
100-200 f/5.6					110	85		
100-300 f/5.6					265	200		
100-500 f/8 APO			1200	950	900	750		

Minolta Mirror Lenses

Lens	New		Mint		Excellent		User	
250mm f/5.6			160	120	125	90		
500mm f/8	430	300	300	275	285	190		
800mm f/8	1195	900	850	690	700	500		
1000mm f/6.3					1800	1250		
1600mm f/11	2895	2500			2000	1600		

Minolta Bellows Lenses

Lens	New		Mint		Excellent		User	
12.5mm f/2 Micro (Bellows)	195							
25mm f/2.5 Micro (Bellows)	195							
50mm f/3.5 Macro (Bellows)	220		180	150				
100mm f/4 Macro (Bellows)	250	185						

Minolta Flashes and Flash Accessories

Item	New		Mint		Excellent		User	
45FPX					60	45		
80PX Macro Ring Flash	325	250	220	170	180	125		
118X		40			25	15		
128					40	30		
132PX	110	75	30	20				
132X		50	45	40	35	25		
200X		100	45	35	35	25		
220X	55	30						
280PX	130	90	75	50	60	40		
320		85			50	35		
320X		145			70	50		
360PX		200	170	140	150	125		
Auto Electro Flash 450 w/bracket					140	120		
Power Grip I Set			150	125				
Power Grip II Set	210	170	140	125	115	85		
NC-2 Charger & Batteries		40						
Off-Camera Shoe		35						

Minolta Accessories

Item	New		Mint		Excellent		User		
Data Back D (XD-series)					185	140			
Data Back G (XG-series)					85	65			
Multi Function Back (X700/570)			150	110					
Quartz Data Back 1 (X700/570)			125	105					
MD-1 Motor Drive (X700/570/370)	260		230	180	140	160	135	125	120
Auto Winder D (XD-11/XD-5)			100	80	100	80			
Auto Winder G (XG's/X700/X570/X370)	140		120	100	85	80	50		
Remote Control Cord L (X700/X570)			50						
Remote Control Cord S (X700/X570)			35						
Auto Bellows I			75	50					
Auto Bellows II			100	75					
Auto Bellows III	240	165	135	125					
Bellows I			50	45					
Bellows II			75	60					
Bellows III	140	100			85	75			
Bellows IV	140	100			95	75			
Compact Bellows	100	80							
Slide Copier			50	40					
Slide Copier II			60	50					
Slide Copier III			110						
Focusing Rail III	130	90							
Macro Stand III	70	50							
MC Auto Extension Tube Set	100	80	50	40					
Copy Stand I			60	50					
Copy Stand II			100						
Copy Stand III			200						
Transmitter IR-1 Set			150		130	100			
Transmitter IR-1N Set			190						
Eyepiece Magnifier V or Vn			50	35	25				
Angle Finder V or Vn			115	90	75				
SR Right Angle Finder					40	25			
XK AE Finder			140	130	125	100			
XK AE-S Finder			170	155	150	120			
XK Prism P			100	75					
XK Waist level Finder			60	40					
XK Magnifier Eyepiece			75	65					

Minolta Maxxum

Maxxum cameras accept only Maxxum bayonet-mount lenses (or aftermarket equivalents). There is no direct interchangeability between the Maxxum mount and the earlier Minolta MC/MD-style bayonet mount. Minolta does offer a teleconverter that will allow the use of these lenses on Maxxum cameras, but they won't autofocus. The following cameras are listed approximately in the order of their introduction.

Maxxum 7000

Minolta's introduction of the Maxxum 7000 shook the 35mm photo industry to its very foundations. This single camera is ushered in explosion in autofocus technology that has continued unabated since its 1985 release. But a good thing can't last forever; the Maxxum 7000 now suffers at the hands of the very revolution it began. By today's standards, the 7000's autofocus mechanism moves lenses into focus in a positively leisurely fashion. This isn't to say its autofocus mechanism is slow, it's just that the latest generation of autofocus cameras now focus at seemingly instantaneous speeds.

The 7000 has two autofocus modes: one-shot (focus priority) and continuous (servo), with AF lock. Exposure modes are program with shift, aperture and shutter priority AE, metered manual and TTL-OTF (Off The Film plane) flash metering with dedicated flash units. Metering is performed by silicon photo cells in a centerweighted pattern. Shutter speeds range from 30 seconds to 1/2000, plus B, with X sync at 1/125. Other features include interchangeable focusing screens, a built-in film winder with continuous speeds up to 2 fps, a self-timer, DX film coding with override, auto film loading and rewind.

Maxxum 5000

Maxxum 5000

The Maxxum 5000 is a simplified, less-costly version of the 7000 that retains its most often used features. A single autofocus mode, single-shot (focus priority), is available. Exposure modes are program and metered manual. Shutter speeds range from 4 seconds to 1/2000, plus B, with X sync at 1/100. Other features include DX film coding, backlight compensation, a self-timer and a built-in 1.5 fps motor drive that provides auto film loading and rewind.

Maxxum 9000

The Maxxum 9000 garnered rave reviews when it was released in 1986 – and for good reason. It was the first member of what has been until recently a very select group: professional-quality autofocus SLRs. Its robust construction, numerous built-in features and wide array of accessories still make it a useful, full-featured SLR. But, because it uses Minolta's first generation of autofocus technology, it won't focus with the speed of even current generation entry level cameras, and is miles behind the Maxxum 9xi. Until the 9xi's introduction, the Maxxum 9000 had been the only Minolta SLR with a top flash sync speed of 1/250 second.

The 9000's standard autofocus mode is continuous (servo) operation

Maxxum 7000

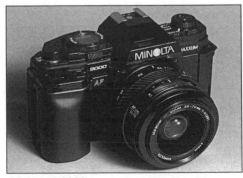
Maxxum 9000

with an AF lock located in the shutter release. When the motor drive or winder is attached, single-shot (focus-priority) is also available. Metering modes are centerweighted averaging and a tight 0.7% spot. Exposure modes include program with shift, aperture and shutter priority AE, metered manual and TTL flash with dedicated flash units. The metering can be biased for shooting in highlighted situations or shadows. Shutter speeds range from 30 seconds to 1/4000, plus B with an elapsed time indicator. Flash sync occurs at 1/250.

Other features include exposure compensation, a PC socket, built-in diopter correction, an eyepiece shutter, interchangeable focusing screens, multiple exposure capability, the retention of manual film advance and rewind capability, and a self-timer. A host of accessories were made for the 9000, from either a winder or motor option (continuous advance speeds to 5 fps with the motor) to a still video back with a video recorder.

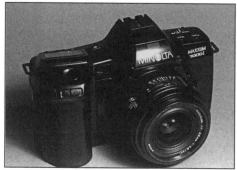

Maxxum 7000i

Maxxum 7000i

The 7000i's autofocus system features the following: it will switch automatically between continuous and one-shot, depending upon subject movement. Predictive focus was added, which allows the camera to track a moving subject, anticipating its location at the time of exposure. It has a wide-area, three-element array of focus sensors, sensitive to both horizontal and vertical subjects.

Exposure modes are program with shift, aperture and shutter priority AE, metered manual and TTL flash with auto fill flash, variable fill ratios and multi-strobe effects when using i-series flash units. The i-series Minoltas' hot shoes will accept only i-series flashes, although Minolta does make an adapter that will allow use of standard ISO flashes. Metering modes include a six-zone multi-pattern evaluative mode and 2.3% spot, with standard centerweighted metering available in the manual exposure mode. Shutter speeds range from 30 seconds to 1/4000, plus B, with X sync at 1/125.

Other features include exposure compensation, a standard PC socket, multi-exposure capability, DX film coding with manual override, a built-in motor drive with film advance speeds up to 3 fps, and auto film loading and rewind.

A feature introduced with the 7000i is Minolta's Creative Expansion Card library. The Creative Expansion Cards are plug-in modules that will customize the camera for fine-tuned control over such exposure situations as autobracketing, program shift, fantasy effects, data memory, highlight/shadow biasing and more.

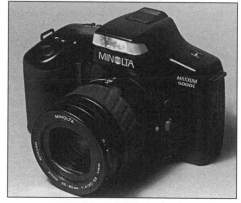

Maxxum 5000i

Maxxum 5000i

The 5000i is a scaled-down little brother to the 7000i with many of the same features. Its wide area array of focus

sensors provide one standard autofocus mode: one-shot (focus priority). Continuous AF is possible with the "Sports Action" Creative Expansion Card. Its exposure modes include program and metered manual. Shutter and aperture priority AE modes are available with optional Creative Expansion Cards. Metering choices are two-zone evaluative in the program mode or centerweighted averaging in the manual mode. Shutter speeds range from 4 seconds to 1/2000, plus B with an elapsed-time indicator.

The 5000i has a built-in flash (GN 50 @ ISO 100) that fires only in low-light and backlit situations when in program and shutter-priority AE, but it fires with every shutter release in aperture-priority AE and manual exposure modes (sounds like a bug in the software, doesn't it?). The camera has an i-series hot shoe that accepts only i-series units. As with the 7000i, it will take an adapter that will allow the user to mount standard ISO flash units. Flash sync occurs at 1/90.

Other features include the line of Creative Expansion Cards as mentioned with the 7000i above, AE lock, a self-timer and an integral motor drive with single frame advance, auto film loading and rewind. Film is DX coded with no override capability.

Maxxum 3000i

An even further simplified i-series camera, the 3000i is designed for the snapshot shooter who may wish to change lenses from time to time. Its wide-area AF sensor array provides one autofocus mode: one-shot (focus priority) with a limited predictive focusing capability. Metering modes are the same as those in the 5000i. It has two program modes: normal and high-speed program, but no manual exposure control. As with other i-series cameras, its hot shoe accepts only i-series flashes, but

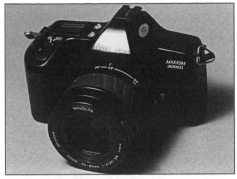

Maxxum 3000i

standard ISO units can be mounted with an optional adapter. Shutter speeds range from 4 seconds to 1/1000, with X sync at 1/60. Other features include a self-timer, integral motor drive with single frame advance, auto film loading and rewind.

Maxxum 8000i

As if the 7000i didn't have enough souped up capabilities, Minolta introduced the 8000i to leave little room for doubt that they could still go head to head with Nikon and Canon. Targeted at the Nikon N8008, the Maxxum 8000i is similar to the 7000i with the following additional features:

The top shutter speed was boosted to 1/8000, with X sync at 1/200 (1/180 with non-Maxxum flash units). A new, on-demand centerweighted metering pattern was added, as was an AF lock button. The 8000i has a high-eyepoint finder, a handy feature for eyeglass wearers. User-redefined ISO settings can be entered for any given DX code. Thus, if you expose your Kodachrome 64 at EI 80, for exam-

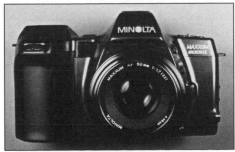

Minolta Maxxum 8000i

ple, you can change the DX setting on the camera so that you don't have to override the DX code manually every time you load a new roll – a nice feature.

□ MAXXUM XI-SERIES SLRS

The Maxxum 7000 was considered a pretty smart camera when it was released in 1985. Then along came the i-series Maxxums, where the "i" stood for "intelligence," and which were a whole lot smarter. The xi-series features what Minolta calls "expert intelligence," hence "xi."

The following xi cameras are listed in numerical, rather than chronological order.

Maxxum 2xi

The littlest brother in the xi line to date, the Maxxum 2xi has enough features to keep most occasional photographers perfectly content. It is compact, lightweight and easy to use, yet contains the same fuzzy logic Expert Program routines that its more full-featured siblings have.

The 2xi's autofocus system uses a single wide-area CCD sensor to handle the focusing chores. The AF system will detect movement and switch automatically to the continuous focus mode, with predictive focus control.

Exposure modes include the following: Program AE, aperture and shutter-priority AE, and manual mode. The 2xi has two metering patterns: a seven-segment honeycomb pattern plus the background, and a spot meter, which uses the central honeycomb segment only. Shutter speeds range from 30 seconds to 1/2000 second. TTL flash exposure is also provided when a dedicated accessory flash is attached. An interesting flash option available with the 2xi is the slow shutter sync option. By depressing and holding the spot-metering button while taking the picture, a

slower shutter speed will be used, thereby increasing exposure of the background – handy for night scenes when one wants background detail brought out.

Other features include auto film advance and rewind, mid-roll rewind, single-frame film advance, DX film coding with no override, and a cancelable self-timer.

Maxxum 3xi & SPxi

The Maxxum 3xi and SPxi are almost identical cameras, except for the differences shown below.

The autofocus system uses a single, wide CCD (charge-coupled device) sensor, activated by the Eye Start feature (see the 7xi section for a description of Eye Start). Depending on subject movement, the system will select either single-shot (focus-priority) or Predictive Focus Control, and will switch automatically between the two modes should the subject move or stop.

An 8-segment honeycomb metering pattern (seven central segments plus the background) determines correct exposure and is the only metering mode in the 3xi. The SPxi has this, plus it also uses the center segment for a spot meter. Exposure modes available include Expert Intelligence program, aperture and shutter-priority AE, metered manual, and TTL flash using either the built-in flash on the 3xi (GN 39 @ ISO 100) or dedicated accessory units. The SPxi has no built-in flash. Shutter speeds range from 30 seconds to 1/2000 second, plus B, with x-sync at 1/90. Another feature supported by the 3xi and SPxi is Auto Stand-by Zoom (ASZ) (see the 7xi section for a description of ASZ).

Other features include DX coding with no override, a built-in winder that provides single-frame advance, auto film loading and rewind, and mid-roll rewind.

Maxxum 5xi

Just as the 7xi and 3xi replaced their respective i-series models, so did the 5xi replace the 5000i. And, like the 5000i, the 5xi fit squarely between the other two xi models in terms of price and features. The 5xi is housed in the same shell as the 3xi's, but has many more of the 7xi's features, and only weighs two ounces more than the 3xi.

The autofocus and exposure systems used in the 5xi are virtually identical to those found in the SPxi – single-shot, predictive autofocus, two metering modes (eight-segment evaluative and spot). Exposure modes available and shutter speed selections on the 5xi are the same as those found on the 3xi and SPxi.

As with other xi cameras, the 5xi supports the Eye-Start and Auto-Standby Zoom features when using xi lenses. The built-in winder can be set for either single-shot or continuous operation, and provides auto film loading and rewind, plus mid-roll rewind. DX coding is automatic, with no override. Many Creative Expansion cards can be used with the 5xi, some with only part of their features implemented. Some, like the function-change card, can't be used at all.

Now, for the new stuff: The 5xi is the first Maxxum camera with a built-in flash that pops up and fires automatically when needed and retracts when not needed. This flash also has a zooming feature, which covers lens focal lengths from 28mm to 85mm and greater. Further, the flash works as an AF illuminator in low light. The 3500xi flash can be used with the 5xi and can be triggered off-camera, without the use of a PC cord (maximum flash-sync shutter speed when doing this is 1/45 second).

Maxxum 7xi

Minolta inserted a new term into the still photographer's lexicon when the

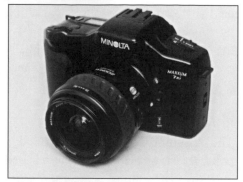

Maxxum 7xi

Maxxum 7xi was released – fuzzy logic. Already a familiar concept to many computer experts and camcorder users, fuzzy logic is a computer algorithm that differs from digital logic by allowing for gradations between the absolute states of on or off. Put in terms more amenable to the photographer, if we let "on" represent white and "off" represent black, then fuzzy logic can interpret the gray scale in between these two absolute values, whereas digital logic cannot (at least, not without lots of added subroutines and more memory requirements). Thus, by incorporating fuzzy logic into the 7xi, Minolta has come up with a memory-management scheme that makes much more efficient use of the camera's computer memory than would be possible using conventional digital logic alone. But, in order to make the most effective use of fuzzy logic with the camera's various "Expert" features, the Minds at Minolta knew a more powerful on-board computer would be needed. In computerese, the heavier requirements led to the adoption of a 16-bit CPU running at a clock speed of 20 MHz, with 64 kilobytes of ROM and 2 kilobytes of RAM. It wasn't all that long ago when specs like these would have been impressive for a full-sized desktop computer. The 7000i, by comparison, sports an 8-bit 10.5 Mhz CPU, with only 20 kilobytes of ROM and 640 bytes of RAM. In plain English, the Maxxum 7xi has roughly four times the computing speed and three times

the memory capacity of earlier i-series models.

According to Minolta, the Maxxum 7xi focuses twice as fast as its i-series predecessors. Partially responsible for this feat is its ultra wide angle phase-detection system, which has four high-density CCD sensors.

The 7xi's wide-area autofocusing system will switch automatically between sensors depending on subject location or movement. It will also switch sensors automatically to accommodate horizontal or vertical subjects. And, if the user desires, he or she may select any of the four sensors at any time. Autofocus modes are single shot (focus priority) and continuous predictive autofocus. Manual focus is assisted with a focus confirmation indicator in the viewfinder. Like most other advanced AF SLRs, the 7xi will detect subject movement and switch automatically to continuous predictive autofocus. A system called Omnidirectional Predictive Focus Control will track a subject moving at variable rates of speed in three-dimensional space as fast as 187 miles an hour (that's 300 kilometers an hour for you metric-minded folks). What this means is that not only will the camera track fast-moving subjects, but it will track them as they accelerate, decelerate, change direction, or all of the above. Assuming you can track a subject with these kind of moves, you can get off more than one shot. The built-in motor drive will burn through a roll of film at the respectable rate of four frames a second.

Whether tracking a fast-moving subject or framing a carefully composed still life, the way an auto-exposure camera's meter responds to light is crucial. Thus, to accommodate most any exposure situation, the 7xi's meter employs a 14-zone honeycomb pattern (13 hexagonal segments plus the background). The 7xi's computer, using the fuzzy logic algorithm, determines the precise metering

pattern and the weighting each of the 14 segments is given. The metering pattern and spot metering (the center hexagonal segment only) are available in all exposure modes, including manual.

To complement the 7xi's advanced metering capabilities, a variety of exposure modes are available. Perhaps the most significant of these is the Expert Program Selection mode. Exposure in this mode is determined based on a number of variables, including lens focal length, subject type, size, movement and distance from the camera. Expert program can be overridden to an "expert" aperture- or shutter-priority mode, which is really just a program shift feature but which allows the photographer to fine tune either shutter speeds or apertures without having to leave the program mode. Standard shutter and aperture-priority AE modes are also available, as is full-metered manual. Other exposure features include exposure compensation, an AE lock, and additional custom exposure control through the use of Minolta's Creative Expansion Cards.

Another feature introduced with the 7xi and unique to xi-series cameras, is the Eye-Start System, a feature which switches on the camera when you pick it up and activates several things at once when you bring it to your eye. Specifically, a pressure switch in the camera's grip detects when its been gripped, which triggers an infrared sensor at the eyepiece. When this sensor detects an object (your face, for example), the camera comes to life and, if you have an xi-series zoom attached, three things happen: the meter evaluates the scene, the AF system decides what your likely subject is and focuses on it, and the ASZ system (more on that in just a second) automatically zooms the lens to a starting focal length. If you're not prepared for all this the first time you pick up one of these cameras, having it suddenly spring to life in your hands can be a bit startling.

With an xi-series Autozoom lens attached to the 7xi, the user has four Expert Autozoom functions at his or her disposal: ASZ, APZ, Image Size Lock, and 150% Wide View Mode. ASZ (Auto-Standby Zoom), is automatically activated by the Eye-Start System, which selects a focal length based on subject distance. APZ (Auto Program Zoom), continuously sets focal length based on changing subject position (currently available only with the "Child" Creative Expansion Card). Image Size Lock is a continuous focal-length adjustment which maintains image size while a subject is moving. Wide-View Modeis a focal-length reset which allows viewing of 50% more of the picture area until the shutter release is pressed partway down.

Shutter speeds range from 30 seconds to 1/8000 second, plus B, and can be selected in half-stop increments. Flash sync tops out at 1/200 using either the built-in TTL flash (GN 40 @ ISO 100) or dedicated accessory units. Other features include DX film coding with override, a self-timer, a remote-control socket, auto film loading and rewind with mid-roll rewind. The built-in motor has single-frame, 2 fps and 4 fps settings.

Maxxum 9xi

In the high-stakes game of hi-tech camera one-upsmanship, Minolta put together another winning combination with the 9xi. Instead of repeating all the details about Minolta's xi technology that have already been explained under the 7xi's heading, we'll take a look at what sets the 9xi apart from the other xi cameras.

First of all, almost all the features found on the 7xi exist on the 9xi. Only a few amateur oriented ones, such as the built-in pop-up flash and autozooming composition mode, have been dropped. While the body's styling is very close to that of the 7xi, there are both major and minor differences. Minor differences, such as the addition of leatherette coverings to the front, are a nice touch. Major differences are much more than cosmetic. The 9xi's body is made up of several durable sub-components. The mirror box is made from stainless steel and zinc, and is coupled to a cast zinc baseplate. Where polycarbonate is used, it is of the fiber-reinforced variety. The controls are well-sealed against moisture and dust intrusion.

When it was introduced, the 9xi supplanted the 7xi as the fastest-focusing SLR in the industry. And, even when judged by today's state-of-the-art, cutting edge standards, the 9xi is still a very capable performer. Although both the 9xi and 7xi share the same fuzzy logic autofocus technology, AF sensors and autofocus mechanisms, the 9xi has an improved mirror-return mechanism over the 7xi, which allows the 9xi to begin autofocusing between exposures sooner than the 7xi. As a direct result of this, the integral motor will run through a roll of film at 4.5 frames per second when shooting in the predictive omnidirectional autofocus mode (the 7xi is good for "only" 4 fps when in this mode).

Because the 9xi performs autofocus with such speed, the default AF mode is focus priority; that is, the camera will not fire until the subject is in focus. This default can be overridden, however, by shutting off the camera, then depressing the self-timer button while turning the camera back on.

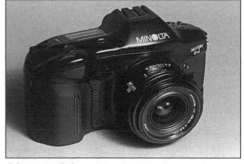
Maxxum 9xi

Even a couple of years after its discontinuation, the 9xi is still on the top of the technological heap in another category. Its highest shutter speed is 1/12,000 second and its highest flash sync speed is 1/300 second when using the 3500xi, the 5400xi, or the 5400HSS flash (1/250 second for non-dedicated flash units, including studio strobes). Its slowest shutter speed is 30 seconds.

Other features include a threaded PC sync terminal, a genuine depth-of-field preview lever, built-in eyepiece diopter correction, a variety of TTL flash options (including off-the-camera, cordless flash), and a "quick-adjust" button, which allows the user to customize override settings for the various controls.

The built-in motor drive has a high-speed rewind mode that will suck the leader back into a 36-exposure roll's cassette in under six seconds. A much quieter and only slightly slower rewind mode is also available for times when the high-speed mode's noise may be intrusive.

Five new Creative Expansion Cards were introduced with the 9xi: the Bracketing Card 2, the Auto Shift Card 2, the Sports Action Card 2, the Fantasy Effect Card 2 and the Memory Card 2. The Bracketing Card 2 allows for autobracketing of exposures with both ambient and flash, providing $1/3$, $1/2$ or full-stop exposure increments, and frame counts of 3, 5, or 7. The Auto Shift Card 2 is an automated "program shift" feature, allowing the user to fire off three frames at varying shutter-speed/aperture combinations, while retaining the same overall exposure. The Fantasy Effect Card 2 defocuses the lens during exposure, thereby providing a soft-focus effect. The Sports Action Card 2 biases the program toward higher, action-stopping shutter speeds. The Data Memory Card 2 will memorize up to four rolls of film's worth of exposure data, and will then play it back to the user via the LCD display.

☐ Maxxum si-series SLRs

In earlier editions of this book, I speculated that all this "i" for 'intelligence' and "xi" for 'expert intelligence' hyperbole must eventually imply omnicience with some future generation of Minolta camera technology. I don't happen to know what "si" stands for, but it doesn't matter. The si cameras certainly have a way to go before omnicience is attained, but they're still pretty durn smart.

Maxxum 300si

If you think of the 300si as an interchangeable-lens point&shoot camera with a couple of exposure modes – well, to mix metaphors, you would be on the right track, but you would be missing the boat. Despite its lowly entry-level status, the camera remains a capable performer. All one needs to do is compare it to an entry-level Minolta SLR from another era, let's say the XG-1, for example, and one will see what I mean.

The autofocus system uses a single sensor passive predictive AF method. Metering is accomplished via an 8-segment evaluative system. Exposure modes consist of program AE, plus five Expert Program modes, which are Night Portrait, Portrait, Sports, Close-up, and Landscape. Exposure compensation is also available, as is TTL flash with redeye reduction via the built-in unit or external Maxxum flashes.

Shutter speeds range from 30 seconds to 1/2000 second, with flash sync occuring at 1/90 second. The built-in winder will advance film at the rate of one frame per second, and also features film prewind and end-of-the-roll rewind. Also present is an AE lock and a self timer.

Maxxum 500si

Continuing with the si evolution, the 500si is a camera that begins to spark a bit of interest for photographers who've begun to experiment with the art.

The 500si shares the same simple AF mode as found on the 400si, but exposure control has been expanded. The 500si has the same exposure features as found on the 400si, but added to the list are multiple exposure capabilities and Minolta's Creative Exposure Control. This feature allos the user to choose shutter speed, aperture, or both, which amount essentially to a shiftable program function. Other exposure options include spot metering and slow-shutter flash sync. The built-in flash (GN 39 in ft. at ISO 100) offers redeye reduction and covers focal lengths down to 28mm.

Other features are a remote release terminal and a quieter film transport mechanism.

Maxxum 600si

If one wants the retro look, push buttons are out, while knobs and dials are in. And since the Maxxum 600si has knobs and dials, it's in. The advantage to the retro look, an apparent return to simplicity, is, well, simplicity. It is a lot easier to interpret a dial or knob's function than it is to ferret out without benefit of an instruction manual, say, "push and hold this button while turning that wheel and watch the LCD display for this symbol." KnowhatImean?

In addition to being easy to understand and use, the 600si is a respectable camera, filled with a well-rounded selection of features.

The 600si's AF system has a 3-sensor array with predictive AF capability, and operates using either auto or manual sensor selection. The 600si also has Minolta's Omni-Directional Predictive Autofocus mode, which allows the user

to track a subject anywhere in 3-dimensional space, whether accelerating or decelerating.

Exposure modes include program AE, shutter- and aperture-priority AE, and metered manual. Exposure compensation and autobracketing are also available.

Metering patterns consist of a 14-segment evaluative pattern, center-weighted averaging, and spot.

Shutter speeds range from 30 seconds to 1/4000 second, plus B, with flash sync at 1/200 second. The built-in winder features auto film prewind and end-of-roll rewind, and advances film at the rate of 2 frames per second. Other features include a self-timer, adjustable diopter correction, depth-of-field preview, DX film coding with override, and AE lock.

Maxxum HTsi and XTsi

One remarkable aspect of today's entry-level camera market is it would appear that the manufacturers are in a race with each other to see how many features they can cram into their selections, while maintaining that under $300 price point. For this reason, Minolta deserves a tip of the hat for its efforts on the HTsi. Priced only moderately higher, the XTsi is clad in the brushed chrome and black look and includes a few nice additions we'll examine shortly. The HTsi has three autofocus sensors – two vertical CCD side sensors and one crosshair-type CCD sensor in the center, providing the user with a wide focusing area. The camera will switch automatically between focus lock and continuouis predictive AF based on sobject movement. One can choose between auto or manual focus via a selector switch.

The HTsi uses Minolta's sophisticated 14-segment honeycomb-pattern system. Spot (5.5%) is aviable, as is TTL OTF flash metering with the built-in unit (GN 39 in ft. at ISO 100, cover-age down to 28mm) or dedicated accessory flash units.

Exposure modes include program AE, 5 Subject Programs portrait, landscape, close-up, sports/action, night portrait), and 3 Creative Expansion Control Programs (aperture priority, shutter priority, and manual). Exposure compensation is available, with a total of ± 3 EV of adjustment in 1/2-step increments. 3-shot AE bracketing is also available in 1/2 EV steps.

And if all that wasn't enough, the HTsi comes with nine built in custom functions, which allow the user to customize the camera's configuration to his or her own set of preferences.

Shutter speeds range from 30 seconds to 1/4000 second, plus B, with flash sync at 1/125 second (up to 1/4000 second with the 5400HS flash). The built-in winder advances film at the rate of 2 frames per second. Other features include DX film coding with override, a self timer, and AE lock.

The XTsi has all the above, plus Minolta's Eye Start system, ten custom functions (compared to the HTsi's nine), panoramic capability (via a side switch), a remote-release terminal, a databack, and a stainless steel lens mount (the HTsi's is plastic).

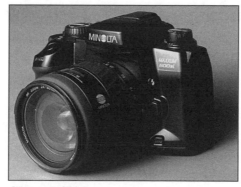

Maxxum 800si

Maxxum 800si

The 800si continues in the tradition – if such a word can even be used with modern photo technology – begun with the 7xi and continued with its most immediate predecessor, the 700si. Like its forerunners, the 800si features the latest generation of Minolta's Omni-directional Predictive Focus Control (see the 7xi for a complete explanation of this feature's capabilities), as well as the same four-CCD phase detection sensor array as used on the 700si.

In addition to the above-mentioned AF system features, the 800si offers : single-shot AF, continuous AF, or the automatic selection of either depending upon subject movement.

The 800si employs Minolta's well-designed 14-segment honeycomb pattern metering system for evaluative, spot (5.5mm, 2.7% viewfinder area), and centerweighted averaging metering.

Exposure modes include program with Expert Program Selection (P mode), aperture-priority program (PA mode), shutter priority program (PS mode), aperture-priority AE, shutter-priority AE, and metered manual. In addition, the 800si has five Subject Program Selection modes: Portrait, Landscape, Close-up, Sports, and Night Portrait/Night View.

Additional exposure options include ± 3 EV exposure compensation in 1/2-step increments, ± 3 EV flash compensation, three, five, or seven step auto- and flash bracketing, and AE lock.

The 800si sports the most powerful built-in flash in its class with a guide number of 66 at the telephoto setting (45 at 24mm) and autozooming capability. Also available with the built-in flash and dedicated accessory units is redeye reduction, second curtain sync, fill flash, and fill flash with redeye reduction.

Also found on the 800si are 16 custom functions, including three user preference settings, and a data memory function that will store up to ten 39-exposure rolls worth of data.

Shutter speeds range from 30 seconds to 1/8000 second, plus B, with flash sync occuring at 1/200 second.

The built-in winder advances features settings for single-frame advance, continuous advance (3 frames per second), exposure/flash bracketing (3, 5, 7 exposures), and multiple exposure (2 - 9 exposures). Other features include a self-timer, diopter adjustment, depth-of-field preview, a remote release terminal, and a threaded PC connector. Addition of the vertical control grip provides the user with the option of using four AA size alkaline batteries, NiCd batteries, or one 6v (2CR5) lithium battery. The vertical control grip has a vertical shutter-release button, an on/off swithc; a PC terminal, and an AE-lock button.

Maxxum 9

The Maxxum 9, Minolta's latest pro-level entry, represents a radical departure from its predecessors and, on the surface at least, appears to be an alumnus of the less-is-more school. Most noticeable on this camera is its pair of large and very grippable knobs, located where one would traditionally expect to find them, on the top deck of the camera. The left knob is used to adjust exposure and flash compensation, and the right one is used to set exposure modes and more. A bit more than a cursory glance, though, will reveal that this camera disguises its true capabilities and strengths.

To arrive at the 9's layout, Minolta took the time to interview a variety of pros, asking what they wanted in a camera, and to its credit, Minolta listened. As a result, there are some interesting dichotomies present. Yes, the camera is solidly built, as one would expect with a pro model. It's thoroughly gasketted against dust and moisture intrusion. The tough, adhesive painted exterior houses an aluminum alloy mirror box, a zinc alloy bottom plate, and a stainless steel top plate. But it also features a pop-up flash (you pull up, you push down), of all things. As it turns out, neophytes aren't the only ones who find pop-up flashes useful. They're great for quick grab shots, especially when they will cover 24mm, and have a little oomph to them. They also make for nice fill flash work, as well. So, unlike other makers who decided to forego pop-up flashes, claiming that they were too fragile, Minolta decided to house the flash in the same stainless steel as it fabricated the top cover from.

It turns out that the pros like lots of electronic features, too, but they don't like having to memorize 95-page instruction manuals to learn how to access them. As a result, Minolta designed the knob, lever, and dial system found on the 9, so that accessing the camera's many features would be intuitive enough to puzzle them out without the manual being an absolute requirement. OK, enough of this. Let's take a look at what the 9 does.

Maxxum SLRs

Camera	Yrs. Made	New		Mint		Excellent		User
Maxxum HTsi	1998-	250	300					
Maxxum SPxi	1991-97			180	155			
Maxxum XTsi	1998-	420	350					
Maxxum 2xi	1993-97			190	165			
Maxxum 3xi	1991-97			200	175			
Maxxum 5xi	1992-97			350	280			
Maxxum 7xi	1991-96			380	340			
Maxxum 9	1998-	1580	1500					
Maxxum 9xi	1992-97			550	495			
Maxxum 300si	1996-98			215	185			
Maxxum 400si	1994-	295	260					
Maxxum 500si	1996-98			225	195			
Maxxum 600si	1996-98			320	290			
Maxxum 700si	1994-97			440	380			
Maxxum 800si	1997-	640	550					
Maxxum 3000i	1987-91			125	100			
Maxxum 5000	1986-88			160	145	135	115	
Maxxum 5000i	1989-91			190	160			
Maxxum 7000 crossed x's	1985-86			325	280	250	200	
Maxxum 7000	1986-88			185	160	150	125	
Maxxum 7000i	1987-91			270	250	250	220	
Maxxum 8000i	1990-91			350	300	280	240	
Maxxum 9000	1986-90			340	300	280	250	

The 9 has three autofocus sensors – two vertical CCD side sensors and one crosshair-type CCD sensor in the center, providing the user with a wide focusing area. The camera will switch automatically between focus lock and continuous predictive AF based on subject movement. One can choose between auto or manual focus via a selector switch. As a further AF enhancement, the 9 also utilizes a near-infrared assist beam with a range of 24 ft (7.3 meters). The camera will select which sensor to use, or whether spot focus, or the user can select which sensor to use. The active sensor is indicated by an illuminated rectangle. The default AF mode is focus-release priority, but this can be switched to shutter-release priority, if desired.

Minolta's tried-and-true 14-segment metering system is used for evaluative, centerweighted, or spot metering. It will work in conjunction with the AF sensors to insure greater exposure accuracy. There is also a four-beam flash sensor to handle TTL flash tasks.

Exposure modes include program AE with shift, shutter- and aperture-priority AE, plus metered manual with a twist. If you're familiar with the EV locks on Hasselblad Zeiss lenses, or the ones on certain Rolleiflex models, then you'll know right off what this is about. The idea is that, once one has determined correct exposure via manual selection of a shutter speed and an aperture setting, this EV can be locked in. Then the user can shift either shutter speed or aperture, and the other setting will follow along, within the given EV range. Autobracketing is available, and allows a range of choices. One can select 3, 5, or 7 frames in either 0.3, 0.5, 0.7, or 1.0 EV increments. Exposure data can be recorded, as well. The camera will remember up to

Maxxum Autofocus Lenses

Lens	New		Mint		Excellent		User	
16mm f/2.8	810	650	500	395				
20mm f/2.8			420	385	350	340		
20mm f/2.8 N	590	500						
24mm f/2.8	400	330	260	220	200	180		
24mm f/2.8 N	420	360						
28mm f/2.0					310	280		
28mm f/2.8	220	150	110	95	95	80		
35mm f/1.4			625	550	575	470		
35mm f/2	300	210	200	180				
50mm f/1.4	275	180	125	100	115	90		
50mm f/1.7	90	55	55	45	45	35		
50mm f/2.8 Macro (early)			250	225	220	185		
50mm f/2.8 Macro (late)		290						
50mm f/3.5 Macro	270	200						
85mm f/1.4			450	410	400	340		
85mm f/1.4 N	710	580						
100mm f/2			290	250	240	180		
100mm f/2.8 Macro w/1:1			430	420				
100mm f/2.8 Macro w/1:1 (late)	575	490						
135mm f/2.8			125	85	90	70		
200mm f/2.8 APO					600	420		
200mm f/2.8 APO (late)	975	850						
300mm f/2.8 APO			2500	2400	2350	2200		
300mm f/2.8 APO (late)	3780	3500	2850	2600				
300mm f/4 APO	1125	990						
400mm f/4.5 APO	2120	1900						
500mm f/8 Reflex	575	450						
600mm f/4 APO			3800	3500				
600mm f/4 APO (late)	7870	7500						
1.4X APO			250	200				
1.4X APO-II	460	375						
2X APO			270	225				
2X APO-II	490	400						
MA-S or -L 2X (MD to Maxxum)	160	120	100	80				

seven 36-exposure rolls of data, which can include lens focal length, aperture and shutter speed, exposure compensation or bracketing, the exposure and metering modes, and more.

The built-in flash will cover lenses down to 24mm and has a guide number of 39 in ft. at ISO 100. It can be used for fill flash and has a cancelable redeye reduction mode.

Shutter speeds range from 30 seconds to 1/12,000 second, plus B, with a maximum flash sync at 1/300 second. The built-in winder features single shot advance, continuous advance at a frame rate of 5.5 fps, autoload, and autorewind. A nice feature permits midroll rewind so the cassette can be removed and then reloaded and advanced to the next unexposed frame.

Other features include 21 custom functions, Minolta's Eye Start system, DX film coding with override, a positive back release reminiscent of that found on the Nikon F2, a self-timer, and depth-of-field preview.

Maxxum Autofocus Zoom Lenses

Lens	New		Mint		Excellent		User
AF 3x-1x Macro Zoom	2025	1800					
17-35 f/3.5	1725	1600					
20-35 f/3.5	595	430					
24-50 f/4	435	360	280	220			
28-80 f/3.5-5.6	210	165					
28-80 f/4-5.6 MZ	145	120					
28-85 f/3.5-4.5			200	175	160	140	
28-105 f/3.5-4.5	360	310	260	220			
28-135 f/4-4.5			315	245	250	215	
35-70 f/3.5-4.5	95	75					
35-70 f/4			125	110	100	85	
35-105 f/3.5-4.5			200	180	170	140	
70-210 f/4			150	120	125	90	
70-210 f/4.5-5.6	195	145					
75-300 f/4.5-5.6	320	255	250	210			
80-200 f/2.8 APO			880	750	700	600	
80-200 f/2.8 Super H.S. APO	1495	1250					
100-200 f/4.5			100	80			
100-300 f/4.5-5.6 APO	550	440					
100-400 f/4.5-6.7 APO	850	700					

Maxxum i-Series Autofocus Lenses

Lens	New		Mint		Excellent	User
24-85 f/3.5-4.5	550	425				
28-70 f/2.8	1250	980				
28-80 f/4-5.6			200	160		
28-85 f/3.5-4.5	340	265				
28-105 f/3.5-4.5			250	220		
35-80 f/4-5.6			100	70		
35-105 f/3.5-4.5			180	140		
70-210 f/3.5-4.5			200	150		
70-210 f/4.5-5.6			130	100		
80-200 f/4.5-5.6			120	95		
100-300 f/4.5-5.6			200	180		

Maxxum xi-Series Autofocus Lenses

Lens	New		Mint		Excellent		User	
28-80 f/4-5.6	230	170						
28-105 f/3.5-4.5	400	220						
35-80 f/4			110	80				
35-200 f/4.5-5.6	420	300						
80-200 f/4.5-5.6	120	90						
100-300 f/4.5-5.6	300	220						

Maxxum Accessories

Item	New		Mint		Excellent		User	
MD-90 Motor Drive only (9000)			200	160	150	125		
MD-90 w/BP-90M			270	250	250	220		
MD-90 w/NP-90M			330	275	290	250		
AW-90 Autowinder	160	100	140	115	120	85		
Battery Pack BP-90M (MD-90)		60						
Battery Pack NP-90M (MD-90)		130						
External Battery Pack EP-1 Set	170	140						
External Battery Pack EP-70			50	35				
Battery Pack B (9xi)		110						
Holding Strap 9xi		70						
Holding Strap 7xi		40						
Holding Strap 7000i/8000i		30						
Data Back DB-3/DB-5/DB-7 (i-series)			85	60	45			
Data Back 70 (5000/7000)		85	50	40				
Data Back QD-7		85	50	40				
Data Back QD9xi		85	70	50				
Program Back PB-7 (7000i/8000i)			120	90				
Program Back 70 (5000/7000)			140	120	100	70		
Program Back Super 70 (7000)			185	150				
Program Back 90			120	90				
Program Back Super 90			255	180	185	160		
EB-90 100-frame Back (9000)			800	500				
Film Magazine Set for EB-90			200	160				
FL-90 Film Loader for EB-90			150	120				
NPC or Forscher Polaroid Back	775	700	500	400				
Creative Expansion Cards		25						
AF Extension Tube 12		60						
AF Extension Tube 25		70						
Macro Stand 1000	265	200						
Slide Copy Unit 1000	275	220						
Angle Finder VN	135	105						
Magnifier VN	65	45						
Flash Wireless Remote Control 9xi		105						
IR-1n Set	275	200						
RC1000L		40						
RC1000S		35						
Panorama Set	55	25						

Maxxum Flashes

Item	New		Mint		Excellent		User
D314i			35	25			
D316i			45	35			
1200AF Macro			250	210			
1200AF-N Macro (i/xi/si-series)	280	200					
1800AF			55	45	45	35	
2000i			75	50			
2000xi			85	55			
2800AF			55	45			
3200i	110	80					
3500xi	170	135					
4000AF			170	150	140	110	
5200i			200	160			
5400xi	295	235					
5400 HS	320	260					
EP-1 Set External Battery Pack	190	140					
TC-1000 Triple Connector	55	35					
Off-Camera Cable OC-1100	50	35					
Off-Camera Shoe OS-1100	50	35					
FS-1100 Shoe	45	25					
FS1200 Shoe	45	25					
Wireless Remote Flash Controller	145	100					
Control Grip CG-1000 Set (2800AF/4000AF)			155	135	145	120	
VC-700 Grip			150	120			

Nikon

Explanatory notes for Nikon cameras are grouped by series. F-series cameras (F, F2, F3, F4, and F5) are grouped at the beginning, followed by the Nikkormats (including the Nikon EL2), then the compact Nikons, which include the FE, FG, FM and other compact manual-focus Nikons without integral motor drives, and finally, the N-series cameras.

□ NIKON F-SERIES CAMERAS

All Nikon F-Series Cameras, from the original, meterless, mechanical F of 1959 to the amazing F5 of 1997, have a few things in common. All are system cameras, meaning each model has interchangeable viewfinders, focusing screens, backs, and motor drive capabilities. All have a mirror lock-up feature. They provide 100% image visibility within the viewfinder. And, of course, all accept the F-type bayonet mount lenses.

For further information on the various Nikon F models, as well as a wealth of information on other Nikon-related subjects, I recommend that you visit Stephen Gandy's very nicely done Internet website, located at *http:// cameraquest.com/*.

The Nikon F

The original Nikon F was introduced in 1959. In its various derivations, the F was in production for fifteen years with over nine hundred fifty thousand units produced. Nikon had already begun to assemble a loyal following of professionals with their fine line of rangefinder cameras by the time the F was introduced. But it was the F, with its system concept and robust construction – along with a healthy dose of shrewd marketing – that was largely responsible for earning Nikon its world-wide reputation as a builder of rugged, professional quality equipment – a reputation that has endured for over thirty-five years.

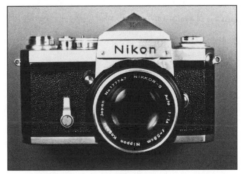

Nikon F with standard prism

There have been many misconceptions about the serial numbering system Nikon instituted with the F and continued with the F2. This misconception often leads to misunderstandings and warrants clarification, so that which follows is a brief explanation: Serial numbering for the Nikon F began at 6400001. During the mid-to-late 1960's, as a matter of coincidence, the first two digits of the serial numbers began to approximate the years of manufacture. Some people say that when this took place, Nikon adopted it into their numbering process and from then on the first two digits of a camera's serial number reflected its year of manufacture.

Others claim that the serial number on a later camera could differ by as much as a couple of years from the actual date of manufacture. Either way, there is no disputing the fact that the numbers remained close, and it does seem probable that once the coincidence occurred there was some intentional design on Nikon's part to keep the numbers close to the year of manufacture.

Now that serious collecting interest in the Nikon F has begun to emerge, this serial numbering system can also have a demonstrative affect on the value of a camera. Very early Fs with serial numbers that begin with 64 have become highly collectible. The lower this number is, the higher the camera's value. Be forewarned, though – countefeits do exist. In this guide, I will show separate price listings for Fs with serial numbers that are less than 6499999 but greater than 6410000. If you have an F with a serial number below 6410000 or are contemplating buying one, I would recommend that you seek out the services of a knowledgeable and reputable collector or dealer to insure that the correct value is established, and that it is indeed the genuine article. Fs with very low serial numbers, say below 6401000, can command prices in the multiple thousands of dollars, so it would behoove you to do your homework before venturing into such deep waters.

Other variations have begun to affect price due to collecting interests and are now reflected in the following

listings. Currently, those Fs that are affected are those with a red dot next to the serial number, and Fs which have F2-style film-advance levers and self-timers.

The Nikon F Red Dot, as it has come to be called by collectors, is identified by a red dot next to the serial number. This dot was used only during production runs of cameras with serial numbers beginning with 65 or 66. It was intended as a visual means of identifying which cameras had come from the factory pre-modified to accept the then-new Photomic metered finder. There were some 20,000 Fs made with serial numbers beginning with 65, but only about 3,500 or so with serial numbers beginning with 66. Obviously, a 66 Red Dot will command a hefty premium over more pedestrian 66s, or even 65 Red Dots.

The **Nikon F Apollo** is an F with an F2-style film advance lever and self-timer. These cameras appeared late in the 73 number run and throughout the 74 number run. Apparently, the "Apollo" moniker was assigned by collectors due to the belief that this camera was associated with the NASA Apollo space program. From what I have been able to uncover, however, the Nikon Fs used by the Apollo program are entirely different animals, having been extensively modified not only for the special rigors and requirements of the space program, but for use with the bulky gloves that the astronauts wore. For whatever reason, however, the nickname has stuck, and is sure to generate much future speculation as to its origin, whether in print, in usenet newsgroups and mailing lists on the internet, or around the dealer tables at camera shows, for years to come.

Exposure metering with the Nikon F is handled by the viewfinder, so it's common to see early model bodies with late model finders. The derivations of the Nikon F are determined by its viewfinder. For those of you who may not know

the differences between them, they are: The meterless F has the standard, traditional-looking, pentaprism-shaped viewfinder with a large "F" inscribed on the front.

The **F Photomic**, introduced in 1962, has a large, non-TTL finder with a round meter window in front of the shutter speed dial. An angle of acceptance restrictor and an incident light attachment came with the finder when new. Either one or both can be threaded into the meter window for use. When not in use, they are threaded into the finder's side, one on top the other. It is not unusual to find Fs with early Photomic meters that are missing these accessories.

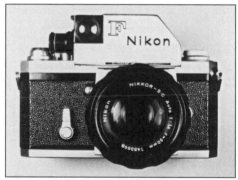

Nikon F with early Photomic finder. Note the round meter window. Also note the angle of acceptance restrictor mounted to the side of the finder.

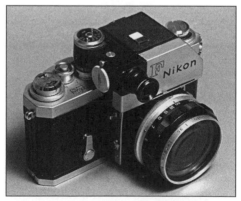

Nikon F with early Photomic finder showing the angle-of-acceptance restrictor positioned for use.

This finder exists in two variants: the early variant has a semaphore-style on-off lever that uncovers the metering cell when the meter is on, while the later

style uses a push-button to turn the meter on and off. Finders with the semaphore switch are generally priced somewhat higher than those with the push button. I haven't separated the prices in the following listings, but one should lean a bit toward the higher end of the range when pricing the earlier model.

The **F Photomic T**, introduced in 1965, has a finder with a TTL meter (Nikon's first) that is a little smaller than the early Photomic finder and lacks the round window.

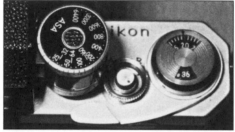

Top view of a Nikon F with the Photomic T finder. Note the aperture numbers on the side of the ASA setting dial.

The F Photomic Tn, introduced in 1967, looks like the F Photomic T, but performs centerweighted metering and has an "N" on the top of the finder just below the meter on-off button.

Top view of a Nikon F with the Photomic Tn finder. Note the 'N' just below the meter on/off button.

Lastly, the **F Photomic FTn**, introduced in 1968, provides semi-automatic maximum aperture indexing, done by rocking the aperture ring back and forth. It can be identified easily by the short aperture index slot located on the front face of the viewfinder with the numbers 5.6 – 2.8 – 1.2 above it. This is also the only F finder that displays shutter speeds

in the viewfinder. Of all the metered finders for the F, the FTn finder is, by far, the most popular and the most useful. With earlier finders, the photographer had to readjust the ASA dial each time he or she changed lenses of a different maximum aperture so they would index correctly with the meter.

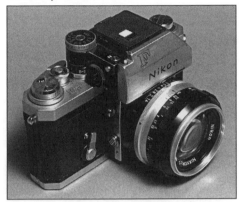

Nikon F with Photomic Tn finder

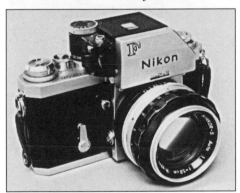

Nikon F with Photomic FTn finder. Note the short aperture slot with numbers 5.6—2.8—1.2 above.

The metered F finders have proven themselves to be generally accurate and reliable, but they do wear out after lots of use. When trying out an F's meter, rotate the aperture ring or shutter speed dial while keeping the viewfinder centered on a well-lighted subject. Observe the needle. It should track smoothly from one end of its range to the other. If it quivers or jumps, chances are the variable resistor inside the finder is either dirty or scratched. If it's scratched the problem will deteriorate. If it's dirty and not cleaned promptly, the dirt could scratch the resistor and . . .well, you get my drift. This procedure for checking

the meter applies not only to the F, but to the various F2 metered finders and to mechanical Nikkormats, as well. Nowadays, there are lots of dead F Photomic meters out there and parts for them are from scarce to impossible to come by. So test before you buy and buy with caution.

A couple of other aspects of Nikon Fs bear mentioning. The first has to do, once again, with finders. If you have a pre-Red Dot F and wish to mount a metered finder on the camera, a slight modification will be required if it hasn't already been done. It involves a little bit of grinding that any qualified repair technician can do in a few minutes for a nominal charge. The second has to do with adapting a motor drive, such as the F-36, to the camera. Two small holes must be drilled into the inside baseplate of the camera. Only a small number of Fs came from Nikon predrilled, so if your camera has never had a motor drive attached, chances are the necessary holes aren't there. Most any qualified repair technician can do this in minutes for a nominal charge.

In addition to the metering options discussed above, the Nikon F's basic features include: shutter speeds ranging from 1 second to 1/1000, plus B and T, with X sync at 1/60; depth-of-field preview; mirror lock-up; a self-timer; interchangeable focusing screens, viewfinders and backs; and a motor drive option.

The Nikon F2

The Nikon F2, billed by Nikon as an improved version of the original F during its 1971 debut, was in reality a totally new design. Many regard the F2 as the finest mechanical 35mm SLR ever built. It was Nikon's last hand-built camera. Clean examples are still highly prized and much sought after.

The serial numbering system that evolved with the F continued with the F2, which allows one to arrive at its

approximate date of manufacture by looking at the first two digits. It should be reemphasized that this method only approximates years of manufacture. The most convincing argument in favor of this view is based on Nikon's later habit of coordinating serial numbers with trim. F2s displaying serial numbers beginning with 74, 76, 78 and 80 have chrome trim, whereas F2s having serial numbers beginning with 75, 77 and 79 have black trim. It seems highly unlikely that Nikon would have devoted an entire year's production to only one type of finish. Earlier F2s having serial numbers beginning with 71, 72 and 73 can be either black or chrome. It seems likely that these cameras' serial numbers more closely approximate their actual years of manufacture than later ones do.

The F2, like the F, depends on the viewfinder that is attached for its exposure metering options, and it is the meter that determines the model (e.g., an F2 with a DP-1 finder is an F2 Photomic). Also, as with the F, it is not uncommon to see earlier F2s with late model finders, especially the DP-11 (F2A) and DP-12 (F2AS) finders.

When first introduced, the F2 was available in two models: the **standard F2** (meterless DE-1 eye-level finder), and the **F2 Photomic** (DP-1 finder). The latter provides TTL full-aperture 60/40 center-weighted metering with the shutter speeds, aperture and meter needle shown in the viewfinder.

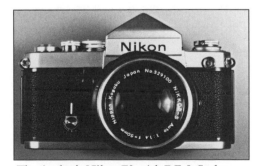

The Author's Nikon F2 with DE-1 finder

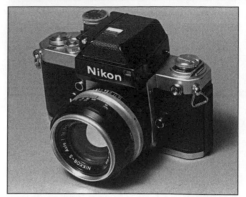

Nikon F2 Photomic (DP-1 finder)

The **F2 Photomic S** (DP-2 finder) was introduced in 1973. The three principal differences between the F2S and the F2 Photomic were: 1. The addition of a slow-speed ring above the shutter speed ring, which, when engaged, allows the DP-2 to meter down to 10 seconds. 2. Nikon had caught LED fever by then and substituted the meter needle for two LEDs. When both are lit, exposure is correct. 3. The addition of a coupler for the EE Aperture Control Attachment DS-1 or DS-2, which allowed the camera to be used in shutter-priority AE. The DP-2 finder also developed a strange hump on top to house the LEDs.

Nikon F2S (DP-2 finder). Note the aperture index window above the small 'n', the coupling attachment for the DS-1 or DS-2 (right side), and the hump.

In 1976, Nikon refined the F2S and called it the **F2 Photomic SB** (DP-3 finder). The F2SB differs from the F2S in several areas, the most useful being an easier-to-use 3-LED readout in the viewfinder in the shapes of a minus sign, a zero and a plus sign. Obviously, the minus sign indicates underexposure, the plus sign indicates overexposure and the

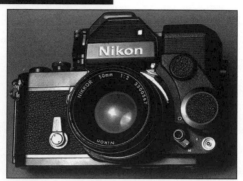

Nikon F2S with DS-2 attached

zero indicates correct exposure. Silicon photodiode metering cells were incorporated into the DP-3 for faster metering response, as was an eyepiece shutter. Nikon also got rid of the hump. The slow speed metering ring and provision for the DS-1 or DS-2 were retained.

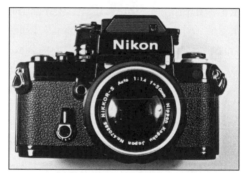

Nikon F2SB (DP-3). Note the aperture index window above the second 'n' and the coupling attachment for the DS-1 or DS-2 (right side).

Nikon F2A (DP-11 finder). Note the 'A' at the bottom right hand corner of the finder.

The **F2 Photomic A** (DP-11 finder), introduced in 1977, was the first Nikon to allow automatic indexing (AI) of the lens' maximum aperture. The

F2A's appearance is very close to that of the original F2 Photomic, but can be told apart easily by the small white "A" at the lower right front of the viewfinder just above the AI coupling lever. The F2 Photomic A has no provisions for attaching the DS-1 or DS-2.

Nikon's last variant of the F2, the **F2 Photomic AS** (DP-12 finder), also introduced in 1977, is the AI version of the F2SB. Like the F2A, the F2AS can be identified by the white "AS" located above the AI coupling lever. Shutter-priority AE is possible with the F2AS when using the Aperture Control Attachment DS-12.

Nikon F2AS (DP-12 finder). Note the 'AS' at the bottom right hand corner of the finder and the attachment for the DS-12 (right side).

Nikon also built a few **F2Ts**. The T stands for titanium. The F2T came with a standard eye level prism, which was made from titanium as were the top plates and base plate. Except for some very small production runs of purpose built cameras for NASA and an equally few F2 High Speed motor drive cameras, the F2T was produced primarily in two models, the more common of the two apparently intended for use by the Japanese press corps. It seems some excess F2Ts were shipped to the U.S. and Canada. The other model, known as the F2 Titan, is apparently the more rare of the two, although this is the matter of some debate. I've only seen one of these beauties. It had a textured matte black finish and the word Titan was engraved in script on the front left (facing the

camera). One rumor has it that the Titan was a special model built in small numbers for NASA, but this is likely not the case, since the very few F2s that were built for NASA were in fact highly modified from those that were sold to the general public.

The F2T is built like a tank and is the ultimate photographic workhorse. Even the pedestrian variety is somewhat rare and expensive. I haven't listed prices for the F2 Titan because of its rarity, and because prices for rare pieces like the Titan are usually determined entirely by one party's eagerness to buy and the other party's eagerness (or lack thereof) to sell.

In addition to the various finders discussed above, other features of the Nikon F2 include: shutter speeds ranging from 1 second to 1/2000, plus B, with X sync at about 1/90 (it's an intermediate setting between 1/60 and 1/125); interchangeable finders, focusing screens (interchangeable with those used in the F) and backs; depth-of-field preview; mirror lock-up; a variable self-timer that's good for more than just delaying the shutter; and an optional choice of three different motor drives.

Here's something I'll bet many of you who have F2s and have used them for years may not know, especially if your camera does not have a finder with low light metering capability (DP-2, DP-3 or DP-12). The Nikon F2 is possibly the only mechanical 35mm SLR with slow shutter speeds that will go all the way down to 10 seconds. "Wait a minute!" you say. "The shutter speed dial's slowest setting is 1 second!" You'd think so, wouldn't you? But with the Nikon F2, the slowest shutter speed on your dial is accessed from the B setting. And, no, I'm not talking about tripping the shutter with a cable release and counting "one thousand one, one thousand two..."

Lets say, for the sake of this discussion, you want to take an eight second exposure of a dimly-lit scene, but for whatever reason, you don't want to use a cable release and count off the seconds. Not a problem. Just set your shutter speed dial to B and the collar surrounding the shutter release to T (See Illustration 1). Advance the self timer to the 8 second mark (See illustration 2). Then, trip the shutter using a cable release. (Do not push the button above the self-timer; as this will cause the self-timer to work in its usual fashion.) The shutter opens and the self-timer activates, timing out eight seconds. When the self-timer finishes, the shutter closes. Presto! A mechanical, eight-second exposure.

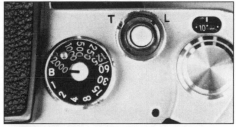
Illustration 1

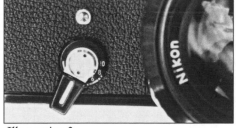
Illustration 2

For those of you who do have one of the finders with low-light metering ability, you may be nodding your head right about now and thinking, "So that's what that slow speed ring is for."

The Nikon F3

Although the F3 designation may lead the uninformed to believe that this camera was a continuation of the traditions set by its mechanical predecessors, one who is better informed might at best reply, "Well, maybe..." This is not meant to belittle the F3. An excellent camera it

is, but, when introduced, it did represent a departure in Nikon's approach toward professional cameras. Many pros took a dim view initially to the battery-dependent F3 (okay, so you still have B and 1/80 without the battery, but that's not much of a selection) and took to hoarding F2s. Many still do. In the ensuing years, however, the F3 has proven its ability to take the hard use a professional camera is often subjected to, such that most pros came to rely on it, although they'd sooner be caught with an expired passport than be without spare batteries.

The F3 offers several niceties that earlier F-series cameras did not, such as TTL flash automation, both aperture priority AE and metered manual exposure modes, an AE lock, exposure compensation, a six frame per second motor drive option, which will power the camera in the event of battery failure, and an exposure meter built into the body instead of the viewfinder. The **F3HP**, released in 1982, offers greater ease of use for eyeglass wearers by allowing one inch of eye-relief from the viewfinder while still providing total visibility of the viewing area and viewfinder exposure information.

Besides the standard F3 and the F3HP, Nikon makes or has made other models: the **F3HP Press**, **F3AF**, the **F3P**, and the **F3T**. Nikon has also made a **High-Speed F3** in very limited quantities.

Nikon F3HP. Note the letters 'HP' on the bottom right of the finder.

Nikon's first autofocus outfit: the F3AF atop a MD-4 motor drive with the 80mm f/2.8 AF and 200mm f/3.5 ED AF lenses

The **F3AF** debuted in 1983 and was an early attempt at autofocus. Its autofocus system provides continuous focusing only, and is housed entirely in the removable finder, which results in a very large finder and a top-heavy-looking camera. Unlike other autofocus Nikon SLRs, the F3AF does not autofocus by using a mechanical drive coupling between camera and lens. Instead, focus information is communicated by a series of electrical contacts in the base of the finder through a set of pin contacts in the camera body to electrical contacts on the two autofocus lenses made for this camera. These lenses, the AF 80mm f/2.8 and the AF 200mm f/3.5, contain their own drive motors and will autofocus on the F3AF only (power for the motors is supplied by two AAA batteries housed in the finder). The F3AF accepts manual focus lenses and provides focus confirmation with lenses of f/3.5 and faster maximum apertures. Standard F3 finders can be used on the F3AF and the F3AF finder (DX-1) can be used on a standard F3. It will provide focus confirmation, but not autofocus.

The **F3P** is the "professional" model F3HP. Many people have found this designation confusing since the F3 is, after all, a professional-level camera. It turns out the F3 often becomes temperamental in the damp and just flat refuses to work in very cold weather. It has to be "winterized" to work properly.

Nikon's answer to this problem was the F3P, conceived plainly with the idea of inclement weather in mind.

Nikon F3P with MD-4 motor drive attached. Note: non-TTL hot shoe on finder, no self timer switch, no cable release socket on shutter release, redesigned on/off switch, restyled frame counter, and no multiple exposure lever.

Nikon F3P rear view. Note the serial number and the MF-6B back (standard)

The F3P is thoroughly gasketed against moisture intrusion. The shutter speed dial is oversized and the main on-off switch was redesigned, both changes made for ease of operation with gloved hands. The cable release socket was eliminated, as was the self-timer, the eyepiece shutter, the camera back lock lever, and the multiple-exposure lever. One nice addition is a hot shoe atop the removable, titanium-clad finder (although it's non-TTL). The camera comes standard with the Type B focusing screen and the MF-6B back, which leaves the film leader protruding from the film cassette after power-rewinding the film with the MD-4 motor drive. Many pros grouse that this camera is the F3 Nikon should have built from the beginning. Did Nikon take this

well-meaning criticism to heart? Well, yes – but it took them a while. The camera was discontinued in 1989, but as near as I can determine, Nikon has replaced the F3T with an updated model called the F3HP Press, which appears to be identical to the F3P. In the following price listings, I have the F3HP Press listed separately from the F3P, although I may combine the two at a future date.

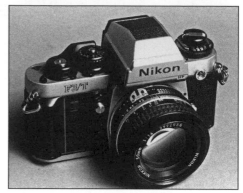

A "pre-war" Nikon F3T Champagne

The **F3T** is an F3HP housed in Titanium. It has been produced in two color schemes: standard black and champagne. The champagne model's top plate, bottom plate and finder are a muted pink chrome color. That's right, pink. If you've never seen one, trust me, the camera looks much better than it sounds. In fact, the champagne F3 is the

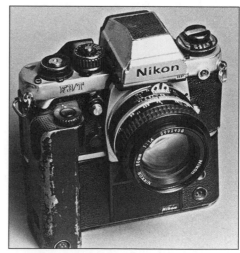

A Nikon Champagne F3T veteran of the press corps wars, complete with an equally battle-scarred MD-4 motor drive.

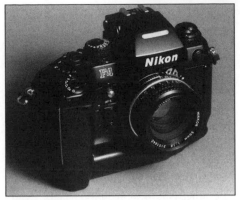

Nikon F4s

more durable of the two cameras, because there is no paint to chip or wear off. I once came across a few champagne F3Ts that were veterans of several years of heavy press corps duty. It was obvious they had been used heavily because of the deep wear they exhibited. But, amazingly enough, not one had a dent or ding anywhere! When Nikon stated in the brochure, "Bump it. Bang it," they weren't kidding.

Now that the F4 has come and gone and been obsolesced by the F5, and now that working professionals have come to rely on the hi-tech marvels of modern computerized photo technology, many of them have long since dumped their F3s. This activity has resulted in a deluge of F3s on the used market that first began back in the late 1980s. Despite this, however, the F3 has retained its value on the used market surprisingly well. The camera has actually shown an admirable degree of longevity, having been in production now longer than any other F-series camera. Nikon states it will continue to produce the F3 for as long as there is a demand for it. It would appear there is, to the point where Nikon introduced (or perhaps "reintroduced" might be a better word), for a short time at least, the F3HP Press, highly reminiscent of the discontinued, and much missed, F3P.

Other basic features not listed above, yet common to all F3s include: a strongly centerweighted (80/20) metering pattern; shutter speeds ranging from 8 seconds to 1/2000, plus B and T, with X sync at 1/80; interchangeable focusing screens, finders and backs; depth-of-field preview; and mirror lock-up.

The Nikon F4

The F4 was marketed in two versions when new: the F4 and the F4s, the difference being the battery pack included with the camera. The F4s is the standard U.S. model. It has the larger battery pack/grip (the MB-21) that accommodates six AAs and powers the motor drive to a conservatively-rated 5.7 fps. The smaller MB-20 battery pack, which takes four AAs, is the standard battery pack in Japan and Europe, and is available as an option in the States. The F4 with the MB-20 is good for a top speed of "only" 4 fps, but the package is considerably lighter and more compact. A lot of folks opt for the MB-20 option to reduce weight. Another optional battery pack, the MB-23, was also a popular option. Still available, it allows the use of NiCads and offers increased performance over the MB-21, or so Nikon has claimed, but the motor's maximum continuous rate is still the same as when using the MB-21. The MB-23 also adds another 5 ounces of weight to an already heavy system.

The F4's autofocus modes are one-shot (focus priority) and continuous (servo), with predictive autofocus. "Freeze focus" (trap focus) is available with the MF-21 Multi-Control Back. The camera has an AF lock button. Exposure modes include program, high-speed program, shutter and aperture priority AE, and metered manual. Metering options include Nikon's acclaimed five-zone matrix metering system, 60/40 centerweighted averaging and a 5mm central spot selection. The matrix metering option switches automatically between two sensitivity patterns depending on whether the camera is held horizontally or vertically and will choose between four different metering programs: centerweighted, highlight-bias, shadow-bias, or a five-segment averaging method.

Shutter speeds range from 30 seconds to 1/8000 (4 seconds to 1/8000 in manual mode), plus B and T, with X sync at 1/250. The integral motor has three continuous advance modes: hi-speed (5.7 fps), low speed (3.4 fps) and "silent" (1 fps), although "stealth" seems a more appropriate label for the latter. The motor makes this strange, subdued chugging sound as it sneaks the film to the next frame. Single frame advance is also available.

Flash photography with the SB-24 or later Speedlights provides the user with a variety of TTL exposure options, including auto fill flash with variable fill ratios, multistrobe effects, second-curtain sync and variable power levels. And, yes, Nikon did think to include a PC socket.

Other features include interchangeable viewfinders and screens, interchangeable backs, DX film setting with override, multiple exposure capability, AE lock, exposure compensation, built-in diopter correction, an eyepiece shutter, mirror lock-up, a manual rewind option, depth of field preview, a rubberized body, moisture resistant seals and a whole lot more.

The F4 accepts all F-mount Nikkor lenses. Focus confirmation is provided for with non-AF lenses. Matrix metering is possible with AI or AIs (non-AF) lenses, but when using non-AI lenses centerweighted metering is the only mode available.

Nikon F5

The first time I saw a Nikon F5, I did a double take. Yes, the pentaprism displayed "Nikon" in big, prominent letters, and, yes, the camera bore the tell-

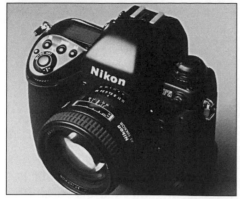

Nikon F5

tale red stylepoint that has become a de facto Nikon trademark, but all that was predictable. What struck me was the uncanny resemblance it bore to a Canon EOS. This prompted my half-joking remark to the owner that it looked more like an EOS-2 than a Nikon. His expression immediately froze in mid-smile – apparently he didn't appreciate my humor. That's OK, though. . . I was only half-joking to begin with. The fact remains that the F5, with its Command Control Dials and its four-position rocker switch located where the EOS's thumbwheel is, and its external LCD display instead of the F4's control knob, and, well, just its general appearance – it does bear a strong resemblance to an EOS. To my way of thinking, the degree to which Nikon went to adopt much of the "look and feel" of its arch-rival's top-of-the-line camera illustrates just how serious the erosion among the ranks of Nikon loyalists had become.

As you probably know, for the better part of the past four decades Nikon has enjoyed an almost total monopoly among press and sports photographers and photojournalists. About a year after Nikon released the F4, Canon introduced the EOS-1, whose superior autofocus speed put Nikon on notice. Then in 1994, Canon released the EOS-1n, a completely redesigned camera. Canon's commitment to the professional segment of the market was further emphasized when it began releasing one eye-popping

optic after another, broadening its lens line until it had an appeal all its own. This, combined with the significant fact that Nikon's long optics' performance with the F4 was considerably below everybody's expectations during that time frame, was enough of a reason for many sports and action photographers to dump their F4s and switch to Canon.

But as the desertions increased, to its credit, Nikon kept its collective head. Slowly and methodically, Nikon laid the groundwork for the F5. First the "D" lenses were released, with their distance information contacts, then the AF-I lenses, with their internal focusing motors, and more recently, the AF-S lenses with their "silent wave" internal motors. Nikon's strategy was apparently to have the lens lines largely in place prior to the release of the F5, which was just the reverse of the approach employed by Canon. (Bear in mind that the distance information transmitted by the "D" lenses is not supported on the F4 and that while the AF-I lenses will operate on the F4, the combination is slow). The above strategy appears to have been a sound one because it enables the F5-using pro to hit the ground running with not only what is arguably the most advanced camera in the world, but with high-performance lenses tailored for it. Time will tell if this strategy will be sufficient to coax the errants back to the Nikon fold. If and when they return, I suspect that, after using the F5 for a while, they will decide that this is a camera that has been well worth the wait.

No one is likely to question the fact that there are indeed breakthrough features found on the F5, like its 1,005-sensor color-sensitive metering array, or its 8 frame-per-second motor drive (the fastest of any camera with a movable mirror), or the fact that it can track fast-moving subjects and maintain this high rate of fire. Most significant to this writer, however, is the fact that photo

automation technology has reached such a level of maturity with the F5 that it should remain a top contender in 35mm photography for years to come despite the rate at which photo technology is being improved. We must not forget that emulsion-based photography is primarily concerned with recording images and events that take place in the physical world and not the virtual one. And it is due to the constraints that the physical world places upon objects which reside within it that we can expect the F5, with its current suite of features, to be a useful and competitive camera for the foreseeable future. To illustrate what I mean, let's take a look at its autofocusing speed. The F5's high-speed AF system is able to track, autofocus on, and photograph at the rate of 8 frames per second a subject moving in any direction relative to the photographer at speeds up to 200 miles per hour (320 km per hour). Granted, this is a truly amazing feat of engineering, but what makes it so significant is that even from the standpoint of a photographer who specializes in high-speed action events such as motorsports, the occasion on which one will need an AF system that exceeds these capabilities will be quite rare. Even at special events, such as the U.S. Navy Blue Angels or U.S. Air Force Thunderbirds exhibitions, where the photographer might be able to challenge the F5's speed, the old technique of panning, which works perfectly well with manual focus cameras, should work equally well with the F5. What this means is this: because the F5 is able to handle just about any focusing and photographic task that will arise in the physical world, now or in the future, its AF capabilities will not likely be obsolesced until the physical world is the one doing the obsolescing. Thus, improvements that will eventually surpass the F5's capabilities are perhaps better viewed as refinements, and, in many if not most cases, simply academic.

We can make the same argument regarding the F5's 1,005-segment metering system. I'll admit that, when I first read of this, I thought it was a gimmick. I've always been partial to selective-area metering, you see, so I tend to be somewhat skeptical of all this multi-segment stuff. I mean, 1,005 segments seemed to be more than just a bit excessive, and besides, would this system really make a demonstrable difference? The answer to that question appears to be a clear "yes." The F5's metering system is so intelligent that even the most difficult lighting situation is interpreted properly. Of course, we've all read this sort of hyperbole in advertizing before, ever since the origin of multi-segment metering patterns, in fact. Many of the cameras that already sport multi-segmented metering perform very well, but they can still be fooled into delivering incorrect exposure (or incorrect meter readings in manual mode) in certain unusually lit situations. But in the F5's case, the hype seems to hold up under real-world conditions because the metering area can be segmented to a sufficiently fine degree that most all unusual lighting situations can be accounted for. Thus, once again, until real-world conditions change, which isn't likely to happen any time soon, the metering technology found on the F5 should serve its users well into the future.

The F5's autofocusing modes are Single Servo AF (one-shot) with focus priority and Continuous Servo AF with release priority. The latter is capable of delivering up to 8 frames per second with full-AF operation with Lock-on. This is about 60% faster than any other AF system currently available. Lock-on is an interesting feature that ignores momentary interruptions caused by subjects that may interfere with your composition (for example, if somebody walks in front of a subject you're tracking, momentarily blocking your view, the

camera should ignore this, and not attempt to refocus on the offending party). The F5 employs a wide-area cross-type sensor design with 5 selectable sensors. It is sensitive to both horizontal and vertical subjects, and has the capability to hand off the focusing chores from one sensor to another as the subject moves across the field of view.

The 3D Color Matrix Meter was first introduced on the F5. The matrix component, which employs the 1,005 individual measuring cells, is actually built into the F5's DP30 finder, as is the RGB sensor that is used to evaluate a scene's colors. It can even detect if the light source is natural light, tungsten, or fluorescent. When used in conjunction with Nikon lenses that have Distance Signal Technology, additional exposure accuracy can be mustered up, plus if the photographer is using either the SB-26 or SB-27, a pre-flash monitor will add even more exposure accuracy to the equation.

The meter employs more traditional metering methods as well, including a new type of center-weighted metering called Flexible Center-Weighted Metering. When selected, it defaults to the traditional method, in which 75% of the metering sensitivity occurs within a central 12mm circle and 25% of the sensitivity occurs exterior to it. But, using a feature unique to the F5, the user can also vary the size of the circle from 12mm to 8mm, 15mm, or 20mm. Spot metering is also available, with five separate meters to choose from. Not unexpectedly, the five spot sensors are located in the same areas of the viewfinder as the five autofocus sensors are.

Exposure modes consist of the standard selection of shiftable program AE, shutter- and aperture-priority AE, as well as metered manual. Other exposure features include a generous ±5 EV range of exposure compensation in 1/3-step increments, multiple exposure, and auto

exposure bracketing in 1/3, 1/2, or full-stop increments. When using D-type lenses and a dedicated flash that supports all the features found on the F5, such as the SB-26 or SB-27, Nikon's 3D Multi-Sensor Balanced Fill-Flash is available, which provides a host of options to tame the most challenging of lighting situations. Shutter speeds range from 30 seconds to 1/8000 second, plus B, with flash sync at 1/250 second. This can be increased to 1/300 second via Custom Setting #20 under certain circumstances (more on the Custom Settings shortly). When using the SB-26 set to FP High-Speed Sync mode, flash sync pictures at speeds up to 1/4000 are possible. Other flash options are slow and rear-curtain sync, off-camera TTL flash with the SC-18, SC-19, or SC-24, plus it has a dedicated TTL hot shoe, as well as a non-TTL PC terminal.

Other features are legion. 24 Custom Settings are available. If you have a Macintosh System 7.1 or Windows 95-based personal computer (or later), or if you have access to one, you may want to take a look at Nikon's optional Photo Secretary software. With the F5 connected via the proper cable (AC-1WE for Windows platforms and AC-1ME for the Mac), a whole new world opens up. All the camera's current settings can be displayed, the number of custom settings becomes expanded to 42, color and brightness distribution of a scene can be displayed, exposure data of each frame can be downloaded, and a whole lot of other neat stuff.

The F5 retains time-proven and revered F-system traditions such as 100% viewing area visibility, interchangeable viewfinders and focusing screens, a depth-of-field preview lever, and mirror pre-lock. Other niceties that have been retained are an eyepiece shutter, both auto and manual rewind, and, in addition to the full-information exterior LCD panel, it has a full-information

viewfinder as well. The built-in high-speed motor drive provides single-shot, 3 fps continuous low-speed, 8 fps continuous high-speed, and 1 fps continuous silent modes. You even get a choice of power sources for the motor drive: the nickel-metal-hydride (Ni-MH) MN-30 battery unit (good for 8 fps) or an alkaline battery unit (good for 7.5 fps). One accessory that bears mentioning, and should be strongly considered, is the MF-28 Multi-Control Back. The MF-28 can imprint a copyright symbol, date and photographer's name (up to 22 characters) between frames (e.g., ©2000 M. W. McBroom), which not only supplements copyright protection, it provides additional safeguards against film being lost or misplaced after processing. The MF-28 also allows a greater bracketing range, an intervalometer, freeze-focus (a very nice feature, sometimes called "trap focus" where the camera fires when a moving subject reaches a prefocused point in the frame), long time exposures up to 999 hours, and more.

Nikon F100

Is the F100 an F5 Lite? Well, yes and no. The F100 is crammed with most of the best features found on the F5, but won't feel like a workout with free weights when it comes time to use it. With its host of advanced features, some of which are improvements over those found on the F5, the F100 is obviously an SLR intended for the professional or advanced amateur, yet it also manages to leave behind much of the bulk and weight of its more robust big brother. As such, it will make an ideal second or backup camera for the pro. For pros whose work does not demand the massive, rugged construction of the F5, the F100 may well be an ideal first choice.

Let's start with the features shared by both cameras, but that have been improved for the F100. The F100 has the same 5-sensor dynamic autofocus system that will switch manually or automatically between the two vertical linear sensors or the three horizontal cross sensors. Unlike the F5, however, the active sensor is illuminated in the viewfinder (taking another page out of the EOS playbook, it would seem), and its brightness is determined by ambient light levels. Speaking of the viewfinder, its display has been improved for easier legibility. The typical Nikon black or green on gray numeral display has been replaced with a bright green display on a black background. The F100 has the same EOS-thumbwheel-looking AF-area selector as is found on the F5, but with a couple of refinements: the addition of a primary AF sensor identifier switch and a primary sensor lock. And, if you want to call weight and size reduction an improvement, the difference is dramatic: with batteries, the F100 weighs 31.2 ounces (874 grams), compared to the F5's 50.4 ounces (1411 grams).

Now, let's look at the most important features shared by both the F100 and F5 that have not yet been mentioned. The F100 has the F5's focusing sensors – the largest focus sensor area of any SLR, Nikon claims. The F5's focus tracking feature, in which focus of an object will be maintained, even if an object briefly blocks one's view, is there. So is the F5's 3-D Matrix Metering, five 4mm spot metering sensors, and 75/25 centerweighted metering. And so is the five-segment balanced TTL fil flash, exposure bracketing options, adjustable program, shutter-priority, aperture-priority, and manual modes. The shutter speeds from 30 seconds to 1/8000 with flash sync at 1/250 are the same as well. Other shared features include second-curtain and slow speed flash sync, depth-of-field preview, multiple exposure capability, thorough gasketing against moisture and dust intrusion, and ±5 EV exposure compensation.

Finally, in areas where the cameras differ, the most obvious one is the metering pattern. The F100 does not have the F5's 1,005-segment color-sensitive metering system, but has instead a 10-segment 3-D Matrix metering system, similar to that found on the N90s, but a bit more advanced. The F100 has also been designed for speed and ease of use. The F5 has a number of switches and locks that must be moved to release controls to better insure that they are not accidentally reset. By contrast, the F100 has most of these inhibitors removed, the result being that it can be a very fast camera to set up, operate, and change settings on. In the finder department, the F5 has a removable one, will accept several accessory finders, and has an excellent selection of focusing screens (12 at this time). The F100's finder is fixed, and currently there are only two available focusing screens, although this number will most likely be expanded. The F5 also has an eyepiece shutter, while the F100 does not, and the F5 has a good old-fashioned manual rewind crank. A surprising exclusion (at least to me) is the omission of a mirror lock-up feature for the F100, which the F5 has. The F100 has the capability to upload and download data to a personal computer directly, whereas the F5 requires the addition of a multifunction control back to do the same. Lastly, the F100 has 22 built in custom function settings, which allow the user to modify much of the F100's default settings.

☐ THE VENERABLE NIKKORMAT

Nikon introduced the Nikkormat **FT** and **FS** in 1965 as lower cost alternatives to the F. These were the first models in the series of mechanical Nikkormats. The FT features a TTL exposure meter, mirror lock-up and shutter speeds from 1-1/1000 plus B, with X sync at 1/125. The FS is a

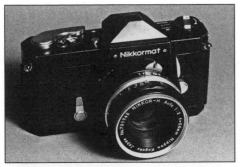

Nikkormat FT

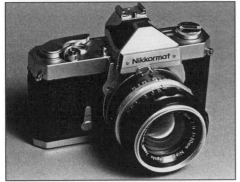

Early Nikkormat FTN with accessory 'cold' shoe

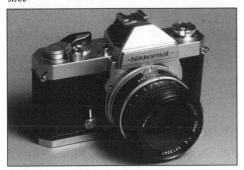

Nikkormat FT3

simplified FT with no exposure meter and no mirror lock-up.

In 1967, the Nikkormat **FTN** was introduced. It differs from the FT in one primary area: the meter was given a centerweighted pattern. An update of the FTN was released in the early 1970's. The new camera had a film advance lever with a plastic tip and an improved mechanism for setting film ASA speeds.

The next mechanical Nikkormat, the **FT2**, was introduced in 1975. The FT2 is essentially a late FTN with a hot shoe.

In 1977 the final version of the mechanical Nikkormat, the **FT3**, was introduced. The FT3 is an FT2 that takes AI lenses.

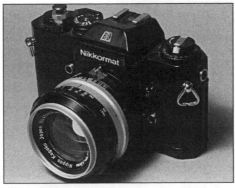

Nikkormat EL

The first of the electronic Nikkormats appeared in 1972. Dubbed the **EL**, it was Nikon's first auto-exposure SLR. It features aperture-priority AE, electronically-controlled shutter speeds from 8 seconds to 1/1000, plus B, 1/125 second flash sync (the speed available without a battery), match-needle manual metering and mirror lock-up.

An "improved" version of the EL, the **ELW**, was introduced in 1976. It is identical to the EL, except it can use the single-shot-only AW-1 winder.

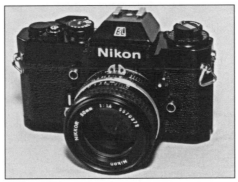

Nikon EL2

The final electronic Nikkormat received a name change. The Nikon EL2 is an ELW with SPD (silicon photo diode) metering cells and an AI lens mount. The EL2 is the immediate predecessor to the FE and shares several characteristics with the FE. The similarities are: shutter speeds from 8 seconds to 1/1000, 1/125 flash sync, match-needle manual metering and battery dependence. The major differences are: non-interchangeable focusing screens on the EL2 (interchangeable screens on FE), mirror lock-up (the FE comes

close) and the EL2 takes the sluggish, single-frame AW-1 winder only (the FE takes the MD-11 or MD-12 motor drive). The EL2 is also heavier than the FE and is a much sturdier camera.

Of all the Nikkormats, the most highly prized (and most expensive) are the AI-mount FT3 and EL2. If you can live without the AI mount, it's not difficult to find clean examples of older FTNs, FT2s, and ELs for more reasonable prices. Regardless of the mounting style or features, all Nikkormats have two things in common: they are extremely rugged and very reliable cameras that often go overlooked because the name plate says Nikkormat instead of Nikon.

Incidentally, some of these cameras have name plates that say Nikomat. A Nikomat is a domestic (Japanese) market Nikkormat. The reason for the name difference? Well, Nikomat is easier for a Japanese person to pronounce than Nikkormat, that much is fact. Apparently though, Zeiss objected to Nikon's use of a name so similar to their own trademark, Ikomat, and brought legal pressure to bear, to which Nikon relented and changed the name plates on the export cameras to Nikkormat.

☐ THE COMPACT NIKONS

The following grouping of cameras consists of the FA, and the FE, FG and FM families. When introduced, these cameras were considered to be amateur-oriented SLRs, but they have proven their value as reliable photographic tools over the ensuing years. Several models now enjoy a loyal professional and advanced amateur following.

One handy feature most of the following cameras have in common is a pseudo-mirror-lock-up capability, done by using the self-timer. The mirror rises when the self-timer is activated, providing about ten seconds for vibration to settle down before the photo is taken, which is usually plenty of time.

A word of caution: of the cameras listed in this grouping, only the FE and FM will allow the use of Non-AI lenses. Damage can result to any of the other camera if one attempts to mount a Non-AI lens. Non-AI lenses that have been "AI'd," that is, converted to the AI-style meter coupling design, will mount properly and can be used without problems.

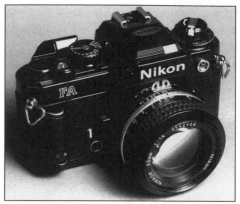

Nikon FA

Nikon FA

The Nikon FA, as a discontinued camera, is more popular now than when it was available new. Nikon's Automatic Multi-Pattern Metering (AMP) system, originally introduced with the FA, is the same basic metering pattern still employed in the latest Nikons, such as the N8008s and F4. The FA was also the first Nikon to support the AIs feature.

The FA features a 1/4000 second top shutter speed with flash sync at 1/250 and five exposure modes: metered manual, aperture and shutter-priority AE, and two program modes: standard and high-speed (with AIs lenses, the camera will bias shutter speeds automatically according to the focal length mounted), plus cybernetic override just in case the user makes a mistake with one of his or her choices.

Other features include exposure compensation, interchangeable focusing screens, TTL flash metering with dedicated flash units, multiple exposure capability, depth-of-field preview, a self-timer and a motor drive option using either

the MD-11, MD-12 or MD-15. While the MD-11 and MD-12 motor drives offer slightly higher top speeds (3.5 fps vs. 3.2 fps), the MD-15 will supply power to the FA in the event of on-board battery failure.

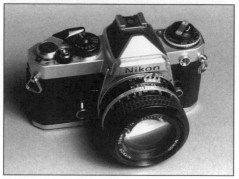

Nikon FE

Nikon FE & FE2

The Nikon FE was the immediate successor to the Nikon EL2 and shares many of its features. It has two exposure modes: aperture priority AE and match-needle-metered manual. The metering pattern is Nikon's tried-and-true 60/40 averaging method, that is, 60% of the metering is concentrated within a moderately large circle seen within the viewfinder, while the other 40% of the weighting is given to the remainder of the image. Shutter speeds range from 8 seconds to 1/1000, plus B, with X sync at 1/125. Other features include exposure compensation, interchangeable focusing screens, non-TTL flash automation, multiple exposure capability, depth-of-field preview, a self-timer and a 3.5 fps motor drive option using either the MD-11 or MD-12.

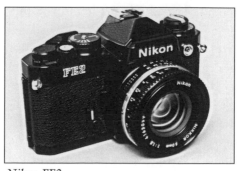

Nikon FE2

The FE2 differs from the FE in a few important areas. The FE2 was given a high-speed shutter. Slow speeds stayed the same, but the top speed was increased to 1/4000, and X sync was increased to 1/250. Brighter focusing screens were also introduced with the FE2, as was TTL flash metering.

When offered new, the FE2 was a popular camera. Since its discontinuation, it has become something of a modern classic. The demand for the camera is so heavy, in fact, that it frequently commands higher prices than its more full-featured cousin, the FA. In the case of the FE2, less does indeed seem to be more.

Nikon FG

Nikon FG, FG-20 & EM

The Nikon FG was the first Nikon to offer a program mode. Often thought of as a camera for the tyro, it is frequently the butt of much derision voiced by elitists who think more (i.e., more money, more features, more weight) is better. I say this in a self-deprecating fashion because I was one of those souls until I had the occasion to play around with an FG for a few weeks. I came to appreciate, of all things, its performance in manual mode, and the amazing accuracy of its quartz-controlled shutter.

The FG employs Nikon's 60/40 centerweighted metering (see FE for explanation) for its three exposure modes: program, aperture-priority AE and metered manual. Shutter speeds range from 1 second to 1/1000 in man-

ual (longer in program or aperture-priority AE), plus B, with a mechanical X sync at 1/90. TTL flash automation is available with dedicated flash units. Other features include exposure compensation, a backlight control, a self-timer and a motor drive option with the MD-14 or MD-E.

Nikon FG-20

The FG-20 is a scaled-down version of the FG. Gone are the program mode and TTL flash automation. All other features are the same as the FG.

Nikon EM

The EM is the simplest 35mm SLR Nikon has produced. Designed for the neophyte, the EM features aperture- priority AE as the only exposure mode. Shutter speeds range from 1 second to 1/1000. The only manual shutter speed settings, though, are 1/90 and B. The 1/90 setting is flash sync. Both these speeds are the only ones that will operate if the battery fails. The EM has a self-timer and will accept the same motor drive options as the FG and FG-20.

Nikon FM, FM2 & FM2n

The Nikon FM is a perfect camera for the student on a budget, or for a pro-

Nikon FM2n

fessional who has no need for bells and whistles, but who is looking for a low-priced, reliable camera that won't cause him or her to wince in sympathetic agony every time it picks up a new ding. It is lightweight, yet full-featured enough for most any photographic occasion.

The FM is a manual exposure only camera, using Nikon's 60/40 center-weighted metering system. It employs an array of three, cross-coupled LEDs (i.e., coupled to both apertures and shutter speeds) that light up next to either a plus, a minus or a zero sign on the edge of the viewfinder. Zero is correct exposure. Its all mechanical shutter provides speeds ranging from 1 second to 1/1000, plus B, with X sync at 1/125. Other features include multiple exposure capability, depth-of-field preview, a hot shoe and PC socket, a self-timer and a 3.5 fps motor drive option with the MD-11 or MD-12.

Because the demand for FM2s is so strong, FMs can often be purchased for very reasonable prices. Thus, if you don't need the FM2's features, you can save a sizable chunk of change.

The FM2 differs from the FM in almost the same way as the FE2 differs from the FE. The FM2 has the high-speed shutter with a top speed of 1/4000 and flash sync at a non-metered 1/200. It takes the bright, interchangeable FE2 focusing screens (the FM's screen is non-removable). Also, the meter information in the

viewfinder was improved. Instead of having LEDs next to plus, minus and zero signs, the signs have become LEDs. This greatly aids metering in low light situations.

The FM2n has one big improvement over the FM2. The 1/250 setting on the shutter-speed dial became the flash sync setting also. There are two ways to tell the FM2n apart from the FM2. One is to look at the shutter speed dial. The FM2n has a red 1/250 setting. Another way is to check the serial number. If the number is preceded by an N, then it's an FM2n.

□ NIKON N-SERIES SLRS

The N-series Nikons, from the original, manual-focus N2000 to the high-tech N90s, have a few things in common—integral motor drives and polycarbonate construction are the most obvious. Additionally, as is true with some of the above-mentioned models, N-series cameras will not accept Non-AI lenses. Damage to these cameras may result if you attempt to mount Non-AI lenses. So don't.

Nikon N50

Intended to replace the N5005, the N50 retains the ease of use that is necessary for the entry level model of a camera line, but it also has a well-rounded selection of more advanced features so that, as the user's capabilities grow, the camera can meet them. The N50 uses a "Simple/Advanced" dial. On the Simple setting, the tyro can choose between general, landscape, close-up, and portrait selections. Switched to Advanced, and the budding photojournalist can select between program with shift AE, shutter- and aperture-priority AE, metered manual (only with AF Nikkors, however), and other special programs. The built-in TTL flash even provides Nikon's Matrix Balanced Fill-Flash.

Focusing modes consist of single shot AF, continuous predictive AF, and manual. The metering system, in AE modes, uses a six-segment evaluative system, while in manual mode, it uses centerweighted averaging. Shutter speeds range from 30 seconds to 1/2000, plus T (a good substitute for B, since it does not have a provision for a cable release). The built-in motor drive provides single-frame advance, as well as film prewind and end-of-roll rewind. Other features include DX coding with override, and ± 5 EV exposure compensation.

Nikon N60

The N60 replaces the N50 as Nikon's entry level autofocus SLR model, yet offers a suite of features that most any photographer, regardless of abilities, will find useful. The concept behind the N60 is that a compleat neophyte can pick one up, switch it on, and begin taking correctly exposed and sharp pictures from the git-go. In this respect, Nikon has borrowed a concept that Canon introduced several years ago, known as the PHD (Push Here Dummy) setting. The key to the successful proliferation of the PHD setting is the fact that it works surprisingly well. It is generally so accurate that it has been known, in fact, to cause accomplished photographers just to say, "Aw, what the hey," set it to PHD, and fire away. Nikon gives this PHD setting found on the N60 the inauspicious title of "General-Purpose Program."

Autofocusing on the N60 is automated simplicity as well. It's called Auto-Servo AF, where the camera will automatically choose between Single-Servo AF or Continuous Servo AF, depending upon subject movement. Exposure modes include the aforementioned General-Purpose Program, plus Auto-Multi Program (essentially a program mode with shift), shutter- and aperture-priority auto, metered manual, plus five

Vari-Program modes (Portrait, Landscape, Close-Up, Sport, Night Scene). Exposure compensation of ± 3 EV in fistep increments is also available. Metering modes consist of Nikon's excellent 3-D Matrix available with D-type Nikkors, six-segment Matrix with non-D-type AF Nikkors, and centerweighted averaging in manual or with the AE-lock engaged.

Shutter speeds range from 30 seconds to 1/2000 second with flash sync at 1/125 second. Other features include an integral winder with auto film wind and rewind and continuous speeds up to 1 frame per second, a self-timer, diopter adjustment, a built-in TTL flash with redeye reduction, and a hot shoe.

Nikon N70

The N70 sits squarely in the middle of Nikon's autofocus SLR lineup, loaded with many advanced features rivaling those found on the N90s, while commanding roughly half the price. Such a camera makes an ideal choice for the thoughtful amateur, and can arguably be a reasonably astute selection as a backup or second camera for the working professional.

Autofocusing modes include single shot and continuous predictive AF. The user can select between wide-area AF and spot AF for better focusing control, same as on the N90 and N90s. The N70 also sports focus tracking with Lock-On, and will track subjects at frame rates up to 3.1 frames per second. The N90s' metering systems are also shared by the N70 – eight-segment Matrix, 75/25 centerweighted, and spot. In addition, the N70 also features 3D Multi-Sensor Balanced Fill-flash with both the built-in flash and accessory Nikon Speedlights. The two cameras also share almost identical exposure modes: program AE with shift, shutter- and aperture-priority AE, and metered manual, but the N70 has eight Vari-Program modes compared to

the N90s' seven. Added to the N70's Vari-Program lineup are "low-light" and "slow-shutter blur", but deleted is the portrait-with-red-eye-reduction Vari-Program found on the N90s.

Shutter speeds range from 30 seconds to 1/4000 second, with flash sync at 1/125 second. The integral winder has three settings: single frame, continuous low speed (2 frames per second), and continuous high speed (3.7 frames per second). Other features include a Quick Recall function, which allows the user to recall the factory default point-and-shoot setting or one of three user configurable settings, a high-eyepoint viewfinder, an AE lock button, and a built-in flash with coverage down to 28mm.

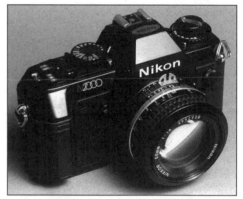

Nikon N2000

Nikon N2000 & N2020

The N2000 was Nikon's first 35mm SLR with a built-in motor drive and the second Nikon to support the "s" feature of AIs lenses. Its centerweighted metering pattern is used for all four exposure modes: standard program, high-speed program (AIs lenses are necessary to engage this function), aperture-priority AE and metered manual. Other exposure features include TTL flash metering with dedicated flash units, an AE lock and exposure compensation. Shutter speeds range from 1 second to 1/1000, plus B, with X sync at 1/125. Other features include DX film coding with override, a self-timer and, as was mentioned above, an integral motor drive that has continu-

ous speeds up to 2.5 fps. The motor features auto film loading, but film must be rewound manually.

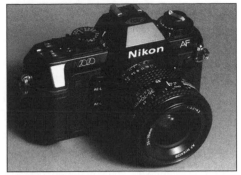

Nikon N2020

Nikon's second autofocus SLR, the N2020, is an N2000 with the addition of two autofocus modes: single shot (focus priority) and continuous (servo). All AF-Nikkors will autofocus on the N2020 (except those for the F3AF and some of the D-type AF Nikkors). Focus confirmation is provided for with AI'd, AI, or AIs lenses.

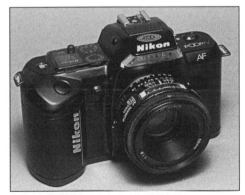

Nikon N4004s

Nikon N4004/N4004s & N5005

Nikon's bid for the entry-level autofocus consumer's dollar back in 1987 was the N4004. Its autofocusing system provided rather ho-hum performance and offered only one autofocus mode: single shot (focus priority). The shutter will not release unless the subject is in focus. For what it's worth, this fail-safe feature can be circumvented with the self-timer. Manual focus with focus confirmation is provided for when using lenses

that have maximum apertures of f/5.6 or faster.

Exposure modes available are two program modes (normal and high-speed), aperture- and shutter-priority modes, and manual. A three-zone matrix metering system evaluates exposure in the camera's AE modes. The camera switches over to Nikon's 60/40 center-weighted metering for manual exposure or when the AE lock is used. In any of the above auto-exposure modes, the shutter will lock when lighting conditions are unfavorable. Shutter speeds range from 1 second to 1/2000, plus B, with X sync at 1/100.

The N4004 has a built-in, dedicated flash (GN 39 @ ISO 100), which provides TTL flash automation and auto fill flash. TTL and autofocus TTL flash are also possible with dedicated accessory flash units. Other features include DX film coding with no override, an integral winder with single-frame advance only and a self timer.

While most lenses employing Nikon's AI meter-coupling style will mount onto the N4004 and the camera will provide focus confirmation, the metering systems will operate only when autofocus lenses are mounted. In other words, with Non-AF lenses, the N4004 becomes a non-metered, manual-focus camera. Please read the cautionary notes regarding the use of some lenses with this camera, following the description on the N5005.

The **N4004s** superceded the N4004 in 1989 and is basically the same camera. Most significantly, it inherited the N8008's autofocus system, which drastically improved focusing performance. The other improvement was the addition of a locking pin on the top deck to prevent the dials from being bumped off their settings. All other features of the N4004 were retained.

The **N5005** replaced the N4004s. It closely resembles its predecessor, yet

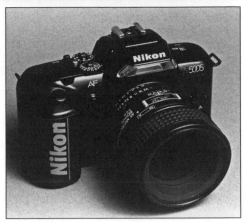

Nikon N5005

boasts several nice improvements. For starters, the autofocus system was given a boost with the addition of predictive-focus capability. The shutter speed range was extended also: 30 seconds to 1/2000 second (1 second to 1/2000 in shutter-priority and manual modes); and the flash sync speed was increased to 1/125. The built-in flash has the same rated guide number, but its angle of coverage was increased to include 28mm lenses (35mm lenses on the N4004/N4004s). Additionally, matrix balanced fill-flash is available using either the built-in flash or dedicated accessory units. The N5005 also has a T setting, an unusual feature for this class of camera. All other features of the N4004s are on the N5005.

Caution: Do not attempt to mount Non-AI lenses or lenses that have been "AI'd" (by having notches machined in their aperture rings) on the above three cameras. These cautionary notes apply only to the N4004, N4004s and N5005. Read on to find out why.

Beginning with the N4004 and continuing through to the N5005, Nikon did away with the AI meter-coupling tab that communicates lens aperture settings to the camera's meter. Instead, the electrical contacts shared by the camera and AF lenses are used for this. (This is why these cameras' meters operate only with autofocus lenses) To access the program or shutter-priority AE modes, however,

Nikon borrowed another idea from the Mind of Minolta and incorporated a minimum-aperture sensing switch to tell the camera when the lens was set to its minimum aperture, which doubles as the AE setting. When facing the camera, this switch is located at about the 8 o'clock position and engages a seldom-used and often-ignored additional tab found on the aperture rings of AI and later lenses. (See the photo of the AI lens in the Nikon lens section. On the far right of the lens, you'll notice this tab protruding from the back of the aperture ring.)

This minimum-aperture sensing switch can present a potentially costly problem to the unsuspecting user. If a photographer owns a non-AI lens they had "AI'd" by someone other than Nikon, they may think that it will work just fine. Unfortunately, if they mount such a lens, they run the risk of crushing this switch, just as if the lens had never been AI'd to begin with. Why? Because a lens AI'd by someone other than Nikon has a single, long notch cut in the aperture ring for the AI meter tab. No notch is cut for the sensing switch. Nikon circumvented this problem by replacing the entire aperture ring when it updated lenses to the AI meter-coupling style.

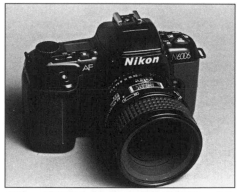

Nikon N6006 with 55mm Micro Nikkor AF

Nikon N6006 & N6000

Released simultaneously, both cameras filled gaping holes in Nikon's two SLR camera lines that had existed prior to their introduction. After the N2020

was discontinued, there was a rather large gap in both capabilities and price between the N4004s and the N8008s. The N6006 fits snugly between the two cameras, although a little closer to the N8008s in both price and performance. Prior to the introduction of the N6000, if one wished to buy a new manual-focus Nikon, the choice had been reduced to two cameras: the FM2n and the F3. Both are very fine cameras, but that isn't much of a selection.

Exposure options include two program modes with shift, shutter and aperture-priority AE, and metered manual. Metering patterns include Nikon's Matrix metering, 75/25 centerweighted averaging and spot. Other exposure features are an AE lock, exposure compensation and autobracketing. Shutter speeds range from 30 seconds to 1/2000, plus B, with X sync at 1/125.

The N6006 has a built in flash (GN 43 @ ISO 100) that provides TTL exposure automation, fill flash and second-curtain sync. The N6006 also has a hot shoe, which will provide the above features with more powerful dedicated units.

Other features include DX film coding with override, a self-timer and the integral motor drive. The motor offers two continuous speeds (2 fps and 1.2 fps), single-frame advance, and auto film loading and rewind.

Manual focus Nikkors with the AI meter-coupling style can be used on the N6006 without losing a host of features. Focus confirmation is provided. Exposure modes still available are aperture priority and metered manual. In aperture priority, the Matrix metering pattern is employed; in manual, either centerweighted metering or spot is available.

The **N6006** offers a somewhat simplified autofocus selection when compared to the N8008s. Its autofocus modes, both single and continuous,

operate in focus-priority only. There is no continuous servo. And, with a maximum film winding speed of 2 fps, there doesn't seem to be the slightest need for it either. The N6000 shares most of the features of the N6006. Those that were not included on the N6000 are the spot meter, the autobracketing function, the built-in flash (although TTL flash is still available with dedicated units) and, of course, autofocus. Interestingly, the N6000 was designed to be used with AF Nikkors – all the electrical contacts are there. When using AIs, AI or AI'd Nikkors, available exposure modes are aperture-priority AE and metered manual using centerweighted metering only. Matrix metering is not available except with AF Nikkors.

Nikon N8008 & N8008s

The N8008 was the first 35mm SLR in the world to offer a top shutter speed of 1/8000 second. At the time of its introduction, this single feature caused quite a stir among photographers and competitors alike. Such a speed could freeze action in a way that had not been possible previously unless one used high speed strobes. In addition to this, the N8008 was packed full of other innovations, which made it the autofocus hit of 1988. Superceded by the N8008s, this camera continued to be a runaway best seller for Nikon.

Autofocus modes available with the N8008 are: single shot (focus priority) or continuous (servo) operation. It has an AF lock button. "Freeze focus" (trap focus) is available with the optional MF-21 Multi-Control Back. Exposure modes include program with shift, high speed program, "dual" program, aperture or shutter priority AE, and metered manual. The "dual" mode switches automatically between normal and high-speed programs depending on the lens focal length. Other exposure features include exposure compensation

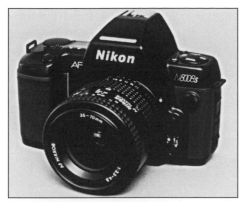

Nikon N8008s

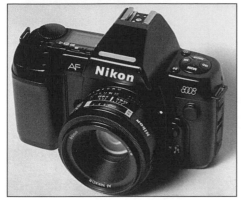

Nikon N8008

and an AE lock. Metering patterns available on the N8008 are Nikon's five-zone segmented Matrix pattern, 75/25 centerweighted averaging and, with the N8008s, spot metering.

Shutter speeds range from 30 seconds to 1/8000, plus B, with X sync at 1/250. TTL flash automation is available with dedicated units. When using the SB-24 or SB-25, auto fill flash, variable fill ratios, multistrobe effects, second curtain sync and variable power levels are all at the user's fingertips.

Other features include DX film coding with override, interchangeable focusing screens, interchangeable backs, depth-of-field preview, a variable self-timer with up to 30 seconds of delay and a one or two shot option, multiple exposure capability and a built-in motor drive that provides continuous film advance speeds up to 3.3 fps.

If one wishes to use manual focus lenses on the N8008, it will accept AIs, AI and AI'd lenses, with varying degrees of flexibility. Focus confirmation is possi-

ble with all the above lenses. Matrix metering is retained with AIs lenses only. The camera defaults to centerweighted metering with all others.

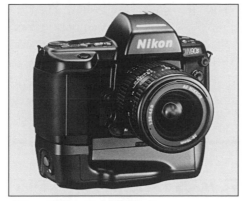

Nikon N90s with MB-10 grip

Nikon N90 and N90s

When introduced, The N90 fell between the N8008s and the F4 as far as price is concerned, but as one would expect with a later-generation AF SLR, the N90 contains several state-of-the-art features not found on any of its cousins produced prior to its release. Its styling, switch and button placement are very similar to that found on the N8008s, but housed beneath the familiar exterior is a broadly updated tool.

The most significant feature found on the N90 is its 3D Matrix Metering exposure system. Sounds impressive, but what does it mean, you may ask? Well, most anyone who has advanced beyond the snapshot level of photography knows that a proper composition often requires that the principal subject be located off center. True, having the camera stay focused on a stationary off-center subject is easy enough with most AF cameras, but what about exposure? (Having to set an AF code and hold down the shutter release halfway might not be very simple or convenient.) In deference to the anapshot crowd, most camera makers design their auto-exposure systems to bias exposure toward the center of the image. But this exposure method will not always expose correctly for an

off-center subject, especially if the lighting conditions are unusual. Nikon's 3D Matrix Metering has solved this problem.

To enable this feature, an AF D lens must be used. AF D lenses will communicate distance information to the 3D Matrix Metering exposure system, which will then adjust exposure for the subject at that distance. This same system is available for TTL flash exposure when using the SB-25 or later strode units.

Other features include a user-selectable P multiprogram mode, which biases autoexposure based on the lens focal length, Vari-Programs (close-up, high speed, hyperfocal depth, landscape, sihouette and sports, plus provisions for adding user-customized ones), and an updated set of AF sensors: a broad-based horizontal sensor and a vertical cross sensor, which can be switched to a tight, high-density cross spot sensor. One other feature worth noting is the provision for linking the N90 to selected Sharp Electronic Organizers via Nikon's Data Link IC Card AC-1E. Using a Sharp Electronic Organizer (like the Wizard 8000) the photographer can customize exposure modes, lengthen exposures, store up to five rolls worth of exposure data and more.

The exposure system also includes aperture and shutter-priority AE, plus metered manual. Metering patterns include the eight-segmented 3-D Matrix Metering pattern, 75% centerweighted metering, and a 1% spot meter. Other exposure features include an AE lock and ±5 EV exposure compensation in $^1/_3$ steps. Shutter speeds range from 30 seconds to 1/8000, plus B. X sync is available up to 1/250 second.

Some of the N90's many other features include: a built-in motor drive with single frame and continuous advance (to 3.8 fps), autoloading and power rewind, interchangeable focusing screens, and a self-timer.

Nikon incorporated its latest technological advances into its N90 "update," the N90s. The autofocusing system was substantially improved both at the software and hardware levels, including an updated CPU (the camera's internal computer) with increased processing speed. New AF algorithms were introduced, as was a new cross-type wide-area AF sensor. The result is that the N90's Focus Tracking with Lock-On technology allows for image capturing at the impressive rate of up to 4.1 fps. The N90s has five main exposure modes: metered manual, AutoMulti Program, shutter-priority, aperture-priority, Flexible Program, plus it has a set of seven Vari-Program modes, most of which are described in the previous N90 description. Retained is Nikon's excellent 8-segment 3-D Matrix Meter, and 3-D Multi-Sensor Balanced Fill Flash. Also retained is ability to link the camera to a Sharp Electronic Organizer if one wishes to change default settings or download stored information, but the N90s also has the capability to be linked to an IBM-compatible personal computer to perform these same tasks as well.

Nikon SLRs

Camera	Yrs. Made	New		Mint		Excellent		User		
EM	1979-84			140	120	125	90			
F no prism S/N <6500000, >6409999	1959-63?						350	300	250	200
F no prism Red Dot S/N 65xxxxx	1963?					425	365	325	350	275
F no prism Red Dot S/N 66xxxxx	1965?					1695	1000			
F no prism chr	1965-73					225	130	120	110	
F no prism blk	1965-73					285	190	200	160	
F std prism chr	1965-73					475	350	320	280	
F std prism blk	1965-73					550	385	350	300	
F early Photomic chr	1962-65					400	250			
F early Photomic blk	1962-65					550	375			
F Photomic T chr	1965-68					280	225			
F Photomic T blk	1965-68					350	260			
F Photomic Tn chr	1967-69					275	210			
F Photomic Tn blk	1967-69					325	240			
F Photomic FTn chr	1969-73					450	360	340	290	
F Photomic FTn blk	1969-73					595	450	370	320	
F Apollo no prism chr	1973-74					350	275	250	200	
F Apollo no prism blk	1973-74					450	345	350	300	
F Apollo w/Photomic FTn chr	1973-74			900	675	600	475	370	290	
F Apollo w/Photomic FTn blk	1973-74					750	550	400	320	
F2 no prism chr	1971-80					300	175	170	130	
F2 no prism blk	1971-80					325	185	175	130	
F2 (DE-1) chr	1972-80					425	320	250	200	
F2 (DE-1) blk	1972-80					495	355			
F2 Photomic (DP-1) chr	1972-77			495	450	375	250	235	210	
F2 Photomic (DP-1) blk	1972-77			550	485	425	325	275	240	
F2A (DP-11) chr	1977-80			550	450	475	340			
F2A (DP-11) blk	1977-80			650	550	495	380	335	250	
F2AS (DP-12) chr	1977-80			750	650	630	475			
F2AS (DP-12) blk	1977-80			900	750	780	585	540	400	
F2S (DP-2) chr	1973-77			700	595	475	345	320	250	
F2S (DP-2) blk	1973-77			800	650	545	395	380	290	
F2SB (DP-3) chr	1976-77			780	740	700	595	550	440	
F2SB (DP-3) blk	1976-77			850	775	750	645			
F2T	1976-80			1595	1450	1300	890	875	750	
F3	1980-84			620	575	550	450	490	375	
F3AF (w/DX-1 finder)	1983-87			810	700	720	600			
F3HP	1983-	1310	995	895	795	750	590	550	450	
F3HP Press (new old stock?)	1997-		1495							
F3P	1987-89			1490	1225	1150	900	850	750	

Nikon SLRs (cont'd)

Camera	Yrs. Made	New		Mint		Excellent		User	
F3T	1983-97			1225	900	995	675	650	470
F4 (MB-20)	1988-97					1125	950		
F-4E (MB-23)	1988-97			1395	1195				
F4s (MB-21)	1988-97			1200	1100	1095	1000		
F5	1998-	2195	1795						
F100	1998-	1395	1300						
FA chr	1983-87			450	385	395	300	270	240
FA blk	1983-87			450	400	390	325	300	250
FE chr	1978-83			300	265	280	220	250	180
FE blk	1978-83			350	280	320	230	260	200
FE2 chr	1983-87			460	400	380	300		
FE2 blk	1983-87			480	425	400	350	360	280
FG chr	1982-87			200	165	175	130		
FG blk	1982-87			240	185	200	160		
FG20	1984-88			175	150	140	120		
FM chr	1977-83			280	240	225	175	180	165
FM blk	1977-83			285	250	250	200	200	165
FM2 chr	1983-85			295	250	250	225		
FM2 blk	1983-85			315	280	285	250		
FM2n chr	1985-	510	380	380	320	340	280		
FM2n blk	1985-	540	400	380	320	340	280	270	250
FM2T (titanium)	1994-97	720	690	580	525				
FM10	1998-	195	150						
FE10	1998-	225	180						
Nikkormat EL chr	1972-77			250	200	195	150		
Nikkormat EL blk	1972-77			300	220	210	165	160	120
Nikkormat ELW chr	1976-78					250	170		
Nikkormat ELW blk	1976-78					270	190		
Nikon EL2 chr	1977-78			350	280	275	220	190	165
Nikon EL2 blk	1977-78			380	300	310	235		
Nikkormat FS	1965-69					150	100		
Nikkormat FT	1965-67					150	100		
Nikkormat FTN chr	1967-74			250	190	180	145	120	75
Nikkormat FTN blk	1967-74					220	150	130	90
Nikkormat FT2 chr	1975-78			250	220	240	170	150	110
Nikkormat FT2 blk	1975-78					275	195	175	120
Nikkormat FT3 chr	1977-78			375	300	320	225	195	150
Nikkormat FT3 blk	1977-78			415	330	350	260		
N50	1994-98			310	250				
N60	1998-	360	300						
N70	1994-	540	435						
N90	1992-96			630	550				
N90s	1994-	980	750	685	620				
N2000 (F301)	1985-90			250	185	195	140		
N2020 (F501)	1986-90			285	215	245	190		
N4004 (F401)	1987-89			150	120	130	100		
N4004s	1989-91			225	195	175	140		
N5005	1991-96			250	215				
N6000	1990-96			295	240				
N6006	1990-	395	300	260	220	240	200		
N8008 (F801)	1988-91			380	320	350	295		
N8008s	1991-96			475	430	450	385		

□ NIKON LENSES

Since 1959, F-mount Nikon lenses have been available in only three mechanical meter coupling styles: Non-AI (the original), AI (for Auto Indexing), and AIs (AI lenses with an additional notch; the "s" stands for "shutter"). AF Nikkors, sporting an array of electrical contacts in addition to the AIs meter coupling, communicate aperture indexing information via these contacts to autofocus Nikons that require it. Some F-mount lenses, such as the Reflex Nikkors, have no meter coupling facility at all. In addition, Nikon has produced several variations of a single focal length in a given coupling style. The differences may be in the coating, or the size or material of the focusing ring or such, or may represent a totally redesigned lens. If the differences are minor, they usually affect the value only slightly, if at all, and are not listed separately. But when the difference does affect the value, each model is listed.

Nikon Non-AI lens

Non-AI Nikkor Lenses

Non-AI lenses have the traditional meter coupling shoe located on the aperture ring, which engages the meter coupling post of early Nikon SLR cameras. When mounting one of these or later lenses with a meter coupling shoes to pre-1977 Nikkormats or to Fs with pre-FTn finders, the aperture ring must be set to f/5.6 for the lens to couple with the meter properly. Even Fs with FTn finders and F2s with non-AI coupling posts will cou-

ple much easier if this procedure is followed.

Only nine AI-coupling style Nikon cameras have been produced that will accept Non-AI lenses. These are the F2A, F2AS, F3, F4, F5, FE, FM, and the EL2 and FT3 Nikkormats. All other AI, AIs, or AF-mount cameras will not take Non-AI lenses. Damage can result to the cameras if these lenses are mounted.

Before mounting a Non-AI lens on the F2A or F2AS, the AI coupling lever must be pushed up into the finder until it clicks in place. After dismounting the lens, the sliding switch above the lever is pushed and the lever snaps back into place. On all other models that accept Non-AI lenses, the meter coupling tab must be raised out of harm's way before mounting Non-AI lenses. Next to the tab is a small button. Depressing this button unlocks the tab, allowing it to be raised. Releasing the button then locks the tab in the raised position. With either arrangement, metering must be done via the stop-down method.

Non-AI lenses that have been "AI'd" by Nikon have had replacement AI aperture rings installed, which are designed specifically for these older lenses. Some older Non-AI lenses are not "AI-able" by Nikon, but can be AI'd by others. This method involves cutting a notch in the aperture ring for the AI coupling lever and adding a sticker showing the f/stops so that the Aperture Direct Readout scale will be visible within the viewfinders of cameras supporting that feature. It doesn't look as nice as a replacement ring (and the lens is still worth about the same as a Non-AI model), but it works just fine on most Nikon SLRs. (If you have a late N-series camera, see the warning regarding the use of these lenses following the N5005's description.) When you see references to AI'd lenses in the following listings, only Non-AI lenses that have been AI'd by Nikon are shown.

Now that early Nikon Fs have become collectible, it shouldn't be particularly surprising to anyone that the lenses made for this camera are becoming collectible as well. The most sought after examples are those that display focal lengths in centimeters instead of millimeters. Most collectible interest is still confined at this point to lenses in mint or near-mint condition, or lenses that have very low serial numbers. I do not show separate price listings for these lenses for two primary reasons: first, interest in these early lenses is still a fairly recent phenomenon, and secondly, in keeping with the theme of this book, I prefer to list items that people buy to use, not to collect. Of course, overlap will be inevitable, so my advice to you is to do your homework first if you have examples of these early lenses you are interested in either buying or selling. Perhaps the best place to start would be to contact the Nikon Historical Society, but don't rule out camera clubs in your area, or even dealers in collectible cameras, most of whom are quite reputable and knowledgeable on the subject. Be sure to check the Appendix for listings of possible Internet sources.

Nikon AI lens. Note the ridge on the back of the aperture ring that begins at f/8.

AI Nikkor Lenses

AI lenses retain the meter coupling shoe to insure backward compatibility for older Nikon SLRs, but also have a ridge on the back of the aperture ring that engages the AI coupling lever on 1977 and later Nikons.

Nikon AIs lens, rear view. Note the small, rounded notch on the left side of the lens flange.

AIs Nikkor Lenses

AIs lenses have an additional dish-shaped notch machined into the rear of the lens mount (see illustration), which, along with other protrusions back there, communicates to certain cameras the focal length and maximum aperture of the lens that has been mounted. This notch matters only with the FA, N2000, N2020 and F4, and then its only purpose is to allow the camera to bias toward certain shutter speeds when used in program modes (e.g.: a long telephoto will cause the program mode to favor higher shutter speeds in order to reduce the possibility of camera shake).

Series E Nikon Lenses

Early Series E lenses are AI mount, later models are AIs. Neither have the meter coupling shoe for earlier model Nikons. Series E lenses were designed for amateur use and were originally introduced with the Nikon EM in 1979. Although less rugged in construction than their Nikkor equivalents, they are generally of high optical quality, and rep-

resent a good bargain. Certain Series E lenses are stand-outs in terms of both optical quality and price, most notably the three zoom lenses.

Autofocus Nikkor Lenses

Nikon's Autofocus lenses use the AIs mount and, like the Series E lenses, do not have the meter coupling shoes. They do, however, have tiny dimples on their aperture rings, showing where the screws that hold the shoes in place would be mounted if one felt the need to add them for his or her beloved old FTn. In addition, they have a series of electrical contacts that communicate various information electronically to Nikon autofocus cameras and to the N6000, a manual focus camera.

AF Nikkors have been produced in the following designs: the original AF Nikkor, AF-D, AF-I, and AF-S.

The D stands for "depth." In matrix metering modes, the scene as metered through a D lens is broken up, where each of the meter's segments evaluates its contents for contrast, brightness, patterns, and relative depth. Algorithms within the camera's microprocessor compare the scene with examples stored in its memory, and determine the best fit exposure based on these stored patterns. It's important to note that the D feature is active only in matrix metering mode.

The AF-I and AF-S are D lenses enhanced for speed via the inclusion of focusing motors – the I stands for "internal" and the S stands for "super quiet," or some such word-play, basically Nikon's answer to Canon's "Ultrasonic" lens line.

◻ Pricing Strategies

Nikon's line of manual focus lenses remains popular despite the ever-growing line of fast-focusing AF Nikkors. Some of the old standbys, such as the 35/2, 50/1.4, and even the 180/2.8 ED are still available new, although apparently only through gray market sources. These factors, plus a recently strong dollar with respect to the yen, have served to erase most of the price-spikes in manual focus Nikkors that occurred in the early to mid 1990s. Thus, in many cases, the prices for Nikon lenses is presently at a level close to, and in some cases a bit lower than where they were in the last edition of this book.

AI and Non-AI lenses that have been AI'd by Nikon often sell for less on the used market than their AIs counterparts – probably just because they are older. Non-AI lenses and those that have been AI'd by someone other than Nikon are usually substantially less. This isn't a strict rule, however. In a few cases, AI lenses sometimes command higher prices than some of the latest model AIs lenses, no doubt because the earlier models are often sturdier in construction. Often the price differences are negligible between meter-coupling styles, especially with lenses that are in high demand. When major price differences exist, each coupling style is listed separately. Series E lenses are grouped with the manual focus lenses, but are always listed separately. AF Nikkors are grouped in their own listings, with the various subtypes being identified.

Nikon Manual Focus Lenses

Lens	New		Mint		Excellent		User	
6mm f/2.8 fisheye	9995		7500					
6mm f/5.6 fisheye (w/finder)					1450	1275		
7.5mm f/5.6 fisheye (w/finder)					1000	900		
8mm f/2.8 fisheye	2000	1700	1345	1195	1250	995		
8mm f/8 fisheye (w/finder)					1400	1295		
10mm f/5.6 fisheye (w/finder)					875	750		
13mm f/5.6			7500	5000				
15mm f/3.5	2070	1800	1600	1475	1450	1100		
15mm f/5.6 Non-AI			980	855	840	750		
16mm f/2.8 fisheye	855	750	675	625	595	480		
16mm f/3.5 fisheye AI					500	435		
16mm f/3.5 fisheye AI'd or Non-AI					480	385		
18mm f/3.5	1210	1080	955	860	850	690	620	495
18mm f/4 AI					625	500		
18mm f/4 AI'd or Non-AI			650	600	575	400		
20mm f/2.8 AIs	640	520	495	430	460	400	370	270
20mm f/3.5 AIs (52mm)			485	440	450	380		
20mm f/3.5 AI (52mm)			370	325	350	275		
20mm f/3.5 Non-AI, AI'd (72mm)			325	250	270	200		
20mm f/4 AI			325	275	295	225		
20mm f/4 Non-AI			275	210	225	185		
21mm f/4 (w/finder)			350	325	300	195		
24mm f/2	750	600	550	495	480	375	350	300
24mm f/2.8	450	360	350	250	320	195	200	150
24mm f/2.8 Non-AI			240	200	215	180	165	150
28mm f/2	655	600	400	350	380	275		
28mm f/2 AI'd			380	300	300	200	180	150
28mm f/2 Non-AI			300	250	260	195		
28mm f/2.8	390	320	300	225	270	190	200	170
28mm f/2.8 AI'd or Non-AI			250	200	200	150		
28mm f/2.8 E			150	125	130	95		
28mm f/3.5			150	140	130	110		
28mm f/3.5 AI'd					150	100		
28mm f/3.5 Non-AI			145	115	100	80	65	50
28mm f/3.5 PC	1130	830	750	700	680	595		
28mm f/4 PC Non-AI			625	500	540	480		
35mm f/1.4	825	615	485	400	400	340		
35mm f/1.4 Non-AI			380	340	330	250		
35mm f/2	420	340	270	225	215	175	165	120
35mm f/2 AI'd					215	160	150	120
35mm f/2 Non-AI			220	190	150	125		
35mm f/2.5 E			125	100	100	85	70	60
35mm f/2.8			160	125	150	100		
35mm f/2.8 AI'd			120	95	85	70	65	60
35mm f/2.8 Non-AI			100	85	80	60		
35mm f/2.8 PC	730	620	465	400	380	340		
35mm f/3.5 PC			370	330	340	300		
45mm f/2.8 GN AI, AI'd or Non-AI				150	120	130	100	
50mm f/1.2	500	425	325	275	250	225	220	160
50mm f/1.4	375	280	250	200	180	120		
50mm f/1.4 AI			160	125	130	85		

Nikon Manual Focus Lenses (cont'd)

Lens	New		Mint		Excellent		User	
50mm f/1.4 AI'd					130	80	80	70
50mm f/1.4 Non-AI					85	50	55	40
50mm f/1.8 AI, early AIs			115	80	95	60		
50mm f/1.8N late AIs	120		95	75	70	60		
50mm f/1.8 E			60	40	50	30		
50mm f/2 AI or AI'd			100	75	75	55	55	45
50mm f/2 Non-AI			65	55	50	35	40	25
55mm f/1.2 AI, AI'd or Non-AI			220	180	170	125		
55mm f/2.8 Micro			280	210	250	190		
55mm f/3.5 Micro AI, AI'd or Non-AI	220		175	190	145	155	125	
58mm f/1.2 Nocturnal	1650	1550	1200	985				
58mm f/1.4 Non-AI			150	100	95	60		
85mm f/1.4	895	840	600	550	530	440		
85mm f/1.8 AI			290	275	280	200		
85mm f/1.8 AI'd or Non-AI					220	140		
85mm f/2			270	225	240	200	200	150
100mm f/2.8 E			135	120	120	100		
105mm f/1.8	750	650	560	500	480	390		
105mm f/2.5	380	310	280	200	225	175	180	150
105mm f/2.5 AI'd			185	150	160	140		
105mm f/2.5 Non-AI			175	140	140	110	125	95
105mm f/2.8 Micro	630	530	500	450	435	390		
105mm f/4 Micro			400	330	350	300	290	240
105mm f/4 Micro Non-AI			330	300	300	225	200	170
105mm f/4 Bellows			450	400	375	290		
105mm f/4.5 UV (w/AF-1 & UR-2)	3000	2590						
120mm f/4 Medical Nikkor (LA-2/LD-2 req'd)	1600	1275	1150	1000	950	800		
135mm f/2	1050	750	720	650	650	500		
135mm f/2 AI'd or Non-AI					500	400		
135mm f/2.8	385	350	275	250	225	175	150	140
135mm f/2.8 AI'd			190	125	140	100		
135mm f/2.8 Non-AI			140	120	125	80		
135mm f/2.8 E			150	120	125	90		
135mm f/3.5			135	110	110	70		
135mm f/3.5 AI'd or Non-AI			100	85	80	50	50	45
135mm f/4 Bellows (w/BR-1 tube)			350	300	250	200		
180mm f/2.8 ED	995	800	720	650	625	520		
180mm f/2.8 AI or AI'd			525	460	450	400	350	295
180mm f/2.8 Non-AI					400	250	225	200
200mm f/2 EDIF	4625	4200	3300	2900	2850	2300	2350	1895
200mm f/4			220	205	195	165	150	120
200mm f/4 AI'd			150	140	120	90	80	65
200mm f/4 Non-AI			140	120	125	90	80	65
200mm f/4 Micro IF	890	750	665	625	595	540		
200mm f/5.6 Medical Nikkor (w/LA-1)					550	400		
300mm f/2 EDIF			25000+					

The 300mm f/2 EDIF was discontinued in 1989. At that time it was a special-order-only item with a list price of about $13,000. These lenses are still in very high demand within the motion picture industry and are currently commanding prices in excess of $25,000.

Lens	New		Mint		Excellent		User	
300mm f/2.8 EDIF			2750	2470	2350	2000	1450	1195
300mm f/2.8 EDIF N	3300		2995	2850				

Nikon Manual Focus Lenses

Lens	New		Mint		Excellent		User	
300mm f/4.5 EDIF	1050		795	750	695	580		
300mm f/4.5 ED AI, AI'd or Non-AI					550		490	
300mm f/4.5			500	425	450	300	325	275
300mm f/4.5 AI'd or Non-AI			375	300	320	225	250	195
400mm f/2.8 EDIF	7500	7000			4500	3500		
400mm f/3.5 EDIF	4755	4600	3700	2995	2795	1995	2095	1800
400mm f/4.5 (w/focusing unit)					995	750		
400mm f/5.6 ED					1000	725		
400mm f/5.6 EDIF	2150		1695	1350	1300	1050		
400mm f/5.6 AI'd or Non-AI					650	450		
500mm f/4 EDIF P	5140	4200	4195	3800	3650	3100		
500mm f/5 Reflex			1350	1000	995	750		
500mm f/8 Reflex (latest)	815	690	650	575	560	450		
500mm f/8 Reflex (early)			385	350	325	225	285	220
600mm f/4 EDIF	6800	6000	5100	4600	4650	3950	3300	
600mm f/5.6 EDIF	4750	4200	3800	3495	3350	2995	2650	2300
600mm f/5.6 (w/focusing unit)					1200	1000		
800mm f/5.6 EDIF	6400	6200	5895	4800				
800mm f/8 (w/focusing unit)					1450	1250		
800mm f/8 ED			2850	2495				
800mm f/8 EDIF			2995	2650				
1000mm f/6.3 Reflex*					12000	10000		
1000mm f/11 Reflex (early)			1000	850	800	700		
1000mm f/11 Reflex (late)	1865	1570	1350	1200	1250	1050		
1200mm f/11 (w/focusing unit)					1995	1600		
1200mm f/11 ED			3450	3300				
1200mm f/11 EDIF			4250	3900				
2000mm f/11 Reflex*					7000	5000		
TC1 Non-AI			385	255	245	150		
TC2 Non-AI					250	200		
TC14 AI					330	225	195	
TC14A AIs	300	250			225	200	195	
TC14B AIs	630	535	450	400	385	300		
TC200 AI					175	120	130	95
TC201 AIs	300	250	220	200	190	140	125	
TC300 AI			350	275	375	275		
TC301 AIs	630	515	470	400	380	325		

* Both the 1000mm f/6.3 and the 2000mm f/11 Reflex Nikkors are huge and heavy, and the 1000mm at least was made in very small numbers. Most imported into the USA were sold to the military. Although rare, they do appear on the used market from time to time. The prices shown are entirely the result of this rarity and collector interest. If you have a genuine need for lenses with these focal lengths and speeds, get a Celestron or Meade 8" f/6.3 (1280mm) or f/10 (2000mm) telescope. Their diffraction-limited optics have greater light-gathering ability, more advanced multi-coatings, will resolve objects typically down to 1/2 arc second, focus down to 25 feet, and complete with tripods and motors sell new for a tiny fraction of what these big Nikkors go for.

Nikon Manual Focus Zoom Lenses

Lens	New		Mint		Excellent		User	
25-50 f/4			495	425	450	375		
28-45 f/4.5 AI			250	200	220	190	175	140
28-45 f/4.5 AI'd or Non-AI					175	130		
28-50 f/3.5					400	275		
28-85 f/3.5-4.5		530	485	400	425	340		
35-70 f/3.3-4.5	275	260	225	165	150	120		
35-70 f/3.5 (62mm)					425	325		
35-70 f/3.5 (67mm)			400	350	350	290		
35-70 f/3.5 AI or AI'd (72mm)			375	325	300	225		
35-105 f/3.5-4.5		400	350	280	350	250		
35-135 f/3.5-4.5		550	400	375	400	325		
35-200 f/3.5-4.5	940	840	730	650	650	500		
36-72 f/3.5 E					180	130		
43-86 f/3.5			175	140	140	120	130	110
43-86 f/3.5 AI'd or Non-AI			150	120	125	80	90	70
50-135 f/3.5			315	280	290	245		
50-300 f/4.5 ED	2995	2600	2200	1975	1850	1400	1320	1000
50-300 f/4.5 AI or AI'd			625	500	525	425		
50-300 f/4.5 Non-AI					450	375		
70-210 f/4 E			300	250	275	180	200	150
70-210 f/4.5-5.6	140	110						150
75-150 f/3.5 E			225	175	175	150	135	120
80-200 f/2.8 ED			1450	1300	1250	1100		
80-200 f/4	820	730	650	570	550	440	425	360
80-200 f/4.5 AI or AI'd			395	280	295	240	225	175
80-200 f/4.5 Non-AI					230	190	180	160
85-250 f/4-4.5 (Nikon's 1st Zoom)			280	225	240	150		
100-300 f/5.6	600	500	425	350	375	300		
180-600 f/8 ED			5200	4900	4800	4400		
200-400 f/4 ED			4275	3895	3450	3390		
200-600 f/9.5-10.5 (Nikon's 2nd Zoom)				985	750	650	485	
360-1200 f/11 ED					5000+			

The 360-1200 ED Zoom Nikkor was offered for only a short time and few were sold. The above price is probably the least you can expect to pay for one, assuming you can find one at all.

AF Nikkor Lenses

Lens	New		Mint		Excellent		User	
16mm f/2.8D	730	580						
18mm f/2.8D	1265	1000						
20mm f/2.8			350	295				
20mm f/2.8D	485	390						
24mm f/2.8			250	220	225	185		
24mm f/2.8D	355	290						
28mm f/1.4D	1790	1570						
28mm f/2.8			150	140				
28mm f/2.8D	270	220						
35mm f/2			270	230				
35mm f/2 D	345	280						
50mm f/1.4			180	140				
50mm f/1.4D	295	250						
50mm f/1.8	120	90	65	50				
55mm f/2.8 Micro			270	250	245	200		
60mm f/2.8 Micro			295	260				
60mm f/2.8D Micro	410	355						

AF Nikkor Lenses (cont'd)

Lens	New		Mint		Excellent		User
80mm f/2.8 (F3AF)*			250	200	180	150	
85mm f/1.4D IF	1150	890					
85mm f/1.8			280	240	240	200	
85mm f/1.8D	425	360					
105mm f/2D DFC	895	800					
105mm f/2.8 Micro			450	420			
105mm f/2.8D Micro	625	540					
135mm f/2D DFC	985	850					
180mm f/2.8D EDIF	835	665					
180mm f/2.8N EDIF			600	525			
180mm f/2.8 EDIF (early)			500	460	480	435	
200mm f/3.5 ED (F3AF)*			500	400			
200mm f/4D Micro	1455	1250					
300mm f/2.8D EDIF AF-S/I	5300	4500					
300mm f/2.8 EDIF AF-I	5000	4800					
300mm f/2.8 EDIF (earlier models)			3200	2650			
300mm f/4 EDIF	1050	880	825	750			
400mm f/2.8D EDIF AF-I	8000	7700					
500mm f/4D EDIF AF-S/I	8150	7000					
600mm f/4D EDIF AF-I	9000	8600					
600mm f/4D EDIF AF-S	9800	8000					
TC14E	545	450					
TC-16A			180	150	150	100	
TC-16AF (F3AF)			70	125	115	90	
TC-20E	595	470					

The AF 80mm f/2.8 and AF 200mm f/3.5 will autofocus on the F3AF only, but can be used on any Nikon SLR.

AF Nikkor Zoom Lenses

Lens	New		Mint		Excellent		User
20-35 f/2.8D	1720	1600					
24-50 f/3.3-4.5	450	330	350	300			
24-120 f/3.5-5.6D	560	480					
28-70 f/3.5-4.5 Aspherical			270	235			
28-70 f/3.5-4.5D	360	300					
28-80 f/3.5-5.6D	220	185					
28-85 f/3.5-4.5	400	350	360	320	330	250	
28-200 f/3.5-5.6D	575	490					
35-70 f/2.8			520	400	385	350	
35-70 f/2.8D	685	600					
35-70 f/3.3-4.5			120	110	115	100	
35-80 f/4-5.6D	140	100					
35-105 f/3.5-4.5					220	180	
35-105 f/3.5-4.5D	360	300					
35-135 f/3.5-4.5	440	370	360	300			
70-180 f/4.5-5.6D ED	980	850					
70-210 f/4			280	225	200	180	
70-210 f/4-5.6	345	280	210	170	190	140	
70-210 f/4-5.6D	410	320					
70-300 f/4-5.6D ED	320	280					
75-300 f/4.5-5.6	650	530	480	420			
80-200 f/2.8 EDIF			695	650	675	625	
80-200 f/2.8D EDIF	1000	820					
80-200 f/4.5-5.6D	200	150					

Nikon Motor Drives, Winders & Accessories

Item	New	Mint	Excellent	User
Generic Winder (FA/FE/FE2/FM/FM2)	75	55	30	25
AW-1 (ELW/EL2)			120 75	
F-36 w/Remote Pack (F)			285 200	
F-36 Cordless (F)		425 350	295 250	
F-250 (w/back, batt pack & cassettes)			300	200
MD-E (EM/FG/FG20)		120 100	100 65	
MD1/MB1 (F2) *		400 300	325 250	
MD2/MB1 (F2) *		600 525	500 350	320 280
MD3/MB2 (F2) *		340 290	275 200	
MD4 (F3)	495 400	380 320	340 280	
MD4/MN2 (F3)			380 330	
MD11 (FA/FE/FE2/FM/FM2) **		150 140	140 100	110 90
MD12 (FA/FE/FE2/FM/FM2) **	390 280	250 220	200 180	
MD14 (EM/FG/FG20)		180 130	140 115	
MD15 (FA only)		300 230	240 175	160 140
MB-20 (F4)	55 45	40 25		
MB-21 (F4)	210 155			
MB-22 (F4) External Power Regulator	280	200		
MB-23 (F4 - High Output)	355 300			
MH-1 Charger for MN-1			50 40	
MN-1 Nicads for MD1,MD2 (pair, refurbished)		125 100		
MH-2 Charger for MN-2	200 140	125 85	75 60	
MN-2 Nicads for MD4	150 110	110 80	90 60	
MH-20 Charger for MN-20	190 135			
MN-20 Nicads for MB-23	130 100			
F Bulk Film Cassette	15 10			
AM-1 36 exp reloadable cassette (F2)			15	10
MZ-1 Bulk Film Cassette (All 250s)		55	40 30	
Bulk Film Loader	340 275	180 150	140 125	
AH-2 or 3 Tripod Adapter		30	25 20	
AH-4 Tripod Adapter	65 55			
AP-2 Panoramic Head	100 80			
MK-1 Firing Rate Converter (MD4)	160 130	90 65		
MR-2 Aux shutter release		20 15		
MR-3 Aux shutter release (MD4)	40 35			
ML-1 Modulite Remote Control Set		220 180	195 150	
ML-2 Modulite Remote Control Set	385 330			
ML-3 Modulite Remote Control Set (N90s)	165 135			
MW-1 Remote Control Set			780 620	
MW-2 Remote Control Set	1775 1650	1175 1000		
MT-1 Intervalometer			650 500	
MT-2 Intervalometer	1000 825			
Pistol Grip			30 25	
Pistol Grip 2		40 25		
DB2 Cold Battery Pack	50 55			
DB4 Cold Battery Pack	50 55			
DB5 Cold Battery Pack (N8008s)	100 90			
DB6 External Battery Pack	240 215			

* The MB1 battery pack will power either the MD1, MD2 or MD3 to 4 frames per second or so (about 5.5 fps w/NiCads). The MB2 is good for only 2 1/2 fps. Expect to pay $50-70 more for the MD3/MB1 combination than the MD3/MB2 combination listed above.

** Although the MD-11 and MD-12 are interchangeable and may look the same, there are a couple of important differences: the MD-11 has a nasty habit of draining its batteries if the power switch is left on when not in use. Nikon corrected this problem with the MD-12. While they were at it, they gave the MD12 a new electric motor with more torque.

Nikon Backs

Item	New		Mint		Excellent		User	
MF-1 (250 exp for F2)			290	200	250	180		
MF-3 (Stops film rewind w/MD2)			125	90	95	60		
MF-4 (250 exp for F3)	1140	1050	750	700	700	500		
MF-6B (Stops film rewind w/MD4)		120	90	60	50	45	35	
MF-11 (Data back for MF-1)					175	150		
MF-12 (FE/FM)					100	60		
MF-14 (F3)	215	195	140	120	110	70		
MF-15 (FG)			100	80	90	60		
MF-16 (FA/FE2/FM2)	235	215	160	130	120	80		
MF-17/MF-4 set		4600						
MF-18 (F3)	385	335	225	200	180	150		
MF-19 (N2000/N2020)			170	150	140	100		
MF-20 (N8008/s)			70	60				
MF-21 (N8008/s)	210	155	140	125				
MF-22 (F4)	170	130	110	75				
MF-23 (F4)	400	350			365	300		
MF-24 (250 exp MF23)		5500						
MF-25 (N90s)	130	115						
MF-26 (N90s)	240	180						
MF-28 (F5)	550	440						
Speed Magny RF (F)					700	600		
Speed Magny 45 (F)					600	450		
Speed Magny 45-2 (F2)					700	600		
Speed Magny 100 (F)					350	200		
Speed Magny 100-2 (F2)					400	250		
Speed Magny 100-3 (F3)					1200	800		
Forscher or NPC Polaroid Back (various models)	750	650			585	450		
Datalink Introductory Package (AC-1E w/MC-27 & Sharp Wizard 8200s)	550	480						
AC-2E Datalink System (N90s)	220	160						

Nikon Finders and Finder Accessories

Item	New		Mint		Excellent		User	
F Eye Level Prism (blk or chr)			175	150	150	95	60	40
F Waist Level Finder (blk or chr)			100	70	70	60		
F Sportfinder (blk or chr)			295	250	250	165		
F Photomic (non-TTL) (blk or chr)					60	50		
F Photomic T (blk or chr)					60	50		
F Photomic TN (blk or chr)					70	55		
F Photomic FTN (blk or chr)			250	190	185	140	125	85
DA-1 Sportfinder (F2)			250	195	190	150		
DA-2 Sportfinder (F3)	480	350	250	200	225	175		
DA-20 Sportfinder (F4)	800	610						
DA-30 Sportfinder (F5)	1030	850						
DE-1 Eye Level Prism (F2)			140	125	120	90		
DE-2 Eye Level Prism (F3)			100	90	80	75	80	70
DE-3 High Eye Point Prism (F3)	300	200	200	150	140	100		
DG-2 2X Eyepiece Magnifier	60	40	35	30	35	25		
DP-1 (F2 Photomic)			190	150	170	120	110	90
DP-2 (F2S)			210	170	175	140	135	100
DP-3 (F2SB)			400	325	310	260		

Nikon Finders and Finder Accessories (cont'd)

Item	New	Mint	Excellent	User
DP-11 (F2A)			270 200	180 160
DP-12 (F2AS)		450 395	410 355	330 295
DP-20 Multi meter (F4)	520 490			
DP-30 Multi meter (F5)	420 390			
DR-2 Right Angle Finder			45 40	
DR-3 Right Angle Finder	150 90			
Right Angle Finder (early)		35 30	30 20	
DS-1 Servo EE (w/DH1 chgr & DN1 NiCads) *			150 100	
DS-2 Servo EE (w/DH1 chgr & DN1 NiCads) *			190 125	
DS-12 Servo EE (w/DH1 chgr & DN1 NiCads) *			270 200	220 150
DH-1 Charger for DN-1		95 75	85 50	
DN-1 Nicads for DS-1/2/12	35 30			
DW-1 (F2 waist level)		110 80	80 50	
DW-2 (F2 6X)		250 175	200 125	120 85
DW-3 (F3 waist level)	120 80	70 50	50 40	
DW-4 (F3 6X)	280 180	165 100		
DW-20 (F4 waist level)	230 185		120 100	
DW-21 (F4 6X)	435 340			
DW-30 (F5 waist level)	240 200		120 100	
DW-31 (F5 6X)	405 340			
DX-1 (AF finder for F3AF) **		200 185	160 125	

Addition of the DS-1 or DS-2 Servo EE unit to a Nikon F2S or F2SB allows the camera to operate in shutter-priority AE. The DS-2 is identical to the DS-1, but has a PC connector. The PC connector on the front of the camera is sacrificed with the DS-1, since the connector's threads are the main attachment point. Even though the AS-1 flash adapter can still be used for flash work with the DS-1, the DS-2 (with a built-in PC connection) is the non-AI model most everyone wants. The DS-12 is the AI version of the DS-2 and works with the F2AS only.

**The DX-1 can be used on a non-autofocus F3. The camera won't autofocus, but it does provide focus direction and confirmation with manual and auto-focus lenses that are f/3.5 or faster.*

Nikon Close-up Accessories

Item	New	Mint	Excellent	User
Bellows 2		125 90	85 70	
Bellows 3		150 100	120 75	
PB-4 Bellows *		300 250	280 200	
PB-5 Bellows *		150 120	125 100	
PB-6 Bellows *	300 210	200 140		
Slide Copier 2 (fits Bellows 2)		110 75	80 75	
PS-4 Slide Copier		100 90	90 80	
PS-5 Slide Copier		50 40	35 20	
PS-6 Slide Copier for PB-6	195 135	115 80	80 70	
PB-6D Spacer (2 req'd), each	70 50			
PB-6E Bellows Ext for PB-6	225 160	120 100		
PB-6M Macro Stage	75 45		25 20	
PF-2 Stage		40 30		
PF-4 Repro Copy Outfit	745 670		295 250	
PG-2 Focusing Stage	220 150			
M or M2 Ext Tube (1:1 w/55mm Non-AI Micro)			25 20	

The PB-4 Bellows provides Tilt-Shift capability, whereas the PB-5 and PB-6 do not. The PB-6 has the socket for the double cable release built into the front standard for convenient auto-aperture stop-down. To achieve the same result with the PB-4 or PB-5, the BR-4 ring (equipped with a cable release socket) must be used between the lens and the front standard. The PS-4 or PS-5 Slide Duplicators can be interchanged between the PB-4, PB-5 and most other early Nikon bellows. However, the PS-4 and PS-6 allow up/down/sideways movement of the slide for cropping, whereas the PS-5 does not. The PB-6E is an extension unit that fits onto the end of the PB-6 allowing a total extension of 438mm.

Nikon Close-up Accessories (cont'd)

Item	New		Mint		Excellent		User	
PK-2 Ext Tube					25	20		
PK-3 Ext Tube			40	35	35	30		
PK-11 Ext Tube			40	25				
PK-11A Ext Tube (AIs) **	80	60	50	40				
PK-12 Ext Tube (AI-14mm)	80	60	50	40				
PK-13 Ext Tube (AI) **	80	60	50	40				
PN-1 Ext Tube (Non-AI) **			75	70				
PN-11 Ext Tube (AI) **	135	95	100	75				
Ext. Ring Set K **			60	50	40	30		

** The PN-11, when used with the 105 AI/AIs Micro, provides from 1:2 to 1:1 image size. The PN-1 is the non-AI version. The PK-13 does the same thing, but for the 55 AI/AIs Micro. The PK-11A, while providing full function with any AI camera/lens, was designed to clear the contacts on the N2020 (and, presumably, will clear the contacts on other autofocus Nikons as well). The Extension Ring Set K is a set of five rings which can be used separately or in combination.

Nikon Speedlites and Speedlite Accessories

Item	New		Mint		Excellent		User	
SB-E (EM)			40	30	25	20		
SB-1 w/batt pack (Handle-mount)					75	50		
SB-2 (F/F2)			110	90				
SB-3 (ISO shoe)					60	50		
SB-5 (Handle-mount)					275	250		
SB-6 (F/F2 or ISO w/adapter)			1450	1400				
SB-7E (F/F2)			110	95				
SB-8E (ISO shoe)			65	60				
SB-9 (ISO shoe)			45	35	35	25		
SB-10 (FE)			50	40	45	35	30	25
SB-11 (Handle-mount - F3 TTL)			200	160	180	145		
SB-12 (F3 TTL)			60	50	50	25		
SB-14 (Handle-mount - F3 TTL)			300	250	200	130		
SB-15 (TTL ISO shoe)			135	90	120	85		
SB-16A (F3 TTL)	335	295	250	225	230	180	150	130
SB-16B (TTL ISO shoe)	315	275	240	210	200	160		
SB-17 (F3 TTL)	215	185	150	135	120	85		
SB-18 (TTL ISO shoe)			60	50	40	35		
SB-19 (ISO - FG20/EM)			50	40				
SB-20 (AF TTL)			190	165	150	120		
SB-21A Macrolite (F3 TTL)	460	420	360	325				
SB-21B Macrolite (TTL ISO shoe)	465	390	365	325				
SB-22 (AF TTL)			120	85				
SB-23 (AF TTL)	120	85	80	60	70	50		
SB-24 (AF TTL)			225	175	165	145		
SB-25 (AF TTL)			250	225				
SB-26 (AF TTL)	325	270						
SB-27 (AF TTL)	225	170						
SB-28 (AF TTL)	290	250						
SM-1 Macro Ringlite *					55	45		
SM-2 Macro Ringlite *			225	150				
SR-1 Macro Ringlite *					50	40		
SR-2 Macro Ringlite *			180	160				

* The SM-1 and SM-2 attach to reverse-mounted Nikkors. The SR-1 and SR-2 thread into the 52mm front filter threads. The SM-1 and SR-1 draw power from another flash unit's power supply, such as the SB-1 or SB-7. The SM-2 and SR-2 are powered by the LD-1 battery pack or the LA-1 AC power supply.

Nikon Speedlites and Speedlite Accessories (cont'd)

Item	New	Mint	Excellent	User
LA-1 AC Unit (SM-2/SR-2)		125 100		
LA-2 AC Unit (120mm Med Nikkor)	300 250			
LD-1 DC Batt Pack (SM-2/SR-2)		125 110		
LD-2 DC Batt Pack (SB-21/120mm Med Nikkor)	195 150	140		
SD-7 Batt Pack (SB-14)	160 125			
SD-8 Hi-Perf Batt Pack (SB-11/20/22/24)	155 120	100 100	85	
SK-6 Power Bracket	280 240			
AS-1 (ISO foot to F/F2 shoe)	25		20 15	
AS-2 (F/F2 foot to ISO shoe)	25		15 10	
AS-3 (F/F2 foot to F3 shoe)	25		20 15	
AS-4 (ISO foot to F3 shoe) **	30		20 15	
AS-5 (F3 foot to F/F2 shoe)	30			
AS-6 (F3 foot to ISO shoe) **	40		25 20	
AS-7 (F3/ISO foot to F3 shoe) **	75		60 50	
AS-8 (F3 foot for SB-16)	190 160	90 75	80 70	
AS-9 (ISO foot for SB-16)	140 110		65 50	
AS-10 (ISO TTL Multi-flash adapter)	40 35	30 20		
AS-11 (F3 foot tripod adapter)	40 35		25 15	
AS-12 (F3 foot for SB-21)	290 250	180 150		
AS-14 (ISO foot for SB-21)	290 250	180 150	155 125	
AS-15 (PC adapter for N8008)	25 20			
SC-6 (3 Prong to PC)	30 25			
SC-10 (ISO foot to PC)	25 20			
SC-11 (SB11/14 sync cord)	25 20		10 10	
SC-12 (F3 TTL to SB11/14)	170 140			
SC-13 (Remote sensor cord - SB11/14)	120 90			
SC-14 (F3 TTL)	75 60		40 30	
SC-15 (PC to PC)	25 20			
SC-17 (ISO TTL)	60 50		40 30	
SC-18 (TTL Multi-flash - 5 ft)	40 30			
SC-19 (TTL Multi-flash - 10 ft)	55 30	25 20		
SC-21 (120mm Medical Nikkor to SB-21 A/B)	60 40			
SC-23 (ISO TTL to SB11/14)	150 120			
SC-24 (TTL cord - F4)	65 55			

** The AS-7 Flash Coupler is designed to allow the flash to stand off from the F3 camera body, permitting film rewind/removal without having to dismount the flash. It also permits the use of flashes with either the F3 foot or the standard ISO foot. TTL flash is still possible with flashes that have the F3 foot, but not for flashes with the standard ISO foot, even if they provide TTL flash on other Nikons. TTL flash is also lost when using the AS-4 or AS-6. The only way around this is to buy a base for each shoe type. But this option exists only for the SB-16 (AS-8/AS-9) and SB-21 (AS-12/AS-14), and it's an expensive one.

Olympus

□ OLYMPUS' OM-SERIES SLRs

Olympus' OM-series cameras have many strong points. Most often extolled are their compactness and light weight. But there are other notable advantages. Almost any OM camera will accept almost any OM accessory. For example, both Motor Drives 1 & 2 will work with the OM-1MD, OM-1N, OM-2, OM-2N, OM-2S, OM-3, OM-4, OM-4T, OM-G & OM-F. Most OM cameras have interchangeable focusing screens and it doesn't matter which camera you have, either. Any OM screen will fit any OM camera that has that capability. Another characteristic of the OM system is a depth-of-field preview button located on OM lenses, which means all OM-mount cameras support this feature.

In the following listings, the only current OM camera is the OM-4T, Olympus' highly regarded professional model. Apparently, Olympus' brief foray into the AF interchangeable-lens SLR market met with little success. Not only has Olympus discontinued the OM-77 and OM-88, but its entire line of AF lenses has met with the same fate. The explanation given to me by an Olympus representative was that the IS-1 and subsequent models have become so popular that the company sees no reason to market amateur-level interchangeable-lens AF SLRs at this time. He also indicated that Olympus has no plans to replace the OM-4T with a professional-level AF SLR. We'll see.

Olympus OM-1 MD

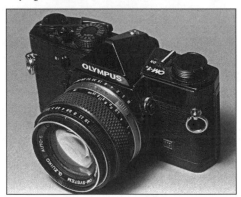
Olympus OM-1n

Olympus M-1/OM-1, OM-1MD & OM-1N

The M-1, actually the first OM camera and identical to the OM-1, was marketed for a short time before Leica protested the designation. Though it is somewhat rare, I've listed it below because it isn't particularly expensive.

The OM-1 is a compact, mechanical, manual exposure SLR. Its TTL meter provides centerweighted, center-the-needle metering. Shutter speeds range from 1 second to 1/1000, plus B, with flash sync at 1/60. Other features include a self-timer, mirror

lock-up and provisions for the attachment of an accessory hot shoe.

Introduced a couple of years later, the OM-1MD can use a winder or a motor drive (The MD stands for Motor Drive). Otherwise, it's the same camera. Most OM-1MDs have a label that says MD on the front, but not all do. If in doubt, turn the camera over and look at the baseplate. The standard OM-1 will have one port for the batteries. The MD model will have an additional port for the motor drive.

The OM-1N was the last of the OM-1 series. With the accessory Shoe 4 and a dedicated flash unit, the OM-1N has a ready light that will appear in the viewfinder.

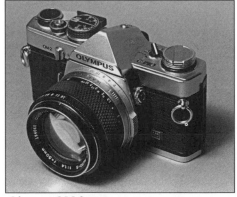
Olympus OM-2

Olympus OM-2, OM-2N & OM-2S Program

The OM-2 series cameras feature Olympus' off-the-film (OTF) method of determining exposure, and are renowned for their super-long, auto-exposure capability for truly amazing low-light results. The OM-2's exposure

modes are aperture-priority AE and metered manual. Manual shutter speeds range from 1 second to 1/1000, plus B, with flash sync at 1/60. In aperture-priority, the OTF metering system is active and, while the viewfinder may show a certain speed, the OTF system may select another. If the camera deems it necessary, speeds can time out to well over one minute. I've read of one photographer who claims to take low-light photos of up to 30 minutes and longer with an original OM-2 on the auto setting. Other features include mirror lock-up, a self-timer and compatibility with the long list of OM accessories.

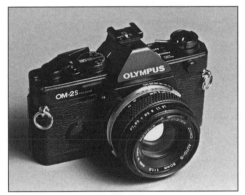

Olympus OM-2s Program

The OM-2N features TTL (OTF, I presume) flash. Olympus changed the main computer chip with this model, which resulted in shortening its low-light exposure times, but they're still plenty long.

The OM-2s Program is a completely redesigned camera. Exposure modes are program, aperture-priority, metered manual and TTL flash. The standard centerweighted metering pattern is used in the AE modes. In the manual mode, the user has a choice between centerweighted and spot metering patterns. In program or aperture-priority, the camera meters the film plane during exposure and shutter speeds can range from about 1 minute to 1/1000 second. In manual, the standard range of shutter speeds is available, plus B, with X sync at 1/60. Other features include exposure

compensation, a self-timer and all the other accessories that are part of the OM system.

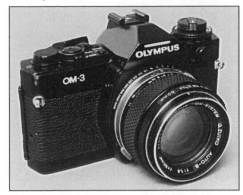

Olympus OM-3

Olympus OM-3 & OM-3Ti

The OM-3 saw a somewhat brief production history, due perhaps to lackluster sales. Since its discontinuation, however, it has become the most highly sought-after camera of all OM models. Clean examples routinely command higher prices than new OM-4Ts. Something of a high-tech return to basics, the OM-3 is a manual-exposure-only, mechanical camera that features two metering patterns: centerweighted averaging and spot. The mechanical shutter provides speeds ranging from 1 second to 1/2000, plus B. Other features you'd expect, such as interchangeable focusing screens, a self-timer, and compatibility with most all OM accessories round out the capabilities of this camera.

Almost a decade after the OM-3's demise, Olympus did an amazing thing and re-introduced the camera, albeit this time clad in titanium. The OM-3Ti is perhaps the epitome of a back-to-basics SLR – with a price to match. Metering capabilities were improved; it has the ability to store and average multiple spot readings, plus it has a highlight/shadow control, like the one found on the OM-4T. Flash capabilities have also been enhanced. The OM-3Ti features an improved Fine Lumi-Micron Matte focusing screen, TTL flash capability,

and supports full synchronization up to 1/2000 second with the F280T flash.

Olympus OM-4 & OM-4T

The current Pro-level OM camera is the OM-4T, successor to the original OM-4. The original OM-4 features two exposure modes, aperture-priority AE and metered manual. Either center-weighted metering or spot can be employed. The spot function will allow up to eight readings to be stored and averaged for critical exposure control. Other exposure features are a highlight/shadow bias function, exposure compensation and TTL flash with dedicated flash units. Shutter speeds in the aperture priority mode range from 4 minutes to 1/2000, plus B, with X sync at 1/60. In manual mode, shutter speeds range from 1 second to 1/2000.

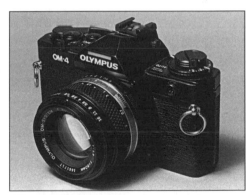

Olympus OM-4

The OM-4T, nowadays marketed as the OM-4Ti, but still labeled with a "T", is much the same camera as the OM-4, with a few very nice improvements. For starters, it is housed in titanium (hence the T). It is well-gasketed against dust and moisture intrusion. A diopter adjustment was added. But the most interesting feature of the OM-4T is its flash capability. When coupled with the Full Synchro Flash F280 strobe, it's possible to take flash pictures at any shutter speed – all the way up to the OM4-T's top shutter speed of 1/2000. Power consumption of the F280 flash is prodigious, however, and output is somewhat

low. Of course, the OM-4 and OM-4T are compatible with the entire array of OM accessories, from focusing screens to motor drives.

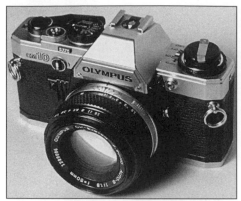

Olympus OM-10

Olympus OM-10, OM-G & OM-F

Designed as an entry-level camera, the OM-10 meets most photographic situations with a minimum of fanfare, yet performs its job quite capably. A single exposure mode, aperture priority AE, is available standard. With the installation of the Manual Adapter, metered manual is also available. Shutter speeds range from 2 seconds to 1/1000, plus B. TTL OTF flash is available with dedicated flash units. Other features include a self-timer, a winder option and compatibility with most OM accessories.

The OM-G is essentially an OM-10 with the manual mode built in. The OM-F is an OM-G with a focus assist

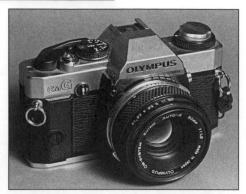

Olympus OM-G

feature, the direct predecessor, and the next best thing to autofocus. This feature is particularly useful to those folks whose eyes 'ain't what they used to be', but who may balk at the idea of buying into an autofocus system. The OM-F offers a very serviceable alternative.

Olympus OM-77AF

The OM-77AF's autofocus modes are single shot (Focus priority) and continuous (servo). It will manual-focus AF lenses in the "Power Focus" mode only. Exposure options include a program mode, which adjusts for lens focal length, a shift function, aperture-priority AE and AE lock. Shutter speeds range from 2 seconds to 1/2000, with X sync at 1/100. When using the F280 Full Synchro Flash, flash photography is possible at all shutter speeds. Other features include an integral motor drive with continuous speeds up to 1.5 fps, auto film

loading and rewind, and DX film coding with no override.

Either autofocus or manual focus lenses can be used. With the latter, only aperture-priority AE is possible.

Olympus OM-88

The Olympus OM-88 is unique in that it is neither a manual-focus camera, nor is it an autofocus camera— it's an almost autofocus camera, using a system Olympus called "Power Focus." The camera accepts PF (Power Focus), AF and manual focus lenses. When using PF or AF lenses, the user pushes a button to focus the lens. This activates a motor that drives the lens in the focus direction desired – an interesting novelty, but not interesting enough, it would seem. The OM-88 was discontinued in 1991.

The OM-88's exposure options include program, aperture-priority AE (when using manual focus lenses) and metered manual (with Manual Adapter 2). Shutter speeds range from 2 seconds to 1/2000, plus B (when using the optional Manual adapter 2), with X sync at 1/80. TTL flash is possible with dedicated flash units. Other features include a backlight control, a built-in single-frame-only motor drive, auto film loading and rewind, DX film coding with no override, a dedicated hot shoe and a self-timer.

Olympus OM-series SLRs

Camera	Yrs. Made	New		Mint		Excellent		User	
M-1	1972					350	275		
OM-1 chr	1973-79			180	145	160	125	130	100
OM-1 blk	1973-79					200	140		
OM-1MD chr	1975-79					175	140		
OM-1MD blk	1975-79			260	220	200	150		
OM-1N chr	1979-87			225	175	180	150	150	120
OM-1N blk	1979-87			250	220	200	160	170	130
OM-2 chr	1975-79			210	175	200	150		
OM-2 blk	1975-79			260	200	220	170		
OM-2N chr	1979-84			220	195	200	165		
OM-2N blk	1979-84				300	225	180	190	160
OM-2S	1984-88			350	300	275	225	200	165
OM-3	1983-86			700	500	450	350	300	260

Olympus OM2000

After several years of apparently no more interest in releasing a new interchangeable lens 35mm camera (neglecting, for the moment, the re-release of the OM-3Ti), Olympus turned a few heads with the release of the OM2000. What's remarkable about the OM2000 is it is a mechanical, manual-focus, and manual exposure camera. Equipped with centerweighted averaging and a spot meter, it appears to bear more than a passing resemblence, in terms of features at least, with the classic OM-3. Shutter speeds range from 1 second to 1/2000 second, plus B, with flash sync at 1/125 – a faster sync, incidentally, than either incarnation of the OM-3 or OM-4. Other features include a self-timer and multiple exposure capability.

Olympus OM-PC

The OM-PC was the first Olympus to feature its ESP (Electro Selective Pattern) metering system. ESP employs a comparative recognition system that monitors the contrast levels of a scene and spots difficult lighting situations. The camera then adjusts the shutter speed and/or aperture to produce the best possible exposure, then continues to monitor the scene during exposure via the OTF metering method. TTL OTF flash automation is also available with dedicated flash units.

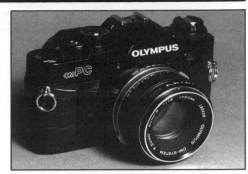

Olympus OM-PC

Shutter speeds range from 2 seconds to 1/1000, plus B (1 second to 1/1000 in manual). The OM-PC's exposure modes are program, aperture-priority AE and metered manual. Other features include a self-timer, DX film coding with manual override, and use of virtually the full line of Olympus accessories.

Olympus OM-series SLRs (cont'd)

Camera	Yrs. Made	New		Mint		Excellent		User	
OM-3T blk	1996-	1650	1500						
OM-4 chr	1984-87			450	400	400	315		
OM-4 blk	1984-87					400	350	325	300
OM-4T chr	1987-	1195	1000	500	460	475	395		
OM-4T blk	1990-	1195	1000	520	490				
OM-10	1979-87			130	75	85	65		
OM-10 Quartz	1984-87			120	90				
OM-F (Focus Assist)	1983-87			180	150	150	120		
OM-G	1983-87			240	215	100	85		
OM-PC	1985-87			220	150	165	125		
OM-77AF	1986-91			180	150	155	125		
OM-88 w/50 PF	1988-91			175	160	150	135		
OM-2000	1998-	210	160						

Zuiko Manual Focus Lenses

Lens	New		Mint		Excellent		User	
8mm f/2.8	1500	950	870	800	820	600		
16mm f/3.5	995	880	550	500	520	400		
18mm f/3.5	1010	890	500	450	450	390		
20mm f/2 Macro (Bellows)	440	395	200	180	175	140		
20mm f/3.5 Macro (Bellows)			125	100				
21mm f/2	1025	900	450	380	340	290		
21mm f/3.5	570	490	225	200	200	150		
24mm f/2	775	680	340	280	270	250		
24mm f/2.8	320	290	250	220	200	180	185	160
24mm f/3.5 PC	1620	1480	940	890	850	700		
28mm f/2	750	670	325	265	275	230		
28mm f/2.8	260	210	145	120	120	95		
28mm f/3.5			95	80	80	65		
35mm f/2	460	370	195	170	180	130		
35mm f/2.8	310	250	115	80	90	65		

Zuiko Manual Focus Lenses (cont'd)

Lens	New		Mint		Excellent		User	
35mm f/2.8 PC	825	740	450	400				
38mm f/2.8 Macro (Bellows)	450	395						
38mm f/3.5 Macro (Bellows)			175	125				
40mm f/2			100	85	90	75		
50mm f/1.2	395	340	250	225	225	190		
50mm f/1.4	230	190	160	95	100	80		
50mm f/1.8	145	110	50	40	45	35		
50mm f/2 Macro	540	480	325	280	250	200		
50mm f/3.5 Macro	420	350	180	150	160	125		
80mm f/4 Macro (Bellows)	545	380	200	170	180	150		
85mm f/2	420	370	250	235	230	190		
90mm f/2 Macro	845	770	450	400	400	350		
100mm f/2	550	490	400	375	380	325		
100mm f/2.8	320	260	200	170	160	125		
135mm f/2.8		100	150	125	135	90		
135mm f/3.5		80	85	50	55	45		
135mm f/4.5 Macro (Bellows)	550	350	200	190	170	150		
180mm f/2		3000	2200	1850				
180mm f/2.8	1000	800	520	470	425	350		
200mm f/4	370	300	200	140	150	120		
200mm f/5		200			120	90		
250mm f/2	4250	4300			2950	2500		
300mm f/4.5	695	600	420	375	350	300		
350mm f/2.5 ED			3700	3200				
350mm f/2.8		5500	3650	3000	3100	2750		
400mm f/6.3		1750	1000	900	850	700		
500mm f/8	625	480	450	400	390	300		
600mm f/6.5	2200	2000	1450	1380	1350	1200		
1000mm f/11			1350	1250	1200	950		
1.4X-A	395	350	240	200	200	150		
2X-A	295	200	140	110	90	75		

Zuiko Zoom Lenses

Lens	New		Mint		Excellent		User	
28-48 f/4					180	120		
35-70 f/3.5-4.5			160	100	100	80		
35-70 f/3.5-4.8		80						
35-70 f/3.6			300	240	270	200		
35-70 f/4			160	125	145	90		
35-70 f/4 AF			160	120				

The 35-70 f/4 AF will autofocus on any Olympus OM-series SLR.

Lens	New		Mint		Excellent		User	
35-80 f/2.8	1240	1150						
35-105 f/3.5-4.5		270	235	220	210	150		
50-250 f/5			550	485	450	350		
65-200 f/4			250	200	200	145		
70-210 f/4.5-5.6	160	125						
75-150 f/4		120	150	100	120	85		
85-200 f/4					170	150		
85-250 f/5					290	225		
100-200 f/5			150	70	85	60		

Olympus Autofocus Lenses

Lens	New		Mint		Excellent		User
24mm f/2.8			150	125	105	85	
28mm f/2.8			70	50			
50mm f/1.8			40	35			
50mm f/2 PF (OM-88)			50	40			
50mm f/2.8 Macro			190	175			
28-85 f/3.5-4.5			120	100			
35-70 f/3.5			90	85			
35-70 f/3.5 PF (OM-88)			90	80			
35-105 f/3.5-4.5			140	100			
70-210 f/3.5-4.5			170	140			
70-210 f/3.5-4.5 PF (OM-88)			200	150			

Olympus Motor Drives, Winders & Accessories

Item	New		Mint		Excellent		User
Motor Drive 1 (w/18v Control Grip 1)					185	150	

The Motor Drive 1 and 2 fit OM-1MD/1N, OM-2/2N/2S, OM-3, OM-4/4T, OM-G, OM-F, OM-PC — but not the OM-10. The Motor Drive 2 features power film rewind. The Winder 1 and 2 fit all of the above and the OM-10.

Item	New		Mint		Excellent		User
Motor Drive 2	480	375	230	180	170	150	

Requires M15 NiCad Control Pack or M18V Control Grip 2 - not included.

Item	New		Mint		Excellent		User
Motor Drive 2 w/18V Control Grip			550	320	280	300	250
Motor Drive 2 w/NC Control Pack 2 & chgr					360	300	
M18V Control Grip 2		185	100	70			
Nicad Control Pack w/chgr	250	170					
Nicad Control Pack 2 w/chgr	260	180					
Winder 1			80	70	75	50	
Winder 2	185	160	100	85	90	65	
Generic Winder	60	45			35	25	
Motor AC Control Box 1	380	270	220	190			
M Quartz Remote Control Intervalometer	200	160					
Manual Adapter (OM10)		30	25				
Manual Adapter 2 (OM88)	30	25					

Olympus Backs

Item	New		Mint		Excellent		User
250 Exp Back (OM-1/MD/N/OM-2/N)					400		300
250 Exp Back (OM-2S/3/4/4T)					600	450	
250 Film Magazine (2 req'd)	70	40					
250 Bulk Film Loader	180	110					
Recordata Back 1			45	40			
Recordata Back 2			125	80	65	50	
Recordata Back 3					110	75	
Recordata Back 4	225	185			60	50	
Recordata Back 100 (OM-77)					50	40	
Recordata Back 200 (OM-88)					50	40	
Forscher or NPC Polaroid Back	825	750			550	450	

Olympus Close Up Accessories

Item	New		Mint		Excellent		User
Telescopic Auto Tube (65-116mm)	280	240	150	125	115	85	
Auto Extension Tube 7mm	80	65					
Auto Extension Tube 14mm	80	65					
Auto Extension Tube 25mm	80	65					
Auto Extension Tube Set (aftermarket)		125	100				
Auto Bellows	290	220	100	90	90	80	
Double Cable Release for above	35	25					
Slide Copier	135	100					
Focusing Rail & Stage	180	140					
Right Angle Finder			45	35			
Varimagni Finder	160	145					

Olympus Flashes & Accessories

Item	New		Mint		Excellent		User
Auto 310					50	35	
F-280	210	175	150	120	115	100	
T-8 Ring Flash 2*	255	185					
T-10 Ring Flash 1*	210	180					
T-18			50	40			
T-20	100	85	65	50	50	40	
T-28 Macro Single 1*	125	100					
T-28 Macro Twin 1*	215	170	90	80			
T-32	210	170	150	125	120	70	
T-45			220	175			
T-45 w/NiCads, chgr			320	280			
T-45 Nicads & chgr	170	120					
T Power Control 1	340	300					
6V Power Pack 2	80	60					
Bounce Grip 1			90	60	55	40	
Bounce Grip 2 (T-20, T-32)	200	170	110	90	90	70	
Shoe 1 (OM-1/2)	25	20			15	10	
Shoe 2 (OM-2 w/310 Flash)	25	20			15	10	
Shoe 3 (OM-2 w/T series Flash)	25	20			15	10	
Shoe 4 (OM-1N/2N)	25	20			15	10	

The T-8 Ring Flash 1 & 2, T-10 Ring Flash 1, T-28 Macro Single and Twin Flash 1's all require either the T Power Control 1 or the 6V Power Pack 2. The 6V Power Pack 2 also powers the Winders 1 and 2.

Olympus Pen

The Olympus Pen SLR, in its various models, is another one of those cameras that is regarded by some people as collectible and by others as a great "user". It has the distinction of being the world's first half-frame 35mm SLR camera. Instead of using a bulky pentaprism, Olympus elected to employ the porroprism method of reflecting light rays, which allowed the design of an almost flat top plate.

All Pen SLRs use a rotary, metal focal-plane shutter that provides speeds from 1 second to 1/500, plus B, and flash sync at all speeds.

Olympus also produced several models of rangefinder Pens with fixed lenses. These are not listed. For more detailed information about Pen SLRs, I highly recommend Peter Dechert's 1988 series on these cameras in *Shutterbug* magazine.

Olympus Pen F. The only model with the gothic F.

Olympus Pen F

Olympus' first 35mm SLR, the Pen F, is the least desirable of the four Pen models from a user standpoint, though it is the camera that founded the Pen's solid reputation. It's the least desirable as a user camera for a couple of reasons: first, it is the oldest of the four models and most likely to be thrashed; second, the FT has a double-stroke film advance mechanism that is prone to mechanical problems. Clean examples remain popular on the used market, mostly due to their collectible value.

Olympus Pen F with external meter.

The Pen F will accept an accessory exposure meter, which clips to the front of the shutter speed dial for non-TTL metering. Flash photography is possible with strobe units only (X sync).

Olympus Pen FT

The Pen FT is the only Pen SLR with a TTL exposure meter. The meter cell is located behind the mirror, which is half-silvered to allow a portion of the light to pass through to the cell. A dimmer viewfinder image is an unavoidable result of this arrangement.

The FT's meter window in the viewfinder has a numerical readout, numbered from 0 to 7. Lenses produced after the release of the FT have a dual aperture scale. One scale has the normal aperture numbers you'd expect to find, the other has the numbers that correspond to those in the viewfinder. By pulling the aperture ring out and rotating it 180 degrees, the user can switch from one scale to another. Earlier lenses will work on the FT, but since they don't have these special numbers engraved on them, the user must resort to guestimation. Your average serious Pen user will ignore the on-board meter and use a hand-held meter instead, since the FT's built-in meter wasn't particularly good even when new and is probably much less than that now. Having said that, though, the prices for the FT listed below are for FTs with working meters. If the meter is inoperative, you should be able to purchase the camera for 25-50% less.

Olympus Pen FT. Note the FT designation on the top plate and the self-timer lever.

Other features new to the FT were a single-stroke film-advance lever, a self-timer and an additional connector for M-class flash bulbs.

Olympus Pen FV

The FV is the same basic camera as the FT, the most important difference being that it doesn't have a built-in meter. This alleviated the necessity of using a half-silvered mirror, so as a direct result the FV's viewfinder is much brighter. Like the F, the FV will accept the clip-on accessory meter. Also like the F, the FV has X sync only.

Olympus Pen F Microscope

As its name suggests, the Pen F Microscope was intended for scientific use. Since the company's inception back in 1920 or so, Olympus has manufactured microscopes. In fact, Olympus started out as a microscope maker exclusively, and was Japan's first. It shouldn't surprise anyone, then, that a maker of microscopes, which also happens to make cameras, would make a microscope camera.

The F Microscope, like the FV, lacks a meter, but like the FT, can use both strobe flash and M-class bulbs. It will take the clip-on accessory meter. It does not have a self-timer. Unique among the Pens, the F Microscope has a focusing screen designed for high-magnification photography, consisting of a plain ground glass screen with a clear center spot. Within the center spot is a fine cross hair.

In the lens listings below, no distinction has been made between F and FT lenses. Price differences range from nonexistent to minor.

While the following camera prices are for bodies without lenses, often you'll find them for sale only with normal lenses, most typically the 38mm f/1.8. Expect to pay $20 to $40 more for a body with lens than the prices listed below.

Olympus Pen SLRs

Camera	Yrs. Made	Mint		Excellent		User
Pen F	1963-66	250	220	200	150	
Pen FT	1966-72	320	280	250	200	
Pen FV	1967-70			280	240	
Pen F Microscope	1966-72			260	210	

Olympus Pen Lenses

Lens	Mint		Excellent		User
20mm f/3.5	395	350	320	250	
25mm f/2.8	370	310	300	250	
25mm f/4	395	325	340	220	
38mm f/1.8	95	80	75	45	
38mm f/2.8 Compact	355	295	290	180	
38mm f/3.5 Macro			395	290	
40mm f/1.4			180	140	
42mm f/1.2	395	270	275	195	
60mm f/1.5			300	260	
70mm f/2	300	260	275	195	
100mm f/3.5			220	150	
150mm f/4	240	210	320	250	
250mm f/5			450	370	
400mm f/6.3			1000+		
800mm f/8 Mirror			1000+		

Both the 400mm and 800mm lenses are rare. The above prices are indicative of this and are estimates, based entirely upon their rarity and collectible value.

	Mint		Excellent		User
50-90 f/3.5 FT	275	230	240	165	
100-200 f/5			350	250	
2X Teleconverter (Vivitar)			50	40	

Pen F Accessories

Item	Mint		Excellent		User
Accessory Shoe			50	25	
External Meter (F & FV)		120	80	50	
Angle Finder	120	70	65	45	
Bellows	130	80	90	50	
Bellows 2	190	150	150	110	
Ext Tube Set			60	45	
Focusing Rail			40	30	
Pen F Camera Slider #2			40	30	
Slide Copier	85	50	40	30	
OM to Pen Adapter			45	35	
T-Mount			40	30	

Pentax

Asahi Optical Company's modern 35mm SLRs have employed two basic lens mount designs, the 42mm screw-mount design originated by Praktica and, beginning in the early 1970's, its own bayonet-mount design. Both designs have become somewhat universal since their introduction. In fact, the Pentax/Praktica 42mm threaded mount is often referred to today as Universal Screw mount.

Several lesser-known camera manufacturers have used both these mounts. I haven't listed any of these cameras, but a few of the more frequently seen names are Chinon, Cosina, Ricoh, Yashica (screw-mount only) and Zenit (screw-mount only). The going used prices for these cameras in good operating condition with normal lenses are usually between $50 and $75. Exceptions would be later model Ricoh and Chinon K-mount SLRs, the top models of which often contain hosts of features, including multiple auto-exposure and metering modes. Sophisticated cameras they are, but even when new, these top-of-the-line models seldom sell for more than about $200, with a lens, and when used they often sell for much less.

Asahi Optical Company's earliest SLRs, the Asahiflexes, are not listed either. These cameras are of limited usefulness to the practicing photographer, mostly because they employ a non-standard screw-mount thread, but also because they are becoming uncommon

due to collecting activity in recent years. Their escalating prices are a reflection of this. Neither have I listed the original Pentax of 1957 or the Pentax K of 1958. They are neither especially common nor collectible, and are of limited usefulness to the practicing photographer these days. Either model is worth about the same as the original Spotmatic in equivalent condition.

Pentax screw-mount cameras and lenses are listed first, followed by the K-type bayonet-mount cameras and lenses.

☐ PENTAX SCREW-MOUNT SLRs

The various Pentax screw-mount cameras and Takumar lenses have a loyal – bordering on fanatical – following. Many a crusty old aficionado would be happy to take you aside and deliver an impromptu lecture on the superior nature of both the cameras and their optics, and will inform you in no uncertain terms that the screw-mount Takumars were the sharpest lenses ever made – by anybody. I say this because I have been the subject of such harangues more than once. Well, I'm still not going to take sides, but I can say with confidence that a screw-mount Takumar will give any modern, computer-designed lens a run for the money in sharpness and contrast – especially the later SMC Takumars. And when these folks talk in glowing terms about their beloved Spotmatics, I can't blame them. The Spotmatic, in its various forms, is proba-

bly the original workhorse and is as reliable as they come.

Screw-mount Pentax cameras officially imported into the U.S. bore the inscription "Honeywell Pentax," and sometimes "Honeywell Heiland Pentax," as a result of a marketing agreement between Asahi Optical Company and Honeywell. Those marketed outside the US were labeled Asahi Pentax.

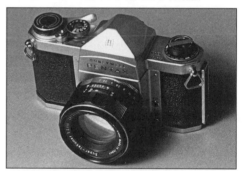

Pentax H1a

Pentax H1a with non-TTL accessory meter attached

Pentax H1, H1a, H2, H3 & H3v

The **H2** preceded both the H1 and H1a models. It features a semi-automatic diaphragm and shutter speeds from 1 second to 1/500. The H3 closely resem-

bles the H2 and was the first Pentax with auto diaphragm operation. The top shutter speed was increased to 1/1000. The **H3v** superceded the **H3**. It's the same camera, but has a self-timer and an automatic-reset film counter. The H1 was released simultaneously with the H3 and also featured an automatic diaphragm. Like the **H2**, its top shutter speed is only 1/500. The **H1a** is an updated model with an automatic reset film counter.

Note: Outside the U.S., these cameras were marketed with "S" prefixes to their model numbers, instead of the "H" prefixes.

The Pentax Spotmatics

The Spotmatic saw a long and successful ten-year production run. The models listed below are the original Spotmatic, the SP500 and SP1000, the Spotmatic II and IIa, the Spotmatic F and the Spotmatic Motor Drive.

The Spotmatic was the first Pentax with a TTL meter. Contrary to what the name seems to imply, it uses a center-weighted averaging system rather than a

spot meter. Employing a CdS cell, the scene is metered at taking apertures by moving a sliding lever on the left side of the camera next to the lens mount. This action both stops down the lens and activates the meter. Shutter speeds range from 1 second to 1/1000, plus B, with X sync at 1/60.

Pentax Spotmatic II

The SP500 is the same basic camera as the Spotmatic, but with a top shutter speed of 1/500 and no self-timer. The SP1000 is the same as the SP500, but has a 1/1000 top shutter speed.

The Spotmatic II is the same as the Spotmatic, but has a hot shoe. The Spotmatic IIa was sort of an oddball

update, with a round flash sensor on the front of the camera, below the rewind lever. The flash sensor was designed to be used with a dedicated Honeywell strobe, but the idea never caught on.

Spotmatic F with SMC Takumar lens

Pentax Spotmatic 1000

The Spotmatic F has all the features of the Spotmatic II, with one big differ-

Pentax Screw–Mount SLRs

While the following prices are for camera bodies only, often they are sold with normal lenses and are not available separately. Despite this, it is not unusual to find screw-mount Pentaxes with normal lenses at close to these same prices.

Camera	Yrs. Made	Mint		Excellent		User	
ES	1972-74	240	190	170	120		
ES II	1973-74	310	245	275	210		
H1	1960-63			100	75		
H1a	1963-71			100	75		
H2	1959-61			100	60		
H3	1960-63			100	60		
H3v	1963-68			125	65		
SP 500	1972-74			125	85		
SP 1000	1974-78			150	100		
Spotmatic	1964-67	175	150	140	100	80	70
Spotmatic II	1971-74	180	150	150	100	85	75
Spotmatic IIa	1972-74			150	100		
Spotmatic F	1972-74	250	185	195	130		
Spotmatic Motor Drive	1972-74			500	350		

w/motor drive, grip, cord

ence: full-aperture metering is possible with SMC Takumar lenses.

The Spotmatic Motor Drive camera is an SP1000 that was factory modified to take the Spotmatic Motor Drive, which powers film advance at speeds up to 2 fps. Incidentally, the motor drive for the Pentax KX and KM Motor Drive cameras can be used on this camera as well.

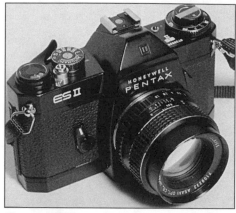

Pentax ES-II

Pentax ES and ES-II

The ES (Electro Spotmatic) was introduced in 1972. It was arguably the first SLR to use integrated microcircuitry. The ES has two exposure modes: Aperture-priority and non-metered manual. Shutter speeds range from 8 seconds to 1/1000 in auto. In manual, only the 1/60-1/1000 mechanical speeds are available. Other features include depth-of-field preview and exposure compensation. The ES provides full aperture metering with SMC Takumar lenses. Earlier Takumars can be used, but metering must be done via the stop-down method.

The ES II is the same as the ES with a few improvements. The battery was relocated to the baseplate. This allowed the addition of a self-timer. An eyepiece shutter was added.

□ TAKUMAR SCREW-MOUNT LENSES

In the lens listings below, the following abbreviations are used: AT = Auto Takumar; T = Takumar; TT = Tele Takumar; ST = Super Takumar; SMCT = Super Multi Coated Takumar. Auto Takumar lenses have a semi-automatic diaphragm; it closes when the exposure is made, but must be manually reset. Takumar lenses and early Tele Takumar have either manual or preset diaphragms. Later Tele Takumars and all Super Takumars use a single diaphragm actuating pin that provides auto diaphragm coupling with cameras that support the feature. The SMC Takumars have two additional registration extensions at the rear of the lens mount. These extra projections communicate the necessary information to those cameras that perform full-aperture metering (the

Takumar Screw-Mount Lenses

Lens	Mint		Excellent		User	
15mm f/3.5 SMCT			400	300		
17mm f/4 Fish Eye ST			250	200		
17mm f/4 Fish Eye SMCT	300	270	260	220		
18mm f/8 Fish Eye		400	250	200		
18mm f/11 Fish Eye ST-M			200	150		
20mm f/2.8 SMCT	350	300				
20mm f/4.5 ST	300	260	270	200		
24mm f/2.8 T			200	200		
24mm f/3.5 ST	160	135				
24mm f/3.5 SMCT			170	125		
28mm f/3.5 ST	90	80	80	65		
28mm f/3.5 SMCT			130	80		
35mm f/2 ST	150	125	125	90		
35mm f/2 SMCT	200	160	170	125		
35mm f/2.3 AT			100	75		
35mm f/3.5 AT			90	65		
35mm f/3.5 ST			70	55		
35mm f/3.5 SMCT			90	70		
35mm f/4 T			55	40		
50mm f/1.4 T			50	30		
50mm f/1.4 ST	65	50	60	40		
50mm f/1.4 SMCT	95	75	75	55		
50mm f/4 T Macro			140	120		
50mm f/4 ST Macro			170	135		
50mm f/4 SMCT Macro	250	200	180	140		
55mm f/1.8 T			35	25		
55mm f/1.8 ST			45	30		

Spotmatic F, ES and ES II). Because the SMC Takumars are the most useful of the Pentax screw-mount lenses, especially when used with the Spotmatic F, ES, or ES II, they often command noticeably higher prices.

Takumar Screw-Mount Lenses (cont'd)

Lens	Mint		Excellent		User	
55mm f/1.8 SMCT			50	30		
55mm f/2 T			30	20		
55mm f/2 ST			40	30		
55mm f/2 SMCT			45	35		
85mm f/1.8 SMCT			250	200		
85mm f/1.9 ST			225	175		
85mm f/1.9 SMCT			250	200		
85mm f/4.5 Ultra-Achromat T			450	300		
100mm f/4 SMCT Macro			250	200		
100mm f/4 T Macro Preset (Bellows)			180		120	
100mm f/4 SMCT Macro Preset (Bellows)			175	125		
105mm f/2.8 T	140	120	110	90		
105mm f/2.8 ST			130	100	90	70
105mm f/2.8 SMCT			125	100		
120mm f/2.8 SMCT	170	150	130	100		
135mm f/2.5 T	100	60	80	50		
135mm f/2.5 ST	130	120	100	70		
135mm f/2.5 SMCT	150	120	130	90		
135mm f/2.8 SMCT			150	150		
135mm f/3.5 T			40	30		
135mm f/3.5 ST	70	55	50	35		
135mm f/3.5 SMCT	75	60	65	50		
150mm f/4 T			90	75		
150mm f/4 ST	150	110	120	90	85	40
150mm f/4 SMCT	150	125	125	100		
200mm f/3.5 T Preset			100	80		
200mm f/4 ST	200	160	120	85		
200mm f/4 SMCT	150	120	125	95		
200mm f/5.6 T Preset			100	70		
300mm f/4 T			290	220		
300mm f/4 ST			300	235		
300mm f/4 SMCT	430	325	325	240		
300mm f/6.3 TT		280	125	85		
400mm f/5.6 TT			350	275		
400mm f/5.6 SMCT			375	300		
500mm f/4.5 T			460	400		
500mm f/4.5 SMCT			500	440		
500mm f/5 T	500	450	425	385		
1000mm f/8 TT			1200	875		
1000mm f/8 SMCT			1450	1025		

Takumar Screw-Mount Zoom Lenses

Lens	Mint		Excellent		User	
45-80 f/4 SMCT			120	80		
45-125 f/4 SMCT	160	125	130	90		
70-150 f/4.5 ST		200	160	130		
85-210 f/4.5 SMCT	350	250	260	180		
135-600 f/6.7 SMCT	1275	950				

Spotmatic Accessories

Item	Mint		Excellent		User	
Spotmatic Motor Drive			250	150		
For Spotmatic, KM and KX Motor Drive cameras only						
Spotmatic 250 Exposure Back			200	180		
Auto Bellows (Screw Mount)			100	80		
Bellows II	80	70				
Slide Copier for Bellows II	50	40				
Screw Mount Auto Ext Tube Set	25	20	20	15		
Screw to Bayonet Adapter	25	15				
Right Angle Finder (K-series, Spotmatic)			55	50		
Magnifier (K-series, Spotmatic)	35	25				
Magnifier 1 (K-series, Spotmatic)	60	40				
Magnifier 2 (K-series, Spotmatic)	75	50				

□ PENTAX K-MOUNT SLRs

In 1973 Pentax released three new camera models, the KM, the KX and the K2, with the advent of their bayonet-mount lens line. This new line of cameras and lenses was produced concurrently with the screw-mount line for about a year before the latter was discontinued. K-mount cameras have evolved steadily since then, while always maintaining their backward compatibility. It is worth noting that Pentax's latest autofocus, picture-taking computers still accept 1973-vintage K-mount lenses, and that only Nikon can make a similar claim. And, while Nikon has made backward compatibility a big selling point for its top-of-the-line F4 and F5, these are the only Nikon AF cameras that can use early Nikon lenses unmodified. Pentax AF cameras have no such limitations, although some auto-exposure functions are lost when using early lenses.

The following listings are in rough chronological order.

Pentax KM & KM Motor Drive, KX & KX Motor Drive

The KM is a Spotmatic F with a bayonet lens mount. Basic features include full-aperture centerweighted TTL metering, shutter speeds from 1 second

to 1/1000, plus B, X sync at 1/60, a depth-of-field preview feature, a hot shoe and a self-timer.

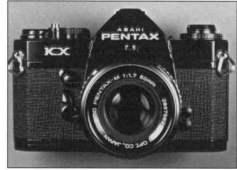

Pentax KX

Intended for the advanced amateur and professional, the KX was the forerunner to the Pentax LX, which inherited a few of its features. Improvements over the KM offered by the KX are such niceties as match-needle metering with full exposure information in the viewfinder and mirror lock-up. All other features of the KM are included on the KX.

Both a KM Motor Drive camera and a KX Motor Drive camera were produced. Both took the same, detachable motor drive. This dedicated motor drive will not work on the standard KM or KX. It provides continuous film winding speeds up to 3 fps. The Spotmatic Motor Drive can be used on these cameras, also.

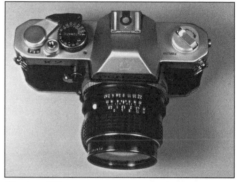

Pentax K2

Pentax K2 & K2DMD

The K2 was an all-new design for Pentax when it was released. For those who were already familiar with the Nikkormat EL, which hit the market the year before, the similarities must have been startling. The K2 is, for all practical purposes, a Nikkormat EL that takes K-mount lenses.

The K2 has two exposure modes: aperture-priority AE and match-needle manual. Electronically-governed shutter speeds range from 8 seconds to 1/1000, plus B, with X sync at 1/125 (B and X sync are mechanical). Other features include exposure compensation, depth-of-field preview, mirror lock-up, a self-timer and a hot shoe.

The K2DMD is a K2 that was designed especially for the K2DMD Motor Drive. It was usually sold as an outfit, which included a bulky watch

databack and the motor. This motor drive will not interchange with the K-series motor drive (for the KM or KX Motor Drive cameras), nor can it be used on a standard K2. The motor provides film advance speeds of 2 fps, 1 fps and 1 frame every two seconds. Clean, used examples of the complete outfit are pricey. With a discount retail price with motor running close to $1,000 when it was introduced in 1976, this was by far Pentax's most expensive camera. This may be why the camera never sold very well.

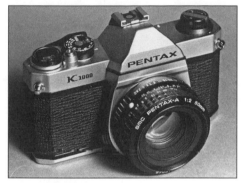

Pentax K1000

Pentax K-1000

The venerable Spotmatic continues to live on, albeit in a somewhat disguised form. The K-1000, like the KM, is a Spotmatic F with a bayonet mount, but with a couple of omitted features: it has no self-timer or depth-of-field preview. Entering its fourteenth year of production and still going strong, the K-1000 is one of the very last of a vanishing breed: a rugged, mechanical, manual exposure only camera. The K-1000 has probably started more beginners down the road toward careers in photography during the past couple of decades than any other camera. Pentax claims it has no intentions of discontinuing the K-1000 as long as sales justify its continued production.

Pentax LX

The discontinued LX is Pentax's former flagship model and often went overlooked when professional quality SLRs were discussed. Its design is simple, straightforward – in a word, elegant. Although compact, it features stout construction and the full array of attributes associated with a professional camera.

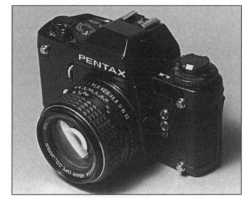

Pentax LX with FA-1 finder

The LX offers a unique system of interchangeable finders, which is just as effective, but much more economical than the traditional accessory finder options offered by Canon and Nikon. Rather than having a different finder for each use, the LX has a system finder base, called the FB-1, to which an action eyepiece, a magnifier eyepiece, or a standard eyepiece can be fitted. For the purists, however, a more traditional magnifier finder and a waist level finder are also available.

The LX has two exposure modes, aperture-priority AE and metered manual, using the centerweighted metering method. The LX can meter down to an extraordinarily dim -6.5 EV – that's 2 minutes at f/1.2 using ISO 100 film! In aperture-priority AE, the LX uses OTF (Off The Film plane) metering, so any change in lighting conditions during long exposures will be factored into the exposure.

The LX is an electro-mechanical hybrid, having electronically controlled shutter speeds from 2 minutes to 1/2000 and mechanically controlled speeds from 1/75 to 1/2000. So if the battery should fail, the user still has shutter speeds from 1/75 (flash sync) to 1/2000 and B at his or her disposal. In the manual mode, speeds from 4 seconds to 1/2000 can be selected.

Other features include TTL flash with dedicated strobe units, interchangeable focusing screens, eyepiece diopter adjustment, depth-of-field preview, mirror lock-up, multiple-exposure capability and a self-timer. The LX will accept either the Motor LX or Winder LX. Either accessory offers motorized film rewind.

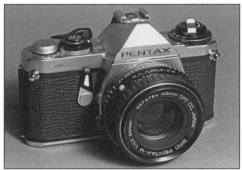

Pentax ME

Pentax ME, ME-F & ME Super

The ME (with the simultaneously-released MX) was Pentax's first entry into the category of downsized SLRs essentially created by Olympus with the release of the OM-1 some five years before. Even smaller than the OM-1, the ME is extremely compact and light, even by today's standards. It has one exposure mode, aperture-priority AE, and exposure compensation. Shutter speeds range from 8 seconds to 1/1000, plus B, with X sync at 1/100 (the latter two are mechanical). Other features include interchangeable focusing screens, a self-timer, a hot shoe and an optional winder for film advance speeds up to 2 fps.

The ME Super has all the above features, plus a few: manual exposure control, a shutter speed range from 4 seconds to 1/2000, flash sync at 1/125 and limited flash AE (auto setting of shutter speed) with dedicated flash units. The addition of these features made the ME Super a very popular camera and it con-

tinues to be a good seller on the used market.

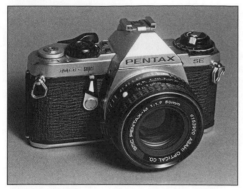

Pentax ME Super

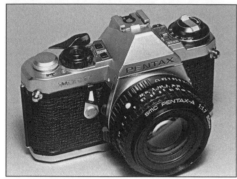

Pentax ME-F

The ME-F is an ME Super with a focus-assist feature, a manual precursor to autofocus technology. When a subject is in focus, a focus confirmation light appears in the viewfinder and, if activated, an alarm will sound.

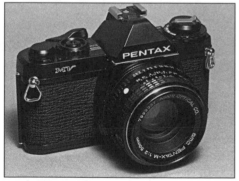

Pentax MV

Pentax MV & MV-1

The MV is essentially a simplified ME. Like the ME, it has aperture-priority AE with no manual mode, but it differs from the ME in that it lacks exposure compensation and winder capability. The MV accepts dedicated flash units for limited flash AE. X sync is a mechanical

1/100. The MV-1 is an MV with a self-timer.

Pentax MX

The MX is the same size as the ME, but is a completely different camera. Designed for the serious student, the advanced amateur, or as a second camera for the working professional, the MX is a lightweight, but durable photographic tool and continues to be a top seller on the used market.

The MX provides manual exposure only, using a counterweighted meter with a match-diode display. The mechanical shutter speeds range from 1 second to 1/1000, plus B, with X sync at 1/60. Other features include interchangeable focusing screens, a self-timer, depth of field preview, a hot shoe and either a winder or motor drive option.

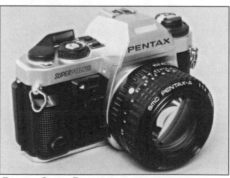

Pentax MX

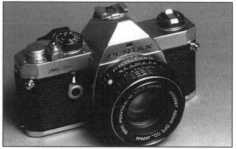

Pentax Super Program

Pentax Program Plus & Super Program

The Super Program features six exposure modes: a standard program mode, aperture-priority and shutter-priority AE, metered manual, TTL flash with dedicated units and Programmed

Auto Flash (non-TTL). Shutter speeds range from 15 seconds to 1/2000, plus B, with X sync at 1/125 (the latter is the only mechanical shutter speed). Other features include exposure compensation, interchangeable focusing screens, a self-timer, depth-of-field preview, and both a winder and a motor drive option.

The Program Plus lacks shutter-pri-

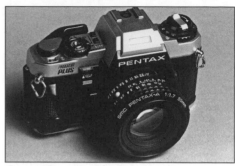

Pentax Program Plus

ority AE and TTL flash capability, but retains the Programmed Auto Flash feature. Shutter speeds range from 15 seconds to 1/1000, plus B, with X sync at 1/100. Other features include exposure compensation, a self-timer, and depth-of-field preview. It has the same winder and motor drive options as the Super Program.

Pentax K-A or later lenses must be used on both the above cameras to engage the program mode, or to engage the shutter-priority mode on the Super Program.

Pentax A3000

The A3000 was designed for people who would rather take pictures than think about taking pictures. Its exposure system features a program mode and aperture priority AE, as well as Programmed Auto Flash (non-TTL). Shutter speeds range from 2 seconds to 1/1000, plus B, with 1/60 flash sync. Other features include exposure compensation, DX film loading with manual override, a self-timer and a built-in motor drive that provides auto film loading and film winding speeds up to 1.5 fps.

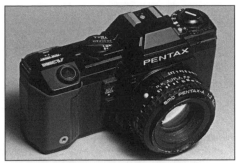

Pentax A3000

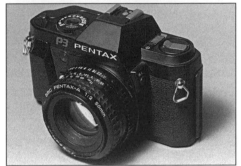

Pentax P3n

Pentax K-A or later lenses must be used to engage the program mode.

Pentax P3 & P3n

The Pentax P3, subsequently superceded by the P3n, is a lot of camera for not a lot of money. Instead of adding a built-in motor (and cost), Pentax elected to leave the P3 and P3n as manual-wind cameras. The P3 has two exposure modes: standard program and metered manual. Shutter speeds range from 1 second to 1/1000, plus B, with X sync at 1/60Programmed Auto Flash (non-TTL) is available with dedicated strobe units. Other basic features include an AE lock, depth-of-field preview and DX film coding.

The P3n has, in addition to the above features, an aperture-priority AE mode, plus a rubberized body.

Pentax K-A or later lenses must be used to engage the program modes on the above cameras.

Pentax P30T

Formerly Pentax's entry level SLR, the P30T nonetheless sports a number of useful features. As with the P3 and P3n, "back to the basics" is a good theme for this camera, but one can select from several auto modes if desired.

Exposure options include program AE, aperture-priority AE, metered manual, and "Programmed Auto Flash", a non-TTL mode where the camera's sync speed is automatically set.

Shutter speeds range from 1 second to 1/1000, plus B. Film is wound and rewound by means of a crank. No built-in motor here. There is no DX film coding, but the camera does have an electronically-controlled 12-second self-timer.

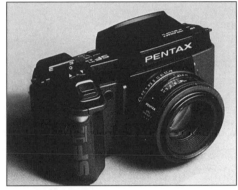

Pentax SF-1

Pentax SF-1 & SF-1n

Pentax's first Autofocus camera, the SF-1 offers a choice of two autofocus modes: single-shot (focus priority) or continuous (servo), plus AF lock.

Exposure modes include a standard program mode, a high speed program mode, a depth of field program mode, aperture and shutter-priority AE, and metered manual. Other exposure features include exposure compensation, autobracketing and an AE lock. TTL flash and auto fill flash are available via the built-in flash unit (GN 14 @ ISO 100) or dedicated accessory strobe units. Shutter speeds range from 30 seconds to 1/2000 (manually set speeds from 1 second to 1/2000), plus B, with X sync at 1/100 (1/60 with non-dedicated units). Other features include interchangeable focusing screens, built-in diopter adjustment, DX film coding, a self-timer with a one to three shot option and a built-in motor that provides auto film loading, advance speeds up to 1.8 fps and auto film rewind.

The Pentax SF-1n is the same camera with souped up shutter speeds. The top shutter speed is 1/4000 and flash sync was boosted to 1/250.

Either the SF-1 or SF-1n can use any K-mount lens. Focus confirmation is provided for with non-AF lenses that have maximum apertures of f/5.6 or greater. All program modes will function with manual focus K-A lenses. When using K-M lenses, only manual and aperture-priority AE are available.

Pentax SF-10

Essentially a scaled down SF-1, the SF-10 offers one autofocus mode: single-shot (focus priority). Exposure modes include program, aperture and shutter-priority AE and metered manual. TTL flash automation and auto fill flash are available with the built-in flash (GN 12 @ ISO 100) or with more powerful, optional dedicated strobe units. Shutter speeds range from 30 seconds to 1/2000 (1 second to 1/2000 in manual), plus B, with X sync at 1/100.

Other features include interchangeable focusing screens, DX film coding and an integral winder that provides auto film loading and rewind. The same restrictions regarding use of non-AF lenses on the SF-1 and SF-1n apply to the SF-10.

Pentax PZ-1 and PZ-1P

Probably the most notable feature that sets the Pentax PZ-1 (and the PZ-10) apart from the SF models is its power zoom feature. When one of the Pentax Intelligent Power Zoom lenses is mounted, four zooming options are available. A slight rotation of the zoom collar causes the lens to zoom from one focal length to another at a slow rate – a useful feature for small framing adjust-

ments. Rotate the zoom collar a little further and the lens zooms at a slightly faster rate. By turning the collar all the way to its stop, the lens zooms at its fastest – useful when quick changes in focal length are desired. Finally, by pulling the zoom collar toward the camera and then turning it, manual zooming is possible.

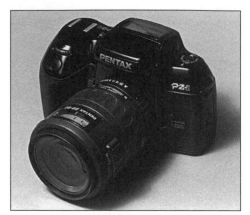

Pentax PZ-1

Several other power-zooming functions are available, including Image-Size Tracking and Zoom Clip. Image-Size Tracking does exactly what the name implies. When this mode is engaged, the lens will track a moving subject and zoom in or out to maintain a constant image size. Zoom Clip allows the user to store up to two predefined focal lengths – a handy feature when concentrating on separate areas of interest, such as home plate and second base at a baseball game. Still another feature is the Zoom Effect mode in which the camera will zoom the lens from one extreme to another during exposure for smooth and spectacular zoomed exposures.

The PZ-1 offers a choice of two autofocus modes: focus-priority (single shot) and continuous (servo). In the continuous mode, focusing switches to predictive focus automatically when subject movement warrants it. Manual focusing with focus confirmation is also available. When using manual-focus lenses, still another focusing option is available, called Snap-in Focus (also known as

Trap Focus). In this mode, the lens is focused on a stationary subject, the shutter button is locked down (with the optional Cable Switch F), and the camera will automatically fire when a moving subject enters the frame at the point of focus.

Exposure modes include a unique feature called Hyper Manual Mode. This can be a manual-exposure mode with full control via the thumb and forefinger driven wheels (one for aperture, one for shutter speeds), or, with the touch of the IF (Interactive Function) button, you can switch to full program mode, called Hyper Program AE. Touching another button activates Memory Lock, which is actually a program shift feature. With the lens moved from the A position, manual exposure is still available, but with depth-of-field preview, if desired. Aperture-priority AE is also available at this setting by touching the IF button. Shutter-priority AE is another option, as is a standard program mode, plus program modes that bias toward high shutter speeds or small apertures. Still another mode, called MTF (for Modular Transfer Function), is available, which first selects the lens' optimum aperture by measuring its highest contrast and then selects a matching shutter speed.

The PZ-1's metering modes include a standard eight-zone evaluative pattern, centerweighted and spot, and will switch automatically depending on lighting conditions. Manual selection of the different patterns is also available.

Shutter speeds range from 30 seconds to 1/8000, plus B, with a maximum X sync of 1/250. Other features include a built-in pop-up TTL flash (GN 45 @ ISO 100), multiple-exposure capability, motorized film advance (up to 3 frames per second) with auto film-loading and rewind, exposure compensation, interchangeable focusing screens, DX film setting with override, an intervalometer and a three-speed self-timer.

Additionally, the PZ-1 comes with 18 "Pentax Functions" that allow the user access various custom settings for further fine tuning of camera operations.

The PZ-1P superceded the PZ-1, and includes several worthwhile refinements. Exposure mode selection was simplified somewhat. Hyper Program and Hper Manual are accessed directly, but the other modes must be accessed through the Pentax Function controls. The built-in TTL flash's maximum lens coverage was expanded from 35mm to 28mm. It also features redeye reduction, "flash control," and second-curtain sync. The built-in winder's continuous frame rate was bumped up from three frames per second to four. The PZ-1P also has a personally programmable setting, called "user," mid-roll "panorama" mode, auto bracketing, flash bracketing, and brighter interchangeable focusing screens. The remaining features are the same as found on the PZ-1.

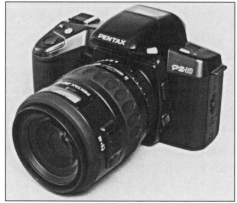

Pentax PZ-10

Pentax PZ-10

The PZ-10 reached the market several months before the PZ-1, but is its less full-featured sibling. It supports the same automated zoom modes found on the PZ-1. Autofocusing modes include the now-standard array of predictive, single-shot and continuous modes. Auto exposure is calculated using a six-segment matrix metering method; centerweighted and spot metering are also available.

Exposure modes include multi-program AE, program AE, shutter-priority AE, and manual. Shutter speeds range from 30 seconds to 1/2000, plus B. The PZ-10 has a built-in pop-up flash that fires automatically when necessary. Dedicated TTL accessory flash units can also be used.

Other features include DX film coding with no override, auto film loading and rewind with the built-in winder, a self-timer, exposure compensation, and an eyepiece with built-in dioptric correction.

Pentax ZX-5 and ZX-5N

Sporting a classic retro look, bedecked with dials and clad in the nouveau chic silver-and-black two-tone color scheme, the ZX-5 is an attractive, lightweight camera that looks simple, but is nevertheless packed with useful features. Autofocusing is accomplished by means of a 3-point AF sensor area that can be switched to an AF spot sensor. AF modes include focus lock and predictive AF.

Pentax's Power Zoom system is accessed when using Pentax FA zoom lenses (see the PZ-1 description for an explanation of this feature).

Exposure modes include program AE, shutter-priority AE, aperture-priority AE, metered manual, and TTL auto flash with the built-in flash (GN 33 in ft. at ISO 100, coverage to 28mm). Auto and manual exposure compensation (± 3 EV in 1/2-setp increments) is also available.

Available metering methods include 6-zone evaluative, centerweighted averaging, and spot.

Shutter speeds range from 30 seconds to 1/2000 second, plus B, with flash sync occuring at 1/100 second. The integral winder will advance the film at the rate of 2 frames per second, and includes auto film advance and rewind. Mid-roll rewind is also possible. Other features include adjustable diopter cor-

rection, a mechicall black-out type panorama frame, DX film coding with override capability, and a self-timer.

The ZX-5N has a few refinements that round out the camera's capabilities nicely. Three new exterior controls were added, otherwise the two cameras appear identical. The improvements are auto-exposure bracketing, AE lock, depth-of-field preview, and an improved selector for switching between wide-area and spot autofocus detection.

Pentax ZX-10

Intended as a camera that a tyro can "grow into," the ZX-10 is simplicity itself in terms of user operation. Its Smart Picture Mode is designed so the camera will select an operating mode from five different Picture Modes (program, lanscape, close-up, action, and portrait) based on subject distance, subject movement, and lens focal length. Of course, the user can also select from these modes manually, as well as shutter- and aperture-priority AE, or metered manual.

The ZX-10 has a 3-sensor predictive AF system, plus its six-zone evaluative meter is linked to the active AF sensor to improve exposure accuracy. The built-in TTL flash features redeye reduction(GN 36 in ft. at ISO 100, covers down to 28mm lenses), plus there is a dedicated hot shoe for larger Pentax flash units.

Shutter speeds range from 30 seconds to 1/2000 second, plus B, with flash sync at 1/100 second. Other features include ± 3 EV exposure compensation, DX film coding with override capability, a self-timer, single frame advance and up to 2 frames per second advance with the integral motor drive, and three-speed power-zooming with Pentax FA lenses.

Pentax ZX-50

Save for its two-tone silver and black color scheme, the ZX-50 appears to be

almost identical to the ZX-10. Intended as Pentax's entry-level AF SLR, it still packs a respectable number of features into its compact and light body. Since the ZX-50 is essentially a simplified ZX-10, rather than relist all the features, only the differences between the two cameras will be addressed.

The ZX-50 has a simplified phase-matching AF sensor that Pentax calls SAFOX V, rather than the three-sensor array found on the ZX-10. The ZX-50 has the same Picture Modes found on the ZX-10, but loses the program AE setting. The ZX-50 loses the power zoom feature as well.

Pentax ZX-M

Looking almost identical to the ZX-5N, the ZX-M moves into the place in the Pentax lineup previously occupied by the K-1000, the final incarnation of the Pentax Spotmatic. Following the same principle that was the hallmark of the K-1000, namely that simplicity is a virtue in and of itself, the ZX-M can be described as a bare-bones camera. But even so, it offers more features than the camera it replaced.

The ZX-M is a manual focus camera, but of course will accept all K-mount Pentax lenses. Exposure modes include program AE, shutter- and aperture-priority AE, plus metered manual. The camera uses a 2-segment metering system for centerweighted averaging metering. Programmed auto flash is available (auto setting of flash sync speed), but there is no TTL capability. Shutter speeds range from 20 seconds to 1/2000, plus B, with flash sync occuring at 1/100 second. The integral winder advances film in single frame and continuous modes at rates up to 2 frames per second. DX film coding with override is there, too. To round out the mix, the camera also includes a depth-of-field preview function and a self-timer.

Pentax K-Mount SLRs

Camera	Yrs. Made	New		Mint		Excellent		User	
A3000	1985-87			160	140	150	120		
K2	1973-82			270	245	150	130	130	120
K2DMD (w/motor and grip)	1976-80					550	500		
K1000	1977-98			175	150	145	95		
K1000SE				125	100	100	85		
KM	1973-78			150	125	120	90		
KM Motor Drive (w/motor)	1973-78					350	300		
KX	1973-78			225	180	185	150		
KX Motor Drive (w/motor)	1973-78					550	400		
LX (w/FA-1 finder)	1980-97			825	795	750	650		
ME, ME SE	1977-81			150	100	100	80		
ME-F						160	120		
ME Super	1979-87			200	180	150	100	110	70
MG				100	75	75	65		
MV	1979-82			125	100	100	80	90	55
MV-1				100	75				
MX	1977-85			220	175	195	150	150	120
P3	1985-89			125	105	125	90		
P3N	1989-			150	120				
P30T	1991-97			180	150				
P5	1988-1989			175	150	140	100		
PZ-1	1991-95			350	325				
PZ-1P	1995-	550	490						
PZ-10	1991-95			265	240				
PZ-20	1994-95			280	265				
Program Plus	1983-86			225	175	175	145		
Super Program	1983-88			290	200	225	150		
SF-1	1988-89			200	175	200	150		
SF-1N	1989-91			250	200	225	170		
SF-10	1988-91			200	180	180	150		
ZX-5	1993-			240	195				
ZX-5N	1998-	360	320						
ZX-10	1997-	295	240						
ZX-50	1998-	220	180						
ZX-M	1998-	200	160						

☐ Pentax K-Mount Lenses

When Pentax introduced its line of bayonet-mount cameras, the line of lenses made to fit these cameras were called SMC-Pentax in an effort to distinguish them from the screw-mount SMC-Takumars. Later, the SMC-Pentax lenses were superceded by the SMC-Pentax M lenses, which were then superceded by the SMC-Pentax A lenses when Pentax introduced the Super Program and Program Plus. Actually, the above state-ment is an over-simplification, since as late as 1985 Pentax was still producing several models of SMC-Pentax and SMC-Pentax M lenses concurrent with its line of SMC-Pentax A lenses. And, just to make things really confusing, a few very late A lenses carry a T suffix in the listings below, short for Takumar-A (it would seem Pentax has come full circle). Of the three above lens styles, only the A lenses have an AE setting, the use of which is necessary to engage the shut-ter-priority and program modes on Pentax SLRs with such features.

To sort out the confusion, the following abbreviations are used in the manual-focus lens listings: A, M, P & T. A = SMC-Pentax A, M = SMC-Pentax M, P = SMC-Pentax and T = a few late-model SMC-Pentax A lenses. A and M lenses with an asterisk after the letter (e.g. A*) incorporate low-dispersion (ED) glass; later A lenses which use low-dispersion glass are labeled A* ED, or, if

they have internal focusing, A* EDIF. Different lens designs sharing the same focal length and apertures are listed separately only when price differences are significant between them.

Pentax autofocus lenses exist in two basic styles, the F-series and FA-series. Both styles are fully compatible with the standard Pentax K-mount and will function as SMC-Pentax A lenses on cameras that support A lens' features. The biggest difference between F and FA lenses is that FA lenses, when used on the Pentax PZ cameras, will support their power-zooming feature.

Pentax K-Mount Manual-Focus Lenses

Lens	New		Mint		Excellent		User	
15mm f/3.5 A/P	1040	900	795	750				
16mm f/2.8 A	520	400						
17mm f/4 Fish-Eye P			275	250	250	200		
18mm f/3.5 P			275	250	225	180		
20mm f/2.8 A	830	700	350	300	290	225		
20mm f/4 M			280	250	200	150		
24mm f/2.8 A					225	180		
24mm f/2.8 P			200	185	170	125		
24mm f/3.5 P			160	140	150	100		
28mm f/2 A	525	450	350	300	275	200		
28mm f/2 M			225	200	225	150		
28mm f/2.8 A			180	100	120	90		
28mm f/2.8 M			125	100	100	80		
28mm f/2.8 T			110	80				
28mm f/3.5 P			75	60	60	45		
28mm f/3.5 Shift	1095	930	675	600	575	450		
30mm f/2.8 P					100	75		
35mm f/2 A			200	170	185	140		
35mm f/2 M					170	130		
35mm f/2.8 A					130	75		
35mm f/2.8 M					90	65		
35mm f/3.5 P					50	35		
40mm f/2.8 M			260	150	170	120		
50mm f/1.2 A/P	735	650	350	300	320	250		
50mm f/1.4 A/M			150	100	120	90		
50mm f/1.7 A/M			60	50	50	40		
50mm f/2 A/M	70	50	45	40	30	25		
50mm f/2.8 A Macro			275	175	170	150		
50mm f/4 M Macro			200	170	165	125		
75mm f/2.8 A			160	125				
85mm f/1.4 A*					450	375		
85mm f/2 M			250	150				
85mm f/2.2 A Soft Focus			200	150				
100mm f/2.8 A/M			190	125	125	100		
100mm f/2.8 A Macro			325	300	230	230		
100mm f/4 A Macro			270	225	220	190		
100mm f/4 M Macro			275	200	210	180		
100mm f/4 Bellows			170	125				
120mm f/2.8 M/P			150	100				
135mm f/1.8 A*			520	450				
135mm f/2.5 P			100	80	75	60		
135mm f/2.8 A			100	80				
135mm f/3.5 M			100	80	40	25		
150mm f/3.5 M			120	100	80	60		

Pentax K-Mount Manual-Focus Lenses (cont'd)

Lens	New		Mint		Excellent		User
200mm f/2.5 P			450	350	350	270	
200mm f/2.8 A* ED	945	800	790	675	650	500	
200mm f/4 A			160	140	130	100	
200mm f/4 M			170	120	125	90	
200mm f/4 A ED Macro			650	500			
300mm f/2.8 A* EDIF			3000	2650			
300mm f/4 A*			550	450			
300mm f/4 M*			500	400			
300mm f/4 P			360	275			
400mm f/2.8 A* EDIF			4450	4000			
400mm f/5.6 A/M			500	450			
500mm f/4.5 P			1450	1000			
600mm f/5.6 A* EDIF			2690	2500	2200	1950	
1000mm f/8 P			1300	1150			
1000mm f/11 Reflex			1000	750			
1200mm f/8 A* EDIF	6700	6000			5750	5000	
2000mm f/13.5 Reflex			5400	5000	4870	4300	
1.4X-S	225	175			125	100	
1.4X-L	340	300	220	180			
2X-A	50	35	35	25			
2X-S	175	120	125	75			
2X-L	380	340	220	180			

Pentax K-Mount Manual-Focus Zoom Lenses

Lens	New		Mint		Excellent		User
24-35 f/3.5 M			160	140			
24-48 f/3.5			180	150			
24-50 f/4 A/M			150	125			
28-50 f/3.5-4.5 M			135	105	115	100	
28-80 f/3.5-4.5 A			125	90			
28-80 f/3.5-4.5 T							
28-135 f/4 A			450	325	300	250	
35-70 f/2.8 AF			150	100	120	100	

The 35-70 f/2.8 AF provides autofocus with the ME-F only

Lens	New		Mint		Excellent		User
35-70 f/2.8-3.5 M					150	140	
35-70 f/3.5-4.5 A			130	110	125	100	
35-70 f/4 A					150	120	
35-80 T			120	85			
35-105 f/3.5 A			225	200	200	145	
35-135 f/3.5-4.5 A			250	200			
35-210 f/3.5-4.5 A			350	300			
40-80 f/2.8-4 M			170	100	105	90	
45-125 f/4 P			160	125	130	90	
70-200 f/4 T			125	90			
70-210 f/4 A			210	185	170	125	
75-150 f/4 M			175	150	140	100	
80-200 f/4.5 M			170	150	150	120	
80-200 T			140	100			
135-600 f/6.7 P			1275	950	1025	700	
400-600 f/8-12 Reflex			650	600	550	500	

Pentax F-Series Autofocus Lenses

Lens	New	Mint	Excellent	User
28mm f/2.8		110 90		
50mm f/1.2		250 200		
50mm f/1.4		125 100		
50mm f/1.7		55 50		
50mm f/2.8 Macro		225 185		
85mm f/2.8 Soft Focus		240 200		
100mm f/2.8 Macro		275 250		
135mm f/2.8		125 100		
300mm f/4.5 EDIF		550 500		
600mm f/4 EDIF		3800 3200		
1.7X (Autofocus w/K-A lenses)		90 50		

Pentax F-Series Autofocus Zoom Lenses

Lens	New	Mint	Excellent	User
17-28 f/3.5-4.5 Fisheye Zoom	470 410			
24-50 f/4		250 200		
28-80 f/3.5-4.5 T		130 100		
28-80 f/3.5-4.5		220 200		
28-85 f/4		250 225		
35-70 f/3.5-4.5		110 80		
35-80 f/4-5.6		120 90		
35-105 f/3.5-4.5		160 130		
35-135 f/3.5-4.5		225 200		
35-210 f/4-5.6		360 325		
70-200 f/4.5 T		125 100		
70-210 f/4.5-5.6		160 125		
80-200 f/4.7-5.6	170 130			
250-600 f/5.6 EDIF		4000 3650		

Pentax FA-Series Autofocus Lenses

Lens	New	Mint	Excellent	User
20mm f/2.8	545 480			
24mm f/2 Aspherical	455 410			
28mm f/2.8	240 175			
28mm f/2.8 SF	380 345			
43mm f/1.9	445 400			
50mm f/1.4	210 175			
50mm f/1.7	150 125			
50mm f/2.8 Macro	385 330			
85mm f/1.4	950 750			
85mm f/2.8 SF	425 380			
100mm f/2.8 Macro	595 500			
135mm f/2.8 IF	420 305			
200mm f/2.8	1310 1100			
300mm f/2.8	4650 4000			
400mm f/5.6 ED	1350 1200			
300mm f/4.5 ED	900 760			
600mm f/4 EDIF	6450 5995			
1.7X Teleconverter PZ	120 90			
2X Teleconverter PZ	150 130			

Pentax LX System Accessories

Item	New		Mint		Excellent		User
Motor Drive LX (w/cord)	820	700	450	350	350	295	
Motor Drive LX (w/NiCads/chgr/cord)		1100	1000	600	450	440	350
Winder LX	615	550	350	295	300	245	
Motor Drive Grip M	185	145					
Remote Cord (Winder/MD LX)							
Nicad Batt Pack LX (w/chgr)			120	95			
Dial Data Back			75	50			
Watch Data Back			195	160			
LX 250 Exp Back			350	250	280	180	

Other Pentax Accessories

Item	New		Mint		Excellent		User
Generic winder (not Pentax)	60	50	35	30			
K-series Motor Drive (w/grip)					250	150	
For KM, KX and Spotmatic Motor Drive cameras only							
K2DMD Motor Drive (w/grip)					275	200	
For K2DMD camera only							
Motor Drive A			200	140	150	110	
For Program Plus, Super Program							
MD Grip II					35	25	
ME Winder			90	60	55	50	
ME II Winder					95	75	
Fits ME, ME Super, MEF, MG, MV1, Program Plus, Super Program							
MX Motor					275	225	
MX Winder			140	95	125	80	
MX 250 Exp Back			250	200	200	150	
Dial Data Back (ME, MX)					60	50	
Digital Data Back M			100	80			
Fits ME Super, ME-F, MG, Super Program, Program Plus							
Interval Data Back F (SF-1/1N/10)	120	90	75	60			
Data Back F (SF-1)	120	90	75	60			
Data Back FB (SF-1/1N/10)	130	110					
Data Back FC	110	90					
Data Back FD	130	110					
Data Back FE	130	110					
Data Back FJ (ZX-M)	50	35					
IR Remote Control Set			175	150			
K-Mount Ext Tube Set	140	110					
Helicoid Tube	120	90					
Auto Ext Tube Set			95	75			
Auto Bellows A	350	300	170	140			
Slide Copier A	140	110					
Macro Focusing Rail III	180	150					
Right Angle Finder A	160	130	95	70			
Right Angle Finder (K series, Spotmatic)					55	50	
Magnifier (K-series, Spotmatic)			35	25			

Other Pentax Accessories (cont'd)

Item	New		Mint		Excellent		User
Magnifier 1 (K-series, Spotmatic)			60	40			
Magnifier 2 (K-series, Spotmatic)			75	50			
Magnifier F (SF-1/SF-1n/SF-10)	55	50					
Magnifier M (M-series, Prog +, Sup. Prog)					45	35	
Stereo Adapter & Viewer	310	260					
Screw-Mount lens to K-Mount adapter		35	25				
Pentax 6x7 lens to K-Mount adapter		120	100				

Pentax Flashes

Item	New		Mint		Excellent		User
AF-14		25					
AF-080C Macro Flash	320	250	175	150			
AF-140 C Macro Flash	395	340					
AF-160					30	15	
AF-160S					20	15	
AF-160SA	40	30	20	15			
AF-200S			40	30			
AF-200SA			50	40	40	30	
AF-200T	90	70	75	60	65	50	
AF-201SA	65	40					
AF-240FT (Autofocus)	110	90					
AF-240Z			50	30			
AF-260 SA	95	60					
AF-280T	170	140	100	80	90	70	
AF-330FTZ	165	140					
AF-400FTZ (Autofocus)	295	265	180	150			
AF-400T Set	390	345	290	245			
510v Power Pack (AF-400T)	180	130					
Transistor Power Pack (AF400T)	165	120					
AF-500 FTZ (Autofocus)	350	280					

Underwater Cameras and Equipment

☐ NIKONOS

The forerunner to the Nikonos was developed by Jacques Cousteau and was called, appropriately enough, the Calypso. The Calypso was the first camera designed for underwater use without a housing. Nikon liked Cousteau's design so much, they bought the company. Enter the Nikonos I, which was basically the same camera and which led to Nikon's domination of the underwater camera market. The Calypso is not included in these listings, since it isn't really a Nikon and because it's an uncommon camera. According to the collector guides, the Calypso with an original lens should sell for about the same as a Nikonos I with lens, which in my estimation is underpriced. If you run across a clean Calypso for a reasonable price, buy it and stash it away. It'll be better than money in the bank at today's interest rates.

Mechanical Nikonos Cameras

The Nikonos models I, II and III are mechanical cameras. The Nikonos I is essentially a Calypso, but rather than using any of the several French-made optics available, Nikon developed its own lenses for this camera. The Nikonos II features minor improvements over the I, mostly in the way the film is rewound. The Nikonos III is the most popular, by far, of these three and remains in high demand. It features a single-stroke film advance mechanism (the previous mod-

els were double-stroke) and an improved film loading design. Non-TTL flash automation is possible with the model III when using the SB-102 underwater strobe and the SU-101 sensor unit.

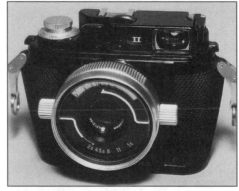
Nikonos II

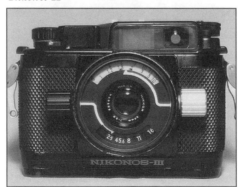
Nikonos III

Electronic Nikonos Cameras

The Nikonos IVa is the first electronic Nikonos and is battery-dependent. It has a TTL light meter and offers aperture-priority exposure only. Non-TTL flash automation is possible when using the SB-101 or the SB-102 strobes with the SU-101 sensor unit.

The Nikonos V is an electronic, battery-dependent camera also, but has a manual mode in addition to aperture-priority AE and provides TTL flash metering when used with the SB-102 or the SB-103.

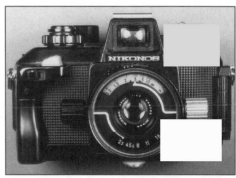
Nikonos IVa

Nikonos V

Nikonos RS

I guess anyone involved with underwater photography knew it had to happen. For the last thirty years, the state of the art of underwater photography has been defined by the Nikonos – a camera with no rangefinder coupling between body and lens, primitive image framing, no motorized film transport and a pauci-

ty of exposure options. For the fortunate few who can afford to invest in a system that would make Hasselblad owners gag, there is finally an alternative.

If the RS were designed for above-water use it would be just another auto-focus SLR. But because it is an underwater camera, its features set it in a category by itself. Like many current above-water SLRs, the RS features ergonomic styling, but unlike the others its styling was designed specifically with underwater use in mind. Its large, contoured, O-ring-sealed body can withstand depths to 300 feet. All control knobs are oversized and can be operated easily with gloved hands. The viewfinder an action finder type, which provides 60mm of eye relief at a nine degree offset angle for easier viewing through a diver's mask.

Five separate focusing modes are available, four of which are selected by rotating a knob on the viewfinder. The modes are: Single-Servo Autofocus (S) with focus lock, Continuous-Servo Autofocus (C), Power Manual Focus (P), Freeze Focus (F), and Focus

Tracking (activated in S & C modes).

Like the Nikonos V, the RS has two exposure modes: aperture-priority AE and manual, but that's where the similarity ends. The RS employs Nikon's tried-and-true five-segment matrix metering pattern in the aperture-priority mode, and 75/25 centerweighted metering in the manual mode, plus exposure compensation. When using the SB-104 strobe (GN of 105 above water, 53 below water, @ ISO 100), a variety of flash-exposure options are available, including matrix-balanced fill-flash, centerweighted TTL flash, variable-power manual flash and second-curtain flash sync (when set for centerweighted TTL). Shutter speeds range from 1 second to 1/2000, plus B, with X sync at 1/125. The RS' integral single-shot film winder offers auto film loading and manually-activated rewind. DX film coding is available, as is the ability to override it.

Currently only three lenses are available for the RS: a 28mm f/2.8, a 50mm f/2.8 Micro and a 20-35 f/2.8 zoom. These lenses use a new double-bayonet

mount that is both airtight and water-tight, and which is not compatible with any other Nikon mount. Each lens has a permanently-attached rubberized hood, but lacks both the aperture and focusing knobs found on other underwater Nikkor lenses. Apertures are set on the camera body, and manual focusing is done by moving a sliding lever below the shutter release. The 28mm and the 20-35mm zoom are underwater lenses only; the 50mm Micro can be used both above and under water.

Does the advent of the RS and its impressive line of lenses and accessories spell the demise of the Nikonos V? Hardly. This is a very expensive and very large system. The camera body alone weighs over 4 1/2 pounds and makes the Nikon F4 seem lightweight by comparison. Demand for the much smaller and cheaper Nikonos V should continue to remain strong as it appeals to photographers who don't need the extensive capabilities of the RS system.

Nikonos Cameras

Camera	Yrs. Made	New		Mint		Excellent		User	
I	1963-68					115	90		
II	1968-75			200	175	180	150		
III	1975-81			595	450	425	3600		
IVa	1980-85					250	210		
V	1984-	685	590	500	450	425	345		
RS	1992-	3100	2895						

Nikonos Cameras with Lenses

Camera	New		Mint		Excellent		User	
I w/35mm f/2.5					200	150		
II w/35mm f/2.5			300	275	250	175		
III w/35mm f/2.5					550	450		
IVa w/35mm f/2.5			400	350	325	275		
V w/35mm f/2.5	880	750	600	550	500	425		

Nikonos Lenses & Accessories

The 15mm and 20mm lenses are for underwater use only. The 28mm focal length exists in both an above-water (LW) and a below-water (UW) design. The 35mm and 80mm lenses can be used either above or below water.

Item	New		Mint		Excellent		User	
15mm f/2.8 w/DF-11 Finder	1950	1450	1270	1200				
20mm f/2.8	850	690	625	580				
28mm f/2.8 LW			320	250				
28mm f/3.5 UW	440	340						
35mm f/2.5	200	165	125	95	85	75		
80mm f/4	440	345	290	250	230	180		
15mm Optical Finder	440	380						
DF-10 Optical Finder (80mm)	100	90	60	50				
DF-11 Optical Finder (15mm)	320	260						
DF-12 Optical Finder (20 & 28mm)	200	160	150	125				
28mm Frame Finder	20	15						
35mm/80mm Frame Finder	25	20						
SB-101 Speedlight			250	195				
SB-102 Speedlight	1100	950						
SB-103 Speedlight	660	550						
SB-105 Speedlight								
SU-101 Sensor	165	120						
Double Bracket Set #10201 (SB102/3)		380	300					
Sensor Holder #10202 (SB102/3)	80	65						
Extension Arm Set #10203 (SB102/3)		185	135					
Double TTL Sync Cord #10204 (SB102/3)	165	135						
On-Land TTL Sync Cord #10205 (SB102/3)	95	85						
Single Sync Cord (SB102/3)	90	80						
Nikonos Close-up Outfit w/case	340	260	240	200				

Nikonos R-UW AF Nikkor Lenses and RS Accessories

Item	New		Mint		Excellent		User	
13mm f/2.8	2450	2100						
20-35 f/2.8	3550	2995						
28mm f/2.8	850	750						
50mm f/2.8	1400	1250						
SB-104 Speedlight	1400	1250						
SK-104 Bracket System (for SB-104)		220	170					
SK-104W Double Bracket System (for SB-104)	280	200						
SH-104 Quick Charger (for SN-104 NiCad Pack)								
SN-104 NiCad Pack (for SB-104)								

Ikelite Accessories for Nikonos

Item	New		Mint	Excellent	User
Ikelite Ext Tube set	120	100			
Ikelite Optical Finder #5002	140	120			
3942.35 Substrobe MS Kit	250	210			
3942.42 Substrobe MV Kit	340	290			
3943.43 Substrobe "50" Kit	460	400			
3945.42 Substrobe MV Kit	400	340			

Ikelite Accessories for Nikonos

Ikelite has been making underwater accessories for years. Probably best known for their sturdy acrylic underwater housings, they are also makers of high-quality underwater strobes. The strobes listed below are the same as those in the Ikelite listings, but are in complete kits for use with Nikonos cameras. For detailed information on these strobe units, refer to the descriptions under the separate Ikelite listing by name rather than model number (e.g., Substrobe MS or Substrobe 225 NiCad).

Item	New		Mint		Excellent		User
3945.46 Substrobe AI Kit	590	495					
3945.47 Substrobe AI/N Kit	580	490					
3945.48 Substrobe 100 Alkaline	620	525					
3945.49 150 D Kit	700	570					
3945.52 150 Nicad Kit	850	695					
3945.56 225 Nicad Kit	920	775					
3945.56 Substrobe 300 Kit	995	860					
3945.57 Substrobe 300 Kit	985	850					
3946.43 Substrobe "50" Kit	540	460					
3946.46 Substrobe "50" Kit	650	570					
3946.62 Substrobe 200 Kit	1140	1000					

Sea & Sea Accessories for Nikonos

Sea & Sea makes four prime lenses for Nikonos cameras, as well as a 16mm conversion lens that will fit on to the front of the Nikonos 35mm f/2.5, and strobes for Nikonos. The strobes must have adapters for Nikonos in order to be used. The YS 50TTL will provide TTL flash automation with the Nikonos V and a TTL flash adapter.

Item	New		Mint		Excellent		User
SWL-16 16mm Conversion Lens	450	345					
12mm f/3.5 Fisheye	1135	950					
WL-15 15mm f/3.5	920	850					
WL-17 17mm f/3.5			500	440			
WL-20 20mm f/3.5	630	565					
Optical FInder (12mm)	450	375					
Optical FInder (15mm)	150	115					
Optical Finder (16mm, 17mm, 20mm)	125	85					
28mm 1:2 Extension Tube	65	55					
35mm 1:1 Extension Tube	65	55					
35mm 1:2 Extension Tube	65	55					
35mm 1:3 Extension Tube	65	55					
YS 50TTL Strobe					200	175	
YS 120 Strobe	750	675					
YS 200 Strobe			500	470			
YS 300 Strobe	1125	900					

Other Accessories for Nikonos

Item	New		Mint		Excellent		User
Close-Up Kit (various makes)					190	150	
Sunpak Marine 32 Strobe			150	100			
Sunpak Marine 2400 Strobe	300	350					

□ SEA & SEA

A relative newcomer to the underwater game, Sea & Sea is making inroads into territory previously enjoyed almost exclusively by the champ, Nikonos. The Motormarine cameras are not as full-featured in some respects as the Nikonos, but they do pack a lot of capabilities into small, easy-to-use packages. And, when comparing their prices and features to Nikonos, they become very tempting alternatives, indeed.

The discontinued Motormarine I was made in two versions. The standard Motormarine I features an integral film winder, a built-in 35mm f/3.5 lens, a built-in flash and aperture-priority AE. The deluxe version has a bulkhead flash connector for attaching auxiliary flash units. The Motormarine II offers all the features of the deluxe Motormarine I, plus a built-in close-up lens, TTL flash

exposure with the built-in flash and with the YS-50TTL optional flash unit, manual exposure control and DX film coding. It has a fixed shutter speed of 1/100 second and apertures ranging from f/3.5 to f/22. The latest Motormarine camera, the Motormarine MX-10, replaces the Motormarine I. It features aperture-priority AE, a fixed 32mm f/4.5 lens, motorized film advance and rewind, a built-in flash, and a unique wireless infrared connector for the handle-mount YS-40 flash. It has a fixed shutter speed of 1/100 and an aperture range of f/4.5 to f/22.

□ IKELITE UNDERWATER HOUSINGS AND STROBES

If you're interested in underwater photography and you already have a favorite 35mm camera and a nice array of lenses, the acrylic underwater housings

Ikelite makes may be just what you're looking for. A typical Ikelite underwater housing is tailored for a specific camera make and model and is good for depths up to 150 feet. It's designed so that the camera will fit snugly within and couple to the exterior via a collection of linkages and gears. Ikelite also makes a universal model underwater housing that can be adapted for use with most SLRs. All normal operation is retained, such as focusing, aperture and shutter-speed selection, film advance and, of course, shutter release.

Underwater strobes built by Ikelite are offered in a wide variety of models to suit most any underwater photographic need. Following is a brief explanation of current models and their features. Most all the following models are also available in kits tailored specifically for use with Nikonos cameras (see Ikelite listings

Sea & Sea Cameras, Lenses & Accessories

In the following descriptions, (I), (II) and (MX10) indicate which cameras they fit.

Item	New		Mint		Excellent	User
Motormarine I			150	130		
Motormarine I (w/bulkhead)			200	175		
Motormarine I 35 SE			245	200		
Motormarine II	625	555	400	350		
Motormarine II w/YS-60 strobe	1075	950	400	350		
Motormarine II Explorer Kit			1000	950		
Motormarine II Endeavor Kit			1400	1200		
Motormarine II 355 E			400	340		
Motormarine MX-10	420	345				
Motormarine MX-10 w/YS-40 flash		620	525			
Close-Up Lens (I)			50	45		
Macro Lens (I)			80	70		
Macro Lens (II)	180	135				
SWL-16 16mm Conversion Lens (I)			225	200		
SWL-16-II 16mm Conversion Lens (II)		380	290			
SWL-20-II 20mm Conversion Lens (II)		395	305			
20mm Conversion Lens (MX20)	250	190				
Optical Finder (15mm/20mm/35mm)		315	265			
Optical Finder (20mm/28mm/35mm)		135	195			
YS 20 Strobe (I)	235	180				
YS 40 (MX10)	210	150				
YS 50ms w/arm, tray (I)			250	200		
YS 50TTL-II w/arm, tray (II)	470	400				
YS120	725	675				
YS 200m III (II)	700	550				
YS 300	995	900				

under Nikonos). All guide numbers are given in feet at ISO 100.

The 4038.7 Substrobe S is a Slave unit for use with the Sea & Sea Motormarine I (bulkhead model). The 4040.5 Substrobe MS is a Manual strobe with Slave (hence the MS) with a surface guide number of 92 and an underwater guide number of 24. The 4042 Substrobe MV is almost the same unit as the Substrobe MS, with the same light output, but it features TTL flash operation with the Nikonos V, the Sea & Sea Motormarine II and TTL SLRs. The 4046 Substrobe AI features TTL and

manual flash for the above-mentioned cameras, with an adjustable coverage angle. It's rated at a surface guide number of 105-120 and an underwater guide number of 28-34, depending on the selected coverage angle. The 4049 Substrobe 150 D and the 4050 Substrobe 150 NiCad are the same strobe units with different power supplies. Both feature a surface guide number of 120 and an underwater guide number of 34, and a modeling light, TTL flash operation with the Nikonos V, the Sea & Sea Motormarine II and TTL SLRs, plus manual and slave operation.

The 4056 Substrobe 225 NiCad has all the features of the Substrobe 150 with a boosted light output. The surface guide number is 145 and the underwater guide number is 40.

Lens coverages for the some of the above-mentioned strobes are: down to 28mm for the Substrobe MS and MV; down to 15mm with a Nikonos or 20mm with SLRs for the Substrobe AI; down to 15mm with the Nikonos or 18mm with SLRs for the Substrobe 150D, 150 NiCad or 225 NiCad.

Ikelite Underwater Housings & Strobes

Item	New		Mint	Excellent		User
Most Housings w/Super Eye	495	440		250	150	
Most Housings w/Dome Kit	620	550		350	250	
Most Housings for AF SLRs	625	565		350	250	
4038.7 Substrobe S	150	100				
4040.5 Substrobe MS	200	135				
4042 Substrobe MV	225	165				
4043 Substrobe 50	335	255				
4046 Substrobe AI	370	315				
4046 Substrobe 100A	420	360				
4047 Substrobe AI/N	390	330				
4048 Substrobe 100	345	285				
4049 Substrobe 150 D	450	380				
4050 Substrobe 150 Nicad	575	490				
4056 Substrobe 225 Nicad	640	560				
4058 Substrobe 400	780	720				
4062 Substrobe 200	730	680				
Substrobe 300 Nicad	780	670				
Substrobe 505 w/slave	285	220				
3949.46 Substrobe AI Kit	500	400				
3949.47 Substrobe AI/N	490	430				
3949.48 100 Alkaline Kit		440				
3949.49 150 D Alkaline Kit	550	500				
3949.52 150 Nicad Kit	630	580				
3949.56 225 Nicad Kit	730	665				

Aftermarket Lenses

The listings below have been confined to independently manufactured lenses that are considered to be close to, as good as, and in some cases superior to lenses produced or marketed by camera manufacturers. One usually pays a premium for lenses that carry the same brand name as that of his or her camera. For those less label-conscious individuals, optics produced by the better independents can represent a real value.

☐ ANGENIEUX

I've chosen these lenses from Angenieux because of Angenieux's long-standing reputation as a producer of superb optics. These lenses are uncommon and expensive. The 180 f/2.3 and 200 f/2.8 are available in mounts for Leica, Nikon, Canon and Contax/Yashica only. The zooms are available for Leica, Nikon, Canon, Contax/Yashica, Minolta, Olympus and Pentax K. Expect to pay a $200 to $300 premium for new lenses with mounts for R-series Leicas.

☐ CENTURY PRECISION OPTICS

Something of a rarity today, Century Precision Optics is a company that offers lenses manufactured right here in the U.S. Shortly after World War II, Century Precision Optics began to manufacture telephoto lenses for 16mm movie cameras and offer a wide variety of custom work for the motion picture industry. The demand for Century optics and services grew steadily during the 1950's and 1960's, and as the demand grew they began to offer a progressively more extensive line of high-quality lenses for 16mm and 35mm movie cameras.

Meanwhile, a few wildlife and surf photographers, who were looking around for high-quality, long telephoto lenses to use on 35mm SLRs, stumbled upon the Century telephotos. Back in

Angenieux Lenses

Lens	New		Mint		Excellent		User
180mm f/2.3 APO	1500	1300	1200	950			
200mm f/2.8 ED	1000	800					
28-70 f/2.6	1500	1300					
35-70 f/2.5-3.3			725	650	600	400	
70-210 f/3.5	1300	1000	850	650	600	495	

Century Tele-Athenar II Telephotos

Lens	New	Mint	Excellent		User
230mm f/2.8	1750		875	440	
300mm f/3.2 *	1750		875	440	
385mm f/4.5 *	925		465	230	
500mm f/3.8	2950		1500	740	
500mm f/5.6 *	950		480	240	
600mm f/4.5	2750		1375	690	
650mm f/6.8 *	975		490	245	
800mm f/4.7	4500		2250	1125	
1000mm f/5.6	4750		2375	1190	
1000mm f/8 *	2850		1425	715	
1200mm f/6.8	4950		2480	1240	

Kiron Lenses

Lens	New	Mint		Excellent		User
24mm f/2		100	80			
28mm f/2				110	75	
105mm f/2.8 Macro		185	160	175	150	
28-70 f/3.5-4.5		125	80	90	60	
28-85 f/2.8-3.8		140	100			
28-105 f/3.2-4.5		160	125	110	80	
28-210 f/4-5.6		150	125	110	85	
30-80 f/3.5-4.5				75	50	
35-105 f/3.5-4.5				110	85	
35-135 f/3.5-4.5				140	90	
70-150 f/4		75	50			
70-210 f/4		140	100	120	80	
80-200 f/4				100	65	
80-200 f/4.5		70	60	55	40	
1.5X		40	30			
2X				30	25	
2X 7-Element		80	50			

the 1960's and early-to-mid 1970's, super telephotos were scarce and expensive commodities. In those days, Century's line of long telephotos was optically second to none, but priced very competitively. What followed was a word-of-mouth, sideline business that has continued to this day in which Century sells their telephotos on a factory-direct basis to still photographers.

A Century telephoto lens consists of a coated, well-corrected achromatic doublet, mounted in a sturdy, aluminum tube. There is no linkage between lens and camera, so TTL metering must be done using the stop-down method. All Century telephotos employ the T-mount system, and can be used on any camera for which a T-mount is made. They come in two styles, the Tele-Athenar and the Tele-Athenar II. The main difference between the two is that the standard Tele-Athenar uses a rotating focusing mechanism (the entire tube forward of the focusing collar rotates), whereas the Tele-Athenar II employs the more traditional (for us still photographers) non-rotating focusing mechanism. Either will work for 35mm applications,

but the Tele-Athenar II is better suited for still photography.

Tele-Athenar II's come in a wide range of focal lengths and f/ratios, from a 230mm f/2.8 to a 1200mm f/6.8. While the entire line of Tele-Athenar II's is listed below, those best suited for 35mm still photography have asterisks following their aperture numbers.

The new prices listed below are factory-direct. The lenses are available on a special-order basis through camera dealers, but only one new price is shown for each focal length because Century offers only small discounts to dealers. The used prices were based on a discussion with Bill Turner, Century's executive vice-president, who estimates that these lenses usually resell at about 25% to 50% of their new prices. If you would like more information about Century's full line of lenses and custom services for both still and movie applications, their address is 10713 Burbank Blvd., North Hollywood, CA 91601. Their phone number is (818) 766-3715.

Lenses in black finish are made for civilian applications; those in a white finish were sold originally for government use.

□ KIRON

You may already be aware that Kiron is one of the manufacturers that makes lenses for Vivitar. This doesn't mean that a Kiron lens and a Vivitar lens of equivalent focal lengths are the same; they are not – or at least they're not supposed to be. Kiron makes lenses for Vivitar as per Vivitar's own exacting specifications.

Kiron lenses are no longer officially imported into the United States. Speculation is that a somewhat severe conflict of interests on Kiron's part (that is, some of their lenses were becoming a little too similar to Vivitar's) led to this cessation. Having said that, though, lenses that were marketed under their own trademark were generally high quality optics.

□ SIGMA

Sigma lenses, especially those in the APO line, have always been a good value. The APO Sigmas are reported to be tack sharp, providing great color and contrast. (APO stands for apo-chromatic, a design which eliminates chromatic and other unwanted aberrations).

Sigma Manual Focus Lenses

Lens	New		Mint		Excellent		User
8mm f/4 Fisheye	720	650	295	200	185	150	
12mm f/8					150	120	
14mm f/3.5	660	600					
15mm f/2.8	510	440					
16mm f/2.8			250	200	190	150	
18mm f/2.8					250	200	
18mm f/3.2					125	100	
18mm f/3.5			300	250			
24mm f/2.8	220	165			120	90	
28mm f/1.8 Aspherical I, !!	220	165					
28mm f/2.8			70	50			
35mm f/2.8					40	30	
50mm f/2.8 Macro			170	140			
90mm f/2.8 Macro			250	220			
135mm f/2.8			50	35			
135mm f/3.5			40	25			
180mm f/2.8 APO Macro	780	600					
180mm f/5.6 APO Macro	350	280					
200mm f/2.8					140	100	
200mm f/3.5					60	50	
200mm f/4			55	50	45	40	
300mm f/2.8 APO	2450	2200					
400mm f/5.6			200	150			
400mm f/5.6 APO	630	500	420	390			
400mm f/5.6 Mirror			190	170			
500mm f/4 Mirror			600	550			
500mm f/4.5 APO	3350	3000			2400	1950	
500mm f/7.2 APO	610	550					
500mm f/8 Mirror					150	125	
600mm f/8 Mirror	400	300	310	280	260	230	
1000mm f/8 APO			2200	1750			
1000mm f/13.5			275	250			
18-35 f/3.5-4.5	380	340					
21-35 f/3.5-4.2	310	250	280	240	225	180	
24-50 f/4-5.6			150	120			
24-70 f/3.5-5.6	190	150					
28-70 f/2.8			250	225			
28-70 f/2.8-4 UC	145	110					
28-70 f/3.5-4.5			95	85			
28-80 f/3.5-4.5					125	75	
28-85 f/3.5-4.5					85	70	
28-105 f/4-5.6 UC			205	150			
28-200 f/3.8-5.6 UC			200	180			
28-200 f/4-5.6			175	140			
35-70 f/2.8-4			100	80	75	60	
35-70 f/3.5-4.5			75	50			
35-70 f/3.5-4.5 UC			100	85			
35-80 f/4-5.6			100	80			
35-105 f/3.5-4.5					90	75	
35-135 f/3.5-4.5			110	90	95	60	

Sigma Manual Focus Lenses (cont'd)

Lens	New		Mint		Excellent		User	
35-135 f/4-5.6 UC			150	125				
35-200 f/4-5.6			140	120				
39-80 f/3.5			80	50				
50-200 f/3.5 APO			185	150				
50-250 f/3.5-4.5 APO			215	190				
55-200 f/4-5.6			120	100				
60-200 f/4-5.6			90	75				
70-150 f/3.5			80	65				
70-210 f/2.8 APO	695	600						
70-210 f/3.5-4.5			120	110				
70-210 f/3.5-4.5 APO	260	190			170	125		
70-210 f/4-5.6			85	70				
70-210 f/4-5.6 II	145	120						
70-210 f/4-5.6 APO UC	260	190						
70-210 f/4-5.6 UC	160	110						
70-210 f/4.5-5.6			100	80	75	60		
70-230 f/4.5					80	70		
70-300 f/4-5.6 APO "DL"	395	285						
75-150 f/3.5					65	45		
75-200 f/2.8-3.5	220	180	150	125				
75-200 f/3.8	150	130						
75-200 f/4			125	85				
75-210 f/3.5-4.5			100	70				
75-250 f/4					120	100		
75-250 f/4.5			120	100				
75-300 f/4-5.6 DL	250	165						
75-300 f/4-5.6 APO UC	315	235						
75-300 f/4.5-5.6 APO	285	215						
75-300 f/4.5-5.6	195	175			120	90		
75-300 f/4.5-5.6 DL	240	180						
80-200 f/3.5					75	50		
80-200 f/3.5-4					70	45		
80-200 f/4.5-5.6			90	75				
100-200 f/4.5			100	80	75	45		
100-500 f/5.6-8 APO	1600	1295	1250	1000				
350-1200 f/11 APO			3800	2900				

Sigma Autofocus Lenses

Lens	New		Mint		Excellent		User	
14mm f/2.8 HSM	795	710						
14mm f/3.5	680	600						
18mm f/3.5			250	225				
24mm f/2.8	210	165						
28mm f/1.8 Asph I, II	210	165						
50mm f/2.8 Macro	280	235						
90mm f/2.8 Macro			295	250				
105mm f/2.8 Macro	425	360						
180mm f/2.8 APO Macro			700	600				
180mm f/5.6 APO Macro			300	250				
300mm f/2.8 APO	2450	2200	1750	1600				
400mm f/5.6	350	230			180	150		
400mm f/5.6 APO	520	430			300	250		

Sigma Autofocus Lenses

Lens	New		Mint		Excellent		User
400mm f/5.6 APO HSM	850	785					
500mm f/4.5 APO	3480	3250					
500mm f/7.2 APO	660	580					
600mm f/8 Mirror (Manual Focus)	385	335					
800mm f/5.6 APO	5800	5000					
1000mm f/8 APO	4280	4130					
18-35 f/3.5-4.5	445	415					
21-35 f/3.5-4.2			260	225			
24-50 f/4-5.6			125	110			
24-70 f/3.5-5.6	180	150					
28-70 f/2.8			275	220			
28-70 f/2.8 EX	360	315					
28-70 f/2.8-4	160	130					
28-70 f/3.5-4.5			90	75			
28-70 f/3.5-4.5 UC	140	115					
28-70 f/3.5-4.5 Power Zoom	175	135					
28-80 f/3.5-4.5			125	100			
28-80 f/3.5-5.6 Aspherical	115	95					
28-105 f/2.8-4 Aspherical	235	200					
28-105 f/4-5.6 UC			150	125			
28-200 f/3.8-5.6			175	150			
28-200 f/3.8-5.6 Aspherical UC	265	235					
28-200 f/4-5.6			200	175			
35-70 f/3.5-4.5			100	75			
35-70 f/3.5-4.5 UC			85	75			
35-80 f/4-5.6			80	65			
35-105 f/3.5-4.5			100	80			
35-135 f/3.5-4.5			125	90			
55-200 f/4-5.6			150	125			
60-200 f/4-5.6			95	75			
70-210 f/2,8 APO	850	790					
70-210 f/2,8 APO HSM	825	750					
70-210 f/3.5-4.5 APO			200	150			
70-210 f/4-5.6			100	85			
70-210 f/4-5.6 UC, II	150	120					
70-210 f/4-5.6 APO			140	120			
70-210 f/4-5.6 Power Zoom			175	140			
70-300 f/4-5.6 APO			225	195			
70-300 f/4-5.6 DL	235	200					
75-200 f/2.8-3.5			170	140	140	125	
75-200 f/3.8			150	125	120	80	
75-300 f/4-5.6 APO UC			200	185			
75-300 f/4-5.6 DL			150	125			
75-300 f/4.5-5.6			180	165	150	120	
75-300 f/4.5-5.6 APO			225	190			
100-300 f/4-6.7 APO	185	140					
135-400 f/4.5-5.6 APO Aspherical		595	500				
170-500 f/5.0-6.3 APO Aspherical		715	610				
1.4X APO Teleconverter	185	150					
2X APO Teleconverter	210	170					

Sigma Autofocus Lenses

Sigma autofocus lenses sell for different prices depending upon which mount is offered. Lenses to fit EOS, for example, have built-in micro motors, while other mounts don't. It's no coincidence then that lenses made for the EOS mount cost more than the others do. To take these price differences into account, the New range of prices shows what to expect when buying from one of the large mail order houses. The low price is usually for either Nikon or Minolta mount, and the high end of the range is EOS

unless the lens is not made for EOS. If you're not buying from one of the large mail order outfits, prices probably will be higher than those I've shown.

All Sigma AF lenses are available for Maxxum. Most are available for Canon and Nikon. Just a few are available for Olympus, Pentax or Yashica.

□ TAMRON

Tamron lenses have long been known for their interchangeable lens mounts. In fact, the term "T-Mount" came from – you guessed it – Tamron. Some early

Tamron lenses used an interchangeable mount that provided auto-diaphragm control called the Adaptamatic. In reality, it was interchangeable only with considerable difficulty. Later, Tamron introduced the Adaptall system, which made changing mounts a lot easier, although for some lens/mount combinations it could still be a bit tedious, requiring adjustments. Finally, the Adaptall-2 system made changing lens mounts a breeze. This interchangeability between camera systems provides a real boon for photographers who either find themselves using more than one system or

Tamron Manual Focus Lenses

Lens	New		Mint		Excellent		User	
SP17mm f/3.5	420	370						
21mm f/4					150	100		
24mm f/2.5	295	250	200	180	150	125		
24mm f/3.5					50	40		
28mm f/2.5					50	40		
SP90mm f/2.5 Macro I					180	150		
SP90mm f/2.5 Macro II			250	200				
1:1 Tube for above			40	30				
SP90mm f/2.8 Macro	450	390						
135mm f/2.5					130	85		
135mm f/2.8 Auto (early)					40	30		
135mm f/2.8					70	45		
135mm f/3.5					50	30		
SP180mm f/2.5 LDIF			650	550	525	450		
200mm f/3.5					110	85		
SP300mm f/2.8 LD (early)					950	800		
SP300mm f/2.8 LDIF w/1.4x			1700	1480	1500	1300		
SP300mm f/2.8 LDIF (latest)	2290	2000						
SP300mm f/5.6 Tele Macro					185	160		
SP350mm f/5.6 Mirror					175	150		
SP400mm f/4 LDIF			1550	1400				
SP500mm f/8 Mirror	395	300	290	270	260	225		
SP24-48 f/3.5-3.8			320	280	285	240		
28-50 f/3.5-4.5			150	125				
28-70 f/3.5-4.5	175	150	125	90				
SP28-80 f/3.5-4.2			245	180				
28-85 f/?					115	95		
28-105 f/2.8	840	750						
SP28-135 f/4-4.5			250	225				
28-200 f/3.8-5.6			225	195				
28-200 f/3.8-5.6 LD Aspherical Super	325		265					
35-70 f/3.5					100	75		
SP35-80 f/2.8-3.8			270	225	240	180		

Tamron Manual Focus Lenses (cont'd)

Lens	New		Mint		Excellent		User	
SP35-105 f/2.8 Aspherical			575	500				
35-135 f/3.5-4.2			240	200	210	160		
SP35-210 f/3.5-4.2			290	240	220	170		
SP60-300 f/3.8-5.4	410	350	280	250				
70-150 f/3.5					150	100		
70-150 f/2.8 Soft Focus					175	140		
SP70-210 f/3.5	410	350	280	250	240	200		
SP70-210 f/3.5-4					175	125		
70-210 f/3.8-4					160	125		
70-210 f/4 AF (IF)			120	100				

The 70-210 AF will autofocus on any SLR for which an Adaptall-2 mount is made.

Lens	New		Mint		Excellent		User	
70-210 f/4-5.6	190	160	120	100				
SP70-350 f/4.5					525	450		
75-250 f/3.8-4.5					175	125		
SP80-200 f/2.8 LD			700	650	650	500		
80-200 f/4.5					80	70		
80-210 f/3.8-4			150	130	130	90		
80-250 f/3.8					125	80		
85-210 f/4.5					75	60		
SP200-500 f/5.6			1000	900	890	700		
200-500 f/6.9			595	500	450	400		
1.4X Custom Converter			120	100	105	75		
2X Flat Field	150	130			75	60		
Adaptall-2 Mount	45	35						

Leica and Contax Adaptall-2 mounts are higher.

Tamron Autofocus Lenses

Tamron makes autofocus lenses for Maxxum, Nikon, EOS, Sigma, and Pentax autofocus cameras. Not all focal lengths are made for each camera make, however, although most are. Older Tamron AF lenses were mostly made for Maxxum and Nikon, with only a few made for EOS and Pentax.

Lens	New		Mint		Excellent		User	
90mm f/2.5 Macro			300	270				
90mm f/2.8 Macro	385	350						
300mm f/2.8 LD IF (w/1.4X)	2590	2300						
20-40 f/2.7-3.5	680	570						
24-70 f/3.3-5.6	265	225						
28-70 f/3.5-4.5			150	120				
28-80 f/3.5-5.6	155	120						
28-105 f/2.8	840	750						
28-200 f/3.8-5.6			225	195				
28-200 f/3.8-5.6 LD Aspherical Super		325	265					
35-90 f/4-5.6			100	85				
35-105 f/2.8 Aspherical			575	500				
35-135 f/3.5-4.5			150	125				
70-210 f/2.8 LD	725	650						
70-210 f/3.5-4.5			150	125	130	100		
70-210 f/4-5.6			140	120				
70-300 f/4-5.6			220	195				
70-300 f/4-5.6 LD	295	250						
80-210 f/4.5-5.6	160	130						

Tamron Autofocus Lenses (cont'd)

Lens	New		Mint		Excellent		User
90-300 f/4-5.6			150	130			
100-300 f/5.0-6.3	235	190					
200-400 f/5.6	480	360					
1.4X Teleconverter	140	110					
2X Teleconverter	160	130					

who decide to change from one system to another.

Tamron has built a reputation for producing outstanding lenses at competitive prices. The premium quality zooms and fixed focal length telephotos, designated SP for Super Performance, such as the 80-200 f/2.8 and 300 f/2.8 (both which incorporate low-dispersion glass elements), are excellent optics and compare very favorably with equivalent lenses produced by camera manufacturers. In the listings below, LD stands for Low Dispersion Glass, and IF stands for Internal Focusing.

New prices are for the lens only and do not include the Adaptall-2 mount

($20-30 more. Contax or Leica: $40-55 more).

☐ TOKINA

Tokina has offered a bewildering variety of lens styles (many for the same focal length) over the years. It has offered manual-focus lenses in the following series, listed more or less in order of quality: ATX, SMZ, SZX, SZ, EMZ and ELZ. Except for the ATX series, I've listed the series names of lenses only if more than one type was made for the same focal length (as an example, see the listings below for 80-200 zooms).

Tokina lenses are generally well made, the stand-outs being those ATX lenses that incorporate SD and HLD

glass. These lenses are outstanding values. In the listings below, SD stands for Super-low Dispersion; HLD stands for High-refractive, Low Dispersion. Lenses with these suffixes incorporate special low-dispersion glass elements for improved sharpness and color rendition.

Tokina Manual Focus Lenses

Lens	New		Mint		Excellent		User
17mm f/3.5 SL	280	230			150	125	
24mm f/2.8 SL			100	80			
28mm f/2.8 SL or ELF	110	80	65	50	50	30	
90mm f/2.5 Macro ATX w/1:1			225	205			
300mm f/2.8 SD ATX			1500	1350	1295	1220	
400mm f/5.6			160	125			
400mm f/5.6 SD			250	225			
400mm f/6.3 Preset?					100	75	
500mm f/8 Mirror			225	195	180	140	
600mm f/8 SL Preset					400	350	
800mm f/8 SL Preset					550	425	
24-40 f/2.8 ATX					175	140	
24-70 f/3.5-4.8 SZX			195	165			
25-50 f/4					100	85	
28-70 f/2.8-4.3 SZX			110	100	100	85	
28-70 f/3.5-4.5 EMZ			80	70			
28-70 f/3.5-4.5 SZX	145	120					
28-70 f/4 SZ			115	80			
28-85 f/3.5-4.5 ATX			150	110	125	80	
28-85 f/4			150	100	120	80	

Tokina Manual Focus Lenses

Lens	New		Mint		Excellent		User	
28-105 f/3.5-4.5 SZX	235	150						
28-105 f/3.8-4.3					150	125		
28-105 f/4-5.3 SZX			130	100				
28-135 f/4-4.6 ATX					200	150		
28-200 f/3.5-5.3 SZX	250	170	140	120				
35-70 f/2.8 ATX			180	150				
35-70 f/3.5-4.5 SZX			90	75				
35-70 f/4 SZ					80	60		
35-105 f/3.5-4.3			150	125	120	85		
35-135 f/3.5-4.5			150	125	115	85		
35-135 f/4-4.5			120	110	90	75		
35-200 f/4-5.6 SZX			180	160	165	140		
35-200 f/3.5-4.5 ATX			220	180				
50-200 f/3.5-4.5 SMZ			180	150				
50-250 f/4-5.6 ATX			225	175	170	140		
60-120 f/2.8 ATX			160	140	125	100		
60-300 f/4-5.6 SZX			175	150				
70-210 f/3.5 SZ					140	125		
70-210 f/4 SMZ			100	80				
70-210 f/4.5 EMZ			90	70				
70-210 f/4-5.6 SZX	160	100	80	60				
75-150 f/3.8			100	80				
80-200 f/2.8 SD ATX			350	325	330	250		
80-200 f/3.5-4.5 SMZ			100	90				
80-200 f/4.5-5.6 SZX			75	50				
80-200 f/4 ELZ (no macro)			90	80	80	60		
80-200 f/4 EMZ (w/macro)			120	100				
80-200 f/4.5					75	50		
100-300 f/4 ATX SD			365	340	350	300		
100-300 f/5.6 SZ			120	100	100	85		
150-500 f/5.6 SD ATX	1200	750	700	600				
2X (4 element)					25	20		
2X (7 element)	110	80	70	50	50	40		

Tokina Autofocus Lenses

Currently, Tokina makes autofocus lenses for EOS, Maxxum, Nikon AF and Pentax AF. Not all of the following lenses will fit the above-mentioned systems, so I've included in parentheses the initial of the AF mounts available.

Lens	New		Mint		Excellent		User	
17mm f/3.5 (E,M,N)	390	280						
100mm f/2.8 Macro ATX (E,M,N)	380	300						
300mm f/2.8 ATX SD (M,N)			1500	1350				
300mm f/2.8 ATX APO II (E,M,N)	2250	1700						
300mm f/4 ATX APO (E,M,N)	795	600						
400mm f/5.6 ATX SD (E,M,N,P)			325	280				
400mm f/5.6 ATX APO (E,M,N)	485	370						
20-35 f/3.5-4.5 ATX HLD (E,M,N)			215	195				
20-35 f/3.5-4.5 ATX HLD II (E,M,N)	325		240					
20-35 f/2.8 ATX Pro Aspherical (E,M,N)	760	600						
24-40 f/2.8 ATX (E,M,N)			400	350				
28-70 f/2.6-2.8 PRO (E,M,N,P)			300	275				

Tokina Autofocus Lenses (cont'd)

Currently, Tokina makes autofocus lenses for EOS, Maxxum, Nikon AF and Pentax AF. Not all of the following lenses will fit the above-mentioned systems, so I've included in parentheses the initial of the AF mounts available.

Lens	New		Mint		Excellent		User
28-70 f/2.6-2.8 PRO II (E,M,N,P)	425	350					
28-70 f/2.8 ATX HLD (E,M,N,P)			250	220			
28-70 f/2.8-4.5 SD (E,M,N,P)			120	90			
28-70 f/3.5-4.5 (M,N,P)			90	80			
28-80 f/3.5-4.5 (M,P,N)			100	100			
28-200 f/3.5-5.3 (M,N)			190	165			
28-210 f/3.5-5.6 (E,M,N)	195	145					
28-300 f/4-6.3 (E,M,N)	285	220					
35-70 f/3.5-4.6 (M,N,P)			100	80			
35-200 f/4-5.6 (E,M,N)			160	135			
35-300 f/4.5-6.7 (E,M,N,P)	285	190					
60-300 f/4-5.6 SZX			180	150			
70-210 f/4-5.6 (E,M,N)			120	90			
70-210 f/4.5 (N,P)			125	95			
75-300 f/4.5-5.6 (M,N)			180	150			
80-200 f/2.8 ATX SD, APO (E,M,N)			450		400		
80-200 f/2.8 ATX PRO (E,M,N,P)	750	600					
100-300 f/4 ATX SD (M,N)			545	495			
100-300 f/4 ATX APO II (E,M,N)	790	660					
100-400 f/4.5-6.7 (E,M,N)	290	230					
2x 7-Element Teleconverter	155	120					

☐ VIVITAR

Vivitar has been designing lenses for 35mm SLRs for almost as long as 35mm SLRs have been around. Although primarily an aftermarket producer of lenses and electronic flashes, Vivitar has long been a pioneer in photo technology. The famous Series 1 line of lenses (abbreviated below as S1) exhibit outstanding sharpness, color and contrast. Series 1 zooms come very close to rivaling the very best fixed focal length lenses in image quality.

Vivitar Manual Focus Lenses

Lens	New		Mint		Excellent		User
17mm f/2.8			150	130			
17mm f/3.5			125	100			
19mm f/3.8	150	110					
20mm f/3.8					120	80	
24mm f/2			100	90	80	60	
24mm f/2.8	110	80			50	40	
28mm f/1.9 (IF) S1			150	130	125	85	
28mm f/2			100	85	80	60	
28mm f/2.5			80	60	70	50	
28mm f/2.8	80	60	50	40	45	35	
35mm f/1.9			130	100	75	50	
35mm f/2.5					40	30	
35mm f/2.8			60	50			
55mm f/2.8 Macro			140	130	125	100	
90mm f/2.5 S1 Macro (w/1:1)			225	215	200	170	
90mm f/2.8 Macro			195	170			

Vivitar Manual Focus Lenses (cont'd)

Lens	New		Mint		Excellent		User	
100mm f/2.8 Macro					180	150		
100mm f/3.5 Macro	145	115			180	150		
105mm f/2.5 S1 Macro					245	200		
105mm f/2.8					65	50		
135mm f/1.5 Professional (T-Mt Preset)					325	250		
135mm f/2.3 S1			180	125	130	95		
135mm f/2.5 TX or dedicated					70	50		
135mm f/2.8 T-4 or dedicated			60	45	50	35		
135mm f/3.5					40	30		
200mm f/3 S1			225	180	175	125		
200mm f/3.5					80	60		
200mm f/3.5 AF (on any SLR)			180	140				
300mm f/5.6			90	75				
400mm f/5.6 Preset			160	140	150	125		
400mm f/5.6					200	130		
450mm f/4.5 S1 Mirror			450	350				
500mm f/6.3 Preset					95	70		
500mm f/8 Mirror	200	120						
600mm f/8 S1 Mirror			550	450	380	350		
600mm f/8 Preset					350	300		
800mm f/8 S1 Mirror					600	500		
800mm f/11 S1 Mirror			550	495				
17-28 f/4-4.5	195	140						
19-35 f/3.5-4.5	200	145						
24-48 f/3.5 S1			195	150	180	120		
24-70 f/3.8-4.5 S1			150	125				
28-50 f/3.5-4.5			110	100	80	65		
28-70 f/3.5-4.8 AF (on any MF SLR)			150		100			
28-70 f/3.5-4.8			75	60				
28-80 f/3.5-5.6	140	100						
28-85 f/2.8-3.8			140	100	95	80		
28-85 f/3.5-4.5			95	75				
28-90 f/2.8-3.5 S1			190	150	170	120		
28-105 f/2.8-3.8 S1	270	220	200	180	170	140		
28-105 f/3.5-4.5	190	140	140	120				
28-135 f/3.5-4.5			170	120				
28-200 f/3.5-5.3			160	150				
28-210 f/3.5-5.6	170	140	125	100	100	70		
35-70 f/2.8-3.8			125	115	95	60		
35-85 f/2.8 S1			200	165	175	125	120	90
35-105 f/3.2-4			125	100	85	60		
35-200 f/3.0-4.5			135	120				
55-135 f/3.5					80	55		
70-150 f/3.5			100	80	90	75		
70-210 f/2.8-3.5 S1			150	140	130	95		
70-210 f/2.8-4 S1	255	190	190	160	150	120		
70-210 f/3.5 S1 (67 & 62mm filter)				175	130	140	125	

Vivitar has made four different Series 1 70-210's. The original is the 70-210 f/3.5 with a 67mm front filter size — big and heavy, but built like a tank. The second, often considered the best, is the f/3.5 model with a 62mm front filter size (while I've combined prices for the two models into one listing, expect to pay a little more for the second one). It's considerably lighter, just as sharp, and has an easier-to-engage macro mode. Next came the f/2.8-3.5, followed by the f/2.8-4, which was the last model produced.

Vivitar Manual Focus Lenses (cont'd)

Lens	New		Mint		Excellent		User
70-210 f/4.5			85	65	80	60	
70-210 f/4.5-5.6			85	50	60	40	
70-300 f/4.2-5.8			140	120			
75-150 f/3.8 close focus					75	60	
75-200 f/4.5			120	100			
75-200 f/4.5 AF (on any SLR)			150	120			
75-205 f/3.5-4.5					90	70	
75-205 f/3.8 2-Ring			75	65	70	50	
75-205 f/3.8 (add for matched 2X)				130	100	90	60
75-260 f/4.5 TX					85	65	
75-300 f/4.5-5.6					140	100	
80-200 f/4					100	80	
80-200 f/4.5			100	95	85	60	
85-205 f/3.8			100	85	75	50	
90-180 f/4 Flat Field Macro			300	250	225	175	
100-200 f/4					60	40	
100-300 f/5 CF					115	85	
100-300 f/5.6			125	125			
100-300 f/5.6-6.7	145	110					
100-500 f/5.6-8 S1			400	375	350	300	
120-600 f/5.6-8			425	400	395	350	
1.5X			40	25			
2X Macro (7 element)	130	90			65	50	
2X	50	35			25	20	
3X			50	40	35	25	

Vivitar Autofocus Lenses

Vivitar's autofocus lenses have been made in mounts to fit EOS, Maxxum, Nikon and Pentax AF. Not all focal lengths are made for each mount, however. Check the abbreviations after each lens description.

Lens	New		Mint		Excellent		User
19-35 f/3.5-4.5 S1 (E,M,N)	195	145					
28-70 f/2.8 S1 (E,M,N,P)	270	170					
28-70 f/3.5-4.5 (M,N,P)			100	90	85	65	
28-105 f/4-5.6 S1 (E,M,N,P)	225	160					
28-200 f/3.5-5.6 S1 (E,M)			180	150			
28-200 f/3.8-5.6 S1 (M,N,P)	240	200					
28-210 f/3.5-5.6 (E,M,N)	200	140					
28-300 f/4-6.3 (E,M,N)	270	200					
35-70 f/3.5-4.6 (M,N,P)			80	60			
70-210 f/2.8 S1 (E,M,N,P)	675	600	550	495			
70-210 f/4.5-5.6 (M,N,P)	155	100					
60-300 f/4-5.6 (M)			200	175			
100-300 f/5.6-6.7 (E,M,N)	200	145					
100-400 f/4.5-6.7 (E,M,N)	280	200					

☐ **MISCELLANEOUS LENSES OF INTEREST**

Below is a selection of lenses, which, for various reasons, captured my interest.

If you have a favorite oddball or unusual lens, available in mounts for popular cameras, that isn't included here, drop me a line describing it. In order to include it in this listing, I'll need verifiable pricing info.

Generic 135mm f/1.8

This lens is more or less a generic Japanese-made optic that can be found under an assortment of brand names, such as Spiratone, Soligor, 5 Star, Rexatar and others. It's big and heavy, sporting an impressive 82mm front element. Sharpness and contrast are acceptable, but this lens is still a bargain considering its maximum aperture. One early version of the lens featured mount interchangeability via the YS system. Later versions had dedicated non-interchangeable mounts.

Lens	Mint	Excellent	User
135mm f/1.8		175 125	

Kalimar

Why do I list an off-brand Korean-made lens like a Kalimar? Well, it's the only wide-angle to long-telephoto zoom I've seen that has a constant maximum aperture. Every other 28-200 (or 28-210 or 35-200 or whatever) I've seen or read about has a variable aperture in the neighborhood of f/4-5.6. I've used this lens. It's a little heavy, but it's not bad at all. Unfortunately, Kalimar has discontinued this lens, replacing it with a more compact and lighter weight model that has a variable aperture like everyone else's.

Lens	Mint	Excellent	User
Kalimar 28-200 f/3.9	140 100		

Kilar Macro Lenses

Kilar lenses were produced by the German company Killfit. The Kilar 40mm f/2.8 was the first true macro lens made. The Kilar 90mm f/2.8 is a beautiful lens that focuses all the way down to 1:1 without an extension tube. Both employ the preset style of aperture selection. These lenses are most frequently found in Exacta mount, but I've seen them in others, such as Nikon, Canon and Pentax screw.

Lens	Mint	Excellent	User
Kilar 40mm f/2.8 Macro		200 165	
Kilar 90mm f/2.8 Macro		435 350	

Schneider

The name Schneider is often associated with top-quality large format and medium format lenses, but the company does make a few for smaller formats. The two listed below are Perspective Control lenses, which are used in architectural photography and other special situations where converging vertical lines would detract from the shot. These lenses are pricey, but of extremely high quality. The prices listed below are a few years old now, but I have been unable to find more recent prices of them at this time. So, it may be better to view these prices as that one should expect for clean used examples.

Lens	New	Mint	Excellent	User
28mm f/2.8 PC	2350 1990			
35mm f/4 PC	1580 1320			

Spiratone

While Spiratone didn't manufacture the lenses it sold over the years, it offered a few with interesting focal lengths, especially ultra-wide angles and fisheyes, which are the ones I've chosen to list. All are generally of high optical quality.

Lens	Mint	Excellent	User
Spiratone 7.5mm f/5.6		160 100	
Spiratone 12mm f/8		125 80	
Spiratone 18mm f/3.5		150 100	
Spiratone 20mm f/2.8	140 100	120 90	
Spiratone 24-40 f/3.5	200 160		

Miscellaneous Mirror Telephotos

Most photographers have seen or shot with the ubiquitous 500mm f/8 CAT mirror at one time or another. It remains popular because of its light weight, close-focus capability, and generally good optical performance. The 300mm is surprisingly small, about the size of a typical 50mm lens. The lenses made by Bausch & Lomb, Celestron, Meade and Questar can be found configured as lenses, spotting scopes or telescopes. For example, the Celestron 1000mm f/11 is also known as the C90 telescope. The basic optics are the same, only the way accessories attach is different. The 500-800mm zoom is marketed by Cambridge Camera in New York City. It's a good performer optically, although somewhat large and heavy, and is one of only two mirror zoom lens I've run across designed specifically for photographic use (the other is a Pentax). All the lenses in this group adapt to cameras via T-mount adapters, so if you run across one and it intrigues you enough to buy it, chances are you won't have to worry about getting it to fit your camera. Prices for the B&L, Celestron and Meade lenses include camera adapters and T-mounts.

Lens	New		Mint	Excellent		User
Generic 300mm f/5.6				125	75	
Generic 500mm f/8				175	125	
B&L Criterion 1000mm f/11				300	200	
Cambron 500-800 f/8-12				350	325	
Celestron 300mm f/5.6				190	150	
Celestron 500mm f/5.6 (old style)				350	275	
Celestron 500mm f/5.6 (new style)	450		340			
Celestron 750mm f/6				600	500	
Celestron 1000mm f/10	370	300		350	250	
Celestron 1000mm f/11				350	250	
Celestron 1250mm f/10				550	400	
Meade 1000mm f/11				350	250	
Pro Optic 500mm f/5.6	265	210				
Questar 700mm f/8				1500	1300	

Miscellaneous Refractor Telephotos and Ultra Long Zooms

The first two telephotos listed are found under a wide variety of house brand names. They are simple, economical telephotos that give surprisingly good results. The Novoflex lenses are made in Germany and are of very high optical quality — with prices to match. The Russian made Zenit Photo Sniper Outfit consists of a Zenit E camera with a 58mm f/2 normal lens, a 300mm f/4.5 telephoto and a gunstock, all of which fits snugly in a nice metal case. The prices shown for the Photosniper are for the complete outfit.

Lens	New		Mint		Excellent		User
400mm f/6.3 Preset	120	100			60	50	
500mm f/8 Preset	140	120			75	60	
800-1200mm f/9.9-14.9	400	330					
Novoflex 400mm f/5.6	1400	1000	850	800			
Novoflex 400mm f/8					450	270	
Novoflex 600mm f/8					750	600	
Novoflex 640mm f/9					550	500	
Pro-Optic 420-800mm f/8.3-11 APO	300	210					
Zenit Photo Sniper Outfit			350	275	250	175	

Advanced Photo System

The disk camera and its View Master-looking film format are history (thankfully), 126-size film has faded into obscurity, and 110-size film is still hanging in there – by its fingernails. So, why is it, you may ask, should we assume that the new APS format will have a better chance at survival when the others didn't fare as well? Further, with the proliferation in recent years of affordable, high-quality, easy-to-use, point&shoot 35mm cameras, and even disposable 35mm cameras that render acceptable print quality, is there a need, or even room, for another amateur-oriented film format? Apparently Kodak, Fuji, Canon, Minolta, and Nikon (the "big five" participants in the development of APS), and another 50 or so manufacturers of photo equipment, film, and processing equipment feel that there is.

Officially designated as the IX240 format, APS has a chance to succeed, not just because the industry supports it, but because, simply put, APS is high tech. In this age of lightning-fast personal computers, the World Wide Web, and digitally-controlled bread machines, the average consumer has been conditioned to believe that high tech is somehow superior to low tech. Without a doubt, this is a questionable attitude to maintain, but there is also no doubt that technology drives the mass consumer market due to this common perception that hi-tech is somehow superior. At least with APS, its high-tech capabilities

have been put to good use: tasks that can be tedious or time consuming with traditional 35mm films and cameras are accomplished virtually without effort. Other, more advanced tasks were possible with 35mm only if the camera was equipped with a sophisticated – and expensive – data back. Still other capabilities are not available at all in the 35mm format, regardless of camera or accessories, or require manual intervention in the production process.

The principle behind APS is something entirely new in photography. In fact, one must look to computing to find the closest analogy, and it is this: just as one can transfer files written on one computer to run on another, with APS the entire photo-producing process has become linked in a similar fashion of information exchange. The exchange medium is the film itself, which provides an unbroken chain of data flow from camera to photofinisher. The camera writes exposure and other information to a magnetic strip on the film itself (a total of 410 bytes, the equivalent of 80 characters). After exposure, the film is transported through APS photofinishing equipment where the magnetic strip is read. The information stored on the strip will "tell" the photofinishing machine how to produce optimum prints, print sizes, whether to print information on the front or back of the photo, and more.

While the differences between APS and all other film formats is fundamental, the most apparent difference between APS and traditional 35mm is the new canister design, which actually resembles a modern video cassette in several ways – if not in form, then certainly in function. Consider the following similarities:

- It isn't a canister anymore. Even Kodak calls it a cassette.
- The APS cassette is a leaderless design. It has a door, which is opened by the camera once the cassette is inserted (just like a video cassette).
- A video cassette has a window to let you know the status of the tape. On the end of the APS cassette is a series of icons which indicate the film's status: a circle means that the roll is unexposed, a half-circle means the roll has been partially exposed, an X means the roll has been exposed, but not developed, and a rectangle means the roll has been developed.
- Like a video cassette in which recorded events are stored, the APS cassette stores the exposed images.

There are ups and downs to storing ones images in the cassette, though. Granted, it eliminates the possibility that some bored, overpaid minimum-wage earner will cut your negative of Aunt Pattie's prize petunias in half, and it virtually eliminates the possibility that your

negatives will get scratched if stored carelessly. But this storage method has raised other concerns. For example, you may wonder what sort of physical changes the film will undergo after long-term storage in its coiled state. Will it be more prone to cracking or warping when, after several years of storage, the time comes to make reprints? According to Kodak, Fuji, and Agfa, the new A-PEN (annealed polyethelene napthalate) film base material, which is 30% thinner, stronger, more resistent to scratching, and has better anti-curl properties than traditional triacetate bases, will negate any such problems. But what do you do if you lose the index print (more on that later) for the cassette? I'll tell you what you do – same thing you do when you discover an exposed roll of film lying in the bottom of your camera bag. Why, you take it to your friendly camera shop or photofinisher and have a set of prints made, that's what you do. Or, in the case of the APS cassette, perhaps you can just opt for another index print. To ameliorate this last problem somewhat, Kodak offers a tidy storage method, called a "Memory Keeper" box, which stores the index prints in the cover and the cassettes in the base. Each "Memory Keeper" box holds twelve cassettes and index prints.

The index print is a familiar enough concept to anyone who has experience with proof sheets or photo CDs. Each developed roll of APS film comes with a color print, matched to the roll by a bar-coded ID number, showing every exposure on that roll. One nice feature of having an index print for every roll is the ability to easily fill in the gaps caused by missing photos. How often have you developed a roll of film, opted for single prints, then, in a fit of generosity, ended up giving away all the best prints of young Amanda to Grandma and Grandpa on their last visit? So, you end up having to pull out the negatives,

match the remaining prints to the negatives, etc., etc., so you can get reprints made of the images you gave away. Fortunately, the index print eliminates all that. You just select the reprints you want based on the numbers listed on the index print, and everything is sweetness and light once again.

Each frame on a roll can be exposed and printed in one of three formats: Classic (C), HDTV (H), or Panoramic (P). Only the HDTV format, which is based on the same aspect ratio as the long-anticipated High-Definition Tele-Vision format, uses the maximum available emulsion area of the negative (in other words, C and P are crops). While the final print size may vary, depending upon the photofinisher one selects, the available print sizes for the formats are as follows:

C: 3.5 x 5 inches (8.90 x 12.70 cm) or
 3.5 x 5.25 inches (8.90 x 13.30 cm)
 or 4 x 6 inches (10.20 x 15.20 cm)

H: 3.5 x 6 inches (8.90 x 15.20 cm) or
 4 x 7 inches (10.20 x 17.80 cm)

P: 3.5 x 8.5 inches (8.90 x 21.60 cm) or
 3.5 x 10 inches (8.90 x 25.40 cm) or
 4 x 10 inches (10.20 x 25.40 cm) or
 4 x 11.5 inches (10.20 x 29.20 cm)

The actual dimensions and aspect ratios of each format are as follows:

C: 16.7 x 25mm, 2:3 aspect ratio (Same aspect ratio as 35mm's 24 x 36mm nominal image area)

H: 16.7 x 30.2mm, 9:16 aspect ratio (approximately 3:5)

P: 10 x 30.2mm, 1:3 aspect ratio

APS film is available in 15, 25, and 40 exposure lengths. Currently, Kodak and Fuji are offering negative emulsions

in ISO 100, 200, and 400 speeds. Kodak also offers an ISO 200 professional emulsion (said to be designed for electronic image scanning), as well as an ISO 100 slide emulsion. Agfa has also begun to offer ISO 100 and 400 speed print films. Expect the selection of film speeds and emulsions to grow as (if?) the APS format becomes more widespread.

While all the above is interesting stuff, the most remarkable aspect of the Advanced Photo System may well be film itself. Not only does it incorporate the new A-PEN base, but the emulsions have been improved over previously available ones, as well. APS film emulsions have the finest grain available, which actually results in images as sharp as, or sharper than their 35mm counterparts. This situation will change, to be sure, as the new emulsion technologies are adapted to 35mm and larger formats.

Perhaps the most significant APS feature of them all, however, is something called Information Exchange, or IX for short, a method by which information is shared by the various components of the Advanced Photo System. To utilize the IX technology, APS films are coated with an optically transparent magnetic layer, on which various types of information is stored. Data recorded on the magnetic layer includes a host of options, some of which are:

- **Print Quality Improvement** (PQI): the recording of specific exposure and lighting data, such as cartridge loading direction (to determine which way is up), magnification, flash fire, flash exposure, camera orientation, back lighting, metering range, subject brightness, and artificial illuminant. The artificial illuminant flag allows the photofinisher to analyze specific lighting conditions in a scene and correct for proper color balance

during the printing process. Among the possible settings are tungsten, fluorescent, flash, and daylight.

- **Selectable Fixed Time Printing Method** (FTPM): allows the photographer to override any exposure or color compensation changes the photofinishing equipment may want to make if it determines the film to be improperly exposed. By using FTPM, the photographer can indicate to the photofinishing equipment that the "improper" exposure is intentional, and that it should be processed without compensation. FTPM, when used, is applied to the entire roll. Adjustments to individual frames are made through the Print Specification information shared between the camera and the photofinishing equipment.

- **Series Scene Feature**: This feature is very similar to FTPM, but can be set on a per-exposure basis. Most useful for handling exposure bracketing, the series scene feature instructs the photofinishing equipment not to adjust for "improper" exposures when processing the prints.

- **Mid-Roll Change** (MRC): APS cameras that have a "read" head can support MRC. The read head senses where the last exposed image is, allowing the camera to automatically load the film to the next frame. Currently, only the more full-featured APS cameras support this feature.

- **Print Quantity Selection**: This feature allows the photographer to specify how many prints he or she would like printed at the time the photograph is taken, from 0-9. If the photographer knows as soon as the shut-

ter is released that it was an awful shot (the subject blinked, etc.), 0 can be selected, and that frame will not be printed (it will still show up on the index print, though). On the other hand, if it looks like it's a real prize-winner, up to 9 prints can be specified.

- **Automatic Recording and Imprinting of Data**: provides the photographer with a complete exposure record of each roll, including shutter speed and aperture combinations for each image, ISO setting, metering mode, maxiumum lens aperture, and lens focal length. This sort of capability has been previously available only on the most expensive 35mm SLRs with equally expensive databacks attached.

- **Date and Time Imprint**: can be printed on any or all images. The photographer has a choice of imprinting on the front or back of the photograph. (Some cameras may only allow imprinting on one side, though.)

- **A selection of 100 different titles to choose from**: These are simple titles, on the order of "Congratulations," "Merry Christmas," "Happy Birthday," etc., and are available in a variety of languages. The camera doesn't actually need to store the titling information. It places a code on the magnetic strip that the photofinisher interprets into the proper title and language.

Please note that the above is not a complete list of APS capabilities, although I've tried to hit the highlights. Also, please be aware that not all of the above features are supported by all APS cameras. Further, not all photofinishers can offer all of the

above features, either. You should check with your photofinisher first.

☐ APS CAMERAS: THE CRITERIA FOR INCLUSION HERE

The APS cameras that are listed in this section are those that will most likely be around for a while. 35mm point&shoot cameras seem to have a six-month to one-year product run, although there are a few notable exceptions. I expect this same practice to be the case with most APS point&shoot cameras, as well. This marketing characteristic results in a leveling of values for the myriads of different models, which is to say that cameras that have similar features tend to command similar prices on the new and used markets – which further means that the tracking of prices for these cameras is largely a fruitless activity. And because this trend will almost certainly extend to APS cameras as well, I can tell you with all candor that this section will never be comprehensive. It will instead maintain a focus on APS SLRs and the higher-end point&shoot APS models – those that are likely to endure beyond that six-month to one-year break point, and become functional classics once their product runs have come to an end.

☐ CANON APS

At the time of this writing, there are four Canon APS models that fit the guidelines for inclusion within this book: the ELPH, the ELPH 490Z, the EOS IX and the EOS IX Lite. The ELPH and ELPH 490Z are fixed lens rangefinder-style AF cameras, whereas the EOS IX cameras, as their name implies, are SLRs.

Canon ELPH

The ELPH has that certain indescribable something – that *je ne sais quoi* – that causes both the jaded and the tyro alike to have sudden and compulsive feelings of covetousness. Canon engi-

neers have managed to combine a tack-sharp all-glass 24mm-48mm zoom using two aspherical elements, a new hybrid active/passive AF system, a real-image viewfinder with built-in masks for APS's three print aspect ratios, and much more – all into an elegantly designed exterior made from durable, corrosion-resistant 316 stainless steel.

The ELPH's hybrid active/passive 3-point AF system will switch from one autofocus method to the other as conditions warrant. The active mode, which operates by means of emitting an infrared beam, is the more traditional method employed with AF lens-shutter cameras. The passive mode, more typical of AF SLRs than a point & shoot, detects differences in subject contrast. By combining the two systems, well-focused photographs are virtually assured. Exposure is determined by a three-zone evaluative metering system, which will enable automatic exposure compensation for backlighted scenes. Shutter speeds range from 2 seconds to 1/500 second.

Flash photography is handled by means of the built-in multi-function flash unit. Available flash modes include auto (with or without red-eye reduction) and a slow-speed sync setting, useful for freezing subject action against a softly lit, but properly exposed, scene.

Canon ELPH 490Z

Billed as "the world's smallest 4x zoom camera" during its release, the ELPH 490Z is packed with features that belie its small size. The ultra-compact 22.5mm-90mm f/5.6-8.9 lens uses a 7-group, 7-element all-glass optical formula, including two aspherical elements for a high degree of aberration control and sharpness. The real-image viewfinder is coupled to the lens, so that as the lens zooms, so will the viewfinder. Parallax correction is built into the viewfinder as well, assuring that the image one sees

will be the precise image recorded on film.

Because of the leaderless design of the APS film cassette, all APS cameras feature improved ease of film loading. Given this fact, discussions of how easily the film is loaded into an APS camera may appear to be somewhat redundant at first blush. However, the ELPH 490Z takes these matters of ease to a somewhat higher plane – high enough, in my view, to justify a few brief comments. To load film in the ELPH 490Z, one must know how to do two things: push a button, and drop an unused film cassette into its receptacle. The 490Z will do the rest. It actually detects when a roll has been loaded, grabs it, draws it into the camera, closes the door, and advances the film to the first frame.

The autofocus system in the ELPH 490Z is suprisingly sophisticated for a camera of this type. It incorporates the same hybrid active/passive technology found in the standard ELPH, but the number of AF sensors has been increased from three to five.

Unique (at present) to the ELPH 490Z is Canon's "Best Shot" dial. This feature, highly reminiscent of the PIC settings found on several EOS models, offers six different shooting modes, each represented by its own icon on the dial: Action, Night Photography, Portraits, Close-Ups, Spotlight, and Full-Automatic.

Borrowing a page from the book of another Canon design experiment known as the Photura – a device that looked more like a miniature, hand-held rocket launcher than a camera – the lens cover serves double duty on the ELPH 490Z. When in the up-flipped position, it exposes the unit's five-mode multi-function flash. At least on the 490Z it looks like a flash. On the Photura, it looked like an aiming reticle. For all the unusual nature of its design, however, the flash unit on the 490Z can handle a

variety of situations. Labeled by Canon as a "5-mode, multi-function flash unit," the five modes consist of auto with red-eye reduction, auto without red-eye reduction, ON, OFF, and slow sync. Neglecting for the moment Canon's apparent argument that an ON-OFF switch is equivalent to two operating modes, it is more useful to think of the ELPH 490Z as having "slow-sync" capability (see the previous comments on the ELPH for an explanation), plus the ability to disable the flash's red-eye reduction. In this respect, the 490Z's flash is identical in capabilities to that found on the original ELPH. One interesting point worth noting is the fact that the distance between the lens and the flash on the ELPH 490Z is greater than that of any other Canon camera with a built-in flash. This characteristic alone should help to reduce the occurrence of red eye in many, if not most, instances.

Other features found on the ELPH 490Z include a variable-diopter eyepiece, triple-zone metering with automatic and manual exposure compensation of up to ±1.5 stops, and a remote control receiver to be used in conjunction with the optional remote controller RC-5 for those times when the photographer feels like being in front of the camera instead of behind it.

EOS IX

In the development of the EOS IX, Canon engineers seem to have taken a few items from Column A, a few from Column B, thrown in a few others from Column IX, and fused them together to come up with a startlingly original design. Like its diminutive cousin, the ELPH, the EOS IX shares the same IX240 film format, and is also clad in 316 stainless steel. For much of the way the IX operates, however, it more closely resembles an Elan II converted to APS . . . and a more expensive Elan II, at that. To be fair, though, much of the expense

is due to the fact that the IX is currently available only with the EF 24-85mm f/3.5-4.5 lens (which can be used on 35mm EOS SLRs, incidentally).

The EOS IX supports the following APS features: Mid-Roll Change (MRC), Print Quality Improvement (PQI), Fixed Time Printing Method (FTPM), automatic recording and imprinting of exposure data on the back of each print, and date and time imprint options. It displays the selected image format, whether HDTV, "Classic," or Panorama, by means of translucent LCD masks in the viewfinder. See the notes in the preceding APS section for explanations of these features.

The autofocus system on the IX exploits Canon's latest generation Multi-BASIS (Based-Stored Image Sensor) technology, using the same three-zone autofocus system found on the EOS Elan II. The camera will automatically select which focusing sensor to use, although this can be overridden. Available AF modes are One-Shot AF, AI Servo and AI Focus. The latter mode is a combination of the first two: the camera starts off in the One-Shot AF mode, then if movement is detected, it switches to AI Servo. The AF system on the IX is part of a larger picture that Canon calls AIM (Advanced Integrated Multi-point control), in which the AF system is linked to the autoexposure and E-TTL flash systems, thereby providing greater accuracy and flexibility.

The IX's metering system offers the same options that are found on the Elan II, as well. The user may choose between 6-zone evaluative metering, partial metering (a tight 6.5% of the image area, actually tighter than the Elan II's 9.5%), and center-weighted averaging.

The exposure options found on the IX share some similarities to both the Elan II and the Rebel G. Available exposure modes include six "Image Zone" modes, similar (if not identical) to the PIC modes found on many EOS models: Full Auto, Portrait, Landscape, Close-Up, Sports, and Night. Other exposure modes include Intelligent Program AE, shutter- and aperture-priority AE, metered manual, AE lock, auto exposure bracketing, a "Series Scene" feature, ±2 EV exposure compensation in fi-stop increments (available when any of the Creative Zone modes is selected), manual ISO setting override, and E-TTL flash automation.

The Series Scene feature is linked to the print specifications information that is shared between the camera and the photofinishing equipment, and works in concert with the IX's AE bracketing and AE lock functions. When either of these modes is selected, the Series Scene feature intercedes during the print process, preventing the photofinishing equipment from correcting the intentional over- and under-exposures. This feature is similar to FTPM, but can be applied to individual frames instead of the whole roll.

The flash system found on the IX is remarkably advanced and comprehensive. Available when combined with the 220EX or 380EX, the E-TTL system of flash automation interfaces with the IX's AIM system, providing total integration of autofocus, metering, and exposure for best results. The E-TTL system utilizes the IX's 6-zone evaluative metering system to measure ambient light, subject position and pre-flash data, so as to provide a natural balance between subject and background. Another flash feature, called FE Lock (FE = Flash Exposure), works in conjunction with the IX's partial metering mode, allowing pre-calculated flash exposure information to be stored for up to sixteen seconds. This allows the photographer ample time to recompose or to make other system adjustments prior to taking the shot, all the while maintaining correct flash exposure information. High-speed flash sync, which can be set at speeds from 1/180 to 1/4000 second, is available on the IX when using the Speedlite 220EX or 380EX set to "FP" (for Focal Plane) mode. The built-in flash (GN 36/11 [ft/m] at ISO 100) features red-eye reduction, provides regular TTL flash control, and covers focal lengths down to 22mm.

Other features found on the EOS IX include Canon's "Whisper Drive" technology to reduce film wind and rewind noise; interface capabilities with either optional remote controls: the RC-1 Infrared Wireless Remote, or the RS-60E3 Wired Remote; and a self-timer.

Canon EOS IX Lite

If you think that the "Lite" in this camera's name implies fewer features, you'd be making a mistake. In the EOS IX Lite's case, it seems to be more objective — this camera is substantially lighter than the EOS IX, weighing just 12.7 ounces (356 grams). For example, instead of the stainless steel cladding found on the IX, the Lite sports a polycarbonate resin exterior with the brushed stainless steel look. In terms of features, however, the IX Lite holds its own quite well, regardless of which camera it is compared to.

Like the IX, the IX Lite will accept any of the more than 50 EOS lenses. It also offers the other APS features found in the EOS IX, such as Print Quality Improvement (PQI) and Information Exchange (IX) technology (see the opening APS remarks). But it also has several features that are lacking – or less refined – on the IX. For example, the IX Lite has a locking film chamber, reducing the chance of accidentally fogged film. The Lite's viewfinder displays opaque masks, depending on the image format selected, thus cropping the viewfinder image accurately, whereas the IX displays translucent masks that may not be visible in subdued lighting.

There are additional improvements, which include a Print Quantity setting (see the opening APS remarks) and the ability to select from over 100 titles in 12 languages to be imprinted on the back of the photograph. The IX Lite also features mid-roll rewind capability, the Fixed Time Printing Mode (FTPM), which gives the photographer creative control over the developing process,

Autofocus modes include One-Shot AF and AI Servo AF. The heart of the AF system is a widely spaced, three-sensor array. The camera will select the best one under normal shooting modes, but the user has the ability to select a particular sensor if desired.

Exposure and metering: The EOS IX Lite incorporates a six-zone evaluative metering system, in which three of the six zones are linked to the three autofocus sensors. This type of exposure metering, where the active metering zones are linked to the AF sensors, greatly improves the chance of obtaining accurately exposed photographs. Centerweighted averaging is also available when shooting in the manual exposure mode. The IX Lite also provides partial metering with AE lock, where the central 6.5% of the viewfinder screen is the active area.

Most of the IX Lite's settings can be selected via the Command Dial located on the camera's back – a very effective control feature that has become an EOS hallmark. Exposure modes available with a turn of the dial include Full Auto, aperture- and shutter-priority AE, program AE with shift, manual, and depth-of-field AE. Preset program modes available include Close-up, Landscape, Night Scene, and Portrait. The built-in TTL flash is adequate for general snapshot photography, and will cover focal length ranges down to 22mm (intended, no doubt, to work with the EOS 22-55mm zoom designed especially for EOS IX cameras).

Canon APS Cameras

Camera	New		Mint	Excellent	User
ELF	250	215			
ELF 490Z	330	275			
EOS IX-	300				
EOS IX w/24-85 f/3.5-4.5 USM	500				
EOS IX Lite	260				
EOS IX Lite w/22-55 f/4-5.6	350				

□ MINOLTA APS
Minolta Vectis S-1

Minolta Vectis S-1

The Minds at Minolta pride themselves on firsts. From the first Japanese camera with front focusing (the Nifca-Dox), to the first 35mm camera with a built-in scaled CdS meter (SR-7), to the first camera with an integral motor drive (SR-M), to the first multi-exposure mode SLR (XD-11), to the first successful autofocus SLR (Maxxum 7000), Minolta has established a tradition of firsts that goes back decades. What's remarkable, though, is that Minolta's firsts tend to be such successful firsts. It's one thing to be first at something; it's another thing entirely to be first at something and to have done a bang-up job on it, too. It appears that the Minds at Minolta have done it again – this time with the Vectis S-1, the first APS SLR.

The Vectis S-1 is the flagship of Minolta's APS line. It's sleek, it's stylish in a sci-fi sort of way, it's compact and undeniably elegant, yet it's crammed full of features. Unlike the other two interchangeable-lens APS SLRs currently available, the Canon EOS IX and the Nikon Pronea 6i, the Vectis sports a unique lens mount, downsized slightly for the smaller APS film. To accompany the Vectis, Minolta has developed a new, compact line of lenses. In a departure from Maxxum lens designs, each Vectis lens houses two motors: one for focusing and another for stopping down the aper-

ture iris. At the time of this writing, available optics consist of four zooms: a 22-80mm f/4-5.6, 28-56mm f/4-5.6, 56-170mm f/4.5-5.6, and an 80-240mm f/4.5-5.6 APO, plus a 50mm f/3.5 Macro lens. A prototype 400mm f/8 reflex has been shown, but there is no information yet as to if or when it will be released. Rumors are that Minolta plans to offer an adapter for the Vectis that will allow the use of Maxxum AF lenses, but they will have limited functionality: no autofocusing and no program mode selection (although shutter- and aperture-priority as well as metered manual should be available).

The most distinguishing characteristic of the Vectis S-1, and that which is responsible for its sleek lines, is its lack of a pentaprism bump. Minolta opted instead for a "sidefinder" design, where the light path from the lens to the eyepiece is folded horizontally. So successful at this design were they that the viewfinder is the brightest in its class. This sidefinder design results in an eyepiece which is positioned at the far left edge of the camera, however – great for us right-eyed shooters, but perhaps somewhat less wonderful for the dominant left-eye shooters among us. The eyepiece is fitted with a dioptric adjustment, providing the user with a a generous +2 to -4 range of correction. For those who prefer to wear their glasses, though, the finder is of the high-eyepoint design, with a full 25mm of eye-relief. The viewfinder uses opaque masks for the H, C, and P formats.

The Vectis has a single autofocusing mode: focus-priority only, and a solitary AF sensor that is sensitive primarily to vertical subjects. Available exposure modes include program AE, shutter- and aperture-priority AE, and metered manual, plus five Subject Program Modes: Portrait, Landscape/Night View, Close-Up, Night Portrait, and Sports Action.

Available metering modes include a 14-segment evaluative method and a 4mm spot. Exposure compensation is also available in half-stop increments, with a total range of ±3 EV. Shutter speeds range from 30 seconds to 1/2000 second, with flash sync occurring at 1/125. The flash system on the Vectis uses a four-segment TTL pattern. The built-in pop-up flash covers focal lengths down to 22mm and offers red-eye reduction. Manual fill flash and slow-shutter sync are also available. The Vectis S-1 has a Maxxum-style hot shoe, and can accept any Maxxum flash unit. It also has the capability to support a remote control accessory TTL flash.

APS features supported on the Vectis include the Fixed Time Print Mode (see the above APS section for an explanation of this and the other APS features), 0-9 print quantity selection, back printing of date and time, a choice of 100 titles in various languages, with any three held in memory, to be printed. If no title is printed, then the shutter speed, film speed, lens focal length, and exposure compensation (if any) can be printed.

Other features include the following: the S-1 has a "splash proof" design, which means it's moisture resistant, but won't survive a dunking; it has manual override of ISO film speed settings; its integral winder is good for film advance speeds up to 1 fps; it has wireless remote control capability.

Minolta Vectis 40

The Vectis 40 is a solid APS workhorse, with sufficient features to handle most photographic necessities. Its 30-120mm f/3.5-9.9 zoom provides the 35mm equivalent of 38-150mm, with enough focal length on the long end to be useful for more than just snapshots. It has a close-up mode, focuses from 1.6 feet to infinity, and features five flash modes: auto, slow-sync, redeye reduction, and

fill flash. Shutter speeds range from 8 seconds to 1/500 second. The body is constructed to be "splashproof," so it should handle the elements reasonably well. APS features include mid-roll film change, select title backprinting, the C, H, and P formats, date & time, and select title imprinting.

Minolta Vectis APS Cameras

Camera	New		Mint	Excellent	User
Vectis 40	360	300			
Vectis S-1	220	170			
Vectis S-1, 28-56 f/4-5.6	300	260			

Minolta Vectis S-1 Lenses

Camera	New	Mint	Excellent	User
22-80 f/4-5.6	260			
25-150 f/4.5-6.3	280			
28-56 f/4-5.6	85			
56-170 f/4.5-5.6	160			
80-240 f/4.5-5.6	400			

□ NIKON APS
Nikon Pronea 6i

The Pronea 6i was designed so that anybody who can read can pick one up and start taking great pictures immediately. It was also designed so that the well-seasoned photographer-cum-gadgeteer can just as easily access its comprehensive array of features. The key to this seemingly mutually exclusive pair of operating modes is the BASIC/ADVANCED selector switch (an idea borrowed from the N50) located atop the camera on the left-hand side. Set to BASIC, the Pronea 6i becomes an interchangeable-lens point & shoot APS camera. Set to ADVANCED, and the Pronea 6i affords the photographer with an in-depth assortment of user-settable features and controls.

Nikon has elected to retain the classic F-mount with the Pronea 6i, although only AF Nikkors and the new line of Nikkor IX lenses will work with the camera. Currently, Nikon is offering a 20-60mm f/3.5-5.6D, a 24-70mm f/3.5-5.6D, and a 60-180mm f/4-5.6D in the new line of compact lenses.

The following APS features are some of those supported on the Pronea 6i (please refer to the beginning of the APS section for more information): Mid-Roll Change, data imprinting of camera settings (aperture, shutter speed, exposure mode, film speed), date imprinting, 99 titles in 12 languages, and selectable print quantity (0-7). Of course, the 6i supports H, P, and C formats, as well. The 6i also supports the "Series Scene" feature, a command that is passed to the photofinishing equipment, instructing it not to compensate for over- or under-exposure. The Series Scene feature is available for bracketing either ambient or flash exposures.

The AF system on the 6i employ's Nikon's proven advanced Cross-Type Wide-Area Autofocus Sensor module, the same technology found in the N70 and N90s. AF modes include single-shot AF with focus priority, or continuous AF with release priority, as well as focus-tracking (servo) to 3.3 fps. Focus area selection is switchable between Wide-Area AF (7mm horizontal and 3mm vertical focus-detection area with 3mm central cross autofocus area) and Spot AF for precise placement of the AF sensor.

The exposure system on the 6i is equally comprehensive. It has a variety of program modes, which include a basic mode, program with shift, and six Vari-Program modes: portrait, hyperfocal, landscape, close-up, sport, and silhouette. Shutter- and aperture-priority AE, and metered manual are also available. Flash exposure features include TTL flash AE, Nikon's Matrix Balanced Fill-Flash, flash bracketing, rear-curtain sync, slow sync, and red-eye reduction. Other exposure options include ±5 EV exposure compensation in fi-stop increments, AE lock, and auto exposure bracketing. The 6i's metering system allows a choice between Nikon's 8-segment 3D Matrix metering, centerweighted metering with a 65/35 balance, and a tight 3.5mm spot. Shutter speeds range from 30 seconds to 1/4000 second, with flash sync at 1/180 second. The 6i's built-in pop-up flash (GN 33 at ISO 100) covers the format down to 20mm. The camera also has an accessory flash shoe.

Other features include the following: a high-eyepoint viewfinder with 20mm eye-relief, single and continuous film advance settings with a top speed of 3.5 fps, auto ISO setting with override capability, a threaded mechanical cable release socket, three-setting memory recall, unlimited multiple exposures, and a light for the large back LCD panel.

Nikon Pronea S

Nikon continues the "so simple, anybody can take great pictures" theme with the Pronea S. With fewer features than its bigger brother, the 6i, it is perhaps intended for users who are more point-and-shoot oriented. But it still has enough features and inherent picture-taking ability to handle most photographic situations with ease.

Rather than list all the features of the Pronea S, let's look at what it has (or doesn't have) in relation to the 6i. Here are the differences in a nutshell:

The Pronea S does not have a full manual exposure mode. It has a single metering mode, Nikon's excellent 6-segment 3-D Matrix metering (no center-weighted or spot capabilities). The top shutter speed is 1/2000 second, instead of the 6i's 1/4000 second, and the flash sync speed is 1/125, instead of 1/180. The Pronea S has ± 2 EV of exposure compensation in 1/2-step increments, not the ± 5 EV found on the 6i. It has no bracketing feature. The flash is somewhat less powerful (ISO 200 GN of 52 in ft.) and its coverage is less (24mm instead of 20mm). The Pronea S's integral winder does not have a continuous shooting mode.

Nikon's AM280F TTL phase-detection module handles both moving and stationary subjects with aplomb. The AF system autmatically selects between single-shot and continous AF with focus tracking, depending upon subject movement.

In terms of APS features (please refer to explanations of each at the beginning of the APS section), the Pronea S supports all three image formats (Classic, HDTV, and Panoramic), Print Quality Improvement, Title Back Imprint (30 different ones in 12 languages), Date/TIme Imprint (front or back), and Mid-Roll Change.

Nikon Pronea APS Cameras

Camera	New	Mint	Excellent	User
Pronea 6i	340			
Pronea S w/IX 30-60 f/4-5.6	370 350			

Nikon Pronea IX Lenses

Camera	New	Mint	Excellent	User
20-60 f/3.5-5.6	380 250			
24-70 f/3.5-5.6	160 125			
60-180 f/4-5.6	250 170			

□ OLYMPUS APS
Olympus Centurion and Centurion S

The lineage of the Centurion and Centurion S is unmistakable. Smart move, if you ask me, for Olympus to continue with the tried-and-proven IS-series design for an APS SLR. Except for cosmetics (the original is black and the S model has a brushed chrome look), the original Centurion and the S model are almost identical. The more recent S model lacks a few of the features found on the original, but has some it doesn't have. The Centurion has a non-detachable 25-100mm f/4.5-5.6 aspherical lens. Shutter speeds range from 1 to 1/1000 second. Exposure modes include Program, Auto-Zoom Mode, Stop Action Mode, Portrait Mode, Landscape Mode, Infinity Mode, and Spot Mode. In addition to standard TTL auto, flash settings include Night-Scene Flash, Fill-In Flash, and a forced-off setting. The film winder provides the standard set of features with single-frame advance only.

The Centurion S lost a few of the Centurion's program features. Gone are the Auto-Zoom, Infinity, and Spot modes. Increased is the slow shutter speed setting, from 1 second to 4 seconds. In most modes, maximum flash sync occurs at 1/125, but in Portrait mode, the flash will sync at all speeds up to 1/2000.

Olympus Centurion APS Cameras

Camera	New	Mint	Excellent	User
Centurion (original)	350	295 250		
Centurion S	350			

Panoramic Cameras

Panoramic photography has been a source of fascination for photographers for just about as long as they've been exposing silver halide crystals to light. Because these cameras have been around for so long, a tremendous variety exists. This section is devoted specifically to those using the rotating lens turret design popularized by Widelux. Other panoramic cameras are included as well, such as the Korona large format banquet cameras and the Fuji G-617, but are found in their respective sections. Some of the more unusual panoramics, such as the full 360-degree models, may be included in a later edition if demand and interest warrants inclusion.

Bogen Horizon 202

Bogen Horizon 202

Manufactured in Russia by Horizon KMZ, the Horizon 202 employs a rotating turret-mounted 28mm f/2.8 lens to render 24mm x 58mm images on 35mm film. This system provides the user with a 120 degree angle of coverage and up to 23 exposures on a conventional 36-exposure roll of film. The Horizon 202 is a simple, bare-bones panoramic camera: it has no meter and no battery. The camera's operation is entirely mechanical. It allows exposure times of 1/250, 1/125, 1/60, 1/8, 1/4 and 1/2 seconds by combining three exposure aperture widths with two panning speeds. Selectable apertures are f/2.8, f/4, f/5.6, f/8, f/11 and f/16. The top-mounted viewfinder provides a 110 degree field of view. Mounted on it is a bubble spirit level, visible from within the viewfinder, to insure the camera has been placed true to horizontal.

Noblex

All Noblex models are medium format roll-film cameras. The Pro 150, Pro 150S and Pro 150HS are "focus-free" cameras with the lenses' focus preset from 30 feet to infinity. The Pro 150 F (the F stands for Focusing) allows the user to focus the camera.

Specifications for all models are as follows: the negative size is 2.25" x 5", the angle of view is 146°, the top-mounted viewfinder provides you with a 90% field of view, the Accu Drive DC drive motor (no springs here) uses 4 AA batteries, the non-interchangeable lens is a 50mm Tessar with an aperture variable from f/4.5 to f/22, and multi-exposure capability. Each camera also comes with a bubble spirit level to aid the user in level placement of the camera.

The Pro 150, Pro 150S and Pro 150F have four shutter speeds: 1/30, 1/60, 1/125 and 1/250. The Pro 150HS has speeds ranging from 1/125 to 1/1000. A Pro 150 slow-speed retrofit is also available, with a full range of speeds from 1/2 second to 1/250 second.

The Pro 150S is a camera designed primarily for architectural work (the S stands for Shift), which allows the user to

Widelux F8

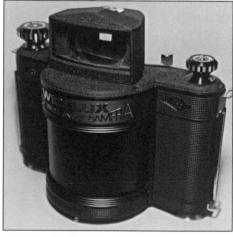

Widelux 1500

keep parallel lines from giving the appearance of converging.

Widelux

Widelux cameras are made by the Japanese manufacturer Panon. Since the early 1950's this tiny company has been producing rotating lens panoramic cameras for the smaller film formats. A number of 35mm Widelux models have been made over the years, such as the FV, F6, F7 and the current model, the F8. Panon also produces the model 1500, which takes 120 film. Earlier models of their 120 film cameras were the Panon Wide Angle Camera and the Panophic. All models provide an effective 140° angle of view. The 35mm models provide 24mm x 55mm images, and the 120 models provide 60mm x 120mm images.

The Widelux F8 has a 26mm f/2.8 lens and offers shutter speeds of 1/15, 1/125 and 1/250. The F7 is essentially the same camera with only minor cosmetic differences. The 1500 has a 50mm f/2.8 lens and shutter speeds of 1/8, 1/60 and 1/250. Earlier model Wideluxes, while not listed, should sell for proportionally less than those shown below.

Bogen Horizon 202

Camera	New		Mint	Excellent	User
Horizon 202	650	525			

Noblex

Camera	New		Mint		Excellent	User
135 S	1250	1000				
135 U	2395	1995				
175 U 5x17		5595				
Pro 6 150 E	2845	2695				
Pro 6 150 FE		3390				
Pro 6 150 U Plus		4545				
Pro 150			1895	1675		
Pro 150F			2900	2495		
Pro 150HS			2550	2200		
Pro 150S			2490	2055		

Widelux

Camera	New		Mint	Excellent		User
Widelux F6 (35mm)			900	800	700	
Widelux F7 (35mm)			1100	950	870	
Widelux F8 (35mm)	1885	1650				
Model 1500 (120 film)	3845	3500		2700		

Roundshot

Camera	New	Mint	Excellent	User
35/35 Mirror Reflex	1795			
35/35S Mirror Reflex	2395			

Medium Format Cameras

Most of the medium format cameras listed in the following pages are SLRs. Despite the often hefty prices of medium format SLRs and lenses, their popularity has risen steadily. Unlike 35mm cameras, medium format cameras come in a variety of image sizes. Whereas most all 35mm cameras have an image size of 24mm x 36mm, medium format cameras come in sizes of 6cm x 4.5cm, 6cm x 6cm, 6cm x 7cm, 6cm x 8cm, 6cm x 9cm, and even wider in a few cases. By far, the most popular are 6cm x 4.5cm, 6cm x 6cm and 6cm x 7cm sizes.

Frequently, medium format cameras are offered for sale, both new and used, as outfits. Typically, a medium format outfit will consist of a camera body, a finder (usually waist-level), a roll-film back and a lens. All this can be purchased separately, of course, if buying new equipment, but it isn't always an option when buying used. So, I've included prices for some of the more common outfits in the following section.

Speaking of price, 6x4.5 systems are generally the most economical. Except for Hasselblad and Rollei, 6x6 systems are usually somewhat cheaper than 6x7 systems. And then there is the Pentax 6x7, which rivals the 6x4.5 systems in economy, and the heavyweights in quality.

A caveat for buyers of used equipment: medium format cameras tend to fall into two categories: heavily used and hardly used. Professionals often trade in their cameras for new ones every few years because of the heavy use to which they subject their equipment. Others, such as former "serious amateurs" may decide to sell their systems because they don't use them enough anymore to justify the investment. So, when considering a used system, inspect it for wear as thoroughly as possible and, if possible, try to find one that obviously didn't get much use.

Bronica

Did you know that Bronica cameras owe their name to the Kodak Brownie? As the story goes, the Japanese still refer to 120 size film as "Brownie size," (Though I've heard Japanese folks call it *roku-roku*, which means 6-6). So, if your camera uses Brownie size film, then it's a Brownie camera, right? Or a Brownie-camera...Brownieca...Bronica! More likely, though, the name is derived from Bronica's founder, whose surname was Zenzaburo. In Japanese, *Zenzaburo no nica* approximates Zenzaburo's camera. Recombining a few of the syllables then gives us Zenza Burononica, which can be contracted further to Zenza Bronica quite easily. Though the first explanation is the more interesting, the latter is more likely.

☐ EARLY BRONICA SLRS

Bronica's first medium format cameras (the C, D and S) had lousy reputations for durability – hanger queens, as one photographer/pilot I know calls them. They were noisy, plagued by excessive vibration and particularly prone to shutter problems. By now, most have died and gone to Brownie heaven. So, needless to say, they aren't listed. If you should run across one, chances are its broken. But if by some miracle it's still working, and you're in a particularly masochistic mood, the going price for one of these cameras in clean condition with a finder, a back (where applicable) and a normal lens is from $250 to $350.

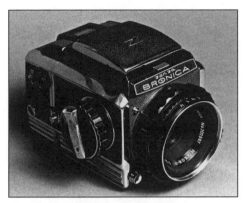

Bronica S2

Bronica S2 & S2A

The Bronica S2 was the first of the early Bronicas that employed the removable helical-focusing mount, which goes between the body and the lens, and was the first Bronica SLR to show some semblance of reliability. Outward appearances between the S2 and S2A are almost identical, but inward differences are more significant. The S2 employs brass gears in the shutter-cocking mechanism, which, after being subjected to heavy use are prone to stripping. The shutter cocking mechanism in the S2A uses stainless steel gears and is much more resistant to wear. To tell the difference between an S2 and S2A, look at the top of the camera body, behind the finder. If the camera is an S2A, it'll say so next to the serial number.

While the S2 is capable of rendering many years of reliable service if not abused, the S2A was the best model in Bronica's line of mechanical, square-format, focal-plane shutter cameras. It's sturdy and reliable and has proven itself over the past twenty years to be capable of withstanding the demands to which medium format equipment is often subjected.

Models prior to the S2 focused by turning a knob on the side of the camera, which racked the lens mount in or out of the camera body, much as is done with a typical twin-lens reflex. For the S2 Bronica abandoned this design in favor of a removable, focusing helical adapter that goes between the body and the lens, and allows the lens to be focused by rotating the helical's focusing collar.

The S2/S2A is a modular system that accepts interchangeable finders, backs and a large assortment of lenses. It features a mechanical, focal-plane shutter with speeds ranging from 1 second to 1/1000, plus B. X sync is 1/60. While 120 backs made for earlier vintage Bronicas will work just fine on the S2 or S2A, the later backs will accept either 120 or 220 film and provide multiple exposure capability.

Bronica EC & EC-TL

The EC and its update, the EC-TL, are somewhat similar in appearance to the S2A and its predecessors, but are entirely different cameras. Like the mechanical models, they are square-format, focal-plane shutter cameras. Unlike earlier models, however, they are battery dependent, having electronically-controlled shutter speeds from 4 seconds to 1/1000, plus B, with X sync at 1/60. Only B and X-sync

will work without a battery. Both the EC and EC-TL have mirror lock-up and multiple-exposure capability, and accept the same removable focusing helicals and lenses as earlier Bronicas (Except the 105mm f/3.5 leaf-shutter Nikkor; this lens will work with the S2, S2A and EC only – not the EC-TL.), but their finders and backs will not interchange with those intended for the S, S2 and S2A.

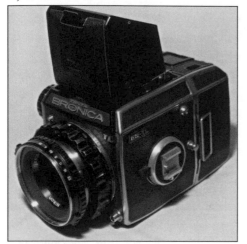

Bronica EC-TL

Incorporated into the EC-TL's body is a selective-area TTL exposure meter, with an LED readout in the viewfinder. The metered portion of the image, which is approximately 10%, is indicated by a circle scribed in the focusing screen. Set the shutter speed dial to "A" and you have an aperture-priority auto exposure camera – a rarity among medium format cameras even to this day.

Here's a little tip for you EC-TL users who may have bought your cameras second hand without instruction books, or who may have lost your instruction books. Have you ever wondered what those different colored dots next to the ASA setting are for? Wonder no more: The white dot is the setting for 40mm to 100mm lenses, the yellow dot is the setting for 135mm to 200mm lenses, and the red dot is the setting for 300mm to 1200mm lenses. A large variety of lenses were made for the Bronica S

and EC-series cameras. The Zenzanons and Nikkors are especially good.

Bronica ETR, ETRC, ETRS & ETRSi

Introduced in 1976, the ETR was Bronica's first leaf-shutter medium-format camera. It uses the 6x4.5 format and is a modular system, offering interchangeable lenses, finders and backs. Other than a few minor mechanical refinements in the ETRS, the ETR and ETRS are the same camera. Basic features include shutter speeds from 1 second to 1/500, plus T, with flash sync at all speeds.

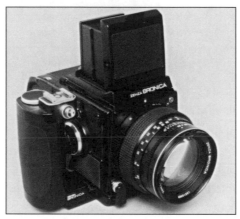

Bronica ETRS with Speed Grip E

The ETRSi is an ETRS with the following improvements: SCA/TTL flash capability with compatible strobes, mirror lock-up, a multiple exposure indicator visible within the viewfinder, and a bulb (B) setting. Also, Ei backs have an improved film transport/pressure plate system that keeps the film flatter during exposure, thereby insuring sharper images.

Lenses for the ETR/C/S/Si incorporate electronically-controlled leaf shutters. The shutters will fire at 1/500 and "T" only in the event of battery failure.

Bronica SQ, SQ-A, SQ-A/M, SQ-Ai, & SQ-B

Bronica's SQ system is a modular 6 x 6 system featuring interchangeable

lenses, finders and 120 or 220 backs. As with the ETR and its descendants, the system uses electronically-controlled leaf-shutter lenses with the standard range of speeds (1 second to 1/500) for flash sync at any setting. Mechanical speeds are 1/500 and "T" only.

In addition to the SQ's features, the SQ-A and SQ-B offer mirror lock-up, plus it has electrical contacts for the AE prism. The SQ-A/M is an SQ-A with a built-in 1 fps winder. The SQ-Ai is an SQ-A with TTL flash capability with the addition of the SCA 386 adapter and an SCA compatible flash unit.

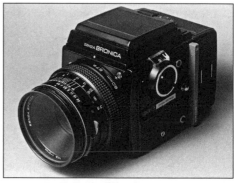

Bronica SQ-A

The SQ-B is essentially an SQ, and represents a return to the basics at an affordable price. As such, it makes for a good starter system, or second system for the pro who needs more than one camera. But should one wish to upgrade the camera, one can. The SQ-B is compatible with the complete line of SQ-Ai accessories.

Bronica GS-1

The GS-1 uses the popular 6X7 format, but is considerably lighter than its primary competitors, the Mamiya RB and RZ 67. As is true with other Bronicas, it is a fully modular system, accepting a full line of lenses, finders and backs. Like the SQA and ETR systems, the GS-1 also uses electronically-controlled leaf-shutter lenses with mechanical speeds of 1/500 and T only. The GS-1 is the only 6x7 camera that offers TTL flash metering (in fact, it was the

first medium format camera to offer it). Unfortunately, its TTL system isn't SCA compatible, so you're locked into using Bronica's GS-1 Speedlite if you want to use TTL flash.

Bronica SLRs

The following SLR prices include the camera body, focusing screen, and waist level finder.

Camera	Yrs. Made	New		Mint		Excellent		User	
ETR	1976-80			345	315	320	240	245	190
ETRC	1978-?					275	190		
ETRS	1980-88			410	375	395	280	275	235
ETRSi	1988-	1150	975	750	675	700	500		
GS-1		1720	1535	1100	1000	980	750		
SQ	c.1980-85					480	400		
SQ-A	c.1985-			565	500	520	450	460	400
SQ-A/M	1990-			790	720	750	635		
SQ-Ai	1991-	1350	1100			950	800		

Bronica Outfits

Camera	Yrs. Made	New		Mint		Excellent		User	
S2, W/L, 75/2.8, 12/24						350	300	325	250
S2A, W/L, 75/2.8, 12/24						500	400	395	350
EC, W/L, 12/24, 75/2.8						500	425	400	350
EC-TL, W/L, 12/24, 75/2.8				725	650	650	525	500	400
ETR, W/L, 120, 75/2.8						895	775		
ETR, AE prism, 120, 75/2.8						950	825		
ETR, Std prism, 120, 75/2.8						900	750		
ETRS, W/L, 120, 75/2.8						800	695		
ETRS, AE prism, 120, 75/2.8II						1200	1000		
ETRS, AE II, 120, 75/2.8II				1495	1250	1295	1150		
ETRS, Std prism, 120, 75/2.8II				1150	975	995	900		
ETRSi, W/L, 120, 75/2.8		2350	2075	1600	1450	1400	1100		
GS-1, W/L, 120, 100/3.5		3495	3185	2320	1900	1800	1450		
GS-1, Std prism, 120, 100/3.5		4025	3785	2330	2100				
GS-1, AE prism, 120, 100/3.5		4565	4285	2995	2750	2675	2500		
SQ, W/L, 120, 80/2.8						900	850		
SQ, Std prism, 120, 80/2.8						975	900		
SQ-A, W/L, 120, 80/2.8				1225	1120	1145	995		
SQ-A, Std prism, 120, 80/2.8				1575	1440	1450	1275		
SQ-A, AE prism, 120, 80/2.8				1750	1600				
SQ-A, ME prism, 120, 80/2.8				1675	1580				
SQ-Ai, W/L, 120, 80/2.8		3095	2740			1650	1475		
SQ Basic (incl. W/L, 120, 80/2.8)		2250	2000						

Lenses for EC, EC-TL, S2 and S2A

Lens	Mint		Excellent		User	
40mm f/4 Nikkor			590	450		
40mm f/4 Zenzanon			450	390		
45mm f/4.5 Komura			275	225		
50mm f/2.8 Nikkor			325	270		
50mm f/2.8 Zenzanon			295	225		
50mm f/3.5 Komura			250	150		
50mm f/3.5 Nikkor			250	200	190	150
75mm f/2.8 Nikkor			100	75	60	55
80mm f/2.4 Zenzanon			100	75		

Lenses for EC, EC-TL, S2 and S2A (cont'd)

Lens	Mint		Excellent		User	
100mm f/2.8 Komura			150	125		
100mm f/2.8 Zenzanon	185	150	175	125		
105mm f/3.5 LS Nikkor			450	385		
135mm f/2.3 Komura preset			180	140		
135mm f/2.8 Komura			125	90		
135mm f/3.5 Komura			100	80		
135mm f/3.5 Nikkor			275	200	190	120
150mm f/3.5 Komura			220	125		
150mm f/3.5 Zenzanon	350	290	275	220		
200mm f/3.5 Komura	240	180	150	110		
200mm f/3.5 Zenzanon	350	285				
200mm f/4 Komura			150	100		
200mm f/4 Nikkor			350	260	225	180
200mm f/4 Zenzanon			250	175		
300mm f/4.5 Zenzanon			490	380		
300mm f/5 Komura Preset			195	150		
300mm f/5.5 Meyer Tele-Megor			250	150		
300mm f/5.6 Nikkor			500	350		
400mm f/4.5 Nikkor			800	700		
400mm f/5.6 Nikkor			700	600		
400mm f/6.3 Komura			350	225		
500mm f/5.6 Zoomar Reflektar			500	400		
500mm f/7 Komura			350	250		
600mm f/5.6 Nikkor			850	750		
800mm f/8 Nikkor			1000	900		
1000mm f/8 Zoomar Reflektar			950	800		
1200mm f/11 Nikkor			1250	1000		
170-320 f/4 Zoomar			850	600		
2X (Vivitar or Komura)	150	125	100	80		

Zenzanon E Lenses (ETR, ETR-C, ETR-S, ETR-Si)

Lens	New	Mint		Excellent		User
30mm f/3.5 PE	2925					
40mm f/4		600	570	550	490	
40mm f/4 PE	1315					
50mm f/2.8		640	510	495	425	
50mm f/2.8 PE	1200					
55mm f/4.5 PCS		3550	3200			
60mm f/2.8 PE	1200					
75mm f/2.8 E, EII		550	500	510	400	
75mm f/2.8 PE	800					
100mm f/4 Macro		685	580	600	500	
100mm f/4 Macro PE	1165					
105mm f/3.5		450	400	390	350	
105mm f/3.5 Macro PE	1300					
135mm f/4 PE	1135					
150mm f/3.5 E, EII		575	525	540	425	
150mm f/3.5 PE	1200					
150mm f/4		500	450	410	340	
180mm f/4.5 PE	1535					
200mm f/4.5				675	500	
200mm f/4.5 PE	1215					
250mm f/5.6		800	695	620	525	
250mm f/5.6 PE	1325					

Zenzanon E Lenses (ETR, ETR-C, ETR-S, ETR-Si) (cont'd)

Lens	New	Mint		Excellent		User
500mm f/8 E, EII		1800	1650	1500	1000	
45-90 f/4-5.6 PE	1440					
70-140 f/4.5		2000	1500	1500	1000	
100-220 f/4.8	1895					
125-250 f/5.6		2250	1700			
1.4X PE	815					
2X E		500	450	425	375	
2X PE	835					
2X Komura		200	150			

Zenzanon S & PS Lenses (SQ, SQ-A, SQ-Ai, SQ-A/M)

Lens	New	Mint		Excellent		User
35mm f/3.5 PS	3095					
40mm f/4		795	700	700	615	
40mm f/4 PS	1800	1450	1325	1280	1000	
50mm f/3.5		650	590	595	475	
50mm f/3.5 PS	1570	1390	1150	1100	950	
65mm f/4 PS	1435	1300	1200	1150	925	
80mm f/2.8		400	350	325	250	
80mm f/2.8 PS	1100	800	720	680	500	
105mm f/3.5		500	440	450	350	
110mm f/4 PS	1570					
110mm f/4 Macro		750	650	700	580	
110mm f/4 Macro PS		1095	960	980	800	
110mm f/4.5 Macro PS	1430					
135mm f/4 PS	1450					
150mm f/3.5		750	650	650	550	
150mm f/4 PS	1570	1250	1150	1100	900	
180mm f/4.5 PS	1995					
200mm f/4.5		800	650	695	550	
200mm f/4.5 PS	1675			1250	950	
250mm f/5.6		750	680	650	600	
250mm f/5.6 PS	1790	1400	1275			
500mm f/8		1650	1450			
500mm f/8 PS		6500	6000			
75-150 f/4.5		2100	695			
140-280 f/5.6		2250	1875			
1.4X PS	865					
2X PS	845	720	600	580	490	
2X Auto TC		450	400	385	300	

Zenzanon PG Lenses (GS-1)

Lens	New	Mint		Excellent		User
50mm f/4.5	1700	1420	1200			
65mm f/4	1515	1370	1150	1120	800	
100mm f/3.5	1150	970	860	825	700	
110mm f/4 Macro	1700	1420	1240			
150mm f/4	1515	1375	1150	650	600	
200mm f/4.5	1595	1395	1200	1090	825	
250mm f/5.6	1600	1400	1200			
500mm f/8		6500	6000			
1.4X Auto Teleconverter	935	790	700			
2X Auto Teleconverter	935	780	700			

Bronica S/S2/S2A Accessories

Item	New		Mint		Excellent		User	
Prism A or C			350	275	295	220		
Sport Finder					40	25		
Waist Level Finder					50	40		
Magnifier Hood					125	75		
12/24 back					200	120	90	70
120 back					100	70		
6X4.5 back					195	125		
Polaroid Back			395	350	360	325		
Bellows					135	100		
Bellows Model 2					275	185		
Ext. Tube Set (4 Piece)					90	70		
Helical Focusing Mount					70	50		
L Grip					45	25		
Pistol Grip T					50	35		

Bronica EC/EC-TL Accessories

Item	New		Mint		Excellent		User	
Waist Level Finder					90	80		
Prism A or C			350	275	295	220		
EC TTL Meter Finder					240	150		
TTL meter finder for EC, not EC-TL								
Magnifier Hood					105	75		
Deluxe Bellows					275	185		
Mini Bellows					125	100		
Ext. Tube Set (4 Piece)					90	70		
Helical Focusing Mount					70	50		
Pistol Grip					45	25		
12/24 Back					300	200		
Polaroid Back					360	310		

Bronica ETR/C/S/Si Accessories

Item	New		Mint		Excellent		User	
Waist Level Finder	125		100	80	75	45		
Prism Finder E	435		330	295	300	240		
AE Finder E			265	250	245	220		
AE-II Finder			750	690	650	500		
AE-III Finder	1000							
Rotary Finder	525		440	380	370	250		
High Eyepoint Finder			450	400				
Action Finder	425		350	300	300	250		
120 or 220 back			260	225	250	200	190	150
Ei 120 or 220 back	360		295	240	260	220		
135-N or W back	470		370	320	300	245		
Polaroid back E	390		300	250	270	220	200	150
NPC Polaroid Back	170				100	85		
Speed Grip E	255		200	160	170	125		
Motor Drive E			280	225	225	175		
Motor Winder Ei	445		350	300				

Bronica ETR/C/S/Si Accessories (cont'd)

Item	New	Mint		Excellent		User
Motor Winder Ei-II	580					
Auto Ext. Tube E14	380	300	250	250	190	
Auto Ext. Tube E28	390	300	255	260	200	
Auto Ext. Tube E42	400	300	260	250	210	
Auto Bellows E	1485			800	725	
ETR Bellows				500	350	
Pro Lens Shade E	380	300	250	270	190	
ETRSi Flash Bracket		110	110			

Bronica SQ, SQ-A, SQ-A/M Accessories

Item	New	Mint		Excellent		User
Waist Level Finder S	165	125	100			
Prism Finder S	640	450	395	400	320	
High Eyepoint Finder		525	480			
AE Prism Finder SQ-i	1210	1055	875	800	640	
AE Prism Finder (SQ-A,A/M,Ai)	990	825	775	800	640	
AE Prism Finder (SQ)				525	400	
45 DS Prism Finder		560	550			
ME (TTL) Prism Finder	875	700	590	600	480	
MF (TTL) Chimney Finder		525	450	470	385	
120 or 220 Ai back	540			270	220	
120 or 220 back (SQ, A, A/M)		275	240	250	200	
120 or 220 6X4.5 back (SQ-J)		375	320	350	250	
135-N or W back	590	495	425	450	320	
Polaroid Back S	450	360	325	350	265	
NPC Polaroid Back	190					
Speed Grip S	275	225	200	300	150	
Pro Shade S	400	350	300	320	220	
Auto Ext. Tube S18	475			210	150	
Auto Ext. Tube S36	475	440	380	395	260	
Auto Bellows S	1650			1000	695	
SQi Motor Drive.	700					

Bronica GS-1 Accessories

Item	New	Mint		Excellent		User
Waist Level Finder	160	120	100			
Prism Finder	600	495	450	460	350	
AE Prism Finder	1100	900	840	870	685	
AE Rotary Prism Finder	1175	950	895	900	725	
120 or 220 Back (6X6,6X7,6X4.5)	500	375	320	350	250	
Polaroid Back	515	410	360	380	295	
NPC Polaroid Back	195					
Speed Grip G	320	270	240	250	190	
G-1 Flash Unit	400			250	200	
Pro Shade G	440	350	325			
Auto Ext. Tube G18	485	425	350			
Auto Ext. Tube G36	485	425	350			
Auto Bellows	1660					
20" Electro Cable Release	40					

Contax

CONTAX 645

When Contax decides to do some-thing, as its past introductions so aptly illustrate, Contax doesn't mess around. The Contax 645, a totally modular, aut-ofocus, medium-format camera system, certainly illustrates this. It is the only camera on the planet that can claim to use autofocus Carl Zeiss lenses. If you read my description of the Contax AX in the 35mm section, you may recall my musings that the reason why Contax had to build a body that autofocuses rather than lenses that do, was most likely pure recalcitrance on Zeiss's part. The fact that Zeiss decided to design AF lenses for the Contax 645 actually tends to reinforce my suspicions. That is, as long as Zeiss had to design a new set of optics, there was no reason why it should not design them to autofocus as well. Anyway, let's take a look at this impres-sive system.

As touched upon above, the Contax 645 is a system camera. Finders, backs, focusing screens, and lenses can be inter-changed. The motor drive is built in to the camera body, as is the exposure meter and autofocus system. The 645 uses a focal plane shutter, which, while not allowing for flash sync at all speeds, permits lens designs with fast maximum apertures and keeps the price of lenses down to a more reasonable level than it otherwise would be.

The 645's autofocus system uses a TTL phase difference detection design, using the EOS principle where each lens has its own on-board focusing motor. Focusing modes include single shot and continuous predictive AF, with AF lock. The 645's lens mount is all new. It is very large, which means that vignetting with large lenses should not be a prob-lem. It also uses electrical contacts to transmit information between the body and the lens; there are no mechanical couplings at all. Power for the lens' onboard focusing and diaphragm motors is supplied by the camera body.

Exposure modes include aperture- and shutter-priority AE, metered manu-al, and TTL pre-flash metering, as well as auto flash TTL either with flashes mounted to the dedicated hot shoe or with SCA-compatible units via an SCA plug located on the side of the camera body. The TTL pre-flash mode amounts to a built-in flash meter, and works with any flash. It is identical to that found on the Contax RTS III. In terms of expo-sure metering, either centerweighted or spot metering modes can be employed. A total of ±2 EV of exposure compensation is available in 1/3-step increments.

The metal-bladed vertically travers-ing focal plane shutter provides shutter speeds ranging from 32 seconds to 1/4000 second (8 seconds to 1/4000 second in manual), plus B and T, with flash sync in auto at 1/125 second and 1/90 second in manual. The integral film winder features single and continous advance at speeds up to 2.5 frames per second, plus mid-roll wind-ahead.

Other features include support for Fuji's film barcode system, which works similar to DX coding on 35mm cassettes, depth-of-field preview, multiple expo-sure capability, mirror lock-up, a cable release socket, a standard PC connector, and a self-timer which can be set to either 2 or 10 seconds.

Contax 645 AF System

Camera	Yrs. Made	New	Mint	Excellent	User
645AF	1999-	1915			
645AF, 80/2.0, back, AE Finder		4000			
35mm, f/3.5 Distagon		2300			
45mm, f/2.8 Distagon		2150			
80mm, f/2.0 Planar		1495			
120mm, f4.0 APO Macro Planar (MF)		2300			
140mm, f/2.8 Sonnar		2150			
210mm, f/4.0 Sonnar		2150			
AE Prism Finder MF-1		965			
Waist Level Finder MF-2		290			
645 Back & Insert		490			
Insert MFB-1A		145			
Polroid Back MFB-2		550			

Fuji

Fuji's medium format rangefinder cameras are lightweight, well-made and have excellent optics. They have mechanical leaf shutters with speeds from 1 second to 1/500 and flash sync at all speeds. Model numbers refer to format size. For example, the GW-690 renders a 6cm x 9cm image. Prefixes (GS, GW, and GSW) indicate the focal lengths of lenses used with the various models: GS indicates a standard focal length, GW indicates a Wide angle focal length, and GSW indicates a Super Wide angle focal length. There are exceptions, however. To reduce confusion, the focal lengths are listed in parentheses following the camera model designations.

The 645 models have built-in meters. The original GS-645 has a retractable 75mm lens and was discontinued several years ago. It fits easily into a coat pocket and remains in high demand because of its size. Newer 645 models have fixed lenses. The latest autofocus models have retractible fixed lenses.

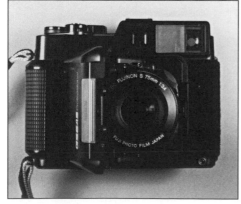

Fuji GS-645

The original G-690 and the GS-690 take interchangeable lenses. Available were a 65mm, 100mm, 150mm and 250mm. The cameras have built-in bright-line finders for the 100mm and 150mm focal lengths. The 65mm and 250mm came with auxiliary finders. Later model 690 and all 670s rangefinders all have fixed, non-interchangeable lenses.

Fuji GA645 and GA645W

Have you ever found yourself wishing for the ease of an auto-everything point & shoot camera, but in medium format? I mean, when you think about it, it would make the ultimate grab-shot camera, wouldn't it? Well, apparently Fuji agreed that this was indeed a great idea, and whadyaknow! The world's first autofocus medium format camera. With a built-in flash, meter, and winder, the GA645 "Professional" begins a new era in the quest for the ultimate grab-shot camera. And to ice the cake, soon after the release of the GA645, Fuji introduced the GA645W. But it would be a real injustice to suggest that this is all these cameras are good for. In fact, what makes either of these cameras so delightfully useful are the many features packed into them just under the surface.

The only differences worth addressing between the GA645 and GA645W are the lenses. Both are Fujinon Super EBC lenses, utilizing Fuji's 7-element, 5-group construction. The GA645 comes with a standard 60mm f/4 lens,

whereas the GA645W has a 45mm f/4 wide angle lens (corresponding to 37mm and 28mm in 35mm format, respectively). With either camera, once the power is switched off, the lens retracts into the camera body.

Both cameras use Fuji's Hybrid Auto Focus, which employs two rangefinding systems: an active system that emits an infrared beam for nearby subjects, and a passive phase difference detection system for distant subjects. Of course, there is a manual focus control as well. Automatic parallax correction is handled by the Bright Frame viewfinder. Exposure modes include program AE, aperture-priority AE, and manual. The built-in pop-up flash offers auto flash and fill flash exposure, and since the lens uses a leaf shutter, flash sync is available at all shutter speeds. The shutter itself is electronically controlled and has speeds from 2 seconds to 1/700 second, plus B. Both cameras also have a built-in data recording feature, obviating the need – and expense – of an accessory data back. The photographer can set date, time, and exposure information in the blank area below each frame.

Film advance has been fully automated, which means no more having to look through the window for the start mark. An end-of-film buzzer alerts the user when the last frame has been reached, plus auto forward winding occurs after the last frame. Other features include a non-dedicated hot shoe, a removable heavy duty lens hood, an

LCD display that indicates just about every bit of data you could think of, a PC socket, a cable release socket, and an absolutely essential feature I've been known to need when using rangefinder cameras in the past – a lens cap alarm buzzer.

Fuji GA645i, GA645Wi, & GA645Zi

The GA645i and GA645Wi are refinements of the previous two cameras, but the GA645Zi is something of another first: it has an integral 55-90mm f/4.5-6.9 zoom lens. The refinements include the following:

The updates have both a top-mounted and front-mounted shutter release. Keep in mind that, when holding the camera horizontally, the 645 image is oriented vertically. Thus if one wishes to take a landscape-oriented photo, the camera must be held vertical-ly. Obviously, having a built in release for holding the camera vertically, without having to incur the expense of an accessory grip to provide this feature, is a major convenience, and a real savings.

Another difference represents a Fuji innovation. Similar to DX coding, Fuji has designed a bar code system for its medium format film, and has included bar code readers in each of the new cameras. The bar coding on the film includes information as to the type of the film, whether 120 or 220, whether it is print or slide film, and, of course, film speed. Of course, the auto ISO setting can be overridden, if desired.

Fuji GX680, GX680 II, GX680 III, & GX-680 IIIs

The GX680 is definitely a high-tech, computer-age looking camera, with lots of knobs and buttons and other cute giz-mos – more than enough to satisfy the latent techie residing within most camera buffs. But to think of it as another gee-whiz camera is to miss the point entirely of this well-thought-out machine. This is a practical, easy-to-use studio view camera that just happens to take 120 film. It features a view cam-era-style front standard with most move-ments: tilt, shift, swing and rise. The lenses come mounted in their own lens boards, which are then attached to the front standard. Fuji even makes an adapter that will allow the use of lenses in shutters mounted in Linhof Technica boards. Each lens has its own electroni-cally-controlled shutter, which provides speeds from 8 seconds to 1/400, plus B. Flash sync is at all speeds. The backs rotate to vertical or horizontal, have ISO setting dials and integral motor drives that automatically advance the film to the first frame without having to align the arrows. The GX680 doesn't have a

Fuji Medium Format Rangefinders

Camera	New		Mint		Excellent		User
GA-645 (60mm f/4 lens)			895	780			
GA-645W (45mm f/4 lens)			1000	895			
GA-645i (60mm f/4 lens)	1530						
GA-645Wi (45mm f/4 lens)	1680						
GA-645Zi (55-90 zoom lens)	1890						
GS-645 (folding 75mm lens)			650	575	590	450	
GS-645S (60mm lens)			595	550	570	480	
GS-645W (45mm lens)			425	400			
G-670 (100mm lens)					500	400	
GW-670II (90mm lens)			660	600			
GW-670III (90mm lens)	1260						
G-690 (w/100mm lens)					525	440	
GL-690 (100mm lens)					475	400	
GS-690 (w/100mm lens)					600	500	
GW-690 (90mm lens)					600	500	
GW-690II (90mm lens)			620	580	550	500	
GW-690III (90mm lens)	1260						
GSW-690II (65mm lens)			645	600			
GSW-690III (65mm lens)	1280						
G-617 (6x17cm Panorama)	3150	2800	2540	2200			
GX-617	2900	2485					

built-in exposure meter; it's an exposure monitor. It monitors illumination off the film, be it ambient or flash, and will issue a warning if the exposure exceeds the ±2EV range it allows. As this is a rather extreme exposure range, this feature is obviously meant as a back-up to an external meter. An AE prism is also available.

The **GX680 II** is an update of the original GX680, with the following improvements: a new focus lock lever was introduced that prevents inadvertent focus shift. Also, a variety of new accessories was introduced, including the Folding Waist-Level Finder II, Instant Film Holder II with 6cm x 8cm mask, and an 80mm extension rail set.

The **GX680 III** and **IIIs** are major updates of the GX680 system. The IIIs is identical to the III, except it does not have any bellows movements, and has shed 12 ounces of weight, making it more useful for outdoor work or hand-held shooting.

The GX680 III is a true, multi-format camera, supporting 6cm x 8cm, 6cm x 7cm, 6cm x 6cm, and 6cm x 4.5cm. Instead of having to buy separate backs, the way you would with most other medium format cameras, you use a different mask for each format. The camera automatically detects which format mask has been inserted into the film holder and knows to make the necessary film advance and film counter adjustments. Wow. Focusing screens are available for each of the formats.

The Film Holder III has been substantially enhanced. Its features include automatic film advance to the first frame, even if the back is not attached to the camera. No need to look for a start mark, either. The holder will also record data in the unused film area alongside the frame, such as date, time, exposure values (Tv, Av), and a six-digit frame number. The advantage of the number is it simplifies record keeping greatly. The photographer is free to compose photographs, instead of notes.

The camera also features a large LCD display that indicates critical settings at a glance. Data to be recorded and the format being used are shown on the display as well, permitting rapid confirmation of current settings.

Another pro feature is the camera's ability to keep track of separate shot counts for the lens, the body, and the film holder, information which can also be displayed on the LCD. (only operational with the new Film Holder III and GXM lenses). Also supported on the GX680 III is Fuji's new barcode system (see the description of the GA645i for an explanation of this feature).

Lenses for G-690 and GS-690

Lens	Mint	Excellent		User
65mm		500	400	
100mm		400	300	
150mm		400	300	
250mm		500	400	

Fuji GA-645 System Accessories

Item	New	Mint	Excellent	User
GA-645 Hi-Power Flash	230			
Flash Bracket	155			
Close-Up Kit	295			
Vari Angle Stand	205			

Fuji GX-680 System SLRs

Item	New	Mint	Excellent	User
GX-680		1680 1500		
GX-680 II		1850 1745		
GX-680 III	2730			
GX-680 III S	2195			

Fuji GX-680 Lenses

Item	New	Mint	Excellent	User
50mm f/5.6	2645			
65mm f/5.6	2095			
80mm f/5.6	1655			
100mm f/4	1145			
125mm f/3.2	1625			
125mm f/5.6	1060			
135mm f/5.6	1045			
150mm f/4.5	1160			
180mm f/3.2	1695			
180mm f/5.6	1230			
190mm f/8 Soft Focus	1415			
210mm f/5.6	1215			
250mm f/5.6	1265			
300mm f/6.3	1780			

Fuji GX-680 Accessories

Item	New	Mint	Excellent	User
120 Back (GX-680)			460 400	
120 Back (GX-680 II)	665			
220 Back (GX-680)			460 400	
220 Back (GX-680 II)	685			
120 or 220 Back (GX-680 III)	860			
Polaroid Back	375			
NPC Polaroid Back	225			
AE Finder		1100 975		
AE Finder II	1475			
Prism Finder			300 225	
Adj. Mag. Finder	345		200 200	
Angle Finder		325 250		
Angle Finder	500			
Battery Pack w/chgr (GX-680)		350 300		
Battery Pack w/chgr (GX-680 II)	415			
Long Bellows	90			
Wide Bellows	90			
Bellows Lens Shade	425			
Focusing Rail Extension	75			
Strap GX	270			
RC Release (1 meter)	200			
RC Release (5 meter)	200			

Hasselblad

If you're thinking about taking the plunge and buying into a Hasselblad system, but are a bit confused over the differences among models, maybe this section will help a bit. First off, I haven't listed the 1000F and 1600F. It isn't that they aren't okay cameras – it's just that they're generally considered obsolete compared to modern Hasselblads. Besides, there is almost no interchangeability between the two systems. The following listings are in alpha numerical order.

Hasselblad 201F

The 201F replaced the 2003FCW, and includes a few notable enhancements. The 201F has a built-in self timer (settable at 2 or 10 seconds), and dedicated TTL/OTF flash metering built in, as well. The flash meter uses a center-weighted pattern and will work with dedicated units using either SCA390 or SCA590 adapters. The focal plane shutter lost its top speed, thus electronically controlled speeds range from 1 second to 1/1000 second, plus B. Flash sync with the focal plane shutter and FE lenses is 1/90 second, whereas it will sync up to 1/250 second with C or CF lenses.

Other features include an Acute Matte focusing screen, mirror lock-up, the abilty to accept an optional 1.3 fps motor drive, and multiple exposure capability. All other other features on the 201F are shared with the 2003FCW (see the 2000-series section for more infoformation).

The 201F is a system camera, thus will accept most Hasselblad options and accessories.

Hasselblad 202FA

The 202FA replaced the 201F in 1998. It shares many of the 201F's features, but also has many improvements. The 203FE was introduced before the 202FA and, with this knowledge in hand, understanding the 203F's operation helps when evaluating the 202FA's capabilities.

The 202FA's shutter appears to be the same as that found on its more full-featured brethren, although it lost its top speed. Thus speeds range from 34 seconds to 1/1000 second (90 seconds to 1/1000 second in auto). Maximum flash sync is 1/90 second, even when using CF lenses. C or CB lenses should not be used on the 202FA.

Metering modes include aperture-priority AE (at either the A or D settings on the control dial) and manual (M setting). Electronic shutter speed lock (ML setting) is also available. In Pr mode the user can program ISO value, selftimer delay and flash exposure adjustment.

TTL centerweighted OTF flash is available with SCA390 and SCA590-compatible flash units. A total of ± 5 EV exposure compensation is available in 1/3-step increments. Other features include a self-timer and multiple exposure capability.

The 202FA is a system camera, thus will accept most Hasselblad options and accessories.

Hasselblad 203FE

Introduced after the 205FCC, the 203FE houses many of the same features, but has been trimmed down somewhat. The settings dial on the 203FE has Ab, A, D, Pr, and M settings. The Zone setting is gone, and the 205FCC's Ab setting has been split into two settings. At the Ab setting, auto bracketing is available, but not aperture-priority AE. The dial must be changed either to A or D to engage aperture-priority AE. The Pr setting controls manual ISO value, self-timer delay, flash exposure adjustment, bracketing step value, and Reference mode on/off. Use of either E-series or TCC film magazines will transfer their ISO settings to the camera. The 203FE shares the same shutter as the 205FCC, but instead of the latter's spot meter, the 203FE's TTL meter uses a 20% selective area pattern. A total of ±5 EV of exposure compensation is available in 1/3-step increments.

The 203FE is a system camera, thus will accept most Hasselblad options and accessories.

Hasselblad 205TCC and 205FCC

The first truly new design from Hasselblad since the advent of the 2000FC, the 205TCC maintains the sense of tradition and backward

compatibility for which Hasselblad has become world famous, yet it offers a host of new high-tech features sure to satisfy even the most jaded of die-hard technophiles.

Hasselblad has introduced a full line of TCC lenses and accessories to exploit the 205TCC's capabilities to the fullest, yet virtually all lenses and accessories made for the 500C and later cameras will operate as they were originally intended with the 205TCC.

The 205TCC is the first Hasselblad with an exposure meter built into the camera body. It provides TTL metering at full aperture with TCC lenses (stopped down metering with earlier ones), has an ISO 100 EV range of -1 to 20 with the 80mm f/2.8 lens, and meters the central 1% of the image, which is indicated by a 6mm central circle scribed onto the focusing screen. While some may grumble that Hasselblad didn't see fit to include a more sophisticated exposure measurement system into the meter's design, others who need critical exposure information will agree that if only one metering pattern is available, a tight spot pattern like the one found on this platform is the one to have.

Four different exposure modes and one programming mode are available by rotating a dial on the left side of the camera. Indicated on the dial by A, Pr, D, Z and M, the modes are Automatic, Programming, Differential, Zone and Manual.

The Automatic mode is an aperture-priority AE mode. You select the aperture, the 205TCC selects the shutter speed in 1/12 stop increments based on the scene's illumination. AE lock is available here by depressing the shutter release part way or by holding down the AE Lock button.

The next mode on the dial, Programming, is not an exposure mode at all (although if the dial is inadvertent-ly left at this setting, the camera defaults to the A mode), but a mode in which three factory program settings can be changed to meet the user's requirements. The first setting is used for changing the default setting of a film's dynamic (contrast) range, the second can alter the self-timer's default setting from 10 seconds to anywhere from 2 seconds to 60 seconds, and the third setting is for selecting a default ISO value when non-TCC film backs are being used. When a TCC film back is used, its own ISO setting will override the default.

The Differential mode will measure the contrast range of a subject and compare it to the contrast range of the film being used. Used in conjunction with the AE Lock button, it amounts to a more sophisticated aperture-priority mode in which the photographer can verify that a scene's contrast range falls within that of the film by moving the metering spot around the subject area. The LCD readout in the viewfinder enables the photographer to determine precisely where in the scene over or under-exposures may occur. Providing that the scene's contrast range is with acceptable limits, the exposure value (EV) can then be locked in and will remain so even if the photographer selects another aperture. The camera will automatically select a corresponding shutter speed to maintain the correct EV. If a scene's contrast range exceeds that of the film, the adjustment buttons are used to bring the exposure within the film's working range.

The Zone mode is, as you may have guessed, modeled after the Zone System pioneered by Ansel Adams. Tradition dictates the use of roman numerals when expressing Zone System values and without going into a detailed explanation of the Zone System here (entire books have been written on the subject), Zone 0 corresponds to absolute black while Zone X means absolute white.

In practice, the Zone mode works not unlike the Differential mode. The photographer meters a medium gray (18%) portion of the subject, which the camera records as Zone V. Then the photographer moves the metering spot to various portions of the subject and reads the Zone values from the LCD display. To vastly oversimplify the technique involved here, the idea is to get as much of the subject as one can to fall between Zones I and IX.

Finally, in the Manual mode, the meter is active and indicates exposure by means of a '+,' '-,' or '0' ('0' being correct exposure).

The 205TCC, like the 2000FC and its updates, has a focal-plane shutter with electronically controlled shutter speeds ranging from 16 seconds to 1/2000 second, plus B. Flash sync is available from B to 1/90 with the focal-plane shutter and at all speeds with leaf-shutter lenses. Other features on the 205TCC include TTL/OTF flash exposure with SCA-compatible flash units, a self-timer, interchangeable backs and finders, motor drive capability, and compatibility with almost everything made for Hasselblads since 1957.

The 205FCC replaced the 205TCC in 1996. A number of features were changed, including shutter speeds and control settings. The 205FCC's electronically controlled shutter speeds range from 34 minutes to 1/2000 second (90 seconds to 1/2000 second in Auto), and are adjustable in 1/2-stop increments. A total of ±5 EV of exposure compensation is available in ±1/4-step increments. Flash sync occurs at 1/90 second with FE lenses, 1/250 second with leaf-shutter lenses. The "A" mode setting on the 205TCC's dial has been changed to "Ab" on the 205FCC. It still provides aperture-priority auto exposure, but at this setting the camera can also perform auto bracketing in 1/4, 1/2, 3/4, or 1-stop increments. In the

Pr mode setting, the user can program several camera functions: manual ISO value, self-timer delay, flash exposure adjustment, bracketing steps and D-mode warning levels.

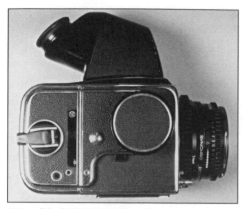

Hasselblad 500CM with 45° prism finder

Hasselblad 500C, 500CM, 501C, 501CM, 503CW, and 503CXi

The 500C is a modular system camera. It has interchangeable lenses, finders and backs. You can lock up the mirror. The Zeiss lenses contain shutters, so flash sync is available at all speeds, from 1 second to 1/500. There have been so many accessories made for this camera that a complete listing with descriptions would fill a fair-sized book.

Next in the series is the 500CM. It differs chiefly from the 500C in the focusing screen mount. The 500C's screen is semi-permanently attached. The 500CM's is held in place by clips (see illustration). This minor difference in focusing screen mounts translates into a major difference in price, though. Just check the listings. Incidentally, some early 500CM's are labeled 500C. After the introduction of the 503CXi, the 500CM was still produced for a couple of more years, available with the 500 Classic outfit, which consisted of the 500CM, an 80mm f/2.8 Planar, a waist-level finder, microprism screen and a 120 back.

The 501C replaced the 500 Classic. The body is essentially the same as the

500 CM, except there is no film confirmation window and it's only available in black. The 501C was available as an outfit when new. With it came an 80mm f/2.8 C T* lens, which lacks the EV interlock found on the CF lenses.

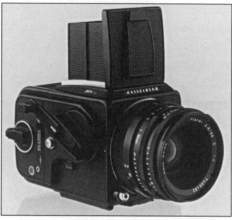

Hasselblad 501C

Hasselblad 500c focusing screen. Note the four mounting screws.

Hasselblad 500CM focusing screen. Note side clips.

The 501CM replaced the 501C and has Hasselblad's Gliding Mirror System, which eliminates vignetting in the

viewfinder with long telephoto lenses. Like the 501C, it is supposedly sold only in a kit with an 80mm f/2.8 CB Planar lens and back, but it is possible to obtain the body separately.

Hasselblad 503CXi

The 503CXi is a 501CM with OTF (Off The Film plane) flash metering using SCA-compatible flash units, and an Acute Matte (extra-bright) focusing screen.

The 503CW is a 503CXi that will accept the Winder CW. The Winder CW has five modes: single, continuous, multiple exposure, infrared remote control and lock/off, and advances frames in the continuous setting at the rate of 1 fps. It can be controlled manually or remotely with the Electric Remote Control lead or the Hasselblad Infrared Remote Control.

Hasselblad 500EL, 500ELM, 500ELX, 553ELX, and 555ELD

The 500EL is essentially a 500C with an integral motor drive. The body should come with NiCad batteries and a charger. It's also quite a bit heavier than the 500C.

The 500ELM's focusing screen is held in place by clips. Other than that, it and the 500EL are the same.

The 500ELX has a larger mirror to eliminate vignetting that can occur in the viewfinder with some lenses. It also has TTL OTF flash capability with SCA compatible flash units.

The 553ELX is a 500ELX with an

Acute Matte screen. The motor was also redesigned to take AA NiCads instead of the large NiCads used in the older style motor drives.

Hasselblad 500 ELM

The 555ELD represents a significant evolution of the integral-motor Hasselblad. This camera has been designed specifically with digital imaging in mind, incorporating several features designed to enhance the process. Even as a workhorse film-based studio camera, though, the 555ELD is an outstanding performer.

The 555ELD has an integral TTL centerweighted OTF flash meter. It also features integrated databus connections that interface directly to digital backs manufactured by leading aftermarket suppliers. A unique release system with a separate front release port on the camera activates the digital back via this data bus. It also has an electronic front release for conventional photography. Alternatively, the camera can be released remotely by an optional cord or infrared remote control. There is a selector dial for shutter/mirror release modes, and a film speed selector for TTL/OTF flash metering. A new mirror suspension system, similar to that of Hasselblad's latest space camera models, greatly prolongs the working-life of the mirror mechanism. And a new coating of the camera's interior reduces stray-light levels to an absolute minimum, enhancing image contrast even further.

Hasselblad 2000FC, 2000FCM, 2000FCW, 2003FCW

Hasselblad's 2000 series cameras incorporate focal plane shutters. The 2000 in the name represents the 1/2000 second top shutter speed, which is a nice feature, but the trade off is a slow flash sync. Zeiss F lenses (no shutter) are ordinarily used with these cameras, but the CF (shutter) lenses can be used also, giving the photographer flash sync at all lens shutter speeds.

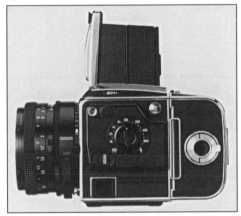

Hasselblad 201F

The 2000FC and 2000FCM differ in one area: The 2000FCM has a provision for moving the shutter curtain out of the way when attaching or removing backs. The 2000FC doesn't. The 2000FCW is a 2000FCM that will take a winder. The 2003FCW is a 2000FCW with an Acute Matte screen.

Hasselblad FlexBody

The Flexbody is apparently Hasselblad's answer to medium format view cameras like the Linhof Technicardan. The built-in advantage to the Hasselblad system, of course, is it takes Hasselblad backs and lenses.

The Flexbody consists of a front and back standard connected to an extendable bellows. The front standard has the Hasselblad lens mount and accepts C, CF, CFE, and CFi lenses.

The rear standard features ±28° of tilt and up to 14mm of shift displacement away from the marked zero setting. It also accepts Hasselblad finders and backs directly and has a film advance crank. The bellows can be extended to a maximum of 22mm for optimum close-focus work.

Hasselblad ArcBody

The ArcBody is somewhat more specialized than the FlexBody. Like the above, it takes the place of a Hasselblad SLR body, and offers in its stead the ability to provide maximum shift and tilt movements, ideal for architectural and industrial work. Unlike the Flexbody, it has no bellows that can be extended, nor does it accept Hasselblad-mount lenses.

The Arcbody is designed to accept any of three large-image-circle Rodenstock Grandagon lenses that were specifically designed for this system. These lenses are the Apo-Grandagon 4.5/35mm, the Apo-Grandagon 4.5/45 mm, and the Grandagon-N 4.5/75 mm.

The rear standard allows ±15° of tilt and 28mm of shift away from the zero mark. It also has built-in spirit levels. Like the FlexBody, the ArcBody also has a film crank and will accept Hasselblad film backs and any Hasselblad viewfinder.

Hasselblad SWC, SWC/M and 903SWC

The Hasselblad SWC has a non-removable 38mm f/4.5 Zeiss Biogon lens mounted in a leaf shutter, a matching, non-TTL viewfinder and takes interchangeable backs. The 38mm lens provides a distortion-free 90 degree angle of coverage.

The SWC/M differs primarily from the SWC in that it will accept Polaroid backs. SWC's can be modified to accept them also. Early SWC/M's came with T* lenses. Later models came with CF lenses.

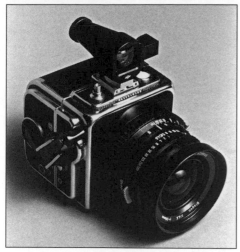

Hasselblad 903 SWC

The 903 SWC is essentially the same as a SWC/M camera with a built-in, bubble spirit level.

Special Edition Hasselblads

Certain Hasselblad models, such as the 500 Gold, Moon Cameras and Anniversary Editions fetch quite a premium. These limited edition cameras are bought and sold exclusively as collectibles. Most are probably never used. And since they aren't used, they aren't listed.

☐ NOTES ON PRICING

Many Hasselblad dealers who advertize prices for new Hasselblad cameras and equipment adhere to the Hasselblad price lists, thus you will see identical prices from one dealer to the next – for the most part. But since this is not universally true, what I have done in the following listings is to list a single new price when I find agreement between the major Hasselblad dealers, and only to list dual new prices when I find a substantial departure in price. Be aware that this difference may be due to gray market imports, but for many people, gray market is not an issue, so I'll leave it up to the reader to decide.

Hasselblad Cameras

Camera prices include bodies with waist level finders and focusing screens.

Camera	Yrs. Made	New		Mint		Excellent		User	
201F	1994-97			3350	2995				
202FA	1997-	3175	2995						
203 FE	1997-	5360	5050						
205FCC	1996-	6990	6595						
205TCC	1991-96			5500	5000				
500C	1957-70			600	450	450	350	385	300
500CM	1970-92			750	590	650	500	560	460
501CM	1991-		1585						
503CX	1988-97			1250	1095				
503CW	1997-	1800	1695						
500EL w/NiCads, chgr	1965-70			600	585	595	450	485	395
500ELM w/NiCads, chgr	1970-?			1075	1000	850	695	650	550
500ELX w/NiCads, chgr	?-1988			1375	1150	1100	950		
553ELX w/NiCads, chgr	1988-98			2100	1995	1955	1890	1845	1500
555ELD w/NiCads, chgr	1998-	2995	2860						
2000FC	1977-?					600	550		
2000FCM						1200	950		
2000FCW				1700	1400				
2003FCW	1989-91			2050	1895				
Arc Body	1997-	2670	2500						
Flex Body	1998-	2295	2095						
SWC (early)	1959-?					1950	1375		
SWC (late)	?-1979			2095	1800	1875	1500	1375	1110
SWC/M (with T* lens)	1980-?			2660	2295	2195	1700		
SWC/M (with CF lens)				3150	2495	2570	2300		
903SWC	1989-	4985	4700	3295	3430				

Hasselblad Arc Body Lenses

The following Rodenstock lenses were designed especially for the Hassleblad Arc Body and will work with this camera only.

Item	New	Mint	Excellent	User
APO-Grandagon 35mm f/4.5	2465			
APO-Grandagon 45mm f/4.5	2080			
APO-Grandagon-N 75mm f/4.5	2905			

Hasselblad Outfits

Outfit	New		Mint		Excellent		User	
500 Classic Kit			2000	1700				
500C, W/L, 80 C, 12 back					1050	825	800	750
500C, W/L, 80 C, A12			1500	1095	1300	1000	950	850
500CM, W/L, 80 C, A12			1750	1500	1550	1345		
500CM, W/L, 80 CF, A12			1900	1595	1750	1350		
501C, W/L, 80 C, A12N		2595						
501CM, W/L, 80 CB, A12N	2695	2595						
503CX, W/L, 80 CF, A12			2995	2750				
503CW, W/L, 80 CF, A12		4210						
500EL, W/L, 80 C, 12 back, chgr					1475	1250		
500ELM, W/L, 80 CF, A12, chgr			2100	1800	1750	1650		
500ELX, W/L, 80 CF, A12, chgr					2200	1800		
2000FC, W/L, 80 F, A12					1450	1250		
2000FCM, W/L, 80 F, A12			1900	1795	1750	1450		
2000FCW, W/L, 80 F, A12			3000	2750				
2003FCW, W/L, 80 F, A12			3550	3250				

Zeiss C & CF Lenses

Lens	New		Mint		Excellent		User	
30mm f/3.5 Distagon C T*			2695	2420	2350	2200		
30mm f/3.5 Distagon CF T*	5800	5370	5100	4895	4750	4280		
40mm f/4 Distagon C			1850	1550	1500	1320		
40mm f/4 Distagon C T*			2575	1995	2100	1595		
40mm f/4 Distagon CF T*			3100	2950	2885	2450		
40mm f/4 Distagon CF FLE	3995	3670						
50mm f/4 Distagon C			1250	980	1050	795		
50mm f/4 Distagon C T*			1500	1375	1400	1100	1050	900
50mm f/4 Distagon CF T*			1950	1380	1430	1200		
50mm f/4 Distagon CF FLE	2695	2450	2050	1725				
60mm f/3.5 Distagon C			1285	795				
60mm f/3.5 Distagon C T*					1300	1100		
60mm f/3.5 Distagon CB T*	2040	1900						
60mm f/3.5 Distagon CF T*			1750	1595	1400	1300		
60mm f/4 Distagon C					800	675		
60mm f/4 Distagon C T*					950	730		
60mm f/5.6 Distagon C					700	500		
80mm f/2.8 Planar C			590	450	485	350	385	325
80mm f/2.8 Planar C T*			725	625	650	525	535	480
80mm f/2.8 Planar CF T*	1720	1500	1250	1050	1000	750		
100mm f/3.5 Planar C			1085	1000	950	795	780	700
100mm f/3.5 Planar C T*			1300	1215	1195	1035		

Zeiss C & CF Lenses (cont'd)

Lens	New		Mint		Excellent		User	
100mm f/3.5 Planar CF T*	2475	2230	1850	1560	1490	1285		
105mm f/4.5 UV Sonnar CF (special order only?)		15000?						
120mm f/4 Macro Planar CF	2775	2500	2100	1895	1780	1540		
120mm f/5.6 S-Planar C					1195	950		
120mm f/5.6 S-Planar C T*					1350	1175		
135mm f/5.6 S-Planar C (Bellows)			1060	895	795	650		
135mm f/5.6 S-Planar C T* (Bellows)					890	800		
135mm f/5.6 Macro Planar CF T* (Bellows)	2455	2200	1800	1550				
150mm f/4 Sonnar C			1250	1095	1175	950		
150mm f/4 Sonnar C T*					1450	1275		
150mm f/4 Sonnar CF T*	2755	2500	2080	1950	1895	1500		
160mm f/4.8 Tessar CB T*	2345	2200						
180mm f/4 Sonnar CF T*	2995	2700						
250mm f/5.6 Sonnar C			1150	945	950	800	790	695
250mm f/5.6 Sonnar C T*			1535	1425	1350	1080		
250mm f/5.6 Sonnar CF T*	3110	2795	2200	2080	1995	1495		
250mm f/5.6 Sonnar Super Achr			2495	2100				
250mm f/5.6 Sonnar Super Achr CF T*		5025	4400	3850	3670	3450	2995	
350mm f/5.6 Tele-Tessar C			2150	1895	1795	1495		
350mm f/5.6 Tele-Tessar C T*					2450	2200		
350mm f/5.6 Tele-Tessar CF T*			3250	2995	2850	2400		
350mm f/5.6 Tele-Tessar Super Achr CFE T*	6990	6500	3250	2995	2850	2400		
500mm f/8 Tele-Tessar C			1500	1350	1350	1195		
500mm f/8 Tele-Tessar C T*			2100	1950	1900	1550		
500mm f/8 Tele-Tessar CF T*			3295	2850	2795	2500		
500mm f/8 Tele-Apotessar CF T*	5675	4900	4390	4050				
140-280 f/5.6 Variogon C			3600	3000	2950	2600		
140-280 f/5.6 Variogon CF	6430	5000	4600	4150	3895	3450		
1.4X Mutar Shift Converter	3395	2840						
1.4X XE Converter	1055	995						
2X Mutar			1095	1025	950	850		
2X E Converter	1280	1200						
2X Vivitar, Kenko or Komura	280	220	175	150	150	125		

Zeiss F Lenses (No shutter)

Lens	Mint		Excellent		User	
50mm f/2.8 Distagon T*	1575	1400	1350	1200		
80mm f/2.8 Planar T*	550	440	425	390		
110mm f/2 Planar T*	1525	1150				
150mm f/2.8 Sonnar T*	1700	1450	1450	1325		
250mm f/4 Tele-Tessar T*	1675	1625	1600	1450		
350mm f/4 Tele-Tessar T*			3500	3000		

Zeiss FE/TCC Lenses

Lens	New		Mint	Excellent	User
50mm f/2.8 Distagon T*	3780	3450			
80mm f/2.8 Planar T*	1855	1750			
110mm f/2 Planar T*	3730	3400			
150mm f/2.8 Sonar T*	3265	3080			
250mm f/4 Tele-Tessar FE T*	3500	3295			
350mm f/4 Tele-Tessar T*	7880	7200			
60-120 f/4.8 Variogon FE	3895	3700			

Hasselblad Accessory Film Magazines

Item	New		Mint		Excellent		User	
12 Film Mag			300	240	285	195		
16 Film Mag					275	200		
16S Film Mag			245	195	180	125		
A12 Film Mag		660	580	495	450	375	355	290
A12N Film Mag	695							
A12 TCC Film Mag			1000	920				
E12 Film Mag	975	920						
A16 Film Mag	795	750	595	450	400	350		
A16S Film Mag			300	230	240	200		
A16 TCC Film Mag			1050	980				
E16 Film Mag	1020	960						
A24 Film Mag	795		595	450	400	350		
A24 TCC Film Mag			1000	900				
E24 Film Mag	1010	950						
A32N Film Mag		865						
70mm 70 Exp Film Mag	1185	1100	570	495	450	350		
70mm 500 Exp Mag					2250	1700		
Polaroid 80 Back					190	120	95	80
Polaroid 100 Back	395	340	350	310	295	240	260	180
NPC Polaroid Back MF-1	240				140	100		
NPC Polaroid Back MF-2	345							

Hasselblad Viewfinders and Prisms

Item	New		Mint		Excellent		User	
HC-1 Prism (90°)			465	380	375	325		
HC-3 Prism (90°)			440	415	380	325		
HC-4 Prism (90°)					550	450		
Meter Prism (45°)					495	425	430	225
NC-2 Prism (45°)			550	500	500	390	350	250
PM Prism (45°)			770	700	650	500		
PME Prism (45°)			1050	880	820	650		
PME-3 Prism (45°)			1150	1030				
PM-5 Prism (45°)	995	935						
PME-5 Prism (45°)			1200	1150				
PME-51 Prism (45°)	1470	1000						
PM-90 Prism (90°)	635	600						
PME-90 Prism (90°)	1195	900						
RM-2 Reflex finder (90°)	1265	1190	850	825				

Hasselblad Viewfinders and Prisms

Item	New		Mint		Excellent		User	
RMFX finder (SWC 903)	245	210	850	825				
Meter Knob			100	80	75	50		
Magnifying Hood (early)			150	120	125	90		
Magnifying Hood (52094)			225	200	190	150		
Magnifying Hood (52096)	430							
Magnifying Hood HM-2 (72524)	225	195						
View Magnifier	240	220						
Waist Level Finder (early)			100	80	85	50		
Waist Level Finder	240		185	150				
TCC Waist Level Finder	240							
SWC Finder			315	275	250	225	240	200
SWC/M Finder	775	675						
Sportfinder			50	30	40	20		
Petersen 6x6 Mag w/ Adapter	150	120						

Hasselblad Close-up Accessories

Item	New		Mint		Excellent		User	
Auto Bellows	1590	1560	1100	975	850	725		
Round Bellows			395	345	350	290		
Square Bellows					250	200		
Lens Shade for Bellows	395							
Ext Tube 8mm	345	300	225	190	180	150		
Ext Tube 10mm					160	130		
Ext Tube 16mm			225	190	180	130		
Ext Tube 16E	295	260						
Ext Tube 16mm TCC			300	225				
Ext Tube 21mm			220	200	185	150		
Ext Tube 32mm			225	190	180	150		
Ext Tube 32E	320	275						
Ext Tube 32mm TCC			300	225				
Ext Tube 55mm					150	105		
Ext Tube 56mm			270	225	215	150		
Ext Tube 56E	365	320						
Ext Tube 56mm TCC			375	300				
Variable Ext Tube 64mm-85mm			540	450				

Other Accessories

Item	New		Mint		Excellent		User	
Double Hand Grip (ELM/ELX)					150	120		
D Flash 40 TTL	440	380						
Hasselblad Pro Flash #4504			500	400				
SCA 390 Adapter	200							
SCA 590 Adapter	200							
Flashgun Bracket (C/CM)					90	65		
Flashgun Bracket #46329 (ELM)			230	175				
Flashgun Bracket #45071			200	175	170	140		
Flash Bracket #45072 (CM,CX,2000)		395	395	240	210			
Flash Bracket #46330 (ELM,ELX)	415	350	250	220				
Macro Flash Set (flash & bracket)		1100	900	750				
Macro Flash Bracket			150	100				
Pistol Grip #45047 (C/CM)			50	45	50	25		
Pistol Grip #46221 (ELM/ELX)	95	70	60	50	45	25		
Pro Shade #40676, 6093T, 93	355		280	220				
Pro Shade (early)			220	200	150	100		
Snap Lock Flash Grip		400						
Tripod Quick Coupling	120							
Winder CW	950	895						
Winder F	940	890						
Winder for 205TCC			700	625				
Winder for 500C/CM (NPC)	490	445			390	325		
Winder for 2000FCW	650	635	570	500				

Mamiya

Over the past couple of decades, Mamiya's medium format cameras have earned solid reputations as reliable workhorses, especially the C and RB series. The company has never shown signs of complacency once it hit on a good thing, however, and has produced a wider spectrum of medium format designs over the years than anyone else. From the now-discontinued Universal Press to the classic C series interchangeable-lens TLRs to the 645 and 67 SLRs to the Mamiya 6 and 7 interchangeable-lens rangefinders, Mamiya has addressed almost the entire realm of medium format photography.

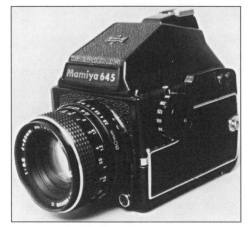
Mamiya M645

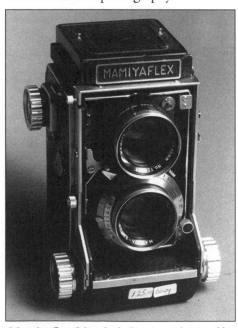
Mamiyaflex: Mamiya's first interchangeable-lens TLR

Mamiya M645, M645J, M645 1000S, M645 Super, M645 PRO, and M645 PRO TL

The original Mamiya M645 was introduced in 1976 and remains very popular among those who prefer the flexibility and ease-of-use of a 35mm system, but who also prefer the almost 3 times larger image size that this camera provides.

The M645 is a modular camera that will accept a variety of finders and lenses, plus a motor drive. It has an electronic focal-plane shutter, offering speeds up to 1/500 second with X sync at 1/60. Other features include interchangeable focusing screens, mirror lock-up and multiple exposure capability.

The M645J is an economy model: the J stands for Junior. It is less rugged in construction, but the biggest difference between the J and its more full-featured sibling is the elimination of the mirror lock-up feature.

The M645 1000S is the same camera as the original M645, with the addition of a quartz-controlled shutter that provides a top speed of 1/1000 second. Its shutter speed settings lock in place to prevent inadvertent changes.

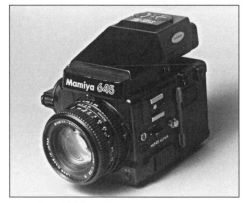
Mamiya 645 Super

The M645 Super was thoroughly redesigned. It's the only M645 that uses interchangeable backs. A motor drive called the Power Drive Grip is available as an option. It shares the 1000S' shutter and other features.

The 645 PRO replaced the Super, continuing the evolution of this workhorse of the format. But the refinements don't come without a price – the street price of the PRO is more than double that of the Super.

Introduced with the PRO was an optional new finder, called the 645 PRO AE Prism Finder. On the A-S setting this metered prism finder determines exposure by evaluating the entire scene and

then selecting an appropriate pattern. It will shift the pattern from average to spot or will calculate a centerweighted average somewhere between the two extremes. This metering mode functions with either the aperture-priority or manual exposure mode engaged. Exposure compensation is available in $\pm^1/_3$ stop increments also. The Average or Spot settings can be selected manually, as well. By the way, this new prism will also work on the 645 Super.

The 645 PRO's electronically controlled focal plane shutter offers speeds from 8 seconds to 1/1000 second. The new electronic self-timer now has a mirror-up feature, obviating the need for a cable release in some situations. The camera's B setting has also been improved, allowing for unlimited time exposures without having to worry about battery drain.

The 645 PRO TL is identical to the 645 PRO, but has TTL-OTF flash metering built in. The PRO TL is available in two kits: the SV Pack and the SVX-II Pack. The SV Pack consists of the PRO TL body, the AE Reflex Finder FK402, 80mm f/2.8 lens, 120 film back, type B screen, crank, front threaded cable release adapter, battery, and neck strap. The SVX-II Pack includes the PRO TL body, the 211-316 Prism Finder, 80mm f/2.8 lens and hood, 120 film back, type B screen, crank, electronic cable release adapter, battery and neck strap.

Mamiya RB67, RB67 Pro S & RB67 Pro SD

The RB67 is a monster of a camera that, with everything attached, is about the same size and weight as a car battery. Okay, so I exaggerate. . .a little. It is an all-mechanical, reliable workhorse. As its name indicates, it uses the 6X7 format and features a revolving, Graflok-style back (RB stands for Revolving Back) that enables the photographer to switch from horizontal to vertical shots easily. This is one reason why the camera is so large; it needs a mirror box and viewing area that is at least 7 centimeters square to accommodate this feature. A wide array of accessory finders, backs and lenses are available for this camera. The lenses incorporate leaf shutters, so flash sync is available at all speeds, from 1 second to 1/400.

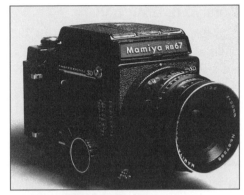

Mamiya RB67 Pro SD

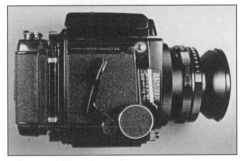

Mamiya RB67

The RB67 Pro S has been the current model since 1974. We aren't talking high-tech here, folks, but it gets the job done well. Features added to the Pro S include a focus lock, an accessory shoe and red horizontal cropping lines visible in the viewfinder when the back is horizontal. When using a Pro S back, there is also a double-exposure prevention feature that can be overridden.

The latest model of the venerable RB67 line, the Pro SD, has a few improvements over its predecessors. Perhaps most significant is its more heavily reinforced lens mount – a mount which enables the use of the new APO lenses. These lenses can be used only on the SD and the RZ67; they cannot be used on earlier RB models.

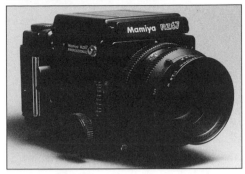

Mamiya RZ67

Mamiya RZ67

The RZ67 might best be described as an electronic RB67. It retains the revolving back of the RB, but offers such up-to-date options as a motor winder and an AE Prism, which will transform the RZ into an aperture- priority AE camera. RZ lenses have electronic shutters, providing speeds from 8 seconds to 1/400 and flash sync at all speeds. Lenses for the RB can be used on the RZ, but not vice-versa.

Mamiya RZ67 Pro II

According to Mamiya, the RZ67 Pro II was not a replacement to the tried-and-true RZ67 when first introduced, but should instead be regarded as a deluxe model. (Translation: Mamiya still had a large inventory of RZ67's, so please buy those first.) The Pro II's upgrades were worthwhile and timely, however.

Several things are new on the Pro II. Starting with the camera body, the focusing system has been improved. The Pro II still has right and left side focusing knobs, but the right one has been changed from a single knob to a coaxial pair of knobs, larger in diameter than the old one. The outer knob operates the RZ67 Pro II's rack-and-pinion focusing mechanism in the traditional manner. The inner knob is a fine-focus control, which should ease critical focusing tasks greatly.

Shutter speeds can now be set in half-stop increments from 1/200 second to 4 seconds.

The Pro II has an improved focusing screen with three LED displays that render the following information: the first will remind you if the camera hasn't been cocked when you try to take a picture, the second reminds you to remove the dark slide (doubles as a battery indicator), and the third indicates when a Pro II-dedicated flash is ready to fire (there are no Pro II-dedicated flashes available yet, though).

A new AE Prism Finder is also being produced for the Pro II. Its shape is more rounded than predecessors and its control layout is reminiscent of that on the Mamiya M645 Pro. The finder has a shutter speed control, ±3 EV of exposure compensation in 1/3 stop increments, and a meter pattern selector. The available patterns are Spot, Averaging and an automatic switching mode, which evaluates the contrast in a scene and which will switch between Spot or Averaging as the situation dictates.

Also new for the Pro II is a redesigned film magazine. It's basically the same as earlier RZ67 film magazines, but for one very handy feature: there are now two film counter windows, which means that one is always visible from the top of the camera, no matter what position the back happens to be in.

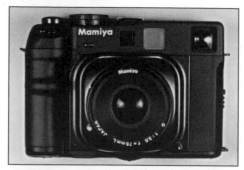

Mamiya 6

Mamiya 6, 6MF, and 7

Not to be confused with the folding-bed Mamiya 6 of the 1940's and 1950's, this latest generation Mamiya 6 has caused quite a stir since its release. Shaped like an oversized 35mm rangefinder, its sleek, contoured polycarbonate body is light, comfortable and a joy to use. It provides 6cm x 6cm exposures on either 120 or 220 film.

Because the Mamiya 6 is a rangefinder camera that takes leaf shutter lenses, its operation is almost silent. The lenses incorporate electronically-controlled shutters for speeds from 4 seconds to 1/500, plus B. The large, bright viewfinder contains the LED meter display.

Other features are as follows: Film winding is done with the single-stroke advance lever, the lens mount retracts part way into the body for added compactness when the camera isn't in use, and it has a top-mounted hot shoe.

The Mamiya 6MF is the same as the Mamiya 6, but will accept 35mm film with an adapter to produce 24mm x 54mm panoramic images.

The Mamiya 7 is essentially the same camera as the Mamiya 6MF, but produces 6cm x 7cm images on 120 or 220 film and 24mm x 65mm images on 35mm film with an adapter. It does not have the lens mount retraction feature of the Mamiya 6/6MF, however.

☐ MAMIYA TWIN LENS CAMERAS

If you have access to the Internet, you have to visit this site: *http://www.btinternet.com/~g.a.patterson/m_faq.htm*. It is dedicated to Mamiya TLRs and was compiled by Graham Patterson of the U.K.. It is one of the most comprehensive and well-documented information resources I have come across on the Internet.

All interchangeable lens Mamiya TLRs use a rack and pinion focusing bellows system that provides a maximum extension of about 56mm. Later models feature removeable waist level finders, which can be replaced by porroflex finders, if desired.

The 3-series TLRs were intended for professional use, while the 2-series cameras were thought to be more for amateur use. This, despite the fact that the last Mamiya 220 is labeled "Professional" as well.

Mamiya Medium Format SLRs

Prices for the following camera bodies include focusing screens and waist level finders.

Camera	New	Mint	Excellent	User
M645		375 350	360 250	
M645J			300 200	195 170
M645 1000S		550 490	475 360	350 320
M645 PRO		850 800		
M645 PRO TL	1600			
M645 Super		725 615	650 470	
RB67 Pro			350 275	250 170
RB67 Pro S		600 535	545 400	410 325
RB67 Pro SD	1450			
RZ67		1295 1150	1075 800	
RZ67 PRO II	2665			

Mamiyaflex

The first of the Mamiya interchangeable lens TLRs, the Mamiyaflex is a simple, utilitarian tool. It uses a knob to advance film, and automatically counts frames, although the frame counter must be manually reset. A manual stop is used to prevent double exposures. The lens shutter is cocked manually. Only 120 film can be used.

Mamiya C2

The C2 incorporates a number of cosmetic changes as well as several functional ones. The functional changes are an exposure compensation scale on the focusing scale, parallax compensation via two ruled lines to be used with the exposure compensation scale, a cold shoe, a removeable back (apparently there was a sheet film back available), and multi-exposure capability.

Mamiya C3

This is the first Mamiya TLR that uses a film wind crank instead of a knob. It differs from the C2 in the following ways: a scale in the finder is used for parallax compensation, and the frame counter automatically resets between rolls. Other minor differences exist that do not affect performance.

Mamiya C22

The C22 could take an optional film wind crank, and was the first 2-series camera that had a removable back. An optional back was available for 220 film.

Mamiya C33

The C33 features automatic parallax and exposure compensation for lenses from 80mm to 180mm. When winding the crank, the lens shutter is cocked. Otherwise, the functionality of the C33 is the same as its predecessor.

Mamiya C220

The C220 features knob-wind film advance, but the knob also has a fold-out crank. The focusing screen has two reference lines to aid in parallax compensation. It also features 220 film capability and an automatic film counter reset, but it lost its removeable back capability.

Mamiya C220f

The 220f lost its predecessor's film wind knob with fold out crank. Its knob is larger, though. It takes a Type 2 waist level finder that lacks a sports finder.

Mamiya C330

The C330 was the first 3-series TLR to accept 220-size film. It was also the first one to have interchangeable focusing screens. A new type of focusing scale using a hexagonal rod was introduced.

Mamiya C330f

The C330f has two shutter releases, one on the "chin" of the camera (the protruding base), and the other on the side. It takes the Type 2 waist level finder.

Mamiya C330s

Like the C330f, the C330s takes interchangeable focusing screens, but they are not interchangeable with earlier models' screens. It also lost its predecessor's removeable back capability.

Mamiya Medium Format SLR Outfits

Outfit	New	Mint	Excellent		User
M645, W/L, 80/2.8			550	490	
M645, Std Prism, 80/2.8			650	600	
M645, AE Prism, 80/2.8			850	700	
M645J, W/L, 80/2.8			550	450	
M645J, CDS Prism, 80/2.8			690	550	
M645 1000S, W/L, 80/2.8, Insert			675	625	
M645 1000S, Std Prism, 80/2.8, Insert	775		700	725	650
M645 1000S, PDS Prism, 80/2.8, Insert		850	750 770	670	
M645 1000S, AE Prism, 80/2.8, Insert		950	900		
M645 SV-II Pack (645 PRO, Prism, 80/2.8, 120)	2000				
M645 SVX-II Pack (above + SV wndr, AE rflx fndr)	2700				
M645 Super, AE Prism, 80/2.8, 120 back		1800	1450		
RB67, W/L, 90/3.5, 120 back			850	700	
RB67 Pro S, W/L, 90/3.5, 120 back			1100		950
RZ67, W/L, 90/3.5, 120 back			1900	1650	
RZ67, W/L, 110/2.8, 120 back			1795	1595	
RZ67, PD Prism, 110/2.8, 120 back			2100	1800	

□ **MAMIYA-SEKOR C LENSES**

The following listings are for Mamiya-Sekor C lenses only. The older, non-C lenses should be 10% to 20% less. Some recent lenses have a W suffix, which indicates an improved mechanical design. The latest lenses for the M645 have an N suffix (meaning New). Like the W lenses, these have mechanical improvements as well. There seems to be almost no difference in used prices between the new-and-improved versions versus the older ones. The abbreviation L.S. following several of the following lens' descriptions stands for Leaf Shutter.

Mamiya-Sekor C Lenses – M645

Lens	New	Mint		Excellent		User
24mm f/4 ULD	2115	1750	1500	1500	1000	
35mm f/3.5				500	370	
35mm f/3.5 N	1030	780	650			
45mm f/2.8		450	400	425	315	
45mm f/2.8 N or S	840	625	580	600	450	
50mm f/4 Shift	1400	1100	900			
55mm f/2.8		370	330	350	290	
55mm f/2.8 N	665	540	470			
55mm f/2.8 L.S.	1620					
70mm f/2.8 L.S.		450	350	390	300	
80mm f/1.9		295	250	275	220	
80mm f/1.9 N	665	520	460	475	380	
80mm f/2.8		230	200	200	150	
80mm f/2.8 N	500	390	320	350	270	
80mm f/2.8 L.S.	1300					
80mm f/4 Macro	1055	850	800	820	650	
Macro Spacer for 80mm f/4 Macro	125					
110mm f/2.8				370	265	
110mm f/2.8 N		620	550			
120mm f/4 APO Macro	1500					
145mm f/4 Soft Focus		1025	950	975	695	
150mm f/2.8	1470					
150mm f/3.5		350	330	315	275	
150mm f/3.5 N	600	500	450	450	340	
150mm f/3.8 L.S.	1590					
150mm f/4		380	350	330	250	
210 f/4		420	380	350	275	
210mm f/4 N	700	580	500			
250mm f/5		500	470			
300mm f/2.8 APO IF	12240					
300mm f/5.6		1100	1000	975	700	
300mm f/5.6 N	1330					
500mm f/5.6	2395	1850	1795	1800	1450	
500mm f/8 Mirror		500	390	420	350	
55-110 f/4.5	1830	1550	1400	1380	1200	
75-150 f/4.5		1025	900	850	770	
105-210 f/4.5 ULD	1700	1470	1300	1325	1050	
2X Teleconverter	740					
2X Vivitar, Kenko, Komura	260	150	125	120	90	

Mamiya-Sekor C Lenses - RB67

The KL lenses are for the RB67 Pro SD

Lens	New	Mint		Excellent		User	
37mm f/4.5	2690	2195	2000	2100	1600		
50mm f/4.5	1640	1400	1250	1300	900		
65mm f/4 KL	1860						
65mm f/4.5		870	750	750	620	600	500
75mm f/3.5 KL	1995						
75mm f/4.5 KL Shift	3000						
90mm f/3.5 KL	1850						
90mm f/3.8		565	500	500	360		
127mm f/3.5 KL	1490						
127mm f/3.8		770	575	550	420		
140mm f/4.5 Macro		1350	1200	1275	980		
140mm f/4.5 KL	1875						
150mm f/3.5 KL	1480						
150mm f/4.5 Soft Focus	1630	840	795	750	640		
180mm f/4.5		860	795	800	650		
180mm f/4.5 KL	1515						
210mm f/4.5 KL APO	3330						
250mm f/4.5		790	750	775	630		
250mm f/4.5 KL	1940						
250mm f/4.5 KL APO	3840						
350mm f/5.6 KL APO	4290						
360mm f/6 KL		1850	1695				
360mm f/6.3		1500	1400	1440	1100		
500mm f/6 KL APO	6000						
500mm f/8	4550	3550	3300	3150	2500		
100-200 f/5.2	3740	3100	2890				
2X (Kenko or Vivitar)	400	180	150	150	100		

Mamiya-Sekor C Lenses - RZ67

Lens	New	Mint		Excellent		User
37mm f/4.5	2690					
50mm f/4.5	1640	1400	1250	1300	900	
50mm f/4.5 ULD	1730					
65mm f/4		1035	825	750	675	
65mm f/4 LA	1875					
75mm f/3.5 L		1500	1445			
75mm f/4.5 Shift	3170			2550	1700	
75mm f/4.5 Short Barrel	1900			2550	1700	
90mm f/3.5	1390	1125	1000	945	720	
110 f/2.8	1430	1150	1000	960	750	
127mm f/3.8				1000	750	
140mm f/4.5 Macro	1875			750	600	
150mm f/3.5	1490					
180mm f/4.5	1515	875	750	790	650	
180mm f/4.5 Short Barrel	1250					
180mm f/4.5 Soft Focus	1630					
210mm f/4.5 APO Z	3330					
250mm f/4.5	1940	1550	1400	1495	1200	
250mm f/4.5 APO Z	3840					
350 f/5.6 APO Z	4290					

Mamiya-Sekor C Lenses – RZ67 (cont'd)

Lens	New	Mint		Excellent		User
360mm f/6		1625	1500	1550	1250	
500mm f/6 APO Z	6200					
500mm f/8	4550			1950	1640	
100-200 f/5.2	3740	2950	2800			
1.4X	870					
2X (Kenko or Vivitar)	275	200	175	150	120	
RZ Tilt-Shift Adapter	1500					
Ext. Tube for Short Barrel Lenses	350					

Mamiya M645 Accessories

Item	New	Mint		Excellent		User
Waist Level Finder		80	65	60	50	
Waist Level Finder, Super/PRO/TL	150	120	100	100	75	
AE Prism, 645 & 1000S	500	400	325	350	270	
AE Prism, Super		650	600	555	480	
AE Prism, PRO/TL	1000					
SV AE Reflex Finder, PRO/TL	530					
CDS Prism		310	250	240	190	
PD Prism		335	260	260	225	
PDS Prism	495	360	300	280	230	
Standard Prism		215	180	190	130	
Standard Prism, Super	350	270	250	240	200	
Standard Prism, PRO/TL	530					
Right Angle Finder				75	60	
Right Angle Finder Model 2	250			110	90	
2X Magnifier N	70					
Flip-Up Magnifier	170	120	90	75	60	
Universal Flip-Up Magnifier	220					
120 or 220 Insert	90	60	50	50	40	
120 or 220 Back, PRO/TL	430					
120 or 220 Back, Super		200	175	190	140	
35mm Back, Super/PRO/TL		265	250	250	200	
35mm Back (w/Panorama Adapter, Super/PRO/TL)	570					
Polaroid Back, Super/PRO/TL	430	370	345			
Revolving Camera Stage	550					
L Grip, Deluxe	105	70	55	50	40	
L Grip Super		150	120	125	90	
Left Hand Grip, PRO/TL	225					
Vari-Angle Grip				80	60	
Pistol Grip	120	75	60	55	40	
Motor Drive w/hand grip				250	170	
Power Drive Grip		220	175	200	150	
Power Drive Grip, Super/PRO/TL	350	325	250	270	195	
Power Drive 2, Super/PRO/TL	550					
Auto Bellows w/cable release		650	590	550	400	
Auto Bellows Super/PRO/TL	1250					
Auto Macro Spacer	145					
Slide Duplicator		80	70			
Auto Ext Tube 1	120					

Mamiya M645 Accessories (cont'd)

Item	New	Mint		Excellent		User	
Auto Ext Tube 2	130						
Auto Ext Tube 3	140						
Auto Ext Tube Set		200	170	150	120		
Bellows Lens Hood	215	135	115	100	80		
Infrared Remote Control, PRO/TL	545						

Mamiya RB67 Accessories

Item	New	Mint		Excellent		User	
Waist Level Finder	150	80		75	65		
CDS Prism		550	480	500	400		
PD Prism (also fits RZ)	1200	950	875	840	600		
Prism Finder		390	350	360	300	285	260
Prism Finder 2 (also fits RZ)	850			375	330		
Adjustable Diopter Magnifier	190						
Magnifier Hood		110	100	90	70		
CDS Magnifier Hood		250	180	175	140		
PD Magnifier Hood		420	395	360	300		
Universal Sports Finder		120	80	95	50		
120 or 220 Back		200	180	180	140	150	120
120 or 220 Pro S Back		265	220	215	160	225	180
120 or 220 Pro SD Back	560						
120 6x4.5 Back		320	250	225	180		
70mm Back		310	260	250	230		
120 or 220 6x4.5 Pro SD Back	600						
Polaroid Back w/adapter		245	175	185	150		
Polaroid Back N (w/built-in adptr)		350	300				
Polaroid Back SD	470						
NPC Polaroid Back	200	140	125				
NPC SX70 Polaroid Back		200	150				
Quadra 72 Sheet Film Back (7.2cm square)	550						
Power Drive w/control pack*				345	250		
Power Drive Back (6X7 or 6X8)*	720	465	420	350	280		
Grip Holder	90			40	30		
Deluxe Grip w/flash swivel				90	55		
Flash Gun Bracket	60						
Pistol Grip				45	35		
Pistol Grip 2	140	100	80				
Multi-Angle Grip		240	200	210	150		
Auto Ext Tube 1	315	240	200	210	150		
Auto Ext Tube 2	350	260	220	235	180		
Auto Ext Tube 1 KL	450						
Auto Ext Tube 2 KL	500						
Bellows Lens Hood G2	190	160	150	150	100		
Bellows Lens Hood G3	520			300	200		

The Power Drive units take either 120 or 220 film

Mamiya RZ67 Accessories

Item	New	Mint		Excellent		User	
Waist Level Finder	150	125	95	100	70		
AE Prism		1000	940	875	650		
AE Prism Finder 2	1200						
PD Prism (also fits RB)	1200	980	900	850	600	625	400
Prism Finder 2 (also fits RB)		600	500				
AE Magnifier Hood	850	650	575	495	400		
120 or 220 Magazine		450	420	425	350	300	250
120 or 220 Pro II Magazine	645						
6x4.5 Magazine		490	395				
6x4.5 Pro II Magazine	720						
6x6 Magazine				275	200		
Polaroid Back	490	395	350	350	225		
NPC Polaroid Back	200						
Quadra 72 Sheet Film Back (7.2cm square)	550						
G Adapter		80	65				
Allows use of RB film magazines and Polaroid backs on RZ							
Motor Winder				250	150		
Power Winder 2	550						
L Grip RZ	210			150	100		
Multi-Angle Grip	290	240	200	200	150		
Auto Ext Tube #1	440	350	300	325	220		
Auto Ext Tube #2	475	395	350				
Bellows Lens Hood G2	190	150	125	135	100		
Bellows Lens Hood G3	520			395	240		

Mamiya 6 & 6MF Systems

Item	New	Mint		Excellent	User
Mamiya 6 Body		1450	1250		
Mamiya 6 MF Body	1700	1450	1250		
50mm f/4	1200	1390	1200		
75mm f/3.5	1300	1000	850		
150mm f/4.5	1800	1500	1300		
Close-up Attachment	490				
NPC Polaroid Back	930				
35mm Panoramic Adapter Set	190				
Stroboframe Flash Bracket	80				

Mamiya 7 System

Camera	New	Mint		Excellent	User
Mamiya 7 Body	1850	1550	1495		
43mm f/4.5	2600				
65mm f/4	1600				
80mm f/4	1300				
150mm f/4.5	1800				
Viewfinder for 150mm lens	220				
35mm Panoramic Adapter	190				
Close-Up Attachment	390				
NPC Polaroid Back	930				
Pro-T Bracket	100				

Mamiya Twin Lens Cameras

Prices are for cameras with normal lenses and waist level finders.

Camera	New		Mint		Excellent		User	
C2					100	80		
C22					120	95		
C220			250	180	215	150	140	90
C220f			295	245	260	225		
C3					125	100		
C33					150	125		
C330					275	180	230	150
C330f			575	500	370	300	270	230
C330s			750	700	650	500		

Mamiya TLR Lenses

Lens	New		Mint		Excellent		User	
55mm f/4.5	995	800	675	600	550	400	375	300
65mm f/3.5			275	230	225	150	170	85
80mm f/2.8	610	495	425	380	400	270	250	200
80mm f/2.8 chr			180	150	170	125		
105mm f/3.5			300	220	245	150		
105mm f/4.5					220	200		
105mm f/4.5 chr					165	125		
135mm f/4.5	640	550	475	420	400	270		
180mm f/4.5 chr					225	150	135	100
180mm f/4.5	870	700	600	550	540	375	350	280
180mm f/8 chr					140	120		
250mm f/6.3	750	600	520	470	450	325		

Mamiya TLR Accessories

Item	New		Mint		Excellent		User	
Waist Level Finder	210	140			50	35		
CDS Magnifier Hood			225	200	190	145		
CDS Finder					200	150		
Chimney Finder					100	90		
Magnifier Hood					70	40		
Porroflex Finder					100	50		
CDS Porrofinder			175	150	150	110		
Prism Finder	550	400	360	330	280	250	235	200
Paramender					70	40		
Paramender 2	160	120			75	50		
Grip Holder C220					40	25		
Grip Holder C330	120	75						
L-Grip					50	25		
Pistol Grip					35	20		
Pistol Grip Model 2	160	120						

Mamiya Press Cameras

Camera	Mint		Excellent		User		
23			170	85	70		
23, 90/3.5, back			220	150			
Super 23			250	100			
Super 23, 100/3.5, back, grip			325	200			
Universal			290	200			
Universal, 90/3.5, back, grip			400	350			
Universal, 100/3.5, back, grip	595	485	450	400			

Mamiya Press Lenses

Lens	New		Mint		Excellent		User	
50mm f/6.3 w/finder	1100	850			580	350		
65mm f/6.3 w/finder					230	180		
75mm f/5.6 w/finder	650	530			475	300		
90mm f/3.5					100	80		
100mm f/2.8	575	490			300	260		
100mm f/3.5			245	200	210	125	100	90
127mm f/4.7	495	410	300	250	280	180		
150mm f/4.5							195	170
150mm f/5.6					275	200		
250mm f/5	1345	1050			600	400		

Mamiya Press Accessories

Item	New		Mint		Excellent		User		
Sports Finder					75	50			
Polaroid Back					200	110			
Film Holder, Knob Wind (6x7 or 6x9)	250		200			95	80	70	45
Film Holder, Lever Wind (6x7 or 6x9)	290		240			150	100	115	75
Model 3 Film Holder (6x7 or 6x9)					150	100			
G or M Adapter Back					60	45			
Focusing Screen Holder	130	90							
Right Angle Back w/screen					140	90			
Magnifying Focus Back w/screen & hood					120	75			
Duophot Adapter			230		60	50			
Tetra Photo Adapter	475	390							
Focusing Hood					75	50			
Extension Ring Set	200	150							
Spacer Set	215	160							

Pentax Medium Format

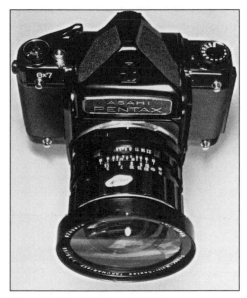

Pentax 6x7 with 55mm f/3.5 lens

Pentax 6x7, 67 and Pentax 67 II

One of the best values on the market in medium format SLRs is the Pentax 67. Dubbed a "Spotmatic on steroids," it looks like a giant-sized 35mm SLR and features interchangeable viewfinders and a wide array of very fine lenses. It accepts both 120 and 220 film. The electronically-controlled, horizontal focal plane shutter provides speeds from 1 second to 1/1000 plus B, with a slow 1/30 flash sync. The camera is not without its drawbacks, however: In the event of battery failure, X sync and B are the only available shutter speeds. With a standard lens and meterless prism, the 67 weighs about the same as a Nikon F2 or Canon F-1 with motor drive attached – heavy, but still hand-holdable. Another drawback is its lack of interchangeable film backs (although NPC makes a polaroid back for the camera). Early 67s lack a mirror lock-up provision whereas later models have it – a nice feature with such a large mirror. Also, earlier models read "6x7" (see above photo), while later models read "67."

The 67 II is a major update of the venerable jumbo Pentax SLR. The most obvious difference between the two is the new ergonomic right hand grip and relocated shutter release. Introduced with the 67 II is the AE Pentaprism Finder 67 II, which offers a more sophisticated, 6-segment metering system for AE and manual exposure modes. Built into the camera is a TTL flash metering system that is compatible with Pentax FTZ flash units via a dedicated 5-pin hot shoe. An external LCD panel was added that provides basic camera status and operating information. Backward compatibility was not forsaken, however. Almost all accessories and attachments that fit the earlier models will fit the 67 II as well, including finders, handgrips, extension bellows, etc. Also added were a self-timer, an improved mirror-up mechanism where, when the mirror is in the up position, there is no battery drain (great for long bulb exposures on cold nights), plus with the new finder, auto setting of shutter speeds from 30 seconds to 1/1000 second is possible.

Pentax Medium Format SLRs

Camera	New	Mint		Excellent		User	
645	1500	1150	1000	1050	900		
645, 75/2.8, 120 insert	2025	1400	1250	1300	950		
645N	2050						
6x7 (early - no finder)				500	450	400	350
6x7 (late - no finder)	1000	845	800	780	690		
67 II (no finder)	1500						
6x7 (late - std prism)	1220			650	600		
6x7 (late - TTL prism)	1440			880	750		
6x7 (early), std prism, 105/2.4				750	670		
6x7 (late), std prism, 105/2.4	1690			850	750		
6x7 (late), TTL prism, 105/2.4	1910	1350	1100	1145	950		

Pentax 645 and 645N

The Pentax 645 is a sophisticated, all-in-one 6cm x 4.5cm medium format SLR. It has a non-interchangeable meter prism and a built-in 1.5 fps motor drive. The electronically controlled focal-plane shutter delivers speeds from 15 seconds to 1/1000, with a top flash sync of 1/60. The shutter operates mechanically at 1/50 second only. Available exposure modes are program, aperture or shutter priority AE, metered manual and TTL OTF flash with dedicated strobe units. A total of ±3 EV of exposure compensation in 1/3-step increments is also available,

as is depth-of-field preview, diopter adjustment, and multiple exposure capabilities.

The Pentax 645N appears quite similar to the 645, even in name. But it is actually quite different, especially in one important respect. The 645N is Pentax's first venture into the medium format autofocus arena.

The autofocus system uses a passive phase detection design to provide focus lock and predictive AF modes. The autofocusing system can be toggled between 3-CCD multizone and spot focusing.

Exposure modes are the same as those on the 645, but the metering system has been improved. The 645N uses a six-segment evaluative meter for centerweighted averaging or spot metering. The built-in motor drive's top speed has been increased to 2 frames per second. Other features include multiple exposure capability, a self-timer, a PC terminal, and a data printing capability, which can record to the out-of-the-image area the following: frame number, exposure mode, shutter speed, metering mode, aperture, exposure compensation value, and lens focal length.

Pentax 645 Lenses

645 and 6x7 lenses followed by LS incorporate leaf shutters. If you need flash sync at higher speeds than either of the cameras normally allows, a leaf-shutter lens is the solution. They provide flash sync at all lens shutter speeds (1 second to 1/500).

Lens	New		Mint		Excellent		User
35mm f/3.5	800	600	595	540	325	425	
45mm f/2.8	730	520	525	480	300	400	
55mm f/2.8	630	450	450	400	290	300	
75mm f/2.8	350	250	250	175	150	350	
75mm f/2.8 LS	720	580	500	450	350	410	
120mm f/4 Macro	760	580	550	525	395	460	
135mm f/4 LS	890	640	650	595	455	300	
150mm f/3.5	580	400	420	575	265	350	
200mm f/4	470	680	490	450	325	250	
300mm f/4 EDIF	2800	2500			1500	1200	
600mm f/5.6 EDIF		3800					
45-85 f/4.5	1500	1000					
80-160 f/4.5	1380	940	995	900	650	750	
1.4X Rear Converter A	370	320	285	250	245	225	
2X Rear Converter A	430	380	300	275			

Pentax 645N Autofocus Lenses

Item	New	Mint	Excellent	User
45mm f/2.8 FA	840			
75mm f/2.8 FA	340			
300mm f/4 FA	2920			
400mm f/5.6 FA	1630			
45-85f/4.5 FA	1400			

Pentax 645 Accessories

Item	New		Mint		Excellent		User	
120 or 220 Insert	175	140	125	100	110	80		
70mm film holder (w/eyepiece)	840	775						
Right Angle Ref converter	240		165	130				
2X Magnifier	90	60						
Auto Bellows	1000	850						
Extension Tube #1		90						
Extension Tube #2		105						
Extension Tube #3		135						
Auto Ext Tube Set	330	310	245	200				
Helicoid Ext Tube	175	130			110	90		
Reverse Adapter Set	140	130						
645 to 6X7 Lens Adapter	135	120	95	80	80	70		
AF-280T Strobe (TTL)			120	100	90	70		
AF-400T Strobe set (TTL)			320	260				
AF-400T Bracket	50	40						
510v Power Pack (AF-400T)			150	110				
Transistor Power Pack (AF400T)			125	90				
Quick Shoe Set	110	90						
Remote Battery Pack	80	60						
NPC Polaroid Back	1500	1300						

Pentax 6x7 Lenses

Lens	New		Mint		Excellent		User	
150mm f/2.8			375	350	325	265		
165mm f/2.8	730	520	540	500	480	325		
165mm f/4 LS	810	680	595	550				
100mm f/4 Macro		980						
200mm f/4	790	590	600	550	560	450		
300mm f/4	1300	970	900	850	820	685		
400mm f/4			1500	1350	1400	1180	1000	850
400mm f/4 EDIF	5800	4400	3885	3700	3550	3190		
500mm f/5.6	2500	2000	1750	1680	1650	1475		
600mm f/4	4000	3000	2680	2500	2435	2200		
800mm f/4	7300	5500			4100	3450		
800mm f/6.7 EDIF	11000	9000			6500	5650		
1000mm f/8		5500			3950	3345		
55-100 f/4.5		1350						
1.4X Teleconverter	520	500						
2X Teleconverter	590	470			350	285		
2X T6 Teleconverter					300	250		
Kenko or Vivitar 2X Teleconverter	415	360	270	220	190	170	150	125
35mm f/4.5	1200	850	895	850	865	700		
45mm f/4	900	640	650	600	615	470		
55mm f/3.5					480	350		
55mm f/4	900	680	680	645	620	490		
75mm f/4.5	580	470	425	380	375	280		
75mm f/4.5 Shift	2100	1570	1250	1100	1050	995		
90mm f/2.8	600	470	450	400				
90mm f/2.8 LS			575	540	560	400	400	300

Pentax 6x7 Lenses (cont'd)

Lens	New		Mint		Excellent		User	
100mm f/4 Macro	980							
105mm f/2.4	470	340	350	325	300	225		
120mm f/3.5 Soft Focus	710	540	485	440				
135mm f/4 Macro	660	500	470	425	435	320		

Pentax 6x7 Accessories

Item	New		Mint		Excellent		User	
Waist Level Finder	120	90	75	60	65	40		
Pentaprism Finder	220	190	170	150	150	125	115	100
Pentaprism Finder II								
AE Pentaprism Finder II								
TTL Prism Finder	440	340	315	240	245	210		
Rigid Mag Hood	200	130	120	100				
Right Angle Finder	260	250	175	150				
2X Magnifier	100	90	65	50				
NPC Polaroid Back	865	780						
Hand Grip	95	85	65	50				
Hand Grip II								
Hot Shoe Hand Grip II								
Auto Bellows	1450	1390	950	850	775	600	500	400
Ext Tube Inner	240	210						
Ext Tube Outer			75	50				
Slide Copier	895	850						
Helicoid Ext Tube	160	140			90	70		
Reverse Adapter (67mm)	75	50						

Rollei Medium Format TLRs

☐ ROLLEIFLEX TWIN LENS REFLEX CAMERAS

Rolleiflex Automat w/Tessar lens and MX sync

Rolleiflex 2.8A with Tessar lens

Rolleiflex 2.8D with Xenotar lens

Most Rollei TLRs, while certainly not modern cameras in terms of dates of manufacture, are quite modern when one considers their capabilities. Thirty and forty year-old Rolleis still see daily use world-wide, undoubtedly due to their almost bullet-proof construction and excellent optics. I've talked to many people who still use the earliest models and swear by the excellent photos these antiques provide.

During the past few years, the used market prices of certain models of Rolleiflexes have risen to almost ridiculous levels because of the demand caused by overseas collectors. Even so, most "ordinary" models, especially those in user condition, still represent a very cost-effective way for one to move into

medium format. Because something like fifty different models of Rolleiflex cameras have been made since the Rolleiflex I of 1929, space does not permit my explaining each model's features. (The exception is the 2.8GX, Rollei's only current TLR camera. Its pertinent data is listed below.)

The Tessar and Planar lenses are made by Zeiss. Xenar and Xenotar lenses are made by Schneider. Collectors prefer the Zeiss lenses, especially the Planars. I've heard different stories about why this is so. One claim I often hear from collectors is that the Zeiss lenses are contrastier than the Schneiders. But I've heard others, who were mostly users, say just the opposite. Gene Lester, a well-known Hollywood photographer and the President of the American Society of Camera Collectors, explained

to me that Rollei conducted rigorous quality-control tests on the Zeiss lenses, rejecting fully sixty percent of the ones they received, and that they didn't subject the Schneider lenses to these same tests. Collectors may be inclined to believe that the Zeiss optics are better because of this. But it sounds to me as if Rollei had a lot more confidence in Schneider's quality control process than Zeiss'. Furthermore, Rollei made no distinction between the two makes of lenses when they priced their cameras. From personal experience, I can tell you this: I've used Rolleiflexes with Schneider and Zeiss lenses, both 3.5's and 2.8's. And I'm here to tell you, they're all so darn sharp and contrasty that I think these folks are splitting hairs. So, if you're looking for a budget medium format camera, get a Rolleiflex with a Schneider 3.5 lens and rest easy with the knowl-

edge that you have acquired one of the finest photographic tools ever made. Take care of it and you'll be passing it on to your grandchildren.

Rolleiflex 3.5E3 with Xenotar lens and meter

Rolleiflex 2.8GX

Continuing the grand tradition of Rolleiflex TLRs, the 2.8GX has such niceties as a Planar 80mm f/2.8 taking lens (manufactured by Rollei under license from Zeiss) mounted in a Synchro Compur between-the-lens leaf shutter, which provides speeds from 1 second to 1/500, plus B, with X sync at all speeds. The 2.8GX uses 120 film only. It offers TTL match-diode metering (through the viewing lens), using a centerweighted pattern. When using SCA-compatible flash units, TTL flash via the dedicated hot shoe is available. Auto film advance to the first frame (an ancient Rollei tradition) was retained, as was multiple- exposure capability.

There is no question that the 2.8GX is expensive, but if one wants the very best, one must be prepared to pay for it.

Rolleiflex 3.5F with Planar lens and meter

The 12/24 selector found on the Rolleiflex 2.8F and 3.5F12/24 models.

In the TLR listings below, letters or numbers in parentheses indicate the following: (m) = m-type flash bulb sync only. (mx) = both m-type bulb and electronic strobe sync. (mx-evs), also called mx-lvs, means the cameras have the above-mentioned flash capabilities, plus Rollei's Automat feature.

The evs, or lvs, stands for "exposure (or light) value setting." It's a system common to a number of different

cameras, where the shutter speeds and apertures are cross-coupled: when one changes the shutter speed, the aperture will change automatically in an inverse-proportional manner ensuring correct exposure. (12/24) refers to an option that was available on certain later model Rolleiflexes that allows the use of either 120 or 220 film.

The Rolleiflex TLRs which follow are arranged in approximate chronological order. You'll note that several listings have no prices. If you have verifiable pricing info for these cameras, I'd appreciate your input.

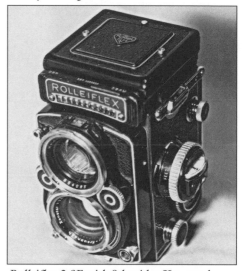

Rolleiflex 2.8F with Schneider Xenotar lens and meter

Rolleiflex TLRs

Camera	Yrs. Made	New		Mint		Excellent		User	
I (orig), Tessar 75/4.5	1929					180	140		
I, Tessar 75/3.8	1929-32					200	160		
Original, Tessar 60/2.8	1931-38								
Original, Tessar 75/3.5	1931-38								
Std, Tessar 75/3.8	1932-41							190	140
Std, Tessar 75/3.5	1932-41								
Std, Tessar 75/4.5	1932-41								
Sports, Tessar 60/2.8	1938-41								
3.5A, Tessar	1937-49					105	90		
3.5A, Xenar	1939-49					110	90		
2.8A, Tessar	1950-51					375	250		
3.5A, Xenar (m)	1949-51					150	120		
3.5A, Tessar (m)	1949-51					150	120		
3.5A, Tessar (mx)	1951-54			240	225	220	150	120	90
3.5A, Xenar (mx)	1951-54					220	130		
3.5A, Tessar (mx-evs)	1954-56			320	250	245	220		
3.5A, Xenar (mx-evs)	1954-56			300	220	240	220		
2.8B, Biometar	1952-53								
2.8C, Planar	1953-55					430	320		
2.8C, Xenotar	1953-55					390	275		
2.8D, Planar	1955-56					400	295	250	200
2.8D, Xenotar	1955-56			525	375	295	220	230	200
2.8E, Planar	1956-59					425	300		
2.8E, Xenotar	1956-59					400	295		
3.5E, Planar	1956-59					350	280	260	185
3.5E, Xenotar	1956-59					330	270	250	170
2.8E2, Planar	1959-62					480	400	300	200
2.8E2, Xenotar	1959-62					425	350		
3.5E2, Planar	1959-60					400	350		
3.5E2, Xenotar	1959-60					390	295	255	140
2.8E3, Planar	1962-65					500	410		
2.8E3, Xenotar	1962-65					470	380		
3.5E3, Planar	1962-65					400	300		
3.5E3, Xenotar	1962-65					380	295		
2.8F, Planar	1965-?					750	520	550	450
2.8F, Planar (12/24)	1965-?			1250	1000	895	725	575	475
2.8F, Xenotar	1965-?					575	420	410	300
2.8F, Xenotar (12/24)	1965-?			1100	950	825	550		
3.5F, Planar	1965-?			810	595	540	470	445	290
3.5F, Planar (12/24)	1965-?			900	650	645	550	480	350
3.5F, Xenotar	1965-?			580	525	500	350	320	240
3.5F, Xenotar (12/24)	1965-?			820	625	575	500	480	415
3.5T, Tessar	1958-75			450	350	390	275		
2.8GX	1986-	2400	2095	1795	1530				
Rolleimagic I	1960-63			200	180	160	120	105	95
Rolleimagic II	1962-67			290	220				
Tele, Sonnar 135/4	1959-?					1265	900		
Wide, Distagon 55/4	1961-67			2995	2590	2495	1450		

□ ROLLEI TLR ACCESSORIES

Rollei has made many, many different accessories for their TLRs over the last several decades. Many of these have become as collectible as the cameras. It's beyond the scope of this book to attempt anything near a complete listing, so I've listed some of the most common.

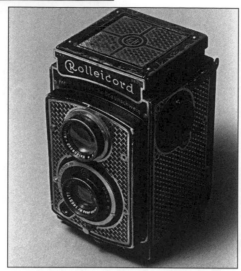

Rolleicord 1 with Art Deco trim

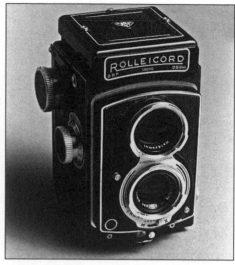

Rolleicord IV

Rollei TLR Accessories

Item	New	Mint		Excellent		User	
45° Prism Finder (2.8 GX)	1330						
90° Prism Finder (2.8 GX)	1330						
Tripod Quick Coupler (2.8 GX)	160						
Pistol Grip (2.8 GX)	280						
Folding Lens Hood	120						
TTL Flash Adapter for SCA 300 systems	130						
Rolleiflex W/L Finder				60	50		
Rolleiprism		350	275	300	175	150	100
Binocular Magnifier		150	100	100	85		
Rolleimeter (3.5 or 2.8)		75	60	60	50		
Rolleifix				50	40	35	30
Rolleigrip				80	50		
Rolleikin				80	60		
Rolleimarine U/W Housing				500	450		
Panorama Head		70	40	50	40		
Rolleicord 24 exp kit		25	20				
Rolleinar Close Up Lens Set				125	70		

Rollei Medium Format SLRs

☐ ROLLEI SL66 SERIES SLRs
Rolleiflex SL66

The SL66 was Rollei's first medium format SLR. It's a mechanical camera and has no built-in meter. The SL66 system is, in the tradition of medium format SLRs, a totally modular one, accepting a wide array of interchangeable finders, focusing screens, lenses and backs. It also has a focal plane shutter, with shutter speeds ranging from 1 second to 1/1000, plus B and with X sync at 1/30 second. Instead of using the more traditional integral focusing helicals, lenses on the SL66 are focused by racking a bellows in and out of the body. Such a system allows for greater close-up focusing flexibility than would otherwise be possible. Another nice feature, one which remains unique to the SL66 line, is Rollei's Retromounting®, which allows some lenses to be reverse-mounted without the use of accessory adapters, giving the photographer easy access to the world of high-magnification photography without having to incur a lot of additional expense. And, in its effort to add

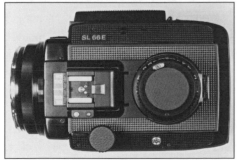

Rolleiflex SL66E

even further control to the final image, Rollei decided to give the SL66 a tilt feature, allowing for ±8 degrees of movement. The SL66 also has a PC connector, a hot shoe, a cable release socket, multiple exposure capability and a mirror pre-release.

Rolleiflex SL66E

The SL66E is an SL66 with a few nice improvements. It has a TTL meter using a centerweighted pattern. The meter readout in the viewfinder is provided by a 5 LED array. Exposure compensation (±1.5 EV) is also available. The SL66E provides TTL auto flash exposure and metering with SCA 356-compatible units. Film emulsion speeds are set on the backs with the SL66E. This information is communicated to the camera's meter via three electrical contacts on the E-type back.

Rolleiflex SL66SE

The SL66SE is similar to the SL66E, with significant improvements. It has three TTL metering patterns: a bottom-centerweighted multi-zone averaging pattern, a spot pattern, and TTL flash metering with SCA 356-compatible flash units. Exposure options include metered manual, shutter-priority AE, aperture-priority AE and TTL auto flash.

Rolleiflex SL66X

The SL66X is an SL66 with slight cosmetic alterations, updated to include

the TTL flash technology found on the SL66E and SL66SE.

☐ ROLLEI SLX & 6000 SERIES SLRs

All the following cameras have several things in common: They all accept the electronic leaf-shutter lenses (in other words, they will not accept lenses for the SL66 series). All cameras have a 14-pole universal socket for external control units and accessories (such as the ME-1 or RC-120). They accept interchangeable finders and focusing screens. They have integral motor drives which allow single and continuous film advance at speeds up to 1.5 fps (2 fps with the 6003, 6008 and 6008 SRC 1000), as well as first-frame prewind and auto film rewind. They are battery-dependent, but the batteries are rechargeable NiCads and can be interchanged in seconds. Each battery provides more than 500 exposures between charges.

Rolleiflex SLX

Introduced in 1977, the SLX was the first model of the new-look Rollei medium format SLRs. Its exposure modes are shutter-priority AE and non-metered manual. In the shutter-priority mode, a centerweighted metering pattern is used. The SLX does not have a provision for mid-roll film back interchangeability. Instead, it uses a fixed (but removable) back into which one pops a pre-loaded film insert. In addition to the above features, the SLX also has a PC

socket and a depth-of-field preview button that doubles as a AE lock.

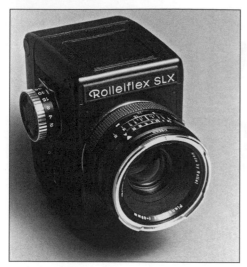

Rolleiflex SLX

Rolleiflex 6001

The Rolleiflex 6001 replaces the 6003 as the system's entry level camera. As such, however, it would not be fair at all to label it a "stripped down" camera.

The camera has no onboard ambient exposure meter, but does have a built-in TTL OTF flash meter that is compatible with SCA300 flash units. The integral motor provides single frame advance and film transport up to 1.5 frames per second in continuous advance mode. Exposure bracketing, flash bracketing, and multiple exposure modes are also available.

Shutter speeds depend upon the lenses mounted, but range from 30 seconds up to 1/1000 second (with the PQS lenses), plus B, with flash sync at all speeds. Speeds are selectable in 1/3-stop increments.

Other features include a PC terminal in addition to the dedicated hot shoe, mirror lock up, an electronic remote release, depth of field preview, a self-timer, and more.

The 6001 is digital back ready, but cannot use the 6008i's Master Control Unit.

Rolleiflex 6002

The 6002 was introduced after the 6006 as a more economical model. Like the SLX, it does not have a provision for changing backs in mid-roll.

Three exposure modes are available: shutter-priority AE, non-metered manual and TTL auto flash with SCA-356 compatible flash units. For metering, a centerweighted pattern is used. The 6002 also has a PC socket in addition to the dedicated hot shoe and a depth-of-field preview button that doubles as an AE lock.

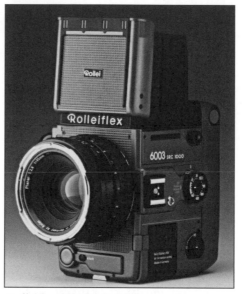

Rolleiflex 6003 SRC 1000

Rolleiflex 6003 SRC 1000 and 6003 Professional

The whole philosophy behind the Rollei 6003 is that you should only have to pay for the features you need, but if you should need more features at a later date, you shouldn't be denied them. The **6003 SRC 1000** is a little smaller and a little lighter than the 6008 SRC 1000, but is very similar to it in terms of its capabilities, so only the points where it differs from the more full-featured model will be addressed here. For starters, the multi-spot metering function is not supported with the 6003. Also, the Action Grip that comes standard with the 6008 is available as an option for the 6003. Mirror prerelease is

done using the RC-120 remote control unit; there is no prerelease button built into the body. The dark slide built into the 6008 is available as an accessory for the 6003. All other features are shared by the two cameras.

The **6003 Professional** is essentially the same as the 6003 SRC 1000. A quick look at its features would include the following:

The 6003 Professional uses a five-segment metering system to provide centerweighted and 1 percent spot readings. Exposure modes include program, shutter- and aperture-priority AE, metered manual with exposure compensation to +2/-42/3 EV in 1/3 step increments. TTL OTF flash metering includes an auto fill-in capability. Shutter speeds range from 30 seconds up to 1/1000 second with PQS lenses, plus B, with flash sync at all speeds. The built-in winder has single frame advance and continuous advance at speeds up to 2 frames per second. Other features include autobracketing, a PC terminal, multiple exposure capability, a self-timer, mirror lock-up, an AE lock, and depth-of-field preview. What's more, the 6003 Professional is digital back ready, but it will not accept the Master Control Unit.

Rolleiflex 6006 & 6006-II

The 6006 has three exposure modes: shutter-priority AE, non-metered manual and TTL auto flash with SCA-356 compatible flash units. For metering, a centerweighted pattern is used.

The 6006 was the first in this series of Rollei SLRs to offer fully interchangeable film backs. Other features include single and continuous film-advance settings (up to 1.5 fps in continuous mode), a PC socket in addition to the dedicated hot shoe, a button that doubles as a depth-of-field preview selector and AE lock, a cable release socket, and a mirror prerelease (the SLX and

6002 require the use of the RC-120 electric remote control release to access this feature).

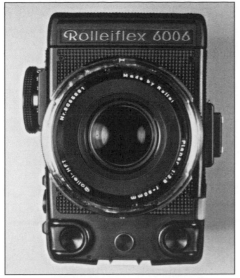

Rolleiflex 6006

The **6006-II** is, as its name implies, an improved 6006. The major difference is the addition of a two-position switch for single or multiple exposures. The two positions are labeled SE and ME. Prior models (the 6006 and 6002) could take multiple exposures only by using the expensive ME-1 multi-exposure control unit or the MRC-120 electric multi-exposure remote release.

Rolleiflex 6008, 6008 SRC 1000 & 6008 SRC Integral

The **6008** has all the features of the 6006-II, plus the following: it supports the 1/1000 top shutter speed on the new PQS lenses. The exposure system uses two metering patterns: a seven-zone, bottom-centerweighted pattern, and a 1% spot pattern. Up to five spot readings can be stored and averaged for critical exposure situations. Exposure modes are program, shutter- and aperture-priority AE, metered manual (a first for this series), and TTL auto flash using SCA 356-dedicated flash units. A three-shot auto-bracketing feature is also available.

New film backs (Rollei prefers to call them magazines) were also devel-oped for the 6008. Instead of setting the film speeds on the camera, as is done with previous models, the film speeds are set on the backs. For the photographer who often shoots using a variety of emulsions and speeds, this is a welcome feature. The older, 6006-style backs will still work on the 6008, but the camera will default to ISO 100. Not to worry, though: the 6008 has such an extreme EV adjustment range available (-4 $^2/_3$ to +2 EV, which is equivalent to ISO 2500 to ISO 25) that the camera's meter and exposure options can still be used. Rollei will convert the older backs to the newer style if one prefers. Also new to the 6008 is the Action Grip. The grip is fitted to the hub of the shutter speed dial on the right side of the camera and has a built-in meter-activation/AE lock switch and a shutter release. In addition, the integral motor drive's continuous advance speed has been improved to 2 frames per second.

The **6008 SRC 1000** differs from the 6008 in only a couple of areas. The SRC, by the way, stands for Scanning Remote Control – we'll get to that shortly. As you may have guessed the "1000" in its name refers to its top shutter speed. The SRC 1000 has the 1/1000 second shutter speed indicated on the shutter speed dial. The older 6008 has two marked (but unlabeled) detents above 1/500, one for 1/750 and the other for 1/1000. They were not labeled on the original 6008 because the high speed leaf shutters were still in development when the camera was ready for release. The 1/750 detent was dropped from the SRC 1000's dial.

The other difference came about as a result of a new accessory for the 6008 and the 6003: Rollei's **Digital ScanPack**. The Digital ScanPack allows the Rollei 6008 SRC 1000 to interface directly with a Macintosh II or IBM-compatible 80386 or higher with a min-imum of 8 MB RAM and 100 MB of free hard disk storage space, and converts it to a state-of-the-art ultra high-resolution digital imaging scanner. Because the Digital ScanPack requires relatively long exposure times (3 seconds and up), the shutter was redesigned so that it is not held open by an electro-magnet on the B setting, eliminating battery drain during long exposures. This improvement will not only be of interest to those working with digital imaging, but to other photographers who regularly use long exposure times in their work.

The **Rollei 6008 SRC Integral**, aka the 6008i, is a relatively minor update of the SRC 1000. One of the complaints of the earlier 6000-series cameras was, when using 645 backs, it was almost impossible to shoot in portrait mode (using the 6000-series cameras sideways, especially with a waist-level finder, is quite awkward). The 6008i allows the latest 6000-series 645 magazines to be mounted either horizontally or vertically. Please note, these magazines currently work on the 6008i and 6001 cameras only. Also, the built-in motor drive's continuous frame rate was increased to 2.5 frames per second.

The optional Master Control Unit attaches to the 6008i's grip mount, and can be used to control the camera remotely or to expand the camera's capabilities, including additional AE control, second-curtain flash sync, an autmatic intervalometer, programmable self-timer delays, silent film advance, and other options. The 6008i is digital back ready.

Rollei Medium Format SLRs

Camera	New		Mint		Excellent		User	
SL66					525	480	370	320
SL66E					850	700		
SL66SE			4895	4500				
SL66X			1995	1750				
SLX					600	350		
6002			1295	1250				
6003 Pro	2200							
6003 SRC 1000	1795							
6006			1825	1500	1100	800		
6006-II			2895	2350				
6008			2800	2525				
6008 SRC 1000			3000	2600				
6008 SRC Integral	2250	2000						

Rollei Medium Format SLR Outfits

Outfit	New		Mint		Excellent		User	
SL66, W/L, 80 Planar, back			1200	895	950	800		
SL66E, W/L, 80 Planar, back			2895	2250	2320	1850		
SL66SE, W/L, 80 Planar, back	9240							
SL66X, W/L, 80 Planar, back			3750	2995				
SLX, 80 Planar, back, chgr			980	895	895	740		
6001 Pro: body, 80/2.8, back, chgr								
6002, 80 Rolleigon, chgr			1150	970	900	800		
6003 Pro: body, 80/2.8, back, chgr	3400	3200						
6003 SRC, 80 Planar, back, chgr			2990	2650				
6006, 80 Planar, back, chgr			1795	1700	1695	1275		
6006-II, 80 Planar, back, chgr			3000	2495	1995	1650		
6008, 80 Planar, back, chgr			3695	3000				
6008 Integral, 80/2.8, back, chgr	4400	3995						
6008 SRC, 80 Planar, back, chgr			4895	4500				

Lenses for Rollei SL66

Lens	New		Mint		Excellent		User	
30mm f/3.5 Distagon HFT	6095				3000	2500		
40mm f/4 Distagon HFT	7220				3300	2780		
50mm f/4 Distagon					860	695		
50mm f/4 Distagon HFT	3655				1425	1095		
75mm f/4.5 Rolleigon PC			4500	4000				
80mm f/2.8 Planar					280	190		
80mm f/2.8 Planar HFT	1500		1500	1450	1295	1100		
80mm f/4 Distagon w/shutter					860	650		
120mm f/4 Makro Planar HFT	5240							
120mm f/5.6 S Planar					920	750		
120mm f/5.6 Opton			760	700	690	500		
150mm f/4 Sonnar					700	510		
150mm f/4 Sonnar HFT	3755		1950	1500	1200	800		
150mm f/4 Sonnar w/shutter			850	670	550	400		
250mm f/5.6 Opton			780	650				
250mm f/5.6 Sonnar					930	750		

Lenses for Rollei SL66 (cont'd)

Lens	New	Mint		Excellent		User
250mm f/5.6 Sonnar HFT	4995	2850	1750			
300mm f/5.6 Tele-APO Kilar				500	460	
350mm f/5.6 Tele-Tessar				800	650	
1000mm f/8 Tele-Tessar	37995					
2X Teleconverter						
2X Teleconverter (E/SE)	1520					

Lenses for Rollei SLX and 6000 Series

Lens	New		Mint		Excellent		User
30mm f/4 Distagon HFT PQ "fisheye"	6780	4495					
40mm f/3.5 Super Angulon PQ	4200	3995					
40mm f/4 Distagon HFT			2500	2200	2300	1950	
40mm f/4 Distagon HFT PQ	4400	4195					
50mm f/2.8 Super Angulon HFT PQS	3500	3400					
50mm f/4 Distagon HFT			1195	1100	1000	875	
50mm f/4 Distagon HFT PQ	2200	2000					
50mm f/4 Rolleigon HFT			750	650			
55mm f/4.5 PCS Super Angulon HFT PQ	7400	7200					
60mm f/3.5 Curtagon HFT PQ			2500	2225			
60mm f/3.5 Distagon HFT			1450	1300			
60mm f/3.5 Distagon HFT PQ			2700	2425			
80mm f/2 Xenotar HFT PQ	3300	3200					
80mm f/2.8 Planar HFT					400	250	
80mm f/2.8 Planar HFT PQ	1500	1400	1200	900			
80mm f/2.8 Planar HFT PQS	1600	1500					
80mm f/2.8 Rolleigon HFT			300	260			
80mm f/2.8 Xenotar HFT PQ			1200	800			
90mm f/4 APO Symmar Macro HFT PQS	3200	3000					
120mm f/4 Makro Planar HFT			2250	1900			
120mm f/4 Makro Planar HFT PQ	3200	3000					
120mm f/5.6 S Planar HFT					1250	950	
150mm f/4 Rolleigon					1095	950	
150mm f/4 Rolleigon HFT					800	750	
150mm f/4 Sonnar HFT			1395	1250	1195	995	
150mm f/4 Sonnar HFT PQ	2350	2200					
150mm f/4 Sonnar HFT PQS	2550	2400					
150mm f/4 Tele-Xenar HFT PQ			2900	2700			
150mm f/4 Tele-Xenar HFT PQS			3500	3300			
150mm f/4.6 APO Symmar (Bellows)	3200	2700					
180mm f/2.8 Tele-Xenar HFT PQ	3500	3400					
250mm f/5.6 Sonnar HFT			1750	1450	1250	900	
250mm f/5.6 Sonnar HFT PQ	2920	2600					
250mm f/5.6 Sonnar HFT PQS	3000	2800					
300mm f/4 APO Tele-Xenar HFT PQ	4400	4200	3600	3200			
350mm f/5.6 Tele-Tessar HFT			2250	1700	1650	1375	
350mm f/5.6 Tele-Tessar HFT PQ	5400	3800					

Lenses for Rollei SLX and 6000 Series (cont'd)

Lens	New		Mint		Excellent		User
500mm f/8 Tele-Tessar HFT PQ	5600	4100					
1000mm f/8 Tele-Tessar	22000	21000			4000	3500	
1000mm f/5.6 Mirotar	50000?						
75-140 f/4.5 Variogon HFT PQ			4500	4000			
75-150 f/4.5 Variogon HFT			3500	2500			
75-150 f/4.5 Variogon HFT PQ	5100	4800					
140-280 f/5.6 Variogon HFT			3700	2800			
140-280 f/5.6 Variogon HFT PQ	5400	5200					
1.4X Longar	1150	1050					
2X Longar	1100	1000			925	695	

Rollei SLX and 6000 Series Accessories

Item	New		Mint		Excellent		User
6x6 120 or 220 back (6002/SLX)			260	200			
6x4.5 120 or 220 back (6002)							
6x6 120 or 220 back (6006)			450	390	385	250	
6x4.5 120 or 220 back (6006)					400	330	
6x6 120 back (6001/3/8)	695	650	600	500			
6x6 220 back (6001/3/8)	795	700	650	550			
6x6 220 data back (6001/3/8)	1735						
6x4.5 120 back (6001/3/8)	990	750					
6x4.5 220 back (6001/3/8)	750						
6x4.5 120/220 rotating back	970						
70mm Bulk Film Magazine			2450	1900			
70mm Vacuum back			2700	2500			
70mm Vacuum Data back (6001/3/8)	3390	3300					
Polaroid Magazine (SLX: no dark slide)			250	200	180	120	
Polaroid Magazine (6006/2/SLX: dark slide)		650	550	425	400	350	
Polaroid Magazine (6001/3/8)	600	550					
Film Insert	90	75	50	40			
Digital Scan Pack	33025						
4x5 Camera Adapter for above	1060						
ME-1 Multi-Exp Control Unit (6006/2/SLX)	1290	1100			450	300	
Electric Multi-Exposure Remote Release	240						
Master Control Unit (6008i)	1100	1000					
SRC Camera Remote Control (6003/8)	305						
Infrared Remote Control Set	700						
Intervalometer Timer	2080						
45° Rotating Prism	540	450	925	770	690	550	
90° Rotating Prism	935	870			650	520	
90° Video Viewfinder	1880						
Magnifying Hood	540	450	290	220	250	200	
W/L Hood	160	140					
Hand Grip, Standard (6008)	140						
Hand Grip, Large (6008)	140						
Pistol Grip (latest)	295	250	190	145	160	130	
Pistol Grip (SLX)					100	75	
Nicad Battery	100						
External Battery Cord (cold weather)	165						

Rollei SLX and 6000 Series Accessories (cont'd)

Item	New		Mint		Excellent		User
Charger	200	130					
12V Adapter for Charger	75						
Compendium Shade (Bay VI)	400				280	250	
Extension Tube, 9mm	500	425	260	240	250	200	
Extension Tube, 17mm	570	485	295	240	250	200	
Extension Tube, 34mm	650	550	325	290	280	225	
Extension Tube, 68mm	690	585	400	295			
Variable Extension Tube 22-68mm	1200						
Auto Bellows	1275						
Auto Reverse Lens Mounting Ring	1175						
6x6 Slide Copying Stage	460						
35mm Slide Copying Stage	440						
Fine focusing drive for copying stages	330						
Accessory Bellows for copying stages	735						
Focusing Shutter Assembly (for Componon Lenses)	1120						
Schneider Componon M 28mm f/4 (for above)	650						
Schneider Componon M 50mm f/4 (for above)	605						
Bay VI Lens Coupling Ring	215						
Focusing Rail	480						
Parallel Alignment Mirror Set	640						
Tripod Quick Release Adapter	50						
SCA 356 Dedicated TTL Flash Adapter	130						
Macro Flash (requires above)	1740						
Flash Meter (shoe-mounted TTL-OTF)	760						
Averaging Meter Back Plate for above	75						
Spot Meter Back Plate for above	75						

Miscellaneous Medium Format Cameras

The point of this section is to provide listings for medium format cameras whose company isn't in business anymore, or that are somewhat obscure, or that are just plain old – but cameras that a lot of folks still use and love. Invariably, I'll be leaving out somebody's favorite, since so many good medium format cameras have been made over the years. These are the ones I know about, either through personal use or through testimonials from those whose views I can rely upon. I'd be interested in hearing from you if I've made some obvious, unconscionable omissions.

☐ Exakta 66 / Practisix / Pentacon 6 / Kiev 6, 60, & 645

While the evolution of these cameras can be traced back better than fifty years, it is a twisted path to follow involving war and the spoils thereof, and the rise and fall of nations and political systems. Such a convoluted history is quite beyond the scope of this book. Thus, we will concentrate instead on a more important subject to the practicing photographer: functionality. In this respect, the following models are quite capable picture takers: rugged, no-frills cameras that share a common lens mount and accept what is arguably the largest selection of medium format lenses ever made. What's more, these optics, many of which have been manufactured by Schneider and Zeiss, are some of the finest made.

The Exakta 66 Model 1 is a large, 35mm-SLR-looking thing with absolutely no bells or whistles. Basically, what you're buying is a light tight box with shutter speeds to which a lens and a finder can be attached. It renders 6x6 exposures on 120 film. Fortunately, it will couple to an array of top-notch optics that are, more often than not, priced very reasonably. The mechanical, horizontal, cloth focal plane shutter provides speeds from 1 second to 1/1000, plus B. X sync occurs at 1/30. A TTL meter prism was made for the Model 1, but it will not fit the Model 2 or 3. The TTL meter prism finder for the Model 2 is not available as this is being written.

The Exakta 66 Model 2 has a larger viewfinder than the Model 1 (showing about 85% of the actual image area), a brighter viewing screen, an improved back catch, and a redesigned film advance lever.

The Exakta 66 Model 3, the current model, features rubberized trim for better grip and protection. It accepts either 120 or 220 and has a large selection of interchangeable viewfinders and focusing screens.

The Practisix and Pentacon 6 are basically the same camera – the Pentacon 6 being the later model. Both have the same basic features found on the Exakta 66 Model 1; in fact the Pentacon 6 was the immediate predecessor of the Exakta 66.

The Kiev 6 was manufactured in Russia, but unlike the Kiev 88 and its descendents, the Kiev 6 was based on the Praktisix/Pentacon 6 design. The Kiev also shares similar features to these other models. The Kiev 60 is the current model and is still in porduction. It features a horizontally travelling cloth focal plane shutter with speeds from 1/2 to 1/1000 second, plus B. Maximum flash sync occurs at 1/30 second. The camera comes with a waist-level finder and TTL-metered prism. Kiev/USA sells a Kiev 645, which is a Kiev 60 that has been internally modified to shoot and correct-

Exakta 66 / Practisix / Pentacon 6 / Kiev 6 / Kiev 60 / Kiev 645

Item	New	Mint	Excellent	User
Exakta 66 Mod. I, W/L		650 600	575	
Exakta 66 Mod. I, W/L, 80/2.8		845 795		
Exakta 66 Mod. II, W/L		875 850		
Exakta 66 Mod. II, W/L, 80/2.8		1200 1150		

Exakta 66 / Practisix / Pentacon 6 / Kiev 6 / Kiev 60/ Kiev 645 (cont'd)

Item	New	Mint	Excellent	User
Exakta 66 Mod. III	1000			
Exakta 66 Mod. III, W/L, 80/2.8	1300			
Kiev 6, W/L			300	250
Kiev 6, W/L, 80/2.8			350	280
Kiev 60, W/L, TTL, 80/2.8	390			
Kiev 60 MLU, W/L, TTL, 80/2.8	590			
Kiev 645, W/L, TTL, 80/2.8	690			
Kiev 645 MLU, W/L, TTL, 80/2.8	890			
Pentacon 6 / Praktisix, W/L, 80/2.8			450	300
Pentacon 6 / Praktisix, Prism, 80/2.8			500	350
30mm f/3.5 Arsat/Zodiac Fisheye	870 525			
30mm f/4.5		600 500		
40mm f/4 Curtagon	7950			
45mm f/3.5 Mir	570 525			
50mm f/4 Flectogon	795		550	400
60mm f/3.5 Curtagon	895			
65mm f/2.8 Flectagon			450	390
65mm f/3.5 Mir	500 395		350	270
65mm f/3.5 Mir PC	850			
80mm f/2.8 Biometar	800			
80mm f/2.8 Zenotar	900		600	
120mm f/2.8 Vega	470 450			
120mm f/2.8 Biometar	800		400	320
150mm f/4 Tele-Xenar	995			
180mm f/2.8 Auto Sonnar	995	695 600	550	430
250mm f/3.5	570			
250mm f/5.6 Tele-Zenar	1395			
300mm f/4 Preset			120	80
300mm f/4 Zeiss			480	350
300mm f/4.5	700			
500mm f/5.6 Arsat	1550			
500mm f/5.6 Meyer	1000		775	600
500mm f/8 Cambron mirror	400			
600mm f/8	800			
1000mm f/11 Zeiss mirror	12000			
75-150 f/4.5 Variogon	7995			
140-280 f/5.6 Variogon	8995			
2x Teleconverter Schneider	1395			
2x Teleconverter	400		125	100
Exakta 66 Prism (Mod 1/Praktisix/Pentacon)		400	350	
Exakta 66 Prism (Mod 2)			350	250
Exakta 66 Prism (Mod 3)	400			
Pentacon/Praktisix Meter Prism (fits Exakta Mod 1)			150	100
Magnifying Finder (Mod 3)	200			
Waist Level Finder (Mod 1/Praktisix/Pentacon)			45	30
Waist Level Finder (fits above, Hi-Magnification)			95	70
Wast Level Finder, Exakta 66 Model 3		130		
Exakta Extension Bellows	1295			
Exakta Extension Tubes, ea. (15, 22.5, 30, 60mm)	270 240			
Auto Extension Tube Set (aftermarket)		200	80	50

ly space vertical-format images at 6cm x 4.5cm. Kiev/USA also offers mirror lock-up as an option on either model.

Kiev 88 / 88B / 88C / Salyut

No, the Kiev is not a Soviet or Russian made camera (not anymore, at least). It's made in Ukraine and, with the Cold War thawed to room temperature and the various former Soviet republics being left to fend for themselves, it is no wonder, one would think, that a solid medium-format SLR like the Kiev with its great low price should become more common in the West. Older Kievs are sometimes found under other brand names, at least one being in Cyrillic – the Salyut.

The Kiev is a mechanical, square-format SLR which closely resembles the venerable Hasselblad 1000F. According to the folks at Kiev/USA, the authorized importer of Kiev products into the USA, the Kiev is actually not a Hasselblad copy. Rather, both the Hassy 1000F and the Kiev are copies of a German medium-format SLR that was found in downed aircraft during WWII. Whether true or not, it certainly makes for an intriguing story, doesn't it?

The Kiev 88 has a metal focal-plane shutter and features interchangeable

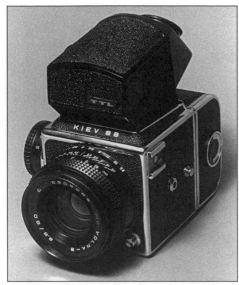

Kiev 88 with 45° Meter Prism

Kiev 88 / Salyut

Item	New		Mint		Excellent		User
88 Body	400	300					
88, 80/2.8, 120/220 back, W/L	600	500	450	350	395	300	
88C, 80/2.8, 120/220 back, W/L	665						
88C kit as above with 45° TTL Prism and W/L	815						
88CB 80/2.8, 120/220 back, W/L	1065						
88CB kit as above with 45° TTL Prism and W/L	1285						
88CC, 80/2.8, 120/220 back, W/L	865						
88CC kit as above with 45° TTL Prism and W/L	1085						
88SWC: 88C, A-12 style back, 30/3.5	1190						
30mm f/3.5 Arsat/Zodiak	800	525	600	500	475	370	
45mm f/3.5 Mir	600	525			325	250	
65mm f/3.5 Mir	540	395			295	220	
65mm f/3.5 Mir PC	850						
80mm f/2.8 Volna (included in outfit)					150		100
120mm f/2.8 Vega	565	450	295	250	250	200	
150mm f/2.8 Kaleinar	620	525	400	340	320	250	
250mm f/3.5 Jupiter	640	525			300	245	
300mm f/4.5 Tair	475				420	350	
500mm f/5.6 Arsat	1550						
2x Teleconverter	220	150	140	120			
Magnifying Hood	185						
45° Prism	395	285	250	200	200	125	
45° Meter Prism			350	250			
45° TTL Finder	320	235					
90° Prism			295	230			
120/220 Back (included in kits)	185	125	90	70			
120 Back (A-12 style)	325						
220 Back (A-12 style)	425						
120 645 Back (A-12 style)	425						
Polaroid Back	220	175					
NPC Polaroid Back	280	220					
Pistol Grip	80	60					
Waist-level Finder	170	140					

lenses, finders and backs. The lenses, finders, and backs will interchange with those designed for the 1000F. Unlike the Hasselblad, no accessory contact shoe is required for flash photography; the Kiev uses a standard PC connector. Early model' shutter speeds range from 1 second to 1/1000, plus B, with X sync at 1/60. Later Kievs have programmed shutter speeds ranging from 1/2 second to 1/1000 second, plus B, with a top flash sync of 1/30 second. The Kiev optics are reported to be excellent and represent an outstanding value.

The basic Kiev outfit usually contains a camera body with a waist-level finder, an 80mm f/2.8 lens, and a 12-exposure back. Often, a carrying case was included. Because of the various and sundry means by which these cameras have been exported, all sorts of configurations are found.

Kiev/USA supplies Kievs in a variety of configurations. Kiev/USA is located in Greenwitch, CT and can be reached on the Web at www.kievusa.com. Kiev/USA upgrades the cameras it imports to meet the sort of fit-and-finish and reliability standards that, let's face it, American consumers have come to expect. Beyond that, however, Kiev/USA also provides a couple of optional

enhancements. Current models offered by Kiev/USA include the Kiev 88, the 88C, 88CB, 88CC, and SWC. Also available from Kiev/USA are the Kiev 60 and Kiev 645 (please see the Exakta 66/Pentacon 6 section for details on these cameras).

In addition to the features found on the above-described 88, the C has a hand crank. The CC has the hand crank and a cloth shutter. The CB is a CC with the K60 lens mount – the medium-format equivalent to the Pentax K-mount. For the photographer who already owns or has access to an Exakta 66 or Pentacon outfit – or a Kiev 60, for that matter – the CB is an easy way to adapt those excellent optics to a modular system. The SWC is actually a kit that includes the 88C, the Arsat/Zodiak 30mm f/3.5 lens, a waist-level finder, a 120 back and other goodies.

☐ Koni Omega

The different Koni Omega models all bear strong resemblance to the Graflex XL and the Mamiya Universal Press: they are boxy rangefinder cameras that take interchangeable lenses and backs. The optics for these cameras are first rate.

Koni Rapid Omega 200

The Koni Omega M and Rapid Omega 100 take interchangeable film holders. The Rapid Omega 200 takes interchangeable film magazines, to which the film holders are attached.

Konica Press 2

Koni Omega

Item	Mint		Excellent		User		
Konica Press 2, 90/3.5, 120 back			400	325			
Omega M, 120 Back, Grip			250	185			
Omega M, 90/3.5, 120 Back			350	250			
Rapid Omega 100, 120 Back			150	100			
Rapid Omega 100, 90/3.5, 120 Back			260		200		
Rapid Omega 200, 120 Back			250	185			
Rapid Omega 200, 90/3.5, 120 Back			320		200	190	150
58mm f/5.6 w/finder			310	220			
60mm f/5.6 w/finder			260	170			
90mm f/3.5			100	80			
135mm f/3.5			200	150			
180mm f/4.5	330	280	260	220			
120 or 220 Film Holder			70	55			
120 or 220 Magazine			100	65			

□ KOWA

Although Kowa has been out of business for a number of years now, a lot of loyal Kowa users are still around. The Kowa Super 66 is the model Kowa aficionados prefer. It has interchangeable lenses, finders and backs. The Kowa 6 takes the same lenses and finders, but film is loaded the same as in a TLR – hence no interchangeable backs. Both cameras have multiple-exposure capability and will take either 120 or 220 film.

Kowa lenses have depth-of-field preview levers, self-timers and mechanical leaf shutters, which provide shutter speeds from 1 second to 1/500, plus B, with M and X sync at all speeds. Finders made for the cameras are the standard waist level finder, a horizontal prism finder, a 45°meter prism and a chimney-style meter finder. Both metered finders have CdS cells to provide TTL metering.

Kowa

Item	Mint	Excellent		User
Kowa 6, W/L, 85/2.8		375	300	
Kowa Super 66, W/L, 12/24, 85/2.8			595	480
35mm f/4.5		650	550	
40mm f/4		500	425	
55mm f/3.5		280	200	
85mm f/2.8		125	80	
110mm f/5.6 Macro		380	290	
150mm f/3.5		295	250	
200mm f/4.5		375	250	
250mm f/5.6		350	260	
2X Teleconverter		225	150	
Extension Tube T1, T2 or T3		125	75	
Meter Finder		250	175	
Meter Prism		350	250	
45° Prism		180	125	
90° Prism		200	140	
Sports Finder		40	25	
120 Back		80	60	
12/24 Back		180	140	
Polaroid Back		225	175	
L Grip		50	30	
Pistol Grip		40	25	

□ PLAUBEL MAKINA

Plaubel has been producing cameras since the early 1900's. But the image that most frequently comes to mind for a photographer, as opposed to a collector, is that of the lens-shutter medium format rangefinders Plaubel has produced since the mid-1970's. Undoubtedly, the Plaubel Makina 67, with its clean and uncluttered rangefinder lines, is the that gave Fuji the inspiration for its rangefinder cameras. Importation of these cameras into the U.S. ceased a few years ago, but recently the 69W Pro-Shift model has reappeared. All are highly sought after, and clean examples are pricey.

Plaubel Makina 67

Plaubel Makina

Camera	New		Mint	Excellent		User
Plaubel Makina 67 (80mm f/3.5 Nikkor)			1900	1495	1395	1250
Plaubel Makina 67W (55mm f/4 Nikkor)					1450	1195
Plaubel Makina 670 (80mm f/2.8)			2495			
Plaubel Makina 69W Pro-Shift	3600	3300		2800	2400	
47mm f/5.6 Schneider Super Angulon						

☐ YASHICA MEDIUM FORMAT TLRS

Yashica's Medium Format TLRs have long been regarded as providing some of the most economical avenues available to enter medium format photography. The optics, especially those found in the more recent models, are quite sharp with good color and contrast. The 124G has been a popular seller on the used market ever since it was discontinued in 1988.

Yashica Mat 124G

Yashica D

Yashica Medium Format TLRs

Camera	Mint		Excellent		User
Yashica 24 (220 film only)			160	150	
Yashica 635 (120/35mm)			125	80	
Yashica A			90	50	
Yashica C			80	65	
Yashica D			75	50	
Yashica EM			100	80	
Yashica LM			95	60	
Yashica Mat			120	80	
Yashica Mat 124			210	150	
Yashica Mat 124G	340	290	260	190	

□ ZEISS SUPER IKONTA

Although Zeiss has made many great cameras over the past several decades, this listing is confined to the Super Ikonta models only, mostly because they are such fine user cameras. When folded, most models are quite compact, easily fitting into a coat pocket. The lenses are superb in sharpness, color and contrast.

Zeiss Super Ikonta B with Synchro-Compur shutter

All Super Ikontas are folding-bed, medium-format, rangefinder cameras. They were produced from 1934 to about 1970 in six principle variations:

the A, B, C, D, III and IV. Super Ikontas exist in a variety of film format sizes, from 6cm x 4.5cm to 6cm x 9cm and each model exists in several sub-variations. The Super Ikonta A, the smallest of the family, is the sole 6cm x 4.5cm model. The Super Ikonta C is the 6cm x 9cm model. The Super Ikonta B is a 6cm x 6cm model, as are the Super Ikonta BX, III and IV. These four cameras differ in the following areas: The BX differs from the B in that it has an uncoupled selenium exposure meter built in to the top plate. The III is essentially a late B with a redesigned rangefinder. The IV resembles the III, but has a built-in selenium meter and uses the EVS system for cross-coupling shutter speeds and apertures. The model D was made for now-obsolete film and is not included in the following listings.

As was stated previously, within each model classification variations exist. Rather than go into deep detail, only the distinctions shown in the following listings will be addressed. The model number (e.g., 532/16) can be found somewhere on the camera body, usually on the back. This is often the only indi-

cation on the camera as to which specific model it is.

The Compur Rapid is an earlier shutter style than the Synchro Compur. Some Compur Rapids have flash sync. All Synchro Compurs do. Early model Super Ikontas usually have uncoated lenses, while the later models' lenses are coated.

Because Super Ikontas are highly collectible, these variations and others, when combined with a camera's condition, can greatly affect price. Examples in mint or near-mint condition are much more expensive than those in user condition now, because overseas collectors have depleted the supplies of clean examples in the U.S., and because many domestic collectors are still willing to pay top dollar for them. Even examples in clean, but not mint condition can be subject to more price volatility than other makes of cameras. Thus, the following prices will be more useful as guidelines, and should be interpreted as such.

Zeiss Super Ikonta

Camera	Mint	Excellent	User
Super Ikonta A (530 w/Compur Rapid, uncoated)		200 150	
Super Ikonta A (530 w/Compur Rapid, coated)		400 250	
Super Ikonta A (531 w/Synchro-Compur, coated)		1495 995	
Super Ikonta B (532/16 w/Compur Rapid, uncoated)		250	150
Super Ikonta B (532/16 w/Compur Rapid, coated)		400	300
Super Ikonta B (532/16 w/Synchro-Compur, coated)		650	495
Super Ikonta BX (532/16 w/Compur Rapid, uncoated)		200	150
Super Ikonta BX (532/16 w/Compur Rapid, coated)		400	300
Super Ikonta BX (532/16 w/Synchro Compur, coated)		650	470
Super Ikonta C (531/2 w/Compur Rapid, uncoated)		200	150
Super Ikonta C (531/2 w/Compur Rapid, coated)		400 280	
Super Ikonta C (531/2 w/Synchro-Compur, coated)		1695	880
Super Ikonta III		550 350	
Super Ikonta IV		800 500	

Multiple Format Cameras and Equipment

Graflex

Literally dozens of different models of Graflex-made cameras have been produced since the introduction of the original Graflex in 1902. The explanations and listings below are confined to the post-war Graphic models and the Graflex XL only. Pre-war models are fine camera. There has even been a resurgence in interest in the large old reflex models as picture taking tools in recent years, but from an ease-of-use and versatility standpoint the post-war models are the most popular, especially models made after 1955.

Persons unfamiliar with these cameras often dismiss them as antiques, useful for little more than Hollywood props. Others think of them as heavy, awkward, unwieldy or inflexible. These folks couldn't be more wrong. In fact, most Graphic models are lighter than many medium format cameras once lenses, finders and backs have been attached.

Graphic cameras offer a variety of front movements for perspective control. They can achieve true 1:1 macro focusing with standard lenses. Many can take an enormous variety of backs and film holders, ranging in format sizes from 4x5 to $2^1/_4$ x $2^1/_4$ on 120 roll film. It's even possible to use some models as enlargers when fitted with Graflarger backs. Ever wished you could enlarge a photograph with the same lens you used to take the picture? You can with a Graphic camera equipped with a Graflarger back.

Century Graphic

Compact and lightweight, the Century Graphic was made in the $2^1/_4$ film size only. Unique among Graflex cameras, the Century's body is constructed from an amazingly durable phenolic bakelite material that almost defies abuse.

Interchangeable lenses, ground glass focusing, front rise, tilt and shift with a drop bed, and a macro focusing capability down to 1:1 are just a few of its many features. A Graflok back is an integral part of the body to which roll film holders in 6cm x 6cm, 6cm x 7cm and 6cm x 8cm sizes can be attached.

The Century Graphic was available in the early-to-mid 1960's as an outfit that included an adjustable side grip, a side-mounted Kalart rangefinder, a 6x7 roll film holder and an 80mm f/2.8 Rodenstock Heligon lens in shutter. Prior to that, the Kalart rangefinder was an option. Other standard lenses available at the time were the 100mm f/3.5 Zeiss Tessar and the 101mm f/4.5 Graflex Graflar, although the Century is by no means limited to the use of just these lenses. Because of its drop-bed style, wide angles can be fitted and because of its long bellows draw, a variety of telephotos can be used as well.

Graflex Speed Graphic

Pacemaker Speed Graphic and Crown Graphic

The Speed Graphic and Crown Graphic are wooden-bodied cameras that were made in three film format sizes: $2^1/_4$ x $3^1/_4$, $3^1/_4$ x $4^1/_4$ and 4x5. Of all these sizes the 4x5 is, by far, the most versatile and the most popular. Because of this, only prices for the 4x5 models are listed below. Expect to pay somewhat less for cameras in the smaller format sizes.

Both Pacemaker cameras have view-camera-style between-the-lens shutters. The Speed Graphic also has a focal plane shutter that provides speeds up to 1/1000. Either design has a shutter release mounted on the body, called a "body release". Both cameras feature front standard movements of rise, tilt and shift, with a drop bed. Ground-glass focusing is possible on either model and the double-extension bellows allows close-focusing down to 1:1 macro size. Because of the long bellows draw, a variety of telephotos can be used. Because of

the drop-bed style, wide angles can be fitted, also.

Grafelx Crown Graphic

Early post-war Pacemakers are often found with Kalart side-mounted rangefinders. Pacemaker cameras made after 1955 have top-mounted optical rangefinders and optical viewfinders, which feature automatic parallax adjustments and interchangeable masks for different focal length lenses. Interchangeable rangefinder cams allow coupled- rangefinder focusing for a wide variety of lenses. A feature unique to the Pacemakers is Graflex's exclusive Rangelite, a built-in device that projects two beams of light on the subject. The focusing knob is turned to converge the two beams. When they converge, the subject is in focus. This eliminates guesswork in low-light situations or for those times when a photographer may be unable to bring the camera to his or her eye.

All three styles of backs (Graphic, Graflex and Graflok) will work on the Pacemaker series cameras, but because of its versatility is the Graflok back is the most desirable.

While these cameras will take a variety of lenses, the ones with which they are most often found are the 127mm f/4.5 Graflex Optar, 135mm f/4.7 Graflex Optar, or the 150mm f/4.5 Schneider Xenar. Some are also found with Kodak Ektars.

Super Graphic and Super Speed Graphic

Both the Super Graphic and Super Speed Graphic have all-metal (extruded aluminum) bodies and built-in coupled rangefinders. As is the case with the Pacemaker series, rangefinder cams can be interchanged as lenses are interchanged. The Supers feature front standard movements of tilt, shift, swing and rise with drop beds, ground glass focusing, macro focusing down to 1:1, revolving Graflok backs and electric shutter releases. The electric shutter release found on the Supers is somewhat prone to failure, especially after a camera has seen lots of use, but the shutter can still be tripped manually. Prices below are for cameras with working electric shutters.

The Super Speed Graphic differs only from the Super Graphic in that it was supplied with a 135mm f/4.5 Graflex Optar mounted in a Graflex 1000 shutter. (The 135mm f/4.5 is actually a Rodenstock. All other Optars were made by Wollensak.) This shutter is a unique Graflex design and is still the only commercially available between-the-lens shutter that offers a 1/1000 second top shutter speed.

Standard lenses available at the time were the 127mm f/4.5 Graflex Optar, the 135mm f/4.7 Graflex Optar or the 150mm f/4.5 Schneider Xenar.

Graflex XL

The Graflex XL was produced in three models, but the most common and most popular is the XL rangefinder model. It's also the only XL model listed below. Other models were the XL Super Wide Angle, which came with either a 47mm Schneider Super Angulon f/8 or f/5.6, and the XL Standard. Neither the XL Super Wide nor the Standard have rangefinders, but both allow ground glass focusing (as does the rangefinder model) and have range focusing scales. The rangefinder model bears a strong resemblance to the Mamiya Universal Press for good reason – Mamiya copied it.

The XL is a completely modular, medium format system, which accepts a large variety of lenses and film holders. While a wide selection of interchangeable lenses was produced in the XL lens mount, the camera is most often found with the 100mm f/3.5 Zeiss Tessar.

☐ GRAPHIC, GRAFLEX AND GRAFLOK BACKS

Graflex originated three different styles of backs over the years: the Graphic, the Graflex and the Graflok. Keeping track of the differences can be confusing, especially since the names are similar. Following is a brief explanation of their features.

The Graphic back, often called a "spring back", was designed for sheet film holders. It has two springs, one at the top and one at the bottom, which hold the ground glass in place and which also permit the ground glass to be drawn back when inserting a film holder. The ground glass and springs act as a pressure plate to keep the film holder firmly in place. Graphic backs will accept only Graphic-style accessories, which can be identified by the raised rib at the dark slide end. Although Graphic-style Grafmatic film magazines will work with a Graphic back, they are not recommended.

The Graflex back was designed to accept roll film holders, multiple film magazines, and sheet film holders. It has two sliding locks that hold the film accessory firmly in place. A ground glass focusing screen is held in place the same way, but must be removed before inserting the film holder. Graflex backs will accept only Graflex-style accessories.

These can be identified by the slot at the dark slide end.

The Graflok back is the most recent style and has become something of an industry standard because of its flexibility. It is made up of three pieces: the back frame itself, a spring-loaded ground glass focusing panel and a viewing hood. With the focusing panel attached, standard Graphic-style sheet film holders can be used. The focusing panel is held in place by the back's built-in slide locks and can be removed easily, which will then allow the attachment of various Graphic-style film holding accessories (the ones with the raised rib). Graphic-style Polaroid and roll-film holders were designed specifically for use with the Graflok back and will not work on either the Graphic or Graflex back. The Graphic-style Grafmatic film magazine was also designed for use on the Graflok back and, while it can be used on a Graphic back, it is not recommended.

Graflex Cameras

The prices below include cameras with normal lenses and Graflok backs.

Camera	Mint	Excellent	User
Century Graphic		350 250	
Crown Graphic 4x5 (side rangefinder)		400 300	
Crown Graphic 4x5 (top rangefinder)		450 300	
Speed Graphic 4x5 (top rfdr)		550 450	
Speed Graphic 4x5 (side rfdr)		400 300	
Super Graphic		550 450	
Super Speed Graphic		600 475	
XL (add $40-50 for grip)		500 350	

Graflex XL Lenses

The 80mm Zeiss Planar, 95mm Rodenstock Heligon, 100mm Zeiss Planar and 150mm Rodenstock Ysarex have top shutter speeds to 1/400. All others have speeds to 1/500.

Lens	Mint	Excellent	User
58mm Rodenstock Grandagon f/5.6		325 275	
80mm Rodenstock Heligon f/2.8		250 200	
80mm Zeiss Planar f/2.8		240 200	
95mm Rodenstock Heligon f/2.8		250 200	
95mm Rodenstock Ysarex f/3.5		200 150	
100mm Zeiss Planar f/2.8		300 250	
100mm Zeiss Tessar f/3.5		120 80	
150mm Rodenstock Ysarex f/4.5		250 200	
180mm Zeiss Sonnar f/4.8		350 300	
270mm Rodenstock Rotelar f/6.6		400 350	

Graflex Accessories

Item	Mint	Excellent	User
Rapid Vance roll film holder		120 80	
Knob Wind roll film holder		100 70	
Grafmatic 4x5 film holder		130 60	
Graphic sheet film holder		10 5	
Type 5: for Graflok and Graphic backs			
Graphic Riteway film holder		15 10	
Improved standard 4x5			
4x5 Graflok Back (complete)		125 75	
4x5 Graflarger Back		125 75	
XL Polaroid Back		160 100	
XL Grip		50 40	

Linhof

☐ LINHOF TECHNIKA

Linhof's line of Technika cameras has been in production since the early 1930's, and has come to represent the technological zenith of the class of folding-bed press cameras. The later series of Linhofs are expensive, but apparently well worth the price, judging by the high demand for clean examples. They are, or have been, available in three sizes: 2x3, 4x5, and 5x7.

This listing will be confined to the Technika III and later models, since it is the consensus among devotees of the marque that these remain the most useful. While the Technika I and II will still provide the user with excellent results, they generally fall within the purview of collectible classics more so than photographic tools.

Linhof has a tradition of letting the marketplace dictate the direction of its products. One sign of this is its practice of continuing the production of an earlier model for a while after the release of a later model. There were periods of concurrent production between the III and IV, the IV and V, the V and Master, and currently between the Master and Master 2000.

Sometimes you will see cameras referred to as "Super Technikas." A Super Technika has a built-in rangefinder, whereas the standard Technika does not. Linhof began offering the Super Technika with the advent of the Technika IV. It was produced in the Technika V and Master Technika series,

as well. The Master Technika 2000 has no built-in rangefinder, although Linhof does produce an accessory electronic rangefinder/viewfinder for it.

The issue of interchangeability should be addressed at this point. Current accessories, including lens boards, ground glass, etc., can be interchanged between models from the Technika IV to the present Master 2000. Cams can be interchanged between models up to, but not including, the Master 2000. The Technika III stands apart from the other models in this regard. Its lens boards, ground glass, and rangefinder cams will not interchange with later models. It should also be emphasized as well that Linhof has repeatedly emphasized that the III is not as robust as the later models. The rigidity of the front standard, focusing rails, and folding bed was improved beginning with the Tecknika IV.

A special comment on rangefinder cams is also in order. The ground glass on both the Technika III and IV is unzeroed, which means this dimension will vary from camera to camera. Thus, each cam must be matched to both the individual lens and the individual camera. The Technika V and Master Technika have zeroed backs, so as long as the cam is matched with the lens, the set can be interchanged between any V and any Master. (The Master 2000 does not use rangefinder cams.)

All Technika cameras discussed here share the following features:

- Triple-extension bellows
- Front standard rise, tilt, and swing
- Rear standard tilt and swing
- Revolving back design that will accept roll-film holders, Polaroid backs, etc.
- Drop bed design
- Cam actuated rangefinder focusing

I am indebted to Bob Salomon of HP Marketing, the U.S. distributor for Linhof, for his kind assistance with the information I've put together for this section. Mr. Salomon and HP Marketing offer a genuine service to the community of Linhof users. If you are unsure as to the exact model you have, or if you have questions about the availability of accessories or service for your Linhof, you may contact Mr. Salomon directly and he will do his best to answer your questions. Be sure to have the serial number of your item handy. Mr. Salomon may be reached at the following addresses:

H.P. Marketing
16 Chapin Road
Pine Brook, NJ 07058
Tel: 1 201 808 9010
Fax: 1 201 808 9004
http://hpmarketingcorp.com

Technika III

The Technika III was manufactured from 1946 to 1956. It houses all the above features within a durable, precision-machined aluminum body. In addition, the III has a built-in rangefinder, plus it will accept accessory optical find-

ers. The focusing rails will accommodate lenses down to a focal length of 75mm. For the 65mm and 58mm focal length lenses, an accessory focusing device is required. Rear tilt and swing adjustments are accomplished by means of four knobs located at the rear corners of the body, which provide a total of 12° of rear standard movement. Each knob controls the in-and-out movement of a rod, which in turn controls the position of one corner of the rear standard, thereby allowing control over tilt and swing. Front movements on the III are somewhat limited. The front standard pivots from the bottom, and will tilt in a backward direction only. A small knob located behind the front standard controls lens rise. Please note the compatibility issues regarding lens boards, cams, etc., outlined in the above paragraphs.

Technika IV

The Technika IV was the first model to accept the current style accessories. Like the III, it has a built-in rangefinder, and accepts accessory optical finders. The front standard tilt design was improved so that it pivots on the optical axis (instead of at the bottom of the standard, as is the case with the III). Plus, the front standard tilts both forward and backward. Also like the III, the IV has a small knob positioned behind the front standard that controls lens rise. Rear movement was increased on the IV as well, from 12° to 15°. Lens focal lengths wider than 75mm require the use of an accessory focusing device (like the lensboards, this differs from the one for the III).

Technika V

The Technika V differs from the IV in a few areas. As mentioned above, the V has a zeroed back, allowing for easier rangefinder cam interchangeability. Control for front lens rise was redesigned: instead of a small knob behind the lens, the V has a lever located in front of the front standard. Rear standard movement was increased to 18°.

The Master Technika, and Master Technika 2000

Only small differences separate the V and the Master models. The most notable difference between the Master and the V is the addition of a lift-up flap on the body housing that allows more lens rise – useful when using short focal length lenses. The Master 2000 is the current model and incorporates a few nice improvements over the earlier models. First of all, both the built-in rangefinder and rangefinder cams have been eliminated. In their stead, the Master 2000 employs an accessory electronic, infrared rangefinder, complete with an LCD frame viewfinder. The Master 2000 also is much more flexible for wide-angle lens photography. It does not require the focusing accessory that earlier models did, plus it will accept lenses as short as 45mm with no additional accessories required.

Regarding format size, the Master models have been made only in 2x3 and 4x5 sizes.

Linhof Technika Cameras

With the exception of the 2x3 Super, in the following listings Technika cameras are generally arranged according to their relative introductions.

Camera	New		Mint		Excellent		User	
2x3 Super Technika	5500	5400			3200	2900		
4x5 Technika III					925	750		
4x5 Technika IV					1450	1100		
4x5 Super Technkika IV					1500	1300	1350	990
5x7 Technika IV					1650	1500		
5x7 Super Technika IV							1390	1250
4x5 Technika V					1800	1700	1500	1390
4x5 Super Technkika V					2150	1850	1690	1550
4x5 Master Technika	6550		4650	3500	3150	2900	2500	2350
4x5 Master Technika Black LE	3800							
4x5 Master Technika Kit (Black LE, 150mm f/5.6)	4990	4800						
4x5 Master Technika 2000	5200		3995	3500				

Linhof Technorama Cameras

Older Linhof Technorama cameras typically came with Schneider Super Angulon lenses, while newer ones may have Rodenstock lenses. Prices include lenses and optical finders.

Camera	New	Mint	Excellent	User
612 PC II Kit (58mm f/5.6)	6200			
612 PC II Kit (65mm f/5.6)	6200			
617s (90mm f/5.6)	4700			
617s III (75mm f/2.6)	5500	5000		
617s III (90mm f/5.6)	5500			

Linhof Kardan and Technikardan View Cameras

Camera	New	Mint	Excellent	User
4x5 Kardan 45s			750	500
4x5 Kardan Bi			1500	1390
4x5 Kardan Bi Monorail			1500	1285
4x5 Kardan GT			1750	1600
4x5 Kardan LT		2350	2200	
4x5 Kardan TE			1600	1400
2x3 Technikardan, 23s	4360		3000	2250
4x5 Technikardan 45s	3400		2200	2150
679	3895	3000		

Large Format Cameras

□ LARGE FORMAT CAMERAS

Large format cameras have been around as long as the art of photography has – over one-hundred-fifty years. Many models still seeing frequent use date back almost that long. This longevity can be attributed to one basic trait: the simple elegance of a large format camera's design. This attribute can be deceptive, however, because it allows the photographer an extraordinary amount of freedom to manipulate ordinary reality and to transform it into the image his mind's eye sees. The dichotomy to large format photography is this: the tools are simple and straightforward, yet flexible and exceedingly complex in their capabilities. In the hands of an expert, these simple, flexible tools are exploited to their fullest and render images that would not be possible with any other film format.

Because of the underlying complexity of large format, it will be assumed in this next section that the reader already has a good understanding of large for-mat photography and has more than a casual familiarity with many of the cameras and lenses available. The explanatory text prefacing each manufacturer's products will be accordingly brief.

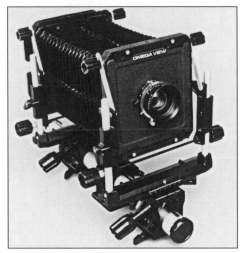

Omega 4x5 monorail view camera

If you're just starting out with large format and are planning to use this section as a reference to help you formulate an equipment list, but are not yet familiar with all the format has to offer, follow the advice given by most large format users: start out with a modestly-priced 4x5 outfit. Make sure the camera is well made and in good repair, and buy the best lenses you can afford.

And don't sell your 35mm stuff just yet. Let's face it, large format is not for everybody. After the newness has worn off, you may decide that all the hassle involved in taking a photograph just isn't worth it. That's fine. That's why medium format and 35mm cameras exist. But, you're better off finding out your true interests before you sink large sums of money into an outfit than after the fact. On the other hand, you may discover that you've found your artistic tool at last—that large format was everything you hoped it would be, and more. If the latter case sounds like you, then welcome to the small, select family of dedicated large-format users.

The prices in the following listings are for camera bodies without lenses, optional backs or film holders.

Agfa/Ansco

Agfa and Ansco joined forces in the late 1920's and marketed a series of capable view cameras up until the mid-1940's. The prices are for Agfa/Ansco models, but should not differ substantially from prices for cameras made before the merger.

Camera	Mint	Excellent	User
4x5 View			
5x7 Commercial Field		400 300	
5x7 Flat Bed View			
5x7 Portrait View		300 200	
8x10 View	1200	345	
8x10 View (Cherrywood)		825	
8x10 Commercial Field		650 550	
8x10 Flat Bed Universal View	800	600	

Burke & James

Burke & James large format cameras have long been regarded as large-format workhorses. They remain popular among amateurs and professionals alike for their sturdiness, reliability and relatively low cost.

Camera	Mint	Excellent	User
4x5 Commercial Field	475 400	350 250	225 150
4x5 monorail (Grover/Orbit/Saturn)		325	250 250 175
4x5 View	475	295	250
5x7 Commercial Field		450 350	250 185
5x7 monorail (Grover/Orbit/Saturn)		330	250 130
5x7 View		450 350	
8x10 Commercial Field	745 650	675 550	395 325
8x10 monorail (Grover/Orbit/Saturn)		595	350 500

Busch

Camera	Mint	Excellent	User
4x5 Pressman w/lens		295 240	

Calumet

Camera	Mint	Excellent	User
4x5 45		330 295	
4x5 45N	450 375	380 330	295 250
4x5 45NX	550 500	480 400	
4x5 C (gray)		250 150	
4x5 C (black)	400 350	325 275	
4x5 CC-400		350 280	195 150
4x5 CC-401		350 300	
4x5 CC-402		350 300	
4X5 CC-403		275 275	
4x5 Wide Angle		350 250	
4x5 Wood Field		350 300	
4x5 Wood Field XM			
8x10 810 N		895	
8x10 C		430 320	250 190
8x10 C-1		750 650	
8x10 C-2 (green)		925 850	
8x10 M (black)		695 600	

Cambo

Camera	Mint	Excellent	User
4x5	300 245	250 220	190 170
4x5 45N	360 340	330 300	
4x5 45NX	600 550	490 420	
4x5 45SR		690 600	
4x5 45SRX			
4x5 Legend PC	1550 850	750	
4x5 SC	400 350	340 305	
4x5 SC-II	490 450	470 350	
4x5 SC-II RS			
4x5 SCX		810	
4x5 Pro			
8x10		1270 750	
8x10 810SRX			
8x10 Legend		1500 1250	
8x10 Legend PC, bag bellows		2500	
8x10 SC		895	
8x10 SC-II		1095 895	
8x10 SCX		1595 1195	
8x10 XM		1495	
Cambo Wide 75	1750		
Cambo Wide 650	2255		

Canham

Camera	New	Mint	Excellent	User
DLC 45	2150			
4X5	2500			
4x10 Panorama	2990			
5x7	2500			
8x10	3500			

Conley

Camera	New	Mint	Excellent	User
8x10 w/5x7 Reducing Back			550 450	

Deardorff

Without question, the most revered name in American-made view cameras is Deardorff. Known world-wide for their excellence of design and craftsmanship, and for their ability to stand up to hard use, Deardorff cameras continue to be some of the most highly sought-after large format cameras available anywhere, for any price. The only models currently available new are the 8x10 and 11x14 Field.

Camera	New	Mint	Excellent	User
4x5 Baby Deardorff			2000 1795	
4x5 Original Style			1095 600	
4x5 Special (front swings)		2250 1950	2175 1695	
5x7 Original Style			1050 620	
5x7 Later Model (front swings)			1895 1575	
8x10 Original Style			1850 1400	
8x10 Later Model (front swings)		2750	2295 1495	1400 1250
8x10 New Model	2800	2495 2000	1895	
8x10 Commercial			995 700	
11x14 Field	3795			

Gandolfi

Gandolfi cameras are not as well known in the U.S. as they are in Europe — Great Britain in particular. The Gandolfi family, based in London, has produced a large variety of high-quality large format cameras for over one hundred years, but the ones most often seen as user cameras are the post-war 4x5 and 8x10 models (listed).

Camera	New	Mint	Excellent	User
4x5 Field		1295 850		
8x10 Field		1750 1395		

Gowland

Peter Gowland made a name for himself back in the 1960s and 1970s as a glamour photographer and is still active in the field. He expanded his business to include a unique array of specialized large-format equipment. Most of the cameras he offers are listed below.

Camera	New	Mint	Excellent	User
Pocket View 4x5 (vert/horiz)	495			370
Pocket View 5x7	950			
Pocket View 8x10	795			
Pocket View 8x10 (vert/horiz)	950			
Aerial-Scenic Cameras:				
4x5 Fixed Focus	595			
4x5 Variable Focus	695			
4x5 Interchangeable Lenses	795			
5x7 Variable Focus	695			
8x10 Variable Focus	895			
Gowlandflex Cameras (large-format twin-lens reflex):				
4x5 (90-210)	795			
4x5 (180-250)	995			
4x5 (300)	1055			
5x7 (240-300)	1095			
8x10 (360-500)	3500			

Graflex

Only the monorail Graflexes, the Graphic View and the Graphic View II are listed below. See the Graflex chapter in the multiformat section for more information on Graflex and the folding-bed Graphic cameras.

Camera	Mint	Excellent	User
Graphic View		300 225	190 130
Graphic View II		400 270	250 170

Hoffman

Camera	New	Mint	Excellent	User
4x5 Master View	2395			
5x7 Master View	2395			
8x10 Master View	3495			

Horseman

Camera	New		Mint		Excellent		User
45 FA	2895	2695					
45 HD	2175	1980					
450	1830		1350		1000	880	
450B	1250	1050					
450EM			1370				
450EMB	1675		1475	1400	1370	1285	
810N			3230	2300			
ER-1	2100						
L 45 EX			1600		1275	1000	
L 450			1200				
L 810			2000				
LB	2250	2045					
LB 4X5	1770						
LE 4X5			1350				
LS 4X5	2715						
LM	2770	2165					
LMC	2800	2650					
LMX	3870						
LMX-C	4760						
LS 4X5	3200	3050					
LX 4X5	3850	3600	2695				
LX 8X10			6025				
LX-C 4X5	4800	4500					
LX-C 8X10			7020				
SW-612	1400	1250					
VH	2250	2070					
VHR	3550	3185			1900	1550	
Woodman 45			1080				

Ikeda

Camera	New	Mint	Excellent		User
4x5 Field			450	325	
5x7 Field			450	350	

Iston (Chinese)

Camera	New	Mint	Excellent	User
4x5 WF45 Special	500			

Kodak

These old Kodaks have been around a long time and, judging by their longevity and steady popularity, they'll be around for a while longer. Of the following cameras, the 8x10 2D is by far the most popular.

Camera	Mint		Excellent		User	
5x7 2D			350	250		
8x10 Century			500	400		
8x10 Commercial			615	490		
8x10 2D	650	550	400	300	330	225
8x10 Master	1350		920	695		

Korona (Gundlach)

Camera	Mint	Excellent	User
4x5		300 225	
5x7		340 250	
7x17 Panoramic View		1500 1350	
8x10 View		500 350	
8x20 Panoramic View		2250 1875	
12x20 Panoramic View		3000 2400	

Nagaoka

Camera	New	Mint	Excellent	User
4x5 Field			400 350	

New Vue (Newton Photo Products)

Camera	New	Mint	Excellent	User
4x5 New Vue bi-rail			225 175	

Omega (Toyo)

Camera	New	Mint	Excellent	User
45C			550 450	
45D		480 395	400 340	275 220
45E		500 450	425 330	290 250
45F		615 525	550 495	
45G		710 580		
450			330 250	

Osaka

Camera	New	Mint	Excellent	User
4x5 Field	650 585			
8x10 Field	1750 1625	1300 900	850 690	

Rajah (Protech)

Camera	New	Mint	Excellent	User
4x5 Wood Field	350 295			
5x7 Wood Field			350 300	
8x10 Wood Field	500 400	450		

Sinar

Camera	New	Mint	Excellent	User
4x5 A1	850		795 700	
4x5 A1 Image Kit (150mm Lens)	1795			
4x5 F1 Image Kit (210mm Lens)	1995			
4x5 Alpina		625	495 430	
4x5 C			1750 1650	
4x5 C Expert Kit		2995		
4x5 F		1050 970	900 730	
4x5 F+		950	800 650	
4x5 F1	1395	1100		
4x5 F1 Image Kit (150mm Lens)	3500			
4x5 F1 Image Kit (210mm Lens)	3800			
4x5 F2	1790		1675 1450	
4x5 F2 Image Kit (150mm Lens)	4050	2450 1975		
4x5 F2 Image Kit (210mm Lens)	4400			
4x5 Norma			1950 1100	
4x5 P			2880 2150	
4x5 P Expert Kit			5750 4800	
4x5 P2	6500			
4x5 P2	6895 6500		4870 4495	
4x5 P2 Expert Kit	10450 7900			
4x5 P2 Pro Kit	11850 9295			
4x5 X	3000			
5x7 P		3300 2800		
8x10			2195 1750	
8x10 C		2500		
8x10 F			2450 1800	
8x10 F1	3975 3795	2500	1950	
8x10 F2			4140 3500	
8x10 P		6200 5700	4000 2450	2150
8x10 P2	9455 8950	7200 6500		
8x10 P2 Expert Kit	14400 13150			
8x10 P2 Pro Kit	15650 13850			
8x10 P2	8950			
8x10 P2 Expert Kit	13150			

Tachihara

Camera	New	Mint	Excellent	User
4x5 Field		500 450		
8x10 Field		1200 1050	900 750	

Toyo

Camera	New	Mint	Excellent	User
45 A Field		1350 250	1200 1050	1095
45 AII Field	2140			
45 AR Field			950 730	
45 AX Field	1500			
45 C	1080	650 545		
45 CX	550			
45 D	620 530	425	400 300	
45 E			615 450	
45 F			565 475	
45 G			1250 950	995 850
45 GII	2615		1895	
45 GB	1800			
45 GX	3115			
4x5 Robos	3175	2900 2700	2650	
810 G		2895 2615	2425 1900	
810 GII	5130			
810 GB	2995			
810 M Field			2395 1900	
810 MII Field	4515			
VX 125	5995	5000		
VX 125R	3815			

Wisner

Wisner cameras are widely regarded as the finest wooden view cameras made. Models with "(aluminum/brass)" following their name use brass-plated aluminum hardware to save weight. The Panorama cameras are built to order.

Camera	New	Mint	Excellent	User
4x5 Expedition	2195			
4x5 Pocket	2495			
4x5 Technical Field	1850	1475		
4x5 S Traditional	1495			
4x10 Panorama	2195			
5x7 Classic Convertible		1750 1400		
5x7 Technical Field	2675			
8x10 Classic Convertible		2150 1800		
8x10 Expedition	4195			
8x10 Technical Field	3495			
8x10 Tech (aluminum/brass)	3400			
8x10 Traditional S Field	2595			
8x20 Panorama	4000			
11x14 Technical Field	4495			
11x14 Tech (aluminum/brass)	4400			
12x20 Panorama	5000			
20x24 Technical	8900			

Wista

Camera	New	Mint	Excellent	User
4x5 45 DX Field (Cherrywood)	1310	850 780	750 650	
4x5 45 DX Field (Rosewood)	1140 1065			
4x5 45 DX Field (Ebony)	1645 1550	1450		
4x5 45 DX II (Cherrywood)	1250			
4x5 45 DX II (Cherrywood) w/shift		1120		
4x5 45 DX II (Rosewood)	1610			
4x5 45 DX II (Rosewood) w/shift	1660			
4x5 45 DX III-W (Rosewood)	1900			
4x5 M-450	1300 1145			
4x5 Tech 45 RF	3100		1900 1560	
4x5 Tech 45 SP	2150		1290 900	
4x5 Tech 45 VX	2000	1095 945		
8x10 Field Double (26")	2350			
8x10 Field Triple (30")	2575 2400	2050 1900		
8x10 M Wood Field	1270			
8x10 Wood Field (Early)	950			

Zone VI

Camera	New	Mint	Excellent	User
4x5 Field	795	650 525		
4x5 Field Classic	1195	1050 1000	900 625	
4x5 Walnut.	1335 1095			
4x5 Mahogany	995			
8x10 Field	1995	1740 1600	1670 1450	
Wood Field (Early)	1695 1250			
Wood Field (Current Style)	1675			

☐ LARGE FORMAT LENSES

Many of the lens makers who have produced lenses for the larger film formats recorded their lenses' focal lengths in either inches or millimeters and, in a few cases, both. Nowadays, most everybody uses millimeters.

However, some older lenses indicate only the format they cover (Bausch & Lomb 8x10 Protar, for example). Thus, in order to make it as easy as possible for you to locate a particular optic when a manufacturer has used both inches and millimeters to measure a lens' focal length, lenses are listed in a combined format [e.g.: (Goerz) 210mm (8¼") f/6.8 Gold Dot Dagor]. If a lens was made with its focal length marked in inches only, it will be found at the end of the manufacturer's listing.

Another method of grouping the lenses was used in addition to the above.

Where applicable, each manufacturer's lenses in shutters are listed first, followed by lenses in barrels. In the case of lenses in shutters, the prices take into account shutters of good quality that are also in good mechanical condition.

Bausch & Lomb Lenses in Shutters

Lens	Mint	Excellent	User
72mm B&L Macro Tessar		125	
88mm f/6.8 Wide Angle		410 250	115
158mm B&L Macro Tessar		140	
185mm f/6.3 B&L Tessar			100
190mm f/4.5 B&L Tessar	70	50 40	
210mm f/4.5 B&L Tessar	350 325		140
250mm f/4.5 B&L Zeiss Tessar		190	
4 7/16" f/18 Protar Series V		295 250	
5"/8¾" B&L Zeiss Protar Series VII		450	
6" f/4.5 B&L Zeiss Tessar Series Ic			90
8"/16" B&L Convertible		300	
11" f/4.5 B&L Zeiss Tessar Series Ic			130
12"/18"/36" B&L Triple Convertible		270	
13"/16" B&L Protar Convertible	495		
19" f/4 Portrait		300	
20" (508mm) f/5.6 B&L Anastigmat		750 675	
8x10 f/12.5 B&L Series IV		200	
11x14 B&L Zeiss Protar Series IIa	875		

Bausch & Lomb Lenses in Barrels

Lens	Mint	Excellent	User
90mm f/18 B&L Protar		150 125	
100mm f/2.3 B&L Anastigmat		70	
102mm f/18 B&L Zeiss Protar V		70	
210mm f/4.5 B&L Tessar		100	
260mm f/4.5 B&L (Zeiss) Tessar (coated)	250	95	
300mm f/4.5 B&L Zeiss Tessar		100	
6" B&L Metrogon		195 150	
6½"/8" f/18 B&L Zeiss Protar Series V		150	
8"/16" B&L Series VII		300	
9"/14"/19" B&L Zeiss Convertible Anastigmat		300	
10" f/6.3 B&L Tessar IIc		95	
12" f/5.6 Pastigmat Portrait	425		
13" f/10 B&L Process Anastigmat		150	
16" f/10 B&L Process Anastigmat		195	

Bausch & Lomb Lenses in Barrels (cont'd)

Lens	Mint	Excellent	User
19" B&L APO Tessar		200	
5x7 f/18 B&L Zeiss Protar Series V		150	125
5x8 B&L Tessar Ic	95		
6½ x 8½ B&L Rapid Rectilinear		250 200	
8x10 f/18 B&L Protar Series V		150	
8x10 f/12.5 B&L Zeiss Protar Series IV		185	
11x14 f/18 B&L Zeiss Protar Series V		225	
12x15 B&L Protar Series IV		375	
32x36 B&L Zeiss APO Tessar Series VIII		795	

Calumet

Lens	Mint	Excellent	User
65mm f/4.5 Caltar II			
65mm f/4.5 Caltar II-N MC	695 650		
65mm f/4.5 Caltar Professional	550	400	
65mm f/8 Caltar W II		450	
75mm f/4.5 Caltar II		365	
75mm f/6.8 Caltar II		230	
75mm f/6.8 Caltar II-N MC		550	
90mm f/4.5 Caltar II-N MC	750		
90mm f/5.6 Caltar Professional MC		660	
90mm f/6.8 Caltar II		355	
90mm f/6.8 Caltar II-N MC	695 550		
90mm f/8 Caltar II	550 395	290	
90mm f/8 Ilex-Calumet		360 250	
90mm f/8 Caltar HR		720	
90mm f/8 Caltar W		550 375	
90mm f/8 Caltar W II		650 600	
115mm f/6.8 Caltar II-N		995	
135mm f/5.6 Caltar II	380	275	
135mm f/5.6 Caltar II-N		395 275	
135mm f/5.6 Caltar S-II	395		
150mm f/5.6 Caltar-S		275 240	
150mm f/5.6 Caltar II	225	260	
150mm f/5.6 Caltar II-N	450 380	335 275	
150mm f/5.6 Caltar-S II	385 350	325 280	
150mm f/5.6 Caltar HR	450 295		
165mm f/6.3 Caltar		250 150	
180mm f/5.6 Caltar II		275	
180mm f/5.6 Caltar II-N	590 485	425 300	
210mm f/5.6 Caltar II	375	365	
210mm f/5.6 Caltar II-E		450 325	
210mm f/5.6 Caltar II-N	595	550 475	495 370
210mm f/5.6 Caltar-S II		465 435	385 320
210mm f/5.6 Caltar HR	695 495	445	
210mm f/5.6 Caltar-S		285	
210mm f/5.6 Caltar Professional	400		
210mm f/6.8 Caltar	295		
210mm f/6.8 Caltar II	340 240	360	
210mm f/6.8 Caltar II-E		325 250	
210mm f/6.8 Caltar HR		350	

Calumet

Lens	Mint		Excellent		User
210mm f/6.8 Caltar-S					
240mm f/5.6 Caltar Professional			450		
240mm f/5.6 Caltar II N	995	870			
240mm f/5.6 Caltar-S II			650	550	
240mm f/5.6 Caltar-S			600		
240mm f/6.8 Caltar Y			440		
300mm f/5.6 Caltar Professional			600		
300mm f/5.6 Caltar II			700	590	
300mm f/5.6 Caltar II-N MC	795		780	700	
300mm f/5.6 Caltar-S II	950		850	825	600
300mm f/5.6 Caltar HR			700		
305mm (12") f/6.3 Ilex-Calumet	450		395	300	
355mm f/? Ilex-Calumet			375		
360mm f/5.6 Caltar II-N	1300				
360mm f/6.8 Caltar II			845		
360mm f/6.8 Caltar II-N MC	1195	1050	995	795	
360mm f/6.8 Caltar-S II	1195	995	865		
375mm f/6.3 Ilex-Caltar		625	600		
8¼" f/6.1 Caltar Pro			280		
8½" f/6.3 Caltar			225	170	
8½"/14" f/4.8-10 Caltar-S	350	315	185	165	
10" f/6.3 Ilex-Calumet			280	200	
14" Ilex Caltar		495			
14½" f/6.3 Ilex-Calumet			570		
14¾" f/6.3 Ilex-Calumet			570		460
14¾" f/6.3 Caltar Acutar	460	395	475	425	
20" f/7 Ilex-Calumet		695	575	500	425
25" Ilex Calumet Series S		475			

Fuji

Fuji does not directly distribute its large format lenses into the U.S. A handful of dealers here have contacts in Japan which enable them to supply Fuji lenses to their customers. As a result of this sort of supply network, inventories in the US are spotty. Del's and The f Stops Here, both in Santa Barbara, CA, carry new and used Fujinons when they can get them.

Lens	New		Mint		Excellent		User
65mm f/5.6 SW EBC	780		675	650			
65mm f/5.6 SWD					725		
65mm f/8 SW			550	495	425	325	
75mm f/5.6 EBC			695		440		
75mm f/5.6 SWD	995		1075	795			
75mm f/8 EBC			440	380			
75mm f/8 SW			385	350	325	265	
90mm f/5.6 SW	1130	870					
90mm f/5.6 SWD					900	790	
90mm f/8 NWS			500				
90mm f/8 SW			695		450	395	
105mm f/5.6 NWS	465		300		300		
105mm f/5.6 W	350						
105mm f/8 SW	985		800				
120mm f/8 SW					850		
125mm f/5.6 NWS	485						

Fuji (cont'd)

Lens	New	Mint	Excellent	User
125mm f/5.6 W		830	625	415
135mm f/5.6 NWS	485			
135mm f/5.6 W			295 250	
150mm f/5.6 NWS	465	410 385	360 290	
150mm f/5.6 W		395 275	275 240	
150mm f/6.8			335	
180mm f/4.5			230	
180mm f/5.6 A or AS			225	
180mm f/5.6 W	585		395	
180mm f/9 AS	750 600			
210mm f/5.6 W		520 425	410 370	
240mm f/9 A or AS	750	695	475 415	395 350
250mm f/5.6 SF		660 525	495	
250mm f/6.3 NWS			480	
250mm f/6.3 W	955	850 725	685 565	
250mm f/6.7 WS		950 785	680 600	
300mm f/5.6 L		740	710 535	
300mm f/5.6 W	1340	995 895	775 650	
300mm f/5.6 SW	1120			
300mm f/8 T	1190			
300mm f/8.5 CS APO	1035			
300mm f/9 M	735			
360mm f/6.3 W		995 925	850	
360mm f/6.3 WS	1725		850	
360mm f/9 A or AS			895 775	
360mm f/10 A or AS		950	750	
400mm f/8 T	1590	900	865	
420mm f/5.6 SF (bbl)		325		
420mm f/8 L			950 750	700 600
450mm f/12.5 CS APO	1185			
600mm f/11.5 CS APO	2295			
600mm f/12 T	2385		1325	

Goerz Lenses

With Goerz lenses, as with most other German-made lenses, the name denotes a lens formula. The following listings have been alphabetized according to lens formula, e.g. Artar or Dagor, even though there may be a prefix to the name that would seem to put it out of alphabetical sequence.

The most widely known and widely used Goerz lenses are the Artars and Dagors. The Artar formula is an APO formula, even though not all Artar lenses will be inscribed "APO Artar". Red Dot Artars are supposedly premium versions of the Artar formula, but the consensus among Goerz cognoscenti is that the Red Dot designation was largely a marketing ploy. This same reasoning largely applies to the Gold Ring and Gold Dot Dagors. In both cases, however, you'll note that the premium versions command higher prices than the standard ones.

Goerz Lenses in Shutters

Lens	New	Mint	Excellent	User
35mm f/8 Wide Angle Dagor			295	
75mm f/9 Dagor			280	
90mm f/6.8 Dagor			650 495	
90mm (3⅝") f/8 Wide Angle Dagor			375	250
130mm f/6.8 Dagor Double Anastigmat				300
150mm f/5.6 Gold Ring Dagor			690	
150mm f/6.3 Dagor			320	
150mm (6") f/6.8 Dagor			550 350	
150mm f/9 Red Dot Artar			400	
150mm f/9 Dagor			675	
165mm f/8 WA Gold Dot Dago	1450			
180mm f/9 Dagor	1800			
180mm f/? American Dagor			325	
190mm (7½") f/4.5 Dagor			275	
203mm (8") f/6.8 Dagor			510 450	
203mm (8") f/6.8 Gold Dagor		750	650	
210mm f/? American Dagor			575	
210mm f/5.6 Dagor Series V			350	
210mm (8¼") f/6.8 Dagor			650 550	
210mm (8¼") f/6.8 Gold Dot Dagor		950	795	
210mm (8¼") f/9 APO Red Dot Artar		500	375 400	325
240mm (9½") f/6.8 Dagor			400 375	275 230
240mm f/6.8 Gold Dot Dagor				395
240mm (9½") f/6.8 Red Dot Artar			375 310	
240mm f/9 APO Red Dot Artar			575 390	
260mm f/9.5 APO Red Dot Artar			380	
270mm f/6.8 American Dagor			775	300
270mm f/7.7 Berlin Dagor			625 570	
270mm f/9.5 APO Artar			325	
276mm/480mm Pantar Convertible			500	
300mm f/9.5 APO Artar			375	
300mm f/9.5 Red Dot Artar			475	
300mm (30cm) f/6.8 Dagor			325 250	
300mm f/6.8 Gold Dagor			650 495	
305mm (12") f/6.8 Double Anastigmat			140	
305mm (12") f/6.8 Dagor			575 475	
305mm (12") f/9 APO Red Dot Artar		650	550 475	400
355mm (14") f/8 Gold Dot Dagor		895 795		
355mm (14") f/9 Red Dot Artar		595	475	
360mm f/7.7 American Dagor			1000 850	
360mm f/11 APO Artar			450	
360mm f/11 Red Dot Artar			375	
360mm f/8 Gold Dot Dagor			500	
420mm f/? American Dagor			850	
420mm (16½") f/7.7 Dagor			1250 920	
420mm (16½") f/9.5 APO Red Dot Artar		995	950	880 700
420mm f/11 Red Dot Artar			850	
420mm f/11 APO Artar			775	
480mm (19") f/11 Red Dot Artar (APO)		975	615	
600mm f/? Red Dot Artar			1750 1500	
3" f/4.5 Hycon			2500 1800	
4⅜" f/8 Wide Angle Dagor			795 625	

Goerz Lenses in Shutters (cont'd)

Lens	Mint		Excellent		User
5" f/4.5 Dogmar			250		
5¼" f/4.5 Dogmar			155		
6" f/6.3 Planigon	775		700		
6" f/6.8 Dagor (uncoated)			250	225	
6" f/9 APO Red Dot Artar			360	280	
6" f/9 Red Dot Artar			350	240	
6¼" f/6.8 Dagor			125		
6½" f/6.8 Dagor			650		
6½" f/8 Golden Dagor			1195	1000	
7" f/6.8 Dagor	480		375		
9½" f/9 Red Dot Artar	550				
10¼" f/6.8 APO Red Dot Artar			490	400	
10¾" f/? Artar			700		
10¾" f/? Dagor					170
12" f/6.8 Golden Dagor			900		
12" f/9 APO Artar			375	325	
14" f/5.5 Celor			190		
14" f/7.7 Dagor			395		
14" f/9 APO Red Dot Artar	625	595	580	450	
14" f/11 Red Dot Artar			500		
18" f/11 Artar			300		
19" f/11 APO Red Dot Artar			750	580	
24" f/11 APO Artar			595	480	
30" f/12.5 Red Dot Artar			2000		
42" f/14.5 Red Dot Artar			2050		
47" f/15 APO Artar			350		

Goerz Lenses in Barrels

Most of the Goerz lenses listed here are uncoated.

Lens	Mint		Excellent		User
90mm f/4.5 Goerz Berlin			85		
210mm f/5.6 Dagor Series V			350		
240mm f/6.8 Dagor			200		
270mm f/9.5 Red Dot Artar			175		
300mm f/9.5 APO Artar			175		
360mm f/11 APO Artar			175		
420mm f/11 APO Artar			125		
480mm f/11 APO Artar			275	175	
480mm (19") f/5.5 Dogmar			300		
600mm f/7.7 Berlin Dagor			430		
875mm f? APO Artar			900		
6¼" f/6.8 Dagor			125		
6.5" f/6.8 Dagor	325				
7½" F/4.5 Dogmar					75
8¼" f/6.8 Dagor			160		
10¼" f/9.5 APO Artar	225	190			
10¼" Dagor			250		
12" f/4.5 Dogmar			125		
12" f/5 Goerz Portrait			250		
12" f/9 APO Red Dot Artar	495		385	285	

Goerz Lenses in Barrels (cont'd)

Lens	Mint		Excellent		User	
12" f/10 Gotar			80			
14" f/5.5 Celor					70	
14" f/? Ross Goerz Double Anastigmat			150			
14" f/8 Gotar			200			
14" f/9 APO Artar	335					
14" f/9 Red Dot Artar			425	350		
14" f/11 Blue Dot Trigor	595					
16½" f/9.5 APO Red Dot Artar					350	280
19" f/5.5 Dogmar			300			
19" f/11 APO Artar			275	200		
19" f/11 Red Dot Artar	625	500	450	315		
24" f/11 APO Artar			625			
24" f/11 APO Red Dot Artar			700		345	280
30" f/12.5 APO Artar	650		625			
35" f/12.5 APO Artar	1250		695			
42" f/14.5 APO Artar	800		750			
47½" f/15 APO Artar			750			

Graflex

Lens	Mint		Excellent		User	
90mm f/6.8 Wide Angle Optar	285	250	225	160	130	
101mm f/4.5 Graflar or Optar			100	60		
135mm f/4.7 Optar			110	80		
162mm f/4.5 Optar	175		165			
202mm (8") f/5.6 Tele-Optar			275	200		
203mm f/7.5 Optar					250	170
250mm f/5.6 Tele-Optar	295	250	250	175		
380mm f/5.6 Tele-Optar			225	195		

Horseman

Lens	Mint		Excellent		User	
65mm f/7 Super	1100	550	420	400	285	
75mm f/3.5 Pro		475				
75mm f/5.6 Pro	900	350		230		
75mm f/5.6 VHR		425		380		
90mm f/5.6	890	495		320		
105mm f/3.5		395	350	325		
105mm f/4.5 Super			445	330		
150mm f/5.6 Super			340	300		
180mm f/5.6 Pro	1000	495		370	290	
180mm f/5.6 Super ER		635				
180mm f/5.6 VHR		475				

Ilex

Lens	Mint	Excellent	User
65mm f/8 Wide Angle Acugon		340 250	
75mm f/1.9 Oscillo-Paragon		65 50	
90mm f/8 Wide Angle	250		
140mm (5½") f/4.5 Paragon Anastigmat		100	80
162mm f/4.5 Paragon		120	
165mm (6½") f/4.5 Paragon		100	40
165mm f/6.3 Acutar	215	175	
180mm f/4.5 Acutar		175	
180mm/247mm f/4.8 Acugon Convertible		225	
190mm (7½") f/4.5 Paragon	275	225 180	
190mm (7½") f/5.6 Pargon		165	
210mm f/6.3 Acutar	250	215	
215mm (8½") f/4.5 Paragon		270 200	
215mm (8½") f/6.3 Acutar		300 230	
229mm (9") f/5.6 Paragon	100 80		
240mm (9½") f/? Dago-Ilex (uncoated)		250	
250mm f/6.3 Paragon		400	
254mm (10") f/6.3 Acutar		240	
305mm (12") f/4.5 Paragon Anastigmat		400	
305mm f/6.3		400 250	
305mm (12") f/6.8 Ilex Bruning Wide Angle (bbl)	195		
305mm (12") f/9 Ilex Copy Paragon (bbl)			165
375mm f/6.3 Acutar		500 350	
375mm (14¾") f/6.3 Paragon	595		
9½" f/4.5 Paragon (bbl)	100		
12"/19"/23" Protar	985		

Kodak Lenses in Shutters

Lens	Mint	Excellent	User
80mm f/6.3 Wide Field Ektar		295 200	
100mm f/6.3 Wide Field Ektar		450 395	345 270
101mm f/4.5 Ektar		180 125	70 60
105mm f/3.7 Ektar	225	140	
107mm f/3.7 Anastigmat		100	
127mm f/4.5 Anastigmat		115	
127mm f/4.5 Ektar		155	
127mm f/4.7 Ektar	195 130	135 85	95 60
135mm f/6.3 Wide Field Ektar		395 325	275
152mm f/4.5 Ektar		250 210	
178mm (7") Zeiss Kodak Anastigmat		80	
190mm (7½") f/4.5 Ektar	525 350	375 285	
190mm (7½") f/6.3 Ektar	315	350	
190mm (7½") f/6.3 Commercial Ektar		315	
190mm (7½") f/6.3 Wide Field Ektar		550	385
203mm (8") f/7.7 Ektar (coated)	350 325	250 200	175
210mm (8¼") f/6.3 Commercial Ektar		325	275 235
210mm (8¼") f/6.3 Wide Field Ektar		290	
250mm f/6.3 Wide Field Ektar		995 750	650
250mm f/6.3 Commercial Ektar		450 400	
300mm f/6.3 Commercial Ektar		650	

Kodak Lenses in Shutters (cont'd)

Lens	Mint	Excellent	User
305mm f/4.5 Portrait Ektar	750 700	695	
360mm f/6.3 Commercial Ektar		575	
360mm f/6.3 Ektar		300	
405mm (14") f/4.5 Portrait		270	
610mm f/6 Aero Ektar		260	
6" f/2.5 Aero Ektar		200	
6" f/2.8 Aero Ektar		200	
6" f/3.5 Aero Ektar		170	
6^3/$_8$" f/4.5 Anastigmat #32	175		
8" f/6.3 Commercial Ektar	350		
8^1/$_2$" f/4.5 Anastigmat		265 195	
8^1/$_2$" f/6.3 Commercial Ektar	650	495 350	250
10" f/6.3 Ektar			
10" f/6.3 Commercial Ektar	550 450	495 375	300 250
10" f/6.3 Wide Field Ektar	850 750	745 625	
12" f/4.5 Ektar		595 395	295
12" f/4.5 Commercial Ektar		460 395	330
12" f/4.8 Portrait Ektar	695 550	475 330	
12" f/6.3 Ektar			375 300
12" f/6.3 Commercial Ektar	750	595 495	390 300
14" f/6.3 Ektar		415	
14" f/6.3 Commercial Ektar	750 675	695 595	450 425
16" f/4.5 Portrait Ektar	650		

Kodak Lenses in Barrels

Lens	New	Mint	Excellent	User
4^3/$_8$" f/1.5 Fluro Ektar			95	
5^1/$_2$" f/4.5 Anastigmat			50	
6^3/$_8$" f/4.5 Anastigmat			55 40	
7" f/2.5 Aero Ektar			125 100	
7^1/$_2$" f/4.5 Anastigmat		110 95		
7^1/$_2$" f/4.5 Ektar		120		
10" f/4.5 Anastigmat			225	90
12" f/4.5 Portrait		450		
12" f/10 Copying Ektanon		295		
13^1/$_2$" f/3.5 Anastigmat			200	
17" f/10 Copying Ektanon		325 225		
18" f/10 APO Process Ektar		295		
18^1/$_2$" f/10 Copying Ektanon		225		
18^1/$_2$" f/10 Anastigmat			125 95	
18^3/$_4$" f/10 Ektanon			175	
19^3/$_4$" f/10 Anastigmat			150	
21^1/$_4$" f/10 Anastigmat			175	

Komura

Lens	New	Mint	Excellent	User
47mm f/6.8 W			245	
75mm f/5.6 Super W			350	
90mm f/5.6		450		
90mm f/6.3 Super W			315 300	
152mm f/2.8			350	
210mm f/6.3 Commercial			225	
300mm f/5			240	
400mm f/8 Komuranon			400	

Nikon

Lens	New	Mint	Excellent	User
65mm f/4 SW	1070 990	900 825		
70mm f/5 Micro-Nikkor			240	
75mm f/4.5 SW	1220 1120	995		
90mm f/4.5 SW	1320 1250	1050 1000	995 850	
90mm f/8 SW	840 730	675 600		
105mm f5.6 W	500 460	395 350	360 250	
120mm f/5.6 AM-ED Macro	1080 1000	840 780	750 640	
120mm f/8 SW	1120 1020	940 875	850 700	
135mm f/5.6 W	580 525	450 400	390 320	
150mm f/5.6 W	550 510	425 375	350 290	
150mm f/8 SW	2200 2100	1745 1650	1580 1300	
180mm f/5.6 W	640 600	500 450	455 350	
200mm f/8 M	610 570	480 425	450 325	
210mm f/5.6 AM-ED Macro	2300 1900		1650 1400	
210mm f/5.6 W	675 600	525 460	495 350	
240mm f/5.6 W	1200 1000	850 725		
270mm f/6.3 ED T	1470 1400			
300mm f/5.6 W	1560 1480	1250 1080		
300mm f/9 M	690 660	435	375	
305mm f/9 APO (bbl)			295	
360mm f/6.5 W	1660 1580	1230 1070	1000 800	
360mm f/8 ED T	1900 1695	1500 1420	1375 1100	
Rear Unit 360	500 460			
360mm f/9 APO		850 700		
420mm f/9 APO-Nikkor		850		
450mm f/9 M	1200 1080	950 855	765 650	
480mm f/9 APO-Nikkor			460	
500mm f/11 ED T	1970 1830			
Rear Unit 500	570 500			
600mm f/9 ED T	2500 2350	2190 1995	1850 1640	
Rear Unit 600	640 610			
610mm f/9 APO-Nikkor		1280 880		
720mm f/16 ED T	2110 1970		1400 1200	
Rear Unit 720	710 670			
800mm f/12 ED T	2930 2770			
Rear Unit 800	740 700			
1200mm f/18 ED T	3100 2900			
Rear Unit 1200	950 900			

Rodenstock

Lens	New	Mint	Excellent	User
45mm f/4.5 APO Grandagon N	1135			
45mm f/5.6 Grandagon		990 880		
55mm f/4.5 APO Grandagon N	1210			
55mm f/5.6 Grandagon		1095 950		
58mm f/5.6 Grandagon		475	350 300	
65mm f/4.5 Grandagon-N	1250 1060	950 750	695	
75mm f/4.5 Grandagon-N	1295 1150	1050 975		
75mm f/6.8 Grandagon		695 625	600 550	
75mm f/6.8 Grandagon N	910 850			
80mm f/2.8 Heligon		295		
90mm f/3.2 Heligon			450	
90mm f/4.5 Grandagon-N	1590		880 760	
90mm f/6.8 Grandagon		675 640	610 550	
90mm f/6.8 Sironar			850	
90mm f/8 WA Geronar			410 360	
90mm f/8 Grandagon			495	
100mm f/5.6 Sironar		350 300		
100mm f/5.6 Sironar-N	475 420	365 320	290 230	
100mm f/5.6 APO Sironar-N	625 500			
115mm f/6.8 Grandagon-N	1595	1400 1195	995	
120mm f/5.6 Sironar-N		595 540		
127mm f/4.7 Ysarex		100 80		
135mm f/4.5 Ysarex			170	
135mm f/5.6 Sironar-N		415 375	360 275	
135mm f/5.6 APO Sironar-N	675 560		460	
135mm f/5.6 APO Sironar-S ED	700			
150mm f/4.5 Ysarex			225 195	
150mm f/5.6 APO-Sironar		900 800		
150mm f/5.6 APO Sironar-N	715 540			
150mm f/5.6 APO Sironar-S ED	845 750			
150mm f/5.6 APO Sironar-W ED		995 850		
150mm f/5.6 Sironar-N		460 350	375 325	300 240
150mm f/6.3 Geronar	345 245	250 225	290	
150mm f/9 APO-Ronar		695 625	500 380	
155mm f/6.8 Grandagon		2450 2000		
155mm f/6.8 Grandagon N	3300			
180mm f/4.5 Tele-Rotelar			395	
180mm f/5.6 Sironar		350	290	
180mm f/5.6 Sironar-N		600 475	425 365	
180mm f/5.6 APO Sironar-N	895 785			
180mm f/5.6 APO Macro Sironar	1470			
180mm f/5.6 APO Sironar-S ED	995 880			
200mm f/5.8 Imagon		675 570	600 490	
200mm f/6.8 Grandagon		3800 3400	2900 2400	
200mm f/6.8 Grandagon N	4500			
210mm f/5.6 APO-Sironar		1425 1250		
210mm f/5.6 APO Sironar-N	940 860	595		
210mm f/5.6 APO Sironar-S ED	1180 990			
210mm f/5.6 APO Sironar-W ED	1940 1630	1550		
210mm f/5.6 Sironar		450 370		190
210mm f/5.6 Sironar-N		795 650	625 550	
210mm f/5.6 Macro Sironar-N	1515 1430	935	875	
210mm f/6.3 Ysarex			220	125

Rodenstock (cont'd)

Lens	New		Mint		Excellent		User
210mm f/6.8 Geronar			350	300	290	250	
240mm f/5.6 Sironar-N			1000	775			
240mm f/5.6 APO Sironar-N	1580	1440					
240mm f/5.6 APO Sironar-S ED	1895	1730					
240mm f/9 APO-Ronar			750	595	560	350	
250mm f/6.8 Imagon			795	665			
250mm f/8 Imagon					480		
270mm f/5.6 Tele-Rotelar					540	495	
300mm f/5.6 Imagon			650	600	585	395	500
300mm f/5.6 APO Sironar			2500	2000			
300mm f/5.6 APO Sironar-N	2145	1905					
300mm f/5.6 APO Sironar S ED		2390					
300mm f/5.6 APO Sironar-W ED	3695	3500					
300mm f/5.6 Sironar-N			1525	1250	1100	995	
300mm f/5.6 Macro Sironar-N			2475	2050	1450		
300mm f/6.8 Imagon					490	400	
300mm f/6.8 APO Sironar-S ED			1995	1500			
300mm f/9 APO-Gerogon			400		215	200	
300mm f/9 APO-Ronar			900	820	750	675	
300mm f/9 Geronar			525	460			
360mm f/5.8 Imagon			895	500			
360mm f/6.8 Sironar-N			1575	1450	1275		900
360mm f/6.8 APO Sironar-N	2395	2200					
360mm f/9 APO-Gerogon					400		
360mm f/9 APO-Ronar			1250	980	1050	800	
420mm f/5.8 Imagon					750		
420mm f/9 APO-Ronar			1450	1200			
480mm f/8.4 Sironar-N					1595	1300	
480mm f/9 APO-Ronar			1450	1230			
600mm f/9 APO-Ronar					995		

Schneider

Lens	New	Mint		Excellent		User
47mm f/5.6 Super Angulon MC	1040			795		
47mm f/5.6 XL Super-Angulon MC		1410				
47mm f/5.6 Super-Angulon		795	650			
47mm f/8 Super-Angulon		695	600			
53mm f/4 Super Angulon				995		
58mm f/5.6 Super-Angulon MC		895	750			
58mm f/5.6 XL Super-Angulon MC	1215					
60mm Componon				235		
65mm f/5.6 Super-Angulon				695	550	
65mm f/5.6 Super-Angulon MC	1275	925	850			530
65mm f/6.8 Angulon		295	250	275	200	
65mm f/8 Super Angulon		695	550	595	425	
72mm f/5.6 XL Super-Angulon MC		1530				
75mm f/5.6 Super Angulon MC	1350	1095	980	950	800	
75mm f/8 Super-Angulon		550	450	475	375	
80mm f/2.8 Xenotar		500	450	230	170	
90mm f/5.6 Super-Angulon		950	795	755		

Schneider (cont'd)

Lens	New	Mint		Excellent		User	
90mm f/5.6 Super-Angulon MC	1495	1200	1000	825			
90mm f/5.6 Super-Angulon XL	1655						
90mm f/6.8 Angulon				470	295		
90mm f/8 Angulon				240	125		
90mm f/8 Super-Angulon		600	525	500	395	345	300
90mm f/8 Super-Angulon MC	1005	800	675	650	475	375	
100mm f/5.6 Symmar Convertible				195			
100mm f/5.6 Symmar S			300	285			
100mm f/5.6 Symmar-S MC			400	270			
100mm f/5.6 APO-Symmar MC	660			385			
105mm f/2.8 Xenotar		400	350				
105mm f/3.5 Xenar				230	150		
105mm f/4.5 Comparon				220			
105mm f/4.5 Xenar		250	200	165			
110mm f/5.6 XL Super-Symmar HM	2280						
120mm f/5.6 Symmar-S				215	175		
120mm f/5.6 APO-Symmar MC	690	520	475				
120mm f/5.6 Macro Symmar MC	1415	1000	925				
120mm f/5.6 Super Symmar-HM MC		1350	1000	925	750		
120mm f/6.8 Angulon		650	475	395	245		
120mm f/8 Super-Angulon		795	725	715	650		
120mm f/8 Super-Angulon MC	1470	1180	1000				
127mm f/4.7 Press-Xenar				180	120		
135mm f/3.5 Xenotar		460	425	435	295		
135mm f/3.8 Press-Xenar				225	200	185	175
135mm f/4.5 Zecanar				60			
135mm f/4.7 Xenar		200	175	170	125	85	80
135mm f/5.6 Symmar Convertible				300	280	170	
135mm f/5.6 Symmar-S				325	245		
135mm f/5.6 Symmar-S MC		355	320	325	260		
135mm f/5.6 APO-Symmar MC	715	525	510				
135mm f/8 Repro Claron				540	325	250	
150mm f/2.8 Xenotar		595	480	450	300		
150mm f/3.5 Xenar				80			
150mm f/4.5 Xenar		265	200	180	150		
150mm/265mm f/5.6/12 Symmar Convertible				350	300	275	225
150mm f/5.6 Symmar				350	250		
150mm f/5.6 Symmar-S		395	375	350	300		
150mm f/5.6 Symmar-S MC		500	425	395	365		
150mm f/5.6 Super Symmar-HM MC		1750	1420	1300	1250	925	
150mm f/5.6 APO-Symmar MC	710	545	395	450	320		
150mm f/5.6 Xenar	400	300	250	250	190		
150mm f/9 G-Claron	550	450	390	375	295		
165mm f/6.8 Angulon		650	600	595	475		

Schneider (cont'd)

Lens	New	Mint		Excellent		User	
165mm f/8 Angulon						125	
165mm f/8 Super-Angulon		1850	1575	1600	1250	975	
165mm f/8 Super-Angulon MC	3430			2150	1600		
180mm f/3.5 Xenar (bbl)				80			
180mm f/4 Tele-Arton				495	300		
180mm f/5.5 Tele-Arton		455		300			
180mm f/5.5 Tele-Xenar		365		325	275	240	
180mm/315mm f/5.6/12 Symmar Convertible			395	400	350	285	
180mm f/5.6 Symmar				390	350		
180mm f/5.6 Symmar-S				400	300		
180mm f/5.6 Symmar-S MC		550	525	480	400		
180mm f/5.6 APO-Symmar MC	920	650	585				
180mm f/5.6 Macro-Symmar MC	1460						
210mm f/3.5 Xenar				160	120		
210mm f/4.5 Xenar		265	220				
210mm/370mm f/5.6/12 Symmar Convertible		475	450	450	330	325	310
210mm f/5.6 Symmar		500	440	380	325		
210mm f/5.6 Symmar-S			600	595	525		
210mm f/5.6 Symmar-S MC		945	750	595	480		
210mm f/5.6 Super-Symmar HM MC		2820		1850	1650		
210mm f/5.6 APO-Symmar MC	1010	650	570				
210mm f/6.1 Xenar	640			285			
210mm f/6.8 Angulon		1250		750	725	550	
210mm/325mm/405mm f/6.8/12/13 Symmar Triple Conv						310	250
210mm f/8 Super-Angulon		2900	2650	2750	2400		
210mm f/8 Super-Angulon MC	5195						
210mm f/9 G-Claron	755	520	395				
210mm f/9 Repro-Claron				420	350		
240mm f/4.5 Tele-Arton				450	370		
240mm f/4.5 Xenar		450		340	300		
240mm f/5.5 Tele-Arton				350	300		
240mm f/5.5 Tele-Xenar				400	275		
240mm/420mm f/5.6/12 Symmar Convertible			695	575	495	540	325
240mm f/5.6 APO-Symmar MC	1655	1250	1000	940	780		
240mm f/5.6 Symmar				695	465	425	
240mm f/5.6 Symmar-S				750	640		
240mm f/5.6 Symmar-S MC		1000	870				
240mm f/9 APO-Artar		1100	995				
240mm f/9 G-Claron	810	570	525	475	400		
240mm f/9 Repro-Claron				375	300		
250mm f/5.6 Tele-Arton		840	795	765	640		
250mm f/5.6 Tele-Arton MC	1470			995	900		
270mm f/5.5 Tele-Arton				550	395		
270mm f/5.5 Tele-Xenar				595	425		
270mm f/9 G-Claron	1010						
270mm f/11 G-Claron Wide Angle				630			
300mm f/5.5 Tele-Xenar			450	395	300		
300mm/500mm f/5.6/12 Symmar Convertible		795	750	560	495		

Schneider (cont'd)

Lens	New	Mint		Excellent		User
300mm f/5.6 APO-Symmar MC	2195					
300mm f/5.6 Symmar				695	495	
300mm f/5.6 Symmar-S		1095	985	970	850	
300mm f/5.6 Symmar-S MC		1245	1200	1215	900	
300mm f/5.6 Xenar		695	650	500	440	
300mm f/6.8 Symmar Double Anastigmat						350
305mm/560mm (12"/22") f/6.8 Symmar Convertible				350		
305mm f/9 G-Claron	1010	750	675	730	595	
305mm f/9 G-Claron	1010	750	675	730	595	
305mm f/9 Repro-Claron		650	600	575	450	
355mm f/9 G-Claron	1595	1125	850	785	600	
360mm f/5.5 Tele-Xenar		1400	1100	1050	845	
360mm/640mm f/5.6/12 Symmar Convertible			895	795	745	580
360mm f/5.6 Symmar				575	550	
360mm f/6.8 APO-Symmar MC	2440					
360mm f/6.8 Symmar-S		1495	1295	1250	1000	
360mm f/6.8 Symmar-S MC		1550	1425	1350	1100	
360mm f/9 APO-Artar		1500	1350			
400mm f/5.6 APO Tele-Xenar		4000	3500			
420mm f/9 Repro-Claron				630		
480mm f/8.4 APO-Symmar MC	3065					
480mm f/8.4 Symmar-S MC				1650		
480mm f/9 Repro-Claron				700	550	
480mm f/11 APO-Artar		1650	1400			
610mm f/9 Repro-Claron				1295		
800mm f/12 APO Tele-Xenar	8000					

Sinar

Lens	Mint		Excellent	User
90mm f/6.8 Sinaron W	750	650		
135mm f/5.6	385			
150mm f/5.6 Sinaron	400			
210mm f/5.6 Sinaron	750	595		
240mm f/5.6 Sinaron	550			
300mm f/5.6	1075			

Turner-Reich

Lens	Mint		Excellent		User
7½"/12"/18" Triple Convertible	395	300	250	185	
8½"/11"/20" f/6.8 Triple Convertible			395		325
8½"/14"/20" f/6.8 Triple Convertible			395		345
10"/14"/20" Triple Convertible	120				
10½" f/8.8 Triple Convertible			270		
12"/18"/24" Triple Convertible			295		
12"/21"/28" Triple Convertible			400		320
12¼"/19"/25" Triple Convertible			395	300	

Wollensak

Lens	Mint	Excellent	User
65mm Wide Angle Raptar		250 200	
75mm f/1.9 Oscilo-Raptar		130	
83mm f/3.5 Raptar	200		
90mm f/6.8 Wide Angle Raptar	250 200	190 125	100 80
101mm f/4.5 Optar	115		
103mm f/4.5 Graftar		55 45	
108mm (4½") f/6.8 Wide Angle Raptar	325	300 275	200
127mm f/4.5 Raptar	135		
135mm f/4.7 Raptar		140 95	
159mm f/12.5 Extreme Wide Angle		400 320	250
162mm f/4.5 Raptar		200 125	
162mm f/4.5 Velostigmat Series II		175 150	
165mm (6½") f/4.5 Series II		125	
190mm f/4.5 Raptar		190	
190mm f/4.5 Velostigmat (bbl)		75	
203mm (8") f/5.6 Raptar		200	
203mm f/7.5 Raptar	395		
210mm f/5.6 Pro Raptar		495	
210mm f/6.8 Raptar Triple Convertible		550	
240mm (9½") f/4.5 Velostigmat		250	
254mm (10") f/4.5 Raptar		140	
254mm (10") f/5.6 Tele-Optar		225 200	
300mm f/4.5 Velostigmat Series II		300	
302mm f/4.5 Raptar		225	
305mm (12") f/4.5 Velostigmat		300 225	
330mm (13") f/6.8 Raptar		300	
360mm f/6 Veritar/Alphax	325		
380mm (15") f/5.6 Raptar (bbl)		150 100	
380mm f/5.6 Tele-Optar		195	
380mm (15") f/8 Process Anastigmat		175	
405mm f/4.5 Velostigmat		200	
3⅓" f/12.5 Extra Wide Angle Series IIIA (bbl)		80	50
4" f/12.5 Wide Angle Raptar			150
4⁵⁄₁₆" f/12.5 Series III		385	
5¾"/8¼"/12¾" f/7.7 Raptar Triple Convertible	190		
6" f/12.5 Wide Angle Raptar		395	
6¼" Extreme Wide Angle		300 250	
6¼" f/12.5 Wide Angle	395 350		
6¼" Wide Field Anastigmat	375 350		
6½" f/4.5 Velostigmat Series II		70 65	
7" f/9.5 Velostigmat Wide Angle Series III		150	
7¼" f/4.5 Velostigmat Series II		160 125	
7½" f/4.5 Velostigmat Series II		100 85	
8¼" f/4.5 Raptar		250 190	
9½" f/4.5 Velostigmat Series II		250	
10" f/5.6 Raptar		200	
11½" f/4 Verito (bbl)		330 275	
10¼" f/10 APO Raptar	200 150		
10½" f/8 Voltas	295 250		

Wollensak (cont'd)

Lens	Mint	Excellent	User
11" Verito Soft Focus		795	
11½"/20" f/6.3 Convertible			300
12" f/4.5 Series II Soft		550 475	
12" f/12.5 Wide Angle Series III		325	
12½" f/6.3 Velostigmat Triple Convertible Series I		225 180	
13"/20"/25½" f/6.8/12⁵⁄₁₆ Raptar Triple Convertible IA		350	
13" f/10 Raptar (bbl)	175		
14½" Verito Soft Focus		400 275	
15" f/5.6 Tele (bbl)		160 100	
15" f/6 Versar (bbl)		110	
15" f/8 Process Anastigmat (coated) (bbl)		175	
15" f/10 APO Raptar		150 100	
16" f/3.8 Vitax (variable soft focus)		225	170
18" f/4 Verito		250 180	
19" f/10 Process Velostigmat			200
20" f/6 Rapid Rectilinear		475 330	

Zeiss

Lens	Mint	Excellent	User
53mm f/4.5 Biogon	2495	1950	
75mm f/4.5 Biogon	2495 2300	2295 1950	
80mm f/2.8 Planar		495 280	
80mm f/2.8 Tessar		285	
100mm f/2.8 Planar		425	
105mm f/3.5 Tessar		200	
130mm/220mm/290mm Protarlinse (bbl)		225	
135mm f/3.5 Planar		1695 1295	
135mm f/3.5 Planar "T"	3295		
135mm f/3.5 Tessar		155 110	
135mm f/4.5 Tessar		165 100	
150mm f/3.5 Tessar		170 120	
150mm f/4.5 Tessar		150 100	
165mm f/4.5 Tessar		175 125	
165mm f/6.3 Tessar		135 75	
170mm f/9 Protar (coated)		450	
180mm f/4.5 Tessar	235 200	195 150	
180mm f/4.8 Sonnar	595 525	450	
180mm f/6.3 Tessar	125		
210mm f/3.5 Tessar		200	
210mm f/4.5 Tessar		300 225	
210mm f/6.3 Tessar		270 200	
210mm f/6.3 Commercial Astigon Tessar		350	
240mm f/9 APO Tessar		275 200	
300 f/5.6 Tessar (bbl)		350	
300mm f/9 APO Tessar (bbl)		175	
310mm/480mm/590mm Protar Series VII		700	650
350mm f/5 Protar Series IV (uncoated)		200	
360mm f/4.5 Tessar (bbl)		350	
360mm f/9 APO Tessar (bbl)		225	
400mm f/4.5 Tessar		350	
450mm f/9 APO Tessar		350 250	

Miscellaneous Large Format Lenses

Lens	New	Mint	Excellent	User
80mm f/2.8 Heligon			125	
90mm f/6.3 Leitmeyer			310	
90mm f/6.3 Yamasaki			150	
90mm f/6.8 Leitmeyer Weitwinkel Anastigmat			230	
105mm f/4.5 APO-Lanthar			1100	
105mm f/6.8 Leitmeyer Wide Angle			60	
11.5cm f/5.5 Voigtlander Ultragon			2495	1995
120mm f/6.3 Chromar			200	
120mm f/6.3 Osaka			275	
127mm f/4 Ross Wide Angle (bbl)				120
135mm f/3.2 Plaubel Anticomar		350		
135mm f/4.2 Plaubel Anticomar			150	
135mm f/4.5 Astragon			170	110
135mm f/4.5 Laack			80	
135mm f/4.5 Leitmeyer			100	
135mm f/4.5 Voigtlander Heliar		295		
135mm f/4.5 Voigtlander Skopar		175		
135mm f/9 Meyer-Goerlitz Wide Angle Aristostigmat (bbl)				55
135mm/200mm/279mm Dallmeyer Stigmatic (bbl)			100	
149mm f/4.5 Milles Griot			350	300
150mm f/4.5 Voigtlander Heliar			995	650
150mm f/4.5 Voigtlander APO Lanthar		1695	1250	1495 1050
150mm f/5.6 Osaka Commercial			235	
150mm f/6.3 Computar			200	
150mm f/6.3 Prinz Astragon			100	
16cm f/6.3 Meyer Weitwinkel			295	
180mm f/4.5 Plaubel Anticomar			160	
180mm f/6.3 Commercial Astragon				
197mm/321mm Hugo Meyer Double Plasmat			250	
210mm f/4.5 Voigtlander Heliar		750		
210mm f/4.5 Voigtlander APO-Lanthar			680	
210mm f/6.3 Commercial Astragon			170	
210mm f/6.3 Computar Symmetrigon			375	250
210mm f/8 Kern Repro-Kilar (bbl)			100	
210mm f/9 Computar			300	
215mm f/4.8 Acuton			200	
215mm f/5.6 Orbit (Sch. Symmar Conv.)			295	
240mm f/4.5 Voigtlander Heliar			695	600
250mm f/8 Dallmeyer (bbl)			100	
259mm f/3.5 Elgeet Navitar (bbl)			100	
260mm f/4.5 Boyer Paris Saphir (bbl)			80	
260mm f/5.6 E. Krauss Paris Tessar (bbl)			230	
270mm f/8 Carl Meyer Apochromat-Orthox (coated)			265	
270mm f/9 Computar			395	
280mm/360mm/430mm Steinheil Orthostigmat (bbl)			600	
300mm f/4.5 Astragon			100	
300mm f/4.5 Voigtlander Heliar			1495	
300mm f/5.6 Tele-Astragon			240	
300mm f/6.3 Commercial Astragon			350	
300mm f/6.3 Prinz Telephoto			270	
300mm f/7.7 Collinear			350	
305mm f/6.3 Orbit		320		

Miscellaneous Large Format Lenses

Lens	New	Mint	Excellent	User
360mm f/4 Steinheil Cassar (bbl)			150	
360mm f/4.5 Astragon (bbl))		360 300		
360mm f/5.5 Voigtlander Telomar	1175			
36cm f/6.8 Doppel Anastigmat			350	
400mm f/4.5 Steinheil Unifocal Doppel			200	
5" f/4 Ross Wide Angle Express (bbl)			95	
6" f/6.3 Ross Homocentric			350	
6 ¼" f/3.5 Taylor & Hobson Cooke Series IIa		250		
7" f/4 Meyer-Gorlitz Double Plasmat			300	
7" f/6.3 Ross Homocentric		250		
7" f/8 Gundlach Manhattan Triple Convertible			275	
7"/12"/18" f/8/16/22 Gundlach 5x7 Rapid Convertible				150
8" f/2.9 Dallmeyer Pentac (bbl)			95	
8½" f/4.5 Taylor & Hobson (bbl)		150		
10" f/4.5 Elgeet Anastigmat (bbl)			150	
10"/12" Carl Meyer Convertible			430	
12" f/4.5 Dallmeyer Adon Series XI (bbl)			150	
12" f/6.3 Carl Meyer Anastigmat (coated)			430 350	
12" f/6.3 Carl Meyer Wide Field			385 340	
12" f/6.3 Ross Homocentric (bbl)			200	
12" f/7.7 Dallmeyer Dallon Tele-Anastigmat		300		95
12" f/10 Wray London Process Lustrar APO			275	
13" f/10 Taylor & Hobson Cooke Series IX Process (bbl)			195 100	
14" f/4.5 Voigtlander Heliar (bbl)			130	
14" f/5.6 Dallmeyer Tele-Anastigmat			250	
14" f/12.5 Dallmeyer Tele-Anastigmat			250	
16" f/10 Taylor & Hobson Cooke Series IX Process (bbl)			195 100	
18" (12x15) Taylor & Hobson			140	
18" f/10 Wray London Process Lustrar APO			420	
20" f/5.6 Aldis Anastigmat (bbl)			195	
25" f/10 Cooke Process Anastigmat			295	
25" f/11 Hunter Penrose Penray Hilite (bbl)			550	
32¼" f/8 Ross (Zeiss patent) (bbl)			595	
40" f/5 Perkins-Elmer				2800
5x7 f/16 Gundlach Radar Extreme Wide Angle				
8x10 f/18 Gundlach Radar Wide Angle				

Digital Cameras

Digital Imaging

If you have developed an interest in digital imaging, the first assumption we must make here is that you already have a computer, that you have access to one, or that you are planning to buy one. If you have a PC, its processor should be, at a minimum, a very fast 486 (like the Intel DX4-100 or AMD 5x86-133). A 166MHz Pentium or higher is preferable. You'll need at least 16 MB of RAM. 32 is better. 64 or more is best if you plan to do some serious digital imaging. If you prefer Apple, you'll need at least a Macintosh II running System 7.1 or higher. RAM requirements will be similar as those for the PC. Whichever platform you prefer, plan on having at least a 4 gigabyte hard drive. Please bear in mind that, at the time of this writing, the above recommended minimum equipment performance levels and capacities are adequate and are actually several generations removed from the latest state of the art. Current state of the art PC technology would be a 600MHz Pentium III processor with 128MB of 100MHz SDRAM or more and a 12 GB or so Ultra DMA or SCSI Ultra-Wide hard drive. It's anybody's guess where state of the art will be next week.

Before you begin to lay out hundreds, or even thousands, of hard-earned bucks for digital imaging equipment, you really need to ask yourself some simple questions first. Like, how much am I prepared to spend? In what form will the final output of my images be – print, computer screen, video, etc.? Will this final output be the only way, or at least the primary way, in which my images will be displayed? What is the maximum color depth and resolution I'll need? Maximum image size? But perhaps the first question you should ask yourself, strictly from a pragmatic standpoint, is this: how fast of a turnaround time do I need?

The great thing about digital cameras is that you can capture your images instantly, plus they are already in digital form. But if you can get by with waiting a short while for your photographs to be developed, you can end up saving potentially thousands of dollars and still achieve outstanding results.

Most people who wish to take the plunge into digital imaging do not actually need a digital camera. They can achieve excellent results – comparable to digital equipment costing many thousands of dollars – with a relatively small investment, cheaper, in fact, than the price of the cheapest entry-level digital camera. As I write this, 30-bit flatbed scanners with optical resolutions up to 600 dots per inch and interpolated software resolutions as high as 4800 dots per inch are available for less than $100. More full-featured color flatbed scanners (larger image scanning size, greater color depth, higher optical resolution, etc.) range upward in price from there. All scanners that I know of come bundled with image-processing and optical character recognition (OCR) software.

If you have a large collection of print photographs already at your disposal that you would like to digitize, then a scanner is well worth considering. Should your photos be stored as slides, several scanner manufacturers offer as options slide scanners that attach directly to their flatbed scanners. The disadvantage to the slide scanner add-on is it can cost as much as, if not more than the scanner itself, and the resolution is not as high as you might need. But if you will not be enlarging the slides very much, one of these may do what you need. Stand-alone, high-resolution slide and/or negative scanners (typically 2800 dpi or better with 30- or 36-bit color) are available, but are quite expensive by comparison (over $1,000 and up at the time of this writing). Howver, they are still much less than what you would have to pay for a digital camera that provides comparable results.

Digital Cameras

If you decide that a digital camera will best fit your needs, here are the pros and cons, as I perceive them, in a nutshell:

PROS:

- A digital camera provides you with an image virtually instantaneously. Digital images can be downloaded to a computer and then sent electronically anywhere in the world via the Internet, another type of networked environment, or a dial-up connection – all within a few minutes of their being taken (or possibly even less, if you're in a big hurry).
- Most of the recent digital cameras worthy of serious consideration have an image preview and/or review feature via a built-in (or add-on) color LCD screen. If you don't like what you see, you shoot again. No waiting for having the film developed before seeing what you have.
- Because the images are stored in digital form, they are inherently easier to transfer and manipulate.
- And, not only will you have eliminated the time spent by the film developing process, you will have eliminated the expense, as well.

CONS:

- Digital cameras or digital backs that render images the typical discriminating photographer would deem acceptable for high-resolution print applications currently run into the multiple thousands of dollars.
- Cameras priced below $1,000 are good mostly for print applications where low to middle resolutions are acceptable, or for computer-based applications, such as Internet websites, where screen resolutions higher than 800 x 600 pixels are generally not necessary.

- Most of the affordably priced digital cameras have underpowered built-in flashes (a shrinking minority have no flashes at all), and have no provisions for accepting accessory flash units.
- The ISO sensitivities of the image CCDs are generally slow, typically ranging from an ISO 80 equivalent to an ISO 130 equivalent. Couple the relatively slow maximum lens apertures of some of the point & shoot varieties of digital cameras with their tiny underpowered strobes and the slow ISO numbers and you have cameras that are of limited value and functionality in all but bright-sun settings.

☐ DIGITAL CAMERAS: AN OVERVIEW

Digital cameras have been around in various forms for a number of years. It wasn't until 1996, however, that interest (and sales) of digital cameras began to emerge in a significant way. Not only did we begin to see market entries from most of the well-known camera manufacturers, but we also began to see a number of models being produced by companies which heretofore were known primarily within the electronics and computer industries. Thus, we now see familiar marques such as Canon, Kodak, and Nikon going head-to-head for market share with other names like Casio, Hewlett-Packard, and Sony. If you are acquainted with the world of computers or electronics, though, then you already know that this is really nothing new. Most of the makers of photo equipment have been active in electronic imaging or printing for quite some time. Canon, Minolta, and Ricoh produce copiers, fax machines, and laser printers. Agfa, Nikon, and Minolta produce image scanners. Canon builds computers, a variety of color printers, and some of the best color laser printers on the market. Even some of the lesser

known makes have been quite active in the electronics arena. Chinon, for example, is a major manufacturer of floppy drives and CD-ROM drives for computers, and is now producing digital cameras as well.

Prior to 1996, in which the first wave of practical, consumer-oriented digital cameras began to appear, two principal barriers had existed which stood in the way of their mass acceptance: the level of CCD (Charge-Coupled Device) technology, which has been progressing steadily, and the price of RAM (Random Access Memory), which until quite recently had been virtually frozen at usurious heights. To further complicate matters, the capabilities of digital cameras – both in terms of their advantages and disadvantages are still poorly understood by many people. In too many cases, when one asks "What are these things good for?" the answer they receive may not be the one they had anticipated – or even one that they will understand.

Let's start off by addressing the above question first. Digital cameras have been around for a while, but with the exception of a few ultra-expensive models intended for niche-market publishing work, most have been solutions in search of problems. Yes, the idea of having instant photos is appealing, and some digital cameras will output their images to TV, but if one wishes to have a paper copy of a photo, then one must have access to a computer with adequate resources, software that supports the graphics formats used by the digital cameras, and a good color printer. That's a lot of peripheral hardware just to produce a snapshot.

It wasn't really until the explosion of the World Wide Web (the segment of the Internet that supports graphics and other multi-media enhancements) and the proliferation of Web-based graphics, that digital cameras began to receive

some acceptance. In fact, it is within the virtual community – whether for desktop publishing, web publishing, computer graphics artwork, or what have you – that digital cameras have begun to garner an avid following. Consider the alternatives: a person can either take a photo with an emulsion-based film camera, have it processed, scan it into a computer with a scanner, and then save it to a file in a compatible format at an acceptable resolution and size – a time-consuming, multi-step process. Or a person can take a photo with a digital camera and transfer the image to the computer, whether by cable attachment, diskette, card, or whatever, and be viewing or editing the image literally seconds after it was taken. For somebody who is having to handle lots of images, or who is working on a tight schedule or up against a deadline, the latter choice becomes a very appealing one. Now, granted, the digital image will not have the resolution that the film-based image will have, but in many applications, this shortcoming will not matter. We'll see why this is later.

The level of acceptance that digital cameras are beginning to achieve still would not have been possible if it weren't for the successful negotiation of the two barriers I mentioned at the beginning, namely CCD technology and the price of RAM. With the emergence of reasonably priced megapixel CCDs, digital imaging has finally reached a level of maturity where CCD sensors are capable of rendering images that can be used in a growing variety of applications with little or no loss of image quality. The other significant development leading to the appearance of affordable digital cameras was the precipitous drop in RAM prices that occurred in 1996. The price of RAM began to plummet by the second quarter of that year, in some cases by as much as 85%.

To understand why these two developments are so important, we must first understand why the twin areas of CCD technology and RAM storage capacity are of critical importance to digital imaging. Both work in concert to determine the resolution, or sharpness, and the color depth of an image. The CCD defines the maximum possible number of pixels per image, as well as the number of bits per pixel of color depth of an image (both of which affect the amount of RAM required, by the way), whereas the RAM capacity determines the maximum number of pixels per image that can be stored in the camera's memory. Thus, the contrast between the two is the capability of the CCD versus the capacity of the RAM. Ideally, for maximum output, these two factors should be matched, or else one of the two is not being used to its fullest.

A brief explanation of terms is probably in order at this point. If you are already familiar with the terminology I mentioned above, you can safely skip the next few paragraphs. If you don't know a bit from a pixel, however, then I recommend that you continue reading through this section. Please understand that I am not a technical master of digital imaging technology either, so I will explain these terms using language that I can understand, which means that you should be able to understand it, too.

In computer lingo, the word "bit" refers to the smallest quantity of information that can be processed. In the case of binary systems like computers and digital cameras, a bit is represented by either a 1 or a 0. Since one bit represents a choice between two states, each quantity can be represented as a power of 2: one bit = 2^1 or two choices, two bits = 2^2 or four choices, four bits = 2^4 or 16 choices, eight bits = 2^8 or 256 choices, and so on. The word "pixel" is a clever coinage, appearing some time after the emergence of video electronics.

A combination of the slang term "pix" (a variant of "pics" from 'pictures'), and the first syllable of "element", "pixel" has come to mean 'the most basic element of a video image'. Not all pixels are created equal, however. Some are capable of displaying greater color depth than others. This color depth is expressed in terms of bits per pixel, which can, in turn, be related to a total number of available colors. The breakdown is as follows: 4 bits per pixel equal 2^4 or 16 colors, 8 bits per pixel equal 2^8 or 256 colors, 16 bits per pixel equal 2^{16} or 65,536 colors, and 24 bits per pixel equal 2^{24} or 16,777,216 colors. Most recently, devices offering 30 or even 36 bits per pixel have become commonplace. At 30 bits per pixel, the user has 2^{30} or 1,073,741,824 colors to choose from, which, for the time being, should suffice for most uses around the house.

The way in which pixels process this color data for storage can also vary. Currently there are two primary storage methods: RGB (for Red, Green, and Blue) and CYMK (for Cyan, Yellow, Magenta, and Black). RGB uses the additive color process, and is the one most likely found when working with Mac or PC computers. CYMK is a subtractive color process, closest to the 4-color separation methods used in offset printing, and is found in use with higher end products. I mention the above storage methods mostly because they affect the size of the image that will be stored. RGB images consume 3 bytes per pixel, whereas CYMK images occupy 4 bytes per pixel, requiring 33% more storage capacity (one byte = 8 bits, by the way). These bytes-per-pixel numbers are handy to know, because they will also help one estimate the size of image files. For example, if I have a camera with an image resolution of, say, 1024 x 768 pixels and my camera stores the information using the RGB method, the size of each

of my image files will be 1024 x 768 pixels x 3 bytes/pixel or 2,359,296 bytes, or about 2.3 megabytes before any sort of image compression routines are applied.

If you're beginning to feel that all this discussion of pixels and bytes and color depth seems to be taking the topic far afield from traditional photo technology, my reply would be that your intuition is serving you well. Digital photography is as far removed from emulsion-based photography as emulsion-based photography is from painting on canvas – perhaps more so. Thus, discussions about the digital process must take place within a context of discourse suited to the technology. We wouldn't think for a moment of restricting a discussion about emulsion-based photography to concepts and terminologies that have been the traditional domain of brushes and oils, so why should we shy away from discussing digital imaging on its own terms? Let's face it folks, it ain't going away, so we might as well get used to it.

Of course, there's a problem with that view, isn't there? It ignores the fact that there are millions of us out here who already have an emulsion-based photography mindset, and who tend to think both quantitatively and qualitatively in these terms. Isn't there some way we can relate the two technologies without having to relearn everything? Fortunately, within the context of image resolution, there is. Photographers often discuss film resolution capabilities in terms of line pairs per millimeter (lp/mm), while computists (and now digital photographers) discuss resolutions in terms of pixel grids or screen resolutions. For example, an outstanding, fine-grained film may be capable of resolving 100 line pairs per millimeter, while an outstandingly sharp CCD, such as those found on high end digicams, may be able to display an image grid of,

say, 3600 x 2400 pixels. These are two entirely different methods of measurement, however, so one might ask, can they be compared on an equal basis? Fortunately they can be. By making the valid assumption that the width of one line pair is equal to two pixels, we can make a direct comparison of resolutions between the two. With this Rosetta Stone of imaging in our grasp, a simple calculation shows us that a 24mm x 36mm negative or slide of the above fine-grained 35mm film will produce a (24 mm x 100 lp/mm x 2 pixels/lp) x (36 mm x 100 lp/mm x 2 pixels/lp) or 4800 x 7200 pixel image. Multiplying 4800 x 7200 gives us a total pixel density of 34,560,000 pixels, whereas the 3600 x 2400 pixel grid of the very high end digital camera provides us with "only" 8,640,000 pixels. Before you decide that this four-fold decrease in information density between a 35mm slide or negative and a digital image is too great to warrant the use of digital imaging, wait a while. It all depends on how the image will be used.

If an image is intended to be used in a low-resolution setting, such as a graphic on an Internet website, quite low resolutions will yield perfectly acceptable results. Most graphics displayed on Internet websites currently do not exceed full-screen resolutions of 800 x 600 pixels. This means that any graphic that is a fraction of a full screen would require proportionally less pixels to maintain equivalent sharpness. As a practical matter, though, many folks will scan in images at higher resolutions than this – typically 300 dots per inch or higher, and then manipulate the images downward to a more economical resolution (economical in terms of image file size, that is) once they've been scanned into the computer. Just as a quick aside, the term "dots per inch," which is found primarily in refrerence to printer resolution, is, for the purposes of

this discussion, synonymous with pixels per inch.

But where things really get interesting is within the publishing industry. Magazine and newspaper publishers are making extensive use of digital imaging products because these products can hold resolutions at the levels that they require. The scan resolution of a photo in a quality magazine is typically around 1200 dots per inch. This is a very high resolution – twice the resolution of your average 600 dpi laser printer in fact, but it is not beyond the capabilities of the better scanners and high-end digital cameras. Even though this is a very high resolution, it is not nearly as high as an emulsion-based photo, which means that much of the photo's inherent sharpness is wasted by the time it appears in print. It is in this respect that digital imaging has found its niche, namely that since both high-end digital imaging devices and film-based cameras are capable of exceeding the image levels used in the print media, the final image will not be easily distinguishable as to its origin, whether emulsion or digital.

Publishers are putting this technology to use in some rather startling ways, too. Consider the rather well known story about how *National Geographic* decided to alter a cover photo of the Pyramids of Egypt. Apparently one or more of the pyramids was moved in the photo because the art editors didn't like the photograph's composition. It was just a simple job of scanning the photograph into a computer, then loading it into a software package like Adobe PhotoShop, and then performing the requested modifications. We live in a strange, new world, my friends. A world in which even perfectly genuine-looking photographs are no longer representative of reality.

Digital cameras are divided into two groups in the following section. Professional megapixel CCD cameras are

listed together, complete with prices and detailed descriptions, while those intended for less demanding work are grouped together in spreadsheet format, which should facilitate making comparisons between the various models.

Like VCRs, televisions, computers, and other high-tech electronic appliances, digital cameras are subject to very short production runs. When they first began appearing on the market, each of the various models lasted for a while. But now, the rate of change of digital camera models due to advances in technology has caused rapid obsolescense in the field – so rapid that trying to track prices and features of the digital cameras can be a full-time job all by itself. This rapid obsolescence will be exemplified in the following listings, in that I am sure that both the camera models and their prices will be obsolete shortly after this book is available. Nonetheless, the listings may be of some interest to people interested in buying or selling previously owned examples of the listed models.

Regarding the purchase or sale of used digital equipment, allow me to make an additional observation, then I promise to move on: If you're considering the purchase or sale of a discontinued model, a good place to start is by comparing its features to those found on an equivalent current model. Obviously both features and price will change over time, the typical result being that later models will offer enhanced features for less money over earlier equivalent models. So if a used digital camera has half the resolution and storage capacity that a current model has, but is equivalent to the new one in all other important ways, it would not be unrealistic to set a market price of the used camera at about half that of the new one (or less) especially if new cameras with similar features are available in the lower price range. The likely occurrence that a used digital cam-

era sold for more when new than a current model does with the same or better features should have minimal effect on its used market value, although this factor might have an effect on its future collectible value. This is somewhat of a departure from pricing trends of emulsion-based camera systems, but it is not at all uncommon in the world of digital electronics.

□ PROFESSIONAL DIGITAL CAMERAS
Canon EOS

The EOS DCS cameras are the same as the Kodak DCS cameras that bear the same model number. The Canon EOS D2000 is the same as the Kodak DCS 520. Please refer to the Kodak DCS listings for complete descriptions.

Fuji DS-505/DS-515

The DS-505 and DS-515 are the same cameras as the Nikon E2n and E2nS. Please refer to their descriptions in the following Nikon section.

Kodak DCS Models

Currently, Kodak markets a series of digital cameras, plus one digital camera back for medium-format cameras, intended for high-end publishing, scientific, industrial, and production work. The various DCS camera models consist of Nikon N90, N90s, or Canon EOS-1n autofocus bodies coupled to custom-made Kodak backs and image-processing/storage modules. The resulting cameras are large and expensive, but they offer capabilities that few other digital cameras can match – plus all models are completely portable and self-contained. All DCS models, including the DCS 465 back, have a number of features in common:

- They accept PCMCIA-ATA Type II and III hard disks and flash memory cards. (Just in case you're unfamiliar

with the term, the PCMCIA standard was originated by manufacturers of notebook computers, and is now used for everything from cellular phone connectors to hard drives.) PCMCIA hard drives are currently available in sizes up to 340MB.

- All require a SCSI host adapter (SCSI = Small Computer Systems Interface) installed in the computer that will be used to receive and process the images. This adapter is not included with the camera.

- All come with "plug-ins" (software interface modules) for Adobe Photoshop (the most popular brand of photo-manipulation software, available for both the PC and Mac), allowing a direct interface between the DCS camera and a Mac. To interface with PCs, a TWAIN driver is supplied. Adobe Photoshop software is not included with the cameras.

- All DCS models (except the 315 & 330) have a built-in microphone and telephone-quality audio-record capability, useful for recording spoken notes before or after exposure, which can then be used for tagging or identifying each image. The sound files can be manipulated separately, if desired – they don't have to be associated with specific images.

- All color DCS models store their images at a 36-bit color depth, using the RGB (red-green-blue) method (12 bits of color depth for each of the three colors).

- All DCS models are available as either color or monochrome units. With the exception of the DCS 465 back, they are available as infrared models as well, albeit by special order only. The following descriptions and prices are for the color models only.

Kodak DCS 1 and DCS 460

The DCS 1 uses the Canon EOS-1n body, and was marketed by Canon as the EOS-DCS 1. The DCS 460 is identical to the DCS 1, except it uses a Nikon N90 body. These two incorporate a 6 million pixel CCD, rendering a maximum resolution of 3060 x 2036 pixels. Each image is 18MB in size, compressed to take up a bit over 6MB of disk space, so one 170MB hard disk card can store up to twenty-six 18MB images. 200 images can be taken between battery charges (one-hour recharge time to full charge), so when one card is full, the photographer can load in another and keep shooting until it's time to recharge.

Kodak DCS 1c

The DCS 1 and DCS 460 have an equivalent ISO rating of 80. The imaging area is 18.4mm x 27.6mm (resulting in an image magnification of 1.3x), containing a grid of 2036 x 3060 pixels. Images can be recorded at a burst rate of 2 images in 2 seconds, with an additional 8-second pause to store each image. These cameras, being the high-end, high-resolution models that they are, requircs quite a bit of computer horsepower to match their capabilities: either a Mac II or higher, running System 7.1 or higher, and with aof 32 MB RAM, or an IBM compatible running Windows 3.1x or Windows 95 with a minimum of 32 MB RAM.

Kodak DCS 3

The DCS 3 is available as the EOS-1n variant only. It incorporates a 1.3 million pixel CCD sensor, which renders a maximum 1268 x 1012 pixel resolution. The DCS 3 has 16MB of onboard buffer memory for temporary storage of images, enabling continuous shooting of up to 2.7 images per second. Bursts of up to 12 exposures in 4 seconds are possible. Over 120 images can be stored on a 170 MB PCMCIA Type III card. Up to 1,000 images can be taken on a single, one-hour battery charge (unlimited exposures with AC adapter).

The color version has ISO equivalent settings of 200-1600 (400-6400 for the monochrome version). Its imager's dimensions are 16.4mm x 20.5mm, which results in a 1.6x image magnification over standard 35mm format. 14 custom functions are available, including mirror lock up.

Kodak DCS 315 and DCS 330

The DCS 315 and DCS 330 bridge the gap between high-end consumer and pro-level digicams. I detest the portmanteau prosumer, but it fits here. (Unlike digicam, which has a nice sound to it, prosumer ranks right up there with infomercial the way it lightly stumbles across the tongue.). Both digicams are based on the Nikon Pronea 6i subassembly and accept Nikon-mount lenses. The DCS 315 uses a 1.5 megapixel CCD, which renders a maximum image resolution of 1524x1012 pixels at 10 bits/color (30 bit color depth using the RGB method). The image file size is 4.4MB. An image magnification of 2.6 applies to the lens focal length (i.e., a 28-80 zoom mounted on a DCS 315 will behave more like a 70-210 does on a 35mm film camera). It uses removeable PC type II or III cards, has a built-in LCD display, and has an ISO rating of 100 to 400. It can fire a burst rate of 2 frames/sec for a total of 6 frames before having to write to disk. ISO speeds range from 100 to 400. The DCS 330 is a DCS 315 with the addition of a 3 megapixel CCD. It offers a maximum resolution of 2008x1504 pixels, also with a 30 bit color depth, and with an image file size of 8.65MB. ISO speeds are bumped slightly to range from 125 to 400 and image magnification is 1.9. The burst rate drops to 1 frame/second, but it will allow 8 frames to be fired off before having to save the images to disk.

Kodak DCS-420

Kodak DCS 5 and DCS 420

The DCS 5 and DCS 420 differ primarily in the camera bodies used for each. The DCS 5 is based on the Canon EOS-1n, whereas the DCS 420 is based on the Nikon N90s. Either way, virtually all functions, including all metering modes, of each camera are supported. The DCS 5/DCS 420 uses a 1.5 million pixel CCD, which provides a resolution of 1012 x 1524 pixels. Burst rate image capture is 2 images/second for five

images. Approximately 500 images can be recorded between battery charges, and the battery can be recharged in one hour (unlimited exposures with the AC adapter).

ISO equivalent settings are from 100 to 400 with the color models, 200 to 800 with the monochrome ones. The image area is 14mm x 9.3mm, which results in a focal length magnification of 2.5x over 35mm format. To process the images, the DCS requires a Macintosh II or higher with 8MB RAM, or an IBM-compatible 80386 or higher with 8MB RAM, running Windows 3.1x or Windows 95.

Kodak DCS 410

The DCS-410 is identical to the DCS-420, except for a couple of simplifications that translate into a substantial savings: it uses a fixed ISO of 100, and there is no burst rate available. Instead, images are captured at the rate of one every 2.5 seconds.

Kodak DCS 465

The DCS 465 is a direct replacement for a medium format film back. Available interface kits allow it to be used with the Mamiya RB67, RZ67, or the Hasselblad 500 and 503 cameras. The 18.4mm x 27.6mm CCD offers a

six-million pixel resolution. It stores images at a 36-bit color depth (12 bits/color), providing optimum color saturation and details in both highlights and shadows. Images are stored on removable PCMCIA-ATA Type III memory or RAM cards at the rate of one shot every 8 seconds. 26 images can be stored on a 170MB card and 150 images can be taken per battery charge. The area-array imager allows single-shot color photographs, even of moving subjects at any of the cameras available shutter speeds. Like the DCS models, it includes an internal microphone for vocal annotation of images either before or after they are taken.

Kodak DCS 465

The DCS 465 requires a computer with a SCSI host adapter. Either an Apple Macintosh II or higher with a minimum of 32MB RAM, or an IBM-compatible system with an 80386 or higher processor with 32MB RAM, running Win 3.1x or higher is required. It comes bundled with an Adobe Photoshop plug-in for the Mac.

Kodak DCS 520 and DCS 620

The DCS 520 and DCS 620 use different camera subassemblies, otherwise their digital technology is the same. The DCS 520 is based on an EOS-1n and the DCS 620 is based on a Nikon F5. Each sports a 2-megapixel CCD that provides a maximum image resolution of 1728x1152 pixels. With this CCD, a focal length multiplier of 1.6 should be used to determine what the 35mm film equivalent will be for a given lens. Images are stored on PC type II or III cards at up to 12 bits/color (36 bit color depth using the RGB method). Image file size is 5.7MB. The burst mode will record images at the rate of 3.5 frames/sec for a total of 12 frames before the camera must save to disk. ISO values range from 200 to 1600. Both cameras have a built-in LCD viewer. Please note that the Canon EOS D-2000 is the same as the DCS 520.

Kodak DCS Digital Cameras

Camera	New	Mint	Excellent		User
DCS 1			25000	20000	
DCS 3			5000		
DCS 5	7750				
DCS 315	4485				
DCS 330	5400				
DCS 420	7765				
DCS 460			25000	20000	
DCS 465 Back (Hassy, Mamiya, etc)					
DCS 520	12940	9900			
DCS 560	29995				
DCS 620	14650	10450			
DCS 660	29995				

Kodak DCS 560 and DCS 660

The DCS 560 and DCS 660 have superceded the DCS 1 and DCS 460 (described earlier). Like their predecessors, the current x60 models boast a 6-megapixel CCD which offers an impressive 3040x2008 pixel grid. Images are stored on PC type II or III cards at 12 bits/color, in file sizes up to 18MB. Because of the size of the image files, these cameras have stunted burst modes: 1 frame/sec for a total of 3 frames. A focal length multiplier of 1.3 should be used to estimate 35mm-equivalent focal length. ISO speeds range from 80 to 200. Both cameras have built-in LCD viewers.

Minolta RD-175 & Dimâge RD-3000

The **RD-175** is based on the Maxxum 500si body. It stores images at a resolution of 1528 x 1146 pixels. To achieve this high level of resolution, Minolta chose to employ an optical beam splitter to direct primary colors to three 380,000 pixel CCDs, rather than to send the image to a single megapixel CCD (three 380k CCDs are cheaper than a single megapixel CCD). Apart from the cost savings, an additional benefit to the beam-splitter design is that the possible resolution is increased, and color aliasing is all but eliminated. There are tradeoffs, however. The RD-175 has a relatively slow f/6.7 maximum aperture equivalent, a dimmer viewfinder than other cameras of similar capabilities, and a thicker camera back. Accessories include a PC connector, a hot shoe, and an optional wireless flash. Flash sync is 1/90 second.

New dealer stocks of the RD-175 still exist as I write this. The price discrepancies between the RD-175 and its replacement, the RD-3000, reflect the overall downward trend in prices on digital equipment.

The **Dimâge RD-3000** replaces the RD-175 in Minolta's high-end digicam lineup. Clad in a shock-resistant magnesium alloy shell, it is designed for the heavy use professional photo equipment often sees. It closely resembles the Minolta Vectis S-1, and uses the same V lens mount and V lenses. Offering the latest generation of Minolta's multiple-CCD image-stitching technology, the RD-3000 incorporates two 1.5 megapixel CCDs to produce an effective 2.7 megapixel image with a maximum resolution of 1984x1360 pixels. The memory buffer will allow burst shooting at 1.5 frames/second at hi-res mode for a total of 5 frames before the data must be saved to disk. Images are processed at 10 bits/color, but are output at 8 bits/color. The file storage size at the Superfine setting is approximately 9MB. The RD-3000's ISO speed is 200 and its shutter speeds range from 1/2000 second to 2 seconds. The RD-3000 uses PC type I and II cards and has an LCD viewer.

Nikon E2n/E2nS

Jointly developed by Nikon and Fuji, the E2n and E2nS are built around the F4 body, and retain the full F4 features set. The principle difference between the two camera models is the continuous exposure rate – the E2n will expose frames at the rate of 1 frame per second, while the E2nS will expose up to 7 frames at the rate of 3 frames per second. From this point on, I'll refer to both models collectively as the E2n.

The E2n's 2/3", 1.3 megapixel CCD stores 24-bit images at a maximum resolution of 1,280 x 1,000 pixels in 3.67MB files. Files can be stored and compressed in a variety of JPEG compression formats and one TIFF formats, which include High (2.5MB TIFF file), Fine (640k JPEG file), Normal (320k JPEG file), and Basic (160k JPEG file). Data can be stored on ATA Type I or II PC Cards (also known as PCMCIA cards). The Nikon EC-15 card will hold 15MB of data, which translates into 4 uncompressed images or up to 84 images stored in Basic mode.

The built-in NTSC/PAL continuous video mode allows the photographer to connect the E2n to a video monitor for image preview and review.

The E2n incorporates a condenser element that enlarges the image capture area to match the F4 viewfinder. Two things result from this, one good, one not so good. The good thing is that the lenses have the same angle of coverage as they do with 35mm film, which means that guesswork regarding proper focal length is eliminated. The not so good thing is that, with the use of the condenser, an inevitable loss of light occurs. Just as a 2X teleconverter causes a 2-stop loss of light, the element restricts the maximum aperture to no greater than f/6.7. To compensate for this loss, Nikon boosted the equivalent ISO rat-

Minolta Professional Digital Cameras

Camera	New	Mint	Excellent	User
RD-175	4895 4620			
RD-3000	3995 3000			

ings to 800 and 3200. The low-light capability at 3200 is enhanced by a wide dynamic range, exceptionally well-rendered shadow detail, and minimal signal noise. The Standard E2n package includes the camera, an AC adapter/charger with battery, an EC-15 memory card, the ED-10 PC card reader, and software for both the PC and the Macintosh.

Nikon E3/E3s

The E3 and E3s are basically updates of the E2n and E2ns. My information is sketchy, but it appears that the primary difference between the E2 and E3 systems is that the E2 uses the F4 subsystem, while the E3 uses the current F100 for its platform. In the digital department, only a few obvious changes exist, which include an improved burst mode and maximum aperture. The E3s can record up to 12 images in burst mode at 3 frames/second. Improvements in the optical viewfinder system have increased the maximum aperture to f/4.8.

Nikon D1

The D1 becomes the new flagship in Nikon's digital camera lineup, and, if we can judge by its name, is likely the first in a new line of professional digital SLRs. It is obviously the digital equivalent to Nikon's other current state-of-the-art heavyweight, the F5. However, in a departure from most other megapixel digital SLR designs, the Nikon D1 is not based on a film camera subassembly. Electing to start with a clean sheet of paper, Nikon designed the D1 with the professional in mind from the beginning. It sports a 2.7 megapixel CCD, which provides a maximum image resolution of 2012x1324 pixels. The D1 has an impressive burst mode, handling up to 21 shots at 4.5 frames/second. Images can be stored at a maximum 12 bits/color (36 bits/pixel color depth using the RGB storage method). It has the F5's 1,005-sensor metering array, tuned especially for digital work, and also uses Nikon's latest state-of-the-art autofocus technology. Shutter speeds range from 30 seconds to 1/16,000, with a top flash sync speed of 1/500. The D1 supports the Nikon SB-28DX Speedlight's FP sync feature, which allows flash photography at faster-than-sync speeds.

As I write this, the D1 has not been released yet, but prices are available. It will list for about $5,600, which means its street prices should be below $5,000. This price point puts it at odds with the E2/E3 series of cameras, so I suspect that, once it is released and stocks of the E3 are depleted, the E series will either be discontinued or the prices will have to be substantially reduced.

Nikon Professional Digital Cameras

Camera	New	Mint	Excellent	User
D1	5000			
E2n	5500			
E2ns	6500			
E3	6400	5600		
E3s	7900	7000		

Digital Cameras – Model Features and Prices

☐ AGFA EPHOTO 307

New Street Price:	$250
Max Resolution:	640x800
Closest Focusing:	24"
Storage Type:	internal
Storage Size:	2MB
Shutter Speeds:	
Exposure Modes:	program
Viewing Method:	optical vf
Output:	video, serial (PC/Mac)
Flash:	yes
Software:	PhotoWise, PhotoDeluxe, Photoshop plug-in, TWAIN driver
Other Features:	self-timer, flash memory

☐ AGFA EPHOTO 780

New Street Price:	$400
Max Resolution:	1024x768
Closest Focusing:	11.8"
Storage Type:	Smart Media memory card
Storage Size:	2MB
Shutter Speeds:	1/30-1/10000
Exposure Modes:	Program
Viewing Method:	1.8" LCD optical vf
Output:	video, serial (PC/Mac)
Flash:	auto, red-eye reduc.
Software:	PhotoGenie, PhotoWise, PhotoSoap, Photoshop plug-in, TWAIN driver
Other Features:	NTSC/PAL compatible, self-timer, high-speed shutter, captures one image/second

Digital Cameras – Model Features and Prices (cont'd)

□ AGFA EPHOTO 1280

New Street Price:	$500
Max Resolution:	1280x960
Closest Focusing:	3.9"
Storage Type:	Smart Media memory card
Storage Size:	4MB
Shutter Speeds:	1/8-1/500
Exposure Modes:	P/M
Viewing Method:	2" LCD
Output:	video/serial (PC/Mac)
Flash:	auto, fill, redeye reduc., swivel
Software:	PhotoWise, PhotoVista, LivePix, Photoshop plug- in, TWAIN driver
Other Features:	3X optical swivel zoom lens, multifuntion control "mouse," manual/auto focus

□ AGFA EPHOTO 1680

New Street Price:	$620
Max Resolution:	1280x960
Closest Focusing:	3.9"
Storage Type:	Smart Media memory card
Storage Size:	4MB
Shutter Speeds:	1/8-1/500
Exposure Modes:	P/M
Viewing Method:	2" LCD
Output:	video/serial (PC/Mac)
Flash:	auto, fill, redeye reduc., swivel
Software:	PhotoWise, PhotoGenie, LivePix, Photo Vista
Other Features:	3x optical (2x digital) zoom with 280° rotation, auto/manual focus

□ APPLE QUICK TAKE 150

New Street Price:	$550
Max Resolution:	640x480
Closest Focusing:	
Storage Type:	Internal
Storage Size:	1MB
Shutter Speeds:	
Exposure Modes:	Program
Viewing Method:	optical vf
Output:	serial (Mac)
Flash:	auto
Software:	PictureTaker
Other Features:	self-timer

□ CANON POWERSHOT 350

New Street Price:	$400
Max Resolution:	640x480
Closest Focusing:	1.2"
Storage Type:	CompactFlash memory card
Storage Size:	2MB
Shutter Speeds:	
Exposure Modes:	Program
Viewing Method:	1.8" LCD
Output:	video/serial (PC, Mac)
Flash:	auto
Software:	PhotoImpact, PhotoStitch, PhotoDeluxe, Time Tunnel, Photoshop plug-in, TWAIN driver

Other Features:	timer, adjustable angle LCD display

□ CANON POWERSHOT 600

New Street Price:	$800
Max Resolution:	832x608
Closest Focusing:	4"
Storage Type:	Internaal or PCMCIA
Storage Size:	1MB
Shutter Speeds:	1/30-1500
Exposure Modes:	Program
Viewing Method:	optical vf
Output:	docking station
Flash:	TTL meter
Software:	PhotoImpact, Image Pals, TWAIN driver, Mac plug-ins
Other Features:	audio notes, self timer, macro mode

□ CANON POWERSHOT A5

New Street Price:	$500
Max Resolution:	1024 x 768
Closest Focusing:	3.5"
Storage Type:	CompactFlash memory card
Storage Size:	8 MB
Shutter Speeds:	1/6-1/500
Exposure Modes:	P, exp comp
Viewing Method:	2 " LCD
Output:	video, serial (PC/ Mac)
Flash:	auto, red-eye reduc.
Software:	PhotoImpact, PhotoDeluxe, PhotoStitch, Time Tunnel, Zoom Browser, SlideShow Maker, Photoshop plug-in, TWAIN driver
Other Features:	One frame per sec. burst mode for 15 shots, panoramic assist mode

□ CANON POWERSHOT A5 ZOOM AND A50

New Street Price:	$550 (A50)
Max Resolution:	1280 x 960
Closest Focusing:	6.7" (50cm)
Storage Type:	8MB CompactFlash card (included)
Storage Size:	2MB @ max res
Shutter Speeds:	2 seconds to 1/750 second
Exposure Modes:	P
Viewing Method:	2" LCD, optical vf
Output:	video, serial
Flash:	auto, redeye reduc.
Software:	PhotoImpact, PhotoDeluxe, PhotoStitch, Time Tunnel, Zoom Browser, SlideShow Maker, Photoshop plug-in, TWAIN driver
Other Features:	2.5x optical zoom (28-70 equiv in 35mm), supports Digital Print Order Form standard

□ CANON POWERSHOT PRO 70

New Street Price:	$1150
Max Resolution:	1536 x 1024
Closest Focusing:	4.7"
Storage Type:	CompactFlash memory card
Storage Size:	two 8MB cards

Digital Cameras – Model Features and Prices (cont'd)

Shutter Speeds:	1/2-1/8000
Exposure Modes:	P, exp comp.
Viewing Method:	2" LCD
Output:	video, serial (PC/ Mac), hot shoe for EOS, CompactFlash card slots
Flash:	
Software:	PhotoImpact, PhotoStitch, Time Tunnel, Slide Show Maker, Zoom Browser, Photoshop plug-in, TWAIN driver
Other Features:	2.5X optical zoom, 4 fps burst mode up to 20 sec., two flash units

☐ CANON POWERSHOT S10 ZOOM

New Street Price:	
Max Resolution:	1600 x 1200
Closest Focusing:	4.7" (12cm)
Storage Type:	Type I & II CompactFlash cards (8MB card included)
Storage Size:	8MB @ max res
Shutter Speeds:	2 seconds to 1/1000 second
Exposure Modes:	P, M (spot, AE lock, "Image" modes)
Viewing Method:	1.8" LCD, optical vf
Output:	video, serial, USB
Flash:	auto, redeye reduc.
Software:	PhotoDeluxe, PowerShot Browser, PhotoStitch, PhotoShop plug-in, TWAIN driver
Other Features:	2x optical zoom(35mm-70mm equiv in 35mm)/2x-4x digital zoom (8x max combined), ISO 100 to 400, self-timer

☐ CASIO QV-100

New Street Price:	$250 (exc+)
Max Resolution:	640 x 480
Closest Focusing:	
Storage Type:	Internal flash
Storage Size:	4 MB
Shutter Speeds:	1/8-1/4000
Exposure Modes:	Program
Viewing Method:	1.8" LCD
Output:	video, serial (PC/ Mac)
Flash:	auto memory
Software:	QV-Link, PhotoDeluxe, TWAIN driver, Mac plug-ins
Other Features:	Lens swivels 270°, macro mode, self-timer

☐ CASIO QV-120

New Street Price:	$300
Max Resolution:	640 x 480
Closest Focusing:	
Storage Type:	Internal flash memory
Storage Size:	2 MB
Shutter Speeds:	1/8-1/4000
Exposure Modes:	Program
Viewing Method:	1.8" LCD
Output:	video, serial PC, Mac
Flash:	No
Software:	QV-Link, PhotoDeluxe, ixlaphoto, TWAIN driver, Mac plug-ins.
Other Features:	Lens swivels 270°, macro mode, self-timer

☐ CASIO QV-200

New Street Price:	$350
Max Resolution:	640 x 480
Closest Focusing:	4"
Storage Type:	Internal flash memory
Storage Size:	4 MB
Shutter Speeds:	1/8-1/4000
Exposure Modes:	Program
Viewing Method:	1.8" LCD
Output:	video, serial (PC/Mac)
Flash:	No
Software:	QV-Link, PhotoDeluxe, Internet Explorer, ColorDesk Photo, Slides & Sound, ixlaphoto Lite, Spin Panorama,Photoshop plug-in, TWAIN driver
Other Features:	Built-in special effects, image rotation, titling, conversion to gray scale, sepia effect, more

☐ CASIO QV-300

New Street Price:	$400
Max Resolution:	640 x 480
Closest Focusing:	
Storage Type:	Internal flash memory
Storage Size:	4 MB
Shutter Speeds:	1/8-1/4000
Exposure Modes:	Program
Viewing Method:	2.5" LCD
Output:	video, serial (PC/ Mac)
Flash:	No
Software:	QV-Link, PhotoDeluxe, ColorDesk Photo, ixlaphoto Lite, TWAIN driver, Mac plug-ins
Other Features:	Dual focal length lens on swivel (equiv to 46 & 105mm focal lengths in 35mm), macro mode

☐ CASIO QV-700

New Street Price:	$430
Max Resolution:	640 x 480
Closest Focusing:	5.5"
Storage Type:	CompactFlash memory card
Storage Size:	2 MB removeable card included
Shutter Speeds:	1/8-1/4000

Digital Cameras – Model Features and Prices (cont'd)

Exposure Modes:	Program
Viewing Method:	2.5" LCD
Output:	video, serial (PC/Mac)
Flash:	auto, fill
Software:	QV-Link, PhotoDeluxe, Six built-in database folders, Internet Explorer, ColorDesk Photo, Slides & Sound, ixlaphoto Lite, Spin Panorama, Photoshop plug-in, TWAIN driver
Other Features:	Continuous shooting mode, "past" and "future" shooting, editing and cropping features, special effects, titling and more

☐ CASIO QV-770

New Street Price:	$500
Max Resolution:	640 x 480
Closest Focusing:	4 "
Storage Type:	Internal Flash memory
Storage Size:	4 MB
Shutter Speeds:	1/8-1/4000
Exposure Modes:	P, AV, exp comp.
Viewing Method:	1.8" LCD
Output:	video, serial (PC/ Mac)
Flash:	auto, fill
Software:	QV-Link, PhotoDeluxe, Spin, Panorama, Spin Photo Object, ixlaphoto Lite
Other Features:	Swivel lens, macro mode, "Movie" mode (32 fps/0.1 sec), cw meter, image rotation, panorama setting

☐ CASIO QV-5000SX

New Street Price:	$900
Max Resolution:	1280 x 960
Closest Focusing:	4"
Storage Type:	Internal flash memory
Storage Size:	8 MB
Shutter Speeds:	1/8-1/500
Exposure Modes:	P, exp comp., cw meter
Viewing Method:	1.8" LCD, optical vf
Output:	video, serial, (PC, Mac)
Flash:	auto, redeye reduc.
Software:	QV-Link, PhotoDeluxe, Spin ColorDesk, ixlaphoto Lite
Other Features:	2X-4X digital zoom, 48 or 64 Panorama & Photo Object, frame sequence possible at 0.1 second intervals, self-timer

☐ CASIO QV-7000SX

New Street Price:	
Max Resolution:	1280 x 960
Closest Focusing:	4"
Storage Type:	CompactFlash memory card
Storage Size:	8 MB card included
Shutter Speeds:	1/8-1/500
Exposure Modes:	P, M, exp comp., cw meter
Viewing Method:	2.5" LCD
Output:	video, serial (PC/ Mac)
Flash:	auto, redeye reduction
Software:	QV-Link, PhotoDeluxe, Spin Photo

	Object and Panorama, ISR Digital Camera Suite
Other Features:	2X optical/ 4X digital zoom, lens rotates 270 degrees, "Movie" mode as above, special effects modes, more

☐ EPSON PHOTOPC

New Street Price:	$250 (exc+)
Max Resolution:	640 x 480
Closest Focusing:	24"
Storage Type:	Internal, optional memory cards
Storage Size:	1MB, optional 2 MB or 4 MB cards
Shutter Speeds:	
Exposure Modes:	Program
Viewing Method:	optical vf
Output:	serial (PC/Mac)
Flash:	auto
Software:	EasyPhoto, TWAIN driver, Mac plug-in
Other Features:	

☐ EPSON PHOTOPC 500

New Street Price:	$350 (exc+)
Max Resolution:	640 x 480
Closest Focusing:	24"
Storage Type:	Internal, memory cards optional
Storage Size:	1 MB, 2 MB, or 4 MB cards
Shutter Speeds:	1/30-1/10000
Exposure Modes:	Program
Viewing Method:	1.8" LCD, optical vf
Output:	serial (PC/Mac)
Flash:	auto, fill, redeye reduc.
Software:	EasyPhoto, TWAIN driver, (with optional PhotoPix LCD Monitor) Mac plug-in
Other Features:	

☐ EPSON PHOTOPC 550

New Street Price:	$300
Max Resolution:	640 x 480
Closest Focusing:	4"
Storage Type:	Internal, SSFDC or SmartMedia cards
Storage Size:	1 MB int., 2 MB or 4MB cards
Shutter Speeds:	1/4-1/1000
Exposure Modes:	Program
Viewing Method:	optical vf
Output:	video, audio, serial (PC, Mac)
Flash:	No
Software:	Image Expert, TWAIN driver, Mac plug-in
Other Features:	Built-in imcrophone for up to 6 second message per image

☐ EPSON PHOTOPC 600

New Street Price:	$500
Max Resolution:	1024 x 768
Closest Focusing:	8"
Storage Type:	Internal or CompactFlash memory card
Storage Size:	4 MB int., 4 MB to 32 MB/card

Digital Cameras – Model Features and Prices (cont'd)

Shutter Speeds: 1/4--1/500
Exposure Modes: Program
Viewing Method: 2" LCD, optical vf
Output: video, serial (PC/Mac)
Flash: auto
Software: Image Expert, PhotoFile, PhotoFile Uploader, TWAIN driver, Epson Stylus printers
Other Features: 2X digital zoom w/macro, panoramic & multi-image special effects modes, self-timer, prints to Epson Stylus Photo Printer

☐ EPSON PHOTOPC 700

New Street Price: $700
Max Resolution: 1280 x 960
Closest Focusing: 4"
Storage Type: Internal or CompactFlash memory card
Storage Size: 4 MB int.
Shutter Speeds: 1/4-1/500
Exposure Modes: P, exp comp.
Viewing Method: 2" LCD, optical vf
Output: video, serial (PC/Mac)
Flash: auto
Software: Image Exper, Direct Print, Photofile Uploader, TWAIN driver, Epson Stylus printers
Other Features: 2X digital zoom w/macro setting, Glass lens with f/2.8, f/5.6, f/11 stops, prints directly to Epson printers, 2 images/sec continuous mode, more

☐ EPSON PHOTOPC 750Z

New Street Price: $590
Max Resolution: 1600 x 1200
Closest Focusing:
Storage Type: 4MB internal, 8MB CompactFlash card (included)
Storage Size: about 750k (16 images/12MB in max res mode)
Shutter Speeds: 1/4 to 1/750 second
Exposure Modes: P,M
Viewing Method: 2" LCD, optical vf
Output: video, serial
Flash: auto, forced fill, on/off, slow sync
Software: Image Expert, TWAIN and other drivers
Other Features: 3x optical/2x digital (6x combined), ISO 90-360, auto white balance

☐ EPSON PHOTOPC 800

New Street Price: $690
Max Resolution: 1984 x 1488
Closest Focusing: 6"
Storage Type: 8MB CompactFlash card (included)
Storage Size: about 800k (10 images at highest res/8MB card)
Shutter Speeds: 1/2 to 1/750 second
Exposure Modes: P, M, sports, landscape
Viewing Method: 1.8" LCD, optical vf

Output: video, serial, USB
Flash: auto, on/off, slow sync
Software: Image Expert, TWAIN and other drivers
Other Features: 7mm f/2.4 fixed focal-length lens (38mm equiv in 35mm), spot metering, ISO 100 to 400

☐ FUJIFILM DS-7

New Street Price: $300 (exc+)
Max Resolution: 640 x 480
Closest Focusing:
Storage Type: SmartMedia memory card
Storage Size: 2 MB
Shutter Speeds:
Exposure Modes: Program
Viewing Method: 1.8" LCD
Output: serial (PC/ Mac)
Flash: auto
Software: PhotoDeluxe, TWAIN driver, Mac plug-in
Other Features: Self-timer

☐ FUJIFILM DS-220

New Street Price: $500 (exc+)
Max Resolution: 640 x 480
Closest Focusing:
Storage Type: PCMCIA cards
Storage Size: 2 MB
Shutter Speeds:
Exposure Modes: Program
Viewing Method: optical vf, 2 in LCD (with optional PA-D22 LCD Monitor)
Output: video, serial (PC/Mac)
Flash: auto, redeye reduc. (option)
Software: PhotoDeluxe
Other Features: 2x zoom w/macro mode

☐ FUJIFILM DS-300

New Street Price: $1850
Max Resolution: 1280 x 1000
Closest Focusing:
Storage Type: PCATA Type I, II, SmartMedia Card
Storage Size: variable
Shutter Speeds: 1/4-1/100
Exposure Modes: optical
Viewing Method:
Output: video, serial (PC, Mac
Flash: auto & hot shoe external flash
Software: TWAIN driver, Optional PC card reader
Other Features:

☐ FUJIFILM DX-5

New Street Price: $300
Max Resolution: 640 x 480
Closest Focusing: 8"
Storage Type: SmartMedia memory card
Storage Size: 2 MB
Shutter Speeds: 1/4-1/5000
Exposure Modes: Program

Digital Cameras – Model Features and Prices (cont'd)

Viewing Method: 1.8" LCD, optical
Output: serial (PC/Mac)
Flash: auto
Software: PhotoEnhancer, TWAIN driver
Other Features: 3.5" floppy disk drive adapter

☐ Fujifilm DX-7

New Street Price: $500
Max Resolution: 640 x 480
Closest Focusing: 3"
Storage Type: SmartMedia memory card
Storage Size: 2 MB
Shutter Speeds: 1/4-1/5000
Exposure Modes: P, AV, TTL meter
Viewing Method: 1.8 in. LCD, optical vf
Output: serial, PC, Mac
Flash: auto, fill, redeye reduc.
Software: PhotoEnhancer, TWAIN driver
Other Features: Date/time recording, macro setting, image editing functions, copy and playback modes

☐ Fujifilm DX-9

New Street Price: $600
Max Resolution: 640 x 480
Closest Focusing: 8"
Storage Type: SmartMedia memory card
Storage Size: 2 MB
Shutter Speeds: 1/4-1/10000
Exposure Modes: P, AV, TTL meter
Viewing Method: 2" LCD, optical vf
Output: video, serial (PC, Mac)
Flash: auto, fill, redeye reduc.
Software: QuickTime IC, PhotoEnhancer, TWAIN drivers
Other Features: Auto, manual modes, bursts of 4, 9, 16 images in 2 seconds, multi-function dial, image editing and multiple playback modes, more

☐ Fujifilm DX-10

New Street Price: $300
Max Resolution: 1024x768
Closest Focusing: 2.5" (10cm)
Storage Type: SmartMedia memory card
Storage Size: 300k (approx.)
Shutter Speeds: 1/4 to1/5000 second
Exposure Modes: P
Viewing Method: 1.8" LCD, optical vf
Output: video, serial
Flash: auto
Software: Adobe PhotoDeluxe, TWAIN driver
Other Features: 24-bit color, ISO 150, daylight flash sync and slow sync, 7 effects, continuous shooting mode

☐ Fujifilm MX-600Z

New Street Price: $600
Max Resolution: 1280 x 1024
Closest Focusing:
Storage Type: SmartMedia memory cards
Storage Size: 4MB card included

Shutter Speeds:
Exposure Modes: P,M
Viewing Method: 1.8" LCD
Output: serial
Flash: five auto modes
Software: Adobe PhotoDeluxe, TWAIN driver
Other Features: 3x optical zoom, 2x digital zoom (combine for 6x), white balance

☐ Fujifilm MX-1200

New Street Price: $300
Max Resolution: 1280 x 960
Closest Focusing:
Storage Type: SmartMedia memory cards
Storage Size: 4MB card included
Shutter Speeds:
Exposure Modes:
Viewing Method: 1.6" LCD, optical vf
Output: serial
Flash: auto
Software: Adobe PhotoDeluxe, TWAIN driver
Other Features: 2x digital zoom

☐ Fujifilm MX-2700

New Street Price: $650
Max Resolution: 1800 x 1280
Closest Focusing: 3.5"
Storage Type: SmartMedia memory cards
Storage Size: about 1MB at hi-res (8MB card included)
Shutter Speeds:
Exposure Modes: P,M
Viewing Method: 2" LCD, optical vf
Output: video, serial
Flash: auto, fill, redeye reduc.
Software: Fuji Utility, PhotoDeluxe
Other Features: 2.5x digital zoom, special effects

☐ Fujifilm MX-2900

New Street Price: $800
Max Resolution: 1800 x 1200
losest Focusing: 9.8"
Storage Type: SmartMedia memory cards
Storage Size: about 1MB (8MB card included)
Shutter Speeds: 1/4 to 1/2000 second
Exposure Modes: P,M
Viewing Method: 2" LCD, optical vf
Output: video, serial
Flash: auto, fill, redeye reduc.
Software: Fuji Utility, PhotoDeluxe
Other Features: ISO 125, 3x optical/2.5x digital zoom (7.5x combined), hot shoe

Digital Cameras – Model Features and Prices (cont'd)

☐ FUJIFILM MX-700

New Street Price:	$800
Max Resolution:	1280 x 1024
Closest Focusing:	3.5"
Storage Type:	SmartMedia memory card
Storage Size:	2 MB
Shutter Speeds:	1/4-1/10000
Exposure Modes:	P, M
Viewing Method:	2" LCD, optical vf
Output:	video, serial (PC/Mac)
Flash:	auto, manual
Software:	PhotoDeluxe
Other Features:	2X digital zoom, shoot in B&W or color, images can be magnified to 400% in playback mode, more

☐ HEWLETT-PACKARD PHOTOSMART

New Street Price:	$400
Max Resolution:	640 x 480
Closest Focusing:	
Storage Type:	Internal memory, CompactFlash
Storage Size:	2MB int.
Shutter Speeds:	1/30-1/2000
Exposure Modes:	P, exp comp.
Viewing Method:	optical vf
Output:	serial, PC
Flash:	auto only
Software:	PhotoSmart, Microsoft Picture It, TWAIN driver
Other Features:	Macro setting

☐ HEWLETT-PACKARD PHOTOSMART C20 & C30

New Street Price:	$380
Max Resolution:	1152 x 872
Closest Focusing:	9.5"
Storage Type:	CompactFlash
Storage Size:	4 MB card
Shutter Speeds:	1/8-1/500
Exposure Modes:	P, exp comp.
Viewing Method:	1.8" LCD, optical vf
Output:	video, serial, PC, (NTSC/PAL)
Flash:	auto
Software:	PhotoSmart, Microsoft Picture It
Other Features:	Glass lens with f/2.8, f/5.6, f/1

☐ JVC GC-S1U

New Street Price:	$700
Max Resolution:	640 x 480
Closest Focusing:	2.8"
Storage Type:	Internal or CompactFlash memory card
Storage Size:	4 MB int.
Shutter Speeds:	1/7-1/1000
Exposure Modes:	Program
Viewing Method:	1.8" LCD, optical vf
Output:	video, serial, IR wireless (PC/Mac)
Flash:	auto
Software:	Picture Navigator, PhotoSuite SE, PhotoSuite SE
Other Features:	10X optical zoom, f/1.6 swivel-mount lens, manual focus, special effects modes

☐ KODAK DC40

New Street Price:	$300 (exc+)
Max Resolution:	756 x 504
Closest Focusing:	48"
Storage Type:	Internal flash memory
Storage Size:	4 MB
Shutter Speeds:	1/30-1/75
Exposure Modes:	P, exp comp.
Viewing Method:	optical vf
Output:	serial (PC/Mac)
Flash:	auto, fill
Software:	Photo Enhancer, TWAIN driver, Photoshop plug-in
Other Features:	self-timer

☐ KODAK DC50

New Street Price:	$430
Max Resolution:	756 x 504
Closest Focusing:	
Storage Type:	Internal, PCATA Type I, II
Storage Size:	1 MB int.
Shutter Speeds:	1/16-1/500
Exposure Modes:	P, exp comp.
Viewing Method:	optical vf
Output:	serial (PC/Mac)
Flash:	auto
Software:	Picture Works, Photo Enhancer, TWAIN driver, Photoshop plug-in
Other Features:	3X zoom with macro, self-timer

☐ KODAK DC120

New Street Price:	$440
Max Resolution:	1280 x 960
Closest Focusing:	7.9"
Storage Type:	Internal flash memory
Storage Size:	2 MB int.
Shutter Speeds:	1/16-1/500
Exposure Modes:	P, exp comp.
Viewing Method:	1.6" LCD, optical vf
Output:	serial (PC, Mac)
Flash:	auto, fill, redeye reduc.
Software:	Picture Transfer, PhotoEnhancer, Photoshop plug-in, TWAIN driver

Digital Cameras – Model Features and Prices (cont'd)

Other Features: 3x optical zoom, self-timer

☐ KODAK DC200

New Street Price: $350
Max Resolution: 1152 x 864
Closest Focusing: 27"
Storage Type: Compact Flash Card
Storage Size: 4 MB, Optional 10, 20 MB cards
Shutter Speeds: 1/2-1/360
Exposure Modes:
Viewing Method: 1.8 in. LCD, optical vf
Output: video, serial, PC, IR wireless
Flash: auto, fill, redeye reduc.
Software: Picture Easy, Win95 Mounter, TWAIN driver, Science Picture
Other Features: NTSC/PAL compatible, self-timer
Mac drivers optional

☐ KODAK DC210 & DCS 210 PLUS

New Street Price: $450
Max Resolution: 1152 x 864
Closest Focusing: 8"
Storage Type: Compact Flash Card
Storage Size: 4 MB int., Optional 10MB cards
Shutter Speeds: 1/2-1/360
Exposure Modes: P, exp comp.
Viewing Method: 1.8" LCD, optical vf
Output: video, serial, PC, IR wireless
Flash: auto, fill, redeye reduc.
Software: Picture Easy, PhotoDeluxe, Science Picture, PageMill, Win95 Mounter, TWAIN driver
Other Features: 2X optical zoom, infrared computer interface, NTSC/PAL compatible, self-timer

☐ KODAK DC220

New Street Price: $600
Max Resolution: 1152 x 864
Closest Focusing: 8"
Storage Type: Compact Flash Card
Storage Size: 8 MB card included
Shutter Speeds: 1/2-1/360
Exposure Modes: P, M
Viewing Method: 2" LCD, optical vf
Output: video, serial, IR wireless (PC/ Mac)
Flash: auto, fill, redeye reduc.
Software: Picture Easy, PhotoDeluxe, PageMill, Science Picture
Other Features: 2X optical zoom, 2X digital zoom, 8 frame burst mode, time-lapse mode, self-timer, USB, audio note capability, more

☐ KODAK DC-215 AND DC-215 MILLENNIUM 2000

New Street Price: $380 (DC-215), $480 (M2000)
Max Resolution: 1152 x 864
Closest Focusing: 8"
Storage Type: 4MB Kodak Picture (CompactFlash) Card (8MB w/M2000)
Storage Size: about 300k (12 hi-res images/
4MB card)
Shutter Speeds: 1/2 to 1/362 second
Exposure Modes: P
Viewing Method: 1.8" LCD, optical vf
Output: video (NTSC/PAL), serial, USB (M2000 only)
Flash: auto, fill, redeye reduc.
Software: PhotoDeluxe, PageMill, WIN Mounter, TWAIN, Mac plug-in
Other Features: 2x zoom (29mm-58mm equiv in 35mm), ISO 140, self timer

☐ KODAK DC-240

New Street Price: $550
Max Resolution: 1280 x 960
Closest Focusing: 9.8"
Storage Type: 8MB Kodak Picture (CompactFlash) Card (included)
Storage Size: about 380k
Shutter Speeds: 1/2 to 1/755 second
Exposure Modes: P, M
Viewing Method: 1.8" LCD, optical vf
Output: video (NTSC/PAL), USB, serial
Flash: auto, fill, redeye reduc.
Software: Kodak Picture Easy, PhotoDeluxe, PageMill, TWAIN/plug-in
Other Features: 3x optical/2x digital zoom (6x combined)

☐ KODAK DC260

New Street Price: $1000
Max Resolution: 1536 x 1024
Closest Focusing: 12"
Storage Type: Compact Flash Card
Storage Size: 8 MB card included
Shutter Speeds: 1/4-1/400
Exposure Modes: P, M
Viewing Method: 2" LCD, optical vf
Output: video, serial, USB (PC/Mac)
Flash: auto, fill, redeye reduc.
Software: Picture Easy, PhotoDeluxe, Science Picture, PageMill
Other Features: 3X optical, 2X digital zoom, 8-frame burst mode, time-lapse mode, self-timer, audionote capability, USB interface, IR wireless, ext. flash, more

☐ KODAK DC-265

New Street Price: $800
Max Resolution: 1536 x 1024
Closest Focusing: 12"
Storage Type: 16MB Kodak Picture (CompactFlash) Card (included)
Storage Size: about 560k (28 images/16MB card)
Shutter Speeds: 1/4 to 1/400 second
Exposure Modes: P, M
Viewing Method: 2" LCD, optical vf
Output: video (NTSC/PAL), USB, serial, infrared
Flash: auto, fill, redeye reduc.
Software: Kodak Picture Easy, PhotoDeluxe, PageMill, TWAIN/plug-in

Digital Cameras – Model Features and Prices (cont'd)

Other Features: 3x optical/2x digital zoom (6x combined), ISO 100, 6-frame burst mode at 3 frames/second (hi-res)

□ KODAK DC-280

New Street Price: $750
Max Resolution: 1760 x 1168
Closest Focusing: 9.8"
Storage Type: 20MB Kodak Picture (CompactFlash) Card (included)
Storage Size: about 625k (32 hi-res images/20MB card)
Shutter Speeds: 1/2 to 1/755 second
Exposure Modes: P,M
Viewing Method: 1.8" LCD, optical vf
Output: video (NTSC/PAL), USB, serial
Flash: auto, fill, redeye reduc.
Software: Kodak Picture Easy, PhotoDeluxe, PageMill, TWAIN/plug-in
Other Features: 2x optical/3x digital zoom (6x combined), ISO 70, self-timer, four special effects modes

□ KODAK DC-290

New Street Price: $1095
Max Resolution: 2240 x 1500
Closest Focusing: 12"
Storage Type: 20MB Kodak Picture (CompactFlash) Card (included)
Storage Size: about 715k (28 images/20MB card)
Shutter Speeds: 16 seconds to 1/400 second
Exposure Modes: P,M
Viewing Method: 2" LCD, optical vf
Output: video (NTSC/PAL), USB, serial, infrared
Flash: auto, fill, redeye reduc.
Software: Kodak Picture Easy, PhotoDeluxe, PageMill, TWAIN/plug-in
Other Features: 3x optical/2x digital zoom (6x combined), ISO 100, 5-frame burst mode at 3 frames/second (hi-res), audio rec/play, self-timer, special effects

□ KONICA Q-EZ

New Street Price: $400
Max Resolution: 640 x 480
Closest Focusing:
Storage Type: Internal memory, CompactFlash
Storage Size: 2MB int
Shutter Speeds: 1/30-1/2000
Exposure Modes: P, exp comp.
Viewing Method: optical vf only
Output: serial, PC
Flash: auto
Software: PhotoDeluxe, QM-EZ Utilities, TWAIN driver
Other Features: 2X macro zoom, burst mode

□ KONICA Q-M100V

New Street Price: $700
Max Resolution: 1152 x 872
Closest Focusing: 8"
Storage Type: CompactFlash memory card
Storage Size: 4 MB card included
Shutter Speeds: 1/8-1/500
Exposure Modes: Program
Viewing Method: 1.8" LCD, optical vf
Output: video, serial (PC/Mac)
Flash: auto, redeye reduc.
Software: PhotoDeluxe, QM100V Utilities, TWAIN driver, plug-ins for Mac
Other Features: "Speed-Shot" mode (four shot burst), 2X digital zoom, self-timer, more

□ KONIKA Q-MINI

New Street Price: $380
Max Resolution: 640 x 480
Closest Focusing:
Storage Type: CompactFlash memory card
Storage Size: 4 MB card included
Shutter Speeds: 1/4-1/2000
Exposure Modes: P, exp comp
Viewing Method: 1.8" LCD
Output: video, serial (PC, Mac)
Flash: auto, redeye reduc.
Software: PhotoImpact, Stitch, Time Tunnel, TWAIN driver, plug-ins for Mac
Other Features: Macro mode, date/time stamp

□ MINOLTA DIMÂGE V

New Street Price: $350
Max Resolution: 640 x 480
Closest Focusing: 2.4"
Storage Type: SmartMedia memory card
Storage Size: 2 MB
Shutter Speeds: 1/30-1/10000
Exposure Modes: P, exp comp.
Viewing Method: 1.8" LCD, optical vf
Output: serial (PC/Mac)
Flash: auto, fill
Software: PhotoDeluxe, plug-in for Mac, TWAIN driver
Other Features: 2.7X optical zoom, detachable lens, self-timer, time/date stamp

□ MINOLTA DIMÂGE EX ZOOM 1500

New Street Price: $550
Max Resolution: 1344 x 1008
Closest Focusing: 13.8"
Storage Type: CompactFlash
Storage Size: 4 MB card
Shutter Speeds: 1/2-1/4000
Exposure Modes: Program
Viewing Method: 2.5" LCD
Output:
Flash: auto
Software: Digita Desktop, Digita Script
Other Features: Detachable 3X zoom lens

Digital Cameras – Model Features and Prices (cont'd)

☐ NIKON COOLPIX 600

New Street Price:	$550
Max Resolution:	1024 x 768
Closest Focusing:	5.5"
Storage Type:	CompactFlash memory card
Storage Size:	NO card included
Shutter Speeds:	1/4-1/2000
Exposure Modes:	P, exp comp.
Viewing Method:	2" LCD, optical vf
Output:	docking station, video (PC/Mac)
Flash:	auto, detachable
Software:	Nikon View 600, PhotoDeluxe
Other Features:	2X digital zoom, 2 macro modes, docking station, multi-exposure setting, panorama and multi-shot modes, optional PC card adapter

☐ NIKON COOLPIX 700

New Street Price:	$500
Max Resolution:	1600 x 1200
Closest Focusing:	12"
Storage Type:	8MB CompactFlash card (included)
Storage Size:	8MB @ max res
Shutter Speeds:	1 to 1/750 second
Exposure Modes:	P, M
Viewing Method:	1.8" LCD, optical vf
Output:	video, serial
Flash:	auto, force-fill, slow-sync, redeye reduc.
Software:	NikonView Version 2, Hotshots (PictureWorks), IPIX (Interactive Pictures)
Other Features:	4-step digital zoom (1.25x /1.6x /2x /2.5x), ISO 80, white balance, tone curve selection

☐ NIKON COOL PIX 900

New Street Price:	$850
Max Resolution:	1280 x 960
Closest Focusing:	3"
Storage Type:	CompactFlash memory card
Storage Size:	8 MB card included
Shutter Speeds:	1/4-1/750
Exposure Modes:	P, M, exp comp.
Viewing Method:	2" LCD, optical vf
Output:	video, serial (PC/Mac)
Flash:	auto, fill, redeye reduc., slow-sync.
Software:	Nikon View 900, PhotoDeluxe, Slides & Sound, QuickStitch
Other Features:	Pivoting, 3X optical zoom lens, 2X digital zoom, 10-frame burst mode, optional wide-angle & telephoto attachments, optional PC card adapter, more

☐ NIKON COOLPIX 950

New Street Price:	$900
Max Resolution:	1600 x 1200
Closest Focusing:	0.8" (2cm)
Storage Type:	8MB CompactFlash card (included)
Storage Size:	8MB @ max res

Shutter Speeds:	8 seconds to 1/750 second
Exposure Modes:	P, SP, AP, M
Viewing Method:	2" LCD, optical vf
Output:	video, serial
Flash:	auto, force-fill, slow-sync, redeye reduc.
Software:	NikonView Version 2, Hotshots (PictureWorks), IPIX (Interactive Pictures)
Other Features:	3x optical/4-step digital zoom (1.25x /1.6x /2x /2.5x), connector for external Speedlite flash units, 256-segment Matrix Metering, white balance, tone curve selection

☐ OLYMPUS C-2000Z

New Street Price:	$800
Max Resolution:	1600 x 1200
Closest Focusing:	7.9" (20cm)
Storage Type:	8MB SmartMedia card (included)
Storage Size:	8MB @ max res
Shutter Speeds:	1/2 to 1/800 second
Exposure Modes:	P
Viewing Method:	1.8" LCD, optical vf
Output:	video, serial
Flash:	auto, redeye red, fill, external
Software:	PhotoDeluxe, panaroma stitching software and Olympus Utilities
Other Features:	3x optical zoom w/manual control, 2.5x digital tele (SQ mode, VGA selectable 1.6 x, 2x, 2.5 x), self-timer

☐ OLYMPUS C-2500L

New Street Price:	$1360
Max Resolution:	1712 x 1368
Closest Focusing:	0.8" (Super Macro mode)
Storage Type:	Dual slots for CompactFlash & SmartMedia cards (32MB SmartMedia card included)
Storage Size:	about 8MB @ max res
Shutter Speeds:	8 seconds to 1/10,000 second
Exposure Modes:	P, AP, M
Viewing Method:	1.8" LCD, SLR TTL viewfinder
Output:	video, serial
Flash:	auto, redeye reduc. , 1st & 2nd curtain slow sync
Software:	QuickStitch, Camedia Master
Other Features:	3x optical zoom, white balance, ISO 100-400, external hotshoe (takes Olympus dedicated FL40 flash), self-timer, burst mode

Digital Cameras – Model Features and Prices (cont'd)

☐ OLYMPUS **D–200L**

New Street Price:	$300 (exc+)
Max Resolution:	640 x 480
Closest Focusing:	7.9"
Storage Type:	Internal
Storage Size:	2 MB
Shutter Speeds:	1/4-1/2000
Exposure Modes:	P, cw meter
Viewing Method:	1.8" LCD, optical vf
Output:	serial (PC/Mac)
Flash:	auto, fill
Software:	Photo Enhancer, TWAIN driver, Photoshop plug-in, Olympus Utilities
Other Features:	Self-timer

☐ OLYMPUS **D–220L**

New Street Price:	
Max Resolution:	640 x 480
Closest Focusing:	7.9"
Storage Type:	SmartMedia memory card
Storage Size:	2 MB, Optional 4, 8 MB cards
Shutter Speeds:	1/4-1/2000
Exposure Modes:	P, cw meter
Viewing Method:	2" LCD, optical vf
Output:	video, serial (PC/Mac)
Flash:	auto, fill, red-eye reduc.
Software:	PhotoDeluxe, Slides & Sound, Photoshop plug-in, TWAIN driver, Olympus Utilities
Other Features:	Stop-action 9-shots per sec in one frame, self-timer, time/date stamp

☐ OLYMPUS **D–320L**

New Street Price:	$610
Max Resolution:	1024 x 768
Closest Focusing:	7.9"
Storage Type:	SmartMedia memory card
Storage Size:	2 MB, Optional 4MB card
Shutter Speeds:	1/4-1/500
Exposure Modes:	P, cw meter
Viewing Method:	2" LCD, optical vf
Output:	video, serial, IR wireless (PC, Mac)
Flash:	auto, fill, redeye reduc.
Software:	PhotoDeluxe, Slides & Sound, Photoshop plug-in, TWAIN driver, Olympus Utilities
Other Features:	Stop-action 9 shots per sec in one frame, self-timer, time/date function

☐ OLYMPUS **D–340L**

New Street Price:	$700
Max Resolution:	1280 x 960
Closest Focusing:	4"
Storage Type:	SmartMedia memory card
Storage Size:	4 MB card included
Shutter Speeds:	1/4-1/500
Exposure Modes:	P, exp comp., cw meter
Viewing Method:	2" LCD, optical vf
Output:	video, serial (PC/Mac)
Flash:	auto, fill, redeye reduc.
Software:	PhotoDeluxe, Slides & Sound, TWAIN driver, Photoshop plug-in, Panoramic
Other Features:	2X digital zoom, glass lens, 10 image sequence mode, self-timer, more

☐ OLYMPUS **D–500L**

New Street Price:	$700
Max Resolution:	1024 x 768
Closest Focusing:	11.8"
Storage Type:	SmartMedia memory card
Storage Size:	2 MB, Optional 4 MB card
Shutter Speeds:	1/4-1/10000
Exposure Modes:	TTL spot/cw meter, P, exp TTL SLR
Viewing Method:	1.8" LCD
Output:	serial, PC, Mac
Flash:	auto, redeye reduc., 16' range.
Software:	PhotoDeluxe, Slides & Sound, Photoshop plug-in, TWAIN driver, Olympus Utilities
Other Features:	3X optical zoom, manual spot metering, time/date stamp, more

☐ OLYMPUS **D–400** AND **D–450** ZOOM

New Street Price:	$470 (D-450)
Max Resolution:	1280 x 960
Closest Focusing:	
Storage Type:	8MB SmartMedia card (included)
Storage Size:	about 4MB (2 images/card @ max res)
Shutter Speeds:	1/2-1/1000 second
Exposure Modes:	P
Viewing Method:	LCD, optical vf
Output:	Olympus P300/330 printer, serial, video
Flash:	5 modes (D-450): auto, slow sync, redeye red., fill, forced off, no FlashPath adapter on D-450
Software:	PhotoDeluxe, PhotoStitch, Olympus Utilities
Other Features:	3x optical/2x digital zoom (6x combined), ISO 160-640 (D-450), self-timer

☐ OLYMPUS **D–600L**

New Street Price:	$1000
Max Resolution:	1280 x 1024
Closest Focusing:	11.8"
Storage Type:	SmartMedia memory card
Storage Size:	4 MB
Shutter Speeds:	1/4-1/10000
Exposure Modes:	TTL spot/cw meter, P, exp comp.

Digital Cameras – Model Features and Prices (cont'd)

Viewing Method:	
Output:	
Flash:	TTL SLR red., 12 ft. range
Software:	Photoshop plug-in, TWAIN driver, Olympus Utilities, Mac
Other Features:	Zoom, manual spot metering, time/date stamp, more

☐ OLYMPUS D-620L

New Street Price:	$960
Max Resolution:	1280 x 1024
Closest Focusing:	11.8"
Storage Type:	8MB SmartMedia card (included)
Storage Size:	about 1MB @ max res
Shutter Speeds:	1/4 to 1/10,000 second
Exposure Modes:	P
Viewing Method:	1.8" LCD, SLR TTL viewfinder
Output:	Olympus P300/330 printer, serial, video
Flash:	six modes: auto low-light/back light, redeye reduc., fill, forced off, fill w/ext flash, ext flash only, PC connector
Software:	PhotoDeluxe, PhotoStitch, Olympus Utilities
Other Features:	3x optical zoom, 3.3 frame/sec burst mode (5 images total) at max res

☐ PANASONIC COOL SHOT

New Street Price:	$600
Max Resolution:	640 x 480
Closest Focusing:	
Storage Type:	CompactFlash memory card
Storage Size:	2 MB card included
Shutter Speeds:	
Exposure Modes:	Program
Viewing Method:	1.8" LCD, optical vf
Output:	
Flash:	No
Software:	PhotoDeluxe
Other Features:	

☐ PANASONIC PALMCAM DC1080

New Street Price:	
Max Resolution:	640 x 480
Closest Focusing:	15.7"
Storage Type:	CompactFlash memory card
Storage Size:	2 MB card included
Shutter Speeds:	1/10-1/20000
Exposure Modes:	Program
Viewing Method:	1.8" LCD, optical vf
Output:	video, serial (PC/ Mac)
Flash:	auto
Software:	PhotoDeluxe
Other Features:	2x digital zoom, docking station, optional PCMCIA adapter, more

☐ PANASONIC PALMCAM DC1580

New Street Price:	$600
Max Resolution:	1024 x 768
Closest Focusing:	6"
Storage Type:	CompactFlash memory card
Storage Size:	8 MB card included
Shutter Speeds:	1/4-1/2000
Exposure Modes:	Program
Viewing Method:	2" LCD, optical vf
Output:	video, serial (PC/Mac)
Flash:	auto
Software:	PhotoDeluxe, TWAIN driver, Mac plug-ins
Other Features:	Wide angle mode, docking station, 9-image sequence mode, more

☐ PHILIPS ESP 60

New Street Price:	$400
Max Resolution:	640 x 480
Closest Focusing:	
Storage Type:	SmartMedia memory card
Storage Size:	4 MB card included
Shutter Speeds:	1/5-1/8000
Exposure Modes:	P, exp comp., cw meter
Viewing Method:	1.8' LCD
Output:	video, serial (PC/Mac)
Flash:	auto, fill
Software:	PhotoStudio Lite, TWAIN driver, Mac plug-ins
Other Features:	Date/time stamp, optional PC card adapter

☐ PHILIPS ESP 80

New Street Price:	$800
Max Resolution:	1280 x 960
Closest Focusing:	
Storage Type:	SmartMedia memory card
Storage Size:	4 MB card included
Shutter Speeds:	1-1/500
Exposure Modes:	P, exp comp., cw meter
Viewing Method:	2" LCD
Output:	video, serial (PC/Mac)
Flash:	auto, fill, swivel
Software:	PhotoStudio Lite, TWAIN driver, Mac plug-ins
Other Features:	Date/time stamp, optional PC card adapter

☐ POLAROID PHOTOMAX PDC 640

New Street Price:	$240
Max Resolution:	640 x 480
Closest Focusing:	6"
Storage Type:	SmartMedia memory card
Storage Size:	2 MB card included
Shutter Speeds:	
Exposure Modes:	Program
Viewing Method:	1.8" LCD, optical vf
Output:	serial (PC/Mac)
Flash:	auto
Software:	PhotoMax Image Maker
Other Features:	Self-timer

Digital Cameras – Model Features and Prices (cont'd)

☐ POLAROID PDC 2000

New Street Price:	$1500 (/40)
Max Resolution:	1600 x 1200 (/40 and /60 models)
Closest Focusing:	10"
Storage Type:	Internal storage
Storage Size:	40 MB or 60 MB
Shutter Speeds:	1/25-1/500
Exposure Modes:	Program
Viewing Method:	optical vf
Output:	serial (PC/Mac)
Flash:	auto
Software:	PDC Direct, TWAIN driver, Mac plug-ins
Other Features:	Optional PCMCIA SCSI interface, optional (35mm equiv focal length) 60mm lens

☐ POLAROID PDC 3000

New Street Price:	$2100
Max Resolution:	1600 x 1200
Closest Focusing:	11"
Storage Type:	CompactFlash memory card
Storage Size:	20 MB card included
Shutter Speeds:	1/15-1/500
Exposure Modes:	Program
Viewing Method:	optical vf
Output:	serial (PC/Mac)
Flash:	auto
Software:	PDC Direct, TWAIN driver, Mac plug-ins
Other Features:	Optional PCMCIA SCSI interface, optional (35mm equiv. focal length) 60mm lens

☐ RICOH RDC-1

New Street Price:	$400
Max Resolution:	768 x 576
Closest Focusing:	0.5"
Storage Type:	PCMCIA cards
Storage Size:	2 MB
Shutter Speeds:	1/8-1/2000
Exposure Modes:	Program
Viewing Method:	optical vf, 2.5 in LCD (with optional DM-1 LCD Monitor, 2 MB card)
Output:	video, serial (PC/Mac)
Flash:	auto
Software:	TWAIN driver, Mac plug-ins
Other Features:	3X zoom with macro setting, 6 image recording modes

☐ RICOH RDC-2

New Street Price:	$440
Max Resolution:	768 x 576
Closest Focusing:	
Storage Type:	Internal storage
Storage Size:	2 MB
Shutter Speeds:	1/8-1/1000
Exposure Modes:	P, exp comp.
Viewing Method:	2" LCD, optical vf
Output:	video, serial (PC/Mac)
Flash:	auto

Software:	PhotoStudio, TWAIN driver, Mac plug-ins
Other Features:	Dual focal length lens (35mm & 55mm equiv in 35mm format), macro mode, self-timer, audio notation recording, more

☐ RICOH RDC-2E

New Street Price:	$500
Max Resolution:	768 x 576
Closest Focusing:	
Storage Type:	Internal storage
Storage Size:	2 MB
Shutter Speeds:	1/8-1/1000
Exposure Modes:	P, exp comp.
Viewing Method:	1.8" LCD
Output:	video, serial (PC/Mac)
Flash:	No
Software:	PhotoStudio, TWAIN driver, Mac plug-ins
Other Features:	Date/time stamp, self-timer

☐ RICOH RDC-300

New Street Price:	$360
Max Resolution:	640 x 480
Closest Focusing:	
Storage Type:	Internal storage
Storage Size:	4 MB
Shutter Speeds:	1/4-1/16000
Exposure Modes:	Program
Viewing Method:	1.8" LCD
Output:	video, serial (PC/ Mac)
Flash:	auto, fill
Software:	PhotoStudio Lite
Other Features:	self-timer

☐ RICOH RDC-300Z

New Street Price:	$470
Max Resolution:	640 x 480
Closest Focusing:	0.5"
Storage Type:	SmartMedia memory card
Storage Size:	2 MB card included
Shutter Speeds:	1/5-1/8000
Exposure Modes:	P, exp comp.
Viewing Method:	1.8" LCD
Output:	video, serial (PC, Mac)
Flash:	auto, fill
Software:	PhotoStudio Lite, TWAIN driver
Other Features:	3X optical zoom w/macro, self-timer, date/time stamp, remote control

☐ RICOH RDC-4300

New Street Price:	$500
Max Resolution:	1280 x 960
Closest Focusing:	3.2"
Storage Type:	SmartMedia memory card
Storage Size:	4 MB card included
Shutter Speeds:	1/8-1/500
Exposure Modes:	TTL meter, P, exp comp.
Viewing Method:	2" LCD

Digital Cameras – Model Features and Prices (cont'd)

Output: video, serial (PC/Mac)
Flash: auto, fill
Software: PhotoStudio, Show & LogoMotion, Power Show, QuickStitch, PhotoBase
Other Features: Lens & flash rotate 360°, audio notation, self-timer, 3X zoom w/macro

☐ SANYO VPC-X300

New Street Price:
Max Resolution: 1024 x 768
Closest Focusing: 7.8"
Storage Type: SmartMedia memory card
Storage Size: 4 MB card included
Shutter Speeds:
Exposure Modes: Program
Viewing Method: 2" LCD, optical vf
Output: video, serial, (PC/Mac)
Flash: auto
Software: PhotoSuite, Photoshop plug-in, TWAIN driver
Other Features: 3X digital zoom, self-timer, 9 image burst function at 0.1 or 0.2 sec. intervals, audio notes (4 sec.), time/date stamp

☐ SONY DKC ID1

New Street Price: $850
Max Resolution: 768 x 576
Closest Focusing:
Storage Type: Internal flash memory
Storage Size: 10 MB int.
Shutter Speeds: 1/15-1/4000
Exposure Modes: P, TV, exp comp.
Viewing Method: 1.8" LCD
Output: serial (PC/Mac)
Flash: auto
Software: PhotoStudio, TWAIN driver, Mac plug-ins
Other Features: 12X zoom w/macro, accepts PC cards w/optional adapter

☐ SONY DSC F–1

New Street Price: $740
Max Resolution: 640 x 480
Closest Focusing: 3"
Storage Type: Internal flash memory
Storage Size: 4 MB
Shutter Speeds: 1/8-1/1000
Exposure Modes: P, exp comp.
Viewing Method: 1.8" LCD
Output: video, serial (PC/Mac)
Flash: auto
Software: PhotoStudio, IR wireless
Other Features: Lens rotates for low-angle shots and self-portraits, date/time stamp, four recording modes, more

☐ SONY MAVICA MVC-FD5

New Street Price: $430
Max Resolution: 640 x 480
Closest Focusing: 1"
Storage Type: 3.5" floppy disk
Storage Size: 1.44 MB
Shutter Speeds: 1/60-1/4000
Exposure Modes: Program
Viewing Method: 2.5" LCD
Output: 3.5" floppies
Flash: auto
Software: PhotoStudio
Other Features: Self-timer

☐ SONY MAVICA MVC-FD7

New Street Price: $685
Max Resolution: 640 x 480
Closest Focusing: 1"
Storage Type: 3.5" floppy disk
Storage Size: 1.44 MB
Shutter Speeds: 1/60-1/4000
Exposure Modes: P, exp comp.
Viewing Method: 2.5" LCD
Output: 3.5" floppies (PC/ Mac)
Flash: auto
Software: PhotoStudio
Other Features: 10X optical zoom w/macro, 4 pre-programmed exposure modes, special effects modes, date/time stamp, more

☐ SONY MAVICA MVC-FD51

New Street Price: $470
Max Resolution: 640 x 480
Closest Focusing:
Storage Type: 3.5" floppy disk
Storage Size: 1.44 MB
Shutter Speeds: 1/60-1/4000
Exposure Modes: P, exp comp.
Viewing Method: 2.5" LCD
Output: 3.5" floppies (PC/Mac)
Flash: auto
Software: PhotoStudio
Other Features: Auto/manual exposure, special effects modes, more

☐ SONY MAVICA MVC-FD71

New Street Price: $660
Max Resolution: 640 x 480
Closest Focusing: 1"
Storage Type: 3.5" floppy disk
Storage Size: 1.44 MB
Shutter Speeds: 1/60-1/4000
Exposure Modes: Six AE modes +
Viewing Method: 2.5" LCD
Output: 3.5" floppies (PC/Mac)
Flash: auto
Software: PhotoStudio
Other Features: 10X optical zoom, auto/manual focus, macro mode, 9-image manual burst modes, self-timer, more

Digital Cameras – Model Features and Prices (cont'd)

☐ SONY MAVICA MVC-FD81

New Street Price:	$850
Max Resolution:	1024 x 768
Closest Focusing:	1"
Storage Type:	3.5" floppy disk
Storage Size:	1.44 MB
Shutter Speeds:	
Exposure Modes:	Program
Viewing Method:	2.5" LCD
Output:	3.5" floppies (PC/Mac)
Flash:	auto
Software:	PhotoSuite SE
Other Features:	3X optical zoom, auto/manual focus, MPEG mode for 60 sec. video capture, special effects modes, self-timer, more

☐ SONY MAVICA MVC-FD91

New Street Price:	$1000
Max Resolution:	1024 x 768
Closest Focusing:	1"
Storage Type:	3.5" floppy disk
Storage Size:	1.44 MB
Shutter Speeds:	
Exposure Modes:	Program
Viewing Method:	2.5" LCD
Output:	3.5" floppies (PC/Mac)
Flash:	auto
Software:	PhotoSuite SE
Other Features:	14X optical zoom, auto/manual focus, MPEG mode for 60 sec. video capture, special effects modes, self-timer, more

☐ TOSHIBA PDR-2

New Street Price:	$260
Max Resolution:	640 x 480
Closest Focusing:	
Storage Type:	SmartMedia memory card
Storage Size:	2 MB card included
Shutter Speeds:	1/8-1/1000
Exposure Modes:	Program
Viewing Method:	optical vf
Output:	PC card or FDD adapter
Flash:	No
Software:	No
Other Features:	Direct attachment to PC or laptop

☐ TOSHIBA PDR-5

New Street Price:	
Max Resolution:	640 x 480
Closest Focusing:	4"
Storage Type:	SmartMedia memory card
Storage Size:	2 MB card included
Shutter Speeds:	
Exposure Modes:	P, M
Viewing Method:	2.5" LCD
Output:	
Flash:	auto
Software:	Image Expert
Other Features:	Self-timer

☐ TOSHIBA PDR-M1

New Street Price:	$700
Max Resolution:	1280 x 1024
Closest Focusing:	2.5"
Storage Type:	SmartMedia memory card
Storage Size:	4 MB card included
Shutter Speeds:	
Exposure Modes:	Program
Viewing Method:	1.8" LCD, optical vf
Output:	video, serial (PC/Mac)
Flash:	auto
Software:	Image Expert, Picture Shuttle, EZ Touch
Other Features:	Glass lens, self-timer

☐ VIVITAR VIVICAM 2700

New Street Price:	$400
Max Resolution:	640 x 480
Closest Focusing:	10"
Storage Type:	Internal flash memory, optional CompactFlash memory card
Storage Size:	2 MB
Shutter Speeds:	1/60-1/1000
Exposure Modes:	Program
Viewing Method:	1.8" LCD, optical vf
Output:	serial, PC
Flash:	auto, fill
Software:	Photo Plus, TWAIN driver
Other Features:	30-frames-per-sec. NTSC video output, self-timer

☐ VIVITAR VIVICAM 3000

New Street Price:	$400
Max Resolution:	1000 x 800
Closest Focusing:	40"
Storage Type:	Internal flash memory, optional PCMCIA memory
Storage Size:	400 KB int.
Shutter Speeds:	1-1/2000
Exposure Modes:	Program
Viewing Method:	Optical vf
Output:	video, serial, audio, PC
Flash:	auto
Software:	LIvePix, Photo Vista
Other Features:	Sound recording (4 sec. per image), self-timer, more, no PCMCIA card included

Digital Cameras – Model Features and Prices (cont'd)

☐ VIVITAR VIVICAM 3100

New Street Price:	$500
Max Resolution:	1920 x 1600
Closest Focusing:	40"
Storage Type:	Internal flash memory, optional PCMCIA memory
Storage Size:	200 KB int.
Shutter Speeds:	1-1/2000
Exposure Modes:	Program
Viewing Method:	Optical vf
Output:	video, serial, audio, PC
Flash:	auto
Software:	LivePix, Photo Vista
Other Features:	Sound recording (20 sec per image), self-timer, selectable noise filter, more

☐ YASHICA KC-600

New Street Price:	$500
Max Resolution:	640 x 480
Closest Focusing:	8.6"
Storage Type:	CompactFlash memory card
Storage Size:	2 MB card included
Shutter Speeds:	1/8-1/4000
Exposure Modes:	P, exp comp., cw meter
Viewing Method:	1.8" LCD, optical vf
Output:	video, serial (PC/Mac)
Flash:	auto, fill, redeye reduc.
Software:	PhotoSuite SE, TWAIN driver, Mac plug-ins
Other Features:	Glass lens, self-timer, 4-frame, burst mode, more

Aftermarket Strobes

This listing has been confined to somewhat recent vintages of the three most popular makes of camera-mount or hand-held strobes: Metz, Sunpak and Vivitar. There are other good ones around, but they aren't as common as the three makes listed here. Because of the relatively small market the makers of studio strobes cater to, their high-end professional models haven't been included in this listing, either.

Metz

Item	New		Mint		Excellent		User
30 BCT-4	105	80					
32 BCT-4	170	150					
32 CT-3	130	115	110	70			
32 CT-4			125	100			
32 CT-7	220	170	125	105			
32 Z-1		110					
32 Z-2		130					
32 MZ-3		155					
36 CT-3	265	215	175	150			
40 MZ-2		315					
45 CL-1/CT-1	260	205	160	135			
45 CL-1/CT-1 w/NiCads	300	245					
45 CL-3/CT-3	320	265			180	160	
45 CL-3/CT-3 w/NiCads	395	310					
45 CL-4/CT-4	365	300	225	200	200	150	
45 CL-4/CT-4 w/NiCads	425	345					
45 CT-5			285	260			
50 M25		540					
50 M25 (w/controller)		725					
60 CT-1	525	465			295	280	
60 CT-1 w/NiCads	545	485					
60 CT-2			350	300	280	250	
60 CT-2 w/NiCads			380	325			
60 CT-4	675	580	470	450	460	385	
60 CT-4 w/NiCads	695	600					

Sunpak

Item	New		Mint		Excellent		User
30DX w/module			70	60	50	40	
120J Pro	325	275					
144			35	25			
144D			40	30			
144PC			40	30			
211					40	30	
220					50	40	
221D					40	30	

Sunpak (cont'd)

Item	New		Mint		Excellent		User	
266D			50	40				
321					25	20		
322			50	40				
333					35	30		
333AZ			60	50				
344D			60	50	50	40		
383 Super	85	70						
388			50	40				
411			85	80				
421					25	20		
422D w/module					70	60		
433D w/module	100	75			65	60		
433AF	110	85						
444D w/module	150	125	100	70				
511					100	90		
522					100	90		
544	185	135	125	85				
555	210	160						
611 w/remote sensor, A/C adapt			160	145				
622 w/std head	330	220			160	140		
622 w/zoom head	360	250						
622 Super Zoom Kit	395	285						
993			70	65	60	50		
1600A			25	20				
2000DZ			40	30				
DX 8R Ring Flash	220	150						
DX 12R Ring Flash	260	225						

Vivitar

Item	New		Mint		Excellent		User	
252					25	20		
265					35	30		
273					65	50		
275					45	40		
283	80	65			50	45		
285					70	60		
285 HV	95	80			70	65		
292					50	40		
365 w/vari-sensor & bracket					200	150		
550 FD	60	45						
600 Series 1	100	75						
628 AF	70	50						
636 AF	110	85						
728 AF	65	50						
736 AF	100	75						
836 AF Zoom	240	180						
1900	25	15						
2000	30	25						
2600	30	25						
2600 D	35	30						
2800	35	30						
2800 D	50	40	30	25				
3500 w/module	70	60			35	30		
3700 w/module	105	70			50	30		
3900 w/bracket	145	115			100	75		
4600					70	60		
5000 Ring Light Macro Flash	100	65						
5200 w/module	115	100	85	75	65	60		
5600 w/module			120	110	115	75		

Exposure Meters

Calcu-Light (Quantum)

Item	New		Mint		Excellent		User
Calcu-Flash					75	65	
Calcu-Flash II	215	185	125	100	110	75	
Calcu-Flash S	130	115			75	65	
Calcu-Light X	145	120	80	75			
Calcu-Light XP	170	135	90	80			
Photometer 1 and Lux	185	165					
Photometer 2	210	180					

Gossen

Item	New		Mint		Excellent		User
Color Pro 2F	535	490					
Color Pro 3F	810	735					
Flash Meter					80	60	
Flash Meter II					120	100	
Luna Lux	150	130			85	70	
Luna Pro			130	110	110	90	
Luna Pro Digital	190	155					
Luna Pro F	325	250	220	180	175	150	
Luna Pro S	210	175					
Luna Pro SBC	260	220	180	150	140	120	
Luna Six 3 (European Luna Pro)					90	70	
Luna Star F			220	200			
Luna Star F II	345	275					
Multi Pro	385	325	285	260			
N100	120	95	70	60			
Panlux	495	430					
Pilot II	75	60					
Scout II	55	40					
SixtiColor					150	125	
Super Pilot					50	40	
Ultra Pro	650	570	475	420	430	350	
Ultra Spot 1°	470	425					

Gossen (cont'd)

Item	New		Mint		Excellent		User	
Enlarging Attachment**	55	45						
Fiber Optics Probe**	200	195	150	135				
Luna Color Attachment***	315	250						
Luna Flash Attachment*	240	215			170	100		
Luna Micro Attachment***	60	50						
Luna Probe Attachment***	240	215	160	140				
Luna Sphere Attachment***	190	145	110	95	90	75		
Luna Star 5° Attachment (Star F only)		100	85					
Microscope Attachment**	45	40			25	20		
Multi-Beam (Spot) Attachment***	450	390	250	225	200	175		
Repro-Copy Attachment**	55	45						
Vari-Angle Attachment**	80	65	50	40	40	30		
Vari-Angle Attachment (early)****					35	25		

*Can be used with Luna Pro SBC only

**Can be used with Luna Six 3, Luna Pro, Luna Pro SBC, Luna Pro F, Luna Lux, Multi Pro, Ultra Pro

***Can be used with Luna Pro SBC and Ultra Pro only

****Can be used with Luna Six 3 and Luna Pro only

Minolta

Item	New		Mint		Excellent		User	
Autometer Pro					80	70		
Autometer					80	65		
Autometer II					80	65		
Autometer III	210	165	130	120	120	95		
Autometer IIIF			200	180				
Autometer IVF	310	260						
Auto Spot 2°					150	115		
Auto Spot II					175	125		
Colormeter I			200	180				
Colormeter II	640	550	495	475				
Colormeter IIIF	940	850						
Flashmeter							150	125
Flashmeter II					195	140		
Flashmeter III			395	375	375	325		
Flashmeter IV	520	440	420	385	380	340		
Spotmeter F	445	380	340	300				
Spotmeter M			320	300	270	235		
5° Viewfinder	120	95						
10° Viewfinder	95	80						
Booster II Set	270	220						
Data Receiver DR1000	290	240						
Flash Color Receptor	430	360						
IR Receiver Trigger	235	190						
Mini Receptor	140	110						

Pentax

Item	New		Mint		Excellent		User	
Spotmeter V	325	250			150	100		
Spotmeter V FL	335	260						
Digital Spot	395	330			230	200		

Sekonic

Item	New		Mint		Excellent		User	
L158 Auto-Lumi	40	35						
L164 Marine	270	230						
L188 Auto-Leader	60	45	30	20				
L228 Zoom Meter			100	90	75	60		
L246 Foot Candle Meter	95	75						
L248 Multi-Lumi			60	50				
L256 Flash Meter			140	100				
L308	245	195						
L318 Digi-Light	235	155	130	100				
L318B w/Viewfinder	210	170						
L328 Digi-Lite F	310	250						
L398 (Gold)			100	90				
L398 Studio	160	125	90	85	80	65		
L398 II	120	90						
L428 System Meter			120	90	110	90		
L438 View Spot					175	130		
L448 Studio			265	240				
L458 Digi-Flash			160	140	130	100		
L488 Digi-Spot (w/flash)	385	300	300	200				
L518 Digi-Pro			320	295				
L718 Digi-Pro	495	430						
L778 Dual Spot F (1°/3°)	640	370						
Viewfinder for L518/L718	90	70						
Viewfinder for L428	35	25						

Shephard

Item	New		Mint		Excellent		User	
DM-170	105	95						
FM-800			65	50				
FM-880	100	85						
FM-900			80	65				
FM-990	120	100						
FM-1000	165	145						

Soligor

Item	New		Mint		Excellent		User	
Spot Sensor					75	50		
Spot Sensor II	240	190	120	105	100	85		
Digital Spot	285	230	150	125				
Flash Meter					55	45		

Vivitar

Item	New		Mint	Excellent		User
Flash Meter				80	70	
Flash Meter 2	125	100				

Wein

Item	New		Mint	Excellent	User
WP-500B	90	65			
WP-1000	125	95			

Appendix: Internet Addresses

Adobe Consumer Products:
www.adobe.com

Agfa:
www.agfanet.com

Apple Computer:
www.apple.com

American Society of Magazine Photographers (ASMP):
www.asmp.org

Beseler:
www.beseler-photo.com

Bogen Photo Corp.:
www.bogenphoto.com

Brightscreen:
www.brightscreen.com

Bronica:
www.tamron.com

Paul C. Buff (White Lightning):
www.white-lightning.com

Calumet:
www.calumetphoto.com

Canon Computer Systems, Inc.:
www.ccsi.canon.com

Canon U.S.A., Inc.:
www.usa.canon.com

Casio:
www.casio.com

Contax:
www.contaxcameras.com

Corel:
corel.com

Dycam:
dycam.com

Eastman Kodak Co.:
www.kodak.com

Epson America, Inc.:
www.epson.com

Fuji Photo Film U.S.A. Inc.:
www.fujifilm.com

Hasselblad U.S.A.:
www.hasselbladusa.com

Hewlett Packard Co.:
www.hp.com

Ilford Photo Corp.:
www.ilford.com

Imation:
www.imation.com

Konica:
www.konica.com

Leica Camera, Inc.:
www.leica-camera.com

Lindahl:
www.lslindahl.com

Lowepro:
www.lowepro.com

Lumedyne:
lumedyne.com

LumiQuest:
www.lumiquest.com

Mamiya America Corp:
www.mamiya.com

McBroom's Camera Bluebook:
mcbrooms.com

Microsoft Inc.:
www.microsoft.com

Minolta Corp.:
www.minoltausa.com

Minox:
www.minox.com

New York Institute of Photography:
www.nyip.com

Nikon Inc.:
www.nikonusa.com

Norman Enterprises:
www.normanflash.com

Olympus America Inc.:
www.olympus.com

Panasonic Consumer
Electronics:
www.panasonic.com

Panasonic Interactive Media:
www.truphoto.com

Pelican Products:
www.pelican.com

Pentax Corp.:
www.pentax.com

Phoenix Corp. (Samyang):
www.phoenixcorp.com

PhotoDisc:
www.photodisc.com

Photoflex:
www.photoflex.com

Photo Marketing Assocation
(PMA):
www. pmai.org

Photonet:
www.photonet.com

Play Inc.:
www.play.com

Polaroid Corp.:
www.polaroid.com

Porter's Camera Catalog:
www.porters.com

Quantum Instruments:
www.qtm.com

Ricoh Corp.:
www.ricohcpg.com

Rollei Fototechnic:
www.rolleifoto.com

Samsung Opto-Electronics:
www.simplyamazing.com

Satter/Omega:
www.omega.satter.com

Saunders Group, The:
www.saundersphoto.com

Schneider Optics:
www.schneideroptics.com

Sekonic:
www.sekonic.com

Sigma Corp. of America:
www.sigmaphoto.com

Sony:
www.sony.com

Sunpak:
www.sunpak.com

SyQuest Technology:
www.syquest.com

Tamron Industries:
www.tamron.com

Tenba:
www.tenba.com

Tiffen Manufacturing Co.:
www.tiffen.com

Toyo:
www.toyoview.com

Vivitar:
www.vivitarcorp.com

Yashica:
www.yashica.com

Glossary

Action Finder:

An accessory viewfinder with a large eyepiece for interchangeable-finder camera systems that allows an eye-relief of up to several inches, while still allowing total visibility of the viewing area. Popular for sports photography and other situations in which the photographer may need to observe action outside the viewfinder frame.

AE: Auto Exposure.

A system in which the camera determines a scene's exposure based on lighting conditions and selects the correct aperture for a user-selected shutter speed, or the correct shutter speed for a user-selected aperture, or, with Program AE, both.

AE Lock: Auto Exposure Lock.

Usually a button that locks in the selected AE setting. Most useful for holding an AE reading when recomposing a scene in unusual lighting situations.

AF: Auto Focus.

Angle Finder: An viewfinder accessory that attaches to the eyepiece of a camera, which projects the image at a 90 degree angle. Useful for copy work and other instances in which straight-on viewing may be awkward.

Aperture:

The interior opening of a lens. Usually the aperture size can be varied by an iris diaphragm mechanism to control the amount of light reaching the film plane. Some lenses have fixed apertures; that is, they cannot be varied in size.

Aperture Numbers:

See F/stop.

Aperture-Priority AE:

An auto exposure mode in which the camera determines the shutter speed based on a scene's light conditions and the lens aperture the user has selected.

Auto Bracketing:

A feature on many modern cameras that will automatically vary exposure for a series of frames, usually in $1/2$ stop increments. This slight variation in exposure between successive shots is called bracketing and is often used to insure that at least one frame in a series is properly exposed.

Auto Diaphragm:

A lens diaphragm that is coupled by means of a mechanical or electronic link to a camera body such that it will close down to a pre-selected opening size just prior to and during exposure.

Auto Film Loading:

A system on many modern cameras in which the camera secures the film to the film take-up spool and automatically winds the film to the first frame.

Auto Film Rewind:

A system in which the camera will rewind the film automatically once the last frame has been exposed.

ASA:

American Standards Association. Former standard used to determine film speed and, for all practical purposes, synonymous with the current designation, ISO. See ISO, Film Speed.

Auto Winder:

Also called a winder, an auto winder is a film winding accessory that is usually attached to the bottom of a camera. Typical settings on a winder are S for Single frame and C for Continuous. A winder will usually advance film at rates up to 2 frames per second when on the continuous setting. Not all winders have a Continuous setting. Not all cameras will accept winders.

Averaging Meter:

An exposure meter which reads and averages all light values within its range of acceptance, and which recommends exposure based on the lighting situation.

B: Bulb.

A manual setting on a camera in which the shutter will remain open for as long as the shutter release is depressed.

BLC: Back Light Control.

Usually a button on auto exposure cameras that, when depressed, will overexpose the frame by $1 1/2$ to 2 stops. Used in situations where the subject is close to

a bright light source, such as a window. Often this sort of lighting situation will fool a camera's meter and cause the subject to be underexposed.

Bottom-Centerweighted Metering:

Centerweighted metering that has a stronger emphasis toward the bottom of the image area. The idea behind this is to reduce the influence a bright sky may have on outdoor subjects.

CdS: Cadmium Sulfide.

The first substance used in metering cells for battery-powered light meters. It offers better low-light sensitivity and more accurate response to light temperature than Selenium meters.

Continuous AF:

An autofocus selection in which a camera will autofocus continually on a subject, especially a moving one, and will allow exposures to be taken whether or not the subject is in focus. Also called Servo AF.

Data Back:

An accessory camera back that will imprint data on the film emulsion, usually within the frame. A typical databack will imprint the current date, but little else. Databacks with advanced features, usually available only for cameras with advanced features, may offer such additional options as printing information between frames, printing exposure information, an intervalometer and film-rewind options.

Depth-of-Field Preview:

A feature on many cameras, usually a button or a lever, that allows the user to examine the actual depth of focus at a given aperture. The smaller the aperture (the larger the aperture number), the greater the depth of focus.

DX Film Coding:

On cameras supporting it, a feature that will automatically set a film's ISO (ASA) speed based on coded information on the film cassette. Some cameras allow users to override this feature and select their own ISO settings.

EI: Exposure Index.

A user-assigned film speed that differs from that recommended by the film manufacturer.

EV: Exposure Value.

EV is a light measurement method in which a given exposure ratio between apertures and shutter speeds is assigned a number independent of film speed. For example: 1/60 @ f/8 = 1/125 @ f/5.6 = 1/250 @ f/4 and so on. These settings represent equivalent exposure values and have the same EV number. In the above example, that number is EV 12 and will always be EV 12, no matter what the film speed is. Each successively higher whole number on the EV scale represents a doubling of the amount of light or exposure a subject receives, just as each successively lower number represents a decrease in exposure by one-half. When metering a scene at different ISO settings, however, the EV number will change. A scene metered at EV 12 at ISO 100 will need an exposure of 1/60 @ f/8 (or its equivalent). This same scene, when metered at ISO 400, will have an EV of 14, requiring an exposure of 1/60 @ f/16 (or equivalent). The difference of 2 steps on the EV scale corresponds to a 2x2, or a four-fold increase in light or light sensitivity, which is exactly the difference between that of ISO 100 and ISO 400. If it sounds confusing, just think about it for a minute. It makes sense. The handy thing about the EV system, once one gets the hang of it, is that one can think in simplified terms when calculating exposure.

Exposure Compensation:

A feature on most auto-exposure cameras that allows the user to bias exposure, typically in $1/3$ or $1/2$ stop increments, usually over a 2-stop range. Useful for unusual lighting situations that may otherwise fool a camera's meter.

Extension Tube:

Often available as a set with three to four different lengths. An extension tube placed between lens and camera, will reduce the minimum focusing distance, while increasing the magnification. Auto extension tubes retain the coupling mechanism between lens and camera, allowing auto diaphragm operation.

Film Speed:

The "speed" of a film's emulsion is determined by its relative sensitivity to light. A "fast" film is one that is sensitive to small amounts of light, enabling shorter exposure times in low-light situations. A "slow" film, on the other hand, is better able to handle extremely bright situations. The trade-offs are: a fast film's inherent grainy structure will reduce a photograph's sharpness whereas a slow film has a much smaller grain size, hence much better sharpness; a slow film is inconvenient to use in low or subdued-light situations because of the longer exposure times involved.

Fish Eye:

A very short focal length lens (typically in the range from 6mm to 8mm for 35mm cameras) with a 180° or more field view. Fish eye lenses cause extreme distortion of perspective and make a circular image. Straight lines that pass through the center of the image area remain straight; all others become progressively more distorted as they are located closer to the edge of the image area.

Flash Sync:
The fastest shutter speed setting at which a flash can be used. See M sync and X sync.

FPS:
Frames Per Second.

F/ratio:
Theoretically, the mathematical ratio of a lens' focal length to the diameter of its front element. For example, (100mm focal length)÷ (50mm front element diameter) = 2, so this lens would be considered a 100mm f/2. The larger the maximum aperture, the lower the f/ratio and the more light an optic gathers. Lenses with low f/ratios are frequently referred to as "fast" lenses because they allow faster shutter speeds than lenses with smaller maximum apertures.

F/stop:
A ratio of a lens' focal length to the size of the opening of its interior diaphragm. With adjustable diaphragms, this ratio can change and is expressed as a logarithmic scale on the lens' aperture ring. The higher the number, the smaller the opening. See F/ratio.

Focus Priority AF:
An autofocus feature in which the camera will not allow an exposure to be made until the subject is in focus.

Focusing Screen:
The ground glass or fresnel panel, made from either glass or plastic, on which the image actually appears for viewing. Some 35mm and medium format cameras have interchangeable focusing screens, which provide the user with a greater variety of composition or viewing options.

Full-Frame Fish Eye:
An apparent contradiction in terms, a full-frame fish eye lens has a focal length typically in the range of 15mm to 16mm for 35mm cameras. The image is distorted as is the case with a fish eye lens, but the image is not circular, hence the designation "full-frame." A full-frame fish eye lens has a 180° field of view measured on the diagonal.

GN or Guide Number:
A measurement of a strobe's light output that can be used to determine exposure according to the following formula: (Camera to Subject Distance) x (Lens Aperture) = Guide Number. In the U.S., the Distance to Subject is expressed in feet (elsewhere, it's expressed in meters) and the Lens Aperture is expressed in f/stops. The guide number of a strobe is always given in terms of feet or meters at a particular ISO number. When a guide number is cited in this book, it is given in feet at ISO 100.

ISO: International Standards Organization.
In photography, the letters ISO are most often associated with film emulsion speeds. To the casual observer ISO may seem synonymous with the older film-speed rating, ASA (and it is treated the same in this book), but that isn't quite the case. When used as a film-speed rating, ISO incorporates both the ASA rating used in the U.S. and the DIN rating used in Europe. Using the former standards, a film emulsion rated at ASA 100, for example, carried the equivalent DIN rating of 21°. The ISO rating of this same film emulsion is now expressed as 100/21°.

Macro:
In photography, a term denoting higher than normal magnification and usually expressed as a ratio. For example, a macro ratio of 1:2 means that the image size on the film is ½ its actual size. Generally, "true" macro magnification is considered to begin at a ratio of 1:2. Macro is also a setting found on many zoom lenses that allows a degree of close focus. Most zoom lenses with a macro setting do not offer true macro focusing, in that they cannot focus down to a minimum of a 1:2 ratio.

Macro Lens:
Also called a Micro lens. Macro lenses are specially designed, flat-field optics with close-focusing capabilities and maximum macro ratios of usually either 1:2 or 1:1 (½ or full life size at the film plane), depending upon make and model. Macro lenses (except some bellows lenses) retain infinity focus and work well for regular photography. Some macro lenses are designed especially for use with bellows and cannot be focused without them.

Macrophoto Lens:
A special, high-magnification lens that must be used in conjunction with a bellows. Image magnifications from 2x to 20x life size are possible with sufficient extension.

Manual Diaphragm:
A variable, iris-bladed mechanism inside a lens that is coupled to an aperture ring, but has no coupling linkage to the camera. When using a lens with a manual diaphragm on cameras with TTL meters, metering must be done at the lens' taking aperture using either stop-down metering or aperture priority AE.

Manual Exposure Mode:
An exposure method in which the user selects both the aperture and shutter speed according to either the camera's built-in meter or an external source.

Micro Lens:
See Macro Lens.

Mid-Roll Rewind:
A feature on many modern SLRs with built-in motordrives that allows the user

to rewind a roll of film before it is totally exposed. This is a useful feature when the photographer wishes to change film emulsion types before the existing roll is finished. Most cameras that offer this feature wind the film back into the cassette, leaving no film leader protruding. Some cameras allow the user to select an option which stops rewinding just short of sucking the leader back into the cassette, which makes it much easier to reload the roll at a later time.

Mirror Lock-Up:

A feature on many professional-oriented SLRs in which the camera's mirror can be raised and locked manually. Its main purpose is to minimize mirror-induced vibration when taking high magnification photos, or when using slow shutter speeds, or both. Most 35mm SLRs that have vertical focal-plane shutters offer a pseudo mirror lock-up capability, which can be employed by using the self-timer. After charging the self-timer mechanism (or selecting the self-timer option on an electronic SLR), when the shutter is released the mirror raises immediately. In most cases the ensuing delay is sufficient to eliminate fuzzy photos caused by mirror-induced vibration.

Motor Drive:

A high-speed film winding accessory that attaches to the base of a camera and that typically offers continuous film winding speeds which may range anywhere from 3 frames per second to over 6 frames per second (depending on the model, the camera, and the shutter speeds selected). Most motor drives offer a single-frame setting and many offer two or more continuous speeds. Some motor drives have motorized rewind.

M sync:

The flash sync setting or switch for M-class flashbulbs.

Multiple Exposure Capability:

The ability to take more than one exposure on a single frame. Many cameras that offer this feature have a separate switch for this. Others require that the film-rewind button on the bottom of the camera be depressed prior to each additional exposure. Still other cameras don't support this feature at all.

OTF: Off The Film plane.

This refers to a method of either TTL exposure metering or TTL flash metering in which the reflectance of the film is used to calculate correct exposure. See TTL.

Partial Metering: Also called Selective Metering.

A metering system in which only a specified central area within the viewfinder meters a scene. This system is more useful in critical exposure situations than the various averaging methods, since extraneous light in a scene will not affect a camera's meter as long as it remains outside the metering area.

PC Lens: A Perspective Control, or Shift lens.

Allows the front element of the lens to be shifted away from the centerline. Most common in focal lengths ranging from 24mm to 35mm. A PC lens is used mostly for architectural photography and other situations in which converging lines are undesirable.

PC Socket: Push Connector Socket.

A receptacle for standard flash cords, enabling a flash to be used off the camera.

Pentaprism:

A solid, five sided, aluminized prism used to reflect the image from a camera's focusing screen to the eyepiece.

Polycarbonate:

Marketing jargon for plastic. To be fair, though, polycarbonate is a general term which includes a variety of plastics, all of which are noted for durability and a high melting temperature. When reinforced with carbon fibers or fiberglass, the resulting composite's strength and durability rivals and, in some cases, surpasses that of many metals.

Porroprism:

A series of mirrors used to reflect an image from the focusing screen to the eyepiece.

Predictive Focus:

A feature on some of the latest-generation autofocus cameras that, when engaged, will track a moving subject and predict its location and correct focus at the instant of exposure.

Preset:

This term applies to certain manual-diaphragm lenses that have an additional ring adjacent to the aperture ring. When rotated one way, this additional ring will open the aperture to its maximum, facilitating ease of focus. The ring is then rotated in the opposite direction to close the iris down to the preselected taking aperture.

Program:

An auto exposure mode in which the camera selects both the aperture and shutter speed according to a scene's lighting conditions.

Program Shift:

An adjustment to the program setting that allows the user to bias toward higher or lower shutter speeds, or greater or smaller apertures, while maintaining the inversely proportional relationship between the two values.

Rangefinder:

A term used to indicate a camera design, but which is more precisely a component of a camera design. An optical rangefinder is a system of prisms or mirrors or both that use a parallax method of measurement to determine distance and correct focus. Focus is obtained by bringing a double image visible in the center of the viewfinder frame into coincidence. A big advantage to a rangefinder camera is the lenses it can use. Lenses for rangefinder cameras often exhibit superior sharpness and contrast because of their less complex design. (A general rule in optics is that the more elements a lens has, the greater the image degradation it will experience.) Another plus is that because a rangefinder camera does not have a reflex mirror it is much quieter than an SLR and produces much less vibration. Its disadvantages include an inability to see exactly that which the lens sees (although most rangefinders have parallax correction) and a limited lens selection, especially in focal lengths greater than 135 millimeters.

SBC: Silicon Blue Cell.

A recent-technology metering cell that offers improved sensitivity over silicon photo cells.

SCA: Sync Cord Adapter.

A system of compatibility for flash photography that has become the standard in Europe and is slowly gaining in popularity elsewhere.

Selective Metering:

See Partial Metering.

Servo AF:

See Continuous AF.

Shift:

See Program Shift.

Shift Lens:

See PC Lens.

Shutter-Priority AE:

An auto exposure mode in which the camera determines the lens aperture based on the scene's light conditions and the shutter speed selected by the user.

Shutter Speed:

The time that a shutter remains open. Typically expressed in whole numbers on a shutter speed dial or display, the numbers above 1 are actually reciprocals (i.e. 250 is actually 1/250 second). The numbers below 1 on certain electronic SLRs are multiples of seconds (i.e. 8 = 8 seconds).

Single Shot AF:

Usually coupled with a camera's focus priority feature, this system allows only one exposure at a time, and then only after the subject is in focus.

SLR: Single Lens Reflex.

The design of most interchangeable-lens 35mm and medium format cameras. Most SLRs have a mirror located directly behind the lens, which projects the image onto a focusing screen, then through a pentaprism (or in some cases a porroprism), which provides the user with a right-side-up, left-to-right corrected image. In a typical SLR the mirror swings up immediately before exposure, allowing the image to be projected directly onto the film plane. Advantages to the SLR design include: most SLRs have TTL metering and many have TTL flash metering; what you see is what you get because you're observing the scene through the lens; a wide range of accessories and lenses. Disadvantages include: the user cannot see the image at the moment of exposure because the mirror rises, momentarily blanking out the scene visible from within the viewfinder (Exceptions to this include a handful of SLR's that have fixed, pellicle mirrors. Their main disadvantage, however, is an inherently dimmer viewfinder.); a higher noise and vibration level due to the mirror assembly's operation.

SPD: Silicon Photo Diode.

A widely-used type of metering cell that has all but replaced its CdS predecessors. Its advantages over CdS is a faster response, increased light sensitivity range, and no "memory," an affliction of CdS meters in which the meter will "remember" a bright scene for a while after being exposed to it.

Sport Finder:

See Action Finder.

Spot Meter:

A light meter that is either hand-held or, in some cameras, built in to the camera. A true spot meter features a 1° angle of acceptance, thereby allowing the photographer to make critical exposure measurements of a scene. A built-in spot meter meters the central area of the viewfinder only, typically from 1% to 3% of the viewfinder image.

Stop:

Sometimes synonymous to f/stop, "stop" also means a single gradation of exposure value (see EV). When a photographer says, for example, that a scene has a three-stop range between highlight and shadow, he or she is referring to a three step range in exposure values, or to put it another way, that the highlight area is receiving eight times the light that the shadow area is.

Stop-Down Metering:

A metering method that measures exposure at a lens' taking aperture. Used nowadays primarily with lenses that have manual or fixed apertures. Many early SLRs with TTL meters use this method for determining exposure. Modern full-featured SLRs retain this capability.

Strobe:
Electronic Flash.

T: Time.
When making an exposure with a camera set on "T," the shutter will remain open until the T setting is disengaged. Seen now mostly on older cameras, the T setting is essentially "B" with a built-in lock.

Teleconverter:
This device fits between the lens and the camera. It is an economical method of increasing a lens' focal length without affecting its minimum focusing distance. The most popular configuration is the 2x teleconverter, which doubles a lens' focal length. Other magnifications are, however, available: most common being 1.4x and 3x. But you never get something for nothing. The increase in power also corresponds to the amount of light lost when using one; e.g. a 2X increase in focal length results in a two-stop loss of light. However, if your camera has a TTL meter, it will automatically take into account this light loss and display the resulting correct exposure.

TLR: Twin Lens Reflex.
A camera with separate taking and viewing lenses. A mirror is used in conjunction with the viewing lens to reflect the image onto a focusing screen. The image is right-side-up, but uncorrected from right to left (i.e. backwards).

Trap Focus:
A feature on some latest-generation autofocus cameras in which the camera will automatically take a photograph once a subject enters a pre-determined area of focus.

TTL: Through The Lens.
This acronym is often used when referring to viewing an image, a meter design, or a flash metering method. All have the same thing in common in that they refer to the ability to evaluate a scene as the lens sees it, or Through The Lens.

Variable Aperture:
A design common to modern zoom lenses in which the aperture setting changes as the focal length is changed. Usually as much as one stop of light is lost when zooming from the shortest focal length to the longest. This presents little problem when using a camera in an auto exposure mode, but can be annoying when using it in manual or when using it with a manual strobe, especially at intermediate focal lengths.

Varifocal Lens:
Often mis-categorized as a zoom lens, a varifocal "zoom" requires refocusing after a shift in focal length, except at infinity focus. Advantages to the varifocal design include fewer lens elements than a true zoom of the same focal length, and a more compact size.

Waist Level Finder:
A collapsible hood, which, when opened, gives the photographer a direct view of the camera's focusing screen. Called a waist level finder due to the fact that the focusing screen is corrected for best viewing from that distance. Often, a waist level finder will have a magnifier incorporated into its design, which can be moved into position above the focusing screen, and which enables the photographer to examine a magnified image for critical focus. The view through a waist level finder is not corrected from right to left (i.e., images seen are backwards).

Winder:
See Auto Winder.

X sync:
The fastest shutter speed setting at which an electronic flash can be used. Often symbolized by a lightning bolt.

Zoom Lens:
Available in two basic designs, known as either two-ring or one-touch, zoom lenses provide photographers with continuously variable focal lengths throughout their range. Many two-ring, or two-touch, zooms are older vintage lenses, whereas most newer zooms are of the one-touch style. Exceptions to this are autofocus zooms, which are two-touch. Each style has its advantages and disadvantages: The two-ring style allows zooming without accidentally shifting focus, but because it has separate rings for focus and zoom control, it is a little slower to use (not a problem with autofocus cameras, however). The one-touch style is quicker to use, since the single collar allows simultaneous focusing and zooming, but the focus can be shifted inadvertently when zooming from one focal length to another.

Index

Darkroom Books From
Amherst Media, Inc.

Other Books from
Amherst Media, Inc.

Basic 35mm Photo Guide

Craig Alesse

Great for beginning photographers! Designed to teach 35mm basics step-by-step — completely illustrated. Features the latest cameras. Includes: 35mm automatic, semi-automatic cameras, camera handling, *f*-stops, shutter speeds, and more! $12.95 list, 9x8, 112p, 178 photos, order no. 1051.

Build Your Own Home Darkroom

Lista Duren & Will McDonald

This classic book teaches you how to build a high quality, inexpensive darkroom in your basement, spare room, or almost anywhere. Includes valuable information on: darkroom design, woodworking, tools, and more! $17.95 list, 8½x11, 160p, order no. 1092.

Into Your Darkroom Step-by-Step

Dennis P. Curtin

This is the ideal beginning darkroom guide. Easy to follow and fully illustrated each step of the way. Includes information on: the equipment you'll need, set-up, making proof sheets and much more! $17.95 list, 8½x11, 90p, hundreds of photos, order no. 1093.

Wedding Photographer's Handbook

Robert and Sheila Hurth

A complete step-by-step guide to succeeding in the world of wedding photography. Packed with shooting tips, equipment lists, must-get photo lists, business strategies, and much more! $24.95 list, 8½x11, 176p, index, b&w and color photos, diagrams, order no. 1485.

Lighting for People Photography, 2nd edition

Stephen Crain

A fully up-to-date guide to lighting. Includes: set-ups, equipment information, strobe and natural lighting, and much more! Features diagrams, illustrations, and exercises for practicing the techniques discussed in each chapter. $29.95 list, 8½x11, 112p, b&w and color photos, glossary, index, order no. 1296.

Outdoor and Location Portrait Photography

Jeff Smith

Learn how to work with natural light, select locations, and make clients look their best. Step-by-step discussions and helpful illustrations teach you the techniques you need to shoot outdoor portraits like a pro! $29.95 list, 8½x11, 128p, b&w and color photos, index, order no. 1632.

Make Money with Your Camera

David Arndt

Learn everything you need to know in order to make money in photography! David Arndt shows how to take highly marketable pictures, then promote, price and sell them. Includes all major fields of photography. $29.95 list, 8½x11, 120p, 100 b&w photos, index, order no. 1639.

Guide to International Photographic Competitions

Dr. Charles Benton

Remove the mystery from international competitions with all the information you need to select competitions, enter your work, and use your results for continued improvement and further success! $29.95 list, 8½x11, 120p, b&w photos, index, appendices, order no. 1642.

Freelance Photographer's Handbook

Cliff & Nancy Hollenbeck

Whether you want to be a freelance photographer or are looking for tips to improve your current freelance business, this volume is packed with ideas for creating and maintaining a successful freelance business. $29.95 list, 8½x11, 107p, 100 b&w and color photos, index, glossary, order no. 1633.

Wedding Photography: Creative Techniques for Lighting and Posing

Rick Ferro

Creative techniques for lighting and posing wedding portraits that will set your work apart from the competition. Covers every phase of wedding photography. $29.95 list, 8½x11, 128p, b&w and color photos, index, order no. 1649.

Professional Secrets of Advertising Photography

Paul Markow

No-nonsense information for those interested in the business of advertising photography. Includes: how to catch the attention of art directors, make the best bid, and produce the high-quality images your clients demand. $29.95 list, 8½x11, 128p, 80 photos, index, order no. 1638.

Lighting Techniques for Photographers

Norm Kerr

This book teaches you to predict the effects of light in the final image. It covers the interplay of light qualities, as well as color compensation and manipulation of light and shadow. $29.95 list, 8½x11, 120p, 150+ color and b&w photos, index, order no. 1564.

Infrared Photography Handbook

Laurie White

Covers black and white infrared photography: focus, lenses, film loading, film speed rating, batch testing, paper stocks, and filters. Black & white photos illustrate how IR film reacts. $29.95 list, 8½x11, 104p, 50 b&w photos, charts & diagrams, order no. 1419.

How to Shoot and Sell Sports Photography

David Arndt

A step-by-step guide for amateur photographers, photojournalism students and journalists seeking to develop the skills and knowledge necessary for success in the demanding field of sports photography. $29.95 list, 8½x11, 120p, 111 photos, index, order no. 1631.

How to Operate a Successful Photo Portrait Studio

John Giolas

Combines photographic techniques with practical business information to create a complete guide book for anyone interested in developing a portrait photography business (or improving an existing business). $29.95 list, 8½x11, 120p, 120 photos, index, order no. 1579.

Fashion Model Photography

Billy Pegram

For the photographer interested in shooting commercial model assignments, or working with models to create portfolios. Includes techniques for dramatic composition, posing, selection of clothing, and more! $29.95 list, 8½x11, 120p, 58 photos, index, order no. 1640.

Computer Photography Handbook

Rob Sheppard

Learn to make the most of your photographs using computer technology! From creating images with digital cameras, to scanning prints and negatives, to manipulating images, you'll learn all the basics of digital imaging. $29.95 list, 8½x11, 128p, 150+ photos, index, order no. 1560.

Achieving the Ultimate Image

Ernst Wildi

Ernst Wildi teaches the techniques required to take world class, technically flawless photos. Features: exposure, metering, the Zone System, composition, evaluating an image, and more! $29.95 list, 8½x11, 128p, 120 b&w and color photos, index, order no. 1628.

Black & White Portrait Photography

Helen Boursier

Make money with b&w portrait photography. Learn from top b&w shooters! Studio and location techniques, with tips on preparing your subjects, selecting settings and wardrobe, lab techniques, and more! $29.95 list, 8½x11, 128p, 130+ photos, index, order no. 1626

The Beginner's Guide to Pinhole Photography

Jim Shull

Take pictures with a camera you make from stuff you have around the house. Develop and print the results at home! Pinhole photography is fun, inexpensive, educational and challenging. $17.95 list, 8½x11, 80p, 55 photos, charts & diagrams, order no. 1578.

Stock Photography

Ulrike Welsh

This book provides an inside look at the business of stock photography. Explore photographic techniques and business methods that will lead to success shooting stock photos — creating both excellent images and business opportunities. $29.95 list, 8½x11, 120p, 58 photos, index, order no. 1634.

Profitable Portrait Photography

Roger Berg

A step-by-step guide to making money in portrait photography. Combines information on portrait photography with detailed business plans to form a comprehensive manual for starting or improving your business. $29.95 list, 8½x11, 104p, 100 photos, index, order no. 1570

Professional Secrets for Photographing Children

Douglas Allen Box

Covers every aspect of photographing children on location and in the studio. Prepare children and parents for the shoot, select the right clothes capture a child's personality, and shoot story book themes. $29.95 list, 8½x11, 128p, 74 photos, index, order no. 1635.

Telephoto Lens Photography

Rob Sheppard

A complete guide for telephoto lenses. Shows you how to take great wildlife photos, portraits, sports and action shots, travel pics, and much more! Features over 100 photographic examples. $17.95 list, 8½x11, 112p, b&w and color photos, index, glossary, appendices, order no. 1606.

Handcoloring Photographs Step-by-Step

Sandra Laird & Carey Chambers

Learn to handcolor photographs step-by-step with the new standard in handcoloring reference books. Covers a variety of coloring media and techniques with plenty of colorful photographic examples. $29.95 list, 8½x11, 112p, 100+ color and b&w photos, order no. 1543.

Special Effects Photography Handbook

Elinor Stecker Orel

Create magic on film with special effects! Little or no additional equipment required, use things you probably have around the house. Step-by-step instructions guide you through each effect. $29.95 list, 8½x11, 112p, 80+ color and b&w photos, index, glossary, order no. 1614.

Fine Art Portrait Photography

Oscar Lozoya

The author examines a selection of his best photographs, and provides detailed technical information about how he created each. Lighting diagrams accompany each photograph. $29.95 list, 8½x11, 128p, 58 photos, index, order no. 1630.

Family Portrait Photography

Helen Boursier

Learn from professionals how to operate a successful portrait studio. Includes: marketing family portraits, advertising, working with clients, posing, lighting, and selection of equipment. Includes images from a variety of top portrait shooters. $29.95 list, 8½x11, 120p, 123 photos, index, order no. 1629.

The Art of Infrared Photography, *4th Edition*

Joe Paduano

A practical guide to the art of infrared photography. Tells what to expect and how to control results. Includes: anticipating effects, color infrared, digital infrared, using filters, focusing, developing, printing, handcoloring, toning, and more! $29.95 list, 8½x11, 112p, order no. 1052

The Art of Portrait Photography

Michael Grecco

Michael Grecco reveals the secrets behind his dramatic portraits which have appeared in magazines such as *Rolling Stone* and *Enter-tainment Weekly*. Includes: lighting, posing, creative development, and more! $29.95 list, 8½x11, 128p, order no. 1651.

Essential Skills for Nature Photography

Cub Kahn

Learn all the skills you need to capture landscapes, animals, flowers and the entire natural world on film. Includes: selecting equipment, choosing locations, evaluating compositions, filters, and much more! $29.95 list, 8½x11, 128p, order no. 1652.

Photographer's Guide to Polaroid Transfer

Christopher Grey

Step-by-step instructions make it easy to master Polaroid transfer and emulsion lift-off techniques and add new dimensions to your photographic imaging. Fully illustrated every step of the way to ensure good results the very first time! $29.95 list, 8½x11, 128p, order no. 1653.

Black & White Landscape Photography

John Collett and David Collett

Master the art of b&w landscape photography. Includes: selecting equipment (cameras, lenses, filters, etc.) for landscape photography, shooting in the field, using the Zone System, and printing your images for professional results. $29.95 list, 8½x11, 128p, order no. 1654.

Wedding Photojournalism

Andy Marcus

Learn the art of creating dramatic unposed wedding portraits. Working through the wedding from start to finish you'll learn where to be, what to look for and how to capture it on film. A hot technique for contemporary wedding albums! $29.95 list, 8½x11, 128p, order no. 1656.

Studio Portrait Photography of Children and Babies

Marilyn Sholin

Learn to work with the youngest portrait clients to create images that will be treasured for years to come. Includes tips for working with kids at every developmental stage, from infant to pre-schooler. Features: lighting, posing and much more! $29.95 list, 8½x11, 128p, order no. 1657.

Professional Secrets of Wedding Photography

Douglas Allen Box

Over fifty top-quality portraits are individually analyzed to teach you the art of professional wedding portraiture. Lighting diagrams, posing information and technical specs are included for every image. $29.95 list, 8½x11, 128p, order no. 1658.

Photographer's Guide to Shooting Model & Actor Portfolios

CJ Elfont, Edna Elfont and Alan Lowry

Learn to create outstanding images for actors and models looking for work in fashion, theater, television, or the big screen. Includes the business, photographic and professional information you need to succeed! $29.95 list, 8½x11, 128p, order no. 1659.

Photo Retouching with Adobe Photoshop

Gwen Lute

Designed for photographers, this manual teaches every phase of the process, from scanning to final output. Learn to restore damaged photos, correct imperfections, create realistic composite images and correct for dazzling color. $29.95 list, 8½x11, 128p, order no. 1660.

Creative Lighting Techniques for Studio Photographers

Dave Montizambert

Master studio lighting and gain complete creative control over your images. Whether you are shooting portraits, cars, table-top or any other subject, Dave Montizambert teaches you the skills you need to confidently create with light. $29.95 list, 8½x11, 128p, order no. 1666.

Fine Art Children's Photography

Doris Carol Doyle and Ian Doyle

Learn to create fine art portraits of children in black & white. Included is information on: posing, lighting for studio portraits, shooting on location, clothing selection, working with kids and parents, and much more! $29.95 list, 8½x11, 128p, order no. 1668.

Infrared Portrait Photography

Richard Beitzel

Discover the unique beauty of infrared portraits, and learn to create them yourself. Included is information on: shooting with infrared, selecting subjects and settings, filtration, lighting, and much more! $29.95 list, 8½x11, 128p, order no. 1669.

Black & White Photography for 35mm

Richard Mizdal

A guide to shooting and darkroom techniques! Perfect for beginning or intermediate photo-graphers who wants to improve their skills. Features helpful illustrations and exercises to make every concept clear and easy to follow. $29.95 list, 8½x11, 128p, order no. 1670.

Secrets of Successful Aerial Photography

Richard Eller

Learn how to plan for every aspect of a shoot and take the best possible images from the air. Discover how to control camera movement, compensate for environmental conditions and compose outstanding aerial images. $29.95 list, 8½x11, 120p, order no. 1679.

Professional Secrets of Nature Photography

Judy Holmes

Learn how to improve your nature photography right away with the techniques in this must-have book. Covers every aspect of making top-quality images, from selecting the right equipment, to choosing the best subjects, to shooting techniques for professional results every time. $29.95 list, 8½x11, 120p, order no. 1682.

Macro and Close-up Photography Handbook

Stan Sholik

Learn to get close and capture breathtaking images of small subjects – flowers, stamps, jewelry, insects, etc. Designed with the 35mm shooter in mind, this is a comprehensive manual full of step-by-step techniques. $29.95 list, 8½x11, 120p, order no. 1686.

Photographing Children in Black & White

Helen T. Boursier

Learn the techniques professionals use to capture classic portraits of children (of all ages) in black & white. Discover posing, shooting, lighting and marketing techniques for black & white portraiture in the studio or on location. $29.95 list, 8½x11, 128p, order no. 1676.

Marketing and Selling Black & White Portrait Photography

Helen T. Boursier

A complete manual for adding b&w portraits to the products you offer clients (or offering exclusively b&w photography). Learn how to attract clients and deliver the portraits that will keep them coming back. $29.95 list, 8½x11, 128p, order no. 1677.

Outdoor and Survival Skills for Nature Photographers

Ralph LaPlant and Amy Sharpe

An essential guide for photographing outdoors. Learn all the skills you need to have a safe and productive shoot – from selecting equipment, to finding subjects, to preventing (or dealing with) injury and accidents. $17.95 list, 8½x11, 80p, order no. 1678.

Art and Science of Butterfly Photography

William Folsom

Learn to understand and predict butterfly behavior (including feeding, mating and migrational patterns), when to photograph them and even how to lure butterflies. Then discover the photographic techniques for capturing breathtaking images of these colorful creatures. $29.95 list, 8½x11, 120p, order no. 1680.

Infrared Wedding Photography

Patrick Rice, Barbara Rice & Travis HIll

Step-by-step techniques for adding the dreamy look of black & white infrared to your wedding portraiture. Capture the fantasy of the wedding with unique ethereal portraits your clients will love. $29.95 list, 8½x11, 128p, order no. 1681.

Practical Manual of Captive Animal Photography

Michael Havelin

Learn the environmental and preservational advantages of photographing animals in captivity – as well as how to take dazzling, natural-looking photos of captive subjects (in zoos, preserves, aquariums, etc.). $29.95 list, 8½x11, 120p, order no. 1683.

Composition Techniques from a Master Photographer

Ernst Wildi

In photography, composition can make the difference between dull and dazzling. Master photographer Ernst Wildi teaches you his techniques for evaluating subjects and composing powerful images. $29.95 list, 8½x11, 128p, order no. 1685.

Innovative Technqiues for Wedding Photographers

David Arndt

Spice up your wedding photography (and attract new clients) with dozens of creative techniques from nop-notch professional wedding photographers. $29.95 list, 8½x11, 120p, order no. 1684.

Dramatic Black & White Photography:
Shooting and Darkroom Techniques

J.D. Hayward

Create dramatic fine-art images and portraits with the master b&w techniques in this book. From outstanding lighting techniques to top-notch, creative darkroom work, this book takes b&w to the next level. $29.95 list, 8½x11, 128p, order no. 1687.

Photographing Your Artwork

Russell Hart

A step-by-step guide for taking high-quality slides of artwork for submission to galleries, magazines, grant committees, etc. Learn the best photographic techniques to make your artwork (be it 2D or 3D) look its very best. $29.95 list, 8½x11, 128p, order no. 1688.

AMHERST MEDIA'S CUSTOMER REGISTRATION FORM

Please fill out this sheet and send or fax to receive free information about future publications from Amherst Media.

CUSTOMER INFORMATION

DATE

NAME

STREET OR BOX #

CITY **STATE**

ZIP CODE

PHONE ()

OPTIONAL INFORMATION

I BOUGHT *McBroom's Camera Bluebook* **BECAUSE**

I FOUND THESE CHAPTERS TO BE MOST USEFUL

I PURCHASED THE BOOK FROM

CITY **STATE**

I WOULD LIKE TO SEE MORE BOOKS ABOUT

I PURCHASE **BOOKS PER YEAR**

ADDITIONAL COMMENTS

FAX to: 1-800-622-3298

Name_____
Address_____
City_____State_____
Zip_____ — _____

Place
Postage
Here

Amherst Media, Inc.
PO Box 586
Amherst, NY 14226

FREE

Free Study Tips DVD

In addition to the tips and content in this guide, we have created a FREE DVD with helpful study tips to further assist your exam preparation. **This FREE Study Tips DVD provides you with top-notch tips to conquer your exam and reach your goals.**

Our simple request in exchange for the strategy-packed DVD is that you email us your feedback about our study guide. We would love to hear what you thought about the guide, and we welcome any and all feedback—positive, negative, or neutral. It is our #1 goal to provide you with top-quality products and customer service.

To receive your **FREE Study Tips DVD**, email freedvd@apexprep.com. Please put "FREE DVD" in the subject line and put the following in the email:

a. The name of the study guide you purchased.

b. Your rating of the study guide on a scale of 1-5, with 5 being the highest score.

c. Any thoughts or feedback about your study guide.

d. Your first and last name and your mailing address, so we know where to send your free DVD!

Thank you!

ATI TEAS Test Study Guide 2018 & 2019

ATI TEAS 6 Study Manual 2018-2019 Sixth Edition & Practice Test Questions for the 6th Edition Exam

APEX Test Prep Nursing Team

Table of Contents

Test Taking Strategies

1. Reading the Whole Question

A popular assumption in Western culture is the idea that we don't have enough time for anything. We speed while driving to work, we want to read an assignment for class as quickly as possible, or we want the line in the supermarket to dwindle faster. However, speeding through such events robs us from being able to thoroughly appreciate and understand what's happening around us. While taking a timed test, the feeling one might have while reading a question is to find the correct answer as quickly as possible. Although pace is important, don't let it deter you from reading the whole question. Test writers know how to subtly change a test question toward the end in various ways, such as adding a negative or changing focus. If the question has a passage, carefully read the whole passage as well before moving on to the questions. This will help you process the information in the passage rather than worrying about the questions you've just read and where to find them. A thorough understanding of the passage or question is an important way for test takers to be able to succeed on an exam.

2. Examining Every Answer Choice

Let's say we're at the market buying apples. The first apple we see on top of the heap may *look* like the best apple, but if we turn it over we can see bruising on the skin. We must examine several apples before deciding which apple is the best. Finding the correct answer choice is like finding the best apple. Some exams ask for the *best* answer choice, which means that there are several choices that could be correct, but one choice is always better than the rest. Although it's tempting to choose an answer that seems correct at first without reading the others, it's important to read each answer choice thoroughly before making a final decision on the answer. The aim of a test writer might be to get as close as possible to the correct answer, so watch out for subtle words that may indicate an answer is incorrect. Once the correct answer choice is selected, read the question again and the answer in response to make sure all your bases are covered.

3. Eliminating Wrong Answer Choices

Sometimes we become paralyzed when we are confronted with too many choices. Which frozen yogurt flavor is the tastiest? Which pair of shoes look the best with this outfit? What type of car will fill my needs as a consumer? If you are unsure of which answer would be the best to choose, it may help to use process of elimination. We use "filtering" all the time on sites such as eBay® or Craigslist® to eliminate the ads that are not right for us. We can do the same thing on an exam. Process of elimination is crossing out the answer choices we know for sure are wrong and leaving the ones that might be correct. It may help to cover up the incorrect answer choices with a piece of paper, although if the exam is computer-based, you may have to use your hand or mentally cross out the incorrect answer choices. Covering incorrect choices is a psychological act that alleviates stress due to the brain being exposed to a smaller amount of information. Choosing between two answer choices is much easier than choosing between four or five, and you have a better chance of selecting the correct answer if you have less to focus on.

4. Sticking to the World of the Question

When we are attempting to answer questions, our minds will often wander away from the question and what it is asking. We begin to see answer choices that are true in the real world instead of true in the world of the question. It may be helpful to think of each test question as its own little world. This world may be different from ours. This world may know as a truth that the chicken came before the egg or may

assert that two plus two equals five. Remember that, no matter what hypothetical nonsense may be in the question, assume it to be true. If the question states that the chicken came before the egg, then choose your answer based on that truth. Sticking to the world of the question means placing all of our biases and assumptions aside and relying on the question to guide us to the correct answer. If we are simply looking for answers that are correct based on our own judgment, then we may choose incorrectly. Remember an answer that is true does not necessarily answer the question.

5. Key Words

If you come across a complex test question that you have to read over and over again, try pulling out some key words from the question in order to understand what exactly it is asking. Key words may be words that surround the question, such as *main idea, analogous, parallel, resembles, structured,* or *defines.* The question may be asking for the main idea, or it may be asking you to define something. Deconstructing the sentence may also be helpful in making the question simpler before trying to answer it. This means taking the sentence apart and obtaining meaning in pieces, or separating the question from the foundation of the question. For example, let's look at this question:

> Given the author's description of the content of paleontology in the first paragraph, which of the following is most parallel to what it taught?

The question asks which one of the answers most *parallels* the following information: The *description* of paleontology in the first paragraph. The first step would be to see *how* paleontology is described in the first paragraph. Then, we would find an answer choice that parallels that description. The question seems complex at first, but after we deconstruct it, the answer becomes much more attainable.

6. Subtle Negatives

Negative words in question stems will be words such as *not, but, neither,* or *except.* Test writers often use these words in order to trick unsuspecting test takers into selecting the wrong answer—or, at least, to test their reading comprehension of the question. Many exams will feature the negative words in all caps (*which of the following is NOT an example*), but some questions will add the negative word seamlessly into the sentence. The following is an example of a subtle negative used in a question stem:

> According to the passage, which of the following is *not* considered to be an example of paleontology?

If we rush through the exam, we might skip that tiny word, *not,* inside the question, and choose an answer that is opposite of the correct choice. Again, it's important to read the question fully, and double check for any words that may negate the statement in any way.

7. Spotting the Hedges

The word "hedging" refers to language that remains vague or avoids absolute terminology. Absolute terminology consists of words like *always, never, all, every, just, only, none,* and *must.* Hedging refers to words like *seem, tend, might, most, some, sometimes, perhaps, possibly, probability,* and *often.* In some cases, we want to choose answer choices that use hedging and avoid answer choices that use absolute terminology. Of course, this always depends on what subject you are being tested on. Humanities subjects like history and literature will contain hedging, because those subjects often do not have absolute answers. However, science and math may contain absolutes that are necessary for the question to be answered. It's important to pay attention to what subject you are on and adjust your response accordingly.

8. Restating to Understand

Every now and then we come across questions that we don't understand. The language may be too complex, or the question is structured in a way that is meant to confuse the test taker. When you come across a question like this, it may be worth your time to rewrite or restate the question in your own words in order to understand it better. For example, let's look at the following complicated question:

> Which of the following words, if substituted for the word *parochial* in the first paragraph, would LEAST change the meaning of the sentence?

Let's restate the question in order to understand it better. We know that they want the word *parochial* replaced. We also know that this new word would "least" or "not" change the meaning of the sentence. Now let's try the sentence again:

> Which word could we replace with *parochial*, and it would not change the meaning?

Restating it this way, we see that the question is asking for a synonym. Now, let's restate the question so we can answer it better:

> Which word is a synonym for the word *parochial*?

Before we even look at the answer choices, we have a simpler, restated version of a complicated question. Remember that, if you have paper, you can always rewrite the simpler version of the question so as not to forget it.

9. Guessing

When is it okay to guess on an exam? This question depends on the test format of the particular exam you're taking. On some tests, answer choices that are answered incorrectly are penalized. If you know that you are penalized for wrong answer choices, avoid guessing on the test question. If you can narrow the question down to fifty percent by process of elimination, then perhaps it may be worth it to guess between two answer choices. But if you are unsure of the correct answer choice among three or four answers, it may help to leave the question unanswered. Likewise, if the exam you are taking does *not* penalize for wrong answer choices, answer the questions first you know to be true, then go back through and mark an answer choice, even if you do not know the correct answer. This way, you will at least have a one in four chance of getting the answer correct. It may also be helpful to do some research on the exam you plan to take in order to understand how the questions are graded.

10. Avoiding Patterns

One popular myth in grade school relating to standardized testing is that test writers will often put multiple-choice answers in patterns. A runoff example of this kind of thinking is that the most common answer choice is "C," with "B" following close behind. Or, some will advocate certain made-up word patterns that simply do not exist. Test writers do not arrange their correct answer choices in any kind of pattern; their choices are randomized. There may even be times where the correct answer choice will be the same letter for two or three questions in a row, but we have no way of knowing when or if this might happen. Instead of trying to figure out what choice the test writer probably set as being correct, focus on what the *best answer choice* would be out of the answers you are presented with. Use the tips above, general knowledge, and reading comprehension skills in order to best answer the question, rather than looking for patterns that do not exist.

FREE DVD OFFER

Achieving a high score on your exam depends not only on understanding the content, but also on understanding how to apply your knowledge and your command of test taking strategies. **Because your success is our primary goal, we offer a FREE Study Tips DVD. It provides top-notch test taking strategies to help you optimize your testing experience.**

Our simple request in exchange for the strategy-packed DVD is that you email us your feedback about our study guide.

To receive your **FREE Study Tips DVD**, email freedvd@apexprep.com. Please put "FREE DVD" in the subject line and put the following in the email:

 a. The name of the study guide you purchased.

 b. Your rating of the study guide on a scale of 1-5, with 5 being the highest score.

 c. Any thoughts or feedback about your study guide.

 d. Your first and last name and your mailing address, so we know where to send your free DVD!

ATI TEAS Overview

Function of the Test

The TEAS test is a standardized Test of Essential Academic Skills given by the Assessment Technologies Institute (ATI) Nursing Education. Those who want to be considered for admissions into nursing school or an allied health school must take the TEAS as part of an overall assessment of qualification for the program. The TEAS test is nationwide and offered in both the United States and Canada. The newest version of the TEAS is called the ATI TEAS.

The TEAS test is very important in determining admissions to nursing programs, although the preferred score by nursing schools varies. The TEAS can be taken by students wishing to be considered for a nursing or health program, or for professionals already in the industry who want to advance their certification.

Test Administration

The TEAS test is offered by ATI Testing in PSI testing centers or at nursing schools or allied health schools at least once a week all year round. You can determine where these centers are by visiting the PSI exam's website directly or through beginning registration through atitesting.com. Once you start your registration for the TEAS, you will be shown various testing locations to choose from by city and state, ranging from metropolitan cities to less-populated towns. Retaking the test is permitted, but the rules vary by school. Disability accommodations can be made available by contacting the testing administration site.

Test Format

Once you present your ID to the staff, you will have a seat in the testing area. The format of the exam can either be computerized or on paper. Keep in mind that proctors will be standing around the room to monitor for disruption. The proctor will provide you with a calculator and scratch paper.

Breaks will begin at the end of each section. Other than these breaks, the testing clock will not stop. The staff at the administration center ask that you raise your hand for any kind of issues with the test. The following table depicts the sections on the TEAS, the number of questions, and the time limit given for each section:

Subject	Questions	Time
Reading	53	64 minutes
Math	36	54 minutes
Science	53	63 minutes
English and Language Usage	28	28 minutes
Total	**170**	**209 minutes**

Scoring

Scores are available immediately after taking the online version of the test. For those who take the paper version of the test, ATI Nursing Education will process the scores within 48 hours of receiving the test. The scores will provide your total scores, the individual content scores, and which specific topic areas were missed. Nursing programs all have a different minimum of TEAS scores required for admission into the program, so you will have to check with the appropriate schools. Nursing programs typically look at the

composite score listed at the top of the score report. The report will also show the national mean and the program mean—the national mean composite score is usually between a 65% and a 75%.

Recent/Future Developments

The ATI TEAS is the sixth version of the test and was released in August 2016. Calculators may now be used on the newest version of the test. The ATI TEAS is the same difficulty level but has slightly different topic areas than its predecessor. The English and Language Usage section has been reduced, with the elimination of the Earth Science subsection.

Reading

Key Ideas and Details

Summarizing a Complex Text

An important skill is the ability to read a complex text and then reduce its length and complexity by focusing on the key events and details. A summary is a shortened version of the original text, written by the reader in their own words. The summary should be shorter than the original text, and it must be thoughtfully formed to include critical points from the original text.

In order to effectively summarize a complex text, it's necessary to understand the original source and identify the major points covered. It may be helpful to outline the original text to get the big picture and avoid getting bogged down in the minor details. For example, a summary wouldn't include a statistic from the original source unless it was the major focus of the text. It's also important for readers to use their own words, yet retain the original meaning of the passage. The key to a good summary is emphasizing the main idea without changing the focus of the original information.

The more complex a text, the more difficult it can be to summarize. Readers must evaluate all points from the original source and then filter out what they feel are the less necessary details. Only the essential ideas should remain. The summary often mirrors the original text's organizational structure. For example, in a problem-solution text structure, the author typically presents readers with a problem and then develops solutions through the course of the text. An effective summary would likely retain this general structure, rephrasing the problem and then reporting the most useful or plausible solutions.

Paraphrasing is somewhat similar to summarizing. It calls for the reader to take a small part of the passage and list or describe its main points. Paraphrasing is more than rewording the original passage, though. Like summary, it should be written in the reader's own words, while still retaining the meaning of the original source. The main difference between summarizing and paraphrasing is that a summary would be appropriate for a much larger text, while paraphrase might focus on just a few lines of text. Effective paraphrasing will indicate an understanding of the original source, yet still help the reader expand on their interpretation. A paraphrase should neither add new information nor remove essential facts that change the meaning of the source.

Inferring the Logical Conclusion from a Reading Selection

Making an inference from a selection means to make an educated guess from the passage read. Inferences should be conclusions based off of sound evidence and reasoning. When multiple-choice test questions ask about the logical conclusion that can be drawn from reading text, the test-taker must identify which choice will unavoidably lead to that conclusion. In order to eliminate the incorrect choices, the test-taker should come up with a hypothetical situation wherein an answer choice is true, but the conclusion is not true.

For example, here is an example with three answer choices:

> Fred purchased the newest PC available on the market. Therefore, he purchased the most expensive PC in the computer store.
>
> What can one assume for this conclusion to follow logically?
>
> a. Fred enjoys purchasing expensive items.
> b. PCs are some of the most expensive personal technology products available.
> c. The newest PC is the most expensive one.

The premise of the text is the first sentence: Fred purchased the newest PC. The conclusion is the second sentence: Fred purchased the most expensive PC. Recent release and price are two different factors; the difference between them is the logical gap. To eliminate the gap, one must equate whatever new information the conclusion introduces with the pertinent information the premise has stated. This example simplifies the process by having only one of each: one must equate product recency with product price. Therefore, a possible bridge to the logical gap could be a sentence stating that the newest PCs always cost the most.

Identifying the Topic, Main Idea, and Supporting Details

The *topic* of a text is the general subject matter. Text topics can usually be expressed in one word, or a few words at most. Additionally, readers should ask themselves what point the author is trying to make. This point is the *main* idea of the text, the one thing the author wants readers to know concerning the topic. Once the author has established the main idea, they will support the main idea by supporting details. Supporting details are evidence that support the main idea and include personal testimonies, examples, or statistics.

One analogy for these components and their relationships is that a text is like a well-designed house. The topic is the roof, covering all rooms. The main idea is the frame. The supporting details are the various rooms. To identify the topic of a text, readers can ask themselves what or who the author is writing about in the paragraph. To locate the main idea, readers can ask themselves what one idea the author wants readers to know about the topic. To identify supporting details, readers can put the main idea into question form and ask "what does the author use to prove or explain their main idea?"

Let's look at an example. An author is writing an essay about the Amazon rainforest and trying to convince the audience that more funding should go into protecting the area from deforestation. The author makes the argument stronger by including evidence of the benefits of the rainforest: it provides habitats to a variety of species, it provides much of the earth's oxygen which in turn cleans the atmosphere, and it is the home to medicinal plants that may be the answer to some of the world's deadliest diseases.

Here is an outline of the essay looking at topic, main idea, and supporting details:

Topic: Amazon rainforest
Main Idea: The Amazon rainforest should receive more funding in order to protect it from deforestation.
Supporting Details:
 1. It provides habitats to a variety of species
 2. It provides much of the earth's oxygen which in turn cleans the atmosphere
 3. It is home to medicinal plants that may be the answer to some of the world's deadliest diseases.

Notice that the topic of the essay is listed in a few key words: "Amazon rainforest". The main idea tells us what about the topic is important: that the topic should be funded in order to prevent deforestation. Finally, the supporting details are what author relies on to convince the audience to act or to believe in the truth of the main idea.

Following a Given Set of Directions

To follow directions, an individual must hold them in short-term memory while using working memory and language to comprehend the information. Certain word types are found more often than others in directions; these include adjectives, negatives, conjunctions, and prepositions. Understanding the concepts that these word types represent is important, especially in academics. For example, the CELF (Clinical Evaluation of Language Fundamentals) subtest on Concepts and Following Directions is one of most frequently administered assessment instruments for evaluating how well people follow directions, and almost every item on this subtest combines negatives, conjunctions, and prepositions. Being able to follow a direction requires understanding of the direction's specific words. Even single-step directions can be challenging, especially when they contain negatives ("Do *not* circle the even-numbered items"). In addition to language comprehension, the ability to follow directions requires interest in the activity, motivation to follow the directions, and paying attention to the directions.

Basic one-step directions use simple syntax and kid's earliest learned words, like the following:

- Give me the cup
- Tie your shoe
- Say your name
- Close the door
- Throw that away

Expanded one-step directions add a few negatives, contractions, and slightly more advanced vocabulary, like the following:

- Don't touch the blue one
- Show me which one is not yellow
- Use the bigger pen
- Throw all of your trash away
- Take out your small, green notebook

Basic two-step directions include one basic conjunction, or one added phrase, like the following:

- Take off your socks and put them in the hamper
- Close the door and then sit down

- Write your name on the test before beginning
- Give me the glass that is empty

Expanded two-step directions have a structure added to two steps, like the following:

Throw your partner's trash away before you start the assignment

Complex directions include vocabulary and syntax that develop later, plus multiple clauses, like the following:

Please turn off all cell phones after you have taken your seats

The following example shows why it's extremely important to read all the directions in a test setting first before acting on any of them. Follow the directions below:

1. Carefully read everything in the directions before you do anything.
2. Write your name on the top of this page.
3. Put your birthday and date underneath your name.
4. Write an "Z" on an empty space anywhere on the page.
5. Circle the "Z" and draw a line below it referring to "Y."
6. Draw a line from "Y" referring to "X."
7. Draw a box at the bottom of this page.
8. Describe the shape you drew around the letters inside the box.
9. Write your name inside the box.
10. Now that you've carefully read everything, follow only directions (1) and (2).

Those who get to direction 10 without having acted on any instructions yet will save a lot of wasted time opposed to those who immediately begin to act on the instructions. Remember, read all the directions before you begin, and you will have a better idea of what the bigger picture entails!

Identifying Specific Information from a Printed Communication

Business Memos

Whereas everyday office memos were traditionally typed on paper, photocopied, and distributed, today they are more often typed on computers and distributed via e-mail, both interoffice and externally. Technology has thus made these communications more immediate. It is also helpful for people to read carefully and be familiar with memo components. For example, e-mails automatically provide the same "To:, From:, and Re:" lines traditionally required in paper memos, and in corresponding places—the top of the page/screen. Readers should observe whether "To: names/positions" include all intended recipients in case of misdirection errors or omitted recipients. "From:" informs sender level, role, and who will receive responses when people click "Reply." Users must be careful not to click "Reply All" unintentionally. They should also observe the "CC:" line, typically below "Re:," showing additional recipients.

Classified Ads

Classified advertisements include "Help Wanted" ads informing readers of positions open for hiring, real estate listings, cars for sale, and home and business services available. Traditional ads in newspapers had to save space, and this necessity has largely transferred to online ads. Because of needing to save space, advertisers employ many abbreviations. For example, here are some examples of abbreviations:

- FT=full-time
- PT=part-time

- A/P=accounts payable
- A/R=accounts receivable
- Asst.=assistant
- Bkkg.=bookkeeping
- Comm.=commission
- Bet.=between
- EOE=equal opportunity employer
- G/L=general ledger
- Immed.=immediately
- Exc.=excellent
- Exp.=experience
- Eves.=evenings
- Secy.=secretary
- Temp=temporary
- Sal=salary
- Req=required
- Refs=references
- Wk=week or work
- WPM=words per minute

Classified ads frequently use abbreviations to take up less space, both on paper and digitally on websites. Those who read these ads will find it less confusing if they learn some common abbreviations used by businesses when advertising job positions. Here are some examples:

- Mgt.=management
- Mgr.=manager
- Mfg.=manufacturing
- Nat'l=national
- Dept.=department
- Min.=minimum
- Yrs.=years
- Nec=necessary
- Neg=negotiable
- Oppty=opportunity
- O/T=overtime
- K=1,000

Readers of classified ads may focus on certain features to the exclusion of others. For example, if a reader sees the job title or salary they are seeking, or notices the experience, education, degree, or other credentials required match their own qualifications perfectly, they may fail to notice other important information, like "No benefits." This is important because the employers are disclosing that they will not provide health insurance, retirement accounts, paid sick leave, paid maternity/paternity leave, paid vacation, etc. to any employee whom they hire. Someone expecting a traditional 9 to 5 job who fails to observe that an ad states "Evenings" or just the abbreviation "Eves" will be disappointed, as will the applicant who overlooks a line saying "Some evenings and weekends reqd." Applicants overlooking information like "Apply in person" may e-mail or mail their resumes and receive no response. The job hopeful with no previous experience and one reference must attend to information like "Minimum 5 yrs. exp, 3 refs," meaning they likely will not qualify.

Employment Ads

Job applicants should pay attention to the information included in classified employment ads. On one hand, they do need to believe and accept certain statements, such as "Please, no phone calls," which is frequently used by employers posting ads on Craigslist and similar websites. New applicants just graduated from or still in college will be glad to see "No exp necessary" in some ads, indicating they need no previous work experience in that job category. "FT/PT" means the employer offers the options of working full-time or part-time, another plus for students. On the other hand, ad readers should also take into consideration the fact that many employers list all the attributes of their *ideal* employee, but they do not necessarily expect to find such a candidate. If a potential applicant's education, training, credentials, and experience are not exactly the same as what the employer lists as desired but are not radically different either, it can be productive to apply anyway, while honestly representing one's actual qualifications.

Atlases

A road atlas is a publication designed to assist travelers who are driving on road trips rather than taking airplanes, trains, ships, etc. Travelers use road atlases to determine which routes to take and places to stop; how to navigate specific cities, locate landmarks, estimate mileages and travel times; see photographs of places they plan to visit; and find other travel-related information. One familiar, reputable road atlas is published by the National Geographic Society. It includes detailed, accurate maps of the United States, Canada, and Mexico; historic sites, scenic routes, recreation information, and points of interest; and its Adventure Edition spotlights 100 top U.S. adventure destinations and most popular national parks. The best-selling road atlas in the United States, also probably the best-known and most trusted, is published annually by Rand McNally, which has published road atlases for many years. It includes maps, mileage charts, information on tourism and road construction, maps of individual city details, and the editor's favorite road trips (in the 2016 edition) including recommended points of interest en route.

Owners' Manuals

An owner's manual is typically a booklet, but may also be as short as a page or as long as a book, depending on the individual instance. The purpose of an owner's manual is to give the owner instructions, usually step-by-step, for how to use a specific product or a group or range of products. Manuals accompany consumer products as diverse as cars, computers, tablets, smartphones, printers, home appliances, shop machines, and many others. In addition to directions for operating products, they include important warnings of things *not* to do that pose safety or health hazards or can damage the product and void the manufacturer's product warranty, like immersion in water, exposure to high temperatures, operating something for too long, dropping fragile items, or rough handling. Manuals teach correct operating practices, sequences, precautions, and cautions, averting many costly and/or dangerous mishaps.

Food Labels

When reading the labels on food products, it is often necessary to interpret the nutrition facts and other product information. Without the consumer's being aware and informed of this, much of this information can be very misleading. For example, a popular brand name of corn chips lists the calories, fat, etc. per serving in the nutrition facts printed on the bag, but on closer inspection, it defines a serving size as six chips—far fewer than most people would consume at a time. Serving sizes and the number of servings per container can be unrealistic. For example, a jumbo muffin's wrapper indicates it contains three servings. Not only do most consumers not divide a muffin and eat only part; but it is moreover rather difficult to cut a muffin into equal thirds. A king-sized package of chili cheese-flavored corn chips says it

contains 4.5 servings per container. This is not very useful information, since people cannot divide the package into equal servings and are unlikely to eat four servings and then ½ a serving.

Product Packaging

Consumers today cannot take product labels at face value. While many people do not read or even look at the information on packages before eating their contents, those who do must use more consideration and analysis than they might expect to understand it. For example, a well-known brand of strawberry-flavored breakfast toaster pastry displays a picture of four whole strawberries on the wrapper. While this looks appealing, encouraging consumers to infer the product contains wholesome fruit—and perhaps even believe it contains four whole strawberries—reading the ingredients list reveals it contains only 2 percent or less of dried strawberries. A consumer must be detail-oriented (and curious or motivated enough) to read the full ingredients list, which also reveals unhealthy corn syrup and high fructose corn syrup high on the list after enriched flour. Consumers must also educate themselves about euphemistically misleading terms: "enriched" flour has vitamins and minerals added, but it is refined flour without whole grain, bran, or fiber.

While manufacturers generally provide extensive information printed on their package labels, it is typically in very small print—many consumers do not read it—and even consumers who do read all the information must look for small details to discover that the information is often not realistic. For example, a box of brownie mix lists grams of fat, total calories, and calories from fat. However, by paying attention to small details like asterisks next to this information, and finding the additional information referenced by the asterisks, the consumer discovers that these amounts are for only the dry mix—not the added eggs, oil, or milk. Consumers typically do not eat dry cake mixes, and having to determine and add the fat and calories from the additional ingredients is inconvenient. In another example, a box of macaroni and cheese mix has an asterisk by the fat grams indicating these are for the macaroni only without the cheese, butter, or milk required, which contributes 6.4 times more fat.

Ingredients' Lists

Consumers can realize the importance of reading drug labeling through an analogy: What might occur if they were to read only part of the directions on a standardized test? Reading only part of the directions on medications can have similar, even more serious consequences. Prescription drug packages typically contain inserts, which provide extremely extensive, thorough, detailed information, including results of clinical trials and statistics showing patient responses and adverse effects. Some over-the-counter medications include inserts, and some do not. "Active ingredients" are those ingredients making medication effective. "Inactive ingredients" including flavorings, preservatives, stabilizers, and emulsifiers have purposes, but not to treat symptoms. "Uses" indicates which symptoms a medication is meant to treat. "Directions" tell the dosage, frequency, maximum daily amount, and other requirements, like "Take with food," "Do not operate heavy machinery while using," etc. Drug labels also state how to store the product, like at what temperature or away from direct sunlight or humidity.

Many drugs which were previously available only by doctor prescription have recently become available over the counter without a prescription. While enough years of testing may have determined that these substances typically do not cause serious problems, consumers must nevertheless thoroughly read and understand all the information on the labels before taking them. If they do not, they could still suffer serious harm. For example, some individuals have allergies to specific substances. Both prescription and over-the-counter medication products list their ingredients, including warnings about allergies. Allergic reactions can include anaphylactic shock, which can be fatal if not treated immediately. Also, consumers must read and follow dosing directions: taking more than directed can cause harm, and taking less can be ineffective to treat symptoms. Some medication labels warn not to mix them with certain other drugs to

avoid harmful drug interactions. Additionally, without reading ingredients, some consumers take multiple products including the same active ingredients, resulting in overdoses.

Identifying Information from a Graphic Representation of Information

Line Graphs

Line graphs are useful for visually representing data that vary continuously over time, like an individual student's test scores. The horizontal or x-axis shows dates/times; the vertical or y-axis shows point values. A dot is plotted on the point where each horizontal date line intersects each vertical number line, and then these dots are connected, forming a line. Line graphs show whether changes in values over time exhibit trends like ascending, descending, flat, or more variable, like going up and down at different times. For example, suppose a student's scores on the same type of reading test were 75% in October, 80% in November, 78% in December, 82% in January, 85% in February, 88% in March, and 90% in April. A line graph of these scores would look like this.

Bar Graphs

Bar graphs feature equally spaced, horizontal or vertical rectangular bars representing numerical values. They can show change over time as line graphs do, but unlike line graphs, bar graphs can also show differences and similarities among values at a single point in time. Bar graphs are also helpful for visually representing data from different categories, especially when the horizontal axis displays some value that is not numerical, like basketball players with their heights:

Pie Charts

Pie charts, also called circle graphs, are good for representing percentages or proportions of a whole quantity because they represent the whole as a circle or "pie", with the various proportion values shown as "slices" or wedges of the pie. This gives viewers a clear idea of how much of a total each item occupies. For example, biologists may have information that 62% of dogs have brown eyes, 20% have green eyes, and 18% have blue eyes. A pie chart of these distributions would look like this:

Pictograms

Magazines, newspapers, and other similar publications designed for consumption by the general public often use pictograms to represent data. Pictograms feature icons or symbols that look like whatever category of data is being counted, like little silhouettes shaped like human beings commonly used to represent people. If the data involve large numbers, like populations, one person symbol might represent one million people, or one thousand, etc. For smaller values, such as how many individuals out of ten fit a given description, one symbol might equal one person. Male and female silhouettes are used to differentiate gender, and child shapes for children. Little clock symbols are used to represent amounts of time, such as a given number of hours; calendar pages might depict months; suns and moons could show days and nights; hourglasses might represent minutes. While pictogram symbols are easily recognizable and appealing to general viewers, one disadvantage is that it is difficult to display partial symbols for in-between quantities.

Recognizing Events in a Sequence

Sequence structure is the order of events in which a story or information is presented to the audience. Sometimes the text will be presented in chronological order, or sometimes it will be presented by displaying the most recent information first, then moving backwards in time. The sequence structure depends on the author, the context, and the audience. The structure of a text also depends on the genre in which the text is written. Is it literary fiction? Is it a magazine article? Is it instructions for how to complete a certain task? Different genres will have different purposes for switching up the sequence of their writing.

Narrative Structure

The structure presented in literary fiction is also known as *narrative structure*. Narrative structure is the foundation on which the text moves. The basic ways for moving the text along are in the plot and the setting. The plot is the sequence of events in the narrative that move the text forward through cause and effect. The setting of a story is the place or time period in which the story takes place. Narrative structure has two main categories: linear and nonlinear.

Linear Narrative

Linear narrative is a narrative told in chronological order. Traditional linear narratives will follow the plot diagram below depicting the narrative arc. The narrative arc consists of the exposition, conflict, rising action, climax, falling action, and resolution.

- Exposition: The exposition is in the beginning of a narrative and introduces the characters, setting, and background information of the story. The importance of the exposition lies in its framing of the upcoming narrative. Exposition literally means "a showing forth" in Latin.

- Conflict: The conflict, in a traditional narrative, is presented toward the beginning of the story after the audience becomes familiar with the characters and setting. The conflict is a single instance between characters, nature, or the self, in which the central character is forced to make a decision or move forward with some kind of action. The conflict presents something for the main character, or protagonist, to overcome.

- Rising Action: The rising action is the part of the story that leads into the climax. The rising action will feature the development of characters and plot, and creates the tension and suspense that eventually lead to the climax.

- Climax: The climax is the part of the story where the tension produced in the rising action comes to a culmination. The climax is the peak of the story. In a traditional structure, everything before the climax builds up to it, and everything after the climax falls from it. It is the height of the narrative, and is usually either the most exciting part of the story or is marked by some turning point in the character's journey.

- Falling Action: The falling action happens as a result of the climax. Characters continue to develop, although there is a wrapping up of loose ends here. The falling action leads to the resolution.

- Resolution: The resolution is where the story comes to an end and usually leaves the reader with the satisfaction of knowing what happened within the story and why. However, stories do not always end in this fashion. Sometimes readers can be confused or frustrated at the end from lack of information or the absence of a happy ending.

Nonlinear Narrative

A nonlinear narrative deviates from the traditional narrative in that it does not always follow the traditional plot structure of the narrative arc. Nonlinear narratives may include structures that are disjointed, circular, or disruptive, in the sense that they do not follow chronological order, but rather a nontraditional order of structure. *In medias res* is an example of a structure that predates the linear narrative. *In medias res* is Latin for "in the middle of things," which is how many ancient texts, especially epic poems, began their story, such as Homer's *Iliad*. Instead of having a clear exposition with a full development of characters, they would begin right in the middle of the action.

Modernist texts in the late nineteenth and early twentieth century are known for their experimentation with disjointed narratives, moving away from traditional linear narrative. Disjointed narratives are depicted in novels like *Catch 22*, where the author, Joseph Heller, structures the narrative based on free association of ideas rather than chronology. Another nonlinear narrative can be seen in the novel *Wuthering Heights*, written by Emily Bronte, which disrupts the chronological order by being told retrospectively after the first chapter. There seem to be two narratives in *Wuthering Heights* working at the same time: a present narrative as well as a past narrative. Authors employ disrupting narratives for various reasons; some use it

for the purpose of creating situational irony for the readers, while some use it to create a certain effect in the reader, such as excitement, or even a feeling of discomfort or fear.

Sequence Structure in Technical Documents

The purpose of technical documents, such as instructions manuals, cookbooks, or "user-friendly" documents, is to provide information to users as clearly and efficiently as possible. In order to do this, the sequence structure in technical documents that should be used is one that is as straightforward as possible. This usually involves some kind of chronological order or a direct sequence of events. For example, someone who is reading an instruction manual on how to set up their Smart TV wants directions in a clear, simple, straightforward manner that does not leave the reader to guess at the proper sequence or lead to confusion.

Sequence Structure in Informational Texts

The structure in informational texts depends again on the genre. For example, a newspaper article may start by stating an exciting event that happened, and then move on to talk about that event in chronological order, known as *sequence* or *order structure*. Many informational texts also use *cause and effect structure*, which describes an event and then identifies reasons for why that event occurred. Some essays may write about their subjects by way of *comparison and contrast*, which is a structure that compares two things or contrasts them to highlight their differences. Other documents, such as proposals, will have a *problem to solution structure*, where the document highlights some kind of problem and then offers a solution toward the end. Finally, some informational texts are written with lush details and description in order to captivate the audience, allowing them to visualize the information presented to them. This type of structure is known as *descriptive*.

Craft and Structure

Distinguishing Between Fact and Opinion, Biases, and Stereotypes

Facts and Opinions

A fact is a statement that is true empirically or an event that has actually occurred in reality, and can be proven or supported by evidence; it is generally objective. In contrast, an opinion is subjective, representing something that someone believes rather than something that exists in the absolute. People's individual understandings, feelings, and perspectives contribute to variations in opinion. Though facts are typically objective in nature, in some instances, a statement of fact may be both factual and yet also subjective. For example, emotions are individual subjective experiences. If an individual says that they feel happy or sad, the feeling is subjective, but the statement is factual; hence, it is a subjective fact. In contrast, if one person tells another that the other is feeling happy or sad—whether this is true or not—that is an assumption or an opinion.

Biases

Biases usually occur when someone allows their personal preferences or ideologies to interfere with what should be an objective decision. In personal situations, someone is biased towards someone if they favor them in an unfair way. In academic writing, being biased in your sources means leaving out objective information that would turn the argument one way or the other. The evidence of bias in academic writing makes the text less credible, so be sure to present all viewpoints when writing, not just your own, so to avoid coming off as biased. Being objective when presenting information or dealing with people usually allows the person to gain more credibility.

Stereotypes

Stereotypes are preconceived notions that place a particular rule or characteristics on an entire group of people. Stereotypes are usually offensive to the group they refer to or allies of that group, and often have negative connotations. The reinforcement of stereotypes isn't always obvious. Sometimes stereotypes can be very subtle and are still widely used in order for people to understand categories within the world. For example, saying that women are more emotional and intuitive than men is a stereotype, although this is still an assumption used by many in order to understand the differences between one another.

Recognizing the Structure of Texts in Various Formats

Text structure is the way in which the author organizes and presents textual information so readers can follow and comprehend it. One kind of text structure is sequence. This means the author arranges the text in a logical order from beginning to middle to end. There are three types of sequences:

- Chronological: ordering events in time from earliest to latest

- Spatial: describing objects, people, or spaces according to their relationships to one another in space

- Order of Importance: addressing topics, characters, or ideas according to how important they are, from either least important to most important

Chronological sequence is the most common sequential text structure. Readers can identify sequential structure by looking for words that signal it, like *first, earlier, meanwhile, next, then, later, finally;* and specific times and dates the author includes as chronological references.

Problem-Solution Text Structure

The problem-solution text structure organizes textual information by presenting readers with a problem and then developing its solution throughout the course of the text. The author may present a variety of alternatives as possible solutions, eliminating each as they are found unsuccessful, or gradually leading up to the ultimate solution. For example, in fiction, an author might write a murder mystery novel and have the character(s) solve it through investigating various clues or character alibis until the killer is identified. In nonfiction, an author writing an essay or book on a real-world problem might discuss various alternatives and explain their disadvantages or why they would not work before identifying the best solution. For scientific research, an author reporting and discussing scientific experiment results would explain why various alternatives failed or succeeded.

Comparison-Contrast Text Structure

Comparison identifies similarities between two or more things. *Contrast* identifies differences between two or more things. Authors typically employ both to illustrate relationships between things by highlighting their commonalities and deviations. For example, a writer might compare Windows and Linux as operating systems, and contrast Linux as free and open-source vs. Windows as proprietary. When writing an essay, sometimes it is useful to create an image of the two objects or events you are comparing or contrasting. Venn diagrams are useful because they show the differences as well as the similarities between two things. Once you've seen the similarities and differences on paper, it might be helpful to create an outline of the essay with both comparison and contrast. Every outline will look different, because every two or more things will have a different number of comparisons and contrasts. Say you are trying to compare and contrast carrots with sweet potatoes.

Here is an example of a compare/contrast outline using those topics:

- Introduction: Talk about why you are comparing and contrasting carrots and sweet potatoes. Give the thesis statement.
- Body paragraph 1: Sweet potatoes and carrots are both root vegetables (similarity)
- Body paragraph 2: Sweet potatoes and carrots are both orange (similarity)
- Body paragraph 3: Sweet potatoes and carrots have different nutritional components (difference)
- Conclusion: Restate the purpose of your comparison/contrast essay.

Of course, if there is only one similarity between your topics and two differences, you will want to rearrange your outline. Always tailor your essay to what works best with your topic.

Descriptive Text Structure

Description can be both a type of text structure and a type of text. Some texts are descriptive throughout entire books. For example, a book may describe the geography of a certain country, state, or region, or tell readers all about dolphins by describing many of their characteristics. Many other texts are not descriptive throughout, but use descriptive passages within the overall text. The following are a few examples of descriptive text:

- When the author describes a character in a novel
- When the author sets the scene for an event by describing the setting
- When a biographer describes the personality and behaviors of a real-life individual
- When a historian describes the details of a particular battle within a book about a specific war
- When a travel writer describes the climate, people, foods, and/or customs of a certain place

A hallmark of description is using sensory details, painting a vivid picture so readers can imagine it almost as if they were experiencing it personally.

Cause and Effect Text Structure

When using cause and effect to extrapolate meaning from text, readers must determine the cause when the author only communicates effects. For example, if a description of a child eating an ice cream cone includes details like beads of sweat forming on the child's face and the ice cream dripping down her hand faster than she can lick it off, the reader can infer or conclude it must be hot outside. A useful technique for making such decisions is wording them in "If...then" form, e.g. "If the child is perspiring and the ice cream melting, it may be a hot day." Cause and effect text structures explain why certain events or actions resulted in particular outcomes. For example, an author might describe America's historical large flocks of dodo birds, the fact that gunshots did not startle/frighten dodos, and that because dodos did not flee, settlers killed whole flocks in one hunting session, explaining how the dodo was hunted into extinction.

Interpreting the Meaning of Words and Phrases Using Context

When readers encounter an unfamiliar word in text, they can use the surrounding context—the overall subject matter, specific chapter/section topic, and especially the immediate sentence context. Among others, one category of context clues is grammar. For example, the position of a word in a sentence and its relationship to the other words can help the reader establish whether the unfamiliar word is a verb, a noun, an adjective, an adverb, etc. This narrows down the possible meanings of the word to one part of speech. However, this may be insufficient. In a sentence that many birds *migrate* twice yearly, the reader can determine the word is a verb, and probably does not mean eat or drink; but it could mean travel, mate, lay eggs, hatch, molt, etc.

Some words can have a number of different meanings depending on how they are used. For example, the word *fly* has a different meaning in each of the following sentences:

- "His trousers have a fly on them."
- "He swatted the fly on his trousers."
- "Those are some fly trousers."
- "They went fly fishing."
- "She hates to fly."
- "If humans were meant to fly, they would have wings."

As strategies, readers can try substituting a familiar word for an unfamiliar one and see whether it makes sense in the sentence. They can also identify other words in a sentence, offering clues to an unfamiliar word's meaning.

Denotation and Connotation

Denotation refers to a word's explicit definition, like that found in the dictionary. Denotation is often set in comparison to connotation. Connotation is the emotional, cultural, social, or personal implication associated with a word. Denotation is more of an objective definition, whereas connotation can be more subjective, although many connotative meanings of words are similar for certain cultures. The denotative meanings of words are usually based on facts, and the connotative meanings of words are usually based on emotion. Here are some examples of words and their denotative and connotative meanings in Western culture:

Word	Denotative Meaning	Connotative Meaning
Home	A permanent place where one lives, usually as a member of a family.	A place of warmth; a place of familiarity; comforting; a place of safety and security. "Home" usually has a positive connotation.
Snake	A long reptile with no limbs and strong jaws that moves along the ground; some snakes have a poisonous bite.	An evil omen; a slithery creature (human or nonhuman) that is deceitful or unwelcome. "Snake" usually has a negative connotation.
Winter	A season of the year that is the coldest, usually from December to February in the northern hemisphere and from June to August in the southern hemisphere.	Circle of life, especially that of death and dying; cold or icy; dark and gloomy; hibernation, sleep, or rest. Winter can have a negative connotation, although many who have access to heat may enjoy the snowy season from their homes.

Evaluating the Author's Purpose in a Given Text

Authors may have many purposes for writing a specific text. Their purposes may be to try and convince readers to agree with their position on a subject, to impart information, or to entertain. Other writers are motivated to write from a desire to express their own feelings. Authors' purposes are their reasons for

writing something. A single author may have one overriding purpose for writing or multiple reasons. An author may explicitly state their intention in the text, or the reader may need to infer that intention. Those who read reflectively benefit from identifying the purpose because it enables them to analyze information in the text. By knowing why the author wrote the text, readers can glean ideas for how to approach it.

The following is a list of questions readers can ask in order to discern an author's purpose for writing a text:

- From the title of the text, why do you think the author wrote it?
- Was the purpose of the text to give information to readers?
- Did the author want to describe an event, issue, or individual?
- Was it written to express emotions and thoughts?
- Did the author want to convince readers to consider a particular issue?
- Was the author primarily motivated to write the text to entertain?
- Why do you think the author wrote this text from a certain point of view?
- What is your response to the text as a reader?
- Did the author state their purpose for writing it?

Students should read to interpret information rather than simply content themselves with roles as text consumers. Being able to identify an author's purpose efficiently improves reading comprehension, develops critical thinking, and makes students more likely to consider issues in depth before accepting writer viewpoints. Authors of fiction frequently write to entertain readers. Another purpose for writing fiction is making a political statement; for example, Jonathan Swift wrote "A Modest Proposal" (1729) as a political satire. Another purpose for writing fiction as well as nonfiction is to persuade readers to take some action or further a particular cause. Fiction authors and poets both frequently write to evoke certain moods; for example, Edgar Allan Poe wrote novels, short stories, and poems that evoke moods of gloom, guilt, terror, and dread. Another purpose of poets is evoking certain emotions: love is popular, as in Shakespeare's sonnets and numerous others. In "The Waste Land" (1922), T.S. Eliot evokes society's alienation, disaffection, sterility, and fragmentation.

Authors seldom directly state their purposes in texts. Some students may be confronted with nonfiction texts such as biographies, histories, magazine and newspaper articles, and instruction manuals, among others. To identify the purpose in nonfiction texts, students can ask the following questions:

- Is the author trying to teach something?
- Is the author trying to persuade the reader?
- Is the author imparting factual information only?
- Is this a reliable source?
- Does the author have some kind of hidden agenda?

To apply author purpose in nonfictional passages, students can also analyze sentence structure, word choice, and transitions to answer the aforementioned questions and to make inferences. For example, authors wanting to convince readers to view a topic negatively often choose words with negative connotations.

Narrative Writing

Narrative writing tells a story. The most prominent examples of narrative writing are fictional novels. Here are some examples:

- Mark Twain's The Adventures of Tom Sawyer and The Adventures of Huckleberry Finn
- Victor Hugo's *Les Misérables*
- Charles Dickens' Great Expectations, David Copperfield, and A Tale of Two Cities
- Jane Austen's Northanger Abbey, Mansfield Park, Pride and Prejudice, Sense and Sensibility, and Emma
- Toni Morrison's Beloved, The Bluest Eye, and Song of Solomon
- Gabriel García Márquez's One Hundred Years of Solitude and Love in the Time of Cholera

Some nonfiction works are also written in narrative form. For example, some authors choose a narrative style to convey factual information about a topic, such as a specific animal, country, geographic region, and scientific or natural phenomenon.

Since narrative is the type of writing that tells a story, it must be told by someone, who is the narrator. The narrator may be a fictional character telling the story from their own viewpoint. This narrator uses the first person (*I, me, my, mine* and *we, us, our,* and *ours*). The narrator may simply be the author; for example, when Louisa May Alcott writes "Dear reader" in *Little Women*, she (the author) addresses us as readers. In this case, the novel is typically told in third person, referring to the characters as he, she, they, or them. Another more common technique is the omniscient narrator; i.e. the story is told by an unidentified individual who sees and knows everything about the events and characters—not only their externalized actions, but also their internalized feelings and thoughts. Second person, i.e. writing the story by addressing readers as "you" throughout, is less frequently used.

Expository Writing

Expository writing is also known as informational writing. Its purpose is not to tell a story as in narrative writing, to paint a picture as in descriptive writing, or to persuade readers to agree with something as in argumentative writing. Rather, its point is to communicate information to the reader. As such, the point of view of the author will necessarily be more objective. Whereas other types of writing appeal to the reader's emotions, appeal to the reader's reason by using logic, or use subjective descriptions to sway the reader's opinion or thinking, expository writing seeks to do none of these but simply to provide facts, evidence, observations, and objective descriptions of the subject matter. Some examples of expository writing include research reports, journal articles, articles and books about historical events or periods, academic subject textbooks, news articles and other factual journalistic reports, essays, how-to articles, and user instruction manuals.

Technical Writing

Technical writing is similar to expository writing in that it is factual, objective, and intended to provide information to the reader. Indeed, it may even be considered a subcategory of expository writing. However, technical writing differs from expository writing in that (1) it is specific to a particular field, discipline, or subject; and (2) it uses the specific technical terminology that belongs only to that area. Writing that uses technical terms is intended only for an audience familiar with those terms. A primary example of technical writing today is writing related to computer programming and use.

Persuasive Writing

Persuasive writing is intended to persuade the reader to agree with the author's position. It is also known as argumentative writing. Some writers may be responding to other writers' arguments, in which case they make reference to those authors or text and then disagree with them. However, another common

23

technique is for the author to anticipate opposing viewpoints in general, both from other authors and from the author's own readers. The author brings up these opposing viewpoints, and then refutes them before they can even be raised, strengthening the author's argument. Writers persuade readers by appealing to their reason, which Aristotle called *logos;* appealing to emotion, which Aristotle called *pathos;* or appealing to readers based on the author's character and credibility, which Aristotle called *ethos.*

Evaluating the Author's Point of View in a Given Text

When a writer tells a story using the first person, readers can identify this by the use of first-person pronouns, like *I, me, we, us,* etc. However, first-person narratives can be told by different people or from different points of view. For example, some authors write in the first person to tell the story from the main character's viewpoint, as Charles Dickens did in his novels *David Copperfield* and *Great Expectations.* Some authors write in the first person from the viewpoint of a fictional character in the story, but not necessarily the main character. For example, F. Scott Fitzgerald wrote *The Great Gatsby* as narrated by Nick Carraway, a character in the story, about the main characters, Jay Gatsby and Daisy Buchanan. Other authors write in the first person, but as the omniscient narrator—an often unnamed person who knows all of the characters' inner thoughts and feelings. Writing in first person as oneself is more common in nonfiction.

Third Person

The third-person narrative is probably the most prevalent voice used in fictional literature. While some authors tell stories from the point of view and in the voice of a fictional character using the first person, it is a more common practice to describe the actions, thoughts, and feelings of fictional characters in the third person using *he, him, she, her, they, them,* etc.

Although plot and character development are both necessary and possible when writing narrative from a first-person point of view, they are also more difficult, particularly for new writers and those who find it unnatural or uncomfortable to write from that perspective. Therefore, writing experts advise beginning writers to start out writing in the third person. A big advantage of third-person narration is that the writer can describe the thoughts, feelings, and motivations of every character in a story, which is not possible for the first-person narrator. Third-person narrative can impart information to readers that the characters do not know. On the other hand, beginning writers often regard using the third-person point of view as more difficult because they must write about the feelings and thoughts of every character, rather than only about those of the protagonist.

Second Person

Narrative written in the second person addresses someone else as "you." In novels and other fictional works, the second person is the narrative voice most seldom used. The primary reason for this is that it often reads in an awkward manner, which prevents readers from being drawn into the fictional world of the novel. The second person is more often used in informational text, especially in how-to manuals, guides, and other instructions.

First Person

First person uses pronouns such as *I, me, we, my, us, and our.* Some writers naturally find it easier to tell stories from their own points of view, so writing in the first person offers advantages for them. The first-person voice is better for interpreting the world from a single viewpoint, and for enabling reader immersion in one protagonist's experiences. However, others find it difficult to use the first-person narrative voice. Its disadvantages can include overlooking the emotions of characters, forgetting to

include description, producing stilted writing, using too many sentence structures involving "I did....", and not devoting enough attention to the story's "here-and-now" immediacy.

Using Text Features

Table of Contents and Index

When examining a book, a journal article, a monograph, or other publication, the table of contents is in the front. In books, it is typically found following the title page, publication information (often on the facing side of the title page), and dedication page, when one is included. In shorter publications, the table of contents may follow the title page, or the title on the same page. The table of contents in a book lists the number and title of each chapter and its beginning page number. An index, which is most common in books but may also be included in shorter works, is at the back of the publication. Books, especially academic texts, frequently have two: a subject index and an author index. Readers can look alphabetically for specific subjects in the subject index. Likewise, they can look up specific authors cited, quoted, discussed, or mentioned in the author index.

The index in a book offers particular advantages to students. For example, college course instructors typically assign certain textbooks, but do not expect students to read the entire book from cover to cover immediately. They usually assign specific chapters to read in preparation for specific lectures and/or discussions in certain upcoming classes. Reading portions at a time, some students may find references they either do not fully understand or want to know more about. They can look these topics up in the book's subject index to find them in later chapters. When a text author refers to another author, students can also look up the name in the book's author index to find all page numbers of all other references to that author. College students also typically are assigned research papers to write. A book's subject and author indexes can guide students to pages that may help inform them of other books to use for researching paper topics.

Headings

Headings and subheadings concisely inform readers what each section of a paper contains, as well as showing how its information is organized both visually and verbally. Headings are typically up to about five words long. They are not meant to give in-depth analytical information about the topic of their section, but rather an idea of its subject matter. Text authors should maintain consistent style across all headings. Readers should not expect headings if there is not material for more than one heading at each level, just as a list is unnecessary for a single item. Subheadings may be a bit longer than headings because they expand upon them. Readers should skim the subheadings in a paper to use them as a map of how content is arranged. Subheadings are in smaller fonts than headings to mirror relative importance. Subheadings are not necessary for every paragraph. They should enhance content, not substitute for topic sentences.

When a heading is brief, simple, and written in the form of a question, it can have the effect of further drawing readers into the text. An effective author will also answer the question in the heading soon in the following text. Question headings and their text answers are particularly helpful for engaging readers with average reading skills. Both headings and subheadings are most effective with more readers when they are obvious, simple, and get to their points immediately. Simple headings attract readers; simple subheadings allow readers a break, during which they also inform reader decisions whether to continue reading or not. Headings stand out from other text through boldface, but also italicizing and underlining them would be excessive. Uppercase-lowercase headings are easier for readers to comprehend than all capitals. More legible fonts are better. Some experts prefer serif fonts in text, but sans-serif fonts in headings. Brief subheadings that preview upcoming chunks of information reach more readers.

Text Features

Textbooks that are designed well employ varied text features for organizing their main ideas, illustrating central concepts, spotlighting significant details, and signaling evidence that supports the ideas and points conveyed. When a textbook uses these features in recurrent patterns that are predictable, it makes it easier for readers to locate information and come up with connections. When readers comprehend how to make use of text features, they will take less time and effort deciphering how the text is organized, leaving them more time and energy for focusing on the actual content in the text. Instructional activities can include not only previewing text through observing main text features, but moreover through examining and deconstructing the text and ascertaining how the text features can aid them in locating and applying text information for learning.

Included among various text features are a table of contents, headings, subheadings, an index, a glossary, a foreword, a preface, paragraphing spaces, bullet lists, footnotes, sidebars, diagrams, graphs, charts, pictures, illustrations, captions, italics, boldface, colors, and symbols. A glossary is a list of key vocabulary words and/or technical terminology and definitions. This helps readers recognize or learn specialized terms used in the text before reading it. A foreword is typically written by someone other than the text author and appears at the beginning to introduce, inform, recommend, and/or praise the work. A preface is often written by the author and also appears at the beginning, to introduce or explain something about the text, like new additions. A sidebar is a box with text and sometimes graphics at the left or right side of a page, typically focusing on a more specific issue, example, or aspect of the subject. Footnotes are additional comments/notes at the bottom of the page, signaled by superscript numbers in the text.

Text Features on Websites

On the Internet or in computer software programs, text features include URLs, home pages, pop up menus, drop-down menus, bookmarks, buttons, links, navigation bars, text boxes, arrows, symbols, colors, graphics, logos, and abbreviations. URLs (Universal Resource Locators) indicate the internet "address" or location of a website or web page. They often start with www. (world wide web) or http:// (hypertext transfer protocol) or https:// (the "s" indicates a secure site) and appear in the Internet browser's top address bar. Clickable buttons are often links to specific pages on a website or other external sites. Users can click on some buttons to open pop-up or drop-down menus, which offer a list of actions or departments from which to select. Bookmarks are the electronic versions of physical bookmarks. When users bookmark a website/page, a link is established to the site URL and saved, enabling returning to the site in the future without having to remember its name or URL by clicking the bookmark.

Readers can more easily navigate websites and read their information by observing and utilizing their various text features. For example, most fully developed websites include search bars, where users can type in topics, questions, titles, or names to locate specific information within the large amounts stored on many sites. Navigation bars (software developers frequently use the abbreviation term "navbar") are graphical user interfaces (GUIs) that facilitate visiting different sections, departments, or pages within a website, which can be difficult or impossible to find without these. Typically, they appear as a series of links running horizontally across the top of each page. Navigation bars displayed vertically along the left side of the page are also called sidebars. Links, i.e. hyperlinks, enable hyperspeed browsing by allowing readers to jump to new pages/sites. They may be URLs, words, phrases, images, buttons, etc. They are often but not always underlined and/or blue, or other colors.

Integration of Knowledge and Ideas

Identifying Primary Sources in Various Media

A primary source is a piece of original work. This can include books, musical compositions, recordings, movies, works of visual art (paintings, drawings, photographs), jewelry, pottery, clothing, furniture, and other artifacts. Within books, primary sources may be of any genre. Whether nonfiction based on actual events or a fictional creation, the primary source relates the author's firsthand view of some specific event, phenomenon, character, place, process, ideas, field of study or discipline, or other subject matter. Whereas primary sources are original treatments of their subjects, secondary sources are a step removed from the original subjects; they analyze and interpret primary sources. These include journal articles, newspaper or magazine articles, works of literary criticism, political commentaries, and academic textbooks.

In the field of history, primary sources frequently include documents that were created around the same time period that they were describing, and most often produced by someone who had direct experience or knowledge of the subject matter. In contrast, secondary sources present the ideas and viewpoints of other authors about the primary sources; in history, for example, these can include books and other written works about the particular historical periods or eras in which the primary sources were produced. Primary sources pertinent in history include diaries, letters, statistics, government information, and original journal articles and books. In literature, a primary source might be a literary novel, a poem or book of poems, or a play. Secondary sources addressing primary sources may be criticism, dissertations, theses, and journal articles. Tertiary sources, typically reference works referring to primary and secondary sources, include encyclopedias, bibliographies, handbooks, abstracts, and periodical indexes.

In scientific fields, when scientists conduct laboratory experiments to answer specific research questions and test hypotheses, lab reports and reports of research results constitute examples of primary sources. When researchers produce statistics to support or refute hypotheses, those statistics are primary sources. When a scientist is studying some subject longitudinally or conducting a case study, they may keep a journal or diary. For example, Charles Darwin kept diaries of extensive notes on his studies during sea voyages on the *Beagle*, visits to the Galápagos Islands, etc.; Jean Piaget kept journals of observational notes for case studies of children's learning behaviors. Many scientists, particularly in past centuries, shared and discussed discoveries, questions, and ideas with colleagues through letters, which also constitute primary sources. When a scientist seeks to replicate another's experiment, the reported results, analysis, and commentary on the original work is a secondary source, as is a student's dissertation if it analyzes or discusses others' work rather than reporting original research or ideas.

Making Predictions and Inferences

One technique authors often use to make their fictional stories more interesting is not giving away too much information by providing hints and description. It is then up to the reader to draw a conclusion about the author's meaning by connecting textual clues with the reader's own pre-existing experiences and knowledge. Drawing conclusions is important as a reading strategy for understanding what is occurring in a text. Rather than directly stating who, what, where, when, or why, authors often describe story elements. Then, readers must draw conclusions to understand significant story components. As they go through a text, readers can think about the setting, characters, plot, problem, and solution; whether the author provided any clues for consideration; and combine any story clues with their existing knowledge and experiences to draw conclusions about what occurs in the text.

Making Predictions

Before and during reading, readers can apply the reading strategy of making predictions about what they think may happen next. For example, what plot and character developments will occur in fiction? What points will the author discuss in nonfiction? Making predictions about portions of text they have not yet read prepares readers mentally for reading, and also gives them a purpose for reading. To inform and make predictions about text, the reader can do the following:

- Consider the title of the text and what it implies
- Look at the cover of the book
- Look at any illustrations or diagrams for additional visual information
- Analyze the structure of the text
- Apply outside experience and knowledge to the text

Readers may adjust their predictions as they read. Reader predictions may or may not come true in text.

Making Inferences

Authors describe settings, characters, character emotions, and events. Readers must infer to understand text fully. Inferring enables readers to figure out meanings of unfamiliar words, make predictions about upcoming text, draw conclusions, and reflect on reading. Readers can infer about text before, during, and after reading. In everyday life, we use sensory information to infer. Readers can do the same with text. When authors do not answer all reader questions, readers must infer by saying "I think....This could be....This is because....Maybe....This means....I guess..." etc. Looking at illustrations, considering characters' behaviors, and asking questions during reading facilitate inference. Taking clues from text and connecting text to prior knowledge help to draw conclusions. Readers can infer word meanings, settings, reasons for occurrences, character emotions, pronoun referents, author messages, and answers to questions unstated in text. To practice inference, students can read sentences written/selected by the instructor, discuss the setting and character, draw conclusions, and make predictions.

Making inferences and drawing conclusions involve skills that are quite similar: both require readers to fill in information the author has omitted. Authors may omit information as a technique for inducing readers to discover the outcomes themselves; or they may consider certain information unimportant; or they may assume their reading audience already knows certain information. To make an inference or draw a conclusion about text, readers should observe all facts and arguments the author has presented and consider what they already know from their own personal experiences. Reading students taking multiple-choice tests that refer to text passages can determine correct and incorrect choices based on the information in the passage. For example, from a text passage describing an individual's signs of anxiety while unloading groceries and nervously clutching their wallet at a grocery store checkout, readers can infer or conclude that the individual may not have enough money to pay for everything.

Comparing and Contrasting Themes from Print and Other Sources

The theme of a piece of text is the central idea the author communicates. Whereas the topic of a passage of text may be concrete in nature, by contrast the theme is always conceptual. For example, while the topic of Mark Twain's novel *The Adventures of Huckleberry Finn* might be described as something like the coming-of-age experiences of a poor, illiterate, functionally orphaned boy around and on the Mississippi River in 19th-century Missouri, one theme of the book might be that human beings are corrupted by society. Another might be that slavery and "civilized" society itself are hypocritical. Whereas the main idea in a text is the most important single point that the author wants to make, the theme is the concept or view around which the author centers the text.

Throughout time, humans have told stories with similar themes. Some themes are universal across time, space, and culture. These include themes of the individual as a hero, conflicts of the individual against nature, the individual against society, change vs. tradition, the circle of life, coming-of-age, and the complexities of love. Themes involving war and peace have featured prominently in diverse works, like Homer's *Iliad*, Tolstoy's *War and Peace* (1869), Stephen Crane's *The Red Badge of Courage* (1895), Hemingway's *A Farewell to Arms* (1929), and Margaret Mitchell's *Gone with the Wind* (1936). Another universal literary theme is that of the quest. These appear in folklore from countries and cultures worldwide, including the Gilgamesh Epic, Arthurian legend's Holy Grail quest, Virgil's *Aeneid*, Homer's *Odyssey*, and the *Argonautica*. Cervantes' *Don Quixote* is a parody of chivalric quests. J.R.R. Tolkien's *The Lord of the Rings* trilogy (1954) also features a quest.

One instance of similar themes across cultures is when those cultures are in countries that are geographically close to each other. For example, a folklore story of a rabbit in the moon using a mortar and pestle is shared among China, Japan, Korea, and Thailand—making medicine in China, making rice cakes in Japan and Korea, and hulling rice in Thailand. Another instance is when cultures are more distant geographically, but their languages are related. For example, East Turkestan's Uighurs and people in Turkey share tales of folk hero Effendi Nasreddin Hodja. Another instance, which may either be called cultural diffusion or simply reflect commonalities in the human imagination, involves shared themes among geographically and linguistically different cultures: both Cameroon's and Greece's folklore tell of centaurs; Cameroon, India, Malaysia, Thailand, and Japan, of mermaids; Brazil, Peru, China, Japan, Malaysia, Indonesia, and Cameroon, of underwater civilizations; and China, Japan, Thailand, Vietnam, Malaysia, Brazil, and Peru, of shape-shifters.

Two prevalent literary themes are love and friendship, which can end happily, sadly, or both. William Shakespeare's *Romeo and Juliet*, Emily Brontë's *Wuthering Heights*, Leo Tolstoy's *Anna Karenina*, and both *Pride and Prejudice* and *Sense and Sensibility* by Jane Austen are famous examples. Another theme recurring in popular literature is of revenge, an old theme in dramatic literature, e.g. Elizabethans Thomas Kyd's *The Spanish Tragedy* and Thomas Middleton's *The Revenger's Tragedy*. Some more well-known instances include Shakespeare's tragedies *Hamlet* and *Macbeth*, Alexandre Dumas' *The Count of Monte Cristo*, John Grisham's *A Time to Kill*, and Stieg Larsson's *The Girl Who Kicked the Hornet's Nest*.

Themes are underlying meanings in literature. For example, if a story's main idea is a character succeeding against all odds, the theme is overcoming obstacles. If a story's main idea is one character wanting what another character has, the theme is jealousy. If a story's main idea is a character doing something they were afraid to do, the theme is courage. Themes differ from topics in that a topic is a subject matter; a theme is the author's opinion about it. For example, a work could have a topic of war and a theme that war is a curse. Authors present themes through characters' feelings, thoughts, experiences, dialogue, plot actions, and events. Themes function as "glue" holding other essential story elements together. They offer readers insights into characters' experiences, the author's philosophy, and how the world works.

Evaluating an Argument and its Specific Claims

When authors write text for the purpose of persuading others to agree with them, they assume a position with the subject matter about which they are writing. Rather than presenting information objectively, the author treats the subject matter subjectively so that the information presented supports his or her position. In their argumentation, the author presents information that refutes or weakens opposing positions. Another technique authors use in persuasive writing is to anticipate arguments against the position. When students learn to read subjectively, they gain experience with the concept of persuasion in

writing, and learn to identify positions taken by authors. This enhances their reading comprehension and develops their skills for identifying pro and con arguments and biases.

There are five main parts of the classical argument that writers employ in a well-designed stance:

- Introduction: In the introduction to a classical argument, the author establishes goodwill and rapport with the reading audience, warms up the readers, and states the thesis or general theme of the argument.

- Narration: In the narration portion, the author gives a summary of pertinent background information, informs the readers of anything they need to know regarding the circumstances and environment surrounding and/or stimulating the argument, and establishes what is at risk or the stakes in the issue or topic. Literature reviews are common examples of narrations in academic writing.

- Confirmation: The confirmation states all claims supporting the thesis and furnishes evidence for each claim, arranging this material in logical order—e.g. from most obvious to most subtle or strongest to weakest.

- Refutation and Concession: The refutation and concession discuss opposing views and anticipate reader objections without weakening the thesis, yet permitting as many oppositions as possible.

- Summation: The summation strengthens the argument while summarizing it, supplying a strong conclusion and showing readers the superiority of the author's solution.

Introduction
A classical argument's introduction must pique reader interest, get readers to perceive the author as a writer, and establish the author's position. Shocking statistics, new ways of restating issues, or quotations or anecdotes focusing the text can pique reader interest. Personal statements, parallel instances, or analogies can also begin introductions—so can bold thesis statements if the author believes readers will agree. Word choice is also important for establishing author image with readers.

The introduction should typically narrow down to a clear, sound thesis statement. If readers cannot locate one sentence in the introduction explicitly stating the writer's position or the point they support, the writer probably has not refined the introduction sufficiently.

Narration and Confirmation
The narration part of a classical argument should create a context for the argument by explaining the issue to which the argument is responding, and by supplying any background information that influences the issue. Readers should understand the issues, alternatives, and stakes in the argument by the end of the narration to enable them to evaluate the author's claims equitably. The confirmation part of the classical argument enables the author to explain why they believe in the argument's thesis. The author builds a chain of reasoning by developing several individual supporting claims and explaining why that evidence supports each claim and also supports the overall thesis of the argument.

Refutation and Concession and Summation
The classical argument is the model for argumentative/persuasive writing, so authors often use it to establish, promote, and defend their positions. In the refutation aspect of the refutation and concession part of the argument, authors disarm reader opposition by anticipating and answering their possible objections, persuading them to accept the author's viewpoint. In the concession aspect, authors can

concede those opposing viewpoints with which they agree. This can avoid weakening the author's thesis while establishing reader respect and goodwill for the author: all refutation and no concession can antagonize readers who disagree with the author's position. In the conclusion part of the classical argument, a less skilled writer might simply summarize or restate the thesis and related claims; however, this does not provide the argument with either momentum or closure. More skilled authors revisit the issues and the narration part of the argument, reminding readers of what is at stake.

Integrating Data from Multiple Sources in Various Formats, Including Media

Books as Resources

When a student has an assignment to research and write a paper, one of the first steps after determining the topic is to select research sources. The student may begin by conducting an Internet or library search of the topic, may refer to a reading list provided by the instructor, or may use an annotated bibliography of works related to the topic. To evaluate the worth of the book for the research paper, the student first considers the book title to get an idea of its content. Then the student can scan the book's table of contents for chapter titles and topics to get further ideas of their applicability to the topic. The student may also turn to the end of the book to look for an alphabetized index. Most academic textbooks and scholarly works have these; students can look up key topic terms to see how many are included and how many pages are devoted to them.

Journal Articles

Like books, journal articles are primary or secondary sources the student may need to use for researching any topic. To assess whether a journal article will be a useful source for a particular paper topic, a student can first get some idea about the content of the article by reading its title and subtitle, if any exists. Many journal articles, particularly scientific ones, include abstracts. These are brief summaries of the content. The student should read the abstract to get a more specific idea of whether the experiment, literature review, or other work documented is applicable to the paper topic. Students should also check the references at the end of the article, which today often contain links to related works for exploring the topic further.

Encyclopedias and Dictionaries

Dictionaries and encyclopedias are both reference books for looking up information alphabetically. Dictionaries are more exclusively focused on vocabulary words. They include each word's correct spelling, pronunciation, variants, part(s) of speech, definitions of one or more meanings, and examples used in a sentence. Some dictionaries provide illustrations of certain words when these inform the meaning. Some dictionaries also offer synonyms, antonyms, and related words under a word's entry. Encyclopedias, like dictionaries, often provide word pronunciations and definitions. However, they have broader scopes: one can look up entire subjects in encyclopedias, not just words, and find comprehensive, detailed information about historical events, famous people, countries, disciplines of study, and many other things. Dictionaries are for finding word meanings, pronunciations, and spellings; encyclopedias are for finding breadth and depth of information on a variety of topics.

Card Catalogs

A card catalog is a means of organizing, classifying, and locating the large numbers of books found in libraries. Without being able to look up books in library card catalogs, it would be virtually impossible to find them on library shelves. Card catalogs may be on traditional paper cards filed in drawers, or electronic catalogs accessible online; some libraries combine both. Books are shelved by subject area; subjects are coded using formal classification systems—standardized sets of rules for identifying and labeling books by subject and author. These assign each book a call number: a code indicating the

classification system, subject, author, and title. Call numbers also function as bookshelf "addresses" where books can be located. Most public libraries use the Dewey Decimal Classification System. Most university, college, and research libraries use the Library of Congress Classification. Nursing students will also encounter the National Institute of Health's National Library of Medicine Classification System, which major collections of health sciences publications utilize.

Databases

A database is a collection of digital information organized for easy access, updating, and management. Users can sort and search databases for information. One way of classifying databases is by content, i.e. full-text, numerical, bibliographical, or images. Another classification method used in computing is by organizational approach. The most common approach is a relational database, which is tabular and defines data so they can be accessed and reorganized in various ways. A distributed database can be reproduced or interspersed among different locations within a network. An object-oriented database is organized to be aligned with object classes and subclasses defining the data. Databases usually collect files like product inventories, catalogs, customer profiles, sales transactions, student bodies, and resources. An associated set of application programs is a database management system or database manager. It enables users to specify which reports to generate, control access to reading and writing data, and analyze database usage. Structured Query Language (SQL) is a standard computer language for updating, querying, and otherwise interfacing with databases.

Practice Questions

The next two questions are based off the following passage:

Rehabilitation rather than punitive justice is becoming much more popular in prisons around the world. Prisons in America, especially, where the recidivism rate is 67 percent, would benefit from mimicking prison tactics in Norway, which has a recidivism rate of only 20 percent. In Norway, the idea is that a rehabilitated prisoner is much less likely to offend than one harshly punished. Rehabilitation includes proper treatment for substance abuse, psychotherapy, healthcare and dental care, and education programs.

1. Which of the following best captures the author's purpose?
 a. To show the audience one of the effects of criminal rehabilitation by comparison.
 b. To persuade the audience to donate to American prisons for education programs.
 c. To convince the audience of the harsh conditions of American prisons.
 d. To inform the audience of the incredibly lax system of Norway prisons.

2. Which of the following describes the word *recidivism* as it is used in the passage?
 a. The lack of violence in the prison system.
 b. The opportunity of inmates to receive therapy in prison.
 c. The event of a prisoner escaping the compound.
 d. The likelihood of a convicted criminal to reoffend.

Nutrition Facts

8 servings per container

Serving size	2/3 cup (55g)

Amount per 2/3 cup

Calories 230

% DV*	
12%	**Total Fat** 8g
5%	Saturated Fat 1g
	Trans Fat 0g
0%	**Cholesterol** 0mg
7%	**Sodium** 160mg
12%	**Total Carbs** 37g
14%	Dietary Fiber 4g
	Sugars 1g
	Added Sugars 0g
	Protein 3g
10%	Vitamin D 2mcg
20%	Calcium 260mg
45%	Iron 8mg
5%	Potassium 235mg

* Footnote on Daily Values (DV) and calories reference to be inserted here.

3. A customer who eats two servings of the above food would consume how many carbohydrates?
 a. 74mg
 b. 74g
 c. 460g
 d. 8g

The next three questions are based off the following passage from Virginia Woolf's Mrs. Dalloway*:*

> What a lark! What a plunge! For so it had always seemed to her, when, with a little squeak of the hinges, which she could hear now, she had burst open the French windows and plunged at Bourton into the open air. How fresh, how calm, stiller than this of course, the air was in the early morning; like the flap of a wave; the kiss of a wave; chill and sharp and yet (for a girl of eighteen as she then was) solemn, feeling as she did, standing there at the open window, that something awful was about to happen; looking at the flowers, at the trees with the smoke winding off them and the rooks rising, falling; standing and looking until Peter Walsh said, "Musing among the vegetables?"— was that it? —"I prefer men to cauliflowers"— was that it? He must have said it at breakfast one morning when she had gone out on to the terrace — Peter Walsh. He would be back from India one of these days, June or July, she forgot which, for his letters were awfully dull; it was his sayings one remembered; his eyes, his pocket-knife, his smile, his grumpiness and, when millions of things had utterly vanished — how strange it was! — a few sayings like this about cabbages.

4. The passage is reflective of which of the following types of writing?
 a. Persuasive
 b. Expository
 c. Technical
 d. Narrative

5. What was the narrator feeling right before Peter Walsh's voice distracted her?
 a. A spark of excitement for the morning.
 b. Anger at the larks.
 c. A sense of foreboding.
 d. Confusion at the weather.

6. What is the main point of the passage?
 a. To present the events leading up to a party.
 b. To show the audience that the narrator is resentful towards Peter.
 c. To introduce Peter Walsh back into the narrator's memory.
 d. To reveal what mornings are like in the narrator's life.

7. According to the map, which of the following is the highest points on the island?
 a. Volcano Terevaka
 b. Maunga Ana Marama
 c. Puakatike Volcano
 d. Vaka Kipo

The next question is based on the following passage from The Federalist No. 78 *by Alexander Hamilton.*

According to the plan of the convention, all judges who may be appointed by the United States are to hold their offices *during good behavior,* which is conformable to the most approved of the State constitutions and among the rest, to that of this State. Its propriety having been drawn into question by the adversaries of that plan, is no light symptom of the rage for objection, which disorders their imaginations and judgments. The standard of good behavior for the continuance in office of the judicial magistracy, is certainly one of the most valuable of the modern improvements in the practice of government. In a monarchy it is an excellent barrier to the despotism of the prince; in a republic it is a no less excellent barrier to the encroachments and oppressions of the representative body. And it is the best expedient which can be devised in any government, to secure a steady, upright, and impartial administration of the laws.

8.What is Hamilton's point in this excerpt?

a. To show the audience that despotism within a monarchy is no longer the standard practice in the states.

b. To convince the audience that judges holding their positions based on good behavior is a practical way to avoid corruption.

c. To persuade the audience that having good behavior should be the primary characteristic of a person in a government body and their voting habits should reflect this.

d. To convey the position that judges who serve for a lifetime will not be perfect and therefore we must forgive them for their bad behavior when it arises.

9. Which of the following is an acceptable heading to insert into the blank space?

Chapter 5: Literature and Language Usage

 I. Figurative Speech

 1. Alliteration

 2. Metaphors

 3. Onomatopoeia

 4. _____

a. Nouns

b. Agreement

c. Personification

d. Syntax

10. Based on the image above, which element is under Group V, Period 6?
 a. Pb
 b. Bi
 c. Uup
 d. At

11. Felicia knew she had to be <u>prudent</u> if she was going to cross the bridge over the choppy water; one wrong move and she would be falling toward the rocky rapids.

Which of the following is the definition of the underlined word based on the context of the sentence above?

 a. Patient
 b. Afraid
 c. Dangerous
 d. Careful

The next three questions are based on the passage from Many Marriages *by Sherwood Anderson.*

There was a man named Webster lived in a town of twenty-five thousand people in the state of Wisconsin. He had a wife named Mary and a daughter named Jane and he was himself a fairly prosperous manufacturer of washing machines. When the thing happened of which I am about to write he was thirty-seven or thirty-eight years old and his one child, the daughter, was seventeen. Of the details of his life up to the time a certain revolution happened within him it will be unnecessary to speak. He was however a rather quiet man inclined to have dreams which he tried to crush out of himself in order that he function as a washing machine manufacturer; and no doubt, at odd moments, when he was on a train going some place or perhaps on Sunday afternoons in the summer when he went alone to the deserted office of the factory and sat several hours looking out at a window and along a railroad track, he gave way to dreams.

12. What does the author mean by the following sentence?

"Of the details of his life up to the time a certain revolution happened within him it will be unnecessary to speak."

 a. The details of his external life don't matter; only the details of his internal life matter.
 b. Whatever happened in his life before he had a certain internal change is irrelevant.
 c. He had a traumatic experience earlier in his life which rendered it impossible for him to speak.
 d. Before the revolution, he was a lighthearted man who always wished to speak to others no matter who they were.

13. What point-of-view is this narrative told in?
 a. First person limited
 b. First person omniscient
 c. Second person
 d. Third person

14. What did Webster do for a living?
 a. Washing machine manufacturer
 b. Train operator
 c. Leader of the revolution
 d. Stay-at-home husband

15. According to the image above, what is the temperature in Fahrenheit?
 a. 17°
 b. 20°
 c. 61°
 d. 62°

16. After Sheila recently had a coronary artery bypass, her doctor encouraged her to switch to a plant-based diet to avoid foods loaded with cholesterol and saturated fats. Sheila's doctor has given her a list of foods she can purchase in order to begin making healthy dinners, which excludes dairy (cheese, yogurt, cream) eggs, and meat. The doctor's list includes the following: pasta, marinara sauce, tofu, rice, black beans, tortilla chips, guacamole, corn, salsa, rice noodles, stir-fry vegetables, teriyaki sauce, quinoa, potatoes, yams, bananas, eggplant, pizza crust, cashew cheese, almond milk, bell pepper, and tempeh.

Which of the following dishes can Sheila make that will be okay for her to eat?

 a. Eggplant parmesan with a salad
 b. Veggie pasta with marinara sauce
 c. Egg omelet with no cheese and bell peppers
 d. Quinoa burger with cheese and French fries.

17. Maritza wanted to go to the park to swim with her friends, but when she got home, she realized that nobody was there to take her.

Follow the numbered instructions to transform the sentence above into a new sentence.
1. Replace the phrase "wanted to go" with "went."
2. Replace the word "but" with the word "and."
3. Replace the word "home" with "there."
4. Replace the phrase "nobody was there" with "they had thrown."
5. Take out the phrase "to take."
6. Add the words "a surprise party!" at the end of the sentence.

a. Maritza went to the park to swim with her friends, and when she got home, she realized they had thrown her a surprise party!
b. Maritza wanted to go to the park to swim with her friends, but when she got home, she realized they had thrown her a surprise party!
c. Maritza went to the park to swim with her friends, and when she got there, she realized that they had thrown her a surprise party!
d. Maritza went to the park to swim with her friends, and when she got there, she realized that nobody had thrown her a surprise party!

18. According to the pie chart above, which browser is most used on Wikimedia in October 2011?
 a. Firefox
 b. Chrome
 c. Safari
 d. Internet Explorer

19. A reader comes across a word they do not know in the book they are reading, and they need to find out what the word means in order to understand the context of the sentence. Where should the reader look?

 a. Table of contents

 b. Introduction

 c. Index

 d. Glossary

The next two questions are based on the following passage from the biography Queen Victoria *by E. Gordon Browne, M.A.:*

> The old castle soon proved to be too small for the family, and in September 1853 the foundation-stone of a new house was laid. After the ceremony the workmen were entertained at dinner, which was followed by Highland games and dancing in the ballroom.
>
> Two years later they entered the new castle, which the Queen described as "charming; the rooms delightful; the furniture, papers, everything perfection."
>
> The Prince was untiring in planning improvements, and in 1856 the Queen wrote: "Every year my heart becomes more fixed in this dear Paradise, and so much more so now, that *all* has become my dearest Albert's *own* creation, own work, own building, own laying out as at Osborne; and his great taste, and the impress of his dear hand, have been stamped everywhere. He was very busy today, settling and arranging many things for next year."

20. Which of the following is this excerpt considered?

 a. Primary source

 b. Secondary source

 c. Tertiary source

 d. None of these

21. How many years did it take for the new castle to be built?

 a. One year

 b. Two years

 c. Three years

 d. Four years

22. What does the word *impress* mean in the third paragraph?

 a. to affect strongly in feeling

 b. to urge something to be done

 c. to impose a certain quality upon

 d. to press a thing onto something else

Relatives Explained by Tysen

23. What does the chart mean by "Grand nieces and nephews" in relation to "You"?
 a. They are the grandchildren of your brother or sister.
 b. They are the children of your brother and sister.
 c. They are the first cousins of your brother and sister.
 d. They are the second cousins of your brother and sister.

24. What does the chart mean by "First cousin-in-law" in relation to "You"?
 a. They are the parents of your spouse.
 b. They are the aunts and uncles of your spouse.
 c. They are the cousins of your spouse.
 d. They are the children of your spouse.

The next three questions are based on the following passage from The Life, Crime, and Capture of John Wilkes Booth *by George Alfred Townsend.*

Having completed these preparations, Mr. Booth entered the theater by the stage door; summoned one of the scene shifters, Mr. John Spangler, emerged through the same door with that individual, leaving the door open, and left the mare in his hands to be held until he (Booth) should return. Booth who was even more fashionably and richly dressed than usual, walked thence around to the front of the theater, and went in. Ascending to the dress circle, he stood for a little time gazing around upon the audience and occasionally upon the stage in his usual graceful manner. He was subsequently observed by Mr. Ford, the proprietor of the theater, to be slowly elbowing his way through the crowd that packed the rear of the dress circle toward the right side, at the extremity of which was the box where Mr. and Mrs. Lincoln and their companions were seated. Mr. Ford casually noticed this as a slightly extraordinary symptom of interest on the part of an actor so familiar with the routine of the theater and the play.

25. How is the above passage organized?
 a. Chronological
 b. Cause and effect
 c. Problem to solution
 d. Main idea with supporting details

26. Based on your knowledge of history, what is about to happen?
 a. An asteroid is about to hit the earth.
 b. The best opera of all times is about to premiere.
 c. A playhouse is about to be burned to the ground.
 d. A president is about to be assassinated.

27. What does the author mean by the last two sentences?
 a. Mr. Ford was suspicious of Booth and assumed he was making his way to Mr. Lincoln's box.
 b. Mr. Ford assumed Booth's movement throughout the theater was due to being familiar with the theater.
 c. Mr. Ford thought that Booth was making his way to the theater lounge to find his companions.
 d. Mr. Ford thought that Booth was elbowing his way to the dressing room to get ready for the play.

28. A document explaining how to use an LCD flat screen TV is known as what kind of document?
 a. Technical
 b. Persuasive
 c. Narrative
 d. Cause and effect

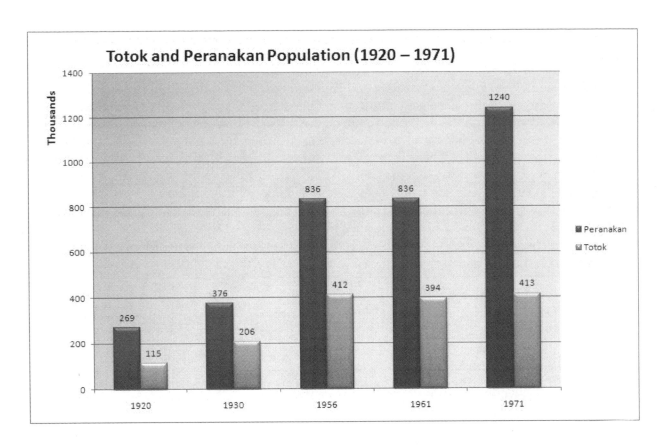

29. According to the graph above, what is the population of Totok in 1961?
 a. 115,000
 b. 206,000
 c. 394,000
 d. 836,000

30. According to the graph, what is the difference between the population in Peranakan in 1971 and Peranakan in 1961?
 a. 394,000
 b. 403,000
 c. 404,000
 d. 412,000

The next five questions are based on the following passage from The Story of Germ Life *by Herbert William Conn.*

When we study more carefully the effect upon the milk of the different species of bacteria found in the dairy, we find that there is a great variety of changes which they produce when they are allowed to grow in milk. The dairyman experiences many troubles with his milk. It sometimes curdles without becoming acid. Sometimes it becomes bitter, or acquires an unpleasant "tainted" taste, or, again, a "soapy" taste. Occasionally a dairyman finds his milk becoming slimy, instead of souring and curdling in the normal fashion. At such times, after a number of hours, the milk becomes so slimy that it can be drawn into long threads. Such an infection proves very troublesome, for many a time it persists in spite of all attempts made to remedy it. Again, in other cases the milk will turn blue, acquiring about the time it becomes sour a beautiful sky-blue colour. Or it may become red, or occasionally yellow. All of these troubles the dairyman owes to the presence in his milk of unusual species of bacteria which grow there abundantly.

31. What is the author's purpose in writing this passage?
 a. To show the readers that dairymen have difficult jobs.
 b. To show the readers different ways their milk might go bad.
 c. To show some of the different effects of milk on bacteria.
 d. To show some of the different effects of bacteria on milk.

32. What is the tone of this passage?
 a. Excitement
 b. Anger
 c. Neutral
 d. Sorrowful

33. Which of the following reactions does NOT occur in the above passage when bacteria infect the milk?
 a. It can have a soapy taste.
 b. The milk will turn black.
 c. It can become slimy.
 d. The milk will turn blue.

34. What is the meaning of "curdle" as depicted in the following sentence?

 Occasionally a dairyman finds his milk becoming slimy, instead of souring and <u>curdling</u> in the normal fashion.

 a. Lumpy
 b. Greasy
 c. Oily
 d. Slippery

35. Why, according to the passage, does an infection with slimy threads prove very troublesome?
 a. Because it is impossible to get rid of.
 b. Because it can make the milk-drinker sick.
 c. Because it turns the milk a blue color.
 d. Because it makes the milk taste bad.

The next question is based on the following directions.

Follow these instructions to transform the word into something new.

- • 1. Start with the word AUDITORIUM.
- • 2. Eliminate all vowels except for the letter O.
- • 3. Eliminate the "T."

36. Which of the following is the new word?
 a. Door
 b. Torn
 c. Dorm
 d. Tram

37. According to the image, what's the highest speed you can measure on this odometer?
 a. 120mph
 b. 125mph
 c. 128mph
 d. 130mph

38. According to the image above, how many miles have been driven on this car?
 a. 125 miles
 b. 1,308 miles
 c. 91,308 miles
 d. 3,800 miles

39. Although Olivia felt <u>despondent</u>, she knew her sister would be home to cheer her up.

In the sentence above, what is the best definition of the underlined word?

 a. Depressed
 b. Joyful
 c. Pathetic
 d. Humorous

The next four questions are based on the following passage. It is from Oregon, Washington, and Alaska. Sights and Scenes for the Tourist, *written by E.L. Lomax in 1890:*

Portland is a very beautiful city of 60,000 inhabitants, and situated on the Willamette river twelve miles from its junction with the Columbia. It is perhaps true of many of the growing cities of the West, that they do not offer the same social advantages as the older cities of the East. But this is principally the case as to what may be called boom cities, where the larger part of the population is of that floating class which follows in the line of temporary growth for the purposes of speculation, and in no sense applies to those centers of trade whose prosperity is based on the solid foundation of legitimate business. As the metropolis of a vast section of country, having broad agricultural valleys filled with improved farms, surrounded by mountains rich in mineral wealth, and boundless forests of as fine timber as the world produces, the cause of Portland's growth and prosperity is the trade which it has as the center of collection and distribution of this great wealth of natural resources, and it has attracted, not the boomer and speculator, who find their profits in the wild excitement of the boom, but the merchant, manufacturer, and investor, who seek the surer if slower channels of legitimate business and investment. These have come from the East, most of them within the last few years. They came as seeking a better and wider field to engage in the same occupations they had followed in their Eastern homes, and bringing with them all the love of polite life which they had acquired there, have established here a new society, equaling in all respects that which they left behind. Here are as fine churches, as complete a system of schools, as fine residences, as great a love of music and art, as can be found at any city of the East of equal size.

40. What is a characteristic of a "boom city," as indicated by the passage?
 a. A city that is built on solid business foundation of mineral wealth and farming.
 b. An area of land on the west coast that quickly becomes populated by residents from the east coast.
 c. A city that, due to the hot weather and dry climate, catches fire frequently, resulting in a devastating population drop.
 d. A city whose population is made up of people who seek quick fortunes rather than building a solid business foundation.

41. According to the author, Portland is:
 a. A boom city.
 b. A city on the east coast.
 c. An industrial city.
 d. A city of legitimate business.

42. What type of passage is this?
 a. A business proposition
 b. A travel guide
 c. A journal entry
 d. A scholarly article

43. What does the word *metropolis* mean in the middle of the passage?
 a. Farm
 b. Country
 c. City
 d. Valley

The following two questions are based on the excerpt from The Golden Bough *by Sir James George Frazer.*

> The other of the minor deities at Nemi was Virbius. Legend had it that Virbius was the young Greek hero Hippolytus, chaste and fair, who learned the art of venery from the centaur Chiron, and spent all his days in the greenwood chasing wild beasts with the virgin huntress Artemis (the Greek counterpart of Diana) for his only comrade.

44. Based on a prior knowledge of literature, the reader can infer this passage is taken from which of the following?
 a. A eulogy
 b. A myth
 c. A historical document
 d. A technical document

45. What is the meaning of the word "comrade" as the last word in the passage?
 a. Friend
 b. Enemy
 c. Brother
 d. Pet

Follow the directions below.
- 1. Drive from Florida to Georgia.
- 2. Drive from Georgia to Texas.
- 3. Drive from Texas to Oklahoma.
- 4. Drive from Oklahoma to California.

46. Translate the above into general cardinal directions.

 a. Drive west, then south, then north, then west.
 b. Drive north, then west, then north, then south.
 c. Drive north, then west, then north, then west.
 d. Drive south, then west, then north, then south.

The next two questions are based on the following passage from Walden *by Henry David Thoreau.*

> When I wrote the following passages, or rather the bulk of them, I lived alone, in the woods, a mile from any neighbor, in a house which I had built myself on the shore of Walden Pond, in Concord, Massachusetts, and earned my living by the labor of my hands only. I lived there two years and two months. At present I am a sojourner in civilized life again.

47. Where in a text is this passage most likely to be found?
 a. Introduction
 b. Appendix
 c. Dedication
 d. Glossary

48. What does the word *sojourner* most likely mean at the end of the passage?
 a. Illegal alien
 b. Temporary resident
 c. Lifetime partner
 d. Farm crop

49. Based on the label above, this juice contains the most of which two ingredients?
 a. Vitamin C and cornstarch
 b. Corn syrup and Vitamin C
 c. Water and corn syrup
 d. Water and cornstarch

50. On the label above, how many calories would you consume if you drank two bottles of this drink?
 a. 80 calories
 b. 100 calories
 c. 160 calories
 d. 180 calories

The following is a preface for Poems by Alexander Pushkin *by Ivan Panin. The next three questions are based on the following passage.*

> I do not believe there are as many as five examples of deviation from the literalness of the text. Once only, I believe, have I transposed two lines for convenience of translation; the other deviations are (*if* they are such) a substitution of an *and* for a comma in order to make now and then the reading of a line musical. With these exceptions, I have sacrificed *everything* to faithfulness of rendering. My object was to make Pushkin himself, without a prompter, speak to English readers. To make him thus speak in a foreign tongue was indeed to place him at a disadvantage; and music and rhythm and harmony are indeed fine things, but truth is finer still. I wished to present not what Pushkin would have said, or [Pg 10] should have said, if he had written in English, but what he does say in Russian. That, stripped from all ornament of his

wonderful melody and grace of form, as he is in a translation, he still, even in the hard English tongue, soothes and stirs, is in itself a sign that through the individual soul of Pushkin sings that universal soul whose strains appeal forever to man, in whatever clime, under whatever sky.

51. From clues in this passage, what type of work is the author doing?
 a. Translation work
 b. Criticism
 c. Historical validity
 d. Writing a biography

52. Where would you most likely find this passage in a text?
 a. Appendix
 b. Table of contents
 c. First chapter
 d. Preface

53. According to the author, what is the most important aim of translation work?
 a. To retain the beauty of the work.
 b. To retain the truth of the work.
 c. To retain the melody of the work.
 d. To retain the form of the work.

Answer Explanations

1. A: To show the audience one of the effects of criminal rehabilitation by comparison. Choice *B* is incorrect because although it is obvious the author favors rehabilitation, the author never asks for donations from the audience. Choices *C* and *D* are also incorrect. We can infer from the passage that American prisons are probably harsher than Norway prisons. However, the best answer that captures the author's purpose is Choice *A*, because we see an effect by the author (recidivism rate of each country) comparing Norwegian and American prisons.

2. D: The likelihood of a convicted criminal to reoffend. The passage explains how a Norwegian prison, due to rehabilitation, has a smaller rate of recidivism. Thus, we can infer that recidivism is probably not a positive attribute. Choices *A* and *B* are both positive attributes, the lack of violence and the opportunity of inmates to receive therapy, so Norway would probably not have a lower rate of these two things. Choice *C* is possible, but it does not make sense in context, because the author does not talk about tactics in which to keep prisoners inside the compound, but ways in which to rehabilitate criminals so that they can live as citizens when they get out of prison.

3. B: 74g. Choice *A* has the correct number, but the unit of measurement is in "mg" instead of "g." Choices *C* and *D* are incorrect.

4. D: The passage is reflective of a narrative. A narrative is used to tell a story, as we see the narrator trying to do in this passage by using memory and dialogue. Choice *A*, persuasive writing, uses rhetorical devices to try and convince the audience of something, and there is no persuasion or argument within this passage. Choice *B*, expository, is a type of writing used to inform the reader. Choice *C*, technical writing, is usually used within business communications and uses technical language to explain procedures or concepts to someone within the same technical field.

5. C: A sense of foreboding. The narrator, after feeling excitement for the morning, feels "that something awful was about to happen," which is considered foreboding. The narrator mentions larks and weather in the passage, but there is no proof of anger or confusion at either of them.

6. C: To introduce Peter Walsh back into the narrator's memory. Choice *A* is incorrect because, although the novel *Mrs. Dalloway* is about events leading up to a party, the passage does not mention anything about a party. Choice *B* is incorrect; the narrator calls Peter *dull* at one point, but the rest of her memories of him are more positive. Choice *D* is incorrect; although morning is described within the first few sentences of the passage, the passage quickly switches to a description of Peter Walsh and the narrator's memories of him.

7. A: According to the map, Volcano Terevaka is the highest point on the island, reaching 507m. Volcano Puakatike is the next highest, reaching 307m. Vaka Kipo is the next highest reaching 216m. Finally, Maunga Ana Marama is the next highest, reaching 165m.

8. B: To convince the audience that judges holding their positions based on good behavior is a practical way to avoid corruption.

9. C: Personification. The chapter on Literature and Language Use has a subsection, "Figurative Speech." The sections located under Figurative Speech all have to do with language that uses words or phrases that are different from their literal interpretation. Personification is included in figurative speech, which means

giving inanimate objects human characteristics. Nouns, agreement, and syntax all have to do with grammar and usage, and are not considered figurative language.

10. B: Bi. The element listed under Group V, Period 6 in the table is Bi. The other elements are close by, but they do not fall under this group and period.

11. D: Felicia had to be prudent, or careful, if she was going to cross the bridge over the choppy water. Choice *A*, patient, is close to the word careful. However, careful makes more sense here. Choices *B* and *C* don't make sense within the context—Felicia wasn't hoping to be *afraid* or *dangerous* while crossing over the bridge, but was hoping to be careful to avoid falling.

12. B: Whatever happened in his life before he had a certain internal change is irrelevant. Choices *A*, *C*, and *D* use some of the same language as the original passage, like "revolution," "speak," and "details," but they do not capture the meaning of the statement. The statement is saying the details of his previous life are not going to be talked about—that he had some kind of epiphany, and moving forward in his life is what the narrator cares about.

13. B: First-person omniscient. This is the best guess with the information we have. In the world of the passage, the narrator is first-person, because we see them use the "I," but they also know the actions and thoughts of the protagonist, a character named "Webster." First-person limited tells their own story, making Choice *A* incorrect. Choice *C* is incorrect; second person uses "you" to tell the story. Third person uses "them," "they," etc., and would not fall into use of the "I" in the narrative, making Choice *D* incorrect.

14. A: Webster is a washing machine manufacturer. This question depends on reading comprehension. We see in the second sentence that Webster "was a fairly prosperous manufacturer of washing machines," making Choice *A* the correct answer.

15. D: 62°. Choice *A* is the Celsius temperature, not Fahrenheit. Choices *B* and *C* are incorrect, although Choice *C* is just one degree off.

16. B: Veggie pasta with marinara sauce. Choices *A* and *D* are incorrect because they both contain cheese, and the doctor gave Sheila a list *without* dairy products. Choice *C* is incorrect because the doctor is also having Sheila stay away from eggs, and the omelet has eggs in it. Choice *B* is the best answer because it contains no meat, dairy, or eggs.

17. C: Maritza went to the park to swim with her friends, and when she got there, she realized that they had thrown her a surprise party!" Following the directions carefully will result in this sentence. All the other sentences are close, but Choices *A*, *B*, and *D* leave at least one of the steps out.

18. D: According to the pie chart, Internet Explorer (I.E.) is the most used browser in October 2011. Following that is Firefox with 23.6% usage, Chrome with 20.6% usage, and Safari with 11.2% usage.

19. D: Glossary. A glossary is a section in a book that provides brief definitions/explanations for words that the reader may not know. Choice *A* is incorrect because a table of contents shows where each section of the book is located. Choice *B* is incorrect because the introduction is usually a chapter that introduces the book about to be read. Choice *C* is incorrect because an index is usually a list of alphabetical references at the end of a book that a reader can look up to get more information.

20. B: Secondary source. This excerpt is considered a secondary source because it actively interprets primary sources. We see direct quotes from the queen, which would be considered a primary source. But

since we see those quotes being interpreted and analyzed, the excerpt becomes a secondary source. Choice *C*, tertiary source, is an index of secondary and primary sources, like an encyclopedia or Wikipedia.

21. B: It took two years for the new castle to be built. It states this in the first sentence of the second paragraph. In the third year, we see the Prince planning improvements, and arranging things for the fourth year.

22. C: To impose a certain quality upon. The sentence states that "the impress of his dear hand [has] been stamped everywhere," regarding the quality of his tastes and creations on the house. Choice *A* is one definition of *impress*, but this definition is used more as a verb than a noun: "She impressed us as a songwriter." Choice *B* is incorrect because it is also used as a verb: "He impressed the need for something to be done." Choice *D* is incorrect because it is part of a physical act: "the businessman impressed his mark upon the envelope." The phrase in the passage is meant as figurative, since the workmen did most of the physical labor, not the Prince.

23. A: They are the grandchildren of your brother and sister. Nieces and nephews refer to the children of your brother and sister, and then your grand nieces and nephews are the grandchildren of your brother and sister, and the children of your nieces and nephews.

24. C: They are the cousins of your spouse. The parents of your spouse are called your Mother-in-law or Father-in-law. The aunts and uncles of your spouse are called Aunts and Uncles-in-law. The children of your spouse would be your children or your step-children.

25. A: Chronological order. The passage presents us with a sequence of events that happens in chronological order. Choice *B* is incorrect. Cause and effect organization would usually explain why something happened or list the effects of something. Choice *C* is incorrect because problem and solution organization would detail a problem and then present a solution to the audience, and there is no solution presented here. Finally, Choice *D* is incorrect. We are entered directly into the narrative without any main idea or any kind of argument being delivered.

26. D: A president is about to be assassinated. The context clues in the passage give hints to what is about to happen. The passage mentions John Wilkes Booth as "Mr. Booth," the man who shot Abraham Lincoln. The passage also mentions a "Mr. Ford," and we know that Lincoln was shot in Ford's theater. Finally, the passage mentions Mr. and Mrs. Lincoln. By adding all these clues up and our prior knowledge of history, the assassination of President Lincoln by Booth in Ford's theater is probably the next thing that is going to happen.

27. B: Mr. Ford assumed Booth's movement throughout the theater was due to being familiar with the theater. Choice *A* is incorrect; although Booth does eventually make his way to Lincoln's box, Mr. Ford does not make this distinction in this part of the passage. Choice *C* is incorrect; although the passage mentions "companions," it mentions Lincoln's companions rather than Booth's companions. Finally, Choice *D* is incorrect; the passage mentions "dress circle," which means the first level of the theater, but this is different from a "dressing room."

28. A: Technical document. Technical documents are documents that describe the functionality of a technical product, so Choice *A* is the best answer. Persuasive texts, Choice *B*, try to persuade an audience to follow the author's line of thinking or to act on something. Choice *C*, narrative texts, seek to tell a story. Choice *D*, cause and effect, try to show why something happened, or the causes or effects of a particular thing.

29. C: 394,000. Choice *A* is the population of Totok in 1920. Choice *B* is the population of Totok in 1930. Choice *D* is the population of Peranakan in 1956 and 1961.

30. C: The answer is 404,000. This question requires some simple math by subtracting the total population of Peranakan in 1971 (1,240,000) from the total population of Peranakan in 1961 (836,000) which comes to 404,000.

31. D: To show some of the different effects of bacteria on milk. The passage explains the different ways bacteria can affect milk by detailing the color and taste of different infections. Choices *A* and *B* might be true, but they are not the main purpose of the passage as detailed in the first sentence. Choice *C* is incorrect, since milk does not have an effect on bacteria in this particular passage.

32. C: The tone of this passage is neutral, since it is written in an academic/informative voice. It is important to look at the author's word choice to determine what the tone of a passage is. We have no indication that the author is excited, angry, or sorrowful at the effects of bacteria on milk, so Choices *A, B,* and *D* are incorrect.

33. B: The milk will turn black is not a reaction mentioned in the passage. The passage does state, however, that the milk may get "soapy," that it can become "slimy," and that it may turn out to be a "beautiful sky-blue colour," making Choices *A, C,* and *D* incorrect.

34. A: Lumpy. In the sentence, we know that the word "curdle" means the opposite of "slimy." The words greasy, oily, and slippery are all very similar to the word slimy, making Choices *B, C,* and *D* incorrect. "Lumpy" means clotted, chunky, or thickened.

35. A: Because it is impossible to get rid of. The passage mentions milk turning blue or tasting bad, and milk could possibly even make a milk-drinker sick if it has slimy threads. However, we know for sure that the slimy threads prove troublesome because it can become impossible to get rid of from this sentence: "Such an infection proves very troublesome, for many a time it persists in spite of all attempts made to remedy it."

36. C: Dorm. Eliminating all vowels but the "O" makes Choice *D* incorrect. The "T" is also eliminated, which makes Choice *B* incorrect. *A* is incorrect because there is only one "O" in "auditorium."

37. B: 125mph. We see the number on the odometer reach 120mph, and then there are five marks after the 120, making the top speed 125 mph.

38. C: 91,308 miles. We can see the number of miles driven by the digital numbers underneath the odometer.

39. A: Depressed. We can guess that the word "despondent" means "depressed" by the end of the sentence. We see that although Olivia feels despondent, her sister can "cheer her up." When someone needs cheering up, they are usually sad or depressed about something. Joyful and humorous, Choices *B* and *D,* have opposite meanings of the word "despondent." Choice *C,* pathetic, is close, but Choice *A* is the best option for the context of the sentence.

40. D: A city whose population is made up of people who seek quick fortunes rather than building a solid business foundation. Choice *A* is a characteristic of Portland, but not that of a boom city. Choice *B* is close—a boom city is one that becomes quickly populated, but it is not necessarily always populated by residents from the east coast. Choice *C* is incorrect because a boom city is not one that catches fire

frequently, but one made up of people who are looking to make quick fortunes from the resources provided on the land.

41. D: A city of legitimate business. We can see the proof in this sentence: "the cause of Portland's growth and prosperity is the trade which it has as the center of collection and distribution of this great wealth of natural resources, and it has attracted, not the boomer and speculator . . . but the merchant, manufacturer, and investor, who seek the surer if slower channels of legitimate business and investment." Choices *A*, *B*, and *C* are not mentioned in the passage and are incorrect.

42. B: A travel guide. Our first hint is in the title: *Oregon, Washington, and Alaska. Sights and Scenes for the Tourist.* Although the passage talks about business, there is no proposition included, which makes Choice *A* incorrect. Choice *C* is incorrect because the style of the writing is more informative and formal rather than personal and informal. Choice *D* is incorrect; this could possibly be a scholarly article, but the best choice is that it is a travel guide, due to the title and the details of what the city has to offer at the very end.

43. C: Metropolis means city. Portland is described as having agricultural valleys, but it is not solely a "farm" or "valley," making Choices *A* and *D* incorrect. We know from the description of Portland that it is more representative of a city than a countryside or country, making Choice *B* incorrect.

44. B: A myth. Look for the key words that give away the type of passage this is, such as "deities," "Greek hero," "centaur," and the names of demigods like Artemis. A eulogy is typically a speech given at a funeral, making Choice *A* incorrect. Choices *C* and *D* are incorrect, as "virgin huntresses" and "centaurs" are typically not found in historical or professional documents.

45. A: Friend. Based on the context of the passage, we can see that Hippolytus was a friend to Artemis because he "spent all his days in the greenwood chasing wild beasts" with her. The other choices are incorrect.

46. C: From Florida to Georgia is north. From Georgia to Texas is west. From Texas to Oklahoma is north. From Oklahoma to California is west.

47. A: Introduction. The passage tells us how the following passages of the book are written, which acts as an introduction to the work. An appendix comes at the end of a book, giving extra details, making Choice *B* incorrect. Choice *C* is incorrect; a dedication is at the beginning of a book, but usually acknowledges those the author is grateful towards. Choice *D* is incorrect because a glossary is a list of terms with definitions at the end of a chapter or book.

48. B: Temporary resident. Although we don't have much context to go off of, we know that one is probably not a "lifetime partner" or "farm crop" of civilized life. These two do not make sense, so Choices *C* and *D* are incorrect. Choice *A* is also a bit strange. To be an "illegal alien" of civilized life is not a used phrase, making Choice *A* incorrect.

49. C: Water and corn syrup. The list of ingredients on a food or drink label go from the most common ingredient found to the least common ingredient found. Water and corn syrup are both at the very top of the list. Cornstarch is found in the ingredients, but it is not at the top of the list.

50. C: 160 calories. You would consume 160 calories because one serving of this drink has 80 calories. If you double 80 calories, that gives you 160 calories. The other answer choices are incorrect.

51. A: The author is doing translation work. We see this very clearly in the way the author talks about staying truthful to the original language of the text. The text also mentions "translation" towards the end. Criticism is taking an original work and analyzing it, making Choice *B* incorrect. The work is not being tested for historical validity, but being translated into the English language, making Choice *C* incorrect. The author is not writing a biography, as there is nothing in here about Pushkin himself, only his work, making Choice *D* incorrect.

52. D: You would most likely find this in the preface. A preface to a text usually explains what the author has done or aims to do with the work. An appendix is usually found at the end of a text and does not talk about what the author intends to do to the work, making Choice *A* incorrect. A table of contents does not contain prose, but bullet points listing chapters and sections found in the text, making Choice *B* incorrect. Choice *C* is incorrect; the first chapter would include the translation work (here, poetry), and not the author's intentions.

53. B: To retain the truth of the work. The author says that "music and rhythm and harmony are indeed fine things, but truth is finer still," which means that the author stuck to a literal translation instead of changing up any words that might make the English language translation sound better.

Mathematics

Numbers and Algebra

Definitions

Whole numbers are the numbers 0, 1, 2, 3, Examples of other whole numbers would be 413 and 8,431. Notice that numbers such as 4.13 and $\frac{1}{4}$ are not included in whole numbers. *Counting numbers*, also known as *natural numbers*, consist of all whole numbers except for the zero. In set notation, the natural numbers are the set $\{1, 2, 3, ...\}$. The entire set of whole numbers and negative versions of those same numbers comprise the set of numbers known as integers. Therefore, in set notation, the integers are $\{..., -3, -2, -1, 0, 1, 2, 3, ...\}$. Examples of other integers are −4,981 and 90,131. A number line is a great way to visualize the integers. Integers are labeled on the following number line:

The arrows on the right- and left-hand sides of the number line show that the line continues indefinitely in both directions.

Fractions also exist on the number line as parts of a whole. For example, if an entire pie is cut into two pieces, each piece is half of the pie, or $\frac{1}{2}$. The top number in any fraction, known as the *numerator,* defines how many parts there are. The bottom number, known as the *denominator,* states how many pieces the whole is divided into. Fractions can also be negative or written in their corresponding decimal form.

A *decimal* is a number that uses a decimal point and numbers to the right of the decimal point representing the part of the number that is less than 1. For example, 3.5 is a decimal and is equivalent to the fraction $\frac{7}{2}$ or mixed number $3\frac{1}{2}$. The decimal is found by dividing 2 into 7. Other examples of fractions are $\frac{2}{7}, \frac{-3}{14}$, and $\frac{14}{27}$.

Any number that can be expressed as a fraction is known as a *rational number*. Basically, if a and b are any integers and $b \neq 0$, then $\frac{a}{b}$ is a rational number. Any integer can be written as a fraction where the denominator is 1, so therefore the rational numbers consist of all fractions and all integers.

Any number that is not rational is known as an irrational number. Consider the number $\pi = 3.141592654$ The decimal portion of that number extends indefinitely. In that situation, a number can never be written as a fraction. Another example of an irrational number is $\sqrt{2} = 1.414213662$ Again, this number cannot be written as a ratio of two integers.

Together, the set of all rational and irrational numbers makes up the real numbers. The number line contains all real numbers. To graph a number other than an integer on a number line, it needs to be plotted between two integers. For example, 3.5 would be plotted halfway between 3 and 4.

Even numbers are integers that are divisible by 2. For example, 6, 100, 0, and −200 are all even numbers. Odd numbers are integers that are not divisible by 2. If an odd number is divided by 2, the result is a fraction. For example, −5, 11, and −121 are odd numbers.

Prime numbers consist of natural numbers greater than 1 that are not divisible by any other natural numbers other than themselves and 1. For example, 3, 5, and 7 are prime numbers. If a natural number is not prime, it is known as a composite number. 8 is a composite number because it is divisible by both 2 and 4, which are natural numbers other than itself and 1.

The *absolute value* of any real number is the distance from that number to 0 on the number line. The absolute value of a number can never be negative. For example, the absolute value of both 8 and −8 is 8 because they are both 8 units away from 0 on the number line. This is written as $|8| = |-8| = 8$.

Factorization

Factorization is the process of breaking up a mathematical quantity, such as a number or polynomial, into a product of two or more factors. For example, a factorization of the number 16 is $16 = 8 \cdot 2$. If multiplied out, the factorization results in the original number. A *prime factorization* is a specific factorization when the number is factored completely using prime numbers only. For example, the prime factorization of 16 is $16 = 2 \cdot 2 \cdot 2 \cdot 2$. A factor tree can be used to find the prime factorization of any number. Within a factor tree, pairs of factors are found until no other factors can be used, as in the following factor tree of the number 84:

A factor tree

84 = 2 x 2 x 3 x 7

It first breaks 84 into $21 \cdot 4$, which is not a prime factorization. Then, both 21 and 4 are factored into their primes. The final numbers on each branch consist of the numbers within the prime factorization. Therefore, $84 = 2 \cdot 2 \cdot 3 \cdot 7$. Factorization can be helpful in finding greatest common divisors and least common denominators.

Also, a factorization of an algebraic expression can be found. Throughout the process, a more complicated expression can be decomposed into products of simpler expressions. To factor a polynomial, first determine if there is a greatest common factor. If there is, factor it out. For example, $2x^2 + 8x$ has a greatest common factor of $2x$ and can be written as $2x(x + 4)$. Once the greatest common monomial factor is factored out, if applicable, count the number of terms in the polynomial. If there are two terms, is it a difference of squares, a sum of cubes, or a difference of cubes?

If so, the following rules can be used:

$$a^2 - b^2 = (a + b)(a - b)$$

$$a^3 + b^3 = (a + b)(a^2 - ab + b^2)$$

$$a^3 - b^3 = (a + b)(a^2 + ab + b^2)$$

If there are three terms, and if the trinomial is a perfect square trinomial, it can be factored into the following:

$$a^2 + 2ab + b^2 = (a + b)^2$$

$$a^2 - 2ab + b^2 = (a - b)^2$$

If not, try factoring into a product of two binomials by trial and error into a form of $(x + p)(x + q)$. For example, to factor $x^2 + 6x + 8$, determine what two numbers have a product of 8 and a sum of 6. Those numbers are 4 and 2, so the trinomial factors into $(x + 2)(x + 4)$.

Finally, if there are four terms, try factoring by grouping. First, group terms together that have a common monomial factor. Then, factor out the common monomial factor from the first two terms. Next, look to see if a common factor can be factored out of the second set of two terms that results in a common binomial factor. Finally, factor out the common binomial factor of each expression, for example:

$$xy - x + 5y - 5 = x(y - 1) + 5(y - 1) = (y - 1)(x + 5)$$

After the expression is completely factored, check to see if the factorization is correct by multiplying to try to obtain the original expression. Factorizations are helpful in solving equations that consist of a polynomial set equal to 0. If the product of two algebraic expressions equals 0, then at least one of the factors is equal to 0. Therefore, factor the polynomial within the equation, set each factor equal to 0, and solve. For example, $x^2 + 7x - 18 = 0$ can be solved by factoring into $(x + 9)(x - 2) = 0$. Set each factor equal to 0, and solve to obtain $x = -9$ and $x = 2$.

Converting Non-Negative Fractions, Decimals, and Percentages

Within the number system, different forms of numbers can be used. It is important to be able to recognize each type, as well as work with, and convert between, the given forms. The *real number system* comprises natural numbers, whole numbers, integers, rational numbers, and irrational numbers. Natural numbers, whole numbers, integers, and irrational numbers typically are not represented as fractions, decimals, or percentages. Rational numbers, however, can be represented as any of these three forms. A *rational number* is a number that can be written in the form $\frac{a}{b}$, where a and b are integers, and b is not equal to zero. In other words, rational numbers can be written in a fraction form. The value a is the *numerator,* and b is the *denominator.* If the numerator is equal to zero, the entire fraction is equal to zero. Non-negative fractions can be less than 1, equal to 1, or greater than 1. Fractions are less than 1 if the numerator is smaller (less than) than the denominator. For example, $\frac{3}{4}$ is less than 1. A fraction is equal to 1 if the numerator is equal to the denominator. For instance, $\frac{4}{4}$ is equal to 1. Finally, a fraction is greater than 1 if the numerator is greater than the denominator: the fraction $\frac{11}{4}$ is greater than 1. When the numerator is greater than the denominator, the fraction is called an *improper fraction.* An improper fraction can be converted to a *mixed number,* a combination of both a whole number and a fraction. To convert an improper fraction to a mixed number, divide the numerator by the denominator. Write down the whole number portion, and then write any remainder over the original denominator. For example, $\frac{11}{4}$ is

59

equivalent to $2\frac{3}{4}$. Conversely, a mixed number can be converted to an improper fraction by multiplying the denominator times the whole number and adding that result to the numerator.

Fractions can be converted to decimals. With a calculator, a fraction is converted to a decimal by dividing the numerator by the denominator. For example, $\frac{2}{5} = 2 \div 5 = 0.4$. Sometimes, rounding might be necessary. Consider $\frac{2}{7} = 2 \div 7 = 0.28571429$. This decimal could be rounded for ease of use, and if it needed to be rounded to the nearest thousandth, the result would be 0.286. If a calculator is not available, a fraction can be converted to a decimal manually. First, find a number that, when multiplied by the denominator, has a value equal to 10, 100, 1,000, etc. Then, multiply both the numerator and denominator times that number. The decimal form of the fraction is equal to the new numerator with a decimal point placed as many place values to the left as there are zeros in the denominator. For example, to convert $\frac{3}{5}$ to a decimal, multiply both the numerator and denominator times 2, which results in $\frac{6}{10}$. The decimal is equal to 0.6 because there is one zero in the denominator, and so the decimal place in the numerator is moved one unit to the left. In the case where rounding would be necessary while working without a calculator, an approximation must be found. A number close to 10, 100, 1,000, etc. can be used. For example, to convert $\frac{1}{3}$ to a decimal, the numerator and denominator can be multiplied by 33 to turn the denominator into approximately 100, which makes for an easier conversion to the equivalent decimal. This process results in $\frac{33}{99}$ and an approximate decimal of 0.33. Once in decimal form, the number can be converted to a percentage. Multiply the decimal by 100 and then place a percent sign after the number. For example, .614 is equal to 61.4%. In other words, move the decimal place two units to the right and add the percentage symbol.

Performing Arithmetic Operations with Rational Numbers

The four basic operations include addition, subtraction, multiplication, and division. The result of addition is a sum, the result of subtraction is a difference, the result of multiplication is a product, and the result of division is a quotient. Each type of operation can be used when working with rational numbers; however, the basic operations need to be understood first while using simpler numbers before working with fractions and decimals.

Performing these operations should first be learned using whole numbers. Addition needs to be done column by column. To add two whole numbers, add the ones column first, then the tens columns, then the hundreds, etc. If the sum of any column is greater than 9, a one must be carried over to the next column. For example, the following is the result of 482 + 924:

$$
\begin{array}{r}
1 \\
482 \\
+924 \\
\hline
1406
\end{array}
$$

Notice that the sum of the tens column was 10, so a one was carried over to the hundreds column. Subtraction is also performed column by column. Subtraction is performed in the ones column first, then

the tens, etc. If the number on top is smaller than the number below, a one must be borrowed from the column to the left. For example, the following is the result of 5,424 − 756:

$$4 \ 13 \ 11 \ 14$$
$$\cancel{5 \ 4 \ 2 \ 4}$$
$$- \ 7 \ 5 \ 6$$
$$\overline{4 \ 6 \ 6 \ 8}$$

Notice that a one is borrowed from the tens, hundreds, and thousands place. After subtraction, the answer can be checked through addition. A check of this problem would be to show that 756 + 4,668 = 5,424.

Multiplication of two whole numbers is performed by writing one on top of the other. The number on top is known as the *multiplicand,* and the number below is the *multiplier.* Perform the multiplication by multiplying the multiplicand by each digit of the multiplier. Make sure to place the ones value of each result under the multiplying digit in the multiplier. Each value to the right is then a 0. The product is found by adding each product. For example, the following is the process of multiplying 46 times 37 where 46 is the multiplicand and 37 is the multiplier:

Finally, division can be performed using long division. When dividing a number by another number, the first number is known as the *dividend,* and the second is the *divisor.* For example, with $a \div b = c$, a is the dividend, b is the divisor, and c is the quotient. For long division, place the dividend within the division symbol and the divisor on the outside. For example, with 8,764 ÷ 4, refer to the first problem in the diagram below. First, there are 2 4's in the first digit, 8. This number 2 gets written above the 8. Then, multiply 4 times 2 to get 8, and that product goes below the 8. Subtract to get 8, and then carry down the 7. Continue the same steps. 7 ÷ 4 = 1 R3, so 1 is written above the 7. Multiply 4 times 1 to get 4, and write it below the 7. Subtract to get 3, and carry the 6 down next to the 3. Resulting steps give a 9 and a 1. The final subtraction results in a 0, which means that 8,764 is divisible by 4. There are no remaining numbers.

The second example shows that $4{,}536 \div 216 = 21$. The steps are a little different because 216 cannot be contained in 4 or 5, so the first step is placing a 2 above the 3 because there are 2 216's in 453. Finally, the third example shows that $546 \div 31 = 17\,R19$. The 19 is a remainder. Notice that the final subtraction does not result in a 0, which means that 546 is not divisible by 31. The remainder can also be written as a fraction over the divisor to say that $546 \div 31 = 17\frac{19}{31}$.

If a division problem relates to a real-world application, and a remainder does exist, it can have meaning. For example, consider the third example, $546 \div 31 = 17R19$. Let's say that we had \$546 to spend on calculators that cost \$31 each, and we wanted to know how many we could buy. The division problem would answer this question. The result states that 17 calculators could be purchased, with \$19 left over. Notice that the remainder will never be greater than or equal to the divisor.

Once the operations are understood with whole numbers, they can be used with integers. There are many rules surrounding operations with negative numbers. First, consider addition with integers. The sum of two numbers can first be shown using a number line. For example, to add $-5 + (-6)$, plot the point -5 on the number line. Then, because a negative number is being added, move 6 units to the left. This process results in landing on -11 on the number line, which is the sum of -5 and -6. If adding a positive number, move to the right. Visualizing this process using a number line is useful for understanding; however, it is not efficient. A quicker process is to learn the rules. When adding two numbers with the same sign, add the absolute values of both numbers, and use the common sign of both numbers as the sign of the sum. For example, to add $-5 + (-6)$, add their absolute values $5 + 6 = 11$. Then, introduce a negative number because both addends are negative. The result is -11. To add two integers with unlike signs, subtract the lesser absolute value from the greater absolute value, and apply the sign of the number with the greater absolute value to the result. For example, the sum $-7 + 4$ can be computed by finding the difference $7 - 4 = 3$ and then applying a negative because the value with the larger absolute value is negative. The result is -3. Similarly, the sum $-4 + 7$ can be found by computing the same difference but leaving it as a

positive result because the addend with the larger absolute value is positive. Also, recall that any number plus 0 equals that number. This is known as the *Addition Property of 0.*

Subtracting two integers can be computed by changing to addition to avoid confusion. The rule is to add the first number to the opposite of the second number. The opposite of a number is the number on the other side of 0 on the number line, which is the same number of units away from 0. For example, −2 and 2 are opposites. Consider 4 − 8. Change this to adding the opposite as follows: 4 + (−8). Then, follow the rules of addition of integers to obtain −4. Secondly, consider −8 − (−2). Change this problem to adding the opposite as −8 + 2, which equals −6. Notice that subtracting a negative number is really adding a positive number.

Multiplication and division of integers are actually less confusing than addition and subtraction because the rules are simpler to understand. If two factors in a multiplication problem have the same sign, the result is positive. If one factor is positive and one factor is negative, the result, known as the *product,* is negative. For example, $(−9)(−3) = 27$ and $9(−3) = −27$. Also, a number times 0 always results in 0. If a problem consists of more than a single multiplication, the result is negative if it contains an odd number of negative factors, and the result is positive if it contains an even number of negative factors. For example, $(−1)(−1)(−1)(−1) = 1$ and $(−1)(−1)(−1)(−1)(−1) = 1$. These two examples of multiplication also bring up another concept. Both are examples of repeated multiplication, which can be written in a more compact notation using exponents. The first example can be written as $(−1)^4 = 1$, and the second example can be written as $(−1)^5 = −1$. Both are exponential expressions, −1 is the base in both instances, and 4 and 5 are the respective exponents. Note that a negative number raised to an odd power is always negative, and a negative number raised to an even power is always positive. Also, $(−1)^4$ is not the same as $−1^4$. In the first expression, the negative is included in the parentheses, but it is not in the second expression. The second expression is found by evaluating 1^4 first to get 1 and then by applying the negative sign to obtain −1.

A similar theory applies within division. First, consider some vocabulary. When dividing 14 by 2, it can be written in the following ways: $14 ÷ 2 = 7$ or $\frac{14}{2} = 7$. 14 is the *dividend,* 2 is the *divisor,* and 7 is the *quotient.* If two numbers in a division problem have the same sign, the quotient is positive. If two numbers in a division problem have different signs, the quotient is negative. For example:

$$14 ÷ (−2) = −7, \text{ and } −14 ÷ (−2) = 7$$

To check division, multiply the quotient times the divisor to obtain the dividend. Also, remember that 0 divided by any number is equal to 0. However, any number divided by 0 is undefined. It just does not make sense to divide a number by 0 parts.

If more than one operation is to be completed in a problem, follow the Order of Operations. The mnemonic device, PEMDAS, for the order of operations states the order in which addition, subtraction, multiplication, and division needs to be done. It also includes when to evaluate operations within grouping symbols and when to incorporate exponents. PEMDAS, which some remember by thinking "please excuse my dear Aunt Sally," refers to parentheses, exponents, multiplication, division, addition, and subtraction. First, within an expression, complete any operation that is within parentheses, or any other grouping symbol like brackets, braces, or absolute value symbols. Note that this does not refer to the case when parentheses are used to represent multiplication like $(2)(5)$. An operation is not within parentheses like it is in $(2 · 5)$. Then, any exponents must be computed. Next, multiplication and division are performed from left to right.

Finally, addition and subtraction are performed from left to right. The following is an example in which the operations within the parentheses need to be performed first, so the order of operations must be applied to the exponent, subtraction, addition, and multiplication within the grouping symbol:

$$9-3(3^2-3+4\cdot3)$$

$$9-3(3^2-3+4\cdot3) \quad \text{Work within the parentheses first}$$

$$=9-3(9-3+12)$$

$$=9-3(18)$$

$$=9-54$$

$$=-45$$

Once the rules for integers are understood, move on to learning how to perform operations with fractions and decimals. Recall that a rational number can be written as a fraction and can be converted to a decimal through division. If a rational number is negative, the rules for adding, subtracting, multiplying, and dividing integers must be used. If a rational number is in fraction form, performing addition, subtraction, multiplication, and division is more complicated than when working with integers. First, consider addition. To add two fractions having the same denominator, add the numerators and then reduce the fraction. When an answer is a fraction, it should always be in lowest terms. *Lowest terms* means that every common factor, other than 1, between the numerator and denominator is divided out. For example:

$$\frac{2}{8}+\frac{4}{8}=\frac{6}{8}=\frac{6\div2}{8\div2}=\frac{3}{4}$$

Both the numerator and denominator of $\frac{6}{8}$ have a common factor of 2, so 2 is divided out of each number to put the fraction in lowest terms. If denominators are different in an addition problem, the fractions must be converted to have common denominators. The *least common denominator (LCD)* of all the given denominators must be found, and this value is equal to the *least common multiple (LCM)* of the denominators. This non-zero value is the smallest number that is a multiple of both denominators. Then, rewrite each original fraction as an equivalent fraction using the new denominator. Once in this form, apply the process of adding with like denominators. For example, consider $\frac{1}{3}+\frac{4}{9}$. The LCD is 9 because it is the smallest multiple of both 3 and 9. The fraction $\frac{1}{3}$ must be rewritten with 9 as its denominator. Therefore, multiply both the numerator and denominator times 3. Multiplying times $\frac{3}{3}$ is the same as multiplying times 1, which does not change the value of the fraction. Therefore, an equivalent fraction is $\frac{3}{9}$, and $\frac{1}{3}+\frac{4}{9}=\frac{3}{9}+\frac{4}{9}=\frac{7}{9}$, which is in lowest terms. Subtraction is performed in a similar manner; once the denominators are equal, the numerators are then subtracted. The following is an example of addition of a positive and a negative fraction:

$$-\frac{5}{12}+\frac{5}{9}=-\frac{5\cdot3}{12\cdot3}+\frac{5\cdot4}{9\cdot4}=-\frac{15}{36}+\frac{20}{36}=\frac{5}{36}$$

Common denominators are not used in multiplication and division. To multiply two fractions, multiply the numerators together and the denominators together. Then, write the result in lowest terms. For example:

$$\frac{2}{3} \times \frac{9}{4} = \frac{18}{12} = \frac{3}{2}$$

Alternatively, the fractions could be factored first to cancel out any common factors before performing the multiplication. For example:

$$\frac{2}{3} \times \frac{9}{4} = \frac{2}{3} \times \frac{3 \times 3}{2 \times 2} = \frac{3}{2}$$

This second approach is helpful when working with larger numbers, as common factors might not be obvious. Multiplication and division of fractions are related because the division of two fractions is changed into a multiplication problem. Division of a fraction is equivalent to multiplication of the *reciprocal* of the second fraction, so that second fraction must be inverted, or "flipped," to be in reciprocal form. For example:

$$\frac{11}{15} \div \frac{3}{5} = \frac{11}{15} \times \frac{5}{3} = \frac{55}{45} = \frac{11}{9}$$

The fraction $\frac{5}{3}$ is the reciprocal of $\frac{3}{5}$. It is possible to multiply and divide numbers containing a mix of integers and fractions. In this case, convert the integer to a fraction by placing it over a denominator of 1. For example, a division problem involving an integer and a fraction is:

$$3 \div \frac{1}{2} = \frac{3}{1} \times \frac{2}{1} = \frac{6}{1} = 6$$

Finally, when performing operations with rational numbers that are negative, the same rules apply as when performing operations with integers. For example, a negative fraction times a negative fraction results in a positive value, and a negative fraction subtracted from a negative fraction results in a negative value.

Operations can be performed on rational numbers in decimal form. Recall that to write a fraction as an equivalent decimal expression, divide the numerator by the denominator. For example:

$$\frac{1}{8} = 1 \div 8 = 0.125$$

With the case of decimals, it is important to keep track of place value. To add decimals, make sure the decimal places are in alignment so that the numbers are lined up with their decimal points and add vertically. If the numbers do not line up because there are extra or missing place values in one of the numbers, then zeros may be used as placeholders. For example, $0.123 + 0.23$ becomes:

$$\begin{array}{r} 0.123 \\ +\ 0.230 \\ \hline 0.353 \end{array}$$

Subtraction is done the same way. Multiplication and division are more complicated. To multiply two decimals, place one on top of the other as in a regular multiplication process and do not worry about lining up the decimal points. Then, multiply as with whole numbers, ignoring the decimals. Finally, in the

solution, insert the decimal point as many places to the left as there are total decimal values in the original problem. Here is an example of a decimal multiplication:

$$0.52 \quad \textit{2 decimal places}$$
$$\underline{\times 0.2} \quad \textit{1 decimal place}$$
$$.104 \quad \textit{3 decimal places}$$

The answer to 67 times 4 is 268, and because there are three decimal values in the problem, the decimal point is positioned three units to the left in the answer.

The decimal point plays an integral role throughout the whole problem when dividing with decimals. First, set up the problem in a long division format. If the divisor is not an integer, the decimal must be moved to the right as many units as needed to make it an integer. The decimal in the dividend must be moved to the right the same number of places to maintain equality. Then, division is completed normally. Here is an example of long division with decimals:

**Long division
with decimals**

```
        2 1 2
  6 ) 1 2 7 2
      1 2
      ----
        0 7
          6
          ----
          1 2
```

Because the decimal point is moved two units to the right in the divisor of 0.06 to turn it into the integer 6, it is also moved two units to the right in the dividend of 12.72 to make it 1,272. The result is 212, and remember that a division problem can always be checked by multiplying the answer times the divisor to see if the result is equal to the dividend.

Sometimes it is helpful to round answers that are in decimal form. First, find the place to which the rounding needs to be done. Then, look at the digit to the right of it. If that digit is 4 or less, the number in the place value to its left stays the same, and everything to its right becomes a 0. This process is known as *rounding down.* If that digit is 5 or higher, round up by increasing the place value to its left by 1, and every number to its right becomes a 0. If those 0's are in decimals, they can be dropped. For example,

0.145 rounded to the nearest hundredth place would be rounded up to 0.15, and 0.145 rounded to the nearest tenth place would be rounded down to 0.1.

Another operation that can be performed on rational numbers is the square root. Dealing with real numbers only, the positive square root of a number is equal to one of the two repeated positive factors of that number. For example, $\sqrt{49} = \sqrt{7 \cdot 7} = 7$. A *perfect square* is a number that has a whole number as its square root. Examples of perfect squares are 1, 4, 9, 16, 25, etc. If a number is not a perfect square, an approximation can be used with a calculator. For example, $\sqrt{67} = 8.185$, rounded to the nearest thousandth place. The square root of a fraction involving perfect squares involves breaking up the problem into the square root of the numerator separate from the square root of the denominator. For example:

$$\sqrt{\frac{16}{25}} = \frac{\sqrt{16}}{\sqrt{25}} = \frac{4}{5}$$

If the fraction does not contain perfect squares, a calculator can be used. Therefore, $\sqrt{\frac{2}{5}} = 0.632$, rounded to the nearest thousandth place. A common application of square roots involves the Pythagorean theorem. Given a right triangle, the sum of the squares of the two legs equals the square of the hypotenuse.

For example, consider the following right triangle:

The missing side, *x*, can be found using the Pythagorean theorem.

$$9^2 + x^2 = 10^2$$

$$81 + x^2 = 100$$

$$x^2 = 19$$

To solve for *x*, take the square root of both sides. Therefore, $x = \sqrt{19} = 4.36$, which has been rounded to two decimal places.

In addition to the square root, the cube root is another operation. If a number is a *perfect cube,* the cube root of that number is equal to one of the three repeated factors. For example:

$$\sqrt[3]{27} = \sqrt[3]{3 \cdot 3 \cdot 3} = 3$$

Also, unlike square roots, a negative number has a cube root. The result is a negative number. For example:

$$\sqrt[3]{-27} = \sqrt[3]{(-3)(-3)(-3)} = -3$$

Similar to square roots, if the number is not a perfect cube, a calculator can be used to find an approximation. Therefore, $\sqrt[3]{\frac{2}{3}} = 0.873$, rounded to the nearest thousandth place.

Higher-order roots also exist. The number relating to the root is known as the *index*. Given the following root, $\sqrt[3]{64}$, 3 is the index, and 64 is the *radicand*. The entire expression is known as the *radical*. Higher-order roots exist when the index is larger than 3. They can be broken up into two groups: even and odd roots. Even roots, when the index is an even number, follow the properties of square roots. A negative number does not have an even root, and an even root is found by finding the single factor that is repeated the same number of times as the index in the radicand. For example, the fifth root of 32 is equal to 2 because $\sqrt[5]{32} = \sqrt[5]{2 \cdot 2 \cdot 2 \cdot 2 \cdot 2} = 2$. Odd roots, when the index is an odd number, follow the properties of cube roots. A negative number has an odd root. Similarly, an odd root is found by finding the single factor that is repeated that many times to obtain the radicand. For example, the 4th root of 81 is equal to 3 because $3^4 = 81$. This radical is written as $\sqrt[4]{81} = 4$.

When performing operations in rational numbers, sometimes it might be helpful to round the numbers in the original problem to get a rough check of what the answer should be. For example, if you walked into a grocery store and had a $20 bill, your approach might be to round each item to the nearest dollar and add up all the items to make sure that you will have enough money when you check out. This process involves obtaining an estimation of what the exact total would be. In other situations, it might be helpful to round to the nearest $10 amount or $100 amount. *Front-end rounding* might be helpful as well in many situations. In this type of rounding, each number is rounded to the highest possible place value. Therefore, all digits except the first digit become 0. Consider a situation in which you are at the furniture store and want to estimate your total on three pieces of furniture that cost $434.99, $678.99, and $129.99. Front-end rounding would round these three amounts to $400, $700, and $100. Therefore, the estimate of your total would be $400 + $700 + $100 = $1,200, compared to the exact total of $1,243.97. In this situation, the estimate is not that far off the exact answer. Rounding is useful in both approximating an answer when an exact answer is not needed and for comparison when an exact answer is needed. For instance, if you had a complicated set of operations to complete and your estimate was $1,000, if you obtained an exact answer of $100,000, something is off. You might want to check your work to see if a mistake was made because an estimate should not be that different from an exact answer. Estimates can also be helpful with square roots. If a square root of a number is not known, the closest perfect square can be found for an approximation. For example, $\sqrt{50}$ is not equal to a whole number, but 50 is close to 49, which is a perfect square, and $\sqrt{49} = 7$. Therefore, $\sqrt{50}$ is a little bit larger than 7. The actual approximation, rounded to the nearest thousandth, is 7.071.

Ordering and Comparing Rational Numbers

Ordering rational numbers is a way to compare two or more different numerical values. Determining whether two amounts are equal, less than, or greater than is the basis for comparing both positive and negative numbers. Also, a group of numbers can be compared by ordering them from the smallest amount to the largest amount. A few symbols are necessary to use when ordering rational numbers. The equals sign, =, shows that the two quantities on either side of the symbol have the same value. For example, $\frac{12}{3} = 4$ because both values are equivalent. Another symbol that is used to compare numbers is

<, which represents "less than." With this symbol, the smaller number is placed on the left and the larger number is placed on the right. Always remember that the symbol's "mouth" opens up to the larger number. When comparing negative and positive numbers, it is important to remember that the number occurring to the left on the number line is always smaller and is placed to the left of the symbol. This idea might seem confusing because some values could appear at first glance to be larger, even though they are not. For example, $-5 < 4$ is read "negative 5 is less than 4." Here is an image of a number line for help:

The symbol \leq represents "less than or equal to," and it joins < with equality. Therefore, both $-5 \leq 4$ and $-5 \leq -5$ are true statements and "-5 is less than or equal to both 4 and -5." Other symbols are > and \geq, which represent "greater than" and "greater than or equal to." Both $4 \geq -1$ and $-1 \geq -1$ are correct ways to use these symbols.

Here is a chart of these four inequality symbols:

Symbol	Definition
<	less than
\leq	less than or equal to
>	greater than
\geq	greater than or equal to

Comparing integers is a straightforward process, especially when using the number line, but the comparison of decimals and fractions is not as obvious. When comparing two non-negative decimals, compare digit by digit, starting from the left. The larger value contains the first larger digit. For example, 0.1456 is larger than 0.1234 because the value 4 in the hundredths place in the first decimal is larger than the value 2 in the hundredths place in the second decimal. When comparing a fraction with a decimal, convert the fraction to a decimal and then compare in the same manner. Finally, there are a few options when comparing fractions. If two non-negative fractions have the same denominator, the fraction with the larger numerator is the larger value. If they have different denominators, they can be converted to equivalent fractions with a common denominator to be compared, or they can be converted to decimals to be compared. When comparing two negative decimals or fractions, a different approach must be used. It is important to remember that the smaller number exists to the left on the number line. Therefore, when comparing two negative decimals by place value, the number with the larger first place value is smaller due to the negative sign. Whichever value is closer to 0 is larger. For instance, -0.456 is larger than -0.498 because of the values in the hundredth places. If two negative fractions have the same denominator, the fraction with the larger numerator is smaller because of the negative sign.

Solving Equations in One Variable

An *equation in one variable* is a mathematical statement where two algebraic expressions in one variable, usually x, are set equal. To solve the equation, the variable must be isolated on one side of the equals sign. The addition and multiplication principles of equality are used to isolate the variable. The *addition principle of equality* states that the same number can be added to or subtracted from both sides of an equation. Because the same value is being used on both sides of the equals sign, equality is maintained. For example, the equation $2x = 5x$ is equivalent to both $2x + 3 = 5x + 3$, and $2x - 5 = 5x - 5$. This principle can be used to solve the following equation: $x + 5 = 4$. The variable x must be isolated, so to move the 5 from the left side, subtract 5 from both sides of the equals sign. Therefore, $x + 5 - 5 = 4 - 5$.

So, the solution is $x = -1$. This process illustrates the idea of an *additive inverse* because subtracting 5 is the same as adding -5. Basically, add the opposite of the number that must be removed to both sides of the equals sign. The *multiplication principle of equality* states that equality is maintained when a number is either multiplied times both expressions on each side of the equals sign, or when both expressions are divided by the same number. For example, $4x = 5$ is equivalent to both $16x = 20$ and $x = \frac{5}{4}$. Multiplying both sides times 4 and dividing both sides by 4 maintains equality. Solving the equation $6x - 18 = 5$ requires the use of both principles. First, apply the addition principle to add 18 to both sides of the equals sign, which results in $6x = 23$. Then use the multiplication principle to divide both sides by 6, giving the solution $x = \frac{23}{6}$. Using the multiplication principle in the solving process is the same as involving a multiplicative inverse. A *multiplicative inverse* is a value that, when multiplied by a given number, results in 1. Dividing by 6 is the same as multiplying by $\frac{1}{6}$, which is both the reciprocal and multiplicative inverse of 6.

When solving a linear equation in one variable, checking the answer shows if the solution process was performed correctly. Plug the solution into the variable in the original equation. If the result is a false statement, something was done incorrectly during the solution procedure. Checking the example above gives the following: $6 \times \frac{23}{6} - 18 = 23 - 18 = 5$. Therefore, the solution is correct.

Some equations in one variable involve fractions or the use of the distributive property. In either case, the goal is to obtain only one variable term and then use the addition and multiplication principles to isolate that variable. Consider the equation $\frac{2}{3}x = 6$. To solve for x, multiply each side of the equation by the reciprocal of $\frac{2}{3}$, which is $\frac{3}{2}$. This step results in $\frac{3}{2} \times \frac{2}{3}x = \frac{3}{2} \times 6$, which simplifies into the solution $x = 9$. Now consider the equation $3(x + 2) - 5x = 4x + 1$. Use the distributive property to clear the parentheses. Therefore, multiply each term inside the parentheses by 3. This step results in $3x + 6 - 5x = 4x + 1$. Next, collect like terms on the left-hand side. *Like terms* are terms with the same variable or variables raised to the same exponent(s). Only like terms can be combined through addition or subtraction. After collecting like terms, the equation is $-2x + 6 = 4x + 1$. Finally, apply the addition and multiplication principles. Add $2x$ to both sides to obtain $6 = 6x + 1$. Then, subtract 1 from both sides to obtain $5 = 6x$. Finally, divide both sides by 6 to obtain the solution $\frac{5}{6} = x$.

Two other types of solutions can be obtained when solving an equation in one variable. The final result could be that there is either no solution or that the solution set contains all real numbers. Consider the equation $4x = 6x + 5 - 2x$. First, the like terms can be combined on the right to obtain $4x = 4x + 5$. Next, subtract $4x$ from both sides. This step results in the false statement $0 = 5$. There is no value that can be plugged into x that will ever make this equation true. Therefore, there is no solution. The solution procedure contained correct steps, but the result of a false statement means that no value satisfies the equation. The symbolic way to denote that no solution exists is \emptyset. Next, consider the equation $5x + 4 + 2x = 9 + 7x - 5$. Combining the like terms on both sides results in $7x + 4 = 7x + 4$. The left-hand side is exactly the same as the right-hand side. Using the addition principle to move terms, the result is $0 = 0$, which is always true. Therefore, the original equation is true for any number, and the solution set is all real numbers. The symbolic way to denote such a solution set is \mathbb{R}, or in interval notation, $(-\infty, \infty)$.

Solving Real-World One- or Multi-Step Problems with Rational Numbers

One-step problems take only one mathematical step to solve. For example, solving the equation $5x = 45$ is a one-step problem because the one step of dividing both sides of the equation by 5 is the only step necessary to obtain the solution $x = 9$. The multiplication principle of equality is the one step used to isolate the variable. The equation is of the form $ax = b$, where a and b are rational numbers. Similarly, the

addition principle of equality could be the one step needed to solve a problem. In this case, the equation would be of the form $x + a = b$ or $x - a = b$, for real numbers a and b.

A multi-step problem involves more than one step to find the solution, or it could consist of solving more than one equation. An equation that involves both the addition principle and the multiplication principle is a two-step problem, and an example of such an equation is $2x - 4 = 5$. Solving involves adding 4 to both sides and then dividing both sides by 2. An example of a two-step problem involving two separate equations is $y = 3x, 2x + y = 4$. The two equations form a system of two equations that must be solved together in two variables. The system can be solved by the substitution method. Since y is already solved for in terms of x, plug $3x$ in for y into the equation $2x + y = 4$, resulting in $2x + 3x = 4$. Therefore, $5x = 4$ and $x = \frac{4}{5}$. Because there are two variables, the solution consists of both a value for x and for y. Substitute $x = \frac{4}{5}$ into either original equation to find y. The easiest choice is $y = 3x$. Therefore, $y = 3 \times \frac{4}{5} = \frac{12}{5}$. The solution can be written as the ordered pair $\left(\frac{4}{5}, \frac{12}{5}\right)$.

Real-world problems can be translated into both one-step and multi-step problems. In either case, the word problem must be translated from the verbal form into mathematical expressions and equations that can be solved using algebra. An example of a one-step real-world problem is the following: A cat weighs half as much as a dog living in the same house. If the dog weighs 14.5 pounds, how much does the cat weigh? To solve this problem, an equation can be used. In any word problem, the first step must be defining variables that represent the unknown quantities. For this problem, let x be equal to the unknown weight of the cat. Because two times the weight of the cat equals 14.5 pounds, the equation to be solved is: $2x = 14.5$. Use the multiplication principle to divide both sides by 2. Therefore, $x = 7.25$. The cat weighs 7.25 pounds.

Most of the time, real-world problems are more difficult than this one and consist of multi-step problems. The following is an example of a multi-step problem: The sum of two consecutive page numbers is equal to 437. What are those page numbers? First, define the unknown quantities. If x is equal to the first page number, then $x + 1$ is equal to the next page number because they are consecutive integers. Their sum is equal to 437, and this statement translates to the equation $x + x + 1 = 437$. To solve, first collect like terms to obtain $2x + 1 = 437$. Then, subtract 1 from both sides and then divide by 2. The solution to the equation is $x = 218$. Therefore, the two consecutive page numbers that satisfy the problem are 218 and 219. It is always important to make sure that answers to real-world problems make sense. For instance, if the solution to this same problem resulted in decimals, that should be a red flag indicating the need to check the work. Page numbers are whole numbers; therefore, if decimals are found to be answers, the solution process should be double-checked to see where mistakes were made.

Solving Real-World Problems Involving Percentages

As discussed previously, percentages are defined to be parts per one hundred. To convert a decimal to a percentage, move the decimal point two units to the right and place the percent sign after the number. Percentages appear in many scenarios in the real world. It is important to make sure the statement containing the percentage is translated to a correct mathematical expression. Be aware that it is extremely common to make a mistake when working with percentages within word problems.

An example of a word problem containing a percentage is the following: 35% of people speed when driving to work. In a group of 5,600 commuters, how many would be expected to speed on the way to their place of employment? The answer to this problem is found by finding 35% of 5,600. First, change the percentage to the decimal 0.35. Then compute the product: $0.35 \times 5,600 = 1,960$. Therefore, it would be

expected that 1,960 of those commuters would speed on their way to work based on the data given. In this situation, the word "of" signals to use multiplication to find the answer. Another way percentages are used is in the following problem: Teachers work 8 months out of the year. What percent of the year do they work? To answer this problem, find what percent of 12 the number 8 is, because there are 12 months in a year. Therefore, divide 8 by 12, and convert that number to a percentage: $\frac{8}{12} = \frac{2}{3} = 0.66\overline{6}$. The percentage rounded to the nearest tenth place tells us that teachers work 66.7% of the year. Percentages also appear in real-world application problems involving finding missing quantities like in the following question: 60% of what number is 75? To find the missing quantity, an equation can be used. Let x be equal to the missing quantity. Therefore, $0.60x = 75$. Divide each side by 0.60 to obtain 125. Therefore, 60% of 125 is equal to 75.

Sales tax is an important application relating to percentages because tax rates are usually given as percentages. For example, a city might have an 8% sales tax rate. Therefore, when an item is purchased with that tax rate, the real cost to the customer is 1.08 times the price in the store. For example, a $25 pair of jeans costs the customer $25 \times 1.08 = 27. Sales tax rates can also be determined if they are unknown when an item is purchased. If a customer visits a store and purchases an item for $21.44, but the price in the store was $19, they can find the tax rate by first subtracting $21.44 - $19 to obtain $2.44, the sales tax amount. The sales tax is a percentage of the in-store price. Therefore, the tax rate is $\frac{2.44}{19} = 0.128$, which has been rounded to the nearest thousandths place. In this scenario, the actual sales tax rate given as a percentage is 12.8%.

Applying Estimation Strategies and Rounding Rules to Real-World Problems

Sometimes it is helpful to find an estimated answer to a problem rather than working out an exact answer. An estimation might be much quicker to find, and given the scenario, an estimation might be all that is required. For example, if Aria goes grocery shopping and has only a $100 bill to cover all of her purchases, it might be appropriate for her to estimate the total of the items she is purchasing to tell if she has enough money to cover them. Also, an estimation can help determine if an answer makes sense. For instance, if an answer in the 100s is expected, but the result is a fraction less than 1, something is probably wrong in the calculation.

The first type of estimation involves rounding. As mentioned, *rounding* consists of expressing a number in terms of the nearest decimal place like the tenth, hundredth, or thousandth place, or in terms of the nearest whole number unit like tens, hundreds, or thousands place. When rounding to a specific place value, look at the digit to the right of the place. If it is 5 or higher, round the number to its left up to the next value, and if it is 4 or lower, keep that number at the same value. For instance, 1,654.2674 rounded to the nearest thousand is 2,000, and the same number rounded to the nearest thousandth is 1,654.267. Rounding can be used in the scenario when grocery totals need to be estimated. Items can be rounded to the nearest dollar. For example, a can of corn that costs $0.79 can be rounded to $1.00, and then all other items can be rounded in a similar manner and added together. When working with larger numbers, it might make more sense to round to higher place values. For example, when estimating the total value of a dealership's car inventory, it would make sense to round the car values to the nearest thousands place. The price of a car that is on sale for $15,654 can be estimated at $16,000. All other cars on the lot could be rounded in the same manner, and then their sum can be found. Depending on the situation, it might make sense to calculate an over-estimate. For example, to make sure Aria has enough money at the grocery store, rounding up every time for each item would ensure that she will have enough money when it comes time to pay. A $.40 item rounded up to $1.00 would ensure that there is a dollar to cover that item. Traditional rounding rules would round $0.40 to $0, which does not make sense in this particular

real-world setting. Aria might not have a dollar available at checkout to pay for that item if she uses traditional rounding. It is up to the customer to decide the best approach when estimating.

Estimating is also very helpful when working with measurements. Bryan is updating his kitchen and wants to retile the floor. Again, an over-measurement might be useful. Also, rounding to nearest half-unit might be helpful. For instance, one side of the kitchen might have an exact measurement of 14.32 feet, and the most useful measurement needed to buy tile could be estimating this quantity to be 14.5 feet. If the kitchen was rectangular and the other side measured 10.9 feet, Bryan might round the other side to 11 feet. Therefore, Bryan would find the total tile necessary according to the following area calculation: $14.5 \times 11 = 159.5$ square feet. To make sure he purchases enough tile, Bryan would probably want to purchase at least 160 square feet of tile. This is a scenario in which an estimation might be more useful than an exact calculation. Having more tile than necessary is better than having an exact amount, in case any tiles are broken or otherwise unusable.

Finally, estimation is helpful when exact answers are necessary. Consider a situation in which Sabina has many operations to perform on numbers with decimals, and she is allowed a calculator to find the result. Even though an exact result can be obtained with a calculator, there is always a possibility that Sabina could make an error while inputting the data. For example, she could miss a decimal place, or misuse a parenthesis, causing a problem with the actual order of operations. In this case, a quick estimation at the beginning would be helpful to make sure the final answer is given with the correct number of units. Sabina has to find the exact total of 10 cars listed for sale at the dealership. Each price has two decimal places included to account for both dollars and cents. If one car is listed at $21, 234.43 but Sabina incorrectly inputs into the calculator the price of $2,123.443, this error would throw off the final sum by almost $20,000. A quick estimation at the beginning, by rounding each price to the nearest thousands place and finding the sum of the prices, would give Sabina an amount to compare the exact amount to. This comparison would let Sabina see if an error was made in her exact calculation.

Solving Real-World Problems Involving Proportions

Fractions appear in everyday situations, and in many scenarios, they appear in the real-world as ratios and in proportions. A *ratio* is formed when two different quantities are compared. For example, in a group of 50 people, if there are 33 females and 17 males, the ratio of females to males is 33 to 17. This expression can be written in the fraction form, $\frac{33}{17}$, or by using the ratio symbol, 33:17. The order of the number matters when forming ratios. In the same setting, the ratio of males to females is 17 to 33, which is equivalent to $\frac{17}{33}$ or 17:33. A *proportion* is an equation involving two ratios. The equation $\frac{a}{b} = \frac{c}{d}$, or $a{:}b = c{:}d$ is a proportion, for real numbers a, b, c, and d. Usually, in one ratio, one of the quantities is unknown, and cross-multiplication is used to solve for the unknown. Consider $\frac{1}{4} = \frac{x}{5}$. To solve for x, cross-multiply to obtain $5 = 4x$. Divide each side by 4 to obtain the solution $x = \frac{5}{4}$. It is also true that percentages are ratios in which the second term is 100. For example, 65% is 65:100 or $\frac{65}{100}$. Therefore, when working with percentages, one is also working with ratios.

Real-world problems frequently involve proportions. For example, consider the following problem: If 2 out of 50 pizzas are usually delivered late from a local Italian restaurant, how many would be late out of 235 orders? The following proportion would be solved with x as the unknown quantity of late pizzas: $\frac{2}{50} = \frac{x}{235}$. Cross multiplying results in $470 = 50x$. Divide both sides by 50 to obtain $x = \frac{470}{50}$, which in lowest terms is equal to $\frac{47}{5}$. In decimal form, this improper fraction is equal to 9.4. Because it does not make sense to answer this question with decimals (portions of pizzas do not get delivered) the answer must be rounded.

Traditional rounding rules would say that 9 pizzas would be expected to be delivered late. However, to be safe, rounding up to 10 pizzas out of 235 would probably make more sense.

Solving Real-World Problems Involving Ratios and Rates of Change

Recall that a ratio is the comparison of two different quantities. Comparing 2 apples to 3 oranges results in the ratio 2:3, which can be expressed as the fraction $\frac{2}{3}$. Note that order is important when discussing ratios. The number mentioned first is the numerator, and the number mentioned second is the denominator. The ratio 2:3 does not mean the same quantity as the ratio 3:2. Also, it is important to make sure than when discussing ratios that have units attached to them, the two quantities use the same units. For example, to think of 8 feet to 4 yards, it would make sense to convert 4 yards to feet by multiplying by 3. Therefore, the ratio would be 8 feet to 12 feet, which can be expressed as the fraction $\frac{8}{12}$. Also, note that it is proper to refer to ratios in lowest terms. Therefore, the ratio of 8 feet to 4 yards is equivalent to the fraction $\frac{2}{3}$. Many real-world problems involve ratios. Often, problems with ratios involve proportions, as when two ratios are set equal to find the missing amount. However, some problems involve deciphering single ratios. For example, consider an amusement park that sold 345 tickets last Saturday. If 145 tickets were sold to adults and the rest of the tickets were sold to children, what would the ratio of the number of adult tickets to children's tickets be? A common mistake would be to say the ratio is 145:345. However, 345 is the total number of tickets sold. There were 345 − 145 = 200 tickets sold to children. The correct ratio of adult to children's tickets is 145:200. As a fraction, this expression is written as $\frac{145}{200}$, which can be reduced to $\frac{29}{40}$.

While a ratio compares two measurements using the same units, rates compare two measurements with different units. Examples of rates would be $200 of work for 8 hours, or 500 miles per 20 gallons. Because the units are different, it is important to always include the units when discussing rates. Rates can be easily seen because if they are expressed in words, the two quantities are usually split up using one of the following words: *for, per, on, from, in*. Just as with ratios, it is important to write rates in lowest terms. A common rate that can be found in many real-life situations is cost per unit. This quantity describes how much one item or one unit costs. This rate allows the best buy to be determined, given a couple of different sizes of an item with different costs. For example, if 2 quarts of soup was sold for $3.50 and 3 quarts was sold for $4.60, to determine the best buy, the cost per quart should be found. $\frac{\$3.50}{2} = \1.75 per quart, and $\frac{\$4.60}{3} = \1.53 per quart. Therefore, the better deal would be the 3-quart option.

Rate of change problems involve calculating a quantity per some unit of measurement. Usually the unit of measurement is time. For example, meters per second is a common rate of change. To calculate this measurement, find the amount traveled in meters and divide by total time traveled. The calculation is an average of the speed over the entire time interval. Another common rate of change used in the real world is miles per hour. Consider the following problem that involves calculating an average rate of change in temperature. Last Saturday, the temperature at 1:00 a.m. was 34 degrees Fahrenheit, and at noon, the temperature had increased to 75 degrees Fahrenheit. What was the average rate of change over that time interval? The average rate of change is calculated by finding the change in temperature and dividing by the total hours elapsed. Therefore, the rate of change was equal to $\frac{75-34}{12-1} = \frac{41}{11}$ degrees per hour. This quantity rounded to two decimal places is equal to 3.72 degrees per hour.

A common rate of change that appears in algebra is the slope calculation. Given a linear equation in one variable, $y = mx + b$, the slope, m, is equal to $\frac{rise}{run}$ or $\frac{change\ in\ y}{change\ in\ x}$. In other words, slope is equivalent to the ratio of the vertical and horizontal changes between any two points on a line. The vertical change is

known as the *rise,* and the horizontal change is known as the *run.* Given any two points on a line (x_1, y_1) and (x_2, y_2), slope can be calculated with the formula:

$$m = \frac{y_2 - y_1}{x_2 - x_1} = \frac{\Delta y}{\Delta x}$$

Common real-world applications of slope include determining how steep a staircase should be, calculating how steep a road is, and determining how to build a wheelchair ramp.

Many times, problems involving rates and ratios involve proportions. A proportion states that two ratios (or rates) are equal. The property of cross products can be used to determine if a proportion is true, meaning both ratios are equivalent. If $\frac{a}{b} = \frac{c}{d}$, then to clear the fractions, multiply both sides times the least common denominator, bd. This results in $ac = cd$, which is equal to the result of multiplying along both diagonals. For example, $\frac{4}{40} = \frac{1}{10}$ grants the cross product $4 \cdot 10 = 40 \cdot 1$. $40 = 40$ shows that this proportion is true. Cross products are used when proportions are involved in real-world problems. Consider the following: If 3 pounds of fertilizer will cover 75 square feet of grass, how many pounds are needed for 375 square feet? To solve this problem, a proportion can be set up using two ratios. Let x equal the unknown quantity, pounds needed for 375 feet. Then, the equation found by setting the two given ratios equal to one another is $\frac{3}{75} = \frac{x}{375}$. Cross multiplication gives $3 \cdot 375 = 75x$. Therefore, $1{,}125 = 75x$. Divide both sides by 75 to get $x = 15$. Therefore, 15 gallons of fertilizer is needed to cover 75 square feet of grass.

Another application of proportions involves similar triangles. If two triangles have the same measurement as two triangles in another triangle, the triangles are said to be *similar.* If two are the same, the third pair of angles are equal as well because the sum of all angles in a triangle is equal to 180 degrees. Each pair of equivalent angles are known as *corresponding angles. Corresponding sides* face the corresponding angles, and it is true that corresponding sides are in proportion. For example, consider the following set of similar triangles:

Angles A and R have the same measurement, angles C and T have the same measurement, and angles B and S have the same measurement. Therefore, the following proportion can be set up from the sides:

$$\frac{c}{t} = \frac{a}{r} = \frac{b}{s}$$

This proportion can be helpful in finding missing lengths in pairs of similar triangles. For example, if the following triangles are similar, a proportion can be used to find the missing side lengths, *a* and *b*.

The proportions $\frac{8}{6.4} = \frac{6}{b}$ and $\frac{8}{6.4} = \frac{7}{a}$ can both be cross multiplied and solved to obtain *a* = 5.6 and *b* = 4.8.

A real-life situation that uses similar triangles involves measuring shadows to find heights of unknown objects. Consider the following problem: A building casts a shadow that is 120 feet long, and at the same time, another building that is 80 feet high casts a shadow that is 60 feet long. How tall is the first building? Each building, together with the sun rays and shadows casted on the ground, forms a triangle. They are similar because each building forms a right angle with the ground, and the sun rays form equivalent angles. Therefore, these two pairs of angles are both equal. Because all angles in a triangle add up to 180 degrees, the third angles are equal as well. Both shadows form corresponding sides of the triangle, the buildings form corresponding sides, and the sun rays form corresponding sides. Therefore, the triangles are similar, and the following proportion can be used to find the missing building length:

$$\frac{120}{x} = \frac{60}{80}$$

Cross-multiply to obtain the cross products, 9600 = 60*x*. Then, divide both sides by 60 to obtain *x* = 160. This solution means that the other building is 160 feet high.

Translating Phrases and Sentences into Expressions, Equations, and Inequalities

When presented with a real-world problem that must be solved, the first step is always to determine what the unknown quantity is that must be solved for. Use a variable, such as *x* or *t*, to represent that unknown quantity. Sometimes there can be two or more unknown quantities. In this case, either choose an additional variable, or if a relationship exists between the unknown quantities, express the other quantities in terms of the original variable. After choosing the variables, form algebraic expressions and/or equations that represent the verbal statement in the problem. The following table shows examples of vocabulary used to represent the different operations.

Addition	Sum, plus, total, increase, more than, combined, in all
Subtraction	Difference, less than, subtract, reduce, decrease, fewer, remain
Multiplication	Product, multiply, times, part of, twice, triple
Division	Quotient, divide, split, each, equal parts, per, average, shared

The combination of operations and variables form both mathematical expression and equations. The difference between expressions and equations are that there is no equals sign in an expression, and that expressions are *evaluated* to find an unknown quantity, while equations are *solved* to find an unknown quantity. Also, inequalities can exist within verbal mathematical statements. Instead of a statement of equality, expressions state quantities are *less than*, *less than or equal to*, *greater than*, or *greater than or equal to*. Another type of inequality is when a quantity is said to be *not equal to* another quantity. The symbol used to represent "not equal to" is \neq.

The steps for solving inequalities in one variable are the same steps for solving equations in one variable. The addition and multiplication principles are used. However, to maintain a true statement when using the $<, \leq, >$, and \geq symbols, if a negative number is either multiplied times both sides of an inequality or divided from both sides of an inequality, the sign must be flipped. For instance, consider the following inequality: $3 - 5x \leq 8$. First, 3 is subtracted from each side to obtain $-5x \leq 5$. Then, both sides are divided by -5, while flipping the sign, to obtain $x \geq -1$. Therefore, any real number greater than or equal to -1 satisfies the original inequality.

Measurement and Data

Interpreting Relevant Information from Tables, Charts, and Graphs

Tables, charts, and graphs can be used to convey information about different variables. They are all used to organize, categorize, and compare data, and they all come in different shapes and sizes. Each type has its own way of showing information, whether it is in a column, shape, or picture. To answer a question relating to a table, chart, or graph, some steps should be followed. First, the problem should be read thoroughly to determine what is being asked to determine what quantity is unknown. Then, the title of the table, chart, or graph should be read. The title should clarify what actual data is being summarized in the table. Next, look at the key and both the horizontal and vertical axis labels, if they are given. These items will provide information about how the data is organized. Finally, look to see if there is any more labeling inside the table. Taking the time to get a good idea of what the table is summarizing will be helpful as it is used to interpret information.

Tables are a good way of showing a lot of information in a small space. The information in a table is organized in columns and rows. For example, a table may be used to show the number of votes each candidate received in an election. By interpreting the table, one may observe which candidate won the election and which candidates came in second and third. In using a bar chart to display monthly rainfall amounts in different countries, rainfall can be compared between countries at different times of the year. Graphs are also a useful way to show change in variables over time, as in a line graph, or percentages of a whole, as in a pie graph.

The table below relates the number of items to the total cost. The table shows that 1 item costs $5. By looking at the table further, 5 items cost $25, 10 items cost $50, and 50 items cost $250. This cost can be extended for any number of items. Since 1 item costs $5, then 2 items would cost $10. Though this information isn't in the table, the given price can be used to calculate unknown information.

Number of Items	1	5	10	50
Cost ($)	5	25	50	250

A bar graph is a graph that summarizes data using bars of different heights. It is useful when comparing two or more items or when seeing how a quantity changes over time. It has both a horizontal and vertical axis. Interpreting *bar graphs* includes recognizing what each bar represents and connecting that to the two variables. The bar graph below shows the scores for six people on three different games. The color of the bar shows which game each person played, and the height of the bar indicates their score for that game. William scored 25 on game 3, and Abigail scored 38 on game 3. By comparing the bars, it's obvious that Williams scored lower than Abigail.

A line graph is a way to compare two variables. Each variable is plotted along an axis, and the graph contains both a horizontal and a vertical axis. On a *line graph*, the line indicates a continuous change. The change can be seen in how the line rises or falls, known as its slope, or rate of change. Often, in line graphs, the horizontal axis represents a variable of time. Audiences can quickly see if an amount has grown or decreased over time. The bottom of the graph, or the x-axis, shows the units for time, such as days, hours, months, etc. If there are multiple lines, a comparison can be made between what the two lines represent. For example, the following line graph shows the change in temperature over five days. The top line represents the high, and the bottom line represents the low for each day. Looking at the top line alone, the high decreases for a day, then increases on Wednesday. Then it decreased on Thursday and increases again on Friday. The low temperatures have a similar trend, shown in bottom line. The range in

temperatures each day can also be calculated by finding the difference between the top line and bottom line on a particular day. On Wednesday, the range was 14 degrees, from 62 to 76° F.

Daily Temperatures

Pie charts are used to show percentages of a whole, as each category is given a piece of the pie, and together all the pieces make up a whole. They are a circular representation of data which are used to highlight numerical proportion. It is true that the arc length of each pie slice is proportional to the amount it individually represents. When a pie chart is shown, an audience can quickly make comparisons by comparing the sizes of the pieces of the pie. They can be useful for comparison between different categories. The following pie chart is a simple example of three different categories shown in comparison to each other.

Light gray represents cats, dark gray represents dogs, and the gray between those two represents other pets. As the pie is cut into three equal pieces, each value represents just more than 33 percent, or $\frac{1}{3}$ of the whole. Values 1 and 2 may be combined to represent $\frac{2}{3}$ of the whole. In an example where the total pie represents 75,000 animals, then cats would be equal to $\frac{1}{3}$ of the total, or 25,000. Dogs would equal 25,000 and other pets would hold equal 25,000.

The fact that a circle is 360 degrees is used to create a pie chart. Because each piece of the pie is a percentage of a whole, that percentage is multiplied times 360 to get the number of degrees each piece represents. In the example above, each piece is 1/3 of the whole, so each piece is equivalent to 120 degrees. Together, all three pieces add up to 360 degrees.

Stacked bar graphs, also used fairly frequently, are used when comparing multiple variables at one time. They combine some elements of both pie charts and bar graphs, using the organization of bar graphs and the proportionality aspect of pie charts. The following is an example of a stacked bar graph that represents the number of students in a band playing drums, flutes, trombones, and clairnets. Each bar graph is broken up further into girls and boys.

To determine how many boys play tuba, refer to the darker portion of the trombone bar, resulting in 3 students.

A scatterplot is another way to represent paired data. It uses Cartesian coordinates, like a line graph, meaning it has both a horizontal and vertical axis. Each data point is represented as a dot on the graph. The dots are never connected with a line. For example, the following is a scatterplot showing people's weight versus height.

A scatterplot, also known as a *scattergram,* can be used to predict another value and to see if an association, known as a *correlation,* exists between a set of data. If the data resembles a straight line, the data is *associated.* The following is an example of a scatterplot in which the data does not seem to have an association:

Sets of numbers and other similarly organized data can also be represented graphically. Venn diagrams are a common way to do so. A Venn diagram represents each set of data as a circle. The circles overlap, showing that each set of data is overlapping. A Venn diagram is also known as a *logic diagram* because it

visualizes all possible logical combinations between two sets. Common elements of two sets are represented by the area of overlap. The following is an example of a Venn diagram of two sets A and B:

Parts of the Venn Diagram

Another name for the area of overlap is the *intersection*. The intersection of A and B, $A \cap B$, contains all elements that are in both sets A and B. The union of A and B, $A \cup B$, contains all elements that are in either set A or set B. Finally, the complement of $A \cup B$ is equal to all elements that are not in either set A or set B. These elements are placed outside of the circles.

The following is an example of a Venn diagram in which 22 students were surveyed asking about their siblings. Ten students only had a brother, 7 students only had a sister, and 5 had both a brother and a sister. This number 5 is the intersection and is placed where the circles overlap. Two students did not have a brother or a sister. Eight is therefore the complement and is placed outside of the circles.

Venn diagrams can have more than two sets of data. The more circles, the more logical combinations are represented by the overlapping. The following is a Venn diagram that represents favorite colors. There were 30 students surveyed. The innermost region represents those students that have a cat, bird, and dog.

Therefore, 2 students had all three. In this example, all students had at least one pet, so no one exists in the complement.

30 students

Venn diagrams are typically not drawn to scale, but if they are and their area is proportional to the amount of data it represents, it is known as an *area-proportional* Venn diagram.

Evaluating the Information in Tables, Charts, and Graphs Using Statistics

One way information can be interpreted from tables, charts, and graphs is through statistics. The three most common calculations for a set of data are the mean, median, and mode. These three are called measures of central tendency. Measures of central tendency are helpful in comparing two or more different sets of data. The *mean* refers to the average and is found by adding up all values and dividing the total by the number of values. In other words, the mean is equal to the sum of all values divided by the number of data entries. For example, if you bowled a total of 532 points in 4 bowling games, your mean score was $\frac{532}{4} = 133$ points per game. A common application of mean useful to students is calculating what he or she needs to receive on a final exam to receive a desired grade in a class.

The *median* is found by lining up values from least to greatest and choosing the middle value. If there's an even number of values, then the mean of the two middle amounts must be calculated to find the median. For example, the median of the set of dollar amounts $5, $6, $9, $12, and $13 is $9. The median of the set of dollar amounts $1, $5, $6, $8, $9, $10 is $7, which is the mean of $6 and $8. The *mode* is the value that occurs the most. The mode of the data set {1, 3, 1, 5, 5, 8, 10} actually refers to two numbers: 1 and 5. In this case, the data set is bimodal because it has two modes. A data set can have no mode if no amount is repeated. Another useful statistic is range. The *range* for a set of data refers to the difference between the highest and lowest value.

In some cases, some numbers in a list of data might have weights attached to them. In that case, a weighted mean can be calculated. A common application of a weighted mean is GPA. In a semester, each

class is assigned a number of credit hours, its weight, and at the end of the semester each student receives a grade. To compute GPA, an A is a 4, a B is a 3, a C is a 2, a D is a 1, and an F is a 0. Consider a student that takes a 4-hour English class, a 3-hour math class, and a 4-hour history class and receives all B's. The weighted mean, GPA, is found by multiplying each grade times its weight, number of credit hours, and dividing by the total number of credit hours. Therefore, the student's GPA is:

$$\frac{3 \cdot 4 + 3 \cdot 3 + 3 \cdot 4}{11} = \frac{33}{1} = 3.0.$$

The following bar chart shows how many students attend a cycle on each day of the week. To find the mean attendance for the week, each day's attendance can be added together, $10 + 7 + 6 + 9 + 8 + 14 + 4 = 58$, and the total divided by the number of days, $58 \div 7 = 8.3$. The mean attendance for the week was 8.3 people. The median attendance can be found by putting the attendance numbers in order from least to greatest: 4, 6, 7, 8, 9, 10, 14, and choosing the middle number: 8 people. The mode for attendance is none for this set of data because no numbers repeat. The range is 10, which is found by finding the difference between the lowest number, 4, and the highest number, 14.

Cycle class attendance

A *histogram* is a bar graph used to group data into "bins" that cover a range on the horizontal, or x-axis. Histograms consist of rectangles whose height is equal to the frequency of a specific category. The horizontal axis represents the specific categories. Because they cover a range of data, these bins have no gaps between bars, unlike the bar graph above. In a histogram showing the heights of adult golden retrievers, the bottom axis would be groups of heights, and the y-axis would be the number of dogs in each range. Evaluating this histogram would show the height of most golden retrievers as falling within a certain range. It also provides information to find the average height and range for how tall golden retrievers may grow.

The following is a histogram that represents exam grades in a given class. The horizontal axis represents ranges of the number of points scored, and the vertical axis represents the number of students. For example, approximately 33 students scored in the 60 to 70 range.

Results of the exam

Measures of central tendency can be discussed using a histogram. If the points scored were shown with individual rectangles, the tallest rectangle would represent the mode. A bimodal set of data would have two peaks of equal height. Histograms can be classified as having data *skewed to the left, skewed to the right,* or *normally distributed,* which is also known as *bell-shaped.* These three classifications can be seen in the following chart:

Measures of central tendency images

When the data is normal, the mean, median, and mode are all very close. They all represent the most typical value in the data set. The mean is typically used as the best measure of central tendency in this case because it does include all data points. However, if the data is skewed, the mean becomes less meaningful. The median is the best measure of central tendency because it is not affected by any outliers, unlike the mean. When the data is skewed, the mean is dragged in the direction of the skew. Therefore, if the data is not normal, it is best to use the median as the measure of central tendency.

The measures of central tendency and the range may also be found by evaluating information on a line graph.

In the line graph from a previous example that showed the daily high and low temperatures, the average high temperature can be found by gathering data from each day on the triangle line. The days' highs are 82, 78, 75, 65, and 70. The average is found by adding them together to get 370, then dividing by 5 (because there are 5 temperatures). The average high for the five days is 74. If 74 degrees is found on the graph, then it falls in the middle of the values on the triangle line. The mean low temperature can be found in the same way.

Given a set of data, the correlation coefficient, r, measures the association between all the data points. If two values are correlated, there is an association between them. However, correlation does not necessarily mean causation, or that that one value causes the other. There is a common mistake made that assumes correlation implies causation. Average daily temperature and number of sunbathers are both correlated and have causation. If the temperature increases, that change in weather causes more people to want to catch some rays. However, wearing plus-size clothing and having heart disease are two variables that are correlated but do not have causation. The larger someone is, the more likely he or she is to have heart disease. However, being overweight does not cause someone to have the disease.

Explaining the Relationship between Two Variables

Independent and dependent are two types of variables that describe how they relate to each other. The *independent variable* is the variable controlled by the experimenter. It stands alone and isn't changed by other parts of the experiment. This variable is normally represented by x and is found on the horizontal, or x-axis, of a graph. The *dependent variable* changes in response to the independent variable. It reacts to, or depends on, the independent variable. This variable is normally represented by y and is found on the vertical, or y-axis of the graph.

The relationship between two variables, *x* and *y*, can be seen on a scatterplot.

The following scatterplot shows the relationship between weight and height. The graph shows the weight as *x* and the height as *y*. The first dot on the left represents a person who is 45 kg and approximately 150 cm tall. The other dots correspond in the same way. As the dots move to the right and weight increases, height also increases. A line could be drawn through the middle of the dots to move from bottom left to top right. This line would indicate a *positive correlation* between the variables. If the variables had a *negative correlation*, then the dots would move from the top left to the bottom right.

Height and Weight

A *scatterplot* is useful in determining the relationship between two variables, but it's not required. Consider an example where a student scores a different grade on his math test for each week of the month. The independent variable would be the weeks of the month. The dependent variable would be the grades, because they change depending on the week. If the grades trended up as the weeks passed, then the relationship between grades and time would be positive. If the grades decreased as the time passed, then the relationship would be negative. (As the number of weeks went up, the grades went down.)

The relationship between two variables can further be described as strong or weak. The relationship between age and height shows a strong positive correlation because children grow taller as they grow up. In adulthood, the relationship between age and height becomes weak, and the dots will spread out. People stop growing in adulthood, and their final heights vary depending on factors like genetics and health. The closer the dots on the graph, the stronger the relationship. As they spread apart, the relationship becomes weaker. If they are too spread out to determine a correlation up or down, then the variables are said to have no correlation.

Variables are values that change, so determining the relationship between them requires an evaluation of who changes them. If the variable changes because of a result in the experiment, then it's dependent. If the variable changes before the experiment, or is changed by the person controlling the experiment, then it's the independent variable. As they interact, one is manipulated by the other. The manipulator is the independent, and the manipulated is the dependent. Once the independent and dependent variable are determined, they can be evaluated to have a positive, negative, or no correlation.

Calculating Geometric Quantities

Perimeter and area are two commonly used geometric quantities that describe objects. *Perimeter* is the distance around an object. The perimeter of an object can be found by adding the lengths of all sides. Perimeter may be used in problems dealing with lengths around objects such as fences or borders. It may also be used in finding missing lengths, or working backwards. If the perimeter is given, but a length is missing, use subtraction to find the missing length. Given a square with side length s, the formula for perimeter is $P = 4s$. Given a rectangle with length l and width w, the formula for perimeter is $P = 2l + 2w$. The perimeter of a triangle is found by adding the three side lengths, and the perimeter of a trapezoid is found by adding the four side lengths. The units for perimeter are always the original units of length, such as meters, inches, miles, etc. When discussing a circle, the distance around the object is referred to as its circumference, not perimeter. The formula for circumference of a circle is $C = 2\pi r$, where r represents the radius of the circle. This formula can also be written as $C = d\mu$, where d represents the diameter of the circle.

Area is the two-dimensional space covered by an object. These problems may include the area of a rectangle, a yard, or a wall to be painted. Finding the area may be a simple formula, or it may require multiple formulas to be used together. The units for area are square units, such as square meters, square inches, and square miles. Given a square with side length s, the formula for its area is $A = s^2$. Some other formulas for common shapes are shown below.

Shape	Formula	Graphic
Rectangle	$Area = length \times width$	
Triangle	$Area = \frac{1}{2} \times base \times height$	
Circle	$Area = \pi \times radius^2$ *(handwritten: 3.14 above π)*	

88

The following formula, not as widely used as those shown above, but very important, is the area of a trapezoid:

Area of a Trapezoid

$$A = \frac{1}{2}(a+b)h$$

While some geometric figures may be given as pictures, others may be described in words. If a rectangular playing field with dimensions 95 meters long by 50 meters wide is measured for perimeter, the distance around the field must be found. The perimeter includes two lengths and two widths to measure the entire outside of the field. This quantity can be calculated using the following equation: $P = 2(95) + 2(50) = 290\ m$. The distance around the field is 290 meters.

Perimeter and area are two-dimensional descriptions; volume is three-dimensional. *Volume* describes the amount of space that an object occupies, but it's different from area because it has three dimensions instead of two. The units for volume are cubic units, such as cubic meters, cubic inches, and cubic miles. Volume can be found by using formulas for common objects such as cylinders and boxes.

To find the area of the shapes above, use the given dimensions of the shape in the formula. Complex shapes might require more than one formula. To find the area of the figure below, break the figure into two shapes. The rectangle has dimensions 11 cm by 6 cm. The triangle has dimensions 3 cm by 6 cm. Plug the dimensions into the rectangle formula: $A = 11 \times 6$. Multiplication yields an area of 66 cm². The

triangle area can be found using the formula $A = \frac{1}{2} \times 4 \times 6$. Multiplication yields an area of 12 cm². Add the areas of the two shapes to find the total area of the figure, which is 78 cm².

Instead of combining areas, some problems may require subtracting them, or finding the difference.

To find the area of the shaded region in the figure below, determine the area of the whole figure. Then the area of the circle can be subtracted from the whole.

The following formula shows the area of the outside rectangle: $A = 12 \times 6 = 72 \ ft^2$. The area of the inside circle can be found by the following formula: $A = \pi r^2 = \pi(3^2) = 9\pi = 28.27 \ ft^2$. As the shaded area is outside the circle, the area for the circle can be subtracted from the area of the rectangle to yield an area of 43.73 ft^2.

The following chart shows a diagram and formula for the volume of two objects.

Shape	Formula	Diagram
Rectangular Prism (box)	$V = length \times width \times height$	height · width · length
Cylinder	$V = \pi \times radius^2 \times height$ (3.14)	radius · height

Volume formulas of these two objects are derived by finding the area of the bottom two-dimensional shape, such as the circle or rectangle, and then multiplying times the height of the three-dimensional shape. Other volume formulas include the volume of a cube with side length s: $V = s^3$; the volume of a sphere with radius r: $V = \frac{4}{3}\pi r^3$; and the volume of a cone with radius r and height h: $V = \frac{1}{3}\pi r^2 h$.

If a soda can has a height of 5 inches and a radius on the top of 1.5 inches, the volume can be found using one of the given formulas. A soda can is a cylinder. Knowing the given dimensions, the formula can be completed as follows: $V = \pi (radius)^2 \times height = \pi (1.5)^2 \times 5 = 35.325 \ inches^3$. Notice that the units for volume are inches cubed because it refers to the number of cubic inches required to fill the can.

With any geometric calculations, it's important to determine what dimensions are given and what quantities the problem is asking for. If a connection can be made between them, the answer can be found.

Other geometric quantities can include angles inside a triangle. The sum of the measures of three angles in any triangle is 180 degrees. Therefore, if only two angles are known inside a triangle, the third can be found by subtracting the sum of the two known quantities from 180. Two angles whose sum is equal to 90 degrees are known as *complementary angles*. For example, angles measuring 72 and 18 degrees are complementary, and each angle is a complement of the other. Finally, two angles whose sum is equal to 180 degrees are known as *supplementary angles*. To find the supplement of an angle, subtract the given angle from 180 degrees. For example, the supplement of an angle that is 50 degrees is 180 − 50 = 130 degrees.

These terms involving angles can be seen in many types of word problems. For example, consider the following problem: The measure of an angle is 60 degrees less than two times the measure of its complement. What is the angle's measure? To solve this, let x be the unknown angle. Therefore, its complement is $90 − x$. The problem gives that $x = 2(90 − x) − 60$. To solve for x, distribute the 2, and collect like terms. This process results in $x = 120 − 2x$. Then, use the addition property to add $2x$ to both

sides to obtain $3x = 120$. Finally, use the multiplication properties of equality to divide both sides by 3 to get $x = 40$. Therefore, the angle measures 40 degrees. Also, its complement measures 50 degrees.

Converting Within and Between Standard and Metric Systems

When working with dimensions, sometimes the given units don't match the formula, and conversions must be made. The metric system has base units of meter for length, kilogram for mass, and liter for liquid volume. This system expands to three places above the base unit and three places below. These places correspond with prefixes with a base of 10.

The following table shows the conversions:

kilo-	hecto-	deka-	base	deci-	centi-	milli-
1,000 times the base	100 times the base	10 times the base		1/10 times the base	1/100 times the base	1/1000 times the base

To convert between units within the metric system, values with a base ten can be multiplied. The decimal can also be moved in the direction of the new unit by the same number of zeros on the number. For example, 3 meters is equivalent to .003 kilometers. The decimal moved three places (the same number of zeros for kilo-) to the left (the same direction from base to kilo-). Three meters is also equivalent to 3,000 millimeters. The decimal is moved three places to the right because the prefix milli- is three places to the right of the base unit.

The English Standard system used in the United States has a base unit of foot for length, pound for weight, and gallon for liquid volume. These conversions aren't as easy as the metric system because they aren't a base ten model. The following table shows the conversions within this system.

Length	Weight	Capacity
1 foot (ft) = 12 inches (in) 1 yard (yd) = 3 feet 1 mile (mi) = 5280 feet 1 mile = 1760 yards	1 pound (lb) = 16 ounces (oz) 1 ton = 2000 pounds	1 tablespoon (tbsp) = 3 teaspoons (tsp) 1 cup (c) = 16 tablespoons 1 cup = 8 fluid ounces (oz) 1 pint (pt) = 2 cups 1 quart (qt) = 2 pints 1 gallon (gal) = 4 quarts

When converting within the English Standard system, most calculations include a conversion to the base unit and then another to the desired unit. For example, take the following problem: $3 \ quarts = $ ___ $cups$. There is no straight conversion from quarts to cups, so the first conversion is from quarts to pints. There are 2 pints in 1 quart, so there are 6 pints in 3 quarts. This conversion can be solved as a proportion: $\frac{3 \ qt}{x} = \frac{1 \ qt}{2 \ pints}$. It can also be observed as a ratio 2:1, expanded to 6:3. Then the 6 pints must be converted to cups. The ratio of pints to cups is 1:2, so the expanded ratio is 6:12. For 6 pints, the measurement is 12 cups. This problem can also be set up as one set of fractions to cancel out units. It begins with the given information and cancels out matching units on top and bottom to yield the answer. Consider the following expression:

$$\frac{3 \ quarts}{1} \times \frac{2 \ pints}{1 \ quart} \times \frac{2 \ cups}{1 \ pint}$$

It's set up so that units on the top and bottom cancel each other out:

$$\frac{3 \; quarts}{1} \times \frac{2 \; pints}{1 \; quart} \times \frac{2 \; cups}{1 \; pint}$$

The numbers can be calculated as $3 \times 3 \times 2$ on the top and 1 on the bottom. It still yields an answer of 12 cups.

This process of setting up fractions and canceling out matching units can be used to convert between standard and metric systems. A few common equivalent conversions are 2.54 cm = 1 inch, 3.28 feet = 1 meter, and 2.205 pounds = 1 kilogram. Writing these as fractions allows them to be used in conversions. For the fill-in-the-blank problem 5 meters = ____ feet, an expression using conversions starts with the expression $\frac{5 \; meters}{1} \times \frac{3.28 \; feet}{1 \; meter}$, where the units of meters will cancel each other out, and the final unit is feet. Calculating the numbers yields 16.4 feet. This problem only required two fractions. Others may require longer expressions, but the underlying rule stays the same. When there's a unit on the top of the fraction that's the same as the unit on the bottom, then they cancel each other out. Using this logic and the conversions given above, many units can be converted between and within the different systems.

The conversion between Fahrenheit and Celsius is found in a formula: $°C = (°F - 32) \times \frac{5}{9}$. For example, to convert 78°F to Celsius, the given temperature would be entered into the formula: $°C = (78 - 32) \times \frac{5}{9}$. Solving the equation, the temperature comes out to be 25.56°C. To convert in the other direction, the formula becomes: $°F = °C * \frac{9}{5} + 32$. Remember the order of operations when calculating these conversions.

Practice Questions

1. What is $\frac{12}{60}$ converted to a percentage?
 a. 0.20
 b. 20%
 c. 25%
 d. 12%

2. Which of the following is the correct decimal form of the fraction $\frac{14}{33}$ rounded to the nearest hundredth place?
 a. 0.420
 b. 0.42
 c. 0.424
 d. 0.140

3. Which of the following represents the correct sum of $\frac{14}{15}$ and $\frac{2}{5}$?
 a. $\frac{20}{15}$

 b. $\frac{4}{3}$

 c. $\frac{16}{20}$

 d. $\frac{4}{5}$

4. What is the product of $\frac{5}{14}$ and $\frac{7}{20}$?
 a. $\frac{1}{8}$

 b. $\frac{35}{280}$

 c. $\frac{12}{34}$

 d. $\frac{1}{2}$

5. What is the result of dividing 24 by $\frac{8}{5}$?
 a. $\frac{5}{3}$

 b. $\frac{3}{5}$

 c. $\frac{120}{8}$

 d. 15

6. Subtract $\dfrac{5}{14}$ from $\dfrac{5}{24}$. Which of the following is the correct result?

 a. $\dfrac{25}{168}$

 b. 0

 c. $-\dfrac{25}{168}$

 d. $\dfrac{1}{10}$

7. Which of the following is a correct mathematical statement?

 a. $\dfrac{1}{3} < -\dfrac{4}{3}$

 b. $-\dfrac{1}{3} > \dfrac{4}{3}$

 c. $\dfrac{1}{3} > -\dfrac{4}{3}$

 d. $-\dfrac{1}{3} \geq \dfrac{4}{3}$

8. Which of the following is incorrect?

 a. $-\dfrac{1}{5} < \dfrac{4}{5}$

 b. $\dfrac{4}{5} > -\dfrac{1}{5}$

 c. $-\dfrac{1}{5} > \dfrac{4}{5}$

 d. $\dfrac{1}{5} > -\dfrac{4}{5}$

9. What is the solution to the equation $3(x + 2) = 14x - 5$?

 a. $x = 1$

 b. No solution

 c. $x = 0$

 d. All real numbers

10. What is the solution to the equation $10 - 5x + 2 = 7x + 12 - 12x$?

 a. $x = 12$

 b. No solution

 c. $x = 0$

 d. All real numbers

11. Which of the following is the result when solving the equation $4(x + 5) + 6 = 2(2x + 3)$?

 a. Any real number is a solution.

 b. There is no solution.

 c. $x = 6$ is the solution.

 d. $x = 26$ is the solution.

12. How many cases of cola can Lexi purchase if each case is $3.50 and she has $40?
 a. 10
 b. 12
 c. 11.4
 d. 11

13. Two consecutive integers exist such that the sum of three times the first and two less than the second is equal to 411. What are those integers?
 a. 103 and 104
 b. 104 and 105
 c. 102 and 103
 d. 100 and 101

14. In a neighborhood, 15 out of 80 of the households have children under the age of 18. What percentage of the households have children?
 a. 0.1875%
 b. 18.75%
 c. 1.875%
 d. 15%

15. Gina took an algebra test last Friday. There were 35 questions, and she answered 60% of them correctly. How many correct answers did she have?
 a. 35
 b. 20
 c. 21
 d. 25

16. Paul took a written driving test, and he got 12 of the questions correct. If he answered 75% of the total questions correctly, how many problems were there in the test?
 a. 25
 b. 16
 c. 20
 d. 18

17. If a car is purchased for $15,395 with a 7.25% sales tax, how much is the total price?
 a. $15,395.07
 b. $16,511.14
 c. $16,411.13
 d. $15,402

18. A car manufacturer usually makes 15,412 SUVs, 25,815 station wagons, 50,412 sedans, 8,123 trucks, and 18,312 hybrids a month. About how many cars are manufactured each month?
 a. 120,000
 b. 200,000
 c. 300,000
 d. 12,000

19. Each year, a family goes to the grocery store every week and spends $105. About how much does the family spend annually on groceries?
 a. $10,000
 b. $50,000
 c. $500
 d. $5,000

20. Bindee is having a barbeque on Sunday and needs 12 packets of ketchup for every 5 guests. If 60 guests are coming, how many packets of ketchup should she buy?
 a. 100
 b. 12
 c. 144
 d. 60

21. A grocery store sold 48 bags of apples in one day, and 9 of the bags contained Granny Smith apples. The rest contained Red Delicious apples. What is the ratio of bags of Granny Smith to bags of Red Delicious that were sold?
 a. 48:9
 b. 39:9
 c. 9:48
 d. 9:39

22. If Oscar's bank account totaled $4,000 in March and $4,900 in June, what was the rate of change in his bank account total over those three months?
 a. $900 a month
 b. $300 a month
 c. $4,900 a month
 d. $100 a month

23. Erin and Katie work at the same ice cream shop. Together, they always work less than 21 hours a week. In a week, if Katie worked two times as many hours as Erin, how many hours could Erin work?
 a. Less than 7 hours
 b. Less than or equal to 7 hours
 c. More than 7 hours
 d. Less than 8 hours

24. From the chart below, which two are preferred by more men than women?

Preferred Movie Genres

■ Men ■ Women

 a. Comedy and Action
 b. Drama and Comedy
 c. Action and Horror
 d. Action and Romance

25. Which type of graph best represents a continuous change over a period of time?
 a. Bar graph
 b. Line graph
 c. Pie graph
 d. Histogram

26. Using the graph below, what is the mean number of visitors for the first 4 hours?

Museum Visitors

a. 12
b. 13
c. 14
d. 15

27. What is the mode for the grades shown in the chart below?

Science Grades	
Jerry	65
Bill	95
Anna	80
Beth	95
Sara	85
Ben	72
Jordan	98

a. 65
b. 33
c. 95
d. 90

28. What type of relationship is there between age and attention span as represented in the graph below?

Attention Span

a. No correlation
b. Positive correlation
c. Negative correlation
d. Weak correlation

29. What is the area of the shaded region?

6 m

2 m

3 m

 a. 9 m²
 b. 12 m²
 c. 6 m²
 d. 8 m²

30. What is the volume of the cylinder below?

2 inches

3.5 inches

 a. 18.84 in³
 b. 45.00 in³
 c. 70.43 in³
 d. 43.96 in³

31. How many kiloliters are in 6 liters?
 a. 6,000
 b. 600
 c. 0.006
 d. 0.0006

32. How many centimeters are in 3 feet? (Note: 2.54cm = 1 inch)
 a. 0.635
 b. 91.44
 c. 14.17
 d. 7.62

Answer Explanations

1. B: The fraction $\frac{12}{60}$ can be reduced to $\frac{1}{5}$, in lowest terms. First, it must be converted to a decimal. Dividing 1 by 5 results in 0.2. Then, to convert to a percentage, move the decimal point two units to the right and add the percentage symbol. The result is 20%.

2. B: If a calculator is used, divide 33 into 14 and keep two decimal places. If a calculator is not used, multiply both the numerator and denominator times 3. This results in the fraction $\frac{42}{99}$, and hence a decimal of 0.42.

3. B: Common denominators must be used. The LCD is 15, and $\frac{2}{5} = \frac{6}{15}$. Therefore, $\frac{14}{15} + \frac{6}{15} = \frac{20}{15}$, and in lowest terms the answer is $\frac{4}{3}$. A common factor of 5 was divided out of both the numerator and denominator.

4. A: A product is found by multiplication. Multiplying two fractions together is easier when common factors are cancelled first to avoid working with larger numbers

$$\frac{5}{14} \times \frac{7}{20} = \frac{5}{2 \times 7} \times \frac{7}{5 \times 4} = \frac{1}{2} \times \frac{1}{4} = \frac{1}{8}$$

5. D: Division is completed by multiplying times the reciprocal. Therefore:

$$24 \div \frac{8}{5} = \frac{24}{1} \times \frac{5}{8} = \frac{3 \times 8}{1} \times \frac{5}{8} = \frac{15}{1} = 15$$

6. C: Common denominators must be used. The LCD is 168, so each fraction must be converted to have 168 as the denominator.

$$\frac{5}{24} - \frac{5}{14} = \frac{5}{24} \times \frac{7}{7} - \frac{5}{14} \times \frac{12}{12} = \frac{35}{168} - \frac{60}{168} = -\frac{25}{168}$$

7. C: The correct mathematical statement is the one in which the number to the left on the number line is less than the number to the right on the number line. It is written in answer C that $\frac{1}{3} > -\frac{4}{3}$, which is the same as $-\frac{4}{3} < \frac{1}{3}$, a correct statement.

8. C: $-\frac{1}{5} > \frac{4}{5}$ is incorrect. The expression on the left is negative, which means that it is smaller than the expression on the right. As it is written, the inequality states that the expression on the left is greater than the expression on the right, which is not true.

9. A: First, the distributive property must be used on the left side. This results in $3x + 6 = 14x - 5$. The addition property is then used to add 5 to both sides, and then to subtract $3x$ from both sides, resulting in $11 = 11x$. Finally, the multiplication property is used to divide each side by 11. Therefore, $x = 1$ is the solution.

10. D: First, like terms are collected to obtain $12 - 5x = -5x + 12$. Then, if the addition principle is used to move the terms with the variable, $5x$ is added to both sides and the mathematical statement $12 = 12$ is obtained. This is always true; therefore, all real numbers satisfy the original equation.

11. B: The distributive property is used on both sides to obtain $4x + 20 + 6 = 4x + 6$. Then, like terms are collected on the left, resulting in $4x + 26 = 4x + 6$. Next, the addition principle is used to subtract $4x$ from both sides, and this results in the false statement $26 = 6$. Therefore, there is no solution.

12. D: This is a one-step real-world application problem. The unknown quantity is the number of cases of cola to be purchased. Let x be equal to this amount. Because each case costs $3.50, the total number of cases times $3.50 must equal $40. This translates to the mathematical equation $3.5x = 40$. Divide both sides by 3.5 to obtain $x = 11.4286$, which has been rounded to four decimal places. Because cases are sold whole (the store does not sell portions of cases), and there is not enough money to purchase 12 cases, there is only enough money to purchase 11.

13. A: First, the variables have to be defined. Let x be the first integer; therefore, $x + 1$ is the second integer. This is a two-step problem. The sum of three times the first and two less than the second is translated into the following expression: $3x + (x + 1 - 2)$. This expression is set equal to 411 to obtain

$3x + (x + 1 - 2) = 412$. The left-hand side is simplified to obtain $4x - 1 = 411$. The addition and multiplication properties are used to solve for x. First, add 1 to both sides and then divide both sides by 4 to obtain $x = 103$. The next consecutive integer is 104.

14. B: First, the information is translated into the ratio $\frac{15}{80}$. To find the percentage, translate this fraction into a decimal by dividing 15 by 80. The corresponding decimal is 0.1875. Move the decimal point two units to the right to obtain the percentage 18.75%.

15. C: Gina answered 60% of 35 questions correctly; 60% can be expressed as the decimal 0.60. Therefore, she answered $0.60 \times 35 = 21$ questions correctly.

16. B: The unknown quantity is the number of total questions on the test. Let x be equal to this unknown quantity. Therefore, $0.75x = 12$. Divide both sides by 0.75 to obtain $x = 16$.

17. B: If sales tax is 7.25%, the price of the car must be multiplied times 1.0725 to account for the additional sales tax. Therefore, $15,395 \times 1.0725 = 16,511.1375$. This amount is rounded to the nearest cent, which is $16,511.14.

18. A: Rounding can be used to find the best approximation. All of the values can be rounded to the nearest thousand. 15,412 SUVs can be rounded to 15,000. 25,815 station wagons can be rounded to 26,000. 50,412 sedans can be rounded to 50,000. 8,123 trucks can be rounded to 8,000. Finally, 18,312 hybrids can be rounded to 18,000. The sum of the rounded values is 117,000, which is closest to 120,000.

19. D: There are 52 weeks in a year, and if the family spends $105 each week, that amount is close to $100. A good approximation is $100 a week for 50 weeks, which is found through the product $50 \times 100 = $5,000$.

20. C: This problem involves ratios and percentages. If 12 packets are needed for every 5 people, this statement is equivalent to the ratio $\frac{12}{5}$. The unknown amount x is the number of ketchup packets needed for 60 people. The proportion $\frac{12}{5} = \frac{x}{60}$ must be solved. Cross-multiply to obtain $12 \times 60 = 5x$. Therefore, $720 = 5x$. Divide each side by 5 to obtain $x = 144$.

21. D: There were 48 total bags of apples sold. If 9 bags were Granny Smith and the rest were Red Delicious, then $48 - 9 = 39$ bags were Red Delicious. Therefore, the ratio of Granny Smith to Red Delicious is 9:39.

22. B: The average rate of change is found by calculating the difference in dollars over the elapsed time. Therefore, the rate of change is equal to $4,900–$4,000÷3 months, which is equal to $900÷3 or $300 a month.

23. A: Let x be the unknown, the number of hours Erin can work. We know Katie works $2x$, and the sum of all hours is less than 21. Therefore, $x + 2x < 21$, which simplifies into $3x < 21$. Solving this results in the inequality $x < 7$ after dividing both sides by 3. Therefore, Erin can work less than 7 hours.

24. A: The chart is a bar chart showing how many men and women prefer each genre of movies. The dark gray bars represent the number of women, while the light gray bars represent the number of men. The light gray bars are higher and represent more men than women for the genres of Comedy and Action.

25. B: A line graph represents continuous change over time. The line on the graph is continuous and not broken, as on a scatter plot. A bar graph may show change but isn't necessarily continuous over time. A pie graph is better for representing percentages of a whole. Histograms are best used in grouping sets of data in bins to show the frequency of a certain variable.

26. C: The mean for the number of visitors during the first 4 hours is 14. The mean is found by calculating the average for the four hours. Adding up the total number of visitors during those hours gives $12 + 10 + 18 + 16 = 56$. Then $56 \div 4 = 14$.

27. C: The mode for a set of data is the value that occurs the most. The grade that appears the most is 95. It's the only value that repeats in the set.

28. B: The relationship between age and time for attention span is a positive correlation because the general trend for the data is up and to the right. As the age increases, so does attention span.

29. A: The area of the shaded region is calculated in a few steps. First, the area of the rectangle is found using the formula $A = length \times width = 6 \times 2 = 12$. Second, the area of the triangle is found using the formula: $A = \frac{1}{2} \times base \times height = \frac{1}{2} \times 3 \times 2 = 3$. The last step is to take the rectangle area and subtract the triangle area. The area of the shaded region is $A = 12 - 3 = 9m^2$.

30. D: The volume for a cylinder is found by using the formula: $V = \pi r^2 h = \pi(2^2) \times 3.5 = 43.96 in^3$.

31. C: There are 0.006 kiloliters in 6 liters because 1 liter=0.001kiloliters. The conversion comes from the chart where the prefix kilo is found three places to the left of the base unit.

32. B: The conversion between feet and centimeters requires a middle term. As there are 2.54 centimeters in 1 inch, the conversion between inches and feet must be found. As there are 12 inches in a foot, the fractions can be set up as follows: $3\ feet \times \frac{12\ inches}{1\ foot} \times \frac{2.54\ cm}{1\ inch}$. The feet and inches cancel out to leave only centimeters for the answer. The numbers are calculated across the top and bottom to yield $\frac{3 \times 12 \times 2.54}{1 \times 1} = 91.44$. The number and units used together form the answer of 91.44 cm.

Science

Human Anatomy and Physiology

Humans

Humans are complex organisms. They have many structures and functions that work in conjunction to maintain life. Breaking up the human body into smaller parts makes it easier to understand. Anatomy is the study of external and internal body parts and structures, and their physical relationships to each other. Gross anatomy is the study of large structures that are visible to the naked eye. Microscopic anatomy is the study of structures that can only be seen with the help of magnification, such as under a microscope. Systemic anatomy is the study of the major organ systems. Developmental anatomy is the study of the physical changes that happen between conception and physical maturity. Physiology is the study of the function of living organisms and their body parts. Pathophysiology is the study of how diseases affect organs and organ system functions. The human body is made up of different types of *cells* that join together to form tissues, which then form together to create organs. *Organs* provide functions for the body that are vital for sustaining life.

Levels of Organization of the Human Body

There are six levels of organization that can help describe the human body. These levels, in smallest to largest size order, are chemical, cellular, tissue, organ, organ system, and organism. The *chemical level* includes atoms and molecules, which are the smallest building blocks of matter. When atoms bind together, they form molecules, which in turn make up chemicals. All body structures are made up of these small elements. *Cells* are the smallest units of living organisms. They function independently to carry out vital functions of every organism. Cells that are similar then bind together to form tissues. *Tissues* perform specific functions by having all of the cells work together. For example, muscle tissue is made up of contractile cells that help the body move. *Organs* are made up of two or more types of tissue and perform physiological functions. *Organ systems* are made up of several organs together that work to perform a major bodily function. *Organisms* include the human body as a whole and all of its structures that perform life-sustaining functions.

There are eleven major organ systems of the human body. The *integumentary system* comprises the skin, hair, and nails, which are all on the outside of the body. It is responsible for enclosing and protecting the internal body structures. It contains many sensory receptors on its surface. The *skeletal system* comprises cartilage, bones, and joints. It supports the body and allows for movement of the body in conjunction with the *muscular system,* which is composed of skeletal muscles and tendons and also helps maintain body temperature. The *nervous system* is made up of the brain, spinal cord, and peripheral nerves. It is in charge of detecting and processing sensory information from the entire body and then sending out an appropriate response, such as taking a hand away quickly after touching something hot. The *endocrine system* includes the pituitary gland, thyroid gland, pancreas, adrenal glands, the testes in males, and the ovaries in females. It is responsible for regulating most bodily processes and secreting hormones. The *cardiovascular system* comprises the heart and blood vessels. Together, these structures are responsible for taking nutrients and oxygen to all of the tissues in the body. This system also helps regulate body temperature. The *lymphatic system* includes the thymus, lymph nodes, spleen, and lymphatic vessels. It is in charge of returning bodily fluids to the blood and fighting off pathogens that enter the body. The *respiratory system* includes the nasal passage, trachea, and lungs. It works to take in oxygen from the environment and deliver it to the blood and to remove carbon dioxide from the body. The *digestive system* comprises the stomach, liver, gallbladder, large intestine, and small intestine. It processes food and

liquid into energy for the body and removes waste from undigested food. The *urinary system* includes the kidneys and urinary bladder. It removes and excretes waste from the blood and controls water balance within the body. The *reproductive system* in males includes the epididymis and testes and in females the mammary glands, ovaries, and uterus. Both the male and female systems produce hormones and gametes. The male system delivers its gametes to females. The female system supports an embryo until birth and then produces milk for the baby.

Body Cavities

Body cavities in humans are the fluid-filled spaces that contain the organs. They are located just under the skin. They provide room for the organs to adjust as the body changes position, and they contain protective membranes. Some cavities contain bones that protect the organs as well. The *dorsal cavity* is located along the posterior, or back, side of the body. It contains the brain and spinal cord in the *cranial cavity* and the *spinal cavity*, respectively, although these two subdivided cavities are continuous. The dorsal cavity contains the *meninges,* which is a multilayered membrane that runs around the brain and spinal cord and helps protect these delicate organs. The cranial cavity is the anterior portion of the dorsal cavity. In addition to the brain, it specifically contains the meninges of the brain and cerebrospinal fluid.

The spinal cavity is the posterior portion of the dorsal cavity and contains the meninges of the spinal cord and the fluid-filled spaces in between the vertebrae, in addition to the spinal cord. This portion of the dorsal cavity is the narrowest of all of the body's cavities. The *ventral cavity* is the interior space in the front of the body, anterior to the dorsal cavity. It comprises the *thoracic* and *abdominopelvic cavities*. The thoracic cavity is located within the rib cage in the chest. It encases the cardiovascular and respiratory system organs, as well as the thymus and esophagus. It is lined by two types of membranes: the *pleura,* which is a membrane that goes around the lungs, and the *pericardium,* which is the membrane that lines the outside of the heart. The *abdominopelvic cavity* is located below the thoracic cavity and underneath the diaphragm. The *diaphragm* is a sheet of skeletal muscle that is located just beneath the lungs. This cavity contains the organs of the digestive, renal, urinary, and reproductive systems, as well as some endocrine glands. It is lined by a membrane called the *peritoneum*. It can be divided into four quadrants: right upper, right lower, left upper, and left lower.

Human Tissues
There are four primary types of *tissue* found in the human body: epithelial, connective, muscle, and neural. Each tissue type has specific characteristics that enable organs and organ systems to function properly. *Epithelial tissue* includes epithelia and glands. *Epithelia* are the layers of cells that cover exposed surfaces and line internal cavities and passageways. The cells are laid out in sheets and have tight cell bonds between them. The three main cell shapes in epithelia are squamous, which appear flattened; cuboidal, which appear as cubes; and columnar, which appear as tall columns. The cell layers can be described as simple, which is when the cells are in one row; stratified, which is when there are multiple rows of cells with only one of the layers connected to the basement membrane and the other layers strongly connected to each other; or pseudostratified, which is when cells are in one row but the nuclei of the cells appear stratified and are not in line with each other. Epithelia do not contain blood vessels and can often regenerate quickly to replace dead and damaged cells. Since they are avascular, they receive nutrition from the substances that diffuse through the blood vessels of the underlying connective tissue. *Glands* are structures that are made up of epithelial tissue and are involved in secretion of fluids. They synthesize substances, such as hormones, and then release them into the bloodstream, into inner-body cavities, or onto the surface of the body. Epithelial tissue has five main functions: (1) to protect underlying tissue from toxins and physical trauma, (2) to absorb substances in the digestive tract lining, (3) to regulate and excrete chemicals between body cavities and underlying tissue surfaces, (4) to secrete hormones into the blood vascular system, and (5) to detect sensations.

Connective tissue fills internal spaces and is never exposed to the outside of the body. It provides structural support for the body and stores energy. This type of tissue is also a protective barrier for delicate organs and for the body against microorganisms. Connective tissue is made up of cells, ground substance, and fibers. The cells are surrounded by extracellular fluid. The ground substance is a viscous substance that is clear and colorless and contains glycosaminoglycans and proteoglycans to keep the collagen fibers within the intercellular spaces. The fibers can be collagenous, which bind bones to other tissues; elastic, which allow organs to stretch and return to their original form; or reticular, which form a scaffolding for other cells. Connective tissue can be described as loose or dense based on how many cells are present and how tightly the fibers are woven together in the tissue.

Muscle tissue has characteristics that make it specialized for contraction, which is the force that produces movement in the body. It also helps the body maintain posture and is responsible for controlling body temperature. Three types of muscle tissue are found in the human body: skeletal, smooth, and cardiac. Skeletal muscle contracts voluntarily according to impulses of the central nervous system. It helps support the body and maintain its posture. It also carries out movements of the body. Smooth and cardiac muscle tissue contract involuntarily. They work without conscious thought or impulse to regulate bodily functions. Smooth muscle is found in blood vessels and hollow organs, such as the urinary bladder. Cardiac muscle is found solely in the heart.

Neural tissue conducts electrical impulses, which help send information and instructions throughout the body. Most of it is concentrated in the brain and spinal cord. Neural tissue comprises neurons and neuroglia. The neurons receive and transmit impulses, while the neuroglia provide nutrients to the neuron and help pass the impulses from the neurons through the tissue.

Three Primary Body Planes
Since humans can take on many different positions, it is important to learn about the body from a standard position. Directional and regional descriptions refer to the body in a standard anatomical position, which is the body standing with lower limbs together with feet flat on the floor and facing forward, arms at the sides with palms facing forward and thumbs pointing away from the body, and head

and eyes facing forward. This standard position avoids confusion when discussing the body and making comparisons between individuals.

Body planes are the hypothetical geometric planes that divide the body into different sections. There are three primary planes of the body. The *transverse plane* is a horizontal plane that separates the superior, or top, portion of the body from the inferior, or bottom, portion of the body. It is parallel to the ground and runs through the center of the body. The *sagittal plane* is a vertical plane that separates the right and left portions of the body. It runs perpendicular to the ground. The *midsagittal plane* runs through the center of the body, splitting the head into two equal parts, and all other sagittal planes are parallel to it. The *coronal plane* is a vertical plane that separates the anterior, or front, and posterior, or back, portions of the body. The planes of the body can be used to identify the location of an individual's organs and to describe anatomical motion. The three main planes of the body create an X-Y-Z coordinate system to describe the motion in a three-dimensional manner. The planes are also helpful for describing embryologic changes and development. When a human embryo first develops, the coronal plane of the embryo is horizontal, or parallel to the ground in standard anatomical position of the mother. As the embryo develops into a fetus, its position changes within the mother, and the coronal plane becomes vertical, or perpendicular to the ground with the mother in standard anatomical position.

Medical imaging technology makes use of the body planes. Ultrasounds, CT scans, MRI scans, and PET scans allow images of the body to be seen in all three dimensions. This allows medical issues and the location of anatomical anomalies to be pinpointed within the body.

Body Planes

108

Terms of Direction

In addition to the body planes, using consistent directional terms aids in understanding the human body. It allows different structures to be compared to each other within the same body. There are two other body positions that can be studied in addition to the anatomical position. The *supine* position is when an individual is lying down, face up, in the anatomical position. The *prone* position is when an individual is lying down, face down, in the anatomical position.

There are distinct directional terms used to study the human body. The terms each have an equal and opposite term to describe the opposite side or opposing view of the body. *Anterior* means at or near the front of the body. *Posterior* means at or near the back of the body. The *midline* is the imaginary vertical line that splits the body into equal parts on the left and right. *Lateral* means farther from the midline. *Medial* means closer to the midline. *Superior* means toward the upper part of a structure or toward the head. *Inferior* means toward the lower part of a structure or away from the head. *Superficial* indicates that something is close to the surface of the body. *Deep* means away from the surface of the body. *Proximal* describes something as being near the origin of a structure, whereas *distal* describes it as being away from the origin of a structure. Most of these terms can also be used in combination. For example, a view of the front of the body from above could be called an *anterosuperior* view.

Body Regions

Body regions help separate the body into distinct anatomical compartments. The *axial* part of the body includes everything around the center of the body except the limbs. The *appendicular* part of the body comprises the appendages or limbs. The following table contains a list of body region terms and which part of the body they refer to.

Term	Body Region
Axial	
Head and Neck	
Cephalic	Head
Cervical	Neck
Cranial	Skull
Frontal	Forehead
Nasal	Nose
Occipital	Base of skull
Oral	Mouth
Ocular	Eyes
Thorax	
Axillary	Armpit
Costal	Ribs
Deltoid	Shoulder
Mammary	Breast
Pectoral	Chest
Scapular	Shoulder blade
Sternal	Breastbone
Vertebral	Backbone
Abdomen	
Abdominal	Abdomen
Gluteal	Buttocks
Inguinal	Bend of hip

Lumbar	Lower back
Pelvic	Area between hip bones
Perineal	Area between anus and external genitalia
Pubic	Genitals
Sacral	End of vertebral column
Appendicular	
Upper Extremity	
Antebrachial	Forearm
Antecubital	Inner elbow
Brachial	Upper arm
Carpal	Wrist
Cubital	Elbow
Digital	Fingers and toes
Manual	Hand
Palmar	Palm
Lower Extremity	
Crural	Shin
Femoral	Thigh
Patellar	Front of knee
Pedal	Foot
Plantar	Arch of foot
Popliteal	Back of knee
Sural	Calf
Tarsal	Ankle

Abdominopelvic Regions and Quadrants

The abdominopelvic region of the body can be divided into four quadrants and nine regions. These areas are used to divide the region into smaller areas, since there are quite a few organs and structures located within the abdomen. The four quadrants are created by intersecting a sagittal plane with a transverse plane through the navel. These quadrants are often used by clinicians to pinpoint where abdominal pain is originating. It is important to note that the directional terms that are used refer to that location on the person's body and are not from the clinician's point of view. For example, when looking at a picture of the abdomen, the right upper quadrant is on the left side of the picture when the body is facing forward. The *right upper quadrant* contains the right kidney, a small portion of the stomach, the duodenum, the gallbladder, the head of the pancreas, the right portion of the liver, parts of the small intestine, and parts of the transverse and ascending colon. Pain in this region is often caused by gallbladder inflammation, liver inflammation, or stomach ulcers. The *left upper quadrant* contains the left kidney, the left portion of the liver, part of the stomach, the spleen, the pancreas, portions of the transvers and descending colon, and parts of the small intestine. Pain in this region is often caused by abnormal rotations of the intestine and colon. The *right lower quadrant* contains the cecum, appendix, part of the small intestine, the right ureter, and the right half of the female reproductive system. Appendicitis pain is associated with this quadrant. The *left lower quadrant* contains most of the small intestine, some of the large intestine, the left ureter, and the left half of the female reproductive system. Pelvic inflammatory disease, ovarian cysts, and inflammation of the large intestine can cause pain in this region.

The nine regions of the abdomen are created by two parasagittal planes and two transverse planes centered around the navel. Once again, the directional terms associated with these regions are from the

point of view of the individual's body and not the clinician's view. The nine divisions are the right hypochondriac, left hypochondriac, epigastric, right lumbar, left lumbar, umbilical, right iliac, left iliac, and hypogastric. The *perineum* is the area below the hypogastric region, at the bottom of the abdominopelvic cavity, and can sometimes be considered a tenth region. Most organs are located within two or more regions. The *right hypochondriac* region contains parts of the gallbladder, the right kidney, the small intestine, and the liver. The *left hypochondriac* region contains parts of the left kidney, the pancreas, the stomach, the spleen, and the colon. The *epigastric region* contains the adrenal glands, most of the stomach, and parts of the liver, pancreas, duodenum, and spleen. The *right lumbar region* contains parts of the gallbladder, the left kidney, the liver, and the ascending colon. The *left lumbar region* contains parts of the descending colon, the left kidney, and the spleen. The *umbilical region* contains the navel and parts of the small intestine, both kidneys, and the transverse colon. The *right iliac region* contains the appendix, cecum, and right iliac fossa. The *left iliac region* contains parts of the descending colon, the sigmoid colon, and the left iliac fossa. The *hypogastric region* contains the organs around the pubic bone, including the bladder, the anus, organs of the reproductive system, and part of the sigmoid colon.

Cell Structure and Function

Although there are trillions of cells in the human body, there are only two hundred different types of cells. The cell is the basic functional unit of all living organisms. Humans are made up of eukaryotic cells, which means that the cells contain their DNA in a nucleus that is bound by a membrane, and the cells contain organelles. Organelles are membrane-enclosed structures that each have a specific function. The outside of each cell is surrounded by a phospholipid bilayer membrane, which means that it is a two-layer membrane made up of a chain of phospholipid molecules. Phospholipids have a hydrophobic tail and a hydrophilic head, so the tails of the two layers face each other on the inside, and the hydrophilic heads face the extracellular and internal cellular environments. Molecules can pass through the membrane in a regulated manner. The nucleus of the cell also has a membrane around it to protect the delicate and important DNA inside. The DNA of each cell contains important genetic information from the parent cells and to be passed down to daughter cells. Each organelle contributes a different function to the cell. The endoplasmic reticulum is a network of membranous sacs and tubes that are responsible for packaging and transporting proteins into vesicles to move them out of the cell. The flagella are clusters of microtubules that stick out of the plasma membrane and help the cell move around. The peroxisome contains enzymes that are involved in the cell's metabolic functions. The mitochondrion is the most important cell organelle, as it is responsible for generating the cell's ATP by aerobic cellular respiration. Lysosomes are responsible for digestion of macromolecules. The Golgi apparatus is responsible for composition, modification, organization, and secretion of cell products. Ribosomes make up a complex that manufactures proteins within the cell.

Respiratory System

The *respiratory system* is responsible for gas exchange between air and the blood, mainly via the act of breathing. It is divided into two sections: the upper respiratory system and the lower respiratory system. The *upper respiratory system* comprises the nose, the nasal cavity and sinuses, and the pharynx, while the *lower respiratory system* comprises the larynx (voice box), the trachea (windpipe), the small passageways leading to the lungs, and the lungs. The upper respiratory system is responsible for filtering, warming, and humidifying the air that gets passed to the lower respiratory system, protecting the lower respiratory system's more delicate tissue surfaces.

The human body has two lungs, each having its own distinct characteristics. The *right lung* is divided into three lobes (superior, middle, and inferior), and the *left lung* is divided into two lobes (superior and inferior). The left lung is smaller than the right lung, most likely because it shares space in the chest cavity with the heart. Together, the lungs contain approximately fifteen hundred miles of airway passages, which are the site of gas exchange during the act of breathing. When a breath of air is inhaled, oxygen enters the nose or mouth and passes into the sinuses, which is where the temperature and humidity of the air get regulated. The air then passes into the trachea and is filtered. From there, it travels into the bronchi and reaches the lungs. Bronchi are lined with cilia and mucus that collect dust and germs along the way. Within the lungs, oxygen and carbon dioxide are exchanged between the air in the *alveoli*, a type of airway passage in the lungs, and the blood in the *pulmonary capillaries*, a type of blood vessel in the lungs. Oxygen-rich blood returns to the heart and gets pumped through the systemic circuit. Carbon dioxide-rich air is exhaled from the body.

The respiratory system has many important functions in the body. Primarily, it is responsible for pulmonary ventilation, or the process of breathing. During pulmonary ventilation, air is inhaled through the nasal cavity or oral cavity and then moves through the pharynx, larynx, and trachea before reaching the lungs. Air is exhaled following the same pathway. When air is inhaled, the diaphragm and external

intercostal muscles contract, causing the rib cage to rise and the volume of the lungs to increase. When air is exhaled, the muscles relax, and the volume of the lungs decreases. The respiratory system also provides a large area for gas exchange between the air and the circulating blood. During the process of external respiration, oxygen and carbon dioxide are exchanged within the lungs. Oxygen goes into the bloodstream, binds to hemoglobin in the red blood cells, and circulates through the body. Carbon dioxide moves from the deoxygenated blood into the alveoli of the lungs and is then exhaled from the body through the nose or mouth. Internal respiration is a process that allows gases to be exchanged between the circulating blood and body tissues. Arteries carry oxygenated blood throughout the body. When the oxygenated blood reaches narrow capillaries in the body tissue, the red blood cells release the oxygen.

The oxygen then diffuses through the capillary walls into the body tissues. At the same time, carbon dioxide diffuses from the body tissues into the blood of the narrow capillaries. Veins carry the deoxygenated blood back to the lungs for waste removal. Another function of the respiratory system is that it produces the sounds that the body makes for speaking and singing, as well as for nonverbal communication. The larynx is also known as the voice box. When air is exhaled, it passes through the larynx. The muscles of the larynx move the arytenoid cartilages, which then push the vocal cords together. When air passes through the larynx while the vocal cords are being pushed together, the vocal cords vibrate and create sound. Higher-pitched sounds are made when the vocal cords are vibrating more rapidly, and lower-pitched sounds are made when the vibrations are slower. The respiratory system also helps with an individual's sense of smell. Olfactory fibers line the nasal cavity. When air enters the nose, chemicals within the air bind to the olfactory fibers. Neurons then take the olfactory signal from the nasal cavity to the olfactory area of the brain for sensory processing. In addition to these major functions, the respiratory system also protects the delicate respiratory surfaces from environmental variations and defends them against pathogens and helps regulate blood volume, blood pressure, and body fluid pH.

Respiratory System

Infections of the respiratory system are common. Most upper respiratory infections are caused by viruses and include the common cold and sinusitis. Bacterial infections of the upper respiratory system are less common and include epiglottitis and croup. This part of the respiratory system gets infected by an organism entering the nasal or oral cavity and invading the mucosa that is present. The organism then begins to destroy the epithelium of the upper respiratory system. Infections of the lower respiratory system can be caused by viruses or bacteria. They include bronchitis, bronchiolitis, and pneumonia. These infections are caused by an organism entering the airway and multiplying itself in or on the epithelium in the lower respiratory system. Inflammation ensues, as well as increased mucus secretion and impaired function of the cilia lining the airways and lungs.

Cardiovascular System

The *cardiovascular system* is composed of the heart and blood vessels. It has three main functions in the human body. First, it transports nutrients, oxygen, and hormones through the blood to the body tissues and cells that need them. It also helps to remove metabolic waste, such as carbon dioxide and nitrogenous waste, through the bloodstream. Second, the cardiovascular system protects the body from attack by foreign microorganisms and toxins. The white blood cells, antibodies, and complement proteins that circulate within the blood help defend the body against these pathogens. The clotting system of the blood also helps protect the body from infection when there is blood loss following an injury. Lastly, this system helps regulate body temperature, fluid pH, and water content of the cells.

Blood Vessels
Blood circulates throughout the body in vessels called arteries, veins, and capillaries. These vessels are muscular tubes that allow gas exchange to occur. *Arteries* carry oxygen-rich blood from the heart to the other tissues of the body. *Veins* collect oxygen-depleted blood from tissues and organs and return it back to the heart. *Capillaries* are the smallest of the blood vessels and do not function individually; instead, they work together in a unit called a *capillary bed*.

Blood
Blood is an important vehicle for transport of oxygen, nutrients, and hormones throughout the body. It is composed of plasma and formed elements, which include red blood cells (RBCs), white blood cells (WBCs), and platelets. *Plasma* is the liquid matrix of the blood and contains dissolved proteins. *RBCs* contain hemoglobin, which carries oxygen through the blood. Red blood cells also transport carbon dioxide. *WBCs* are part of the immune system and help fight off diseases. *Platelets* contain enzymes and other factors that help with blood clotting.

Heart
The *heart*, which is the main organ of the cardiovascular system, acts as a pump and circulates blood throughout the body. Gases, nutrients, and waste are constantly exchanged between the circulating blood and interstitial fluid, keeping tissues and organs alive and healthy. The heart is located behind the sternum, on the left side, in the front of the chest. The heart wall is made up of three distinct layers. The outer layer, called the *epicardium*, is a serous membrane that is also known as the *visceral pericardium*. The middle layer is called the *myocardium* and contains connective tissue, blood vessels, and nerves within its layers of cardiac muscle tissue. The inner layer is called the *endocardium*, and is made up of a simple squamous epithelium. It includes the heart valves and is continuous with the endothelium of the attached blood vessels. The heart has four chambers: the *right atrium*, the *right ventricle*, the *left atrium*, and the *left ventricle*. The atrium and ventricle on the same side of the heart have an opening between them that is regulated by a valve. The valve maintains blood flow in only one direction, moving from the atrium to the ventricle, and prevents backflow. The right side of the heart has a *tricuspid valve* (because it

has three leaflets) between the chambers, and the left side of the heart has a *bicuspid valve* (with two leaflets) between the chambers, also called the *mitral valve*. Oxygen-poor blood from the body enters the right atrium through the superior vena cava and the inferior vena cava and is pumped into the right ventricle. The blood then enters the pulmonary trunk and flows into the pulmonary arteries, where it can become re-oxygenated. Oxygen-rich blood from the lungs then flows into the left atrium from four pulmonary veins, passes into the left ventricle, enters the aorta, and gets pumped to the rest of the body.

Cardiac Cycle

The *cardiac cycle* is the series of events that occur when the heart beats. During the cardiac cycle, blood is circulated throughout the pulmonary and systemic circuits of the body. There are two phases of the cardiac cycle—diastole and systole. During the *diastole* period, the ventricles of the heart are relaxed and are not contracting. Blood is flowing passively from the left atrium to the left ventricle and from the right atrium to the right ventricle through the atrioventricular valves. At the end of the diastole phase, both the left and right atria contract, and an additional amount of blood is pushed through to the respective ventricles. The *systole* period occurs when the left and right ventricles both contract. The aortic valve opens at the left ventricle and pushes blood through to the aorta, and the pulmonary valve opens at the right ventricle and pushes blood through to the pulmonary artery. During this phase, the atrioventricular valves are closed, and blood does not enter the ventricles from the atria.

Types of Circulation

Circulating blood carries oxygen, nutrients, and hormones throughout the body, which are vital for sustaining life. There are two types of cardiac circulation: pulmonary circulation and systemic circulation. The heart is responsible for pumping blood in both types of circulation. The *pulmonary circulatory system* carries blood between the heart and the lungs. It works in conjunction with the respiratory system to facilitate external respiration. Deoxygenated blood flows to the lungs through the vessels of the cardiovascular system to obtain oxygen and release carbon dioxide from the respiratory system. Blood that is rich with oxygen flows from the lungs back to the heart. Pulmonary circulation occurs only in the pulmonary loop. The pulmonary trunk takes the deoxygenated blood from the right ventricle to the arterioles and capillary beds of the lungs. Once the blood that is filling these spaces has been reoxygenated, it passes into the pulmonary veins and is transported to the left atrium of the heart.

The *systemic circulatory system* carries blood from the heart to the rest of the body and works in conjunction with the respiratory system to facilitate internal respiration. The oxygenated blood flows out of the heart through the vessels and reaches the body tissues, while the deoxygenated blood flows through the vessels from the body back to the heart. Unlike the pulmonary loop, the systemic loop covers the whole body. Oxygen-rich blood moves out of the left ventricle into the aorta. The aorta circulates the blood to the systemic arteries and then to the arterioles and capillary beds that are present in the body tissues, where oxygen and nutrients are released into the tissues. The deoxygenated blood then moves from the capillary beds to the venules and systemic veins. The systemic veins bring the blood back to the right atrium of the heart.

Here's a visual representation of this:

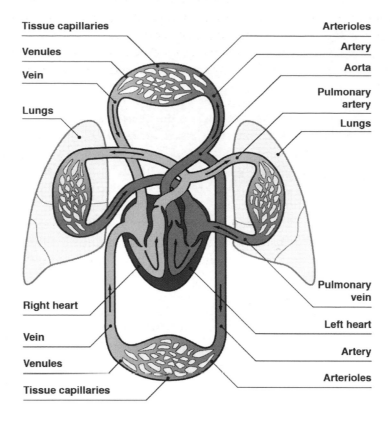

Gastrointestinal System

The *gastrointestinal system* is a group of organs that work together to fuel the body by transforming food and liquids into energy. After food is ingested, it passes through the *alimentary canal*, or *GI tract*, which comprises the mouth, pharynx, esophagus, stomach, small intestine, and large intestine. Each organ has a specific function to aid in digestion. Listed below are seven steps that incorporate the transformation of food as it travels through the gastrointestinal system.

- Ingestion: Food and liquids enter the alimentary canal through the mouth.
- Mechanical processing: Food is torn up by the teeth and swirled around by the tongue to facilitate swallowing.
- Digestion: Chemicals and enzymes break down complex molecules, such as sugars, lipids, and proteins, into smaller molecules that can be absorbed by the digestive epithelium.
- Secretion: Most of the acids, buffers, and enzymes that aid in digestion are secreted by the accessory organs, but some are provided by the digestive tract.
- Absorption: Vitamins, electrolytes, organic molecules, and water are absorbed by the digestive epithelium and moved to the interstitial fluid of the digestive tract.
- Compaction: Indigestible materials and organic wastes are dehydrated and compacted before elimination from the body.
- Excretion: Waste products are secreted into the digestive tract.

Mouth and Stomach

The mouth is the first point at which food and drink enter the gastrointestinal system. It is where food is chewed and torn apart by the teeth. Salivary glands in the mouth produce saliva, which is used to break down starches. The tongue also helps grip the food as it is being chewed and push it posteriorly toward the esophagus. The food and drink then move down the esophagus by the process of swallowing and into the stomach. The inferior end of the esophagus, at the stomach end, has a lower esophageal sphincter that closes off the esophagus and traps food in the stomach. The stomach stores food so that the body has time to digest large meals. It secretes enzymes and acids and also helps with mechanical processing through *peristalsis* or muscular contractions. The upper muscle of the stomach relaxes to let food in, and the lower muscle mixes the food with the digestive juices. The stomach secretes stomach acid to help break down proteins. Once digestion is completed in the stomach, the broken-down contents, called *chyme*, are passed into the small intestine.

Small Intestine

The *small intestine* is a thin tube that is approximately ten feet long and takes up most of the space in the abdominal cavity. The three structural parts of the small intestine are the duodenum, the jejunum, and the ileum. The *duodenum* is shaped like a C and receives the chyme from the stomach along with the digestive juices from the pancreas and the liver. The *jejunum* is the middle portion of the small intestine. It is the section with the most circular folds and villi to increase its surface area. The digestive products are absorbed into the bloodstream in the jejunum. The *ileum* follows the jejunum portion of the small intestine. It mainly absorbs bile acids and vitamin B12 and passes it into the bloodstream. The ileum connects to the large intestine. The entire small intestine secretes enzymes and has folds that increase its surface area and allow for maximum absorption of nutrients from the digested food. The small intestine digestive juice along with juices from the pancreas to liver in combination with peristalsis work to complete the digestion of starches, proteins, and carbohydrates. By the time food leaves the small intestine, approximately 90 percent of the nutrients have been absorbed. These nutrients are carried to the rest of the body. The undigested and unabsorbed food particles are passed into the large intestine.

Large Intestine

The *large intestine* is a long, thick tube that is about five feet in length, also known as the *colon*. It is the final part of the gastrointestinal tract. It has five main sections. The ascending colon connects to the small intestine and runs upward along the right side of the body. It also includes the appendix. The transverse colon runs parallel to the ground from the ascending colon to the left side of the abdominal cavity. The descending colon runs downward along the left side of the body. The sigmoid colon is an S-shaped region that connects the descending colon to the rectum. The rectum is the end of the colon and is a temporary storage place for feces. The function of the large intestine is to absorb water from the digested food and transport waste to be excreted from the body. It also contains symbiotic bacteria that break down the waste products even further, allowing for any additional nutrients to be absorbed. The final waste products are converted to stool and then stored in the rectum.

Pancreas

The pancreas is a large gland that is about 6 inches long. It secretes buffers and digestive enzymes into the duodenum of the small intestine. It contains specific enzymes for each type of food molecule, such as amylases for carbohydrates, lipases for lipids, and proteases for proteins. This digestive function of the pancreas is called the exocrine role of the pancreas. The cells of the pancreas are present in clusters called acini. The digestive enzymes are secreted into the middle of the acini into intralobular ducts. These ducts drain into the main pancreatic duct, which then drains into the duodenum.

In addition to these main organs, the gastrointestinal system has a few accessory organs that help break down food without having the food or liquid pass directly through them. The *liver* produces and secretes *bile*, which is important for the digestion of lipids. The bile mixes with the fat in food and helps dissolve it into the water contents within the small intestine, which helps fatty foods to be digested. The liver also plays a large role in the regulation of circulating levels of carbohydrates, amino acids, and lipids in the body. Excess nutrients are removed by the liver and deficiencies are corrected with its stored nutrients. The gallbladder is responsible for storing and concentrating bile before it gets secreted into the small intestine. It recycles the bile from the small intestine so that it can be used to digest subsequent meals.

Gastrointestinal System

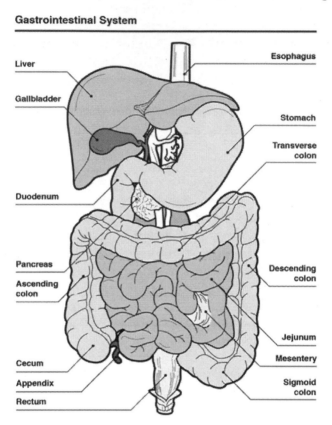

Neuromuscular System

The *neuromuscular system* is composed of all of the muscles in the human body and the nerves that control them. Every movement that the body makes is controlled by the brain. The nervous system and the muscular system work together to link thoughts and actions. Neurons from the nervous system can relay information from the brain to muscle tissue so fast that an individual does not even realize it is happening. Some body movements are voluntary, but others are involuntary, such as the heart beating and the lungs breathing.

Nervous System

The nervous system is made up of the *central nervous system (CNS)* and the *peripheral nervous system (PNS)*. The CNS includes the brain and the spinal cord, while the PNS includes the rest of the neural tissue that is not included in the CNS. *Neurons*, or nerve cells, are the main cells responsible for transferring and processing information between the brain and other parts of the body. *Neuroglia* are cells that support the neurons by providing a framework around them and isolating them from the surrounding environment.

Central Nervous System

The CNS is located within the dorsal body cavity, with the brain in the cranial cavity and the spinal cord in the spinal canal. The brain is protected by the skull, and the spinal cord is protected by the vertebrae. The brain is made up of white and gray matter. The white matter contains axons and oligodendrocytes. *Axons* are the long projection ends of neurons that are responsible for transmitting signals through the nervous system, while *oligodendrocytes* act as insulators for the axons and provide support for them. The gray matter consists of neurons and fibers that are unmyelinated. *Neurons* are nerve cells that receive and transmit information through electrical and chemical signals. Glial cells and astrocytes are located in both types of tissue. Different types of glial cells have different roles in the CNS. Some are immunoprotective, while others provide a scaffolding for other types of nerve cells. Astrocytes provide nutrients to neurons and clear out metabolites. The spinal cord has projections within it from the PNS. This allows the information that is received from the areas of the body that the PNS reaches to be transmitted to the brain. The CNS as a whole is responsible for processing and coordinating sensory data and motor commands. It receives information from all parts of the body, processes it, and then sends out action commands in response. Some of the reactions are conscious, while others are unconscious.

Infections of the CNS include *encephalitis,* which is an inflammation of the brain, and *poliomyelitis,* which is caused by a virus and causes muscle weakness. Other developmental neurological disorders include ADHD and autism. Some diseases of the CNS can occur later in life and affect the aging brain, such as Alzheimer's disease and Parkinson's disease. Cancers that occur in the CNS can be very serious and have high mortality rates.

Peripheral Nervous System

The PNS consists of the nerves and ganglia that are located within the body outside of the brain and spinal cord. It connects the rest of the body, organs, and limbs to the CNS. Unlike the CNS, the PNS does not have any bony structures protecting it. The PNS is responsible for relaying sensory information and motor commands between the CNS and peripheral tissues and systems. It has two subdivisions, known as the afferent, or sensory, and efferent, or motor, divisions. The afferent *division* relays sensory information to the CNS and supplies information from the skin and joints about the body's sensation and balance. It carries information away from the stimulus back to the brain. The afferent division provides the brain with sensory information about things such as taste, smell, and vision. It also monitors organs, vessels, and glands for changes in activity and can alert the brain to send out appropriate responses for bringing the body back to homeostasis. The efferent division transmits motor commands to muscles and glands. It sends information from the CNS to the organs and muscles to provide appropriate responses to sensations.

The electrical responses from the neurons are initiated in the CNS, but the axons terminate in the organs that are part of the PNS. The efferent division consists of the *autonomic nervous system (ANS),* which regulates activity of smooth muscle, cardiac muscle, and glands, and allows the brain to control heart rate, blood pressure, and body temperature, and the *somatic nervous system (SNS),* which controls skeletal muscle contractions and allows the brain to control body movement.

Diseases of the PNS can affect single nerves or the whole system. Single nerve damage, or *mononeuropathy,* can occur when a nerve gets compressed due to trauma or a tumor. It can also be damaged as a result of being trapped under another part of the body that is increasing in size, such as in carpal tunnel syndrome. These diseases can cause pain and numbness at the affected area.

Autonomic Nervous System

The *autonomic nervous system* is made up of pathways that extend from the CNS to the organs, muscles, and glands of the body. The pathway is made up of two separate neurons. The first neuron has a cell body that is located within the CNS, for example, within the spinal cord. The axon of that first neuron synapses with the cell body of the second neuron. Part of the second neuron innervates the organ, muscle, or gland that the pathway is responsible for.

The autonomic nervous system consists of the sympathetic nervous system and the parasympathetic nervous system. The *sympathetic nervous system* is activated when mentally stressful or physically dangerous situations are faced, also known as "fight or flight" situations. Neurotransmitters are released that increase heart rate and blood flow in critical areas, such as the muscles, and decrease activity for nonessential functions, such as digestion. This system is activated unconsciously. The *parasympathetic system* has some voluntary control. It releases neurotransmitters that allow the body to function in a restful state. Heart rate and other sympathetic responses are often decreased when the parasympathetic system is activated.

Somatic Nervous System and the Reflex Arc

The *somatic nervous system* is considered the voluntary part of the PNS. It comprises motor neurons whose axons innervate skeletal muscle. However, nerve muscles and muscle cells do not come into direct contact with each other. Instead, the neurotransmitter acetylcholine transfers the signal between the nerve cell and muscle cell. These junctions are called *neuromuscular junctions*. When the muscle cell receives the signal from the nerve cell, it causes the muscle to contract.

Although most muscle contractions are voluntary, reflexes are a type of muscle contraction that is involuntary. A *reflex* is an instantaneous movement that occurs in response to a stimulus and is controlled by a neural pathway called a *reflex arc*. The reflex arc carries the sensory information from the receptor to the spinal cord and then carries the response back to the muscles. Many sensory neurons synapse in the spinal cord so that reflex actions can occur faster, without waiting for the signal to travel to the brain and back. For somatic reflexes, stimuli activate somatic receptors in the skin, muscles, and tendons. Then, afferent nerve fibers carry signals from the receptors to the spinal cord or brain stem. The signal reaches an integrating center, which is where the neurons synapse within the spinal cord or brain stem. Efferent nerve fibers then carry motor nerve signals to the muscles, and the muscles carry out the response.

Muscular System

There are approximately seven hundred muscles in the body. They are attached to the bones of the skeletal system and make up half of the body's weight. There are three types of muscle tissue in the body: skeletal muscle, smooth muscle, and cardiac muscle. An important characteristic of all types of muscle is that they are *excitable*, which means that they respond to electrical stimuli.

Skeletal Muscles

Skeletal muscle tissue is a voluntary striated muscle tissue, which means that the contractile fibers of the tissue are aligned parallel so that they appear to form stripes when viewed under a microscope. Most skeletal muscle are attached to bones by intermediary tendons. Tendons are bundles of collagen fibers. When nerve cells release acetylcholine at the neuromuscular junction, skeletal muscle contracts. The skeletal muscle tissue then pulls on the bones of the skeleton and causes body movement.

Smooth Muscles

Smooth muscle tissue is an involuntary nonstriated muscle tissue. It has greater elasticity than striated muscle but still maintains its contractile ability. Smooth muscle tissue can be of the single-unit variety or the multi-unit variety. Most smooth muscle tissues are single unit where the cells all act in unison and the

whole muscle contracts or relaxes. Single-unit smooth muscle lines the blood vessels, urinary tract, and digestive tract. It helps to move fluids and solids along the digestive tract, allows for expansion of the urinary bladder as it fills and helps move blood through the vessels. Multi-unit smooth muscle is found in the iris of the eye, large elastic arteries, and the trachea.

Cardiac Muscles

Cardiac muscle tissue is an involuntary striated muscle that is only found in the walls of the heart. The cells that make up the tissue contract together to pump blood through the veins and arteries. This tissue has high contractility and extreme endurance, since it pumps for an individual's entire lifetime without any rest. Each cardiac muscle cell has finger-like projections, called *intercalated disks,* at each end that overlap with the same projections on neighboring cells. The intercalated disks form tight junctions between the cells so that they do not separate as the heart beats and so that electrochemical signals are passed from cell to cell quickly and efficiently.

Reproductive System

The *reproductive system* is responsible for producing, storing, nourishing, and transporting functional reproductive cells, or *gametes*, in the human body. It includes the reproductive organs, also known as *gonads*, the *reproductive tract*, the accessory glands and organs that secrete fluids into the reproductive tract, and the *perineal structures*, which are the external genitalia. The human male and female reproductive systems are very different from each other.

The male gonads are called *testes*. The testes secrete androgens, mainly testosterone, and produce and store one-half billion *sperms cells*, which are the male gametes, each day. An *androgen* is a steroid hormone that controls the development and maintenance of male characteristics. Once the sperm are mature, they move through a duct system where they are mixed with additional fluids that are secreted by accessory glands, forming a mixture called *semen*. The sperm cells in semen are responsible for fertilization of the female gametes to produce offspring. The male reproductive system has a few accessory organs as well, which are located inside the body. The *prostate gland* and the *seminal vesicles* provide additional fluid that serves as nourishment to the sperm during ejaculation. The *vas deferens* is responsible for transportation of sperm to the urethra. The *bulbourethral glands* produce a lubricating fluid for the urethra that also neutralizes the residual acidity left behind by urine.

The female gonads are called *ovaries*. Ovaries generally produce one immature gamete, or *oocyte*, per month. The ovaries are also responsible for secreting the hormones estrogen and progesterone. When the oocyte is released from the ovary, it travels along the uterine tubes, or *Fallopian tubes*, and then into the *uterus*. The uterus opens into the vagina. When sperm cells enter the vagina, they swim through the uterus. If they fertilize the oocyte, they do so in the Fallopian tubes. The resulting zygote travels down the tube and implants into the uterine wall. The uterus protects and nourishes the developing embryo for nine months until it is ready for the outside environment. If the oocyte is not fertilized, it is released in the uterine, or menstrual, cycle. The *menstrual cycle* usually occurs monthly and involves the shedding of the functional part of the uterine lining. *Mammary glands* are a specialized accessory organ of the female reproductive system. The mammary glands are located in the breast tissue of females. During pregnancy, the glands begin to grow as the cells proliferate in preparation for lactation. After pregnancy, the cells begin to secrete nutrient-filled milk, which is transferred into a duct system and out through the nipple for nourishment of the baby.

Integumentary System

The *integumentary system* protects the body from damage from the outside. It consists of skin and its appendages, including hair, nails, and sweat glands. This system functions as a cushion, a waterproof layer, a temperature regulator, and a protectant of the deeper tissues within the body. It also excretes waste from the body. The skin is the largest organ of the human body, consisting of two layers called the epidermis and the dermis. The *epidermis* can be classified as thick or thin. Most of the body is covered with thin skin but areas such as the palm of the hands are covered with thick skin. The epidermis is responsible for synthesizing vitamin D when exposed to UV rays. Vitamin D is essential to the body for the processes of calcium and phosphorus absorption, which maintain healthy bones. The *dermis* lies under the epidermis and consists of a superficial papillary layer and a deeper reticular layer. The *papillary layer* is made up of loose connective tissue and contains capillaries and the axons of sensory neurons. The *reticular layer* is a meshwork of tightly packed irregular connective tissue and contains blood vessels, hair follicles, nerves, sweat glands, and sebaceous glands.

The three major functions of skin are protection, regulation, and sensation. Skin acts as a barrier and protects the body from mechanical impacts, variations in temperature, microorganisms, and chemicals. It regulates body temperature, peripheral circulation, and fluid balance by secreting sweat. It also contains a large network of nerve cells that relay changes in the external environment to the body.

Hair provides many functions for the human body. It provides sensation, protects against heat loss, and filters air that is taken in through the nose. Nails provide a hard layer of protection over soft skin. Sweat glands and sebaceous glands are two important *exocrine glands* found in the skin. *Sweat glands* regulate temperature and remove bodily waste by secreting water, nitrogenous waste, and sodium salts to the surface of the body. *Sebaceous glands* secrete *sebum*, which is an oily mixture of lipids and proteins. Sebum protects the skin from water loss and bacterial and fungal infections.

Endocrine System

The *endocrine system* is made up of ductless tissues and glands, and is responsible for hormone secretion into either the blood or the interstitial fluid of the human body. *Hormones* are chemical substances that change the metabolic activity of tissues and organs. *Interstitial fluid* is the solution that surrounds tissue cells within the body. This system works closely with the nervous system to regulate the physiological activities of the other systems of the body in order to maintain homeostasis. While the nervous system provides quick, short-term responses to stimuli, the endocrine system acts by releasing hormones into the bloodstream, which then are distributed to the whole body. The response is slow but long lasting, ranging from a few hours to even a few weeks. While regular metabolic reactions are controlled by enzymes, hormones can change the type, activity, or quantity of the enzymes involved in the reaction. They can regulate development and growth, digestive metabolism, mood, and body temperature, among many other things. Often very small amounts of a hormone will lead to large changes in the body.

There are eight major glands in the endocrine system, each with its own specific function. They are described below.

- *Hypothalamus:* This gland is a part of the brain. It connects the nervous system to the endocrine system via the pituitary gland and plays an important role in regulating endocrine organs.

- *Pituitary gland:* This pea-sized gland is found at the bottom of the hypothalamus. It releases hormones that regulate growth, blood pressure, certain functions of the reproductive sex

organs, and pain relief, among other things. It also plays an important role in regulating the function of other endocrine glands.

- *Thyroid gland:* This gland releases hormones that are important for metabolism, growth and development, temperature regulation, and brain development during infancy and childhood. Thyroid hormones also monitor the amount of circulating calcium in the body.

- *Parathyroid glands:* These are four pea-sized glands located on the posterior surface of the thyroid. The main hormone that is secreted is called *parathyroid hormone (PTH)* and helps with the thyroid's regulation of calcium in the body.

- *Thymus gland:* This gland is located in the chest cavity, embedded in connective tissue. It produces several hormones that are important for development and maintenance of normal immunological defenses.

- *Adrenal glands:* One adrenal gland is attached to the top of each kidney. Its major function is to aid in the management of stress.

- *Pancreas:* This gland produces hormones that regulate blood sugar levels in the body.

- *Pineal gland:* The pineal gland secretes the hormone melatonin, which can slow the maturation of sperm, oocytes, and reproductive organs. Melatonin also regulates the body's *circadian rhythm*, which is the natural awake-asleep cycles.

Genitourinary System

The *genitourinary system* encompasses the reproductive organs and the *urinary system*. They are often grouped together because of their proximity to each other in the body, and, for the male, because of shared pathways. The external male genitalia include the penis, urethra, and scrotum. Both urine and male gametes travel through the urethra within the penis to exit the body. In both the male and female bodies, the urinary system is made up of the kidneys, ureters, urinary bladder, and the urethra. It is the main system responsible for getting rid of the organic waste products, as well as excess water and electrolytes that are generated by the other systems of the body. Regulation of the water and electrolytes also contributes to the maintenance of blood pH.

Under normal circumstances, humans have two functioning *kidneys*. They are the main organs that are responsible for filtering waste products out of the blood and transferring them to urine. Every day, the kidneys filter approximately 120 to 150 quarts of blood and produce one to two quarts of urine. The kidneys are made up of millions of tiny filtering units called *nephrons*. Nephrons have two parts: a *glomerulus*, which is the filter, and a *tubule*. As blood enters the kidneys, the glomerulus allows for fluid and waste products to pass through it and enter the tubule. Blood cells and large molecules, such as proteins, do not pass through and remain in the blood. The filtered fluid and waste then pass through the tubule, where any final essential minerals can be sent back to the bloodstream. The final product at the end of the tubule is called *urine*. The urine travels through the *ureters* into the *urinary bladder*, which is a hollow, elastic muscular organ. As more and more urine enters the urinary bladder, its walls stretch and become thinner so that there is no significant difference in internal pressure. The urinary bladder stores the urine until the body is ready for urination, at which time its muscles contract and force the urine through the urethra and out of the body.

Immune System

The *immune system* comprises cells, tissues, and organs that work together to protect the body. They recognize millions of different microorganisms, such as parasites, bacteria, and fungi, and viruses that can invade and infect the body. When an attack on the body is sensed, immune cells are activated and communicate with each other through an elaborate network. They begin to produce chemicals and recruit other cells to defend the body at the infection site. It is important for the body's immune system to be able to distinguish between pathogens, such as viruses and microorganisms, and the body's own healthy tissue, so that the body does not attack itself. There are two types of immune systems that work to defend the body against infection: the innate system and the adaptive system.

Innate Immune System

The *innate immune system* is triggered when pattern recognition receptors recognize components of microorganisms that are the same among many different varieties, or when damaged or stressed cells send out help signals. It is always primed and ready to fight infections. This system works in a nonspecific way, which means that it works without having a memory of the pathogens it defended against previously and does not provide long-lasting immunity for the body. It does critical work in the first few hours and days of exposure to a pathogen to fight off infection by producing general immune responses, such as by producing inflammation and activating the complement cascade. During inflammation, immune cells that are already present in the injured tissue are activated, and chemicals stimulate inflammation of the tissue to create a physical barrier against the infection. The complement system is a cascade of events that the immune systems starts to help antibodies fight off pathogens. The proteins that are produced first recruit inflammatory cells and then tag the pathogens for destruction by coating them with opsonin. The proteins also put holes in the pathogen's plasma membrane and, lastly, help rid the body of the neutralized invader.

Mechanical, chemical, and surface barriers all function as part of the innate immune system. Mechanical barriers are the first line of defense against pathogens. Both skin and the respiratory tract are examples of mechanical barriers that provide initial protection against infection. The epithelial layer of the skin is an impermeable physical barrier that wards off many infections. When the epithelium sheds, or goes through desquamation, any microbes that are attached to the skin are removed as well. The top layers of skin are also avascular and lack a blood supply, so the environment is not ideal for survival of microbes. The respiratory tract uses a mucociliary escalator to protect against infection. Pathogens get caught in the sticky mucus that lines the respiratory tract and are moved upward toward the throat. If a mechanical barrier is passed and the pathogen enters the body, chemical barriers are activated. These barriers include cells that have a secondary purpose of fighting off infections. For example, the gastric acid and proteases found in the stomach act as chemical barriers against pathogens that are ingested. They create unfriendly and toxic environments for bacteria to colonize. The group of proteins called interferons helps inhibit the replication of viruses. Biological barriers can also help prevent infection. The bacteria that is naturally found in the gastrointestinal tract acts as a biological barrier by creating competition for nutrients and space against pathogenic bacteria. The eyes have a flushing reflex to push out pathogens that may cause infection. Tears are produced by the tear ducts and collect the microbes to be released along with them from the eye.

Adaptive Immune System

The *adaptive immune system* creates a memory of the pathogen that it fought against previously so that the body can respond again in an efficient manner the next time the pathogen is encountered. When *antigens*, or *allergens*, such as pollen, are encountered, specific antibodies are secreted to inactivate the antigen and protect the body. The response of the adaptive immune system can take several days, which

is much longer than the immediate response of the innate immune system. It uses fewer types of cells to produce its immune response compared to the innate immune system as well. The adaptive immune system provides the body with a long-lasting defense mechanism and protection against recurrent infections. Vaccines use the memory of the adaptive immune system to protect individuals against diseases they have never experienced. When vaccines are administered, an active, weakened, or attenuated virus is injected into the body, which mimics the active virus. The adaptive immune system then starts an immune response and creates a memory of the antigens associated with that disease along with the antibodies to fight them off.

Lymphocytes are the specialized cells that are a part of the adaptive immune system. *B cells* and *T cells* are different types of lymphocytes that are derived from multipotent hematopoietic stem cells and that recognize specific target pathogens. B cells are formed in the bone marrow and then move into the lymphatic system and circulate through the body. These cells are called naive B cells. Naive B cells express millions of antibodies on their surfaces as well as a B-cell receptor (BCR). The BCR helps with antigen binding, internalization, and processing. It allows the B cell to then initiate signaling pathways and communicate with other immune cells. When a naive B cell encounters an antigen that fits one of its surface antibodies, it begins to mature and differentiates into a memory B cell or a plasma cell. Memory B cells retain their surface-bound antibodies. Plasma cells, on the other hand, secrete their antibodies instead of keeping them attached to the cell membrane. The freely circulating antibodies can then identify pathogens that are circulating throughout the body.

T cells are also produced in the bone marrow. They then migrate to the thymus where they mature and start to express T-cell receptors (TCRs) as well as one of two other types of receptors—CD4 or CD8. These receptors help T cells identify antigens that are bound to specific receptors on antigen-presenting cells, such as macrophages and dendritic cells. CD4 and CD8 bind to the receptor-antigen complex on these cells, which activates the T cells to produce an immune response. After maturation, the three types of T cells that are produced are helper T cells, cytotoxic T cells, and T regulatory cells. Helper T cells express CD4 and help activate B cells, cytotoxic T cells, and other immune cells. Cytotoxic T cells express CD8 and remove pathogens and infected host cells. T regulatory cells express CD4 and help distinguish between molecules that belong to the individual and foreign molecules.

Malfunctions of the Immune System
An *immunodeficiency* occurs when the body cannot respond to a pathogen because a component of the immune system is inactive. This can be caused by a genetic mutation or by behavior. For example, smoking paralyzes the mucociliary escalator of the respiratory tract, disabling a critical part of the body's innate immune system. If the immune system is not functioning properly, the body may attack its own self and develop an autoimmune disorder. When the body cannot distinguish between itself and foreign pathogens, the immune system becomes overactive and the body attacks itself unnecessarily. To diagnose an autoimmune disease, it is important to identify which antibodies an individual's body is producing and then determine which of those antibodies is attacking the individual itself. Autoantibody tests look for specific antibodies within an individual's tissues; antinuclear antibody tests are specific autoantibody tests that look for antibodies that attack the nuclei of cells; complete blood count tests count the number of red and white cells in the blood, which reveals if the body is actively fighting an infection; and C-reactive protein tests determine whether there is inflammation occurring throughout the body.

Diseases such as type I diabetes and rheumatoid arthritis are autoimmune disorders. The pancreas contains cells that produce insulin to regulate blood sugar levels. In type I diabetes, auto-aggressive T cells infiltrate the pancreas and destroy the insulin-producing beta cells population. Without the insulin-producing cells, the body cannot regulate blood sugar levels on its own and requires external sources of

insulin to maintain healthy levels. Rheumatoid arthritis occurs when the body's immune system attacks the joint linings of its own body. This causes inflammation and damage in healthy tissue around the joints, leading to pain and immobility.

Skeletal System

The adult *skeletal system* consists of the 206 bones that make up the skeleton, as well as the cartilage, ligaments, and other connective tissues that stabilize them. Babies are born with roughly three hundred bones, some of which fuse together during growth. *Bone* is made up of collagen fibers and calcium salts. The calcium salts are strong but brittle, and the collagen fibers are weak but flexible, so the combination makes bone very resistant to shattering.

Axial Skeleton

The *axial skeleton* comprises the bones found in the head, trunk of the body, and vertebrae—a total of eighty bones. It is the central core of the body and is responsible for connecting the pelvis to the rest of the body. The axial skeleton can be divided into the following five parts:

1. The *skull bones* are made up of the cranium and the facial bones. While the skeleton gets frailer with age, the skull remains strong to protect the brain. The cranium is formed from eight flat bones that fit together without spaces in between. These meeting points are called *sutures*. The brain is held in a space inside the cranium called the *cranial vault*. The lower front part of the skull is formed by fourteen facial bones. Together with the cranium, the facial bones form spaces to hold the eyes, internal ear, nose, and mouth.

2. There are three *middle ear ossicles* in each ear, called the *malleus, incus,* and *stapes,* respectively, positioned between the eardrum and inner ear. They are among the smallest bones found in the human body. These bones transmit sounds from the air to the fluid-filled cochlea, and without them, individuals suffer from hearing loss.

3. The *hyoid bone* is a horseshoe-shaped bone located in the anterior midline of the neck. It is held in place by muscles and is only distantly articulated to other bones. It aids in swallowing and movement of the tongue.

4. The *rib cage* includes the *sternum,* or breastbone, and twelve pairs of *ribs.* The ribs each have one flat end and one rounded end, similar to a crescent shape. The flat ends of the upper seven ribs come together at the sternum, while their rounded ends are attached at joints to the vertebrae. The eighth, ninth, and tenth pairs of ribs connect to the ribs above with noncostal cartilage. The last two sets of ribs are floating ribs and do not attach to any other structure. The rib cage protects the heart and lungs.

5. The adult *vertebral column* comprises twenty-four vertebrae, the sacrum, and the coccyx. The sacrum is formed from five fused vertebrae, and the coccyx is formed from three to five fused vertebrae, so the vertebral column is thought to have thirty-three bones total. The seven cervical vertebrae are the uppermost vertebrae and connect the cranium. Below the cervical vertebrae are twelve thoracic vertebrae, followed by five lumbar vertebrae.

The appendicular skeleton comprises 126 bones that support the body's appendages. It helps with movement of the body as well as with manipulation of external objects and interactions with the environment. It is divided into the following four parts:

1. The _pectoral girdles_ include four bones, which are the right and left clavicle and two scapula bones. The scapulae help keep the shoulders in place.

2. The _upper limbs_ comprise the arms and the hands. The _arms_ each consist of three bones. The _humerus_ is in the upper part of the arm, and the _ulna_ and _radius_ are below the elbow, making up the forearm. The arm bones provide attachment points for muscles that allow for movement of the arms and wrist. Each hand has twenty-seven bones.

3. The _pelvis_ comprises two coxal bones that provide an attachment point for the lower limbs and the axial skeleton.

4. The _lower limbs_ comprise the legs, ankles, and feet. The legs are each made up of four bones. The _femur_ is located in the thigh. The _patella_ covers the knee. The _tibia_ and _fibula_ are in the lower leg below the knee. These bones have muscles attached to them that allow for movement of the leg. The foot and ankle of each leg have twenty-six bones total.

Functions of the Skeletal System

One of the major functions of the skeletal system is to provide structural support for the entire body. It provides a framework for the soft tissues and organs to attach to. The skeletal system also provides a reserve of important nutrients, such as calcium and lipids. Normal concentrations of calcium and phosphate in body fluids are partly maintained by the calcium salts stored in bone. Lipids that are stored in yellow bone marrow can be used as a source of energy. Red bone marrow produces red blood cells, white blood cells, and platelets that circulate in the blood. Certain groups of bones form protective barriers around delicate organs. The ribs, for example, protect the heart and lungs, the skull encloses the brain, and the vertebrae cover the spinal cord.

Compact and Spongy Bone

There are two types of bone: compact and spongy. _Compact bone_ is dense with a matrix filled with organic substances and inorganic salts. There are only tiny spaces left between these materials for the _osteocytes_, or bone cells, to fit into. _Spongy bone_, in contrast to compact bone, is lightweight and porous. It covers the outside of the bone and gives it a shiny, white appearance. It has a branching network of parallel lamellae called _trabeculae_. Although spongy bone forms an open framework around the compact bone, it is still quite strong. Different bones have different ratios of compact to spongy bone depending on their function. The outside of the bone is covered by a _periosteum_, which has four major functions. It isolates and protects bones from the surrounding tissue, provides a place for attachment of the circulatory and nervous system structures, participates in growth and repair of the bone, and attaches the bone to the deep fascia. An _endosteum_ is found inside the bone; it covers the trabeculae of the spongy bone and lines the inner surfaces of the central canals.

Life and Physical Sciences

Basic Macromolecules in a Biological System

There are six major elements found in most biological molecules: carbon, hydrogen, oxygen, nitrogen, sulfur, and phosphorus. These elements link together to make up the basic macromolecules of the

biological system, which are lipids, carbohydrates, nucleic acids, and proteins. Most of these molecules use carbon as their backbone because of its ability to bond four different atoms. Each type of macromolecule has a specific structure and important function for living organisms.

Lipids

Lipids are made up of hydrocarbon chains, which are large molecules with hydrogen atoms attached to a long carbon backbone. These biological molecules are characterized as hydrophobic because their structure does not allow them to form bonds with water. When mixed together, the water molecules bond to each other and exclude the lipids. There are three main types of lipids: triglycerides, phospholipids, and steroids.

Triglycerides are made up of one glycerol molecule attached to three fatty acid molecules. Glycerols are three-carbon atom chains with one hydroxyl group attached to each carbon atom. Fatty acids are hydrocarbon chains with a backbone of sixteen to eighteen carbon atoms and a double-bonded oxygen molecule. Triglycerides have three main functions for living organisms. They are a source of energy when carbohydrates are not available, they help with absorption of certain vitamins, and they help insulate the body and maintain normal core temperature.

Phospholipid molecules have two fatty acid molecules bonded to one glycerol molecule, with the glycerol molecules having a phosphate group attached to it. The phosphate group has an overall negative charge, which makes that end of the molecule hydrophilic, meaning that it can bond with water molecules. Since the fatty acid tails of phospholipids are hydrophobic, these molecules are left with the unique characteristic of having different affinities on each of their ends. When mixed with water, phospholipids create bilayers, which are double rows of molecules with the hydrophobic ends on the inside facing each other and the hydrophilic ends on the outside, shielding the hydrophobic ends from the water molecules. Cells are protected by phospholipid bilayer cell membranes. This allows them to mix with aqueous solutions while also protecting their inner contents.

Steroids have a more complex structure than the other types of lipids. They are made up of four fused carbon rings. Different types of steroids are defined by the different chemical groups that attach to the carbon rings. Steroids are often mixed into phospholipid bilayers to help maintain the structure of the cell membrane and aid in cell signaling from these positions. They are also essential for regulation of metabolism and immune responses, among other biological processes.

Carbohydrates

Carbohydrates are made up of sugar molecules. Monomers are small molecules, and polymers are larger molecules that consist of repeating monomers. The smallest sugar molecule, or monomer, has the chemical formula of CH_2O. Monosaccharides can be made up of one of these small molecules or a multiple of this formula (such as $C_2H_4O_2$). Polysaccharides consist of repeating monosaccharides in lengths of a few hundred to a few thousand linked together. Monosaccharides are broken down by living organisms to extract energy from the sugar molecules for immediate consumption. Glucose is a common monosaccharide used by the body as a primary energy source and which can be metabolized immediately. The more complex structure of polysaccharides allows them to have a more long-term use. They can be stored and broken down later for energy. Glycogen is a molecule that consists of 1700 to 600,000 glucose units linked together. It is not soluble in water and can be stored for long periods of time. If necessary, the glycogen molecule can be broken up into single glucose molecules in order to provide energy for the body. Polysaccharides also form structurally strong materials, such as chitin, which makes up the exoskeleton of many insects, and cellulose, which is the material that surrounds plant cells.

Nucleic Acids

Nucleotides are made up of a five-carbon sugar molecule with a nitrogen-containing base and one or more phosphate groups attached to it. Nucleic acids are polymers of nucleotides, or polynucleotides. There are two main types of nucleic acids: deoxyribonucleic acid (DNA) and ribonucleic acid (RNA). DNA is a double strand of nucleotides that are linked together and folded into a helical structure. Each strand is made up of four nucleotides, or bases: adenine, thymine, cytosine, and guanine. The adenine bases only pair with thymine on the opposite strand, and the cytosine bases only pair with guanine on the opposite strand. It is the links between these base pairs that create the helical structure of double-stranded DNA. DNA is in charge of long-term storage of genetic information that can be passed on to subsequent generations. It also contains instructions for constructing other components of the cell. RNA, on the other hand, is a single-stranded structure of nucleotides that is responsible for directing the construction of proteins within the cell. RNA is made up of three of the same nucleotides as DNA, but instead of thymine, adenine pairs with the base uracil.

Proteins

Proteins are made from a set of twenty amino acids that are linked together linearly, without branching. The amino acids have peptide bonds between them and form polypeptides. These polypeptide molecules coil up, either individually or as multiple molecules linked together, and form larger biological molecules, which are called *proteins*. Proteins have four distinct layers of structure. The primary structure consists of the sequence of amino acids. The secondary structure consists of the folds and coils formed by the hydrogen bonding that occurs between the atoms of the polypeptide backbone. The tertiary structure consists of the shape of the molecule, which comes from the interactions of the side chains that are linked to the polypeptide backbone. Lastly, the quaternary structure consists of the overall shape that the protein takes on when it is made up of two or more polypeptide chains. Proteins have many vital roles in living organisms. They help maintain and repair body tissue, provide a source of energy, form antibodies to aid

the immune system, and are a large component in transporting molecules within the body, among many other functions.

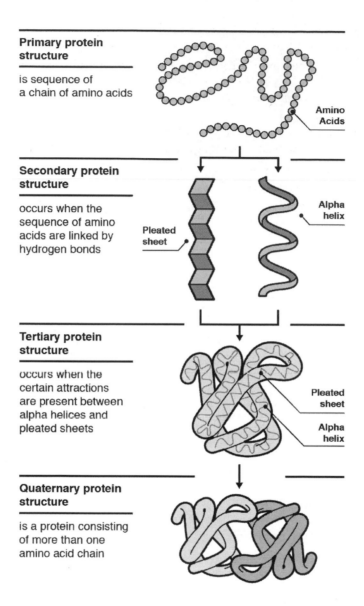

Primary protein structure

is sequence of a chain of amino acids

Amino Acids

Secondary protein structure

occurs when the sequence of amino acids are linked by hydrogen bonds

Pleated sheet

Alpha helix

Tertiary protein structure

occurs when the certain attractions are present between alpha helices and pleated sheets

Pleated sheet

Alpha helix

Quaternary protein structure

is a protein consisting of more than one amino acid chain

Comparing and Contrasting Chromosomes, Genes, and DNA

Chromosomes

A *chromosome* is a molecule of DNA that contains the genetic material of an organism, located in the nucleus of the cell. It is a threadlike structure made up of genes that is coiled tightly around proteins called *histones*. The histones support the more fragile form of the chromosome. Chromosomes are too small to even be seen under a microscope when a cell is not dividing. However, when a cell is undergoing division, the DNA making up the chromosomes becomes much more tightly packed and microscopically visible. During cell division, each chromosome makes an exact copy of itself that it is attached to at a constriction point called the *centromere*. The double chromosome structure, called *sister chromatids,* has an X shape, with one set of the chromosome's arms being longer than the other. In other words, the

centromere is located closer to one end of the chromosome than the other. The shorter part of the chromosome sticking out from the centromere is called the *p-arm*, and the longer arm is called the *q-arm*.

For genetic information to be conserved from one generation to the next, chromosomes must be replicated and divided within the parent cell before being passed on to the daughter cell. Humans have twenty-three pairs of chromosomes. Twenty-two pairs are *autosomes*, or body chromosomes that contain most of the genetic hereditary information, and one pair is an *allosome*, or sex chromosome. Some genetic traits are sex-linked, so those genes are located on the allosome. Chromosomes are divided in humans during the process of meiosis. *Meiosis* is a special type of cell division in which a parent cell produces four daughter cells, each with half the number of chromosomes as the parent cell. As a precursor to meiosis, each chromosome replicates itself to form a sister chromatid. When a sperm cell meets an egg cell, each brings with it twenty-three sister chromatids. When meiosis starts, the homologous chromosomes pair up and undergo a crossing-over event where they can switch gene alleles. The remixed sister chromatids move toward the center of the cell along spindles and then are pulled to opposite poles and divided into two cells. These two cells divide again, breaking up the sister chromatids, and leaving each of the four cells with one set of chromosomes.

Genes

Genes are made up of DNA and are the basic functional unit of heredity. They can be as short as a few hundred DNA base pairs in length to over 2 million DNA base pairs long. Humans have between 20,000 and 25,000 genes on their twenty-three pairs of chromosomes. Each chromosome contains two *alleles*, or variations, of each gene—one inherited from each parent. Genes contain information about a specific trait that was inherited from one of the individual's parents. They provide instructions for making proteins to express that specific trait. Generally, one allele of a gene has a more dominant *phenotype*, or physical characteristic, than the other. This means that when both variations are present on a gene, the dominant variation or phenotype would always be expressed over the recessive phenotype. Since the dominant phenotype is always expressed when present, the recessive phenotype is only expressed when the gene only contains two recessive phenotype alleles. Although this is the case for almost all genes, some gene alleles have either codominance or incomplete dominance expression. With codominance, if both alleles are present, they are equally expressed in the phenotype. For example, certain cows can have red hair with two red hair alleles and white hair with two white hair alleles. However, when one of each allele is present, these cows have a mix of red and white hair on their bodies, not pink hair. Incomplete dominance occurs when two different alleles on a gene produce a third phenotype. For example, in certain types of flowers, two red alleles produce red flowers, and two white alleles produce white flowers. One of each allele produces pink flowers, a completely different color of flower.

Gene Mutations

Sometimes when genes are replicated, a permanent alteration in the DNA sequence occurs, and a gene mutation is formed. Mutations can be small and affect a single DNA base pair or be large and affect multiple genes in a chromosome. They can either be *hereditary*, which means they were present in the parent cell as well, or *acquired*, which means the mutation occurred at some point during cell replication within that individual's lifetime. Acquired mutations do not get passed on to subsequent generations. Most mutations are rare and occur in very small portions of the population. When the genetic alteration occurs in more than 1 percent of the population, it is called a *polymorphism*. Polymorphisms cause many of the variations seen in normal populations, such as hair and eye color, and do not affect a person's health. However, some polymorphisms put an individual at greater risk of developing some diseases.

DNA

DNA is the material that carries all of the hereditary information about an individual. It is present in every cell of the human body. DNA is a double-stranded molecule that coils up into a helical structure. Each strand is made from a sequence of four chemical bases, which are adenine, guanine, cytosine, and thymine. Each base pairs with only one of the four other bases when it is linked to the second strand—adenine with thymine and guanine with cytosine. The order of the base pairs and length of the strand determine what type of information is being coded. It varies for each gene that it makes up.

DNA Replication

An important characteristic of DNA is its ability to replicate itself. Each strand of the double-stranded DNA structure serves as a template for creating an exact replica of the DNA molecule. When cells divide, they require an exact copy of the DNA for the new cell. During DNA replication, the helical molecule is untwisted, and the strands are separated at one end. Specific replication proteins attach to each separated strand and begin forming new strands with matching base pairs for each of the strands. While some of the DNA molecule is untwisted, the remainder becomes increasingly twisted in response. Topoisomerase enzymes help relieve the strain of the excess twisting by breaking, untwisting, and rejoining the DNA strands. Once the replication proteins have copied the strands from one end to the other, two new DNA molecules are formed. Each DNA molecule is made from one original base pair strand and one newly synthesized base pair strand joined together.

Mendel's Laws of Heredity

Gregor Mendel was a monk who came up with one of the first models of inheritance in the 1860s. He is often referred to as the father of genetics. At the time, his theories were largely criticized because biologists did not believe that these ideas could be generally applicable and could also not apply to different species. They were later rediscovered in the early 1900s and given more credence by a group of European scientists. Mendel's original ideas have since been combined with other theories of inheritance and evolution to develop the ideas that are studied today.

Between 1856 and 1863, Gregor Mendel experimented with about five thousand pea plants that had different color flowers in his garden to test his theories of inheritance. He crossed purebred white flower and purple flower pea plants and found that the results were not a blend of the two flowers; they were instead all purple flowers. When he then fertilized this second generation of purple flowers with itself, both white flowers and purple flowers were produced, in a ratio of one to three. Although he used different terms at the time, he proposed that the color trait for the flowers was regulated by a gene, which he called a *factor,* and that there were two alleles, which he called *forms,* for each gene. For each gene, one allele was inherited from each parent. The results of these experiments allowed him to come up with his Principles of Heredity.

There are two main laws that Mendel developed after seeing the results of his experiments. The first law is the Law of Segregation, which states that each trait has two versions that can be inherited. In the parent cells, the allele pairs of each gene separate, or segregate, randomly during gamete production. Each gamete then carries only one allele with it for reproduction. During the process of reproduction, the gamete from each parent contributes its single allele to the daughter cell. The second law is the Law of Independent Assortment, which states that the alleles for different traits are not linked to one another and are inherited independently. It emphasizes that if a daughter cell selects allele A for gene 1, it does not also automatically select allele A for gene 2. The allele for gene 2 is selected in a separate, random manner.

Mendel theorized one more law, called the Law of Dominance, which has to do with the expression of a genotype but not with the inheritance of a trait. When he crossed the purple flower and white flower pea plants, he realized that the purple flowers were expressed at a greater ratio than the white flower pea plants. He hypothesized that certain gene alleles had a stronger outcome on the phenotype that was expressed. If a gene had two of the same allele, the phenotype associated with that allele was expressed. If a gene had two different alleles, the phenotype was determined by the dominant allele, and the other allele, the recessive allele, had no effect on the phenotype.

Basic Atomic Structure

Atoms are the smallest units of all matter and make up all chemical elements. They each have three parts: protons, neutrons, and electrons.

Measurable Properties of Atoms

Although atoms are very small in size, they have many properties that can be quantitatively measured. The *atomic mass* of an atom is equal to the sum of the protons and neutrons in the atom. The *ionization energy* of an atom is the amount of energy that is needed to remove one electron from an individual atom. The greater the ionization energy, the harder it is to remove the electron, meaning the greater the bond between the electron and that atom's nucleus. Ionization energies are always positive because atoms require extra energy to let go of an atom. On the other hand, *electron affinity* is the change in energy that occurs when an electron is added to an individual atom. Electron affinity is always negative because atoms release energy when an electron is added. The *effective nuclear charge* of an atom is noted as Z_{eff} and accounts for the attraction of electrons to the nucleus of an atom as well as the repulsion of electrons to other neighboring electrons in the same atom. The *covalent radius* of an atom is the radius of an atom when it is bonded to another atom. It is equal to one-half the distance between the two atomic nuclei. The *van der Waal's radius* is the radius of an atom when it is only colliding with another atom in solution or as a gas and is not bonding to the other atom.

The Periodic Table and Periodicity

Periodic Table

The *periodic table* is a chart that describes all the known elements. Currently, there are 118 elements listed on the periodic table. Each element has its own cell on the table. Within the cell, the element's abbreviation is written in the center, with its full name written directly below. The atomic number is recorded in the top left corner, and the atomic mass is recorded at the bottom center of the cell in atomic mass units, or *amus*. The first ninety-four elements are naturally occurring, whereas the last twenty-four can only be made in laboratory environments.

The rows of the table are called *periods*, and the columns are called *groups*. Elements with similar properties are grouped together. The periodic table can be divided and described in many ways according to similarities of the grouped elements. When it is divided into blocks, each block is named in accordance with the subshell in which the final electron sits. The blocks are named *alkali metals, alkaline earth metals, transition metals, basic metals, semimetals, nonmetals, halogens, noble gases, lanthanides*, and *actinides*. If the periodic table is divided according to shared physical and chemical properties, the elements are often classified as *metals, metalloids*, and *nonmetals*.

Periodicity

Periodicity refers to the trends that are seen in the periodic table among the elements. It is a fundamental aspect of how the elements are arranged within the table. These trends allow scientists to learn the properties of families of elements together instead of learning about each element only individually. They also elucidate the relationships among the elements. There are many important characteristics that can be

seen by examining the periodicity of the table, such as ionization energy, electron affinity, length of atomic radius, and metallic characteristics. Moving from left to right and from bottom to top on the periodic table, elements have increasing ionization energy and electron affinity. Moving in the opposite directions, from top to bottom and from right to left, the elements have increasing length of atomic radii. Moving from the bottom left corner to the top right corner, the elements have increasing nonmetallic properties, and moving in the opposite direction from the top right corner to the bottom left corner, the elements have increasing metallic properties.

Protons

Protons are found in the nucleus of an atom and have a positive electric charge. At least one proton is found in the nucleus of all atoms. Protons have a mass of about one atomic mass unit. The number of protons in an element is referred to as the element's atomic number. Each element has a unique number of protons and therefore its own unique atomic number. Hydrogen ions are unique in that they only contain one proton and do not contain any electrons. Since they are free protons, they have a very short lifespan and immediately become attracted to any free electrons in the environment. In a solution with water, they bind to a water molecule, H_2O, and turn it into H_3O+.

Neutrons

Neutrons are also found in the nucleus of atoms. These subatomic particles have a neutral charge, meaning that they do not have a positive or negative electric charge. Their mass is slightly larger than that of a proton. Together with protons, they are referred to as the nucleons of an atom. Interestingly, although neutrons are not affected by electric fields because of their neutral charge, they are affected by magnetic fields and are said to have magnetic moments.

Electrons

Electrons have a negative charge and are the smallest of the subatomic particles. They are located outside the nucleus in orbitals, which are shells that surround the nucleus. If an atom has an overall neutral charge, it has an equal number of electrons and protons. If it has more protons than electrons or vice versa, it becomes an ion. When there are more protons than electrons, the atom is a positively charged ion, or cation. When there are more electrons than protons, the atom is a negatively charged ion, or anion.

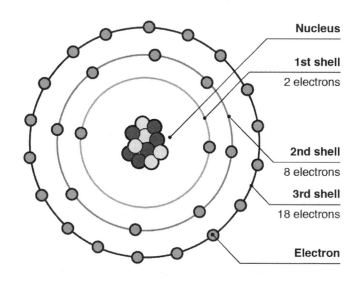

Nucleus

1st shell

2 electrons

2nd shell

8 electrons

3rd shell

18 electrons

Electron

The location of electrons within an atom is more complicated than the locations of protons and neutrons. Within the orbitals, electrons are always moving. They can spin very fast and move upward, downward, and sideways. There are many different levels of orbitals around the atomic nucleus, and each orbital has a different capacity for electrons. The electrons in the orbitals closest to the nucleus are more tightly bound to the nucleus of the atom. There are three main characteristics that describe each orbital. The first is the principle quantum number, which describes the size of the orbital. The second is the angular momentum quantum number, which describes the shape of the orbital. The third is the magnetic quantum number, which describes the orientation of the orbital in space.

Chemical Bonds Between Atoms

Chemical bonds are formed from attractions between atoms that then create chemical compounds or molecules. The bonds can be strong or weak depending on how the bond is formed. A stable compound formed with the total energy of the molecular unit is lower than that of the atoms separately. There are many different types of chemical bonds that can form between atoms, including covalent bonds, ionic bonds, metallic bonds, and hydrogen bonds.

Covalent Bonds
An important characteristic of electrons is their ability to form covalent bonds with other atoms to form molecules. A covalent bond is a chemical bond that forms when two atoms share the same pair or pairs of electrons. There is a stable balance of attraction and repulsion between the two atoms. When these bonds are formed, energy is released because the electrons become more spatially distributed instead of being pulled toward the individual atom's nucleus. There are several different types of covalent bonds. Sigma bonds are the strongest type of covalent bond and involve the head-on overlapping of electron orbitals from two different atoms. Pi bonds are a little weaker and involve the lateral overlapping of certain orbitals. While single bonds between atoms, such as between carbon and hydrogen, are generally sigma bonds, double bonds, such as when carbon is double-bonded to an oxygen atom, are usually one sigma bond and one pi bond.

Covalent bonds can also be classified as *nonpolar* or *polar*. Nonpolar covalent bonds are formed when two atoms share their electrons equally, creating a very small difference of electronegativity between the atoms. Compounds that are formed with nonpolar covalent bonds do not mix well with water and other polar solvents and are much more soluble in nonpolar solvents. Polar covalent bonds are formed when electrons are not evenly shared between the atoms. Therefore, the electrons are pulled closer to one atom than the other, giving the molecule ionic properties and an imbalance of charge. The electronegative difference between the atoms is greater when polar bonds are formed compared to nonpolar bonds.

Coordinate covalent bonds, or dipolar bonds, are formed when the two shared electrons of the molecule come from the same atom. The electrons from one atom are shared with an empty orbital on the other atom, making one atom the electron pair donor and the other atom the electron pair acceptor. The electrons are shared approximately equally when these bonds are created.

Ionic Bonds
When ionic bonds are formed, instead of sharing a pair of electrons, the electrons are transferred from one atom to another, creating two ions. One of the ions is left with a positive charge, and the other one is left with a negative charge. This results in a large difference in electronegativity between the ions. The ionic bonds result from the attraction between the oppositely charged ions. However, the same two ions are not always paired with each other. Each ion is surrounded by ions with the opposite charge but are constantly moving around. Ionic bonds commonly form in metal salts. Metals have few electrons in their outermost orbitals, and by losing those electrons, they become more stable. By taking these electrons

away from the metallic atoms, nonmetals can fill their valence shells and also become more stable. For example, when sodium atoms and chloride atoms combine to form sodium chloride, the sodium atom loses an electron and becomes positively charged with a closed shell of electrons, and the chloride atom gains an electron, leaving it with a full shell of electrons.

Metallic Bonds

Metallic bonds occur when the electrons in the outer shell of an atom become delocalized and free-moving. They become shared by many atoms as they move in all directions around the positively charged metal ions. The free-floating electrons create an environment that allows for easy conduction of heat and electricity between the atoms. They also contribute to the *luster,* or surface reflectivity, that is often characteristic of metals, as well as the high tensile strength of metallic material. Metallic bonds are often seen as a sea of electrons with positive ions floating between them.

Hydrogen Bonds

Hydrogen bonds are different from the previously mentioned bonds because they are formed between a hydrogen atom that is present in one molecule and another atom that is already part of a molecular complex. These types of bonds are intermolecular instead of intramolecular. The hydrogen atom is attracted to an atom that has a high electronegativity in the other molecule. The large difference in electronegativity between the molecules creates a strong electrostatic attraction between the molecules. If a hydrogen atom forms a polar covalent bond with another atom, such as an oxygen atom, the hydrogen end of the molecule remains slightly positively charged, and the oxygen end of the molecule remains slightly negatively charged. The hydrogen of this molecule would then be attracted to other atoms with a slightly negative charge in nearby molecules. Hydrogen bonding is also important in the formation of the DNA double helix molecule. The nitrogenous bases on each strand are situated so they can form hydrogen bonds with the bases that are directly opposite them on the other strand.

Characteristic Properties of Substances

Properties of Water

Water is a polar compound formed from one oxygen atom bonded to two hydrogen atoms. It has many unique properties, such as its ability to exist as a solid, liquid, and gas on Earth's surface. It is the only common substance that can exist in all three forms in this environment. Water is also self-ionizing, breaking itself up into H+ and OH- ions, which also makes it both an acid and a base.

The polarity of water and its attraction to other polar molecules is an important characteristic. *Cohesion* is the attraction of water molecules to each other. The slight negative charge of the oxygen atom in one molecule attracts the slightly positively charged hydrogen atoms of other water molecules. This attraction allows water to have surface tension. Insects, such as water striders, can actually walk across the surface of a pool of water. *Adhesion* is the attraction of water molecules to other molecules with which it can form hydrogen bonds. This attraction creates capillary action. *Capillary action* is the ability of water to "climb" up the side of a tube as it is attracted to the material of the tube. Its polarity also helps it break up ions in salts and bond to other polar substances, such as acids and alcohols. It is used to dissolve many substances and is often described as a *universal solvent* because of its polar attraction to other atoms and ions.

While most compounds become denser when they become solid, ice, the solid form of water, is actually less dense than the liquid form of water. The hydrogen bonds that form between the water molecules become ice crystals and more stable. The bonds remain spaced apart as the liquid freezes, creating a low density in the solid structure. Ice, therefore, floats to the top of a glass of liquid water.

Water is also a great moderator of temperature because of its high specific heat and high heat of vaporization. *Specific heat* is the amount of energy that is needed to change the temperature of one gram of a substance 1°C. When a substance has a high specific heat, it requires a lot of energy to change the temperature. Since water molecules form a lot of hydrogen bonds, it takes a lot of energy to break up the bonds. Since there are a lot of hydrogen bonds to absorb and release heat as they break and form, respectively, temperature changes are minimized. Similarly, *heat of vaporization* is the amount of energy needed to change 1 gram of liquid into gas. It takes a lot of energy to break the hydrogen bonds between liquid water molecules and turn them into water vapor.

Characteristic Properties of Molecules

There are two basic types of properties that can help characterize substances: physical and chemical. Physical properties can be detected without changing the substance's identity or composition. If a substance is subject to a physical change, its appearance changes, but its composition does not change at all. Common physical properties include color, odor, density, and hardness. Physical properties can also be classified as extensive or intensive. Extensive physical properties depend on the amount of substance that is present. These include characteristics such as mass and volume. Intensive properties do not depend on how much of the substance is present and remain the same regardless of quantity. These include characteristics such as density and color.

Chemical properties are characteristics of a substance that describe how it can be changed into a different chemical substance. A substance's composition is changed when it undergoes a chemical change. Chemical properties are measured and observed only as the substance is undergoing a change to become a different substance. Some examples of chemical properties are flammability, reactivity, toxicity, and ability to oxidize. These properties are detected by making changes to the substance's external environment and seeing how it reacts to the changes. An iron shovel that is left outside can become rusty. Rusting occurs when iron changes to iron oxide. While iron is very hard and a shiny silver color, iron oxide is flaky and a reddish-brown color. Reactivity is the ability of a substance to combine chemically with another substance. While some substances are very reactive, others are not reactive at all. For example, potassium is very reactive with water, and even a small amount causes an explosive reaction. Helium, on the other hand, does not react with any other substance.

It is often important to quantify the properties that are observed in a substance. Quantitative measurements are associated with a number, and it is imperative to include a unit of measure with each of those measurements. Without the unit of measure, the number may be meaningless. If the weight of a substance is noted as 100 without a unit of measure, it is unknown whether the substance is equivalent to 100 of something very light, such as milligram measurements, or 100 of something very heavy, such as kilogram measurements. There are many other quantitative measurements of matter that can be taken, including length, time, and temperature, among many others. Contrastingly, there are many properties that are not associated with a number; these properties can be measured qualitatively. The measurements of qualitative properties use a person's senses to observe and describe the characteristics. Since the descriptions are developed by individual persons, they can be very subjective. These properties can include odor, color, and texture, among many others. They can also include comparisons between two substances without using a number; for example, one substance may have a stronger odor or be lighter in color than another substance.

Changes in States of Matter

The universe is composed completely of matter. Matter is any material or object that takes up space and has a mass. Although there is an endless variety of items found in the universe, there are only about one

hundred elements, or individual substances, that make up all matter. These elements are different types of atoms and are the smallest units that anything can be broken down into. Different elements can link together to form compounds, or molecules. Hydrogen and oxygen are two examples of elements, and when they bond together, they form water molecules. Matter can be found in three different states: gas, liquid, or solid.

Gases

Gases have three main distinct properties. The first is that they are easy to compress. When a gas is compressed, the space between the molecules decreases, and the frequency of collisions between them increases. The second property is that they do not have a fixed volume or shape. They expand to fill large containers or compress down to fit into smaller containers. When they are in large containers, the gas molecules can float around at high speeds and collide with each other, which allows them to fill the entire container uniformly. Therefore, the volume of a gas is generally equal to the volume of its container. The third distinct property of a gas is that it occupies more space than the liquid or solid from which it was formed. One gram of solid CO_2, also known as *dry ice,* has a volume of 0.641 milliliters. The same amount of CO_2 in a gaseous state has a volume of 556 milliliters. Steam engines use water in this capacity to do work. When water boils inside the steam engine, it becomes steam, or water vapor. As the steam increases in volume and escapes its container, it is used to make the engine run.

Liquids

A liquid is an intermediate state between gases and solids. It has an exact volume due to the attraction of its molecules to each other and molds to the shape of the part of the container that it is in. Although liquid molecules are closer together than gas molecules, they still move quickly within the container they are in. Liquids cannot be compressed, but their molecules slide over each other easily when poured out of a container. The attraction between liquid molecules, known as *cohesion,* also causes liquids to have surface tension. They stick together and form a thin skin of particles with an extra strong bond between them. As long as these bonds remain undisturbed, the surface becomes quite strong and can even support the weight of an insect such as a water skipper. Another property of liquids is adhesion, which is when different types of particles are attracted to each other. When liquids are in a container, they are drawn up above the surface level of the liquid around the edges. The liquid molecules that are in contact with the container are pulled up by their extra attraction to the particles of the container.

Solids

Unlike gases and liquids, solids have a definitive shape. They are similar to liquids in that they also have a definitive volume and cannot be compressed. The molecules are packed together tightly, which does not allow for movement within the substance. There are two types of solids: crystalline and amorphous. Crystalline solids have atoms or molecules arranged in a specific order or symmetrical pattern throughout the entire solid. This symmetry makes all of the bonds within the crystal of equal strength, and when they are broken apart, the pieces have straight edges. Minerals are all crystalline solids. Amorphous solids, on the other hand, do not have repeating structures or symmetry. Their components are heterogeneous, so they often melt gradually over a range of temperatures. They do not break evenly and often have curved edges. Examples of amorphous solids are glass, rubber, and most plastics.

Matter can change between a gas, liquid, and solid. When these changes occur, the change is physical and does not affect the chemical properties or makeup of the substance. Environmental changes, such as temperature or pressure changes, can cause one state of matter to convert to another state of matter. For example, in very hot temperatures, solids can melt and become a liquid, such as when ice melts into liquid water, or sublimate and become a gas, such as when dry ice becomes gaseous carbon dioxide. Liquids can evaporate and become a gas, such as when liquid water turns into water vapor. In very cold temperatures,

gases can depose and become a solid, such as when water vapor becomes icy frost on a windshield, or condense and become a liquid, such as when water vapor becomes dew on grass. Liquids can freeze and become a solid, such as when liquid water freezes and becomes ice.

Chemical Reactions

A chemical reaction is a process that involves a change in the molecular arrangement of a substance. Generally, one set of chemical substances, called the reactants, is rearranged into a different set of chemical substances, called the products, by the breaking and re-forming of bonds between atoms. In a chemical reaction, it is important to realize that no new atoms or molecules are introduced. The products are formed solely from the atoms and molecules that are present in the reactants. These can involve a change in state of matter as well. Making glass, burning fuel, and brewing beer are all examples of chemical reactions.

Types of Chemical Reactions
Generally, chemical reactions are thought to involve changes in positions of electrons with the breaking and re-forming of chemical bonds, without changes to the nucleus of the atoms. The three main types of chemical reactions are combination, decomposition, and combustion.

Combination
In combination reactions, two or more reactants are combined to form one more complex, larger product. The bonds of the reactants are broken, the elements rearranged, and then new bonds are formed between all of the elements to form the product. It can be written as A + B → C, where A and B are the reactants and C is the product. An example of a combination reaction is the creation of iron(II) sulfide from iron and sulfur, which is written as 8Fe + S8 → 8FeS.

Decomposition
Decomposition reactions are almost the opposite of combination reactions. They occur when one substance is broken down into two or more products. The bonds of the first substance are broken, the elements rearranged, and then the elements bonded together in new configurations to make two or more molecules. These reactions can be written as C → B + A, where C is the reactant and A and B are the products. An example of a decomposition reaction is the electrolysis of water to make oxygen and hydrogen gas, which is written as 2H2O → 2H2 + O2.

Combustion

Combustion reactions are a specific type of chemical reaction that involves oxygen gas as a reactant. This mostly involves the burning of a substance. The combustion of hexane in air is one example of a combustion reaction. The hexane gas combines with oxygen in the air to form carbon dioxide and water. The reaction can be written as $2C_6H_{14} + 17O_2 \rightarrow 12CO_2 + 14H_2O$.

Balancing Chemical Reactions

The way the hexane combustion reaction is written above ($2C6H14 + 17O2 \rightarrow 12CO2 + 14H2O$) is an example of a chemical equation. Chemical equations describe how the molecules are changed when the chemical reaction occurs. The "+" sign on the left side of the equation indicates that those molecules are reacting with each other, and the arrow, "\rightarrow," in the middle of the equation indicates that the reactants are producing something else. The coefficient before a molecule indicates the quantity of that specific molecule that is present for the reaction. The subscript next to an element indicates the quantity of that element in each molecule. In order for the chemical equation to be balanced, the quantity of each element on both sides of the equation should be equal. For example, in the hexane equation above, there are twelve carbon elements, twenty-eight hydrogen elements, and thirty-four oxygen elements on each side of the equation. Even though they are part of different molecules on each side, the overall quantity is the same. The state of matter of the reactants and products can also be included in a chemical equation and would be written in parentheses next to each element as follows: gas (g), liquid (l), solid (s), and dissolved in water, or aqueous (aq).

Catalysts

The rate of a chemical reaction can be increased by adding a catalyst to the reaction. Catalysts are substances that lower the activation energy required to go from the reactants to the products of the reaction but are not consumed in the process. The activation energy of a reaction is the minimum amount of energy that is required to make the reaction move forward and change the reactants into the products. When catalysts are present, less energy is required to complete the reaction. For example, hydrogen peroxide will eventually decompose into two water molecules and one oxygen molecule. If potassium permanganate is added to the reaction, the decomposition happens at a much faster rate. Similarly, increasing the temperature or pressure in the environment of the reaction can increase the rate of the reaction. Higher temperatures increase the number of high-energy collisions that lead to the products. The same happens when increasing pressure for gaseous reactants, but not with solid or liquid reactants.

Extent of reaction

140

Enzymes

Enzymes are a type of biological catalyst that accelerate chemical reactions. They work like other catalysts by lowering the activation energy of the reaction to increase the reaction rate. They bind to substrates and change them into the products of the reaction without being consumed by the reaction. Enzymes differ from other catalysts by their increased specificity to their substrate. They can also be affected by other molecules. Enzyme inhibitors can decrease their activity, whereas enzyme activators increase their activity. Their activity also decreases dramatically when the environment is not in their optimal pH and temperature range.

An enzyme can encounter several different types of inhibitors. In biological systems, inhibitors are many times expressed as part of a feedback loop where the enzyme is producing too much of a substance too quickly and the reaction needs to be stopped. Competitive inhibitors and substrates cannot bind to the enzyme at the same time. These inhibitors often resemble the substrate of the enzyme. Noncompetitive inhibitors bind to the enzyme at a different location than the substrate. The substrate can still bind with the same affinity, but the efficiency of the enzyme is decreased. Uncompetitive inhibitors cannot bind to the enzyme alone and can only bind to the enzyme–substrate complex. Once an uncompetitive inhibitor binds to the complex, the complex becomes inactive. An irreversible inhibitor binds to the enzyme and permanently inactivates it. It usually does so by forming a covalent bond with the enzyme.

pH

In chemistry, *pH* stands for the potential of hydrogen. It is a numeric scale ranging from 0 to 14 that determines the acidity and basicity of an aqueous solution. Solutions with a pH of greater than 7 are considered basic, those with a pH of less than 7 are considered acidic, and solutions with a pH equal to 7 are considered neutral. Pure water is considered neutral with a pH equal to 7. It is important to remember that the pH of solutions can change at different temperatures. While the pH of pure water is 7 at 25°C, at 0°C it is 7.47, and at 100°C it is 6.14. pH is calculated as the negative of the base 10 logarithm of the activity of the hydrogen ions in the solution and can be written as $pH = -\log_{10}(a_H+) = \log_{10}(1/a_H+)$.

One of the simplest ways to measure the pH of a solution is by performing a litmus test. Litmus paper has a mixture of dyes on it that react with the solution and display whether the solution is acidic or basic depending on the resulting color. Red litmus paper turns blue when it reacts with a base. Blue litmus paper turns red when it reacts with an acid. Litmus tests are generally crude measurements of pH and not very precise. A more precise way to measure the pH of a solution is to use a pH meter. These specialized meters act like voltmeters and measure the electrical potential of a solution. Acids have a lot of positively charged hydrogen ions in solutions that have greater potential than bases to produce an electric current. The voltage measurement is then compared with a solution of known pH and voltage. The difference in voltage is translated into the difference in pH.

Acids and Bases

Acids and bases are two types of substances with differing properties. In general, when acids are dissolved in water, they can conduct electricity, have a sour taste, react with metals to free hydrogen ions, and react with bases to neutralize their properties. Bases, in general, when dissolved in water, conduct electricity, have a slippery feel, and react with acids to neutralize their properties.

The Brønsted-Lowry acid–base theory is a commonly accepted theory about how acid–base reactions work. *Acids* are defined as substances that dissociate in aqueous solutions and form hydrogen ions. *Bases* are defined as substances that dissociate in aqueous solutions and form hydroxide (OH^-) ions. The basic idea behind the theory is that when an acid and base react with each other, a proton is exchanged, and the acid forms its conjugate base, while the base forms its conjugate acid. The acid is the proton donor,

and the base is the proton acceptor. The reaction is written as HA + B \leftrightarrow A⁻ + HB⁺, where HA is the acid, B is the base, A⁻ is the conjugated base, and HB⁺ is the conjugated acid. Since the reverse of the reaction is also possible, the reactants and products are always in equilibrium. The equilibrium of acids and bases in a chemical reaction can be determined by finding the acid dissociation constant, K_a, and the base dissociation constant, K_b. These dissociation constants determine how strong the acid or base is in the aqueous solution. Strong acids and bases dissociate quickly to create the products of the reaction.

In other cases, acids and bases can react to form a neutral salt. This happens when the hydrogen ion from the acid combines with the hydroxide ion of the base to form water, and the remaining ions combine to form a neutral salt. For example, when hydrochloric acid and sodium hydroxide combine, they form salt and water, which can be written as $HCl + NaOH \rightarrow NaCl + H_2O$.

Scientific Reasoning

Identifying Basic Scientific Measurement Using Laboratory Tools

Measuring Force

A Newton meter or force meter is a standardized instrument for measuring the force exerted by different elements in the universe that cause movement when they act upon objects by pulling, pushing, rotating, deforming, or accelerating them, such as gravity, friction, or tension. Force is measured in units called Newtons (N), named after Sir Isaac Newton, who defined the laws of motion, including forces. One common example of a force meter is a bathroom scale. When someone steps on the scale, the force exerted on the platform is measured in the form of units of weight. Force meters contain springs, rubber bands, or other elastic materials that stretch in proportion to force applied. A Newton meter displays 50-Newton increments, with four 10-Newton marks in between. Thus if a Newton meter's needle rests on the third mark between 100 and 150, this indicates 130N.

Measuring Temperature

As those familiar with word roots can determine, thermometers measure heat or temperature (*thermo-* is from Greek for heat and *meter* from Greek for measure). Some thermometers measure outdoor or indoor air temperature, and others measure body temperature in humans or animals. Meat thermometers measure temperature in the center of cooked meat to ensure sufficient cooking to kill bacteria. Refrigerator and freezer thermometers measure internal temperatures to ensure sufficient coldness. Although digital thermometers eliminate the task of reading a thermometer scale by displaying a specific numerical reading, many thermometers still use visual scales. In these, increments are typically two-tenths of a degree. However, basal thermometers, which are more sensitive and accurate, and are frequently used to track female ovulation cycles for measuring and planning fertility, display increments of one-tenth of a degree. Whole degrees are marked by their numbers; tenths of degrees are the smallest marks in between.

Measuring Length

Rulers, yardsticks, tape measures, and other standardized instruments are for measuring short distances. Standard rulers and similar measures show distances in increments of feet, inches, and halves, quarters, eights, and sixteenths of an inch. Tape measures have markings indicating one yard or three feet, six feet, and other common multiple-feet measurements. Each inch on a ruler is marked by number from 1 to 12 (or 1 to 36 on a yardstick). Half-inches are the longest of the non-numbered line marks, then quarter-inches, then eighth-inches, then sixteenth-inches. Some American-made rulers also include metric measurements.

Using the Vernier Scale

French mathematician and inventor Pierre Vernier originated the Vernier measurement principle and corresponding scale in 1631. When measuring small increments using other instruments, it can be impossible to determine precisely small fractions within already small divisions. Vernier's invention solved this problem with simple elegance. For example, dividing millimeters in the metric system or 16ths of an inch in the English system into 10ths or smaller portions is impractical, inaccurate, and unreadable without using magnifiers. A metric Vernier caliper features a main scale and a Vernier scale, i.e. a parallel, sliding scale with ten or eleven marks, spaced equally within themselves but differently from the main scale spacing. English Vernier calipers often have $\frac{1}{16}$" main scale divisions and 8 divisions on the Vernier scale, so they can measure lengths as small as $\frac{1}{28}$". To read a Vernier caliper, close its jaws on the object being measured, note the main scale number, rounding down to the next smaller marking, and see which Vernier scale mark aligns with it to obtain the additional fraction.

Using a Micrometer Caliper

A micrometer caliper is similar to a Vernier caliper in that both have a main scale plus a movable scale for measuring fractions of small numbers. Like many medical instruments, micrometer calipers are typically metrical, measuring in millimeters. The main scale markings are in $\frac{1}{2}$ millimeters. A uniform, precise screw moves the micrometer caliper's jaw. It has a rotating thimble on its handle, marked in 50 equal divisions. Rotating the thimble once moves the screw $\frac{1}{2}$ millimeter along the main scale, enabling the user to read measurements as small as one-hundredth of a millimeter. Most micrometers display $\frac{1}{2}$ mm markings on the thimble on the opposite side from the main scale markings on the micrometer sleeve, making it easier to read. Users require some practice, e.g. rounding up $\frac{1}{2}$ mm if a reading is in the top half of a millimeter; only tightening the caliper jaws using the slip clutch to close them snugly without bending them; and making a zero correction using a special wrench so fully closing the jaws yields a zero reading if it did not already.

Critiquing a Scientific Explanation Using Logic and Evidence

According to the scientific method, one must either observe something as it is happening or as a constant state, or prove it through experimenting, to say it is a fact. Scientific experiments are found reliable when they can be replicated and produce comparable results regardless of who is conducting them or making the observations. However, historically many beliefs have been considered facts at the time, only to be disproven later when objective evidence became accessible. For instance, in ancient times many people believed the Earth was flat based on limited visual evidence. Ancient Greek philosophers Pythagoras in the 6th century BCE and Aristotle in the 4th century BCE believed the earth was spherical. This was eventually borne out by observational evidence. Aristotle estimated the Earth's circumference; Eratosthenes measured it c. 240 BCE; in the 2nd century CE, Ptolemy had mapped the globe and developed the latitude, longitude, and climes system.

While many phenomena have been established by science as facts, technically many others are actually theories, though many people mistakenly consider them facts. As one example, gravity per se is a fact; however, the scientific explanation of how gravity functions is a theory. Though a theory is not the same as a fact, this does not presume theories are merely speculative ideas. A scientific theory must be tested thoroughly and then applied to established facts, hypotheses, and observations. Moreover, for a theory to be accepted or even considered scientifically, it must relate and explain a broad scope of observations which would not be related without the theory. People sometimes state opinions as if they were facts to persuade others. For example, advertising might claim a product is the best without concrete supporting

evidence. To evaluate information, one must consider both its source and any supporting evidence to ascertain its veracity.

Relationships Among Events, Objects, and Procedures

When we determine relationships among events, objects, and procedures, we are better able to understand the world around us and make predictions based on that understanding. With regards to relationships among events and procedures, we will look at cause and effect. For relationships among objects, we will take a look at Newton's Laws.

Cause

The cause of a particular event is the thing that brings it about. A causal relationship may be partly or wholly responsible for its effect, but sometimes it's difficult to tell whether one event is the sole cause of another event. For example, lung cancer can be caused by smoking cigarettes. However, sometimes lung cancer develops even though someone does not smoke, and that tells us that there may be other factors involved in lung cancer besides smoking. It's also easy to make mistakes when considering causation. One common mistake is mistaking correlation for causation. For example, say that in the year 2008 a volcano erupted in California, and in that same year, the number of infant deaths increased by ten percent. If we automatically assume, without looking at the data, that the erupting volcano *caused* the infant deaths, then we are mistaking correlation for causation. The two events might have happened at the same time, but that does not necessarily mean that one event caused the other. Relationships between events are never absolute; there are a myriad of factors that can be traced back to their foundations, so we must be thorough with our evidence in proving causation.

Effect

An effect is the result of something that occurs. For example, the Nelsons have a family dog. Every time the dog hears thunder, the dog whines. In this scenario, the thunder is the cause, and the dog's whining is the effect. Sometimes a cause will produce multiple effects. Let's say we are doing an experiment to see what the effects of exercise are in a group of people who are not usually active. After about four weeks, the group experienced weight loss, rise in confidence, and higher energy. We start out with a cause: exercising more. From that cause, we have three known effects that occurred within the group: weight loss, rise in confidence, and higher energy. Cause and effect are important terms to understand when conducting scientific experiments.

Newton's Laws

Newton's laws of motion describe the relationship between an object and the forces acting upon that object, and its movement responding to those forces. Newton has three laws:

Law of Inertia: An object at rest stays at rest and an object in motion stays in motion unless otherwise acted upon by an outside force. For example, gravity is an outside force that will affect the speed and direction of a ball; when we throw a ball, the ball will eventually decrease in speed and fall to the ground because of the outside force of gravity. However, if the ball were kicked in space where there is no gravity, the ball would go the same speed and direction forever unless it hits another object in space or falls into another gravity field.

Newton's Second Law: This law states that the heavier an object, the more force has to be used to move it. This force has to do with acceleration. For example, if you use the same amount of force to push both a golf cart and an eighteen-wheeler, the golf cart will have more acceleration than the truck because the eighteen-wheeler weighs more than the golf cart.

Newton's Third Law: This law states that for every action, there is an opposite and equal reaction. For example, if you are jumping on a trampoline, you are experiencing Newton's third law of motion. When you jump down on the trampoline, the opposite reaction pushes you up into the air.

Design of a Scientific Investigation

Scientific investigation is seeking an answer to a specific question using the scientific method. The scientific method is a procedure that is based on an observation. For example, if someone observes something strange, and they want to understand the process, they might ask how that process works. If we were to use the scientific method to understand the process, we would formulate a hypothesis. A hypothesis explains what you expect to happen from the experiment. Then, an experiment is conducted, data from the experiment is analyzed, and a conclusion is reached. Below are steps of the scientific method in a practical situation:

- Observation: One day, a student observes that every time he eats a big lunch, he falls asleep in the next period.

- Experimental Question: The question the student asks is, what is the relationship between eating large meals and energy levels?

- Formulate a Hypothesis: The student hypothesizes that eating a big meal will lead to lower energy due to the body using its energy to digest the food.

- Conduct an Experiment (Materials and Procedure): The student has his whole class eat two meals for lunch for a week, then he measures their energy levels in the next period. The next week, the student has them eat a small lunch, and then measures their energy levels in the next period.

- Analyze Data: The data in the student's experiment showed that in the first week, sixty percent of the students felt sleepy in the next period class and that in the second week, only twenty percent of the students felt sleepy in the next period class.

- Conclusion: The student concluded that the data supported his hypothesis: student energy levels decrease after the consumption of a large meal.

An important component of scientific research after the experiment is conducted is called peer review. This is when the article written about the experiment is sent to other scientists to "review." The reviewers offer feedback so that the editors can decide whether or not to publish the findings in a scholarly or scientific journal.

Practice Questions

1. How many different types of cells are there in the human body?
 a. Two hundred
 b. One thousand
 c. Ten
 d. Twenty-five

2. What type of tissue provides a protective barrier for delicate organs?
 a. Epithelial
 b. Muscle
 c. Connective
 d. Neural

3. What part of the respiratory system is responsible for regulating the temperature and humidity of the air that comes into the body?
 a. Larynx
 b. Lungs
 c. Trachea
 d. Sinuses

4. True or False: Carbon dioxide-rich blood returns to the heart to get pumped through the systemic circuit.
 a. False
 b. True

5. Which organ is responsible for gas exchange between air and circulating blood?
 a. Nose
 b. Larynx
 c. Lungs
 d. Stomach

6. Which layer of the heart wall contains nerves?
 a. Epicardium
 b. Myocardium
 c. Endocardium
 d. Sternum

7. What is another name for the mitral valve?
 a. Bicuspid valve
 b. Pulmonary valve
 c. Aortic valve
 d. Tricuspid valve

8. Which component of blood helps to fight off diseases?
 a. Red blood cells
 b. White blood cells
 c. Plasma
 d. Platelets

9. Which system consists of a group of organs that work together to transform food and liquids into fuel for the body?
 a. Respiratory system
 b. Immune system
 c. Genitourinary system
 d. Gastrointestinal system

10. During which step that the gastrointestinal system performs do chemicals and enzymes break down complex food molecules into smaller molecules?
 a. Digestion
 b. Absorption
 c. Compaction
 d. Ingestion

11. Which accessory organ of the gastrointestinal system is responsible for storing and concentrating bile?
 a. Liver
 b. Pancreas
 c. Stomach
 d. Gallbladder

12. Which type of muscle helps pump blood through the veins and arteries?
 a. Skeletal
 b. Smooth
 c. Intestinal
 d. Cardiac

13. How do neuroglia support neurons?
 a. Provide nutrition to them
 b. Provide a framework around them and protect them from the surrounding environment
 c. Relay messages to them from the brain
 d. Connect them to other surrounding cells

14. Which nerve system allows the brain to regulate body functions such as heart rate and blood pressure?
 a. Central
 b. Somatic
 c. Autonomic
 d. Afferent

15. Which of the following organs is NOT considered an accessory organ of the male reproductive system?
 a. Testes
 b. Prostate
 c. Vas deferens
 d. Bulbourethral glands

16. How many gametes do the ovaries produce every month?
 a. One million
 b. One
 c. One-half billion
 d. Two

17. In what part of the female reproductive system do sperm fertilize an oocyte?
 a. Ovary
 b. Mammary gland
 c. Vagina
 d. Fallopian tubes

18. What is the largest organ in the human body?
 a. Brain
 b. Large intestine
 c. Skin
 d. Heart

19. Which is a function of the skin?
 a. Temperature regulation
 b. Breathing
 c. Ingestion
 d. All of the above

20. Which accessory organ of the integumentary system provides a hard layer of protection over the skin?
 a. Hair
 b. Nails
 c. Sweat glands
 d. Sebaceous glands

21. Which is a distinct characteristic of tissues and glands that are a part of the endocrine system?
 a. Lack a blood supply
 b. Act quickly in response to stimuli
 c. Secrete bile
 d. Ductless

22. Which endocrine gland is found at the bottom of the hypothalamus?
 a. Pituitary
 b. Thymus
 c. Thyroid
 d. Pancreas

23. Which endocrine gland regulates the blood sugar levels of the body?
 a. Pineal
 b. Parathyroid
 c. Pancreas
 d. Adrenal

24. Which organ is responsible for filtering waste products out of the bloodstream?
 a. Kidneys
 b. Urinary bladder
 c. Pancreas
 d. Urethra

25. True or false: The genital system and urinary system have a shared pathway in males.
 a. True
 b. False

26. What happens to the urinary bladder as urine enters and is stored until the bladder is emptied?
 a. Blood flow to the organ increases.
 b. It secretes waste into the urine.
 c. Its walls stretch and become thinner.
 d. Its internal pressure increases.

27. Which immune system works in a nonspecific way and does not remember pathogens that it previously fought against?
 a. Innate
 b. Adaptive
 c. Hormonal
 d. B cell

28. How does the adaptive immune system work to fight against previously encountered pathogens?
 a. It sends out all antibodies to inactivate the pathogen.
 b. It sends out target-specific antibodies to inactivate the pathogen.
 c. It uses a mechanical barrier, such as the skin, to protect against pathogens.
 d. It uses a chemical barrier, such as gastric acid, to protect against pathogens.

29. What type of disorder can develop if the immune system is not functioning properly?
 a. Adaptive
 b. Innate
 c. Lymphocytic
 d. Autoimmune

30. How many bones are in the adult human skeletal system?
 a. 206
 b. Three hundred
 c. Twenty-seven
 d. Twenty-six

31. Which is a distinct characteristic of spongy bone?
 a. Dense
 b. Filled with organic and inorganic salts
 c. Found inside compact bone
 d. Lightweight

32. Which is NOT an example of a group of bones that forms a protective barrier around delicate organs?
 a. Foot bones
 b. Skull
 c. Ribs
 d. Vertebrae

33. Which molecule is the simplest form of sugar?
 a. Monosaccharide
 b. Fatty acid
 c. Polysaccharide
 d. Amino acid

34. Which type of macromolecule contains genetic information that can be passed to subsequent generations?
 a. Carbohydrates
 b. Lipids
 c. Proteins
 d. Nucleic acids

35. What is the primary unit of inheritance between generations of an organism?
 a. Chromosome
 b. Gene
 c. Gamete
 d. Atom

36. Which one of Mendel's laws theorizes that the alleles for different traits are NOT linked and can be inherited independently of one another?
 a. The Law of Dominance
 b. The Law of Segregation
 c. The Law of Independent Assortment
 d. None of the above

37. In which situation is an atom considered neutral?
 a. The number of protons and neutrons are equal.
 b. The number of neutrons and electrons are equal.
 c. The number of protons and electrons are equal.
 d. There are more electrons than protons.

38. Which is an example of a physical property of substances?
 a. Odor
 b. Reactivity
 c. Flammability
 d. Toxicity

39. Which type of matter has molecules that cannot move within its substance and breaks evenly across a plane caused by the symmetry of its molecular arrangement?
 a. Gas
 b. Crystalline solid
 c. Liquid
 d. Amorphous solid

40. What type of reactions involve the breaking and re-forming of bonds between atoms?
 a. Chemical
 b. Physical
 c. Isotonic
 d. Electron

41. What is the instrument used for measuring the force exerted by different elements in the universe that cause movement when they act upon objects by pulling, pushing, rotating, deforming, or accelerating them?
 a. Isaac force
 b. Newton meter
 c. Micrometer Caliper
 d. Vernier Scale

42. Which of the following describes an invention used to measure small fractions within already small divisions?
 a. A tape measure
 b. A ruler
 c. A yardstick
 d. Vernier Scale

43. When are scientific experiments found reliable?
 a. When all the materials needed for the experiment are used
 b. When the scientists conducting them are credible
 c. When they prove the hypothesis to be true
 d. When they can be replicated

44. Which of the following scenarios describes mistaking correlation for causation?
 a. In the same year, the drinking water was contaminated by a nearby chicken farm and stomach cancer in the area increased 3 percent. The contaminated water obviously caused stomach cancer to increase.
 b. Victoria notices that every time she turns on the stove burner underneath a pot with water in it, the water boils. Victoria realizes that putting heat under water causes it to boil.
 c. We saw that the thunderstorm that day caused all the neighborhoods in the East Village to flood. We could hardly get to the movie that night because of all the rain!
 d. Hector learned in school that when tectonic plates shift, it causes earthquakes to happen. There had been many earthquakes when Hector lived in California, and now he knew that the shifting of plates is what caused them.

45. Harley's sister, Camille, is pushing her on the swing. Camille notices that every time she pushes Camille forward, the swing propels back just as far. This is an example of which of the following of laws?
 a. Law of Inertia
 b. Newton's Second Law
 c. Newton's Third Law
 d. Law of Segregation

46. In the model of the scientific method, which of the following best explains the step of formulating a hypothesis?
 a. Forming a question that relates to the observation.
 b. Writing out an expectation of what's going to happen.
 c. Gathering the materials needed for the procedure.
 d. Summarizing the results of the experiment.

47. When would a peer review be conducted in an experiment?
 a. Before the experiment.
 b. During the experiment.
 c. After the experiment is over and before it is published.
 d. After the experiment is over and published.

Answer Explanations

1. A: There are only two hundred different types of cells in the human body. While there are trillions of cells that make up the human body, only two hundred different types make up that trillion, each with a specific function.

2. C: Connective tissue is located only on the inside of the body and fills internal spaces. This allows it to protect the organs within the body. Epithelial tissue is found on the outside of the body and as a lining of internal cavities and passageways. Muscle tissue allows for movement of the body. Neural tissue sends information from the brain to the rest of the body through electrical impulses.

3. D: After air enters the nose or mouth, it gets passed on to the sinuses. The sinuses regulate temperature and humidity before passing the air on to the rest of the body. Volume of air can change with varying temperatures and humidity levels, so it is important for the air to be a constant temperature and humidity before being processed by the lungs. The larynx is the voice box of the body, making Choice *A* incorrect. The lungs are responsible for oxygen and carbon dioxide exchange between the air that is breathed in and the blood that is circulating the body, making Choice *B* incorrect. The trachea takes the temperature- and humidity-regulated air from the sinuses to the lungs, making Choice *C* incorrect.

4. A: True. The blood needs to be oxygen-rich for the body to function properly. Oxygen-rich blood goes from the lungs to the heart and then is pumped through the systemic circuit to the rest of the body. Carbon dioxide-rich blood goes from the heart to the lungs, where the carbon dioxide is removed from the blood and breathed out of the body.

5. C: The main function of the lungs is to provide oxygen to the blood circulating in the body and to remove carbon dioxide from blood that has already circulated the body. The passageways within the lungs are responsible for this gas exchange between the air and the blood. The nose, Choice *A*, is the first place where air is breathed in. The larynx, Choice *B*, is the voice box of the body. The stomach, Choice *D*, is responsible for getting nutrients out of food and drink that are ingested, not from air.

6. B: The myocardium is the middle layer of the heart wall and contains connective tissue, blood vessels, and nerves. The epicardium, Choice *A*, is the outer layer of the heart wall and is solely made up of a serous membrane without any nerves or blood vessels. The endocardium, Choice *C*, is the inner layer of the heart wall and is made up of a simple squamous epithelium. The sternum, Choice *D*, is the chest bone and protects the heart.

7. A: The mitral valve is also known as the bicuspid valve because it has two leaflets. It is located on the left side of the heart between the atrium and the ventricle. The pulmonary valve, Choice *B*, is located between the right ventricle and the pulmonary artery and has three cusps. The aortic valve, Choice *C*, is located between the left ventricle and the aorta and also has three cusps. The tricuspid valve, Choice *D*, has three leaflets and is located on the right side of the heart between the atrium and the ventricle.

8. B: White blood cells are part of the immune system and help fight off diseases. Red blood cells contain hemoglobin, which carries oxygen through the blood. Plasma is the liquid matrix of the blood. Platelets help with the clotting of the blood.

9. D: The gastrointestinal system comprises the stomach and intestines, which help process food and liquid so that the body can absorb nutrients for fuel. The respiratory system is involved with the exchange

of oxygen and carbon dioxide between the air and blood. The immune system helps the body fight against pathogens and diseases. The genitourinary system helps the body to excrete waste.

10. A: During digestion, complex food molecules are broken down into smaller molecules so that nutrients can be isolated and absorbed by the body. Absorption, Choice *B*, is when vitamins, electrolytes, organic molecules, and water are absorbed by the digestive epithelium. Compaction, Choice *C*, occurs when waste products are dehydrated and compacted. Ingestion, Choice *D*, is when food and liquids first enter the body through the mouth.

11. D: The gallbladder is the organ that is responsible for storing and concentrating bile before secreting it into the small intestine. The liver, Choice *A*, is responsible for producing bile. The pancreas, Choice *B*, is responsible for secreting digestive enzymes specific for different types of food. The stomach, Choice *C*, is where digestion occurs.

12. D: Cardiac muscle cells are involuntary and makes up the heart muscle, which pumps blood through the veins and arteries. Skeletal muscle, Choice *A*, helps with body movement by pulling on the bones of the skeleton. Smooth muscle, Choice *B*, is an involuntary, nonstriated muscle that is found in the digestive tract and other hollow internal organs, such as the urinary bladder and blood vessels. The intestines, Choice *C*, are made up of smooth muscle cells.

13. B: Neurons are responsible for transferring and processing information between the brain and other parts of the body. Neuroglia are cells that protect delicate neurons by making a frame around them. They also help to maintain a homeostatic environment around the neurons.

14. C: The autonomic nerve system is part of the efferent division of the peripheral nervous system (PNS). It controls involuntary muscles, such as smooth muscle and cardiac muscle, which are responsible for regulating heart rate, blood pressure, and body temperature. The central nervous system, Choice *A*, includes only the brain and the spinal cord. The somatic nervous system, Choice *B*, is also part of the efferent division of the PNS and controls voluntary skeletal muscle contractions, allowing for body movements. The afferent division of the PNS, Choice *D*, relays sensory information within the body.

15. A: The testes are the main reproductive organ of the male reproductive system. They are the gonads; they secrete androgens, and produce and store sperm cells. The prostate, vas deferens, and bulbourethral glands are all accessory organs of the male reproductive system. The prostate provides nourishment to sperm, the vas deferens transports sperm to the urethra, and the bulbourethral glands produce lubricating fluid for the urethra.

16. B: The ovaries produce only one mature gamete each month. If it is fertilized, the result is a zygote that develops into an embryo. The male reproductive system produces one-half billion sperm cells each day.

17. D: Once sperm enter the vagina, they travel through the uterus to the Fallopian tubes to fertilize a mature oocyte. The ovaries are responsible for producing the mature oocyte. The mammary glands produce nutrient-filled milk to nourish babies after birth.

18. C: The skin is the largest organ of the body, covering every external surface of the body and protecting the body's deeper tissues. The brain performs many complex functions, the large intestine is part of the gastrointestinal system, and the heart keeps blood pumping throughout the body, but none of these is largest organ in the body.

19. A: The skin has three major functions: protection, regulation, and sensation. It has a large supply of blood vessels that can dilate to allow heat loss when the body is too hot and constrict in order to retain heat when the body is cold. The organs of respiratory system are responsible for breathing and the mouth is responsible for ingestion.

20. B: The nails on a person's hands and feet provide a hard layer of protection over the soft skin underneath. The hair, Choice *A*, helps to protect against heat loss, provides sensation, and can filter air that enters the nose. The sweat glands, Choice *C*, help to regulate temperature. The sebaceous glands, Choice *D*, secrete sebum, which protects the skin from water loss and bacterial and fungal infections.

21. D: The tissues and glands of the endocrine system are all ductless. They secrete hormones, not bile, into the blood or interstitial fluid of the human body. The endocrine system has a slow, long-lasting response to stimuli, unlike the nervous system, whose response is quick and short termed.

22. A: The pituitary gland is a pea-sized gland that is found at the bottom of the hypothalamus. The hormones that it releases regulate growth, blood pressure, and pain relief, among other things. The thymus, Choice *B*, is located in the chest cavity and produces hormones that are important for the development and maintenance of immune responses. The thyroid gland, Choice *C*, is found in the neck and releases hormones responsible for metabolism, growth and development, temperature regulation, and brain development during infancy and childhood. The pancreas, Choice *D*, is located in the abdomen and regulates blood sugar levels.

23. C: The pancreas is responsible for regulating blood sugar levels in the body. The pineal gland regulates melatonin levels, which affect maturation of gametes and reproductive organs, as well as the body's circadian rhythm. The parathyroid gland secretes a hormone that helps the thyroid regulate calcium levels in the body. The adrenal glands help with the body's management of stress.

24. A: The kidneys are the main organs responsible for filtering waste products out of the bloodstream. The kidneys have millions of nephrons, which are tiny filtering units, that filter 120 to 150 quarts of blood each day and produce waste in the amount of approximately one to two quarts of urine daily. The urinary bladder is responsible for storage of urine. The pancreas is responsible for regulating blood sugar levels. The urethra is the passageway through which urine exits the body.

25. A: In the male genitourinary system, both urine and gametes travel through the urethra to exit the body. The sperm is produced by the testes and then travels through the urethra. Urine is produced by the kidneys, is stored in the urinary bladder, and then exits the body through the urethra. In females, the urethra is solely used for urine to exit the body. Gametes exit the body from the uterus and through the vagina.

26. C: The urinary bladder is a hollow, elastic muscular organ. As it fills with urine, the walls stretch without breaking—do to their elasticity—and become thinner. When the urine is emptied, the bladder returns to its original size. The urinary bladder does not secrete any fluids into the urine; it is a storage organ for urine. Pressure inside the urinary bladder does not increase as it is filled because the organ grows larger while filling.

27. A: The innate immune system works based on pattern recognition of similar pathogens that have already been encountered. It does not remember specific pathogens or provide an individually-specific response. The responses it provides are short term and do not work toward long-lasting immunity for the body. The adaptive immune system creates a memory of each specific pathogen that has been encountered and provides a pathogen-specific response. This works toward the long-term immunity of

the body. Hormones are secreted by the endocrine system in response to stimuli. B cells are lymphocytes that work to provide immunity as part of the adaptive immune system.

28. B: The adaptive immune system provides target-specific antibodies to fight against individual pathogens that are encountered. It does not send out a broad range of antibodies because it has memory of the previously encountered pathogens. Mechanical and chemical barriers are part of the innate immune system and do not provide target-specific immunity.

29. D: If the immune system is not functioning properly, it may begin to attack its own healthy cells, which can result in an autoimmune disorder, such as celiac disease, type I diabetes, or rheumatoid arthritis. The adaptive and innate immune systems are the two parts of the body's immune system that need to be working properly to protect the body from pathogens. Lymphocytes are specialized cells that help the adaptive immune system provide target-specific responses to pathogens.

30. A: There are 206 bones in the adult human body. Human babies are born with three hundred bones. As they grow, bones fuse together and the body is left with 206 individual bones. There are twenty-seven bones in one human hand and twenty-six bones in one human foot.

31. D: Spongy bone is porous and lightweight, but also very strong. It covers the outside of dense, compact bone and has a shiny, white appearance. Compact bone is densely filled with organic and inorganic salts, leaving only tiny spaces for osteocytes within the matrix.

32. A: The skull, Choice *B*, is a set of bones that protect the brain. The ribs, Choice *C*, are a set of bones that protect the heart and lungs. The vertebrae, Choice *D*, are a set of bones that protect the spinal cord. The foot bones do not provide protection for delicate organs. They provide structure for the foot and support for the body.

33. A: Monosaccharides are the simplest sugars that make up carbohydrates. They are important for cellular respiration. Fatty acids, Choice *B*, make up lipids. Polysaccharides, Choice *C*, are larger molecules with repeating monosaccharide units. Amino acids, Choice *D*, are the building blocks of proteins.

34. D: Nucleic acids include DNA and RNA, which are strands of nucleotides that contain genetic information. Carbohydrates, Choice *A*, are made up of sugars that provide energy to the body. Lipids, Choice *B*, are hydrocarbon chains that make up fats. Proteins, Choice *C*, are made up of amino acids that help with many functions for maintaining life.

35. B: Genes are the primary unit of inheritance between generations of an organism. Humans each have twenty-three chromosomes (Choice *A*), and each chromosome contains hundreds to thousands of genes. Genes each control a specific trait of the organism. Gametes, Choice *C*, are the reproductive cells that contain all of the genetic information of an individual. Atoms, Choice *D*, are the small units that make up all substances.

36. C: The Law of Independent Assortment states that the alleles for different traits are inherited independently of one another. For example, the alleles for eye color are not linked to the alleles for hair color. So, someone could have blue eyes and brown hair or blue eyes and blond hair. The Law of Dominance, Choice *A*, states that one allele has a stronger effect on phenotype than the other allele. The Law of Segregation, Choice *B*, states that each trait has two versions that can be inherited. Each parent contributes one of its alleles, selected randomly, to the daughter offspring.

37. C: Atoms are considered neutral when the number of protons and electrons is equal. Protons carry a positive charge, and electrons carry a negative charge. When they are equal in number, their charges

cancel out, and the atom is neutral. If there are more electrons than protons, or vice versa, the atom has an electric charge and is termed an ion. Neutrons do not have a charge and do not affect the electric charge of an atom.

38. A: Physical properties of substances are those that can be observed without changing the substances' chemical composition, such as odor, color, density, and hardness. Reactivity, flammability, and toxicity are all chemical properties of substances. They describe the way in which a substance may change into a different substance. They cannot be observed from the surface.

39. B: Solids have molecules that are packed together tightly and cannot move within their substance. Crystalline solids have atoms or molecules that are arranged symmetrically, making all of the bonds of even strength. When they are broken, they break along a plane of molecules, creating a straight edge. Amorphous solids do not have the symmetrical makeup of crystalline solids. They do not break evenly. Gases and liquids both have molecules that move around freely.

40. A: Chemical reactions are processes that involve the changing of one set of substances to a different set of substances. In order to accomplish this, the bonds between the atoms in the molecules of the original substances need to be broken. The atoms are rearranged, and new bonds are formed to make the new set of substances. Combination reactions involve two or more reactants becoming one product. Decomposition reactions involve one reactant becoming two or more products. Combustion reactions involve the use of oxygen as a reactant and generally include the burning of a substance. Choices *C* and *D* are not discussed as specific reaction types.

41. B: Newton meter. A Newton meter is used for such things such as gravity, friction, or tension. A bathroom scale or similar scale is a common example of a force meter. Choice *A* is not an existing term. Choices *C* and *D* are used to measure fractions of small numbers.

42. D: A Vernier Scale is used to measure small fractions within already small divisions. Choices *A*, *B*, and *C* are used for measuring short distances, yet do not go as small as the Vernier Scale.

43. D: Scientific experiments are found reliable when they can be replicated and produce comparable results regardless of who is conducting them or making the observations, making Choice *B* incorrect. Choice *A* is incorrect, although having all the materials needed is ideal for conducting an experiment. Choice *C* is incorrect; a hypothesis is never proven correct, but it can receive credibility if the data supports it in that particular experiment.

44. A: The drinking water being contaminated and the stomach cancer is not necessarily determined by cause and effect. The two events could have just happened at the same time, which is correlation, not causation. The other three examples are very clear examples of cause and effect; we know for a fact that when water becomes hot enough, it boils, or that earthquakes are caused by tectonic plates shifting.

45. C: Newton's Third Law. This law states that for every action, there is an opposite and equal reaction. When Camille pushes Harley forward on the swing, the opposite and equal reaction is the swing going backwards. Choice *A*, law of inertia, is Newton's first law, which states that an object at rest or at motion stays that way unless otherwise acted upon by an outside force, making Choice *A* incorrect. Choice *B*, Newton's second law, states that the heavier, an object, the more force has to be used to move it, making Choice *C* incorrect. Choice *D*, Law of Segregation, has to do with heredity, and states that each trait has two versions that can be inherited, making Choice *D* incorrect.

46. B: Formulating a hypothesis means writing out an expectation of what's going to happen. The hypothesis comes after the experimental question, which is forming a question that relates to the observation, making Choice *A* incorrect. Gathering the materials needed for the procedure is the step where we actually conduct the experiment, making Choice *C* incorrect. Summarizing the results of the experiment is the conclusion, making Choice *D* incorrect.

47. C: After the experiment is over and before it is published. A peer review is when other scientists review the experiment's findings in order to test its validity and methods. Peer review is an important part of scientific research and is a way for the scientific community to provide feedback for the experiment.

English and Language Usage

Conventions of Standard English

Conventions of Standard English Spelling

Homophones

Homophones are words that have different meanings and spellings, but sound the same. These can be confusing for English Language Learners (ELLs) and beginning students, but even native English-speaking adults can find them problematic unless informed by context. Whereas listeners must rely entirely on context to *differentiate* spoken homophone meanings, readers with good spelling knowledge have a distinct advantage since homophones are spelled differently. For instance, *their* means belonging to them; *there* indicates location; and *they're* is a contraction of *they are*; despite different meanings, they all sound the same. *Lacks* can be a plural noun or a present-tense, third-person singular verb; either way it refers to absence—*deficiencies* as a plural noun, and *is deficient in* as a verb. But *lax* is an adjective that means loose, slack, relaxed, uncontrolled, or negligent. These two spellings, derivations, and meanings are completely different. With speech, listeners cannot know spelling and must use context; but with print, readers with spelling knowledge can differentiate them with or without context.

Homonyms, Homophones, and Homographs

Homophones are words that sound the same in speech, but have different spellings and meanings. For example, *to, too,* and *two* all sound alike, but have three different spellings and meanings. Homophones with different spellings are also called heterographs. Homographs are words that are spelled identically, but have different meanings. If they also have different pronunciations, they are heteronyms. For instance, *tear* pronounced one way means a drop of liquid formed by the eye; pronounced another way, it means to rip. Homophones that are also homographs are homonyms. For example, *bark* can mean the outside of a tree or a dog's vocalization; both meanings have the same spelling. *Stalk* can mean a plant stem or to pursue and/or harass somebody; these are spelled and pronounced the same. *Rose* can mean a flower or the past tense of *rise*. Many non-linguists confuse things by using "homonym" to mean sets of words that are homophones but not homographs, and also those that are homographs but not homophones.

The word *row* can mean to use oars to propel a boat; a linear arrangement of objects or print; or an argument. It is pronounced the same with the first two meanings, but differently with the third. Because it is spelled identically regardless, all three meanings are homographs. However, the two meanings pronounced the same are homophones, whereas the one with the different pronunciation is a heteronym. By contrast, the word *read* means to peruse language, whereas the word *reed* refers to a marsh plant. Because these are pronounced the same way, they are homophones; because they are spelled differently, they are heterographs. Homonyms are both homophones and homographs—pronounced and spelled identically, but with different meanings. One distinction between homonyms is of those with separate, unrelated etymologies, called "true" homonyms, e.g. *skate* meaning a fish or *skate* meaning to glide over ice/water. Those with common origins are called polysemes or polysemous homonyms, e.g. the *mouth* of an animal/human or of a river.

Irregular Plurals

One type of irregular English plural involves words that are spelled the same whether they are singular or plural. These include *deer, fish, salmon, trout, sheep, moose, offspring, species, aircraft,* etc. The spelling rule for making these words plural is simple: they do not change. Another type of irregular English plurals does change from singular to plural form, but it does not take regular English –*s* or –*es* endings. Their

irregular plural endings are largely derived from grammatical and spelling conventions in the other languages of their origins, like Latin, German, and vowel shifts and other linguistic mutations. Some examples of these words and their irregular plurals include *child* and *children; die* and *dice; foot* and *feet; goose* and *geese; louse* and *lice; man* and *men; mouse* and *mice; ox* and *oxen; person* and *people; tooth* and *teeth;* and *woman* and *women.*

Contractions

Contractions are formed by joining two words together, omitting one or more letters from one of the component words, and replacing the omitted words with an apostrophe. An obvious yet often forgotten rule for spelling contractions is to place the apostrophe where the letters were omitted; for example, spelling errors like *did'nt* for *didn't. Didn't* is a contraction of *did not.* Therefore, the apostrophe replaces the "o" that is omitted from the "not" component. Another common error is confusing contractions with possessives because both include apostrophes, e.g. spelling the possessive *its* as "it's," which is a contraction of "it is"; spelling the possessive *their* as "they're," a contraction of "they are"; spelling the possessive *whose* as "who's," a contraction of "who is"; or spelling the possessive *your* as "you're," a contraction of "you are."

Frequently Misspelled Words

One source of spelling errors is not knowing whether to drop the final letter *e* from a word when its form is changed by adding an ending to indicate the past tense or progressive participle of a verb, converting an adjective to an adverb, a noun to an adjective, etc. Some words retain the final *e* when another syllable is added; others lose it. For example, *true* becomes *truly; argue* becomes *arguing; come* becomes *coming; write* becomes *writing;* and *judge* becomes *judging.* In these examples, the final *e* is dropped before adding the ending. But *severe* becomes *severely; complete* becomes *completely; sincere* becomes *sincerely; argue* becomes *argued;* and *care* becomes *careful.* In these instances, the final *e* is retained before adding the ending. Note that some words, like *argue* in these examples, drops the final *e* when the *–ing* ending is added to indicate the participial form; but the regular past tense ending of *–ed* makes it *argued,* in effect replacing the final *e* so that *arguing* is spelled without an *e* but *argued* is spelled with one.

Some English words contain the vowel combination of *ei,* while some contain the reverse combination of *ie.* Many people confuse these. Some examples include these:

> *ceiling, conceive, leisure, receive, weird, their, either, foreign, sovereign, neither, neighbors, seize, forfeit, counterfeit, height, weight, protein,* and *freight*

Words with *ie* include *piece, believe, chief, field, friend, grief, relief, mischief, siege, niece, priest, fierce, pierce, achieve, retrieve, hygiene, science,* and *diesel.* A rule that also functions as a mnemonic device is "I before E except after C, or when sounded like A as in 'neighbor' or 'weigh'." However, it is obvious from the list above that many exceptions exist.

Many people often misspell certain words by confusing whether they have the vowel *a, e,* or *i,* frequently in the middle syllable of three-syllable words or beginning the last syllables that sound the same in different words. For example, in the following correctly spelled words, the vowel in boldface is the one people typically get wrong by substituting one or either of the others for it:

> cem**e**tery, quant**i**ties, ben**e**fit, priv**i**lege, unpleas**a**nt, sep**a**rate, independ**e**nt, excell**e**nt, categories, indispens**a**ble, and irrelev**a**nt

160

The words with final syllables that sound the same when spoken but are spelled differently include *unpleasant, independent, excellent,* and *irrelevant.* Another source of misspelling is whether or not to double consonants when adding suffixes. For example, we double the last consonant before *–ed* and *–ing* endings in *controlled, beginning, forgetting, admitted, occurred, referred,* and *hopping;* but we do not double the last consonant before the suffix in *shining, poured, sweating, loving, hating, smiling,* and *hoping.*

One way in which people misspell certain words frequently is by failing to include letters that are silent. Some letters are articulated when pronounced correctly but elided in some people's speech, which then transfers to their writing. Another source of misspelling is the converse: people add extraneous letters. For example, some people omit the silent *u* in *guarantee,* overlook the first *r* in *surprise,* leave out the *z* in *realize,* fail to double the *m* in *recommend,* leave out the middle *i* from *aspirin,* and exclude the *p* from *temperature.* The converse error, adding extra letters, is common in words like *until* by adding a second *l* at the end; or by inserting a superfluous syllabic *a* or *e* in the middle of *athletic,* reproducing a common mispronunciation.

Conventions of Standard English Punctuation

Rules of Capitalization
The first word of any document, and of each new sentence, is capitalized. Proper nouns, like names and adjectives derived from proper nouns, should also be capitalized. Here are some examples:

- Grand Canyon
- Pacific Palisades
- Golden Gate Bridge
- Freudian slip
- Shakespearian, Spenserian, or Petrarchan sonnet
- Irish song

Some exceptions are adjectives, originally derived from proper nouns, which through time and usage are no longer capitalized, like *quixotic, herculean,* or *draconian.* Capitals draw attention to specific instances of people, places, and things. Some categories that should be capitalized include the following:

- brand names
- companies
- weekdays
- months
- governmental divisions or agencies
- historical eras
- major historical events
- holidays
- institutions
- famous buildings
- ships and other manmade constructions
- natural and manmade landmarks
- territories
- nicknames
- epithets
- organizations
- planets

- nationalities
- tribes
- religions
- names of religious deities
- roads
- special occasions, like the Cannes Film Festival or the Olympic Games

Exceptions

Related to American government, capitalize the noun Congress but not the related adjective congressional. Capitalize the noun U.S. Constitution, but not the related adjective constitutional. Many experts advise leaving the adjectives federal and state in lowercase, as in federal regulations or state water board, and only capitalizing these when they are parts of official titles or names, like Federal Communications Commission or State Water Resources Control Board. While the names of the other planets in the solar system are capitalized as names, Earth is more often capitalized only when being described specifically as a planet, like Earth's orbit, but lowercase otherwise since it is used not only as a proper noun but also to mean *land, ground, soil*, etc. While the name of the Bible should be capitalized, the adjective biblical should not. Regarding biblical subjects, the words heaven, hell, devil, and satanic should not be capitalized. Although race names like Caucasian, African-American, Navajo, Eskimo, East Indian, etc. are capitalized, white and black as races are not.

Names of animal species or breeds are not capitalized unless they include a proper noun. Then, only the proper noun is capitalized. Antelope, black bear, and yellow-bellied sapsucker are not capitalized. However, Bengal tiger, German shepherd, Australian shepherd, French poodle, and Russian blue cat are capitalized.

Other than planets, celestial bodies like the sun, moon, and stars are not capitalized. Medical conditions like tuberculosis or diabetes are lowercase; again, exceptions are proper nouns, like Epstein-Barr syndrome, Alzheimer's disease, and Down syndrome. Seasons and related terms like winter solstice or autumnal equinox are lowercase. Plants, including fruits and vegetables, like poinsettia, celery, or avocados, are not capitalized unless they include proper names, like Douglas fir, Jerusalem artichoke, Damson plums, or Golden Delicious apples.

Titles and Names

When official titles precede names, they should be capitalized, except when there is a comma between the title and name. But if a title follows or replaces a name, it should not be capitalized. For example, "the president" without a name is not capitalized, as in "The president addressed Congress." But with a name it is capitalized, like "President Obama addressed Congress." Or, "Chair of the Board Janet Yellen was appointed by President Obama." One exception is that some publishers and writers nevertheless capitalize President, Queen, Pope, etc., when these are not accompanied by names to show respect for these high offices. However, many writers in America object to this practice for violating democratic principles of equality. Occupations before full names are not capitalized, like owner Mark Cuban, director Martin Scorsese, or coach Roger McDowell.

Some universal rules for capitalization in composition titles include capitalizing the following:

- The first and last words of the title
- Forms of the verb *to be* and all other verbs
- Pronouns
- The word *not*

Universal rules for NOT capitalizing include the articles *the, a,* or *an;* the conjunctions *and, or,* or *nor,* and the preposition *to,* or *to* as part of the infinitive form of a verb. The exception to all of these is UNLESS any of them is the first or last word in the title, in which case they are capitalized. Other words are subject to differences of opinion and differences among various stylebooks or methods. These include *as, but, if,* and *or,* which some capitalize and others do not. Some authorities say no preposition should ever be capitalized; some say prepositions five or more letters long should be capitalized. The *Associated Press Stylebook* advises capitalizing prepositions longer than three letters (like *about, across,* or *with*).

Ellipses
Ellipses (. . .) signal omitted text when quoting. Some writers also use them to show a thought trailing off, but this should not be overused outside of dialogue. An example of an ellipses would be if someone is quoting a phrase out of a professional source but wants to omit part of the phrase that isn't needed: "Dr. Skim's analysis of pollen inside the body is clearly a myth . . . that speaks to the environmental guilt of our society."

Commas
Commas separate words or phrases in a series of three or more. The Oxford comma is the last comma in a series. Many people omit this last comma, but many times it causes confusion. Here is an example:

I love my sisters, the Queen of England and Madonna.

This example without the comma implies that the "Queen of England and Madonna" are the speaker's sisters. However, if the speaker was trying to say that they love their sisters, the Queen of England, as well as Madonna, there should be a comma after "Queen of England" to signify this.

Commas also separate two coordinate adjectives ("big, heavy dog") but not cumulative ones, which should be arranged in a particular order for them to make sense ("beautiful ancient ruins").

A comma ends the first of two independent clauses connected by conjunctions. Here is an example:

I ate a bowl of tomato soup, and I was hungry very shortly after.

Here are some brief rules for commas:

- Commas follow introductory words like *however, furthermore, well, why,* and *actually,* among others.
- Commas go between city and state: Houston, Texas.
- If using a comma between a surname and Jr. or Sr. or a degree like M.D., also follow the whole name with a comma: "Martin Luther King, Jr., wrote that."
- A comma follows a dependent clause beginning a sentence: "Although she was very small, . . ."
- Nonessential modifying words/phrases/clauses are enclosed by commas: "Wendy, who is Peter's sister, closed the window."
- Commas introduce or interrupt direct quotations: "She said, 'I hate him.' 'Why,' I asked, 'do you hate him?'"

Semicolons
Semicolons are used to connect two independent clauses, but should never be used in the place of a comma. They can replace periods between two closely connected sentences: "Call back tomorrow; it can

wait until then." When writing items in a series and one or more of them contains internal commas, separate them with semicolons, like the following:

People came from Springfield, Illinois; Alamo, Tennessee; Moscow, Idaho; and other locations.

Hyphens

Here are some rules concerning hyphens:

- Compound adjectives like state-of-the-art or off-campus are hyphenated.
- Original compound verbs and nouns are often hyphenated, like "throne-sat," "video-gamed," "no-meater."
- Adjectives ending in *–ly* are often hyphenated, like "family-owned" or "friendly-looking."
- "Five years old" is not hyphenated, but singular ages like "five-year-old" are.
- Hyphens can clarify. For example, in "stolen vehicle report," "stolen-vehicle report" clarifies that "stolen" modifies "vehicle," not "report."
- Compound numbers twenty-one through ninety-nine are spelled with hyphens.
- Prefixes before proper nouns/adjectives are hyphenated, like "mid-September" and "trans-Pacific."

Parentheses

Parentheses enclose information such as an aside or more clarifying information: "She ultimately replied (after deliberating for an hour) that she was undecided." They are also used to insert short, in-text definitions or acronyms: "His FBS (fasting blood sugar) was higher than normal." When parenthetical information ends the sentence, the period follows the parentheses: "We received new funds ($25,000)." Only put periods within parentheses if the whole sentence is inside them: "Look at this. (You'll be astonished.)" However, this can also be acceptable as a clause: "Look at this (you'll be astonished)." Although parentheses appear to be part of the sentence subject, they are not, and do not change subject-verb agreement: "Will (and his dog) was there."

Quotation Marks

Quotation marks are typically used when someone is quoting a direct word or phrase someone else writes or says. Additionally, quotation marks should be used for the titles of poems, short stories, songs, articles, chapters, and other shorter works. When quotations include punctuation, periods and commas should *always* be placed inside of the quotation marks.

When a quotation contains another quotation inside of it, the outer quotation should be enclosed in double quotation marks and the inner quotation should be enclosed in single quotation marks. For example: "Timmy was begging, 'Don't go! Don't leave!'" When using both double and single quotation marks, writers will find that many word-processing programs may automatically insert enough space between the single and double quotation marks to be visible for clearer reading. But if this is not the case, the writer should write/type them with enough space between to keep them from looking like three single quotation marks. Additionally, non-standard usages, terms used in an unusual fashion, and technical terms are often clarified by quotation marks. Here are some examples:

My "friend," Dr. Sims, has been micromanaging me again.

This way of extracting oil has been dubbed "fracking."

Apostrophes

One use of the apostrophe is followed by an *s* to indicate possession, like *Mrs. White's home* or *our neighbor's dog*. When using the *'s* after names or nouns that also end in the letter *s*, no single rule

applies: some experts advise adding both the apostrophe and the *s*, like "the Jones's house," while others prefer using only the apostrophe and omitting the additional *s*, like "the Jones' house." The wisest expert advice is to pick one formula or the other and then apply it consistently. Newspapers and magazines often use *'s* after common nouns ending with *s*, but add only the apostrophe after proper nouns or names ending with *s*. One common error is to place the apostrophe before a name's final *s* instead of after it: "Ms. Hasting's book" is incorrect if the name is Ms. Hastings.

Plural nouns should not include apostrophes (e.g. "apostrophe's"). Exceptions are to clarify atypical plurals, like verbs used as nouns: "These are the do's and don'ts." Irregular plurals that do not end in *s* always take apostrophe-*s*, not *s*-apostrophe—a common error, as in "childrens' toys," which should be "children's toys." Compound nouns like mother-in-law, when they are singular and possessive, are followed by apostrophe-*s*, like "your mother-in-law's coat." When a compound noun is plural and possessive, the plural is formed before the apostrophe-*s*, like "your sisters-in-laws' coats." When two people named possess the same thing, use apostrophe-*s* after the second name only, like "Dennis and Pam's house."

Sentence Structures

Incomplete Sentences
Four types of incomplete sentences are sentence fragments, run-on sentences, subject-verb and/or pronoun-antecedent disagreement, and non-parallel structure.

Sentence fragments are caused by absent subjects, absent verbs, or dangling/uncompleted dependent clauses. Every sentence must have a subject and a verb to be complete. An example of a fragment is "Raining all night long," because there is no subject present. "It was raining all night long" is one correction. Another example of a sentence fragment is the second part in "Many scientists think in unusual ways. Einstein, for instance." The second phrase is a fragment because it has no verb. One correction is "Many scientists, like Einstein, think in unusual ways." Finally, look for "cliffhanger" words like *if, when, because,* or *although* that introduce dependent clauses, which cannot stand alone without an independent clause. For example, to correct the sentence fragment "If you get home early," add an independent clause: "If you get home early, we can go dancing."

Run-On Sentences
A run-on sentence combines two or more complete sentences without punctuating them correctly or separating them. For example, a run-on sentence caused by a lack of punctuation is the following:

> There is a malfunction in the computer system however there is nobody available right now who knows how to troubleshoot it.

One correction is, "There is a malfunction in the computer system; however, there is nobody available right now who knows how to troubleshoot it." Another is, "There is a malfunction in the computer system. However, there is nobody available right now who knows how to troubleshoot it."

An example of a comma splice of two sentences is the following:

> Jim decided not to take the bus, he walked home.

Replacing the comma with a period or a semicolon corrects this. Commas that try and separate two independent clauses without a contraction are considered comma splices.

Parallel Sentence Structures

Parallel structure in a sentence matches the forms of sentence components. Any sentence containing more than one description or phrase should keep them consistent in wording and form. Readers can easily follow writers' ideas when they are written in parallel structure, making it an important element of correct sentence construction. For example, this sentence lacks parallelism: "Our coach is a skilled manager, a clever strategist, and works hard." The first two phrases are parallel, but the third is not. Correction: "Our coach is a skilled manager, a clever strategist, and a hard worker." Now all three phrases match in form. Here is another example:

Fred intercepted the ball, escaped tacklers, and a touchdown was scored.

This is also non-parallel. Here is the sentence corrected:

Fred intercepted the ball, escaped tacklers, and scored a touchdown.

Sentence Fluency

For fluent composition, writers must use a variety of sentence types and structures, and also ensure that they smoothly flow together when they are read. To accomplish this, they must first be able to identify fluent writing when they read it. This includes being able to distinguish among simple, compound, complex, and compound-complex sentences in text; to observe variations among sentence types, lengths, and beginnings; and to notice figurative language and understand how it augments sentence length and imparts musicality. Once students/writers recognize superior fluency, they should revise their own writing to be more readable and fluent. They must be able to apply acquired skills to revisions before being able to apply them to new drafts.

One strategy for revising writing to increase its sentence fluency is flipping sentences. This involves rearranging the word order in a sentence without deleting, changing, or adding any words. For example, the student or other writer who has written the sentence, "We went bicycling on Saturday" can revise it to, "On Saturday, we went bicycling." Another technique is using appositives. An appositive is a phrase or word that renames or identifies another adjacent word or phrase. Writers can revise for sentence fluency by inserting main phrases/words from one shorter sentence into another shorter sentence, combining them into one longer sentence, e.g. from "My cat Peanut is a gray and brown tabby. He loves hunting rats." to "My cat Peanut, a gray and brown tabby, loves hunting rats." Revisions can also connect shorter sentences by using conjunctions and commas and removing repeated words: "Scott likes eggs. Scott is allergic to eggs" becomes "Scott likes eggs, but he is allergic to them."

One technique for revising writing to increase sentence fluency is "padding" short, simple sentences by adding phrases that provide more details specifying why, how, when, and/or where something took place. For example, a writer might have these two simple sentences: "I went to the market. I purchased a cake." To revise these, the writer can add the following informative dependent and independent clauses and prepositional phrases, respectively: "Before my mother woke up, I sneaked out of the house and went to the supermarket. As a birthday surprise, I purchased a cake for her." When revising sentences to make them longer, writers must also punctuate them correctly to change them from simple sentences to compound, complex, or compound-complex sentences.

Skills Writers Can Employ to Increase Fluency

One way writers can increase fluency is by varying the beginnings of sentences. Writers do this by starting most of their sentences with different words and phrases rather than monotonously repeating the same ones across multiple sentences. Another way writers can increase fluency is by varying the lengths of sentences. Since run-on sentences are incorrect, writers make sentences longer by also converting them

from simple to compound, complex, and compound-complex sentences. The coordination and subordination involved in these also give the text more variation and interest, hence more fluency. Here are a few more ways writers can increase fluency:

- Varying the transitional language and conjunctions used makes sentences more fluent.
- Writing sentences with a variety of rhythms by using prepositional phrases.
- Varying sentence structure adds fluency.

Knowledge of Language

Use Grammar to Enhance Clarity in Writing

Possessives

Possessive forms indicate possession, i.e. that something belongs to or is owned by someone or something. As such, the most common parts of speech to be used in possessive form are adjectives, nouns, and pronouns. The rule for correctly spelling/punctuating possessive nouns and proper nouns is with - *'s*, like "the woman's briefcase" or "Frank's hat." With possessive adjectives, however, apostrophes are not used: these include *my, your, his, her, its, our,* and *their*, like "my book," "your friend," "his car," "her house," "its contents," "our family," or "their property." Possessive pronouns include *mine, yours, his, hers, its, ours,* and *theirs*. These also have no apostrophes. The difference is that possessive adjectives take direct objects, whereas possessive pronouns replace them. For example, instead of using two possessive adjectives in a row, as in "I forgot my book, so Blanca let me use her book," which reads monotonously, replacing the second one with a possessive pronoun reads better: "I forgot my book, so Blanca let me use hers."

Pronouns

There are three pronoun cases: subjective case, objective case, and possessive case. Pronouns as subjects are pronouns that replace the subject of the sentence, such as *I, you, he, she, it, we, they* and *who*. Pronouns as objects replace the object of the sentence, such as *me, you, him, her, it, us, them,* and *whom*. Pronouns that show possession are *mine, yours, hers, its, ours, theirs,* and *whose*. The following are examples of different pronoun cases:

- Subject pronoun: *She* ate the cake for her birthday. *I* saw the movie.
- Object pronoun: You gave *me* the card last weekend. She gave the picture to *him*.
- Possessive pronoun: That bracelet you found yesterday is *mine*. *His* name was Casey.

Adjectives

Adjectives are descriptive words that modify nouns or pronouns. They may occur before or after the nouns or pronouns they modify in sentences. For example, in "This is a big house," *big* is an adjective modifying or describing the noun *house*. In "This house is big," the adjective is at the end of the sentence rather than preceding the noun it modifies.

A rule of punctuation that applies to adjectives is to separate a series of adjectives with commas. For example, "Their home was a large, rambling, old, white, two-story house." A comma should never separate the last adjective from the noun, though.

Adverbs

Whereas adjectives modify and describe nouns or pronouns, adverbs modify and describe adjectives, verbs, or other adverbs. Adverbs can be thought of as answers to questions in that they describe when, where, how, how often, how much, or to what extent.

Many (but not all) adjectives can be converted to adverbs by adding –*ly*. For example, in "She is a quick learner," *quick* is an adjective modifying *learner*. In "She learns quickly," *quickly* is an adverb modifying *learns*. One exception is *fast*. *Fast* is an adjective in "She is a fast learner." However, –*ly* is never added to the word *fast*; it retains the same form as an adverb in "She learns fast."

Verbs

A verb is a word or phrase that expresses action, feeling, or state of being. Verbs explain what their subject is *doing*. Three different types of verbs used in a sentence are action verbs, linking verbs, and helping verbs.

Action verbs show a physical or mental action. Some examples of action verbs are *play, type, jump, write, examine, study, invent, develop,* and *taste*. The following example uses an action verb:

Kat *imagines* that she is a mermaid in the ocean.

The verb *imagines* explains what Kat is doing: she is imagining being a mermaid.

Linking verbs connect the subject to the predicate without expressing an action. The following sentence shows an example of a linking verb:

The mango *tastes* sweet.

The verb *tastes* is a linking verb. The mango doesn't *do* the tasting, but the word *taste* links the mango to its predicate, sweet. Most linking verbs can also be used as action verbs, such as *smell, taste, look, seem, grow,* and *sound*. Saying something *is* something else is also an example of a linking verb. For example, if we were to say, "Peaches is a dog," the verb *is* would be a linking verb in this sentence, since it links the subject to its predicate.

Helping verbs are verbs that help the main verb in a sentence. Examples of helping verbs are *be, am, is, was, have, has, do, did, can, could, may, might, should,* and *must,* among others. The following are examples of helping verbs:

Jessica *is* planning a trip to Hawaii.

Brenda *does* not like camping.

Xavier *should* go to the dance tonight.

Notice that after each of these helping verbs is the main verb of the sentence: *planning, like,* and *go*. Helping verbs usually show an aspect of time.

Transitional Words and Phrases

In connected writing, some sentences naturally lead to others, whereas in other cases, a new sentence expresses a new idea. We use transitional phrases to connect sentences and the ideas they convey. This makes the writing coherent. Transitional language also guides the reader from one thought to the next. For example, when pointing out an objection to the previous idea, starting a sentence with "However," "But," or "On the other hand" is transitional. When adding another idea or detail, writers use "Also," "In addition," "Furthermore," "Further," "Moreover," "Not only," etc. Readers have difficulty perceiving connections between ideas without such transitional wording.

Subject-Verb Agreement

Lack of subject-verb agreement is a very common grammatical error. One of the most common instances is when people use a series of nouns as a compound subject with a singular instead of a plural verb. Here is an example:

> Identifying the best books, locating the sellers with the lowest prices, and paying for them *is* difficult

instead of saying "*are* difficult." Additionally, when a sentence subject is compound, the verb is plural:

> He and his cousins *were* at the reunion.

However, if the conjunction connecting two or more singular nouns or pronouns is "or" or "nor," the verb must be singular to agree:

> That pen or another one like it is in the desk drawer.

If a compound subject includes both a singular noun and a plural one, and they are connected by "or" or "nor," the verb must agree with the subject closest to the verb: "Sally or her sisters go jogging daily"; but "Her sisters or Sally goes jogging daily."

Simply put, singular subjects require singular verbs and plural subjects require plural verbs. A common source of agreement errors is not identifying the sentence subject correctly. For example, people often write sentences incorrectly like, "The group of students *were* complaining about the test." The subject is not the plural "students" but the singular "group." Therefore, the correct sentence should read, "The group of students *was* complaining about the test." The converse also applies, for example, in this incorrect sentence: "The facts in that complicated court case *is* open to question." The subject of the sentence is not the singular "case" but the plural "facts." Hence the sentence would correctly be written: "The facts in that complicated court case *are* open to question." New writers should not be misled by the distance between the subject and verb, especially when another noun with a different number intervenes as in these examples. The verb must agree with the subject, not the noun closest to it.

Pronoun-Antecedent Agreement

Pronouns within a sentence must refer specifically to one noun, known as the *antecedent*. Sometimes, if there are multiple nouns within a sentence, it may be difficult to ascertain which noun belongs to the pronoun. It's important that the pronouns always clearly reference the nouns in the sentence so as not to confuse the reader. Here's an example of an unclear pronoun reference:

> After Catherine cut Libby's hair, David bought her some lunch.

The pronoun in the examples above is *her*. The pronoun could either be referring to *Catherine* or *Libby*. Here are some ways to write the above sentence with a clear pronoun reference:

> After Catherine cut Libby's hair, David bought Libby some lunch.

> David bought Libby some lunch after Catherine cut Libby's hair.

But many times the pronoun will clearly refer to its antecedent, like the following:

> After David cut Catherine's hair, he bought her some lunch.

Formal and Informal Language

Formal language is less personal than informal language. It is more "buttoned-up" and business-like, adhering to proper grammatical rules. It is used in professional or academic contexts, to convey respect or authority. For example, one would use formal language to write an informative or argumentative essay for school or to address a superior. Formal language avoids contractions, slang, colloquialisms, and first-person pronouns. Formal language uses sentences that are usually more complex and often in passive voice. Punctuation can differ as well. For example, *exclamation points (!)* are used to show strong emotion or can be used as an *interjection* but should be used sparingly in formal writing situations.

Informal language is often used when communicating with family members, friends, peers, and those known more personally. It is more casual, spontaneous, and forgiving in its conformity to grammatical rules and conventions. Informal language is used for personal emails and correspondence between coworkers or other familial relationships. The tone is more relaxed. In informal writing, slang, contractions, clichés, and the first- and second-person are often used.

Elements of the Writing Process

Skilled writers undergo a series of steps that comprise the writing process. The purpose of adhering to a structured approach to writing is to develop clear, meaningful, coherent work.

The stages are pre-writing or planning, organizing, drafting/writing, revising, and editing. Not every writer will necessarily follow all five stages for every project, but will judiciously employ the crucial components of the stages for most formal or important work. For example, a brief informal response to a short reading passage may not necessitate the need for significant organization after idea generation, but larger assignments and essays will likely mandate use of the full process.

Pre-Writing/Planning
Brainstorming
One of the most important steps in writing is pre-writing. Before drafting an essay or other assignment, it's helpful to think about the topic for a moment or two, in order to gain a more solid understanding of what the task is. Then, spend about five minutes jotting down the immediate ideas that could work for the essay. Brainstorming is a way to get some words on the page and offer a reference for ideas when drafting. Scratch paper is provided for writers to use any pre-writing techniques such as webbing, freewriting, or listing. Some writers prefer using graphic organizers during this phase. The goal is to get ideas out of the mind and onto the page.

Freewriting
Like brainstorming, freewriting is another prewriting activity to help the writer generate ideas. This method involves setting a timer for two or three minutes and writing down all ideas that come to mind about the topic using complete sentences. Once time is up, writers should review the sentences to see what observations have been made and how these ideas might translate into a more unified direction for the topic. Even if sentences lack sense as a whole, freewriting is an excellent way to get ideas onto the page in the very beginning stages of writing. Using complete sentences can make this a bit more challenging than brainstorming, but overall it is a worthwhile exercise, as it may force the writer to come up with more complete thoughts about the topic.

Once the ideas are on the page, it's time for the writer to turn them into a solid plan for the essay. The best ideas from the brainstorming results can then be developed into a more formal outline.

Organizing

Although sometimes it is difficult to get going on the brainstorming or prewriting phase, once ideas start flowing, writers often find that they have amassed too many thoughts that will not make for a cohesive and unified essay. During the organization stage, writers should examine the generated ideas, hone in on the important ones central to their main idea, and arrange the points in a logical and effective manner. Writers may also determine that some of the ideas generated in the planning process need further elaboration, potentially necessitating the need for research to gather infortmation to fill the gaps.

Once a writer has chosen his or her thesis and main argument, selected the most applicable details and evidence, and eliminated the "clutter," it is time to strategically organize the ideas. This is often accomplished with an outline.

Outlining

An *outline* is a system used to organize writing. When composing essays, outlining is important because it helps writers organize important information in a logical pattern using Roman numerals. Usually, outlines start out with the main ideas and then branch out into subgroups or subsidiary thoughts or subjects. Not only do outlines provide a visual tool for writers to reflect on how events, ideas, evidence, or other key parts of the argument relate to one another, but they can also lead writers to a stronger conclusion. The sample below demonstrates what a general outline looks like:

I. Introduction
 1. Background
 2. Thesis statement
II. Body
 1. Point A
 a. Supporting evidence
 b. Supporting evidence
 2. Point B
 a. Supporting evidence
 b. Supporting evidence
 3. Point C
 a. Supporting evidence
 b. Supporting evidence
III. Conclusion
 1. Restate main points of the paper.
 2. End with something memorable.

Drafting/Writing

Now it comes time to actually write the essay. In this stage, writers should follow the outline they developed in the brainstorming process and try to incorporate the useful sentences penned in the freewriting exercise. The main goal of this phase is to put all the thoughts together in cohesive sentences and paragraphs.

It is helpful for writers to remember that their work here does not have to be perfect. This process is often referred to as *drafting* because writers are just creating a rough draft of their work. Because of this, writers should avoid getting bogged down on the small details.

Referencing Sources

Anytime a writer quotes or paraphrases another text, they will need to include a citation. A citation is a short description of the work that a quote or information came from. The style manual your teacher wants

you to follow will dictate exactly how to format that citation. For example, this is how one would cite a book according to the APA manual of style:

- *Format:* Last name, First initial, Middle initial. (Year Published) *Book Title.* City, State: Publisher.
- *Example:* Sampson, M. R. (1989). *Diaries from an alien invasion.* Springfield, IL: Campbell Press.

Revising

Revising offers an opportunity for writers to polish things up. Putting one's self in the reader's shoes and focusing on what the essay actually says helps writers identify problems—it's a movement from the mindset of writer to the mindset of editor. The goal is to have a clean, clear copy of the essay.

The main goal of the revision phase is to improve the essay's flow, cohesiveness, readability, and focus. For example, an essay will make a less persuasive argument if the various pieces of evidence are scattered and presented illogically or clouded with unnecessary thought. Therefore, writers should consider their essay's structure and organization, ensuring that there are smooth transitions between sentences and paragraphs. There should be a discernable introduction and conclusion as well, as these crucial components of an essay provide readers with a blueprint to follow.

Additionally, if the writer includes copious details that do little to enhance the argument, they may actually distract readers from focusing on the main ideas and detract from the strength of their work. The ultimate goal is to retain the purpose or focus of the essay and provide a reader-friendly experience. Because of this, writers often need to delete parts of their essay to improve its flow and focus. Removing sentences, entire paragraphs, or large chunks of writing can be one of the toughest parts of the writing process because it is difficult to part with work one has done. However, ultimately, these types of cuts can significantly improve one's essay.

Lastly, writers should consider their voice and word choice. The voice should be consistent throughout and maintain a balance between an authoritative and warm style, to both inform and engage readers. One way to alter voice is through word choice. Writers should consider changing weak verbs to stronger ones and selecting more precise language in areas where wording is vague. In some cases, it is useful to modify sentence beginnings or to combine or split up sentences to provide a more varied sentence structure.

Editing

Rather than focusing on content (as is the aim in the revising stage), the editing phase is all about the mechanics of the essay: the syntax, word choice, and grammar. This can be considered the proofreading stage. Successful editing is what sets apart a messy essay from a polished document.

The following areas should be considered when proofreading:

- Sentence fragments
- Awkward sentence structure
- Run-on sentences
- Incorrect word choice
- Grammatical agreement errors
- Spelling errors
- Punctuation errors
- Capitalization errors

One of the most effective ways of identifying grammatical errors, awkward phrases, or unclear sentences is to read the essay out loud. Listening to one's own work can help move the writer from simply the author to the reader.

During the editing phase, it's also important to ensure the essay follows the correct formatting and citation rules as dictated by the assignment.

Recursive Writing Process

While the writing process may have specific steps, the good news is that the process is recursive, meaning the steps need not be completed in a particular order. Many writers find that they complete steps at the same time such as drafting and revising, where the writing and rearranging of ideas occur simultaneously or in very close order. Similarly, a writer may find that a particular section of a draft needs more development, and will go back to the prewriting stage to generate new ideas. The steps can be repeated at any time, and the more these steps of the recursive writing process are employed, the better the final product will be.

Practice Makes Prepared Writers

Like any other useful skill, writing only improves with practice. While writing may come more easily to some than others, it is still a skill to be honed and improved. Regardless of a person's natural abilities, there is always room for growth in writing. Practicing the basic skills of writing can aid in preparations for the TEAS.

One way to build vocabulary and enhance exposure to the written word is through reading. This can be through reading books, but reading of any materials such as newspapers, magazines, and even social media count towards practice with the written word. This also helps to enhance critical reading and thinking skills, through analysis of the ideas and concepts read. Think of each new reading experience as a chance to sharpen these skills.

Developing a Well-Organized Paragraph

A paragraph is a series of connected and related sentences addressing one topic. Writing good paragraphs benefits writers by helping them to stay on target while drafting and revising their work. It benefits readers by helping them to follow the writing more easily. Regardless of how brilliant their ideas may be, writers who do not present them in organized ways will fail to engage readers—and fail to accomplish their writing goals. A fundamental rule for paragraphing is to confine each paragraph to a single idea. When writers find themselves transitioning to a new idea, they should start a new paragraph. However, a paragraph can include several pieces of evidence supporting its single idea; and it can include several points if they are all related to the overall paragraph topic. When writers find each point becoming lengthy, they may choose instead to devote a separate paragraph to every point and elaborate upon each more fully.

An effective paragraph should have these elements:

- Unity: One major discussion point or focus should occupy the whole paragraph from beginning to end.

- Coherence: For readers to understand a paragraph, it must be coherent. Two components of coherence are logical and verbal bridges. In logical bridges, the writer may write consecutive sentences with parallel structure or carry an idea over across sentences. In verbal bridges, writers may repeat key words across sentences.

- A topic sentence: The paragraph should have a sentence that generally identifies the paragraph's thesis or main idea.

- Sufficient development: To develop a paragraph, writers can use the following techniques after stating their topic sentence:

 o Define terms
 o Cite data
 o Use illustrations, anecdotes, and examples
 o Evaluate causes and effects
 o Analyze the topic
 o Explain the topic using chronological order

A topic sentence identifies the main idea of the paragraph. Some are explicit, some implicit. The topic sentence can appear anywhere in the paragraph. However, many experts advise beginning writers to place each paragraph topic sentence at or near the beginning of its paragraph to ensure that their readers understand what the topic of each paragraph is. Even without having written an explicit topic sentence, the writer should still be able to summarize readily what subject matter each paragraph addresses. The writer must then fully develop the topic that is introduced or identified in the topic sentence. Depending on what the writer's purpose is, they may use different methods for developing each paragraph.

Two main steps in the process of organizing paragraphs and essays should both be completed after determining the writing's main point, while the writer is planning or outlining the work. The initial step is to give an order to the topics addressed in each paragraph. Writers must have logical reasons for putting one paragraph first, another second, etc. The second step is to sequence the sentences in each paragraph. As with the first step, writers must have logical reasons for the order of sentences. Sometimes the work's main point obviously indicates a specific order.

Topic Sentences

To be effective, a topic sentence should be concise so that readers get its point without losing the meaning among too many words. As an example, in *Only Yesterday: An Informal History of the 1920s* (1931), author Frederick Lewis Allen's topic sentence introduces his paragraph describing the 1929 stock market crash: "The Bull Market was dead." This example illustrates the criteria of conciseness and brevity. It is also a strong sentence, expressed clearly and unambiguously. The topic sentence also introduces the paragraph, alerting the reader's attention to the main idea of the paragraph and the subject matter that follows the topic sentence.

Experts often recommend opening a paragraph with the topic sentences to enable the reader to realize the main point of the paragraph immediately. Application letters for jobs and university admissions also benefit from opening with topic sentences. However, positioning the topic sentence at the end of a paragraph is more logical when the paragraph identifies a number of specific details that accumulate evidence and then culminates with a generalization. While paragraphs with extremely obvious main ideas need no topic sentences, more often—and particularly for students learning to write—the topic sentence is the most important sentence in the paragraph. It not only communicates the main idea quickly to readers; it also helps writers produce and control information.

Vocabulary Acquisition

Context Clues

Readers can often figure out what unfamiliar words mean without interrupting their reading to look them up in dictionaries by examining context. Context includes the other words or sentences in a passage. One common context clue is the root word and any affixes (prefixes/suffixes). Another common context clue is a synonym or definition included in the sentence. Sometimes both exist in the same sentence. Here's an example:

> Scientists who study birds are *ornithologists*.

Many readers may not know the word *ornithologist*. However, the example contains a definition (scientists who study birds). The reader may also have the ability to analyze the suffix (*-logy*, meaning the study of) and root (*ornitho-*, meaning bird).

Another common context clue is a sentence that shows differences. Here's an example:

> Birds *incubate* their eggs outside of their bodies, unlike mammals.

Some readers may be unfamiliar with the word *incubate*. However, since we know that "unlike mammals," birds incubate their eggs outside of their bodies, we can infer that *incubate* has something to do with keeping eggs warm outside the body until they are hatched.

In addition to analyzing the etymology of a word's root and affixes and extrapolating word meaning from sentences that contrast an unknown word with an antonym, readers can also determine word meanings from sentence context clues based on logic. Here's an example:

> Birds are always looking out for predators that could attack their young.

The reader who is unfamiliar with the word *predator* could determine from the context of the sentence that predators usually prey upon baby birds and possibly other young animals. Readers might also use the context clue of etymology here, as *predator* and *prey* have the same root.

Analyzing Word Parts

By learning some of the etymologies of words and their parts, readers can break new words down into components and analyze their combined meanings. For example, the root word *soph* is Greek for wise or knowledge. Knowing this informs the meanings of English words including *sophomore, sophisticated,* and *philosophy*. Those who also know that *phil* is Greek for love will realize that *philosophy* means the love of knowledge. They can then extend this knowledge of *phil* to understand *philanthropist* (one who loves people), *bibliophile* (book lover), *philharmonic* (loving harmony), *hydrophilic* (water-loving), and so on. In addition, *phob-* derives from the Greek *phobos,* meaning fear. This informs all words ending with it as meaning fear of various things: *acrophobia* (fear of heights), *arachnophobia* (fear of spiders), *claustrophobia* (fear of enclosed spaces), *ergophobia* (fear of work), and *hydrophobia* (fear of water), among others.

Some English word origins from other languages, like ancient Greek, are found in large numbers and varieties of English words. An advantage of the shared ancestry of these words is that once readers recognize the meanings of some Greek words or word roots, they can determine or at least get an idea of what many different English words mean. As an example, the Greek word *métron* means to measure, a

measure, or something used to measure; the English word meter derives from it. Knowing this informs many other English words, including *altimeter, barometer, diameter, hexameter, isometric,* and *metric.* While readers must know the meanings of the other parts of these words to decipher their meaning fully, they already have an idea that they are all related in some way to measures or measuring.

While all English words ultimately derive from a proto-language known as Indo-European, many of them historically came into the developing English vocabulary later, from sources like the ancient Greeks' language, the Latin used throughout Europe and much of the Middle East during the reign of the Roman Empire, and the Anglo-Saxon languages used by England's early tribes. In addition to classic revivals and native foundations, by the Renaissance era other influences included French, German, Italian, and Spanish. Today we can often discern English word meanings by knowing common roots and affixes, particularly from Greek and Latin.

The following is a list of common prefixes and their meanings:

Prefix	Definition	Examples
a-	without	atheist, agnostic
ad-	to, toward	advance
ante-	before	antecedent, antedate
anti-	opposing	antipathy, antidote
auto-	self	autonomy, autobiography
bene-	well, good	benefit, benefactor
bi-	two	bisect, biennial
bio-	life	biology, biosphere
chron-	time	chronometer, synchronize
circum-	around	circumspect, circumference
com-	with, together	commotion, complicate
contra-	against, opposing	contradict, contravene
cred-	belief, trust	credible, credit
de-	from	depart
dem-	people	demographics, democracy
dis-	away, off, down, not	dissent, disappear
equi-	equal, equally	equivalent
ex-	former, out of	extract
for-	away, off, from	forget, forswear
fore-	before, previous	foretell, forefathers
homo-	same, equal	homogenized
hyper-	excessive, over	hypercritical, hypertension
in-	in, into	intrude, invade
inter-	among, between	intercede, interrupt
mal-	bad, poorly, not	malfunction
micr-	small	microbe, microscope
mis-	bad, poorly, not	misspell, misfire
mono-	one, single	monogamy, monologue
mor-	die, death	mortality, mortuary
neo-	new	neolithic, neoconservative

non-	not	nonentity, nonsense
omni-	all, everywhere	omniscient
over-	above	overbearing
pan-	all, entire	panorama, pandemonium
para-	beside, beyond	parallel, paradox
phil-	love, affection	philosophy, philanthropic
poly-	many	polymorphous, polygamous
pre-	before, previous	prevent, preclude
prim-	first, early	primitive, primary
pro-	forward, in place of	propel, pronoun
re-	back, backward, again	revoke, recur
sub-	under, beneath	subjugate, substitute
super-	above, extra	supersede, supernumerary
trans-	across, beyond, over	transact, transport
ultra-	beyond, excessively	ultramodern, ultrasonic, ultraviolet
un-	not, reverse of	unhappy, unlock
vis-	to see	visage, visible

The following is a list of common suffixes and their meanings:

Suffix	Definition	Examples
-able	likely, able to	capable, tolerable
-ance	act, condition	acceptance, vigilance
-ard	one that does excessively	drunkard, wizard
ation	action, state	occupation, starvation
-cy	state, condition	accuracy, captaincy
-er	one who does	teacher
-esce	become, grow, continue	convalesce, acquiesce
-esque	in the style of, like	picturesque, grotesque
-ess	feminine	waitress, lioness
-ful	full of, marked by	thankful, zestful
-ible	able, fit	edible, possible, divisible
-ion	action, result, state	union, fusion
-ish	suggesting, like	churlish, childish
-ism	act, manner, doctrine	barbarism, socialism
-ist	doer, believer	monopolist, socialist
-ition	action, result, state,	sedition, expedition
-ity	quality, condition	acidity, civility
-ize	cause to be, treat with	sterilize, mechanize, criticize
-less	lacking, without	hopeless, countless
-like	like, similar	childlike, dreamlike
-ly	like, of the nature of	friendly, positively
-ment	means, result, action	refreshment, disappointment
-ness	quality, state	greatness, tallness
-or	doer, office, action	juror, elevator, honor
-ous	marked by, given to	religious, riotous

-some	apt to, showing	tiresome, lonesome
-th	act, state, quality	warmth, width
-ty	quality, state	enmity, activity

Practice Questions

1. Which of these is NOT a good way to improve writing style through grammar?
 a. Alternating among different sentence structures
 b. Using fewer words instead of unnecessary words
 c. Consistently using one-subject and one-verb sentences
 d. Writing in the active voice more than passive voice

2. Of the following statements, which is most accurate about topic sentences?
 a. They are always first in a paragraph.
 b. They are always last in a paragraph.
 c. They are only found once in every essay.
 d. They are explicit or may be implicit.

3. Which of the following is considered criteria for a good paragraph topic sentence?
 a. Clear
 b. Subtle
 c. Lengthy
 d. Ambiguous

4. "We don't go out as much because babysitters, gasoline, and parking is expensive." Which grammatical error does this sentence demonstrate?
 a. It contains a misplaced modifier.
 b. It lacks subject-verb agreement.
 c. It introduces a dangling participle.
 d. It does not have a grammar error.

5. Which of the following versions of a sentence has correct pronoun-antecedent agreement?
 a. Every student must consult their advisor first.
 b. All students must talk with their advisors first.
 c. All students must consult with his advisor first.
 d. Every student must consult their advisors first.

6. Which version of this sentence is grammatically correct?
 a. Give it to Shirley and I.
 b. Both Choices C and D.
 c. Give it to Shirley and me.
 d. Give it to me and Shirley.

7. What parts of speech are modified by adjectives?
 a. Verbs
 b. Nouns
 c. Pronouns
 d. Both Choices B and C

8. What part(s) of speech do adverbs modify?
 a. Verbs
 b. Adverbs
 c. Adjectives
 d. All of the above

9. What accurately reflects expert advice for beginning writers regarding topic sentences?
 a. They should use topic sentences in every two to three paragraphs.
 b. They should vary topic sentence positioning in paragraphs.
 c. They should include a topic sentence in every paragraph.
 d. They should make each topic sentence broad and general.

10. Familiarity with English words like *claustrophobia, photophobia, arachnophobia, hydrophobia, acrophobia,* etc. could help a reader not knowing the origin determine that the Greek *phobos* means which of these?
 a. Love
 b. Fear
 c. Hate
 d. Know

11. Which of the following English words is derived from a Greek source?
 a. Move
 b. Motor
 c. Moron
 d. Mobile

12. Homophones are defined as which of these?
 a. They have the same sounds.
 b. They have the same spelling.
 c. They have the same meaning.
 d. They have the same roots.

13. The word *tear,* pronounced one way, means a drop of eye fluid; pronounced another way, it means to rip. What is this type of word called?
 a. A homograph
 b. A heteronym
 c. A homonym
 d. Both *A* and *B*

14. Which of these words is considered a plural?
 a. Cactus
 b. Bacteria
 c. Criterion
 d. Elf

15. Which of these words has an irregular plural that is the same as its singular form?
 a. Louse
 b. Goose
 c. Mouse
 d. Moose

16. Of the following words with irregular plurals, which one has a plural ending *most* different from those of the others?
 a. Ox
 b. Child
 c. Person
 d. Woman

17. Which of the following sentences uses the apostrophe(s) correctly?
 a. Please be sure to bring you're invitation to the event.
 b. All of your friends' invitations were sent the same day.
 c. All of your friends parked they're cars along the street.
 d. Who's car is parked on the street leaving it's lights on?

18. Of the following, which word is spelled correctly?
 a. Wierd
 b. Forfeit
 c. Beleive
 d. Concieve

19. Which of these words has the correct spelling?
 a. Insolent
 b. Irrelevent
 c. Independant
 d. Indispensible

20. Exceptions and variations in rules for capitalization are accurately reflected in which of these?
 a. *Congress* is capitalized and so is *Congressional.*
 b. *Constitution* is capitalized as well as *Constitutional.*
 c. *Caucasian* is capitalized, but *white* referring to race is not.
 d. *African-American* and *Black* as a race are both capitalized.

21. Which of the following statements is true about the Oxford comma?
 a. It is the first comma in a series of three or more items.
 b. It is the last comma in a series before *or,* or before *and.*
 c. It is any comma separating items in series of three or more.
 d. It is frequently omitted because it does not serve a purpose.

22. In the following sentence, which version has the correct punctuation?
 a. Delegates attended from Springfield; Illinois, Alamo; Tennessee, Moscow; Idaho, and other places.
 b. Delegates attended from Springfield Illinois, Alamo Tennessee, Moscow Idaho, and other places.
 c. Delegates attended from Springfield, Illinois; Alamo, Tennessee; Moscow, Idaho; and other places.
 d. Delegates attended from Springfield, Illinois, Alamo, Tennessee, Moscow, Idaho, and other places.

23. Of the following phrases, which correctly applies the rules for hyphenation?
 a. Finely-tuned
 b. Family owned
 c. Friendly looking
 d. Fraudulent-ID claim

24. What is the rule for using quotation marks with a quotation inside of a quotation?
 a. Single quotation marks around the outer quotation, double quotation marks around the inner one
 b. Double quotation marks to enclose the outer quotation and also to enclose the inner quotation
 c. Single quotation marks that enclose the outer quotation as well as the inner quotation
 d. Double quotation marks around the outer quotation, single quotation marks around the inner one

25. Which of the following phrases correctly uses apostrophes?
 a. Dennis and Pam's house
 b. Dennis's and Pam's house
 c. Dennis' and Pam's house
 d. Dennis's and Pam house

26. To make irregular plural nouns possessive, which of these correctly applies the rule?
 a. Geeses' honks
 b. Childrens' toys
 c. Teeths' enamel
 d. Women's room

27. Which of the following is a writing technique recommended for attaining sentence fluency?
 a. Varying the endings of sentences
 b. Making sentence lengths uniform
 c. Using consistent sentence rhythm
 d. Varying sentence structures used

28. Among elements of an effective paragraph, the element of coherence is reflected by which of these?
 a. Focus on one main point throughout
 b. The use of logical and verbal bridges
 c. A sentence identifying the main idea
 d. Data, examples, illustrations, analysis

Answer Explanations

1. C: Good ways to improve writing style through grammatical choices include alternating among simple, complex, compound, and compound-complex sentence structures (Choice *A*) to prevent monotony and ensure variety; using fewer words when more words are unnecessary (Choice *B*); NOT writing all simple sentences with only one subject and one verb each (Choice *C*); and writing in the active voice more often than in the passive voice (Choice *D*). Active voice uses fewer words and also emphasizes action more strongly.

2. D: The topic sentence of a paragraph is often at or near the beginning, but not always (Choice *A*). Some topic sentences are at the ends of paragraphs, but not always (Choice *B*). There is more than one topic sentence in an essay, especially if the essay is built on multiple paragraphs (Choice *C*). The topic sentence in a paragraph may be stated explicitly, or it may only be implied (Choice *D*), requiring the reader to infer what the topic is rather than identify it as an overt statement.

3. A: Criteria for a good paragraph topic sentence include clarity, emphasis rather than subtlety (Choice *B*), brevity rather than length (Choice *C*), and straightforwardness rather than ambiguousness (Choice *D*).

4. B: The sentence lacks subject-verb agreement. Three nouns require plural "are," not singular "is." A misplaced modifier (Choice *A*) is incorrectly positioned, modifying the wrong part. For example, in Groucho Marx's famous joke, "One morning I shot an elephant in my pajamas. How he got into my pajamas I don't know" (*Animal Crackers,* 1930), he refers in the second sentence to the misplaced modifier in the first. A dangling participle (Choice *C*) leaves a verb participle hanging by omitting the subject it describes; e.g. "Walking down the street, the house was on fire."

5. B: Choice *A* lacks pronoun-antecedent agreement: "Every student" is singular but "their" is plural. Choice *B* correctly combines plural "All students" with plural "their advisors." Choice *C* has plural "All students" but singular "his advisor." Choice *D* has singular "Every student" but plural "their advisors."

6. B: When compounding subjects by adding nouns including proper nouns (names) to pronouns, the pronoun's form should not be changed by the addition. Since "Give it to me" is correct, not "Give it to I," we would not write "Give it to Shirley and I" (Choice *A*). "Shirley" and "me" are correct in either position in Choices *C* and *D*. "Give it to" requires an object. Only "me," "us," "him," "her," and "them" can be objects; "I," "we," "he," "she," and "they" are used as subjects, but never as objects.

7. D: Adjectives modify nouns (Choice *B*) or pronouns (Choice *C*) by describing them. For example, in the phrase "a big, old, red house," the noun "house" is modified and described by the adjectives "big," "old," and "red." Adjectives do not modify verbs (Choice *A*); adverbs do.

8. D: Adverbs modify verbs (Choice *A*), other adverbs (Choice *B*), or adjectives (Choice *C*). For example, in "She slept soundly," the verb is "slept" and the adverb modifying it is "soundly." In "He finished extremely quickly," the adverb "especially" modifies the adverb "quickly." In "She was especially enthusiastic," the adverb "especially" modifies the adjective "enthusiastic."

9. C: Experts advise students/beginning writers to include a topic sentence in every paragraph. Although professional writers do not always do this, beginners should, to learn how to write good topic sentences and paragraphs, rather than include a topic sentence in only every second or third paragraph (Choice *A*). Although experienced writers can also vary the positioning of topic sentences within paragraphs, experts

advise new/learning writers to start paragraphs with topic sentences (Choice *B*). A topic sentence should be narrow and restricted, not broad and general (Choice *D*).

10. B: *Phobos* means "fear" in Greek. From it, English has derived the word *phobia*, meaning an abnormal or exaggerated fear; and a multitude of other words ending in *-phobia*, whose beginnings specify the object of the fear, as in the examples given. Another ubiquitous English word part deriving from Greek is *phil* as a prefix or suffix, meaning love (Choice *A*), such as *philosophy, hydrophilic, philanthropist,* and *philharmonic.* The Greek word for hate (Choice *C*) is *miseo,* found in English words like *misogyny* and *misanthrope.* The Greek word meaning wise or knowledge (Choice *D*) is *sophos,* found in English *sophisticated* and *philosophy.*

11. C: The English word *moron* is derived from the Greek *mor-* meaning dull or foolish. *Sophomore* also combines *soph* from Greek *sophos,* meaning wise, with *mor*—i.e. literally "wise fool." The words *move* (Choice *A*), *motor* (Choice *B*), *mobile* (Choice *D*), and many others are all derived from the Latin *mot-* or *mov-*, from the Latin words *movere,* to move and *motus,* motion.

12. A: Homophones are words that are pronounced the same way, but are spelled differently and have different meanings. For example, *lax* and *lacks* are homophones. Words spelled the same (Choice *B*) but with different meanings are homographs. Words with the same meaning (Choice *C*) are synonyms, which are spelled and pronounced differently.

13. D: Words that are spelled the same way are homographs (Choice *A*); if they are pronounced differently, they are heteronyms (Choice *B*). The example given fits both definitions. But homonyms (Choice *C*) are spelled the same way (i.e. homographs) AND also pronounced the same way (i.e. homophones), NOT differently. Therefore, Choices *A* and *B* both correctly describe *tear,* but Choice *C* does not.

14. B: Bacteria is considered a plural word. The singular word for "bacteria" is "bacterium." Cactus, criterion, and elf are all considered singular words, making Choices *A, C,* and *D* incorrect.

15. D: *Moose* is both the singular and plural form of the word. Other words that do not change from singular to plural include *deer, fish,* and *sheep. Louse* (Choice *A*) has an irregular plural, but it is *lice,* not the same as the singular. *Goose* (Choice *B*) has the irregular plural *geese,* also not the same as the singular. *Mouse* (Choice *C*), like *louse,* has the irregular plural *mice,* also different from its singular form.

16. C: The irregular plural of *ox* (Choice *A*) is *oxen.* The irregular plural of *child* (Choice *B*) is *children.* The irregular plural of *woman* (Choice *D*) is *women.* These irregular plurals all end in *–en.* However, *person* (Choice *C*) has the irregular plural of *people,* which has a different ending than the others. It can also be pluralized as *persons;* but this is a regular plural, not an irregular one.

17. B: The plural possessive noun *friends'* is correctly punctuated with an apostrophe following the plural *-s* ending. *Friend's* would indicate a singular possessive noun, i.e. belonging to one friend. *Friends* would indicate a plural noun not possessing anything. In Choice *A*, the second-person possessive is *your,* NOT "you're," a contraction of "you are." In Choice *C*, the third-person plural possessive is *their,* NOT "they're," a contraction of "they are." There are two errors in Choice *D*. The first possessive is *whose,* NOT "who's," a contraction of "who is;" the second is *its,* NOT "it's," a contraction of "it is."

18. B: *Forfeit* is spelled correctly. Choice *A* is misspelled and should be *weird.* Choice *C* is misspelled and should be *believe.* Choice *D* is misspelled and should be *conceive.* Many people confuse the spellings of words with *ie* and *ei* combinations. Some rules that apply to most English words, with 22 exceptions, are: I

before E except after C; except after C and before L, P, T, or V; when sounding like A as in weight; when sounding like I as in height; or when an *ei* combination is formed by a prefix or a suffix.

19. A: *Insolent* is correctly spelled. Many people misspell words that sound the same but are spelled differently by confusing the vowels *a, e,* and *i.* For example, Choice *B* is correctly spelled *irrelevant;* Choice *C* is correctly spelled *independent;* and the correct spelling of Choice *D* is *indispensable.* Confusion is increased by these variations: Choices *B* and *C* sound the same but end with *-ant* and *-ent,* respectively; and while Choice *D* ends with *-able,* other words like *irrepressible* and *gullible* correctly end with *-ible,* which is incorrect in *indispensable.*

20. C: While terms like *Caucasian* and *African-American* are capitalized, the words *white* (Choice *C*) and *black* (Choice *D*) when referring to race should NOT be capitalized. While the name *Congress* is capitalized, the adjective *congressional* should NOT be capitalized (Choice *A*). Although the name of the U.S. *Constitution* is capitalized, the related adjective *constitutional* is NOT capitalized (Choice *B*).

21. B: The Oxford comma is the last comma following the last item in a series and preceding the word *or* or *and.* It is NOT the first (Choice *A*), or any comma separating items in a series (Choice *C*) other than the last. While it is true that many people omit this comma, it is NOT true that it serves no purpose (Choice *D*): It can prevent confusion when series include compound nouns.

22. C: A city and its state should always be separated by a comma. When items in a series contain internal commas, they should be separated by semicolons. City and state are never separated by a semicolon (Choice *A*). The city and its state are never named without punctuation between them (Choice *B*). The reason it is incorrect to use all commas, both between each city and its state and also between city-state pairs (Choice *D*), is obvious: some of the names used can refer to multiple places, causing serious confusion without different punctuation marks to identify them.

23. D: One rule for using hyphens is to clarify meaning: without the hyphen in this phrase, a reader could interpret it to mean that the claim is fraudulent; the hyphen makes it clear that it is the ID that is fraudulent. Another rule is that adverbs with *-ly* endings are not hyphenated, so (Choice *A*) should be *finely tuned.* However, an additional rule is that adjectives with *-ly* endings are hyphenated; hence Choice *B* should be *family-owned* and Choice *C* should be *friendly-looking.*

24. D: The rule for writing a quotation with another quotation inside it is to use double quotation marks to enclose the outer quotation, and use single quotation marks to enclose the inner quotation. Here is an example: "I don't think he will attend, because he said, 'I am extremely busy.'" The correct usage is reversed in Choice *A.* Choices *B* and *C* are incorrect, as this would not distinguish one quotation from the other.

25. A: When two people are named and both possess the same object, the apostrophe-*s* indicating possession should be placed ONLY after the second name, NOT after both names, making Choices *B* and *C* incorrect. It is also incorrect to use the apostrophe-*s* after the first name instead of the second (Choice *D*).

26. D: Irregular plurals that do not end in *-s* are always made possessive by adding apostrophe-*s.* A common error people make is to add *-s*-apostrophe instead of vice versa, as in the other three choices. *Geese* (Choice *A*), *children* (Choice *B*) and *teeth* (Choice *C*) are already plural, so adding an *s* before the apostrophe constitutes a double plural. Adding the *-s* after the apostrophe (i.e. *geese's, children's,* and *teeth's*) correctly makes these plurals possessive.

27. D: Some writing techniques recommended for attaining sentence fluency include varying the beginnings of sentences, making Choice *A* incorrect; varying sentence lengths rather than making them all uniform, making Choice *B* incorrect; varying sentence rhythms rather than consistently using the same rhythm, making Choice *C* incorrect; and varying sentence structures (Choice *D*) among simple, compound, complex, and compound-complex.

28. B: Four elements of an effective paragraph are unity, coherence, a topic sentence, and development. Focusing on one main point throughout (Choice *A*) the paragraph reflects the element of unity. Using logical and verbal bridges (Choice *B*) between/across sentences reflects the element of coherence. A sentence identifying the main idea (Choice *C*) of the paragraph reflects the element of a topic sentence. Citing data, giving examples, including illustrations, and analyzing (Choice *D*) the topic all reflect the element of developing the paragraph sufficiently.

Photo Credits

Greetings!

First, we would like to give a huge "thank you" for choosing us and this study guide for your TEAS 6 exam. We hope that it will lead you to success on this exam and for your years to come.

Our team has tried to make your preparations as thorough as possible by covering all of the topics you should be expected to know. In addition, our writers attempted to create practice questions identical to what you will see on the day of your actual test. We have also included many test-taking strategies to help you learn the material, maintain the knowledge, and take the test with confidence.

We strive for excellence in our products, and if you have any comments or concerns over the quality of something in this study guide, please send us an email so that we may improve.

As you continue forward in life, we would like to remain alongside you with other books and study guides in our library. We are continually producing and updating study guides in several different subjects. If you are looking for something in particular, all of our products are available on Amazon. You may also send us an email!

Sincerely,
APEX Test Prep
info@apexprep.com

FREE

Free Study Tips DVD

In addition to the tips and content in this guide, we have created a FREE DVD with helpful study tips to further assist your exam preparation. **This FREE Study Tips DVD provides you with top-notch tips to conquer your exam and reach your goals.**

Our simple request in exchange for the strategy-packed DVD is that you email us your feedback about our study guide. We would love to hear what you thought about the guide, and we welcome any and all feedback—positive, negative, or neutral. It is our #1 goal to provide you with top quality products and customer service.

To receive your **FREE Study Tips DVD**, email freedvd@apexprep.com. Please put "FREE DVD" in the subject line and put the following in the email:

a. The name of the study guide you purchased.

b. Your rating of the study guide on a scale of 1-5, with 5 being the highest score.

c. Any thoughts or feedback about your study guide.

d. Your first and last name and your mailing address, so we know where to send your free DVD!

Thank you!

11063570R00107

Made in the USA
Lexington, KY
05 October 2018